CÉZANNE

The eye and the mind

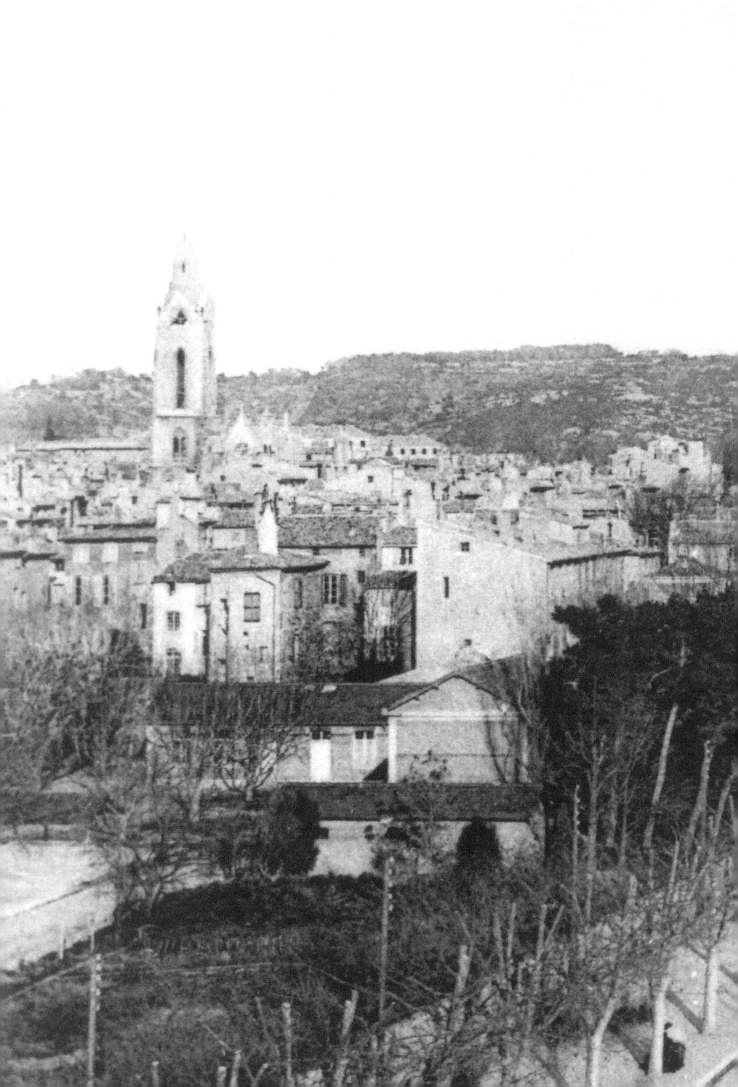

CÉZANNE
The eye and the mind

Pavel Machotka

ÉDITIONS CRÈS

Sponsored by

IMAF
INTERNATIONAL
MUSIC & ART
FOUNDATION

Contents

Acknowledgments

It is only after a text has been written that an object called "book" is imagined at the center of a ring formed by the friends who had helped the author write it. But there is never any ring; there is instead a movement through time, a slow congealing from nebulous impulse to presentable artifact. With this book, it is Gillian Malpass who stands at the nebula stage; she asked me many years ago if I might not have a broader book in mind than the one I had just published on Cézanne's landscapes. I replied with a hazy image of a book describing an "ideal" exhibit of Cézanne paintings; and this imagined exhibit became, with time, a book about Cézanne's development and the workings of his paintings - with a broader reach than any possible exhibit and yet, one hopes, with room to breathe and to wish for more. Standing at many points in the book's development, with criticism, advice and other help, are Jeanne Bouniort, Philippe Cézanne, Pierre Chiapetta, the late Philip Conisbee, Denis Coutagne, Barbara Divver, Walter Feilchenfeldt, Alex Fleming, Jacob Mayne, Xavier Prati, Theodore Reff, Georges Renaud, Richard Shiff, Ted Silveira, Jean-Pierre Silvy and Jayne Warman. Toward the end there appears the International Music and Art Foundation, which made the publication possible. At the very end (and also at many points in between) stands my wife Nina Hansen, who compiled an index that so faithfully reveals what the book is about that it might well be placed at the front, in place of the customary table of contents. When she was done, she knew the text much better than I.

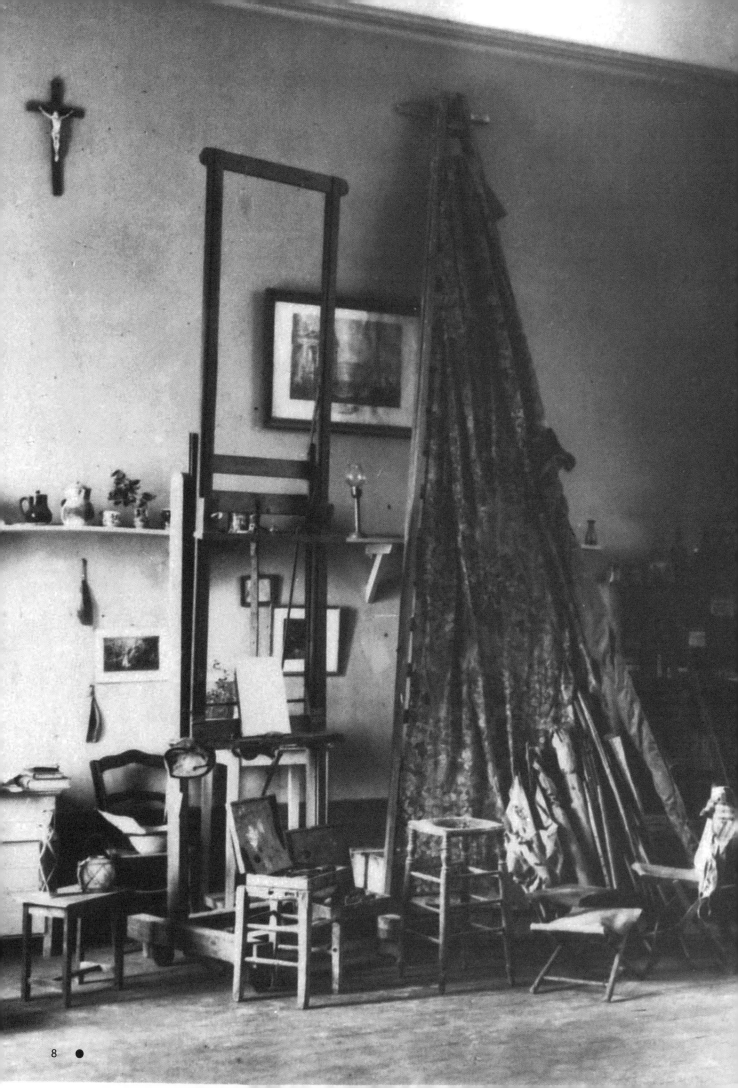

Preface

When understood,
Cézanne's achievement is
universally compelling
without dependence upon
age, mood or preference[1].

Cézanne's studio at Les Lauves,
photo : John Rewald, ca. 1935.

1 - Adrian Stokes, *Cézanne*, p. 2.

Cézanne holds a crucial place in the development of painting in the West: he stands at the pivot of our tradition of representation. He had perfected the art of representing, that is, of creating a convincing analog of the substance, color, and balance of things, yet, by his unending search for schemas that would be adequate to that vision, he radically undermined the commonly understood purposes of painting. Paradoxically, his canvases give us the sense of things as they are, but they also open the way toward abstraction. That is a critical and finely balanced position to occupy.

But his paintings are unique apart from their place in history. They are sensuous yet complex, passionate yet ordered; they elude the major artistic categories, such as the Romantic and the classical, and in so doing they transcend them and make them irrelevant. Viewed as expressions of an individual character, they make visible his fertile internal oppositions: the conflicts between vigorous impulse, passionate investment in color, close observation, and clear thought. But above all, imagined on an easel without a frame, well before they have become objects of reverence on a museum wall, they invite us to study their touches as if we were following the painter at work, as he considers the effect of each touch on the rightness of the portrayal and on the wholeness of the composition. We do not need to be right – we will never know if we were – but simply following up the invitation is enough to force us to look at the paintings in a new way.

Our response to the paintings can be immediate, untutored in art history – as immediate as the response of the few of his contemporaries who admired his work and who could not have known what place in the history of art the paintings would occupy. Among them were Pissarro and Renoir, fellow painters, and Geffroy, a critic; but younger painters, too, responded to the paintings and wrote about them with informed admiration, and the most perceptive of these, Maurice Denis, was able to formulate a judgment that seems balanced a full one hundred years later[2].

My own response to the first Cézannes I saw, as an adolescent visiting the Chicago Art Institute, was also innocent of art history and equally immediate and overwhelming. I then had the sense that I was looking at painting of remarkable power, painting that was at once a vigorous construction guided by a clear mind and a firm hand, and a revelation of the way things really were.

Of course, like everyone, I would later come to see more and find new words for expressing it. The paintings would represent a fine balance between passion and reason, for example; or they would unite an intense attachment to seeing with a thoughtful system of representing; or they would achieve a wholeness of being from the fragments of our perception. Inevitably, the initial response also became informed by all that I learned, as well as by my own painting and teaching; but, as aware as I have to be of Cézanne's place in the history of painting, I am most alive to the paintings themselves, and see them afresh whenever I return to them after a time.

This sense of Cézanne's showing us things as they really are has remained, and I can now perhaps come closer to defining it. Sometimes one feels that it is Cézanne's use

2 - *Denis wrote:* "He is at once the culmination of the classic tradition and the product of the great crisis of freedom and light that rejuvenated modern art. He is the Poussin of Impressionism. He has the fine perception of a Parisian and he is as sumptuous and abundant as an Italian decorative painter. He is as ordered as a Frenchman and as fevered as a Spaniard. He is a Chardin of decadence and sometimes he even surpasses Chardin. There is a bit of El Greco in him and often he has the health of Veronese. But whatever he is, he is natural, and all the scruples of his will and all the assiduousness of his work only serve and heighten his natural gifts." *See M. Denis in Michael Doran,* Conversations avec Cézanne, *Paris, Macula, 1978, and in English translation at Berkeley: University of California Press, 2001, p. 179 in both editions. (The page numbers in the two editions are nearly identical.) Richard Shiff, in* Cézanne and the End of Impressionism, *reminds us that Denis had influenced Roger Fry.*

of edges that creates the sense of reality – they are defined and firm where they need to separate an object from others, fluid or multiple where they need to create a connection. At other times it is his sense of space – neither illusionistic nor flat, but always progressing in depth by calibrated steps. Yet at other times it is his color – always balanced, brilliant in relationships even when muted in its elements, an intrinsic part of form. Sometimes it is the balance between compositional tension and resolution. In his late landscapes – in those where he had started with detached patches and found that they resisted being brought together – it is the relationships that he has set down; they convey a sense of unerring discovery. Perhaps all this is a way of saying that Cézanne calls our attention to the substance of the things we see, to the relationships that exist between them, and to our ways of seeing them, all at once.

The personal response to what Cézanne had integrated and balanced in his paintings, and the historical judgment of his crucial position, are ultimately very close, but they are not identical. My emphasis in this book is on the first – on the complex internal workings of the paintings and the form and dynamics of the painter's development – and I make every effort to judge Cézanne's greatness from what he had achieved rather than from the movements he had inspired. This is of course an idealized position, because we cannot suppress what we had once learned, but I shall make every effort to look at the individual paintings as attainments of the moment rather than anticipations of things to come. As a means to this, and also for its own sake, I shall take up the paintings' rich invitation to look carefully and critically, and try to describe the craft that makes them "work".

Readers familiar with Cézanne literature may point out that something like this had already been done in 1927, by Roger Fry, and developed by later writers; and they would be right. Fry achieved the rare feat of communicating a responsive and authoritative understanding of Cézanne's character and his paintings, and convincing us, after reading his book, that we know the painter better. He showed us how the paintings might be looked at, connected their particular power to Cézanne's life, and conveyed the sense of awe that a sensitive critic and fellow painter feels before Cézanne's best paintings. But if his book has a blemish, it is one of brevity: when we have finished it, we may wish that he had gone on. Turning to later writers we can rely, as I have, on Meyer Schapiro, Lawrence Gowing, Richard Verdi, and Paul Smith[3], to illuminate Cézanne's paintings with an equal sensibility; but, regrettably, none have left us with a comprehensive account.

Not only is there room, then, for such an account, but there is also a need for incorporating into it the many paintings that have come to light since then – culminating in Rewald's 1996 publication of a revised catalogue raisonné; *The Paintings of Paul Cézanne*[4] – and taking into account the more recent research that sheds light on innumerable questions of context, dating, and influence. In thinking these matters through, I have come to weigh or interpret some things differently than Fry. For example, I express not just admiration but also reservations about the civilizing influence of Pissarro on Cézanne's painting; I emphasize, unlike Fry, Cézanne's efforts to resolve his work – even his early work – through consistent style; and unlike him

3 - Roger Fry, Cézanne: A study of his development, *Chicago, University of Chicago Press, 1989; Meyer Schapiro, Cézanne, New York, Abrams, 1952; Lawrence Gowing, esp. "The Logic of Organized Sensations," in William Rubin (ed.),* Cézanne: The Late Work, *New York, The Museum of Modern Art, 1997; Richard Verdi, Cézanne, London, Thames and Hudson Ltd, 1992; and Paul Smith,* Interpreting Cézanne, *London, Tate Publishing, 1996*
4 - Rewald, John, The Paintings of Paul Cézanne, *New York: Abrams, 1996 (henceforth, PPC).*

I give equal weight to other touches than the well known parallel touch. In order to pay due respect to Cézanne's exceptional intelligence, I view his provocative narrative paintings as self-conscious, wry, or ironic comments rather than sincere and overheated expressions. Sometimes I arrive at conclusions I would not have anticipated, as when I come to see Cézanne's portraits as reflecting a closeness and openness to his sitters, or at least to the sitters he knew well, rather than an impersonal detachment.

And I find evidence for a specific source for his progression toward abstraction, more specific than his mastery of technique: his emotional stance toward northern landscapes. There, he appears distant and analytical, whereas in the south he has always been closely attached and fervent; and there, in the late 1880s and early 1890s - years of rapid stylistic evolution - his touch develops more quickly. Now his first lay-in notations become unstudied and informal, and his finished surfaces become more rhythmic: these are precursors of the color patches that inform all his late landscape work, whether northern or southern.

Above all, I place much greater emphasis on Cézanne's need to integrate the contradictory aspects of his personality, and in this I am aware of being influenced especially by Schapiro; his view of Cézanne as someone who transcended opposites speaks as clearly to the complexity of his art as to the psychological work of integrating his own character. If in the process I also redress the older emphasis on the pathological aspects of Cézanne's nature, I find myself in the company of the most recent writers such as Andersen[5].

This book is a critical study, not an art historical one. It is informed by recent art historical research, but cites only a small fraction of it. This is in large part because a critical analysis of paintings is either right or wrong in its own terms, or at least suggestive and challenging, but is neither proved nor disproved by citing others, however much I may have learned from them. And it is a critical study without a thesis, unlike for example the books by Novotny and Loran on Cézanne's effect on renaissance perspective[6], because such theses, which were appropriate when Cézanne's effect was first being assessed, are no longer needed; nor do I wish to reduce what I think is crucial about his work to a single issue. My attention is focused on the paintings themselves.

The admiration I express here for Cézanne's mastery of the conflicting purposes of painting does not blind me to the instances where he falls short. At times we see an awkwardness in execution, or an obstinate reworking of parts of the canvas, which call attention to the conflicts that may have been at work. Some conflicts, such as that between the wish to represent a scene as one sees it and the wish to paint a coherent, balanced, complete composition, are of course inherent to painting. A painter can seldom do both equally well, and must settle for a compromise that works. This is saying nothing new in general, but in Cézanne's case this challenge is specific and documentable. Photographs of his landscape sites[7], and of models who posed for his portraits, let us glimpse the work that had to be done in order to resolve the two wishes, and the occasional peculiarities of his handling call attention to the rare but distinct problems he could encounter. Other conflicts are Cézanne's own, or of his own intensity. They include the well known ambivalence about physical

5 - Andersen, Wayne, The Youth of Cézanne and Zola, Geneva and Boston: Editions Fabriart, 2003.
6 - Fritz Novotny, Cézanne und das Ende der wissenschaftlichen Perspektive, Vienna, 1938, and Erle Loran, Cézanne's Composition, Berkeley: University of California Press, 1985 (1944).
7 - See Erle Loran; Rewald, PPC, passim; and my Cézanne: Landscape into Art, London and New Haven: Yale University Press, 1996.

closeness, which leaves traces in some of his paintings, and the related wish to paint bucolic scenes of bathers, both of which can compete with the formal, compositional needs of his paintings.

Cézanne's paintings in fact seem to me all the more powerful because they often reveal the competing needs that informed their creation. The dilemmas are evident in narrative works, landscapes, and portraits, as I try to make clear in the introduction that follows, but not in the still lives; there they are barely visible. And I must admit that I am unable to decide whether I am more moved by the revelations of conflicting purposes or by the perfect compositions that reveal none - which are for the most part the still lives - but this is not a matter on which my feelings need to be clear.

One of Cézanne's extraordinary accomplishments is to have contributed decisively to three genres of painting - landscapes, portraits, and still lives - and, at times obstinately, at other times heroically, to works of imagination or narrative. This is something about which I do wish to be clear, and I have organized the book to reflect the distinctness of each of these contributions. I divide each chapter into these four parts and discuss the paintings and the painter's development separately; then, to make clear the accomplishments of the period, I bring the strands together. This gives, I hope, full due to what we can see of the differences in the painter's process, as well as a sense of his overall development. It also calls attention to his technical and aesthetic achievements rather than to his biography or psychology, which, though crucial in other contexts, can here remain implicit. After Chapter 1, where I locate Cézanne in his setting, both in his native Aix and in French painting of the time, I introduce the indispensable biographical facts only in connection with his work; I have to let a portrait of the man emerge by degrees, parallel to his work, and to refer the reader to John Rewald's biography, *Cézanne*, for a full account of his life. Only in the last chapter do I need to begin with a portrait: there, the vivid observations of the young painters who visited him in his last years, and the record they have left of his views on art, are too vital to leave out.

The canvases themselves tell us that Cézanne's relentless efforts to integrate his canvases were, in part, attempts to resolve the keenly felt dilemmas of painting, and as such are among the highest examples of the painter's craft. They can also be seen, however, as symbols of a search for personal wholeness, as reminders that some of the artist's work reflects his attempts to integrate his life. The dilemmas of the one are not the same as the contradictions of the other, but they are connected at least in part.

Where now we admire the successful resolutions of what we define as conflicts, Maurice Denis, at the beginning of the twentieth century, saw a brilliant fusion of the reasoned and the passionate, of the classic and the modern. Cézanne's art is all of these things, but we have to step back and remind ourselves that such abstractions - no matter how apt - should serve as no more than an introduction to the study of his work. His work is best seen close up, by an eye open to the workings of the paintings, open to the rich interplays of forms and alert to the just perceptible dilemmas. That is what is meant by "looking hard": an attitude that, however flexible and individual, needs to be the basis of any evaluation of Cézanne's work ■

Introduction:
Looking "hard"

To this feat of concentration
there is perhaps
no parallel in any of the art[8].

Note on titles
The titles of the paintings and
the watercolors are in French, following
the catalogues raisonnés of John
Rewald, *The Paintings of Paul Cézanne*
and *Paul Cézanne: The Watercolors.*
The titles of the drawings, on the other
hand, are in English, as they appear
in the catalogue raisonné by Adrien
Chappuis, *The Drawings of Paul Cézanne.*

La Route du Tholonet,
photo: John Rewald, ca. 1935

8 - *Adrian Stokes, referring to Cézanne's*
power to create at an intense level; p. 4.

● 1 5

I am well aware that two observers, both looking intently at a painting, may not look at it in the same way; there is no single formula, no ideal procedure, no guarantee of arriving at quite the same point. When I speak of looking hard at Cézanne's paintings, I rely on the way they engage me. If the reader, in following my words, finds something about a painting more important than I, or less so, that is only as it should be. As I write, especially about painting, I anticipate a response or a construction that is the reader's own, personal and perhaps quite idiosyncratic. I see myself as inviting a conversation — whose other end I am afraid I cannot hear - one in which the reader, in responding, will be creating a parallel world, in this case a Cézanne that is not necessarily mine but is nevertheless vivid and alive.

I am in any case confident that even if there are no formulas for studying a painting's form, there is a shared core in our approach, however individually shaped or emphasized. There are, I think, two preconditions for this: one is that, to feel the inner workings of Cézanne's paintings, we must look at them with something of the patience with which they were composed. This, too, is a dialogue, but one that takes place between the viewer and the painting; it is more akin to an exchange - receptive and responsive - than to an interview that asks all the questions - grasping and possessive. It is a process where - this is the second condition - we balance what is going on inside us (our state of mind, our free associations) with a responsibility to the painting, to its touch, the relationships of its shapes and colors, the physical work of the painter; we balance what we imagine the painter may have wanted to say with seeing clearly what he did paint and how he painted it. But with due allowance for the former, the emphasis must be on the latter.

Cézanne's paintings are unusually complex in their structure, certainly more so than those of his contemporaries, and invite the kind of looking that will reveal it. Their parts, at their points of contact, are both connected and separated with great care, and across broad areas of the canvas they are linked by a kind of resonance between similar forms; their finely balanced colors, not invariably intense individually, are always intense in relationship to each other. Looking at a painting we may not be aware of these complexities at first, but we may have a profound sense of wholeness; then, as we look, the parts may become distinct and their connections visible.

Hard looking is the rightful counterpart to the painter's work and the source of the observer's deepest pleasure. With Cézanne, it is also the beginning of the most interesting questions about him. His paintings sometimes leave traces of his decisions; we may find ourselves asking why he made this or that choice or what it is that he wanted to achieve, and doing this, we have the impression of following him at work. We do not always ask such questions of other great painters; my impression is that painters of a greater facility, such as Degas, Manet or Toulouse-Lautrec, tend to evoke more forthright, less puzzled, admiration.

We tend to ask such questions particularly when we sense Cézanne's difficulty in bringing things together. Bathers may seem too formally arranged, with the needs of the composition taking precedence over gracefulness and play; landscapes may be punctuated by unfinished sections, or complicated by transparent outlines of indecipherable objects. We may then wonder if Cézanne was working to achieve conflicting purposes, or whether he had intended the puzzling elements to remain, or whether he just failed to notice them. Sometimes the answers are found in his writings, at other times they are suggested by looking hard at the paintings, and at times there are no answers; but even then we understand the paintings better for having asked the questions - because it means that we had been looking at their form. In addition to questions about individual canvases, there are general questions

9 - See examples throughout this book, as well as my Cézanne: Landscape into Art (1996), esp. pp. 52-54.

about Cézanne's relation to the givens of vision. We have clear evidence that his landscape pictures depended upon an intense visual study of his sites, and yet they are resolved and integrated as compositions; how, then, does he cope with an unbalanced site, unsatisfactory colors, or unwelcome detail? Does he avoid problematic sites, or does he accept them and impose his own order on them? Clear answers are possible where landscapes are concerned[9], but portraits raise the question, too, in a related form: it is the problem of transforming likeness, with its many accidents of form, into an interesting composition - or more exactly, choosing what sacrifices to make in order to achieve a balance.

By looking closely at a few examples of his late work I will make the dilemmas of finding satisfactory form more explicit, and also outline what I wish to do in this book: to articulate what I think Cézanne intended to realize in his paintings, describe how he did it, and trace the paintings' development - their intended aims and their styles - over the course of his working life. Ideally, a comprehensive study would give equal emphasis to drawings and watercolors, but then it would be much too long. The paintings are central to his work (although in sheer originality some of the late watercolors surpass them); there is no escaping their physical size, material substance and utter commitment of purpose, no matter how deep one's admiration for the drawings and watercolors. Here we can do no more than ask the latter to help us understand the former, and hope that someday the watercolors will become the subject of their own, comprehensive study.

Drawings reveal what is essential to Cézanne at a given moment, and it is not always the same: the grace of an outline, the nervous intensity of a movement, the crucial traits of a face, or the articulations of houses and trees. Watercolors show how the fundamental relationships of color can reconstruct spaces and objects; with their schematic notations, their omission of all that is unnecessary, their rhythm of voids and solids, they clarify what a canvas might attempt to achieve. Being lighter in purpose and freer in execution, the drawings and watercolors reveal Cézanne's intentions at once, with less labor and no contradiction. Often they are great works in their own right, of course - full grounds for the kind of fame he achieved in painting.

The purposes visible in his paintings, their dilemmas and resolutions, are different in narrative paintings, landscapes, portraits and still lives. For technical reasons, they are different again in the drawings and the watercolors: drawings must do their work with abstract means such as line, edge, and shading, while watercolors (in Cézanne) work by color relationships and intimations of objects and spaces. All four genres need to be introduced, and this is best done with pictures from his maturity, because in them the balance between his competing aims is in the firmest equilibrium.

NARRATIVE WORKS

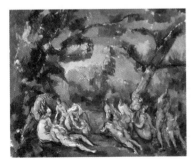

A picture of bathers (*Baigneuses*, R859[10], 1899-1904) introduces Cézanne's narrative work and the complexities of giving expression to imagination: it points up the uneasy relationship existing in his work between formal satisfactions and the portrayal of bucolic happiness. This picture is fluid and free in some parts, but mechanical and repetitious in others; its touches are impulsive and animated in the bodies, with each curving stroke of liquid paint suggesting a

BAIGNEUSES

(R859), ca. 1899-1904,
51 x 62 cm.
Art Institute, Chicago.
Volume 1 number 2.

10 - *Numbers preceded by an R refer to oil paintings described in Rewald's catalogue raisonné,* The Paintings of Paul Cézanne *(henceforth* PPC*), while watercolor numbers from his* Paul Cézanne: The Watercolors *will be preceded by an RW. Whenever I mention a painting without being able to include an illustration, I refer the reader to Volume II of* PPC*, which contains black and white reproductions of all of Cézanne's paintings.*

part of the outline and caressing it, but they are schematic and dry in the foliage and the sky, where short, straight lines abut the branches and do little more than line up along their edges. The touches that outline the bathers, however, are marvels of approximation, with each one defining the form better and setting it more firmly in its space, and paradoxically also leaving the outlines ambiguous – as if the painter wished to retain the individuality and sensuous impulsiveness of each touch and to make sure that the figures would not become too detached from their background. Some of the accumulated touches serve to firm up not the bodies but the composition: the prone bather just to the right of the central gap, for example, is connected to the grassy bank by a firm line, so firm that we see her more as an emphatic, abstract diagonal than as a coherent body – and indeed, that diagonal line is but the clearest of many other diagonals that outline the torsos, or limbs, of each of the bathers in the scene. So these are indeed bathers – at rest, stretching, preparing to go into the water – but they are also willfully arranged forms that make up a set of parallel or competing diagonals.

So important is the bathers' movement on the canvas that they have no heads (or very small ones) and no feet, because – we cannot help thinking – the heads would distract from the simple diagonal thrusts, and the feet would block them altogether. Now we can see the importance of the figure on the far left, which pushes back against this movement and contains it, and the tree on the right, which echoes that push and supports it: the painting is obviously a composition of balanced diagonals. The tree is so emphatic in its purpose that it sports the most unlikely foliage and, where it would make awkward contact with the bather at its base, evaporates into a mere outline; but there is also a graceful figure further to the right, borrowed as we shall see from compositions of male bathers (for example, *Le Bain*, p. 110) whose curved pose aligns without effort with both of the trees.

In our judgment, what weight should we give the portrayal of the scene, and what weight should we give the well-integrated composition of competing diagonals and the delicately balanced cool and warm tones? It may well depend on the purposes that we read into the painting. If it is a study for *Les Grandes baigneuses* (R855, p. 209) in the National Gallery in London, then we may be off the hook, so to speak; we will read our judgment of the more finished painting into this one. But if it is a painting in its own right, then we have to opt for the formal reading and find our satisfaction in the composition, color, and line; that is because we have no idea what is going on in the scene. This smaller picture is freely painted and sensuous, at least in the figures, so we may take pleasure in the freedom of expression Cézanne enjoyed in the smaller format, where the stakes were less high.

We may be tempted, then, to respond to the felicitous composition and dismiss the scene. But in the bather pictures the scene cannot always be dismissed, at least not without missing something important. There is a version of the great bathers, in the Barnes Foundation (R856, p. 207), in which an ambiguous figure, with a phallic stump for a head, looms at the left and startles two of the bathers; surely there is a narrative implied, probably not a pleasant one, that we cannot ignore. We do not know what it is, but we may become aware that the menace creates a tension that heightens our response to the painting as a whole. We can turn to the deep blues and greens and the luminescent flesh tones with relief and see them all the more vividly. In other pictures – for example, *L'Eternel féminin* of about 1880 – our reading of the narrative will be crucial: seen as a personal

11 - *The drawings are referred to by the numbers from the catalogue raisonné of Adrien Chappuis,* The Drawings of Paul Cézanne, *1973. I have chosen a sketch to discuss, rather than any of the beautiful drawings Cézanne was doing after sculpture at the same time, because an actual body, real or imagined, posed more of a challenge to him than a painted or sculpted one.*

fantasy, it will appear crude, while seen as an illustration of a novel by Zola it may become ironic and skillfully condensed. Even its formal excesses will seem purposeful.

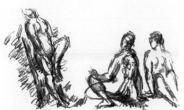

THREE WOMEN BATHERS

(C1104), ca. 1894-98, 13 x 19 cm. Carl Roesch, Diessenhofen. *Volume 1 number 1.*

In the narrative paintings, then, the relation between subject and form varies. In drawings and watercolors, on the contrary, we seldom feel any disjunction. Perhaps we see them not at all as scenes but as works splendidly revealing the painter's hand, and perhaps Cézanne himself was more at ease doing them, either because they were small or because they had none of the rhetorical seriousness of paintings. However we explain our simpler response, we seem never to worry about the story they might tell or how well they do it. We will look at the small, contemporary drawing (*Three women bathers*, C1104[11]) as intended only to work out the formal relations between the three figures; they are separated by empty space and then joined again by the gaze that the two seated bathers direct toward the standing one[12]. Two proposed formal arrangements underscore the importance of the composition: in one the left shin of the middle figure echoes the tree, while in the other the shin connects with the ground - each position offering one or another compositional advantage. The touch is free and firm, the bodies convincing - and, thanks again to the stakes being low, form can merge without effort with narrative purpose, such as it may be.

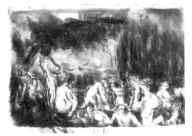

BAIGNEUSES

(RW609), ca. 1903, 22 x 32 cm. Private collection, Zurich. *Volume 1 number 3.*

The two purposes remain integrated in a splendid watercolor from about 1903. It is larger than the drawing, finished, and perhaps because it does not anticipate any painting that we know, self-sufficient. Its purpose, then, is more weighty than that of the drawing, yet its realization remains just as free. The bodies are fluid and convincing whether at rest or in motion; they occupy their space easily - neither too densely nor too sparsely - and they point unobtrusively to a single focus, a figure standing with its arms crossed. The color scheme is a marvel of economy and richness. Moody in its blue cast, it is also harmoniously balanced: limited to three colors (blue, green and an orange brown), it achieves both the suggestion of flesh tones in a dense, sylvan vegetation and a formal balance between the warm and the cool hues. If the trees are less convincing than the bodies (as in the oil painting with which we started), we seem not to notice; the teeming figures and their impulsive outlines are what commands attention. If there is more than a hint of narration - the standing figure is male, and we can think of his stance as possessive, voyeuristic, fatherly, or protective - it is immaterial; the narrative subject remains a mere suggestion, while the formal realization is clear and masterly. Cézanne's loose handwriting, here as in the drawing, is free of the tensions that pervade the paintings.

LANDSCAPES

Cézanne's landscape work exemplifies different tensions. They are not visible in the relation of subject to form - his landscapes are well resolved and betray no conflict over their subject - but are inherent in the process of representation. Any painter who relies on the data of vision must in some way reconcile them with the requirements of form, and in Cézanne the need for reconciliation was particularly acute. He paid unusually close attention to

12 - *The standing figure and the middle figure make their way into the Barnes* Les grandes baigneuses *(R856), but in an entirely different arrangement.*
13 - *That this was a key to Cézanne's work was clear to the young painter Maurice Denis, who visited Cézanne in 1906 and published his critical observations on his painting a year later. In his very perceptive comments he always mentions Cézanne's intense observation and search for style in the same breath. For example, "Nothing is less artificial, let us note, than this effort toward a just combination of style and sensibility." Or "It is the eternal battle between reason and sensibility that forms saints and geniuses." Or, finally, "Synthesizing is not necessarily simplifying in the sense of suppressing certain parts of the object: it's simplifying in* the sense of making intelligible... *submitting each painting to a single rhythm...." (In P.M. Doran, ed.,* Conversations avec Cézanne, *Paris: Macula, 1978, pp. 171, 174, and 179; my translation.) For specific evidence of the relation of reason to sensibility in landscape painting, see Chapter 3 of my* Cézanne: Landscape into Art.

**ROCHERS
PRÈS DES GROTTES**
(R 909),
ca. 1904, 65 x 54 cm.
Musee d'Orsay, Paris.
Volume 1 number 6.

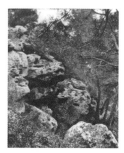

**ROCHERS
PRÈS DES GROTTES**
*Photo:
John Rewald, ca. 1935.*

the givens of perception - the structure, balance, and color relationships of his motifs - and he strove to reconstruct those givens with a variety of systematic ways of setting down his touches of paint[13]. And yet the representational and formal requirements, both so deeply felt, seemed easier to resolve than the dilemmas of narration.

To appreciate the need for reconciliation, we need to look at a painting in relation to its site. To see *Rochers près des grottes au-dessus du Château Noir* (R 909, c. 1904) by itself is to respond at once to its firm shapes and sensuous color. It is a picture of an outcropping of rocks in full sun, in front of a group of small trees, but it seems more than that: it is a complete, self-contained universe of balanced forms. Its dark cobalt sky, for example, painted with a denseness identical to the denseness of the rocks and trees, becomes an opaque surface claiming an equal footing with the solid masses. The rocks seem to lean forward, to the right - so suggests the precarious one at the top left, and the leaning vertical edge of the one in the middle - and the trees, both their trunks and their branches, lean with them. Whatever unease we might feel at this is relieved by the rock at bottom right; it not only sits firmly in place, but its surface, made up as it is of overlapping patches that lean to the left, pushes back. In fact, a substantial branch at the upper right does the same, in very much the same direction, and these balancing pushes come to a perfect resolution. (It should be added that in this respect the rock in the lower left is neutral: it is balanced internally between the brushstrokes and the lines across them.)

The colors are equally balanced: warm Naples yellows[14] and related red-browns are opposed to the cool cobalt blues, together forming the main axis of the color scheme, and dull greens are opposed to red-violets to form a secondary, less conspicuous one. The red-violets are admittedly scattered in the shaded parts of the scene, but though they are neither easily seen from a distance nor visible in reproduction, they contribute materially to the balance. But surely it is the rich integration of the blues with the yellows in the rocks themselves that moves us the most: being so tightly woven together they each make the other seem more brilliant. (The excuse, as it were, for combining the blues and yellows so intimately is that the blues indicate the cool shadows against the sunlit highlights.)

In a way we know everything there is to know about this painting simply by looking at it closely - so complete and resolved does it appear. But if we look at a photograph of the site, even a black and white one taken some twenty-five years later, we will see that the painting is a reconstruction of what Cézanne saw and that it is built up by a number of devices (of his own invention). These devices are the patches of color that he used in his late landscapes. At times they stand for the painter's observation: in the one rock at lower right, for example, the patches are laid down so that one lies above another - the lower one closer to us than the higher one - and the rock's surface is seen to recede in space, as it did in fact. This serves the needs of representation and composition equally well. At other times, however, they have little to do with the actual shapes and much to do with their role in the composition: they are horizontal where stability is needed and variously tilted where an interplay of dynamic pushes is required.

This single example is enough to say that the needs of the painting and the data of vision may be independent and require resolving, even though in this painting they have been resolved unobtrusively - with two exceptions. There is here a tension less well resolved; it is visible in the rock in the lower right, in two puzzling details. Some dark patches on its surface are not bounded on top like the others but are irregular or round, of a dark, dull green, and seem not to lie in the same plane as the others. The photograph explains

14 - *Naples yellow is a brownish yellow, closer to the color of straw than to yellow. Cézanne used it routinely in preference to lemon yellow, but there are some brilliant exceptions to this practice—see, for example, the scarf of* Jeune italienne accoudée *(p. 233) from c. 1900.*

why: they indicate the spots of lichen that dot the stone near the bottom. Even more puzzling, and not explained by the photograph, are the three double lines crossing the rock. Here I must make a conjecture - I think safely, on the evidence of another painting: they stand for saplings that Cézanne found inconvenient because they would clash with the trees above, but that he could not bring himself to suppress altogether. Just this degree of scrupulousness can be found, in fact, in the painting *Dans le parc du Château Noir* (R878, c. 1898), where Cézanne cannot quite conceal the evidence of an intrusive tree and paints in a dotted double line to indicate where it was[15].

The evidence of landscape photographs suggests that most of Cézanne's sites were well balanced to begin with, which would lessen the tension between the givens of vision and the needs of form. It would not lessen the work of integrating the canvas, of course - the process of giving rhythm to the surface so that the painting looks to the observer to be complete in itself. But when the physical landscape failed to be balanced, the tension would require the additional work of deciding in favor of one or the other requirement. This might involve color, where the resolution would always be made in favor of balance, with Cézanne typically modifying the color green to make a better balance between blues and yellows[16]. Or it might involve shape, with Cézanne simplifying a composition by suppressing one or another inconvenient object, as in the Château Noir painting, or redressing an imbalance by tilting a horizon (as in *Rochers à L'Estaque* in Chapter 3). Nevertheless, he altered shape only with reluctance, as if shape were a more fundamental or intractable "given" than color, one that might be reoriented but not altogether denied.

Pencil drawings and watercolors of landscapes do not show this tension any more than the narrative drawings showed theirs, and it is once again perhaps because a less definitive statement was expected of them; we can only guess. Cézanne seems uninhibited, and gives free play to his mastery of each medium, at times using very abstract notations, as in *Route avec arbres sur une pente* below, at other times being literal (see the watercolor of *La Vallée de l'Oise* and its related oil, p. 118). This is not to say that the landscape drawings and watercolors are sketchy or unstudied, like many of their narrative counterparts; rather, they are finished in their own way and seem to be definitive explorations of a manner of seeing their subject through their medium. Drawings either test out a composition or work out the rhythms of space, while watercolors arrive at alternative systems for defining form through color; they invite no additional step, encourage no further translation into paint, suggest no greater conclusiveness to be desired.

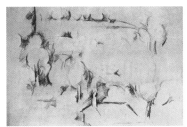

LANDSCAPE WITH HOUSES IN THE FOREGROUND
(C1159), ca. 1892-95, 32 x 54 cm. National Gallery, Prague.
Volume 1 number 4.

A large drawing from 1892-95, *Landscape with houses in the foreground*, explores the essential rhythms of its site, rendering them with dense hatchings and curved outlines. It allows our vision to travel diagonally from the roof planted firmly near the bottom, to the upper left, to pulse in and out, stopping for a moment at the firm vertical which grasps the upper edge, and, released once more, to follow the horizon to the right. The drawing works out the composition both on the surface and in depth, and no more is required of it. Because it records only these essentials - whether or not it was intended to be a preparatory study for a canvas - it seems complete in itself.

The late watercolor studies of landscapes are not merely complete in themselves; they are masterly and perhaps even more original than the oils. They put to a severe test one's trust in words, so relentlessly do they elude categorical formulation; yet to the attentive gaze, they communicate directly, without words. They cannot be encompassed in

15 - Cézanne: Landscape into Art, *pp. 101-2.*
16 - Cézanne: Landscape into Art, *pp. 58.*

ROUTE AVEC ARBRES SUR UNE PENTE
(RW625),
ca. 1904, 47 x 31 cm.
Ernst Beyeler, Basel.
Volume 1 number 5.

however felicitous a phrase, because they accomplish so many different things: here a telegraphic notation, there a dense yet luminous statement, elsewhere a complex quilt merely basted together - not quite woven - into a diaphanous but definitive texture. But one example must be made to serve, and *Route avec arbres sur une pente* from about 1904, a large work and a fully realized one, will do well.

The watercolor owes its intensity to Cézanne's use of a system of overlapping planes of color, painted over planes that had already dried so as to leave them intact; the result is a build-up of patches, like irregular and transparent tesserae, that resemble the patches of oil paint except for their transparency and luminosity. No patch of watercolor pigment ever hides another; they touch and intersect instead and together collaborate to create space, establish color harmony, and draw objects. In *Route*, a system of five colors (blues, ochres, reds, greens, and red-browns) defines foliage, tree-trunk, turn in road, sky, and a distant plane; the economy is breathtaking and the rich accumulation almost satiating. But more crucial and utterly original is the resolution of opposites: of the simultaneous sense of transparency and denseness, of abstract rhythms and real objects, of informality and ascetic ordering.

If in a sense such watercolors served as studies for what might be possible in painting, the sense had to be very broad; paintings could never preserve the transparency or the quick, seemingly casual notations of watercolors. Unlike the thick patch of oil paint, the immaterial patch of watercolor resolved fully the tension between the givens of vision and Cézanne's need for form. It did so by its invariable abstractness, by suggesting the particular (the individuality of solid form) through the general (the rhythmic interweaving of simple, transparent shapes).

PORTRAITS

A portrait is not merely a picture painted from life, as a nude figure may be, but an image of a person's uniqueness; the question for the painter is not if he has captured the likeness, but what he may allow to interfere with it. To a painter of official portraits that should present no difficulty: an adequate placement of the figure in the frame, a good likeness - and some degree of dignity - should be sufficient, and little else should interfere. But to a Cézanne, and painters after him whose way of painting is as important as what they paint, a good painting and a good likeness may be far from the same. One can resolve the dilemma by subordinating the likeness to one's style - Modigliani's and Giacometti's portraits come to mind - or by attempting an analytical deconstruction in all but some features of the face - this goes for Cubist portraits. Cézanne's response to the dilemma varied. He might avoid it by uniting a direct likeness with the simple dynamics of hat, shoulders, and cigar; *Portrait d'Henri Gasquet* of 1896 (number 355 in volume 1) is an example. Or, like some later painters, he might face the dilemma and subordinate the likeness to style; *Madame Cézanne à la jupe rayée* from the very style-dominated year 1877 is a splendid instance (number 125 in volume 1). Both are portraits of intimates, and whether to make style or likeness predominate seems to.... seems to Cézanne a direct enough choice to make. Or the portrait might be an ambitious painting, reflecting either the significance of the sitter (*Portrait de M. Ambroise Vollard*, number 362 in volume 1) or a bold pictorial purpose (*Jeune italienne accoudée*, number 366 in volume 1), and the painter's attention would be divided; there he would have to incorporate the head into a setting where multiple resonances of form and complexly balanced colors dominate. This is the most demanding of his solutions.

The *Portrait de Gustave Geffroy* of 1894-95, like the portrait of Vollard, is an ambitious painting; the sitter is an important critic and the setting is his study. A photograph shows

GUSTAVE GEFFROY
ca. 1894

PORTRAIT DE GUSTAVE GEFFROY
(R791), ca. 1895-96,
116 x 89 cm.
Musée d'Orsay, Paris.
Volume 1 number 9.

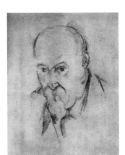

SELF-PORTRAIT
(C1125), ca. 1897-1900,
31 x 24 cm.
R. von Hirsch, Basel.
Volume 1 number 7.

him to be a slight man with sloping shoulders and a smooth, oval head, and this is whom we see in the painting. But although the painting is obviously a portrait rather than a mere study of a figure, the likeness does not extend to all the details. The head and the hairline are smooth and the eyes are generic, and the hands are too schematic to tell us whether they are strong or weak, whether at times they write and at other times caress.

Yet the picture is magnificent, and one's first view of it in the flesh is likely to leave an indelible memory - as it did with me in the 1977 show of Cézanne's late work[17], where it stood alone, brilliantly lit, introducing the exhibit. Something about it is grave and fully realized, and it is not enough to suggest that it is the sitter's monumental stillness; in a black and white reproduction the sitter remains equally still but the painting fails to come to life. It is color that is required to bring out the - one grasps for a word: authority? self-sufficiency? - of that stillness. The color scheme is particular to this painting: the main pivot is the opposition of the complementary blue-black and orange, and there is an unexpected but carefully chosen third element, a cool burgundy.

Complementaries balance naturally, but it is the choice of the third element that is so crucial, and here the burgundy, to the cool side of red, forms a color bridge between them, just as the chair back makes a physical link between the figure and the book case. (With orange dominating as easily as it does, and the pale yellow-brown adding its share of warm tones, the burgundy also lends weight to the cool half of the balance.) The result is daring but right.

Color also guides our grasp of the composition. The orange edging on the flat book in front of the sitter helps stabilize the zigzag of the books on the table, and it also brings our eyes down to look at them - so we can better note that together they parallel the slopes of the sitter's upper arms. Returning upward, we see that the books have pointed us toward the unassuming face, suggesting the very pyramid that culminates in the face itself. The face, once we are there, meets apparent competition in the vivid orange of the shelved books next to it, but this seems to have a twofold advantage: the orange hue pulls us to the right of the head, and the nearness of the books to the head reminds us subtly that the sitter lives as much in his intellect as he does in his body.

Cézanne has set himself a high goal, then: to unite the individuality of the sitter with a complex composition. Because our perception moves easily between the two ways of seeing the painting, he appears to have achieved his goal. We do know, however, that he himself did not think so; after more than one hundred sittings he was unhappy with the picture and gave up working on it. It is difficult to see just where the problem may have been. We ourselves are free to admire the picture as a painting and feel one more pleasure, in its central triumph: the face. The face contains all the colors of the painting. There are blue-greys for the shadows and the eyes, and pale yellows, oranges, even spots of burgundy in the skin. After following Cézanne through his complex thrusts back and forth, then, we return to the luminousness of the face. The painting is once again a portrait, and form has realized its subject.

In portrait drawings Cézanne's aims were more modest. When sketching faces, he would typically draw the head alone and render its structure, expression, or mood, but not the sitter's relation to his setting[18]. The result may be judged by deftness, economy, and

17 - *In the Museum of Modern Art installation, in New York.*
18 - *An apparent exception is* A cardplayer, *C1093, a profile study of the right card player in the series of two card players painted between 1892-96 (R710, 713, and 714); he is firmly seated at his table. But although it is a likeness, it is a study for a larger painting rather than a portrait.*

discipline of line, but not by resolution of competing aims or complexity. His self-portrait of 1897-1900 (C1125) is, indeed, economical and disciplined, and elegant in relating the head tightly to the V of the lapels and the upside down V of the shoulders; its various straight lines for the nose, eyebrows, and clothes form a sparse, firm, and precise language. Because of its size, the drawing is more than a mere sketch, and Cézanne is careful to give it form - the consistencies I have mentioned, as well as balance - within the limits he has imposed. And the discipline is not too ascetic, the straight lines are leavened by curved ones, the likeness is enriched by thoughtful expression: it is a masterly head.

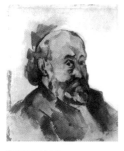

PORTRAIT DE L'ARTISTE (RW486), ca. 1895, 28 x 26 cm. Walter Feilchenfeldt, Zurich. *Volume 1 number 8.*

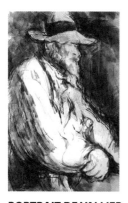

PORTRAIT DE VALLIER DE PROFIL (RW641), ca. 1906, 48 x 32 cm. Private collection, Chicago. *Volume 1 number 11.*

Watercolor lent itself less well to portraits, and what we learn by looking at the few there are is that the abstract patch was not a good device for representing individuality. A self-portrait of about 1895 uses some color patches to articulate the planes of the face and beard, sparsely and consistently, but it is technically modest, more like the pencil self-portrait than the landscape watercolor *Route avec arbres*. The reasons are simple: the facial planes are too continuous, expression is more important than the analysis of space and structure, and the format of the sheet is too small to articulate the face finely[19]. The pleasure, challenge, and triumph of bringing together disparate patches to create a single image - as abstract as representational - must be renounced. But Cézanne can realize some of his aims when he sets his portraits in a landscape. The late study of his gardener Vallier, for example, lets the figure be defined by the setting; it outlines the profile, vigorously and nervously, sets down the dark colors of the background - and leaves the face and body a splendid blank. It is the build-up of the background through overlapping touches that allows Cézanne to leave a void where the head and body should be. Of course they must not appear to be a cut-out, so Cézanne's uses multiple outlines in the head and body to let the figure move into and out of its space. The watercolor is a masterpiece, as fully realized in transparency and exclusion as its cognate oil painting is in thickness and substance[20].

In oil portraits, then, Cézanne gives form to likeness with a particular brilliance; he may set the figure in a space as complex as that of a still life and create a resonance of shapes, or he may bring all the colors of the painting into the face, embedding it firmly in the composition and making it stand for the whole. In drawings he may simply unify the surface with firm, consistent strokes. Only in watercolors does form prove elusive, and the reasons seem purely technical: the planes of the face are too continuous for his system of discrete notations.

STILL LIVES

Cézanne's still lives, however, bring us to a world where neither the pressure of emotion, nor the stubbornness of vision, nor the respect for individuality, need interfere with the pleasure of complex form. It is not that emotion is absent or vision unnecessary: apples do suggest deeper, imagined satisfactions[21], and vision is as fully engaged in studying the subject and integrating the composition as in landscapes. But the emotion is not specific to a time and a place - the fruit is not the last course of a meal - so it cannot distract the painter from his composition. Whatever the painter can assemble, draping his table cloths and rugs and propping up his plates with coins[22], he has created his own universe to paint and now has but to paint it[23]. It is the still lives, above all, that give one the sense

19 - *Qualities which, among others, have led some observers to question its authenticity; see discussion by Rewald,* Paul Cézanne: The Watercolors, *p. 205. Whether or not agreement is reached on this portrait, watercolor was clearly not the right medium for doing heads; it did, however, serve Cézanne for doing full-figure preparatory studies.*
20 - *The oil painting models the head and the white blouse fully, and by its modeling clarifies the light source: the early morning sun. This the probably the last painting on which Cézanne worked, having gotten up to finish it after collapsing outdoors the day before.*
21 - *And by their history in Cézanne's relation to Zola. See Meyer Schapiro's "The apples of Cézanne: an essay on the meaning of still life," in Schapiro,* Modern Art: 19th and 20th Centuries, *New York: Braziller, 1978.*

Roger Fry described of every touch being an event of the highest importance[24], and it is perhaps because Cézanne was the least torn by competing needs when he painted them that, invariably, he achieved such splendid consistency of purpose. *Nature morte* in the Reinhart Collection is as fully realized an example as any of the extraordinary series of late still lives.

Composed of many of the same elements, it is of all of them the most luminous and intensely concentrated. Unlike the better known *Pommes et oranges* (number 389, vol. 1) in the Musée d'Orsay, which is subtler in its color scheme (there, Cézanne seems to challenge himself to place several closely related colors next to each other - reds, oranges, and red browns - without clashing), the Reinhart Collection picture is based on contrasts of color and luminosity: the oranges and yellows are set off against a complementary wall of grey-blues and grey-greens, and the dense center is made incandescent against the dark ochre rug and ochre-brown table. Since the warm colors are in the yellow-orange range, and the cool ones are dominated by grey-blue, the color balance is evident to us right away. It is impossible to say which of the two still lives is the greater picture; each sets out to do something different and achieves it with brilliance.

The straightforward effect of balance and wholeness in *Nature morte* at first obscures

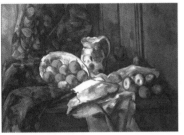

NATURE MORTE
(R848), ca. 1900,
73 x 100 cm.
Sammlung Oskar
Reinhart, Winterthur.
Volume 1 number 12.

how subtly it was achieved. The apparently white tablecloth, for example, is in fact composed of all the tones of the background, its folds painted with lighter shades of grey-green, grey-blue, and ochre; the pitcher is dominated by a large dull flower, halfway between grey-green and grey-blue, instead of the dark pink one that appears in *Pommes et oranges* and other late still lives. These ostensibly white objects, while remaining luminous, now become an integral part of the ground, having been brought together into a coherent color space that is both rich and measured. Other flowers on the pitcher, normally red, are now brown, of a shade that joins them to the table, to the rug in the back, and even to the brown patches on the walls. An effect of unity is important to most kinds of painting, but the degree of unity that Cézanne achieves here is extraordinary and forms one of his most moving accomplishments. It is an effect that, in spite of its elaborate genesis, is given to the viewer at once, on the first viewing especially, forcing a sharp intake of breath.

A gaze open to form reveals the balance of a composition right away; we feel the rightness of the whole and sense our pleasure in it, and only later, slowly and perhaps more passively, do we become aware of the elements of our response. It is a paradox of writing that it cannot convey the part of our visual response that is coherent all at once; it proceeds only in sequence. Only the painting is composed of elements applied in sequence (although the sequence is normally hidden from us and even forgotten by the painter). No matter how coherent a painter's intention for the canvas from the start, the painting is realized only step by step from individual touches whose effect on the whole must be constantly scrutinized. We do not know how Cézanne went about this - whether by turning the canvas upside down, obscuring elements with his hand to see how the whole would change, relying on the first, fresh view of the painting the next day, or something yet different - but we are clear about the results: the workings of his canvases are subtle and complex, and deeply satisfying.

22 - *A practice observed by the young painter Louis Le Bail and quoted by Rewald in his* Cézanne, *1986, p. 228.*
23 - *That is not to say that there will be no further questions of form to resolve, but that they will be less insistent. Cézanne might break up the colors (as in* Nature morte *below, by using greys, green, blues, and browns for what was a monochromatic wall), change them (choosing a cooler green than he sees, so that it would balance his other colors, as I have already indicated), interrupt the outlines (as in* La Grosse poire, *p. 246), or push certain objects back by greying them down (as in the center of* Nature morte avec pommes, *p. 179); all this would be done so the painted form would have its own coherence, richness, and clarity. But the start on coherent form would be made in the arrangement of still life materials itself, and one presumes that Cézanne felt greater mastery over the process at all times.*
24 - *Roger Fry,* Cézanne: A Study of his Development, *1989, pp. 83-84.*

In *Nature morte* we also respond to the organization of the space, and feel a curious tension between the stability of the forms and a distinct hint of disequilibrium. The reason is quite simple. While the pitcher anchors our gaze in the center, it does not quite stay in place: it is somewhat tilted, and so is the table cloth, and so is the right edge of the rug. A diagonal line runs in fact down from the top center through the pitcher all the way to a minor fold in the table cloth at the bottom, and crosses the line defined by the top edge of the table cloth (and the lower edge of the rug). The whole field is turned counterclockwise - but the turn is then resisted by the rightward lean of the mass of the rug and by the pressure down and to the right of the oranges piled against the bottom of the plate. Cézanne composes the painting so as to create a disequilibrium and then resolve it, and in our response we savor the one as much as the other. Anything less would be inert, somewhat like a musical composition that failed to introduce crescendos, key changes, dissonances, or off-beat *sforzandi*, so as to prepare for the pleasure of a resolving coda in the tonic key.

Cézanne's craft - the inventiveness and assurance of his still life work - is illustrated by several other details. The transparent wine glass is, as it were, both there and not there: its stem, too transparent, fuses with the stripe on the wall and the glass half disappears into it. (As the thickness of the paint on the table edge where it crosses the stem indicates, the glass was painted later, in thin paint.) To verify the effect this is intended to have, we must do as a painter would, and obscure the object in question with, say, a thumb or pencil end. Doing this, we detect a gap when the glass is obscured and conclude quickly that the glass has every reason to be there. On the other hand, if we imagine it more brilliant, reflecting the light more sharply, then it stops up the gap between the pitcher and the lonely apple on the right - a gap that gives us a welcome breathing space. Cézanne's compromise comes to seem the only possible one.

I do not mean to suggest that we must always prove Cézanne to have been right - to have made the right choices or achieved the right compromises - but that there is much to be learned about his painting, and our own vision, from looking at his paintings this carefully. He will have been right often enough, but our hard gaze will always have been its own reward. And the still lives, through their sheer visual richness uncomplicated by the compromises Cézanne must make in other genres - with the recalcitrance of appearance or the strength of personal wish - will tender the most sincere invitation to look intently.

The late drawings are simpler and more easily read. There are relatively few still lives as it is; many are sketches of individual objects only, no more than quick notations of shape and

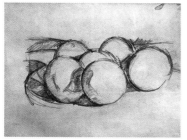

APPLES ON A PLATE
(C1078),
ca. 1891-94,
22 x 27 cm.
Private collection, Paris.
Volume 1 number 13.

modeling - but as such, they show a decisive, firm hand, with an emphasis on structure comparable to that of the paintings. One exceptional drawing, however, explores in pencil both the modeling of the individual fruits - which is to say, by implication, the quality of the light - and also some problems of unifying their arrangement, and in this respect *Apples on a plate* from the early 1890s is both incisive and subtle. The drawing is firm in the outlines and delicate in the shading; Cézanne shows us clearly where the light first disappears as it rounds the sphere (it comes uncharacteristically from the right) and where it reappears when reflected from the tablecloth. He also varies the strength of the outlines, repeating them where he needs to separate the apples and lightening them where they need to remain together. When he is done, he has a rhythm of compression and release that saves the drawing from repetition and, with relatively few lines, suggests coherent space. But the late watercolor still lives go well beyond mastery of composition. They attain that rare balance between a seemingly casual touch and a grave effect of the utmost importance. Like the landscapes, they are rendered in patches - larger and looser because the surfaces they record are simpler -

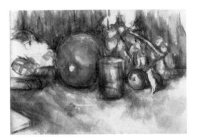

NATURE MORTE AU MELON VERT

(RW610), ca. 1902-06,
32 x 48 cm.
Private collection, England.
Volume 1 number 10.

and they attain a complexity that rivals the oils and a luminescence which surpasses them, and they invite comparably intense looking. Many are large and painted out toward the edges, confirming that they are no mere studies or preparations for canvases, but self-sufficient works.

Nature morte au melon vert is one of the most masterly of these. Its effect is above all chromatic, with complex variations in its surfaces and subtleties in the chords of its colors. Cézanne achieves this in part by choosing a minimal composition, one that seems at first too simple for so large a sheet; but simplicity of form in itself, especially on a sheet of this size (31.5 x 47.5 cm), calls attention to color, which is primary here. The forms are simple and generous: the melon allows for complex modeling of its green skin, the broad table almost invites the many variations in its brown surface, and the background and glass are rendered in a blue-violet that forms a particularly original contrast to the green (but which would be too cold if the brilliant apple did not balance it). Were the objects more crowded, as they often are in still larger sheets, we would be more engrossed in the interplay of forms[25]. Here, to compel us to pay attention that much more closely to the relationships of color, Cézanne even makes us lose sight of the melon as a distinct entity, multiplying its edges and making it vague in size and location.

The white areas themselves have a purpose in the color scheme. The blank spaces in the leaves withold some of the green, so it does not dominate the composition or compete with the melon. The object on the left, what I take to be a basket of bread rolls, would have been brown, and this would have added a warm color to the balance; but it would have added too much, as well as doubled the red-brown hue of the table, so it is best left blank. Even the whites in the table surface act as so many restraints on the warm colors, and so do the pale hues derived from the rest of the work: pale greens, violets, and reds. The watercolor seems complete and balanced, yet at every point it is also abstract and merely suggestive. It reconstructs the objects visible to the painter and deepens their color relationships; yet in some way that is difficult to define, it seems to say that that is how things really are.

These are then some of the achievements of Cézanne; some of his purposes; and some of his resolutions to the dilemmas that are either inherent in painting or peculiar to him. The accomplishments represent the end point of relentless work, thought, and the exercise of inherent gifts, whose direction seems understandable when we keep in mind the outcome, but would not have seemed inevitable had we followed his work as it progressed ■

25 - *For example, in* Bouteilles, pot, réchaud à alcool, pommes, *1900-06 (RW563) and* Pot bleu et bouteille de vin, *1902-06 (RW567).*

CHAPTER I

1860–1871

Beyond tradition and rebellion

He instinctively understood that for the new age the handling was the picture[26].

Paul Cézanne, 1861.

26 - *Lawrence Gowing,* "The logic of organized sensations," *p. 56*

Neither the sensuous richness nor the complex coherence of Cézanne's mature paintings could be predicted from his earliest work, nor would anyone have guessed that his most important contributions would turn out to be in landscapes, portraits, and still lives. Of course, an unpredictable development in a painter is more the norm than the exception, especially in periods of instability like the one that shook French painting in the 1850s[27]. Cézanne had more to respond to than the new ferment, however; he also had to cope with his transition from provincial Aix-en-Provence to Paris, a response that was predictably confused, uncertain, and contradictory. His first images from Aix were predominantly narrative or illustrative, and oscillated between displays of sentimental piety and expressions of rough but powerful impulses; from this kind of beginning to his ultimate achievements the distance seems immeasurable.

But that distance is bridged, in part at least, by Cézanne's constant pursuit of a style appropriate to his subjects, and it is this pursuit that defines his development and makes it coherent. The pursuit becomes evident after his arrival in Paris, with paintings dated in 1862, when he was twenty-three, and guides his work until his death. What we see is a succession of styles, one developing from another, each of which is adopted in order to give form to his observations[28]. The distance is bridged also by a fundamental constancy of his character: even in the late landscapes and still lives, which are based on intense and orderly observation, we sense the same powerful temperament as the one that drove his earliest narrative scenes. This is no mere metaphor for an emotional response on our part; late in life, Cézanne himself made clear just how crucial emotion was in his work. Explaining his love for the Venetian painters to the young poet Gasquet, he said, "I am a sensualist...." "A painting ... must first of all represent colors only. ... [The painter's] psychology is the meeting of two colors; that's where his emotion is." And pointing to a Delacroix, he added, "When I speak of the joy of colors for their own sake, here, this is what I mean... The tones interpenetrate, like silks. Everything is stitched and worked in together.[29]" Cézanne's emotion admittedly became displaced from the drama of human events into the passionate world of color, but his emotive nature, and his need to give it expression, remained the inexhaustible wellspring of his art.

By saying that we can join the poles of Cézanne's development, at least in retrospect, I am merely trying to correct the image we have, thanks to Fry, of the artist who became classical by repressing what was Romantic in him[30]. It is not a wrong notion, but it is too simple. Some "classicism" can be found in the early paintings, at least when they are based on observation, and a "romantic" attachment to color can be found, as we have just seen, in the late ones. We need instead to look at his development more complexly, as an interplay of at least the following strands: a turn away from narrative imaginings toward observation; an achievement of control by coherence of touch and surface; and an alternation of periods when style dominates his perceptions with periods when it is flexible and responsive - the latter best illustrated by his last period, one in which observation and representation are intimately joined in a disciplined yet fluid mode of working. But we also can think of his development as a progression from coping with simple oppositions to integrating more complex ones: from an initial conflict between conservatism and rebellion - the pieties and sentiments of

27 - See especially the discussion of the context for the development of the new art in Rewald, History of Impressionism.
28 - Except for the parallel touch, which gave form first to fantasy; see the last part of the next chapter.
29 - Gasquet's writings on Cézanne are not fully reliable; their language is too often that of an extravagant poet and too seldom that of the precise and thoughtful painter. But they also show too much knowledge of art to be merely his own inventions. I think that attributions such as these, while not necessarily quoting Cézanne's words accurately, do capture the core of Cézanne's thought. The three quotes are from his Cézanne, first written in 1912-1913; it has been reprinted in part in Doran's Conversations avec Cézanne, pp. 130, 136, and 141 respectively.
30 - Roger Fry, p. 83.

his upbringing and the impulses which rose up against them - to a more flexible tension between the lasting (the art of the museums, as he put it) and the inventive (the innovations of the Impressionist movement), and finally to a personal and surely unanticipated synthesis of the revolutionary and the enduring.

From what is known of Cézanne's early life we can point to four formative influences on his artistic career: the education available to him, the adolescent explorations of literature with Zola and Baille, the paintings he may have seen as a young man, and his father's character (the role of his mother, which would not have been less important, is not known, but is presumed to have been protective and encouraging[31]).

At the time of Cézanne's birth, Aix-en-Provence was a provincial capital, both Provençal and French; it was Provençal in its culture - in what remained of it or was being revived - and French in its civic structure and education. Cézanne's education was the one that all French children would receive, and (to anticipate what became important to him in adolescence) it was rigorous in Greek, Latin and French literature. Cézanne responded to it with intelligence and discipline - becoming good at composing verses in Latin - and an evident interest in the romantic themes in the literature he read; this would become apparent in the company of Zola and Baille, at about age sixteen, and later, in some of the paintings of his first decade. His education had at least this significance: it gave him a discipline of thought and clarity of expression, and it would have given him a place anywhere in France, including Paris, if he had felt comfortable enough with it - in spite of the earthy accent of the Provence which he retained all his life.

Paris, as far as we know, only became a goal for Cézanne - that is, an escape from the provincialism of Aix as well as a place to become trained as an artist - as an outcome of the experiences shared with Zola and Baille. It was in most ways an extraordinarily intimate and stimulating friendship, one where their individual interests in the arts were welded into a collective passion for literature, painting, music and poetry. The boys' poetry recitals and dramatic performances have become an indelible part of our image of Cézanne's development[32]. The image does not imply a high-brow or ascetic attitude to art; much of what they read was typically adolescent in its romantic content, although higher in form - Hugo, then de Musset - and some of their time was spent in perfectly ordinary ways, hiking, swimming, hunting, and serenading girls. But all of this does say that art held a pivotal place in Cézanne's adolescence, and does explain why, if one dreamt of a career in art, Paris would come into the boys' plans. (Zola went first, following his mother, and for three years encouraged and even hectored Cézanne to follow.) The experience is also crucial to understanding Cézanne's early, narrative work as a painter, because it tells us that as an adolescent he was equally interested in all the arts; he barely distinguished between verbal and visual representations, since what connected them was their subject matter - the human condition - and their purpose was to portray it, whether in a poetic, prosaic, or pictorial form. It helps above all to explain his ability to think matters through for himself, to transcend the simple antinomy between received pieties and visceral opposition; whatever the boys might think or do was their own, untouched by adult constraints.

31 - In a letter to his mother of September 26, 1874, the only one to her that survives, he cites Pissarro's good opinion of him (and his own of himself), and assures her of his progress as a painter; he even explains some of his artistic aims in detail, apparently presuming that she is interested and will understand. The tone is that of a son justifying his mother's faith in him.
32 - Rewald's description of the development of these artistic passions in the company of Zola and Baille provides an indispensable picture of this part of Cézanne's early life. See his Cézanne, 1986, pp. 12-16, for this account, and the book as a whole for the painter's biography. But also compare Rewald's account with Wayne Andersen's The Youth of Cézanne and Zola, in which he uses the same evidence to argue for a more supportive role of Cézanne's father in his life, and for some parallels between the development of Zola and that of Cézanne.

Cézanne was also Provençal in his roots and sympathies, and, unlike Zola, was ultimately neither absorbed by Paris nor contemptuous of his Aixois origins. On the contrary, in later chapters we shall follow some differences between his portrayals of the landscapes around Paris and those near Aix, which reflect not only their physical differences in light and color, but also his closer attachment to the latter. His early images of what painting[33] was must have been based in part on what he could see around him: Provençal baroque and rococo art and contemporary landscape painting. He was probably familiar with the locally revered tradition of religious painting, which derived ultimately from Caravaggio and was represented by local painters of the seventeenth century[34]; certainly the subject matter of some of his earliest paintings suggests that he had at least seen it. He must have been just as strongly influenced by his own conservative, religious background, if one is to assume it from the lifelong piety of his sisters; we know little about it at first hand, but we do have the evidence of his ironic references to religion in his youthful letters, and his robust contempt for some parts of the religious establishment in his last years, even when he started going to mass and confession again. The pious upbringing was a source of conflict: in the face of paintings where conservative devoutness and repression of impulse are the ostensible subject (as in *Jeune fille en méditation*, p. 34), there erupts an original temperament, aggressive and sensuous (in *La Visitation* and *Scène religieuse*, p. 35).

Starting at age eighteen, Cézanne also studied at the Ecole Spéciale et Gratuite de Dessin in Aix, and by 1861, at age 22, must have seen the landscapes of the Aix master Granet[35]. They would represent secular painting for him and exemplify the qualities we see in his own landscapes much later: they were carefully composed, classically measured, and based on observation. But only one early landscape reflects the character of Granet's paintings directly (*La Tour de César*, p. 46); Cézanne's earliest work is too individual and volatile to admit of consistent models.

The paintings that an artist sees as a young man are only an array from which he will form his idea of art; they do not explain how he develops. In a similar way, the artist's father has a certain character and provides an image of manhood, but he will not determine the son's character. In exceptional cases, as with the severe fathers of Van Gogh and Mondrian, we can expect a certain inhibition of character in the child, but not necessarily an inhibition in work or originality; and in more ambiguous cases, most of the burden of explaining how the child will develop will fall on the child's response to his surroundings. Cézanne's father, Louis-Auguste, was admittedly a strong-willed, shrewd, competent and successful banker, and he also had opposed his son's wish to become a painter. But it is possible to make too much of this, both of his character and his opposition. It is hard in any case to imagine a bourgeois father gladly supporting such an uncertain career, and certainly we are hard put to find such a father among Cézanne's contemporaries[36]. Louis-Auguste would have quite naturally wished for his son to have a secure future in his bank and to support it with a respectable career in law, one safe from the envy and disdain which greeted his own rise to wealth. The conflict between following the father's wishes and asserting one's

33 - *Represented by Emile Loubon, Prosper Grésy (1804-1874), and Adolphe Monticelli (1824-1886), whom Cézanne would later meet and paint with. See Sheon,* Monticelli: His Contemporaries, His Influence, *1978.*

34 - *The cultural background for Cézanne's early interests has been carefully described by Mary Tompkins Lewis in her* Cézanne's early imagery, *Berkeley, University of California Press, 1989. She documents the religious and conservative elements of the culture in which Cézanne was raised as carefully as the painting traditions he would have seen as a young man. What he did see exactly, and how he reacted to it, is speculative, but Lewis's reconstruction of what was current and available is persuasive.*

35 - *François-Marius Granet, 1775-1849. Granet's collection was bequeathed to the Aix museum in 1849 and exhibited in a room of its own beginning in 1861.*

36 - *On this question, see Rewald,* "Cézanne and his father," *and Wayne Andersen,* The Youth of Cézanne and Zola, *Chs. 9 - 12.*

own, however unclear one's own may have been at first, seemed severe at the time but was not uncommon, and it was in any case resolved.

What is particular to Cézanne, however, is that he feared his father more than was justified[37] and admired him unreservedly for qualities he found lacking in himself; but this ultimately was balanced, by the time Cézanne was twenty-two, by the near-certainty that the father understood him and would support him. Cézanne certainly spoke of his father with admiration late in his life; to Bernard he said, "My father, who was intelligent and good-hearted, said to himself, 'My son is a bohemian who will die in misery; I will work for him.' And my father left me enough to live on and paint for the rest of my life."[38]

The three years that Cézanne spent between 1858 and 1861 attempting to please his father by studying law, although he had already decided to become a painter, illustrate their complex relationship. Cézanne intended to follow Zola to Paris right after completing his baccalaureate exams, but instead spent three unhappy years living at home, either too fearful to make his wishes clear or, perhaps, too unsure of how strong they were. But one must credit the son with a passive and sulky persistence, and the father with some mixture of understanding, exasperation, and shrewdness, because in the end, in April 1861, a year after consulting with the drawing teacher Gibert (and receiving a reply that excluded any immediate departure for Paris), Louis-Auguste gave in and accompanied Paul to Paris to set him up properly. Whether he thought that his son would grow tired of the new life, or if he liked it, would at least prove his seriousness, is unrecorded, but his support cannot be questioned. Paul did return to the parental home in September, discouraged, and started work in his father's bank. But this, too, ended with the father accepting the inevitable; Cézanne had continued his studies of drawing (obviously with his father's consent), and in November 1862 went off to Paris once again, with a decent monthly stipend. If Cézanne did succeed in having his way, it must be said that he succeeded in part by passiveness and tenacity, in part thanks to his father's realistic and unsentimental understanding.

Cézanne's relation to this father is much less an illustration of a heroic struggle than a precursor or metaphor for something closer to his artistic development: a conservative identification which I think was the basis for his respect for tradition, and which proved crucial to his painting when he broke with the one innovative movement whose goals he shared at least in part: Impressionism.

Cézanne's earliest work - the paintings done while still in Aix and possibly for a few years after - responds more clearly than any later work to the milieu of Aix and his religious upbringing, and confirms the view of art - formed, as I said, with Zola and Baille - as narrative in purpose and concerned with human events. Technically, like most painters, he began by copying or imitating older models, and many of his works of the time have to be understood as juvenilia. Within about two years after these beginnings, by about 1862, Cézanne would begin to replace copying by free adaptations, and would explore portraits, landscapes, and still lives; doing this, he would begin to rely on direct observation, and the narrative view would no longer suffice. I must emphasize, now that the work of his first fifteen years has had a major public exhibit and could

37 - *The clearest evidence of the fear seems to be Cézanne's doing everything he could, until the early 1880s and perhaps until shortly before his marriage to Hortense Fiquet in 1886, to hide her existence from his father (but not his mother or sister). This is usually explained by his fear of his father's disapproval, and his fear of having his allowance cut off. The latter is reasonable, of course; his father had reduced his allowance once, saying with tongue in cheek that a man who has no dependents can get by with half. But other interpretations are possible - Cézanne's ambivalence about Hortense, for example, or his own feeling that she may not have been right for him. This would weaken the picture of the fearful Cézanne, but not eliminate it.*

38 - *Emile Bernard, "Souvenirs sur Paul Cézanne" in Doran,* Conversations avec Cézanne, *p. 63.*

be studied in the flesh[39], that his original paintings done after 1862 showed much more attention to form and surface – a more constant effort to achieve a consistent style – than had been obvious from reproductions. However distracted we might be by the oscillation between sentimentality and rawness, we would be blind to the obvious were we to see in his earliest paintings only an uncritical response, positive or negative, to the traditions of his province.

I said in the introduction that the complex of motives impelling Cézanne to paint was different in narrative scenes, landscapes, portraits, and still lives. Narrative scenes were the natural vehicle for his conflict between pious tradition and impulsive rebellion, at least until he had been in Paris for a while. By the mid-1860s, he sought narrative inspiration from a broader range, drawing on mythology, contemporary literature, theater and operatic pieces, and the work of painters he either mocked or copied, and his attitude toward them varied from one moment to the next: in pastiches, it was ironic or sarcastic, in copies, admiring. In his own textual illustrations, his rhetorical stance was most often vehement or mock-heroic. But in several paintings of the decade, his attitude was too complex to read: *La Tentation de Saint Antoine* (p. 43), for example, is too original in symbolism and composition to reveal a clear rhetorical stance, and the painting's independence is testimony to the achievements of the first decade.

NARRATIVE PAINTINGS

LES DEUX ENFANTS
(R15), ca. 1860,
55 x 46 cm.
Present whereabouts
unknown.
Volume 1 number 14.

If Cézanne's milieu is reflected best in his narrative paintings, this is in part because so many of the earliest ones are copies; in landscapes, still lives, and portraits, by contrast, he was more independent from the start and copied less[40]. At the beginning, apart from painting an original folding screen and the four *Les Quatre saisons* panels, he mostly copied utterly saccharine narrative pictures, and in doing them he appeared to be searching neither for style nor for form but for congenial narrative material. This material was at first narrow; the pictures were sometimes religious sometimes not, but invariably sentimental, and in a general way reflected his catholic upbringing in spite of his ambivalence toward it. These juvenilia, concerned as they were with subject matter, neither suggest formal concerns on Cézanne's part nor allow any kind of formal analysis.

Two of the early sentimental paintings are *Les Deux enfants*, of about 1860, copied from an engraving after Prud'hon, and *Jeune fille en méditation*. Whether copied or more or less original (the second one was probably inspired by the vernacular religious art of Aix[41]) neither has any claim to be remembered. The one is constricted by the sweet terms of its anecdote, while the other, although fairly competent in portraying the head, is cramped in its space and scattered in its composition. Cézanne is, of course, only a beginning painter, and probably knows too little to feel a conflict between narrative and formal motives, but his attachment to subject matter surely discourages thinking of painting in formal terms. That will begin with paintings done from observation.

But the constraints of acceptable religious portrayal also invite eruptions of rebellion, and in two other early paintings Cézanne begins to reveal the powerful, native temperament that will mark the work of his first decade and animate him in a more

**JEUNE FILLE
EN MÉDITATION**

(R10) ca. 1860, 29 x 18 cm.
Present whereabouts
unknown.
Volume 1 number 17.

39 - See Gowing, ed., Cézanne: The Early Years, 1988.

40 - His early copies do include three landscape (two versions of Paysage avec moulin, R16 and R17, and Vue du Colisée à Rome, d'après F.-M. Granet, R27), and a still life (Pêches dans un plat, R22).

41 - Lewis, p. 119.

LA VISITATION (R11),
ca. 1860,
27 x 20 cm.
Private collection.
Volume 1 number 16.

SCÈNE RELIGIEUSE
(R20), ca.1860-62,
28 x 23 cm.
Private collection.
Volume 1 number 15.

sublimated way later. In one painting we catch a mere glimpse of the temperament, while in the other the temperament dominates. In the first, *La Visitation*, we see a crude intrusion of impulse in the head of Beelzebub erupting into the scene beside a calm and utterly undistinguished portrayal of the Virgin and one of her ancestors – as if something like the painter's rebellion, or an emotional honesty, or an inner demon, had invaded his more conventional thinking ; and the eruption leaves room neither for a plausible space nor a consistent pictorial scale. In the second, *Scène religieuse*, conventional thinking disappears altogether, as Cézanne represents a group of people who surround and worship the sun – a scene ecstatic in its subject and raw in its form, seemingly without control over the inner pressure that had produced it. A brilliant, yellow sun with an orange head in the center emits radial rays of light, illuminating three figures which cast their shadows toward us like the spokes of a wheel. The symmetry is compelling but ultimately static; it is better designed to convey symbolic meaning, as do mandalas, than to create pictorial movement, tension, or conviction. Yet the handling is loose and vigorous, and the figures are as lumpy and solid as in work done later in the decade; in its touch, then, the painting has the Cézannian force we see in his work of the middle of the decade. With this picture some of the early constraints may have been shaken off, though with more vigor than sense; if we were to try to anticipate his future development from it, we would imagine more rawness and originality than painterly discipline.

Cézanne's originality was as verbal as it was visual, and its verbal expression was evident earlier. His letters to Zola, which begin when they were separated in 1858 and Cézanne was nineteen, are themselves full of eruptions, in this case of poetry seemingly composed on the spot. These are poems which for their originality of language and metaphor Zola considered the signs of a greater poet than himself, and which reveal a fertile imagination. As original as the poetry is, however, it is also febrile, obsessed with vice and virtue, sin and retribution, sex and death. The poems are indispensable reading for anyone who wishes to follow the rich convolutions of Cézanne's soul; a single poem of his gives us as full a picture of his impulses and his defenses against them as his erratic bouncing between conventionality and rebellion in the early paintings[44]. Of course, the poems were informal musings filling private letters, unlike the paintings, which are by their nature more public and subject to the scrutiny of others[45]; that would make poems the easier vehicles for Cézanne's imaginings. But like some of the early paintings (and even the later ones with which Cézanne intended to provoke the Salon jury) they reveal a rhetorical stance; we cannot always be sure of what it is, but it can seem shocking, ironic, or mock ironic.

Any hold that early conventionality had on Cézanne was indeed tenuous, and the story of his later development is in part, as I said, that of the gradual resolution of the conflict between tradition and rebellion. If what we see in these earliest works is

42 - *That there was an inner demon is suggested by a head that he painted in 1862-64, with an iron collar and a protruding tongue, entitled* Diable enchaîné *(R32).*

43 - *I speak of inner pressure merely to emphasize it, not to exclude other purposes. In this painting, for example, the medieval dress of one of the figures suggests a specific illustration, and the dramatic lighting and exaggerated gestures suggest a perhaps ironic rhetorical stance; but the painting certainly gives greater vent to Cézanne's temperament than, let us say,* Jeune fille en méditation.

44 - *The poems range from the bawdy (*Poème inédit*, about a happy seduction), through the guilty* Songe d'Hannibal *(about a conflict between a son's carousing and his filial duty), to the mock morbid (*Une terrible histoire*, in which the hero, about to kiss the beautiful breast of a woman, finds her turning into a corpse). We must keep this full range of sentiments and rhetorical attitudes in mind if we are to have a measure of Cézanne's emotional life; while his guilt feelings and their effect on his painting have been justly noted by Reff (1963), they are only part of the picture, and straightforward sexual culmination, as well as irony, are another. For a collection of the other poems, see Rewald,* Cézanne: Letters *(1984).*

45 - *Some paintings hung on the walls of the family home, so they had to please the parents, or at least be acceptable to them;* Le Baiser de la muse*, after Frillié, was actually Cézanne's mother's favorite (Rewald,* Cézanne*, p. 24). One can imagine the constraints imposed on a painter by the wish to please the parents.*

a simple opposition between the commonplace and the untamed (leavened by a rhetorical stance), in the ones from the mid-1860s on we shall see the opposites better merged: unrefined fantasy will be sanctioned and justified by legitimate illustration. Much closer to his maturity we shall see a deeper integration: a subtle balance between Cézanne's respect for tradition - now divorced from the early, specific imagery and transposed into admiration for the art that hung in museums - and his radical innovations in the treatment of surface, space, and color. Put into words, this seems a paradox, but seen in its realization, in the flesh - in the context of paintings by some of his contemporaries, for example - it is no such thing. The closer we come to the final decade, the more his paintings will evoke a sense of culmination of what western painting had been about and a promise of something new. Perfecting a tradition which represents vision, they will also suggest the possibility of treating paintings as independent objects with their own inner forms and rhythms.

But no such complexity is evident in the earliest works - often copied from engravings, juvenile in their sentimentality, and sometimes intended for Cézanne's mother[46] ; this can be said without implying any reproach. But Cézanne's copy after an engraving of Lancret's *Le Jeu de cache-cache* (c.1862-64) aims higher; one can sense the attraction of its rhythmic composition and playful seductiveness, and imagine the challenge of supplying the necessary colors. As it is, Cézanne has been successful; the ambitious painting achieves a plausible eighteenth-century mood (the two-tone silk of the skirt on the left is competently done), and it is well balanced between the warm and the cool colors. The blue skirt on the right relieves the painting of any warm stuffiness, and justifies, in this earliest possible example, Fry's admiration for Cézanne's inherent sense for color harmony[47].

LE JEU DE CACHE-CACHE

(R23), ca. 1862-64, 165 x 218 cm. Mural transferred to canvas. Private collection, Japan.
Volume 1 number 18.

It seems unlikely that Cézanne had been to Paris when he painted the religious pictures I have discussed so far. As he said to Bernard much later, he had gone to Paris "to make religious pictures - since my naiveté of the time did not let me aim any higher and I had been raised in piety,[48]" and that seems a close enough description for these earliest paintings. But art in Paris must have immediately opened his eyes to an altogether different world, with the rigidities of the academic establishment being contested by recognized painters who had stood outside it, and by the very young painters who were to become the new dissidents within a few years. Among the academic group, in 1861 Cézanne mentioned seeing Cabanel, Gérôme, Yvon, Pils, and Meissonier; among the painters standing outside, by 1863 he would have seen at least Corot, Delacroix, Courbet, and Manet. He had certainly brought a disdain for things representing officialdom and academicism to the the work he saw in Paris and declared most of what he saw in the museums and in the Salon to be mere "daubs"; but in spite of a witty and airy dismissal of the lot - of the contemptible *chic* nature of the Salon - he did find a few paintings by Meissonier "magnificent"[49]. In a letter to Cézanne Zola had extolled the virtues of the sentimental Scheffer (whom Baudelaire had called "wretched, dismal, and muddy"), but there is no record of a response[50]. There is however no question about Cézanne's straightforward admiration for Delacroix (and a more complex one for Courbet and Manet), which was life-long and started no

46 - *Rewald, PPC, vol. I, p. 69.*
47 - *Fry (1989), p.13.*
48 - *Bernard, "Souvenirs," in Doran, p. 56.*
49 - *Cézanne's letter to Joseph Huot, a boyhood friend, June 4, 1861; see also the discussion of Cézanne's attitude in Athanassoglou-Kallmyer, p. 486.*
50 - *Zola's letter to Cézanne, March 25, 1860; Wayne Andersen, The Youth of Cézanne and Zola, p. 114.*

later than 1864, when he copied his *Barque de Dante*. But he also registered at the Louvre to copy a Poussin, who might be seen as the embodiment of French classicism[51]. Not only was Cézanne complex enough to be torn between great painters representing traditions sometimes seen as antithetical, but any greater uniformity of taste would have been unnatural for this stage in his development.

Crucial to him in another way would be the third group, the young painters he met at the so-called Atelier Suisse, where they could work from the model but without instruction: they included Pissarro, who was eight years older, and Monet, Renoir, Guillaumin and Guillemet, who were about Cézanne's age. All of them looked to the older painters outside the academy for models, and at the same time searched for something new, of their own, especially through plein air work; Monet, Renoir, Sisley and Bazille painted where the Barbizon school had worked, in the forest of Fontainebleau. While Cézanne may not have painted with them, he did paint outdoors from the start of his stay (Zola having documented their Sunday excursions), and he, too, borrowed from the older models. The influence of Courbet is especially visible in landscapes (*Rochers dans la forêt*, p. 48) and that of Manet in still lives (*Le Pain et les oeufs*, p. 61). Above all, he identified with the ferment itself, participating in the 1863 *Salon des Refusés*, joining (though rarely) the group of artists gathered around Manet for discussions at the Café Guerbois, and later becoming part of the group that gathered at Zola's every Thursday. All of this culminated in Cézanne's joining Pissarro himself in 1872, to work close to him, and in exhibiting with the group in their first exhibit in 1874[52].

La Femme au perroquet, which probably followed Cézanne's introduction to the Atelier Suisse, reveals at least an evolution in his confidence in the handling of paint. The figure of the woman is still sweet, and she has been painted with an admittedly inhibited care, but the rest of the painting is freely realized in thick paste. Whether this reflects a direct influence of what he saw at the Atelier or a greater sense of freedom developed from his own experience is impossible to say. I think that we must give substantial credit to his experience, and see this style as a distinct effect of his progress with paintings done from observation, particularly landscapes. In landscapes dated between 1862 and 1865 this kind of freedom of the brush is seen routinely; in them, thick strokes extend over the whole surface and render the objects straight off, without hesitation. Landscapes such as *Paysage* (p. 46), presumed to be from the same period, release a love for gesture, paint, and expressive vigor, which serves to transcend mere narrative anecdote in *La Femme au perroquet*; but the effect is inconsistent.

LA FEMME AU PERROQUET (R26), ca. 1862-64, 28 x 20 cm. Private collection, Paris. *Volume 1 number 19.*

During the three years between 1862 and 1864, if the dating is plausible, he painted many still lives and portraits and even more landscapes; certainly few narrative pictures remain[53]. Those that survive turn from religion and sentimentality to a rougher, more passionate, pagan mythology. Classical, pagan themes offer Cézanne a broad array of legitimate

51 - *He did so in the same year, 1864. Cézanne's relation to Poussin is too complex to describe by a simple admiration for his "classicism", but he certainly offers a different vision of painting from Delacroix; see the various points of view presented in Richard Kendall (Ed.),* Cézanne & Poussin, *and in particular the chapter by John House (pp. 125-149). On Cézanne's stance toward the "romantic" and the "classic", including Delacroix and Poussin, see Andersen, pp. 211-214.*

52 - *For accounts of Cézanne's relation to painting in Paris in 1862 and his connection with the development of Impressionism, see Rewald,* Cézanne, *pp. 29-43, and his* History of Impressionism, *Chapters I - III.*

53 - *One painting is presumed to fill the gap:* Lot et ses filles *(R76), from sometime in the early sixties. I cannot persuade myself, however, that is it by Cézanne. Its figures are reasonably convincing in outline but erratic in touch; their surface is at times slack and muddy, at other times sinewy. The painting would be hard enough to date in the mid-sixties, and even harder to insert into the styles of Cézanne's work at any time. But the real difficulty is in its straightforward, incestuous, salaciousness. It is not unattractive in a way -* Lot *in flagrante delictu - but it just does not seem quite Cézannian; one would expect greater indirection from him, shown perhaps in irony or satire or exaggeration. While his authorship cannot be excluded, the style is too uncertain, and too problematic for any consistent view of his development, to be considered here.*

possibilities for portraying narrative subjects, and if it took him a while to turn to them – given his education, he could have done so earlier – he may not have been ready, or he may have been laboring under the earlier provincial constraints. The year 1867, however, sees the appearance of four paintings, one large and solemn and three small and cheerful, in which the tension between impulse and inhibition is well resolved and his portrayal of the human body is persuasive. (I pass over a hastily done *Jugement de Pâris* of 1862-64, R92.) They include the well-known *L'Enlèvement* (R121), which is the large picture, with rhetorically powerful if exaggerated figures and a finished, well-developed surface, and the less well-known *Satyres et nymphes* (R124), *Femmes s'habillant* (R123) and *Néréide et Tritons* (below), all small, informal, and spirited. While each of them probably borrows in part from other sources[54], what commends attention is their self-assured, vigorous surface and well integrated composition.

**NÉRÉIDE
ET TRITONS**
ca. 1867, 24 x 31 cm.
Private collection, Japan.
Volume 1 number 21.

Néréide et Tritons, like the other two, is conceived in diagonals, well balanced against each other, with the human forms closely and sensuously packed and the painting's surface built up of either short, curved touches or long, sinewy lines. The style is so well suited for the depiction of lively narratives that one asks why Cézanne had discovered it so late. Again I assume that it is his work with other subjects that paved the way; this style, which he called *couillard*, was above all a way of translating vision – at least in portraits, figures, and still lives. In large figures, such as the portrait of his father of 1866 (p. 56), the touch might be a long, sinewy line, while in still lives the paint might be dabbed on with the knife; in either case the gesture would be emphatic. The narrative paintings seem less consistent in purpose and mood, and therefore in style; and while in *Néréide et Tritons* the vigor of the handling responds to the vitality of the subject and gives it appropriate form, in other narrative subjects this is not always the case. And it must be added that these short, curved strokes, which, like the subject, recall Rubens, never formed part of Cézanne's vocabulary for long. They were especially ill adapted to landscape, where space needed to be made whole rather than broken up, and where detached shapes needed to be connected. Curved, willowy touches are better at conveying vigorous movement than suggesting close interconnections[55].

Cézanne's narrative interests of this first decade culminate, at least in size and ambition, with *Le Festin*, also known as *L'Orgie*, a painting so exceptional in his work that it is difficult to place in any orderly view of his development. It is ambitious, and it was clearly important to Cézanne himself; as late as 1895 he chose it to hang with much more recent paintings in the retrospective at Vollard's[56]. It is forceful, brilliant in color, original in surface – and puzzling; and when we do not understand a painting directly, we tend to ask for help from sources that might have inspired it.

On the matter of sources Lewis has done the most thorough excavation, and it is undeniable that the painting is a synthesis. It refers to Veronese's *Les Noces de Cana*, which Cézanne had studied in the Louvre, and possibly to a painting that was based on it, Couture's *Les Romains de la décadence;* it may also reflect the orgy theme from contemporary theater and Flaubert's description of a feast in *La Tentation de Saint Antoine*[57]. Indeed the painting is no spontaneous eruption of feeling but a finished work that

**LE FESTIN
(L'orgie)**(R 128),
ca. 1867, 130 x 81 cm.
Private collection.
Volume 1 number 20.

54 - See Lewis, pp. 164-170. L'enlèvement, she argues, is in fact the abduction of Proserpine, and one of its sources could be Niccolo dell'Abbate's painting by the same title, while the sources for the others include Rubens and possibly Cabanel.
55 - In landscape his style in c.1867 varied; while some paintings were done in loose strokes of thick paint, a few were also done in sculptural, blocky units with the palette knife. He did use curved touches for a short time in 1881 (see below), but abandoned them.
56 - Rewald, PPC, p. 112.

evolved from three pencil sketches of details and a gouache sketch for the whole composition, and the evolution tells us that, although models had inspired it, the painting is ultimately Cézanne's own.

The composition sketch is in gouache and crayon, and the rows of columns in the back suggest an architectural setting similar to the two models; it is as if Cézanne had taken the right half of the Veronese painting - the right wing of the banquet table - and overlaid his own version of Couture's subject on it. But nothing in it is borrowed directly, and the painting evolved further away from the sketch, in a more original but also more awkward direction. Only one column now supports the canopy and the musicians sitting on top of it, and this simply seems problematic even though we can imagine the unseen one; the sky now reaches down past the tables, and this is quite impossible. But this disingenuousness - which I must presume is part of the precarious effect Cézanne wants to achieve - is balanced by the colors, which are happy, light and brilliant. The touch, too, although it accumulates by careful, repeated applications, conveys the writhing that the subject requires. The painting is conceived on a sharp diagonal, with no attempts made to stabilize it, and its vertiginous space is almost too fitting a setting for the events; in all these ways it is very different from the urbane Veronese and the stuffy Couture, and incalculably more inventive.

The painting's very expressiveness makes if difficult to date. The palette is anchored in the center by blacks and whites, and moves between saturated cobalts, coral reds, flesh tones - and lavender. The dark preparatory sketch suggests as early a date as 1867, while the painting's brilliant colors argue for a date closer to the lighter palette of the Impressionists, such as 1873; for Gowing the ambiguity is best resolved by presuming that it was painted at the earlier date and repainted at the later one[58]. As plausible as this compromise may be - and it is supported by the careful, overworked touch and the traces of columns under the final layer of paint - it is not the resolution of the dating that matters but the barely restrained expression of voluptuous sensuality, and the formal audacity. At about age 30, Cézanne has found at least a few forms adequate to the narratives he wishes to recount.

Surely Cézanne had reason to be pleased with his accomplishment: a sensuous painting in something like the admired Venetian manner which so eluded him. But it was to be the only painting of his youth that came close to the Venetians, if not in brilliance then in intent; not only would vision ultimately become a better guide for him than narrative, but the narrative that demanded personal expression was of a different nature from the Venetian one. It was darker, more violent, more like the subject of *La Toilette funéraire* of 1869.

The starkness of *La Toilette funéraire* is compelling in a different way; its mood is uncertain - is it sardonic, ironic, lugubrious, or yet something else? - its subject is hard to guess, and there is a discord between whatever may be going on and the reassuringly simple composition. It had been presumed to be an autopsy scene, which would invite comparisons with anatomy lesson paintings, but it is now more securely identified as a preparation for burial, and this suggests looking elsewhere. Lewis argues that the Caravaggesque paintings Cézanne may have studied in Provence are its general source, and Bartolommeo della Porta's drawing *Le Christ au tombeau* is the likely specific model for the dead body[59]. But it is only that single body that invites a search for

LA TOILETTE FUNÉRAIRE (R142), ca. 1869, 49 x 80 cm. Private collection. ***Volume 1 number 22.***

57 - *Lewis, pp. 173-183.*
58 - *Rewald,* PPC, *pp. 111-112.*

sources; the other two figures, the composition itself, and the quality of the surface, all call attention to the present, to Cézanne himself. The middle figure is clearly Cézanne (as he appears in *Le Déjeuner sur l'herbe* (p. 42), *Une Moderne Olympia* (p. 70), *L'Eternel féminin* (p. 79), and *Pastorale*, R166), but here he is the protagonist, not a mere onlooker. The decision to participate so centrally is hard to explain: that is, he both intrudes into the painting, which is a rare enough transgression of a painting's boundaries, and he carries out the toilette, by which he moves well beyond the safe confines of illustration into some fantasy of personal involvement. In spite of the record we have of his private musings in the letters to Zola, none pertain to this subject, and I remain ill at ease with the figure's reaching so awkwardly below the table surface.

The figure on the right, however, is less of a mystery: it is there to call attention to the formal pattern. His or her left arm mirrors the slope of the corpse's chest, creating a satisfactory symmetry which helps restrain the disturbing subject, and the yellow hair performs two additional formal functions: it completes the very simple scheme of primary colors and sets up a diagonal from the head to the bowl in the left corner which balances the overly prominent body. The surface is consistent and the brush strokes are forthright, and the colors – blues, reds, golds, and flesh tones on a black/white axis – are similar to those of *Le Festin*; but black is the ground here, as well as the mood. I cannot escape an ambivalent response: this is a satisfying painting but the subject is disquieting.

With a painting such as *La Toilette funéraire* I have begun to talk not only of style and texture - of its vigor or of its adequacy to particular subjects - but of composition; composition now becomes more than a mere unobtrusive presence, but a way of giving form to disturbing content, and perhaps in the long run of providing the painting with its ultimate goal and justification.

If the naked body in *La Toilette funéraire* is done in a summary manner, modeled by broad, white swirls on a black ground, it is for expressive purposes - whatever they might be - and for consistency and originality of style; had Cézanne needed a more literal portrayal, he had but to paint from life as in his academic studies of the beginning of the decade. We must remind ourselves that a style is chosen, not compelled; if his intention in paintings such as this one is to be somber and perhaps provocative, in copies after masters - he did four in 1869-70 - the style could be lighter and less insistent, and vary freely with the mood of the original. Like *La Toilette funéraire*, the four pictures he copied oppose light figures to dark backgrounds, creating an inner luminousness, but they also offer entirely different ways of handling the brush and composing. They include paintings after del Piombo's *Le Christ aux Limbes* (R145), Titian's *Pietà* (R143), Delacroix's *La Barque de Dante* (R172), and Rembrandt's *Bethsabée* (below)[60].

**BETHSABÉE,
D'APRÈS REMBRANDT**
(R142), ca. 1869, 49 x 80 cm.
Private collection.
Volume 1 number 23.

All but the Rembrandt picture are based on vigorous diagonal movements that are so much part of Cézanne's early language; the Rembrandt, however, has the calmness of a later Cézanne. What seems remarkable about Cézanne's copy is the apparent ease with which he sets down a convincing figure and devises a consistent surface; there seems to be none of the minuteness and exactness that so infects copyists. The figures in all of the copies have the grace of their models, and here also the gravity; and probably thanks to the security of having models to follow, Cézanne invents, and apparently just throws off, telegraphic

59 - Lewis, pp. 124-129.
60 - *He may have worked from engravings after seeing the originals--except for the del Piombo; Rewald, PPC, pp. 122-123, 138.*

notations for the surface which could well stand for the final idiom in another painter's work, or for that matter in Cézanne's own later painting. Doing the figure realistically and convincingly is a facility he has, but is not always willing to use in his own original work, and one can understand why he is often given so little credit for having any.

It would be tempting to see mere awkwardness in the tiny, contemporary, *Les Courtisanes*.[61] The subject seems provocative and licentious, but that may be because of the title that was given it; Andersen argues that the subject is dancers dressing, as in a similar drawing by Degas[62]. Whatever the subject, the painting is admittedly unfocused and its lines move like a shuttle between the right and left sides; on the other hand, it is unhesitating in execution. It is clearly only the barest sketch – either an image intended to remain private or a quick lay-in for something he might develop later – and Cézanne had no reason to attempt a more skillful and slower rendering. Once again it is on the vigor of the painting and its simple colors that we must judge the picture: on the juxtaposition of primary reds, greens and blues, and secondary flesh and orange tones, which feel as fresh as the rapid touches of paint themselves.

LES COURTISANES
(R144),
ca. 1870, 17 x 17 cm.
Barnes Foundation,
Merion, PA.
Volume 1 number 24.

Cézanne's styles in imaginative paintings clearly respond to too many requirements in this first decade to maintain any consistency; their subjects may be purely personal or they may illustrate a narrative, they may be studies or finished paintings, and they may be large or small. The human figure, too, may be awkward or graceful, again depending on the context. It seems clear that Cézanne could paint the figure convincingly when copying and when painting from life, but when painting from imagination he was at his best when the format was small and the execution rapid (as in the fluid *Néréide et tritons*). There was one other circumstance where his painting of the figure was convincing, and that was when the picture had a legitimizing context. It is context that accounts for the differences that we see between *Baigneur et baigneuses* and *Baigneuses*, below; the first is simply a bather picture and the second is an illustration.

In each painting a nude figure – a man in *Baigneur* and a woman in *Baigneuses* – gazes out at three nude females. But the first picture has no referent outside itself, with the man merely gazing for erotic pleasure, while the second is quite likely an illustration of a narrative other than Cézanne's. Lewis argues that it depicts the first act of Wagner's *Tannhaeuser*, which would make the gazing figure Venus and her gaze merely a look of acknowledgment[63]. This may well be right, but whatever the subject, it is impersonal; in the first picture, on the other hand, Cézanne is left without a protective narrative and, by identi-

**BAIGNEUR ET
BAIGNEUSES** (R161),
ca. 1870-71, 20 x 40 cm.
Private collection.
Volume 1 number 26.

fying with the male's erotic gaze, is too closely involved as well. Perhaps even the natural setting of the first picture is psychologically too literal, while that of the second is airy, metaphorical, and ultimately distant. All this seems to have an effect on the paintings' form, with the erotic picture more insistent and labored and the operatic one light in touch and seemingly done quickly without obvious corrections.

Not every painting that illustrates someone else's narrative is graceful, although most are, and I must consider an apparent contradiction: the awkward *Le Déjeuner sur l'herbe*, also of about 1870. Lewis argues that it may be an illustration of a picnic scene – and therefore ultimately of a seduction – from Zola's *Madeleine Férat*, and that the picture, like the novel, portrays the darker forces behind the erotic atmosphere. But if she is right, or even if the picture illustrates some other narrative, then Cézanne has failed

BAIGNEUSES (R159),
ca. 1870, 33 x 40 cm.
Private collection.
Volume 1 number 27.

61 - *It is dated 1867-68 by Rewald (PPC, p. 122), c.1871 by Lewis, p. 197, and c.1875 by Shiff (1998, p. 387).*
62 - *Andersen,* The Youth of Cézanne and Zola, *p. 419.*
63 - *Lewis, pp. 186-192.*

to profit from the protection of the story, and managed to realize neither the individual figures nor the composition as a whole; the figures are ungraceful in proportion and movement, and the space of the picture is impossible. Cézanne makes an attempt to order the picture carefully through a series of opposed diagonals, but they seem imposed on the scene rather than inherent in it, and fail to unify it. One might even suggest that as an illustration of more hidden forces – if that was its intention – it fails; things are not so much hidden in the picture as awkward. But another interpretation of the awkwardness is possible. Cézanne was too acutely intelligent to have failed to notice problems such as these, and if he failed to act on them, I would understand the clumsiness to be purposeful. It may well be intended as an ironic and even mocking comment on the urbane Manet's *Le Déjeuner sur l'herbe*, the *succès de scandale* of 1863 (as were, most probably, the two versions of *Une Moderne Olympia*, p. 103). On the first interpretation, it must be said, the result is awkward, while on the second it is heavy-handed.

LE DÉJEUNER SUR L'HERBE (R164), ca. 1870, 60 x 81 cm. Private collection. *Volume 1 number 28.*

In about the same year, however, he does turn with all his force to the subject of two other paintings. Uncompromising and original, they are equal to *Scène religieuse* (above) in giving vent to his uncommon temperament; they are *Le Meurtre* and *La Tentation de Saint Antoine*. In *Le Meurtre*, in spite of its untrammeled appearance, he achieves a brush stroke that is perfectly consistent and ideally suited to the narrative; it flows in a wriggly manner, moving rapidly across the canvas and conveying directly the feverish impulses of the murderers. He expresses the violence by diagonals, with no point of respite anywhere in the composition, and places the scene not in a stage darkness like that of *Baigneuses*, but in a literal, stormy and lugubrious, night.

LE MEURTRE (R165), ca. 1870, 65 x 80 cm. Walker Art Gallery, Liverpool. *Volume 1 number 25.*

One cannot insist enough on the importance for all of Cézanne's work of the temperament that reveals itself in these paintings and in the poetry. It is a direct wellspring for the work of the first decade and an indirect one for the work done later, and the shape it takes is fertile and original; it is a force that Cézanne must cope with and find legitimate forms for. Work based on observation will give him a kind of immediate respite from its excessively direct expression, but indirectly the temperament will inform all his later work. Creating surfaces alive with movement and multiple correspondences, expressing emotion through color, feeling the very need to gaze intently and to paint, will be the sublimated forms of these early impulses.

In his early narrative work, especially in his treatment of the figure in paintings such as these two, the temperament may seem like all that is being expressed. That would be too simple a conclusion; a painter is no simpler in his motives than the rest of us, and his actions, like ours, are overdetermined. A more legitimate question is whether in *Le Déjeuner* and *Le Meurtre*, as in much of his early narrative work, the temperament overwhelms his artistic purpose. *Le Déjeuner* is at least easy to see as ironic, and its elongations and awkward poses as intended; but in *Le Meurtre*, since there is no obvious irony present, it is tempting to suppose that the violent distortions of the bodies are the earnest outcome of his uncontrolled imagination. That has been assumed in writings about Cézanne for quite some time, and it used to be my view as well. But as the early paintings became more accessible and Cézanne's control over their surface more clear – and as paintings whose purpose used to puzzle us, such as *L'Eternel féminin*, came to be better understood (p. 79) – his thought and his impulses had to be given a more equal role. The style of *Le Meurtre* is also the style of landscapes done at l'Estaque; they are equally brooding in tone and equally fluid in touch, but they are clearly works of observation rather than fantasy (*Paysage provençal*,

R133, *La Route de forêt*, R168, *La Neige fondue à l'Estaque*, R157, and *Le Village des pêcheurs à l'Estaque*[64], p. 50). And we have the testimony of Cézanne's friend Marion, who witnessed Cézanne's attempts to master his temperament at first hand, and wrote that "Cézanne still works hard and with all his determination to organize and control his temperament, to impose rules of a calm science upon it[65]." The control he spoke of, we may assume, referred not only to the mastery of artistic style but also to the taming of character.

The darkness that pervades *La Tentation de Saint Antoine* is an equally deliberate stylistic choice. The picture illustrates no specific text, but it does make liberal use of the temptation theme that was common in the mid-nineteenth century and that Flaubert treated in a novel between 1856 and 1857. Cézanne had probably read the serial publication of the novel, but here he does something entirely his own; he deals with only one of the saint's temptations, the sexual one, and invents his cast of characters and his setting altogether. It is not a religious picture in the sense of his juvenilia, but, in part at least, a personal account of temptation and resistance to it[66]. Surely it is also a defensible context for painting four nudes in different poses.

LA TENTATION DE SAINT ANTOINE
(R167),
ca. 1870, 57 x 76 cm.
The E. G. Bührle
Collection, Zürich.
Volume 1 number 29.

As such, it is more thoughtful than would appear at first, but also puzzling. More easily seen in the painting itself than in a reproduction are the four different skin tones, with the squatting woman the whitest and the temptress facing the saint the most orange. Equally subtle is their contrast with the background, which is black-green; the tone is so subtly off-black that it easily disappears when reproduced. (*La Toilette funéraire* contrasts primary colors with a pure black background, and is easier to reproduce.) The two fabrics, one blue and the other orange-red, complete the color scheme. All the figures except the rather unimportant saint are painted in full volume, and this is achieved by two different means, a curved and vigorous touch in the three foreground figures and an abrupt and blockish one in the temptress. It may be that Cézanne intended to create a scene within a scene, by varying the figures' style and their position in the picture, but if he did, then it is difficult to know why.

The form of the picture, nevertheless, brings these puzzles and provocations under control. The bodies, as much as they twist and incite, are set apart at even intervals, and the whole picture is balanced on two diagonals (with the subtler one extending from the saint's head through the arm of the crouching woman); this thoughtful arrangement creates an orderly space that calms the overheated events.

But puzzles do remain. One is the masculine appearance of the figure on the right. In spite of a certain opulence, she is big-boned and ungainly, and her head looks like the portrait of Zola that Cézanne painted in 1862-64 (R78). Both the uncertain gender and the possible identity as Zola[67] make us wonder what Cézanne was really saying. Another puzzle is the crouching figure: her volumes are done more simply than those of the others, with luminous globes for the shoulders and buttocks rather than continuous modeling over the whole figure. The style of modeling can admittedly be seen in *Le Déjeuner sur l'herbe* and *Le Meurtre* above, as well as in *Pastorale* (R166),

64 - *The sites of the latter two pictures have now been identified, by Xavier Prati and Georges Reynaud, who took me to see them; in spite of the build-up of the town, one can establish Cézanne's point of view easily, and find the same buildings, in the same compositions, as in the paintings. For their discoveries, see the chapter on l'Estaque in my* Paul Cézanne: Les Sites provençaux, *Marseille: Crès Editions, 2005.*
65 - *Cited in Doran,* Conversations avec Cézanne, *p. 185, footnote 5 (English edition, p. 226).*
66 - *See T. Reff, "Cézanne, Flaubert, St. Anthony, and the Queen of Sheba," 1962.*

but here it is more extreme, and it is inconsistent with the dignity of the rest of the picture. And the fabric in the lower right corner - the third puzzle - looks more like flames than like a draped cloth, inevitably suggesting the flames of hell.

Perhaps Cézanne had a specific meaning in mind for these details that escapes us, or perhaps an impulse intruded now and then into the conscious intention that even he was not aware of; on the present evidence, we cannot know. Cézanne's drawings during the first decade varied as much as the paintings, and are evidence of a restless search for a style adequate to their subject. His earliest academic nudes were exact in their proportions, precise in their modeling, and inevitably quite stiff; his later drawings after the masters, and unsupervised drawings done from the figure, very quickly became free in the quality of their line and alive with tension or movement - without sacrificing justness of proportion. In drawings that illustrated scenes, and in the rare copies after others, Cézanne tended to use shading or hatching, of varying degrees of discipline, to indicate volume or complete the setting, or perhaps even pay tribute to the original[68]. In drawings that served as sketches, on the other hand, line would usually be dominant. The drawings are indispensable to understanding Cézanne; they reveal an artist of quick, sure judgment and an intuitive sense for the expressiveness of line. A passion for representation and for the impulsive gesture, free of the seriousness of oils and their opportunities for reworking, leaps to the eye.

The narrative drawings during this decade, then, take the two forms I mentioned: the rare, relatively self-sufficient scenes, such as men playing billiards[69] or the scene from a play I reproduce below, and the numerous sketches for paintings. Whole scenes seem to Cézanne to require indications of particularity - of color and space, of identity and expression - and this accounts for the shading; it indicates the setting and the volumes, as well as the dark or light clothes of the figures. Sketches, exempt from this burden, are free to rely purely on expressive line; they are looser and more interesting, and more revealing of Cézanne complex gifts.

Roger Fry said that Cézanne may simply not have had the ability to provide adequate schemata from memory for what he had to draw, and if we look only at drawings of entire scenes we would have to agree. In a drawing such as *Gratify my desire*, for example (1866-70), which illustrates a scene from Molière's *Tartuffe*[70], he seems to be both literal and uncertain of himself. The difficulty seems to be that he needs both to set the figures on a stage and have them communicate recognizable intentions. The former requires only the suggestion of rough shading, and the latter needs emphasis, facial expression, and gesture. The man is therefore drawn more insistently, in black, and on a sharp diagonal, because the scene's drama and humor reside in his desire rather than in the woman's demurral; she on the other hand is modest, upright and clothed in white. All this is communicated clearly, because a diagonal is an unequivocal expression of emotional urgency, but it is neither skillful nor convincing; and perhaps it is the need for a complete, literal picture that inhibits Cézanne from using his hand more freely.

"GRATIFY MY DESIRE" (C132), ca. 1866-70, 13 x 21 cm. Von der Heydt Museum, Wuppertal.
Volume 1 number 30.

67 - *For Reff, this is a projection of Cézanne himself.*

68 - *In his drawing after Rubens's* Apotheosis of King Henri IV, *from c.1865, he used careful and surprisingly disciplined hatchings for the volumes. This drawing has a finish that suggests a formal intention, and possibly was intended as a gift; it is in any case signed by its first owner, a M. Jacomin, who adds that Cézanne had given it to him.*

69 - *For example,* Game of billiards, *C149, 1865-1870.*

70 - *According to Chappuis, it is Scene 5, Act IV, while according to Reff it is Scene 2, Act III. Under the latter interpretation, it is the scene where* Tartuffe *offers his handkerchief to the maid who he believes is tempting him, saying, "Couvrez ce sein que je ne saurois voir". My comments on the expressive quality of the line would apply to either interpretation. See A. Chappuis,* The drawings of Paul Cézanne, *vol. I, p. 78, and T. Reff, "Cézanne, Flaubert, St. Anthony, and the Queen of Sheba", The Art Bulletin, 1962, vol. 44, p. 121.*

STUDIES FOR THE ORGY (C135), ca. 1864–68, 18 x 24 cm. Kunstmuseum, Basel. *Volume 1 number 32.*

When Cézanne is unburdened by this inhibition, his figures are more expressive and powerful. Proportion may suffer, but the freedom and the nervous intensity of the line become eloquent. The drawing *Studies for The Orgy*, for example, is a study of several possible movements for the participants in the feast, and with this modest and nearly private purpose, it has a convincing, fervent, impatient vigor. In drawings such as these Cézanne can let loose with passionate bends and spasms, and the question of clumsiness simply fails to come up. The lines may well be reflections of an inner urgency, but they are above all appropriate to their subject and rhetorical intent.

There were circumstances, then, in which Cézanne's early drawings, even those done from memory, were alive and convincing. I am inclined to think that it was Cézanne's expressive purposes that required the elongations, awkward placements, and diagonal thrusts which, from another point of view, are obvious distortions. His expressive rhetoric may have been complex in itself; knowing as we do that he could cloak his bawdy poems in mock horror, we cannot exclude irony or mockery from drawings that would appear overwrought if we took them seriously.

There are no true watercolors of narrative subjects - there are gouaches, which are opaque, and watercolor additions to drawings - and we have every reason to view them as we do the drawings. The study for *L'Après-midi à Naples*, for example, which may belong either to the end of this decade or the beginning of the next one, is a watercolor only because it sets down some of the hues to be used in the painting; it is in other respects a drawing, and is so dependent on diagonals for expression that it does not even make room for any respite from them. The early narrative watercolors have no independent claim as works of art, and serve no specific purposes derivable from the medium.

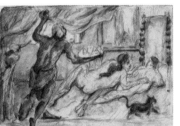

L'APRÈS-MIDI À NAPLES (RW35), ca. 1870–72, 11 x 16 cm. Galerie Krugier & Geofroy, Geneva. *Volume 1 number 31.*

Cézanne's first decade, then, saw him develop from a beginner inhibited both in skill and imagination into a painter who gave free rein to his fantasy, most successfully when it could be incorporated into an illustration; his handling of the brush would then be secure and his compositions balanced. The progression was far from steady, and its least stable element was his rhetorical stance toward his material; he seemed unable to decide - or seemed unable to reveal how he had decided - whether he was speaking directly or with irony, sarcasm, or self-deprecation. The end of the decade, however, saw a number of paintings that confidently ignored the accepted forms in the service of more audacious expression, and remained self-consistent in surface and touch; when they did so, they revealed a search for a coherent pictorial language.

That language developed further, and most securely, in response to painting what he observed. Whether it would have developed merely from further work - from a critical look at the difficulties in painting from imagination, for example - is impossible to say; but it came to be deeply influenced by the two years spent in the company of Pissarro, a period which will begin the account of the next decade. Observation was, however, important for guiding his development in the first decade as well, and its effects can be most clearly followed in his paintings of landscapes.

LANDSCAPES

As they develop during the course of the decade, Cézanne's landscapes, when contrasted with the narrative paintings, will show us an ever firmer grasp of the pushes and pulls that define a firm composition; they will also demonstrate the mastery of several self-consistent, expressive and vigorous styles. But his starting point is no more promising; his very first two landscapes are sentimental and are in fact mere copies of a trite "*Paysage avec moulin*". Only a few years later, on the other hand, between about 1862-64, he will break out of the confines of sentimentality with a single leap, and paint two very large and detailed imaginary landscapes directly on the wall at the *Jas de Bouffan* (R28-30 and R34-41)[71]. These now exist only in portions cut from the whole, but at the time they were about three and a half meters high; one was sweet and romantic, the other was bucolic, with a massive, intrusive nude male figure added later. If we are to infer anything about Cézanne from these few examples, it is that sentimentality was never far as long as he lived at home, and that a landscape painted from imagination could not set up a barrier firm enough to prevent the intrusion of a rougher, more personal, narrative.

**LA TOUR
DE CÉSAR** (R24),
ca. 1862, 19 x 30 cm.
Musée Granet,
Aix-en-Provence.
Volume 1 number 33.

No such intrusion would take place in landscapes painted from observation, however. In 1862 he painted his first landscape in the full sense of the term (*La Tour de César*), having worked evidently on the site, and it must have been important for his development by its calmness, its clearly recognizable and unfussy objects, and the consistent envelope of light that clothes the scene; it was obviously closely observed. Neither sentimentality nor turmoil nor grandiloquence have a place here. The painting is expectably conventional in technique, but it suggests a happy confluence of the calming work *en plein air* and the unobtrusively ordered compositions of the Provençal master Granet[72]. As a first view of the effect of observation on Cézanne's painting, and the first glimpse of its importance for the future, this painting is decisive.

PAYSAGE (R43),
ca. 1862-64, 46 x 38 cm.
Private collection.
Volume 1 number 36.

During the next three years, Cézanne, as if liberated by his initial experience with the palpable present, will flee the conventional in landscape rapidly and, with minor exceptions, permanently. A *Paysage* from 1862-64 has an original touch seen so far only in the contemporary *La Femme au perroquet*, yet here the touch is more consistent and more natural to its subject. The strokes of the palette knife, laid down with the flat part of the blade, incise the tree trunks, the foliage, and even the sky; and as in his mature work, the sky is made to lie in the same plane and to seem as solid as the trees. It is not just the vigor of the touch that leaps to the eye, considerable though it is, or the originality of using only the knife, but an apparently instinctive impulse to paint rather than make mere images. The impulse seems so strong here that it can be satisfied only with diagonals which fan out restlessly from the point where the trees meet the ground. The painting is not a mere record of a scene that is before us, but an object in its own right, independent and self-sufficient. Although it probably describes its motif closely, as do all the landscapes where we know the model[73], it seems unimportant to know just how closely; the canvas draws its power from the convincing handling of the paint. Surely the thickness of the paint contributes to the sense of substance, but it is not only that; our response is the same after all to the thin oils of the mid-eighties and to the still thinner watercolors. Here we see decisive handling and a consistent vision.

71 - *The family residence since at least 1859, when Cézanne's father bought it, but possibly before. It is an imposing 17th century building, testimony to the father's wealth if not standing, and in Cézanne's time it stood splendidly isolated outside the city confines.*
72 - *Rewald, in PPC, vol 1, p. 72, suggests that Cézanne may have been shown them by his teacher Gibert even before the exhibit of 1861.*
73 - *See my* Cézanne: Landscape into Art, *passim.*

No one else around Cézanne is doing anything that audacious. Among landscapists, Corot paints landscapes with a quiet assurance and a diaphanous touch, which stand well apart from the realistic techniques of the academy and have admirers among the young, but he seems no longer the incisive painter of his youth. Renoir does fresh and vividly observed landscapes but they seem conventional by the standards he would achieve a few years later[75]. Monet in 1862-64 pushes in new directions where light and effects of season are concerned and achieves results ranging from the happily sunny to the darkly brooding, but still seems safe in his color and handling of the brush compared to Cézanne[76]. Only Boudin, Monet's teacher and now about forty, seems almost invariably crisp in his color and secure and fluid in his touch[77].

Unlike Cézanne, of course, these painters are more steadfastly consistent, while Cézanne seems unable to settle down; his development seems more prodded by different impulses than guided by a program, more volatile than composed. Alternating with the original Paysage, Cézanne may paint a reticent and constricted landscape[78]; the self-assured handling may become cautious and tentative again. This is only momentary and may reflect no more than too close an approach to Courbet; following the older painter too closely in detail, Cézanne may have chosen an uncongenial site, too dominated by dense intervals and too constricted by fine textures, with a result as awkward as derivative. But he may also follow Courbet at a greater distance, as when he makes free use of the palette knife (in *La Clairière, below*), or adapts Courbet's solid vision to a portrait (in *Louis-Auguste Cézanne, père de l'artiste, lisant l'Evénement*, p. 56). So up to about 1865 there may be timid pauses in an otherwise inexorable development that culminates in the landscapes and portraits of 1865 and 1866.

The style of those two crucial years, in the middle of the decade, is intense, and its vigor, even vehemence, is achieved by a staccato, dabbed-on touch, generally in full paste, at times applied with the knife, at other times with the brush. A touch this emphatic and this separate is in itself new, both for Cézanne and for the painting of the time[79], and in its rhythm and consistency it may even be said to anticipate the parallel touch of 1880 - but only in these, since the parallel touch was subtler and more complex. Here, in the twelve or so landscapes of about 1865[80], of which Paysage is an example, the touch still suggests the actual textures of the dense objects (the bushes, foliage, and ripples in the water), but it also reveals an effort to unify the surface: the lumpy touch in the sky tells the viewer that Cézanne is apprehending the site in terms of paint rather than seeing it as a mere scene. The colors are, admittedly, still close to their actual appearance and the composition is a relatively safe one; the orange anchor for our gaze just below center[81] is conventional, though perfectly satisfactory, and the massive

PAYSAGE (R53),
ca. 1865, 23 x 28 cm.
Private collection.
Volume 1 number 34.

74 - *He is in his sixties now, of course. For the young painters' relation to him, see* Rewald, History of Impressionism, *pp. 100-102.*

75 - *See, for example, his* Clearing in the Woods *of 1865, reproduced on p. 98 of Rewald's* History of Impressionism.

76 - *Compare his* Farm in Normandy *of c. 1863 and his two different* Road at Honfleur *of 1865, on pp. 104 and 115 of* History of Impressionism.

77 - *Cloud Study of 1859, for example, reproduced on p. 43 of Rewald's* History of Impressionism, *and the somewhat later* Fishing Boats at Trouville, *p. 45.*

78 - *For example,* Sous-bois *(R45) of 1862-64; not illustrated.*

79 - *In 1865 Courbet and Monet come close in the roughness of their surface, but not in its forcefully detached strokes. Courbet's* Normandy Coast, *c.1865, is reproduced in Rewald,* History of Impressionism, *p. 129, and Monet's* Beach at Sainte-Adresse, *1864-65, on p. 110.*

80 - *To convey the prolific landscape work of these years, I should like at least to list the paintings:* R48, Paysage; R49, Paysage du Midi; R50, Coin de rivière; R51-53, Paysage; R54, Coin de rivière; R55, Paysage; R57, Paysage; R58, Rochers à l'Estaque; R60, Paysage; R61, La rivière dans la plaine; R62, Le bassin du Jas de Bouffan; R63, L'allée du Jas de Bouffan; R64 *and* R65, Le lion et le bassin du Jas de Bouffan; R66, Paysage à l'Oratoire et le Pont des Trois Sautets; R67, Paysage mediterranéen; R68, Rochers au bord de la Mer; R69, Clairière; *and* R79, Paysage aux environs d'Aix-en-Provence.

81 – *One should resist, better than I have, the temptation to see the early works in terms of the later ones, but I do so in order to emphasize the originality of Cézanne's treatment of the surface. As for the importance of the red anchor point, it is best to convince oneself: one should block it from one's view to see how unbalanced the picture becomes, in shape and in color.*

framing tree recalls Claude Lorrain. But several of the other landscapes are unconventional, and in them, Cézanne couples the nervous touch with a more vehement subject. All twelve bear the stamp of this intense period's originality.

Cézanne's rough but consistent touch is no small achievement, but, having mentioned the parallel touch, I should explain how it differs from the one of 1865. The later touch, too, will be regular and rhythmical, but it will achieve much more: it will give Cézanne an enveloping control over the entire composition. For example, in *Le Pont de Maincy* (p. 116), painted fifteen years later, the touch will unite the natural textures with solid, man-made structures. In the upper center, it will be laid down in groups that echo the stone support on the right and the one overhanging branch above, while in the upper left corner it will reinforce the roof and the left arch; it will also suggest the foliage, although it will not represent it literally[82]. Serving both to represent and to compose, it will both refer to the outside world and create its own, self-contained and self-sufficient universe. But if we did not know of that more crucial development, the one of 1865 which we see in Paysage would seem not only original but accomplished as well.

**LE BAC
À BONNIÈRES** (R96),
ca. 1866, 38 x 61 cm.
Musée Faure, Aix-les-Bains.
Volume 1 number 35.

The technical vigor of these landscapes, and the comparable achievements we shall see in portraits and still lives, tell us yet again that when painting from observation Cézanne was on firm enough ground to innovate, and to feel secure in his touch - neither inhibited nor grandiloquent. What was secure was not the specific touch, but the way whatever touch he chose would serve his composition. With a much simpler touch he could achieve an understated monumentality. In *Le Bac à Bonnières* of 1866 he simply let the forms he saw carry the expressive weight: the up-down and left-right symmetry were sufficient for conveying a calm and natural order[83], and so as not to disturb it, it was best to rely on a quick, loose touch, with no specific expressive character of its own.

LA CLAIRIÈRE (R125)
ca. 1867, 65 x 54 cm.
Jorge Espinoza, Mexico City.
Volume 1 number 37.

In the following year Cézanne changed his touch more than once, and in two paintings used the palette knife to scrape the paint across the canvas rather than trowel it on in full paste; he might have seen the technique in Courbet and the conception of landscape in the Barbizon school[84]. Somewhat of a blind alley for the moment, to judge by its brief appearance, the technique would in fact become an open avenue in the future, although Cézanne evidently did not see it at the time. In the first of these paintings, *La Clairière* of c. 1867, he holds the knife on its edge and drags it down over dabs of paint, and creates streaks of pigment more or less equal in size that become independent of the foliage and move up and down the canvas repetitively, creating their own rhythm. A few literal elements - the literal patches of light, for example - do break into the cadence; they remind us that a more abstract conception, carried to the entire painting surface, would have been before its time. But Cézanne's originality here, if indisputable, is brief; much more expectable from a young painter would have been the more derivative *Rochers dans la forêt*, in which he depicts the surface of the rocks with large, smooth patches, and the foliage with small, rough ones, as Courbet would have done, and the result is not a little prosaic.

It is not until the mid-nineties that it will occur to Cézanne that the innovations we glimpse in *La clairière* could constitute a full conception of landscape, that is, a way of creating a resonant, rhythmical surface while conveying the forms of all the elements

**ROCHERS DANS
LA FORÊT** (R126),
ca. 1865-68, 41 x 33 cm.
Private collection.
Volume 1 number 38.

82 - For an analysis of the use of the parallel touch in Le pont de Maincy, *see my* Cézanne: Landscape into Art, *pp. 4-7.*
83 - The photograph of the site shows this symmetry to be a striking aspect of the scene; see my Cézanne: Landscape into Art, *pp. 32-3.*
84 - Rewald in History of Impressionism, *p. 164, shows a landscape by Diaz de la Pena, and a similar one by Renoir - one of Diaz's followers at the time - of a kind Cézanne may have seen when he worked in Barbizon.*

of the composition. This is the conception we saw in *Rochers près des grottes au-dessus du Château-Noir* in the Introduction: it consists of patches of color which overlap in a way that suggests the shape of the objects while absorbing us in a rhythm best described as elemental and musical. Although it builds on the parallel touch of the late 1870s, it constitutes a different conception of the painting surface once again, and once again makes an incalculably original contribution to painting. Parenthetically, Cézanne was to anticipate the discovery of color patches a mere ten years after *La clairière*, in 1877, in the splendid *L'Etang des Soeurs à Osny* (p. 88), but would then ignore it unaccountably once more.

That his touch should change from year to year, and vary from narratives to landscapes, must be taken to indicate a search for appropriate form rather than inconstancy or nonchalance. The form is, in any case, consistent in each painting. Whatever we may infer about its purpose, the purpose remains constant and gives the picture coherence and distinctness. This cannot be said of every one of his contemporaries: Renoir, for one, painted quite without concern for stylistic consistency and seemed to have let his fascination with fine detail in some spots, and broad surfaces in others, guide the shape and size of his touch. In his *La Grenouillère* of 1869, for example, he reserved one touch for the figures and another for the boats and waves[85]; for him, to innovate meant to refuse to be constrained by stylistic consistency. Cézanne never went so far as to search for a signature style - a kind of handwriting designed to distinguish him from everyone else - but he did strive for a consistency of form adequate to whatever he was painting at the time.

PAYSAGE
(R130),
ca. 1867, 33 x 46 cm.
Present whereabouts
unknown.
Volume 1 number 39.

His effort after pictorial coherence, although forceful, could of course not be absolute; given his attachment to perception, it had to work closely with his response to each site. Even in later years, when his language became highly consistent and disciplined, the touch revealed the structure of each subject as much as it unified his compositions[86]; it became a way of grasping his site and, in his words, a way of seeing it - *ma petite sensation* - but never a mere style or individual script.

In the late 1860s, even when his touch is consistent from painting to painting, it bends with the shape of his motif. In *Paysage* and *La Rue des Saules à Montmartre* - two small paintings done in a quick, loose touch, painted at about the same time and probably near to each other - he depicts an untamed hill in the one and the rigid intersection of two streets in the other[87]. In *Paysage* the flat, loaded touch follows the wobble of the vegetation and muddy road and the threat of the lowering sky, while in *La Rue des Saules* it straightens out to depict the flat planes of the buildings. In both paintings the view is upward, but in *La Rue des Saules* it is unusually sharp and insistent[88]. This projects the roofs at a very oblique tilt and makes the ground floor meet the street at an awkward angle. While *Paysage* is conventional in its composition, *La Rue des Saules* takes considerable risks, and one suspects that Cézanne may have enjoyed the challenge of tweaking the viewer with the rakish geometry. As it is, he has the satisfaction of creating a deep recession quickly, and then stopping it equally abruptly with a building painted in vertical and horizontal touches, in contrasting yellows and blacks, which projects forward toward the observer.

**LA RUE DES SAULES
À MONTMARTRE**
(R131), ca. 1867-68,
32 x 40 cm. Private collection,
New York.
Volume 1 number 40.

85 - *Monet, however, painting in the same spot, remained true to one kind of touch. For his and Renoir's* La Grenouillère, *painted from nearly the same spot, see Rewald*, History of Impressionism, *p. 229.*
86 - *See below, especially in chapter 4, and also in my Cézanne:* Landscape into Art, *pp. 23-30.*
87 - *Paysage also bears the qualifier "l'Estaque?", but the colors and the architecture suggest the hill of Montmartre.*
88 - *See the comparison between the site and the painting in my Cézanne:* Landscape into art, *p. 34.*

Only rarely does Cézanne's style appear to reflect a mood, but the sweeping brushstrokes and lugubrious colors of a number of paintings done in 1870 may well be an exception; among them we find four landscapes that it is difficult to see as other than unsettling. They are each turbulent, not only in touch but also in the space they create. The well-known *La Neige fondue à l'Estaque* (R157) is muddy and lowering, a "fearful image of a world dissolved, sliding downhill[89]"; *Paysage provençal* (R133) is nearly all grey and

LE VILLAGE DES PÊCHEURS À L'ESTAQUE (R134), ca. 1870, 42 x 55 cm. Private collection.
Volume 1 number 42.

its space flies apart; *La Route de forêt* (R168), though sunlit, is listless and unable to settle down; and *Le Village des pêcheurs à l'Estaque*, seems never to find its focus. In *Le Village*, for example, are we to look at the fishing boats in the distance, or at the tiled roofs, or at the hint of a street behind the tangled gate in the foreground? And if that is to remain unanswered, can we at least be guided from one spot to another? It would seem not; we are left to wander. No question of competence arises any more, of course: rather, a disturbance, a mood, or more probably a willful imposition of a style that is designed to evoke a mood, seems to be at work here. Whatever it is, it also affects several narrative paintings from about that year – *Le Meurtre, La Tentation de Saint Antoine*, and *Le Déjeuner sur l'herbe*, as we have seen, and also *Les Voleurs et l'âne* (R163) and *Pastorale* (R166).

This is not all that goes on in landscape in 1870 or close to it. *La Tranchée avec la montagne Sainte Victoire* is on the contrary firmly fixed to the ground and perfectly focused in the center. In fact, its very broad proportions are in themselves part of its stability, as is

41 - LA TRANCHÉE AVEC LA MONTAGNE SAINTE-VICTOIRE

(R156),ca. 1870, 80 x 129 cm. Bayerische Staatsgemäldesammlungen, Munich.
Volume 1 number 41.

the rigorously frontal space: the form closest to us – the boundary wall of the Jas de Bouffan – lies parallel to the canvas, as does the railway line running through the cutting. The frontal stance toward the landscape is not new – it can be seen in a number of his landscapes from 1865 and in *Le Bac à Bonnières*, above – but so decisive a form of it is exceptional. It is one of the irreducible aspects of his forthrightness, which made him reluctant to come any closer to the future Impressionists, and which drew him away after his one close approach, in Pissarro's company, between 1872 and 1874. And it is a stance with which he confronts us without apology: the painting is exceptionally large.

In its touch seemingly quite careless, the painting has a studied composition, with the railway cutting placed firmly in the center and the house and the mountain flanking it nearly symmetrically on both sides; the white guardhouse in the front is in turn fixed in the center, yet torn away from the red earth by its violent contrast with it. It is in fact not as calm a picture as it seems at first. The surface of the cut is in shadow, a dramatic, dark gap in a sunlit landscape, but it is not content to remain dark; the dull red of the earth comes forward to claim its natural red color and reflect some of the light. We are drawn to it and yet uneasy, as if ashamed at lingering too long and yet unable to turn away. Later, after some honest reflection, we may come to recognize that the source of the unease is the violence of the cut through the intact skin of the ground. To find our equilibrium, we may have to turn our gaze back to the symmetry of the composition; and it is perhaps as we take refuge in the calmness while responding to the emotion that we recognize the painting's power[90]. It is an uncanny feeling not unlike that elicited by Piero della Francesca's Flagellation of Christ in the Ducal Palace at Urbino.

In most of the smaller landscapes of the first decade, however, our response is simpler,

89 - Gowing, Cézanne: The Early Years, p. 166. The painting in fact represents a steep hill perfectly faithfully, but its effect is dizzying. The site was discovered by Xavier Prati and Georges Reynaud; personal communication.
90 - For an overview of the importance of this painting for critics and historians see Rewald, PPC, vol. I, p. 130.

**LES MARRONNIERS
ET LE BASSIN
DU JAS DE BOUFFAN**

(R158), ca. 1871,
37 x 44 cm.
Tate Gallery, London.
Volume 1 number 43.

and Cézanne's purpose is much more straightforward; when we sense a landscape's strength, it derives from something altogether different. *In Les Marronniers et le bassin du Jas de Bouffan*, for example, there is a palpable for-thrightness in the touch and in the composition. The time is close to noon – an unusual time of day for Cézanne to paint outdoors – and the painting records sharp contrasts between shadow and light. Where light and shadow meet, Cézanne sees more than a passage from the one to the other: he sees a solid horizontal bar that he can set against the verticals of the trees. The result is a stable and immovable frame, to which Cézanne opposes a forceful movement in the emphatic diagonals of the branches. (One diagonal in fact extends all the way from the upper left to the mass of vegetation in the lower right, and balances the opposed diagonal.) It is a solid construction, thoughtfully counterbalanced, and, in its density, unusual for Cézanne at this moment. A very firm touch supports it: the chestnut leaves are square, parallel blocks, all in thick pigment like the rest of the painting. I confess, however, to being puzzled by the vague nature of the mass in the lower right; vagueness is rare in Cézanne[91].

The painting is difficult to date, and it is its very substance as a painting that causes the trouble. Dates from 1867 to 1874 have been proposed[92], the earlier one presumably for the stark treatment, which should antedate the atmospheric effects learned from his contact with Pissarro, and the later one because it could represent a return to substance afterwards. I am not sure that the question can be resolved on stylistic grounds alone, and prefer to emphasize the picture's substance: it has the classical formality of the later Cézanne and is satisfying not only as a precursor of later work but in its own right. A date before the contact with Pissarro – I would favor the summer of 1871, which Cézanne spent in Aix – would put the *Marronniers* picture close to *Paysage avec moulin à eau*, which may seem strange, because in the *Moulin* painting not a single horizontal line stabilizes the canvas. But the paintings do share a simple, emphatic composition, as different as their form may be, and may perhaps be placed fairly close together in time in spite of the obvious differences. The paint handling, especially, is different: in moulin

**PAYSAGE
AVEC MOULIN À EAU**

(R183), ca. 1871,
41 x 54 cm. Yale
University Art Gallery.
Volume 1 number 44.

it is gritty, with the paint sometimes dabbed on, sometimes brushed on in curved or wobbly strokes whose character echoes the unsteady space. This puts the *Moulin* picture as far at one pole of Cézanne's early work as the insistent rectangular framework of the *Marronniers* painting is at the other, but it also unites them in a commitment to clear structure.

Looking sharply upwards toward the mill, we see it on a diagonal, and we see further diagonals in the paths leading up to it and in the slopes of the hills. The seemingly disparate lines then become resolved: they form two intersecting diagonals, and at their point of intersection we find the red roof of the mill and the black space just under it. This contrast draws our attention back toward the center whenever we stray toward the periphery; it makes the diagonals point toward the center rather than fleeing toward the edges. As close as this painting seems to be to the turbulent group of landscapes of 1870, of which *Le Village des pêcheurs à l'Estaque* was one, it is in fact more studied, with its equilibrium more carefully established and its touches dabbed rather than smeared; responding to the slower touches, our eyes move over its surface more slowly.

Another grey landscape, painted after Cézanne's return to Paris and before he joined

91 - *But we have already seen it in the same corner of* La tentation de Saint Antoine.
92 - *See Rewald's discussion of the controvery in his PPC, vol. I, p. 131.*

PARIS : QUAI DE BERCY. LA HALLE AUX VINS

(R179), ca. 1872, 73 x 92 cm. Private collection.
Volume 1 number 45.

Pissarro in the summer of 1872, is related to the style of 1870, that is, to *Le village des pêcheurs* (p. 50). It is *Paris: quai de Bercy - la halle aux vins*, an interesting but evidently noisy view he could see every day from his window. Its touch and tonality are restless and create a mood similar to those pictures. But photographs of the site show us that it looked very much as it does in this painting, so the mood is suggested by the site, and the sharp sweep of the ramp is something that Cézanne saw rather than invented[93].

Were it not for the sharp turn of the ramp, the painting might be no more than a prosaic city scene. The ramp is a kind of reverse turn in the road, starting parallel to the canvas and turning toward the back, and in this it is the opposite of the kind of turn that is soon to become important in Cézanne's landscape work: a road first going back and then turning right or left[94]. The second kind of turn is both impulsive and controlled, first creating a deep space and then preventing us from following it too far. But here the conception is more romantic, as Fry says[95]; the ramp flees toward the back, with its railing accelerating sharply as one follows it in either direction. The romanticism only goes so far, in any case; the prosaic greyness of the walls and buildings, and the overcast light, dampen the romantic sweep, and the barrels - no mere accidents in the composition - slow down any temptation we might feel to be whisked along by the railing. We know from the work of the psychologist Arnheim that circles stay visually fixed in their place[96], and Cézanne must have known this intuitively; here the barrels in the foreground slow down the horizontal movement of the stone wall, and the red barrels at the right draw our attention away from the ramp as it moves left. However romantic the painting may seem, Cézanne has in fact recorded the space as he saw it and integrated the composition closely, and that is as much as one would ask of any classical landscape.

Cézanne executed very few securely datable drawings in the first decade[97], and their scarcity tells us that he did not yet see the line of the pencil or the pen as suitable for indicating, or working out, the relationships between the elements of a landscape. Of the four drawings that are obviously early[98], one is a study for a painting in The Barnes Foundation and is very similar in style to it: the small and vigorous *La tranchée* (R89) of 1867-68. Like the painting, the sketch is sinewy and emphasizes the diagonal that

THE RAILWAY CUTTING (C120),
ca. 1867-68, 14 x 23 cm.
Present whereabouts unknown.
Volume 1 number 47.

runs down from the house in the upper left. Its style, so purely expressive in the roughly contemporary *Studies for the Orgy*, here both dramatizes and represents; its lines weave and undulate, but they also follow the curves of the hills and the sharp recession of the railbed.

Twenty watercolors dated around 1865 or shortly after, however - gouaches, in fact, because they rely on an occasional opaque touch - do appear as individual responses to particular sites, and they are conservative in composition and nervous in touch; their style mirrors closely the contemporary landscape paintings (see *Paysage*, p. 45) and they provide the same respite from Cézanne's insistent fantasy as do the oils. Unlike

93 - *See Rewald's photograph of the site in* PPC, *vol. 1, p. 141.*
94 - *There are only two turning roads painted before 1872, with neither turn very pronounced:* La route tournante en Provence, R85, *and* La route de forêt, R168.
95 - *Fry,* Cézanne: A Study of his Development, *p. 22.*
96 - *Rudolf Arnheim, Art and visual perception, Berkeley: University of California Press, 1974.*
97 - *Although Chappuis dates four drawings between 1870 and 1873 (Nos. 121-124), the dates are probably later; the drawings either represent the same subjects as later paintings or are done in a style closer to later drawings.*
98 - *Study of a landscape, with a smokestack and small tower, C115, 1859-60; Page of studies, including a bridge, and a detail after Delacroix, C117, 1864-67; Tree and house, C118, 1867-70, and The railway cutting, C120, dated by Chappuis as c. 1870, but more likely contemporary with the painting, between 1867-68.*
99 - *Reproduced in color in my* Cézanne: Landscape into art, *p. 37.*

46 - CABANE (RW13),
ca. 1865-70, 23 x 35 cm.
Private collection, New York.
Volume 1 number 46.

the landscape drawings, they never employ linear flourishes but rely on short, detached touches to form foliage and establish the receding planes. *In Cabane*, from 1865-70, dark touches outline the framing leaves against the sky, while lighter touches describe the volume and the local color of the tree of the left (there are traces of opaque white to lighten pigments that had gotten too dark); more abstract undulations depict the meadow, where they overlap in a way that creates depth. Like paintings, these watercolors have physical weight and presence, but unlike them, they are more derivative, less self-assured; they have yet to be given the brilliance and aesthetic independence of true watercolor.

On the eve of what will be a significant development, through a kind of apprenticeship he had never dared accept before, Cézanne has mastered the pushes and pulls of landscape compositions in oil; always secure in his compositions, by the middle of the decade he has developed a number of styles which give his landscapes an animated surface and a self-consistent vision. On the evidence of our perception we can also say that he has begun to see landscape in terms of space: as we look, we move quickly from the objects to the complex connections between them, and the canvas becomes a frame within which tensions pull this way and that rather than a window through which we see a scene.

PORTRAITS

NU ACADÉMIQUE
(R8), ca. 1860,
83 x 55 cm.
Lionel Mareu, Paris.
Volume 1 number 49.

Among portraits, too, Cézanne will paint a number of exceptional pictures by the end of the decade, and will succeed in unifying likeness with composition, but his beginnings are awkward; in this case the problem is that they are theatrical. There is dramatic lighting in his portraits of others and a self-importance or moodiness in portraits of himself; the self-portraits seem intent on presenting a personal attitude or rhetorical stance. There is no question of his competence in representation: from the start, in fact, as we can see in the first life painting of the human figure attributed to him, *Nu académique*, his ability to draw the figure is adequate.

Painted either from the drawings done at the Ecole Spéciale between 1858 and 1861 or from life, *Nu académique* is a finished painting, fully 83 cm in height. It is clearly a painting done by a student, working perhaps from a pose chosen by the teacher and capable of being held for a long time, and it seems to respond to a directive to get things right - in pose, proportion, detail and play of light - and keep matters decent. In all of these ways the painter succeeds, here as in the related drawings, and in the matter of decency succeeds altogether too well; the honesty of the figure gives way not merely to reticence in the genital area, as in Greek sculptures, but to an embarrassed absence covered by an unrealistic shading in red[100].

MALE NUDE (C77),
ca. 1862, 24 x 15 cm.
Musée Granet et Ecole
des Beaux-Arts,
Aix-en-Provence
Volume 1 number 48.

But it is the competence of the representation that is crucial, and if we cannot be absolutely sure that the Nu was done by Cézanne, we have proof of his competence in signed and dated drawings such as *Male nude*. Its technical adequacy prepares us to see all distortions and excesses in the portraits as willful and expressive or, less often, as youthful and immature. The question of maturity is in fact raised by one of the first recorded portraits, *Portrait d'homme*. Done quickly over an earlier landscape, it is dramatic in light and vigorous in handling. Its light is Caravaggesque and its brushstrokes are firm and clear. But the young painter's expressiveness is still only a shade away from melodrama, and the oval swirl of the hair and beard, repeated in the modeling

100 - *The early figure drawings are comparably and almost pointedly modest, but later drawings, in which Cézanne's pencil line has become free and vigorous, become more straightforward.*

PORTRAIT D'HOMME
(R70), ca. 1862-64, 44 x 32 cm.
Private collection.
Volume 1 number 50.

**PORTRAIT
DE PAUL CÉZANNE**
(R72), ca. 1862-64, 44 x 37 cm.
Private collection.
Volume 1 number 51.

Paul Cézanne, 1861.

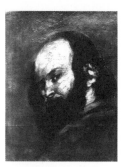

**PORTRAIT
DE CÉZANNE AUX
LONGS CHEVEUX**

(R77), ca. 1865, 41 x 62 cm.
Presumed destroyed.
Volume 1 number 52.

of the torso, seems too youthful and insistent; so do the brushstrokes sweeping down radially from the point of highest reflection in the forehead. Yet it is bold and self-assured, more so than the two other masculine portraits painted at about the same time[101], and thick and positive in its touch. It is also a convincing head, however closely it may represent whoever the sitter is[102].

Making a convincing head from a posed photograph is much more difficult, however; the photograph may offer a likeness, but neither drama nor mood. If the photograph is in color, as it would be now, it will let the painter see only a few hues in the skin compared to what the naked eye can see - and of course if it is in black and white, none whatever. But assuming that the painter supplies satisfactory color, he still has the tyranny of likeness to contend with. His challenge is not to let the photograph become a rigid standard to meet, with the surface and the modeling becoming fussy, flat and sterile. In his first self-portrait, done from a photograph, Cézanne has avoided the problems of lifelessness, color, and fussiness with a simple strategy - by providing the drama, using color expressively rather than realistically, and sacrificing some of the likeness. He has certainly made an expressive head: the touches are swift and sure (but in thin paint this time), the supplied colors are vivid, and the forms are firm and even exaggerated. It is the eyes, above all, that add drama to the photograph; rather than remaining tucked calmly under the upper eyelid, one bulges out and the other looks sharply upward. The result is both accusatory and brooding. The skin tones are no happier, being greenish and sickly, nearly luminescent in their contrast with the dark ground, and it is tempting to see the painting as betraying an unhappy mood.

Cézanne may well have been moody and unhappy, of course, but the painting cannot be used to prove it; all we can say is that that is how he wanted us to see him. But having done this, he has transformed a posed photograph into an expressive, personal view of himself, and that is far from a trivial achievement. And it is difficult not to admire the evidence of Cézanne's determination to think as a painter, no matter how strong the feeling that may be expressed. He can think of the bursts of orange-red in the lips, the corners of the eyes, and the outlines of the black jacket, in formal terms: he can justify them by putting them next to a skin made greenish, to which they are complementary. And in an apparent after-thought - a wedge by which he extends the forehead toward the upper left - he breaks away from the strictures of the photograph and adds the tension that had been lacking. Rather than using the photograph as a model, Cézanne has used it as a faint suggestion on which to build a vivid portrayal.

If portraits in general pose a dilemma between likeness and composition, as I said, in Cézanne's work they will do so especially in large paintings set in a context; but in heads standing alone Cézanne is more likely to focus on the quality of expression, and in self-portraits, on self-image or mood. His lighting may be borrowed from Courbet, and when it is based on a natural source such as a sky-light, may produce a plausible drama that is not out of proportion to its subject[103]; but when a romantic self-view is added, as it is in *Portrait de Cézanne aux longs cheveux* (now lost), the lighting will seem too forced, too calculated. For effect, the head will be seen from below, elongated obliquely, and cocked backward; the result seems pointedly heroic[104]. One is reminded of Delacroix's idealized portrait of Chopin, which is also seen from below;

101 - Portrait d'homme barbu *(R71), 1862-64, and* Tête d'homme *(R73), 1862-64.*
102 - *The suggestion that it is Cézanne himself, although it cannot be excluded, seems implausible to me. Circumstantially, I would note that we do not have any images of him with both a beard and a full head of hair; in the contemporary self-portrait, his hair is still full but he sports only a mustache, while in c.1865, perhaps two years later, he has a full beard but a rapidly receding hairline. Formally and more importantly, I would point out that all his other self-portraits are oblique, as is natural for someone turning toward a mirror to look away from his canvas.*
103 - *As in* Tête d'homme *(R 74) of 1865.*

yet there the painter looks up at the sitter with genuine admiration rather than, as here, at his own image in the mirror, with a hint of smugness[105]. We will never know whether the drama of the black and white reproduction would be tamed by color, but we are free to think that the effect would be slight. To judge by the overpainting in the highlight areas, in which fresh paint was dragged over paint that had barely dried from the day before, the self-portrait was worked on over a period of days, and seemed to Cézanne worth lavishing some care on.

The youthful narcissism of the self-portraits will not last into the next decade; the portraits will be objectively observed and their mood less apparent. His portraits of others will invariably be serious in expression and often utterly original in execution. We must include among them an exceptional portrait that was submitted to the autumn Salon of 1866, on an occasion when Cézanne was sure he would provoke the jury; this is the *Portrait d'Antony Valabrègue*, painted the summer before. Fortuné Marion had written to a friend that Cézanne hoped to be rejected and that his friends were preparing an ovation in his honor when the rejection came through. The question is whether Cézanne, knowing this, painted this portrait in a way that would offend. This seems implausible to me: rejection can be courted more simply and successfully either with less effort or with a more blatant offense. The problem with courting it with a poor painting is that the rejection will mean very little; Cézanne, we presume, would wish to be rejected for a painting of quality, which will put the onus on the Salon jury. And his certainty that he would be rejected very plausibly masked the wish to be accepted, since all that we know about Cézanne's conservatism and his admiration for his father suggests that he wished that, too; he did apply to the Ecole des Beaux-Arts in 1862, for the honor and the approved instruction (but was not accepted), and he did eventually succeed in exhibiting in the Salon, in 1904.

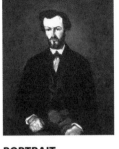

PORTRAIT D'ANTONY VALABRÈGUE (R94), ca. 1866, 116 x 98 cm. National Gallery of Art, Washington, DC. *Volume 1 number 53.*

If the thick palette-knife strokes were provocative – and they seemed to provoke everyone on the jury but Daubigny – the composition and the color, and the very gravity of the pose, might just as plausibly have invited acceptance. The many warm and cool greys, the blacks of the hair, eyes, and coat, could in their interplay claim descent from Velasquez, as could the luminous shocks of flesh color in the hands, face, and connecting shirt-front. The face is perhaps less spontaneously handled than the small, informal knife portraits of the same year, but then the painting is no mere study; it is over a meter high. Most expressive to me is the slight pull to the upper left of the forehead, as in the earlier self-portrait, which corresponds to the tension felt between the two hands. That the forehead is distorted, and that it charges the painting with tension, is demonstrated by the sitter's photograph, which shows his face to be comfortably symmetrical.

I think that we should also see in the painting's mastery the self-assurance that Cézanne had every reason to feel from the consistency and quality of his vigorous touch of that year. Of the paintings done or presumed to have been done in 1866, and perhaps a little before or after, most are striking in their confident paint handling; they include landscapes, still lives, and an unusual number of portraits. We have already seen a quiet kind of mastery in the 1866 *Le bac à Bonnières*, but in the portraits and still lives the

Antony Valabrègue.

104 - Steven Platzman, in his recent study Cézanne: The self-portraits, *also sees the early self-portraits as vehicles of an intended effect. All interpreters, myself included, face the difficulty of deciding just what effect is intended; however, he goes further than I think justified, and sees the gaze as expressing "determination and strength", and suggests that even the artist's "hirsute appearance ... was intended to communicate some message", such as perhaps a connotation of radicalism (p. 37). There no clear evidence of so well-defined an intention.*
105 - *A small self-portrait study, R116, in the palette knife style of the Uncle Dominique series is equally dramatic.*
106 - *Marion to Heinrich Morstatt, March 1866; see Rewald, PPC, vol. 1, p. 93. Rewald says not that Cézanne painted the portrait so as to be rejected, only that Cézanne was sure he would be.*
107 - *See Rewald,* Cézanne, *pp. 38 and 216.*

handling is ostentatious, vigorous and loose. Admittedly, ten portraits were painted of one sitter, his maternal uncle Dominique, and this bravura series affects how we view the year's work. Their very number suggests a feeling of ease and trust on the part of both painter and sitter, and the painter's emotional closeness may well account for the paintings' vitality.

A series of portraits, as against a single one, puts a different kind of burden on the painter: while it helps him master the likeness, it also runs the risk of repetition. Cézanne therefore has his uncle, presumably a good-natured man, don and doff various cloaks and hats, play monk or judge or sportsman, and the series that results varies in color, size, and pose. What is invariable about it is its alla prima surface; it is done with the palette knife with no trace of corrections.

Cézanne's handling of the knife is self-assured. With it he forms eyebrows, eyes, nose, beard, hands, and tunic, and models the face and hair with well-placed dabs for the highlights and shadows. In the smaller pictures we have only the well-done head to admire, while in the larger ones we can appreciate the composition, which is as calmly balanced as the touch is forceful. In *L'Homme au bonnet de coton*, one of the two largest pictures in the series, Cézanne retains all of the spontaneity of the touches of the small versions, and achieves this, I think, by keeping the color scheme and composition simple. With a black and white color foundation, and a neutral grey ground, he sets a red cravatte against a complementary green bonnet, and keeps the colors in equilibrium simply and straightforwardly; he then balances the composition by letting the left lean of the bonnet weigh against the rightward sweep of the white coat. These choices, as right as they are, seem quick and intuitive. Intuitively right, too, is the choice of grey for the ground, which makes the fairly dark skin appear luminous.

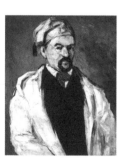

L'HOMME AU BONNET DE COTON (L'ONCLE DOMINIQUE) (R 107), ca. 1866, 80 x 64 cm. Metropolitan Museum of Art, New York. *Volume 1 number 54.*

With the Uncle Dominique series Cézanne reveals that he could integrate a composition even when working at passionate speed, and that when working with the knife, he would know when to stop. Working slowly with the brush, or slowing down after a quick start, allowed him to elaborate or correct his vision, achieve a more adequate expression of a narrative, or realize a more complex integration. But starting directly with the knife meant a kind of commitment to reaching a point of no return; if the touches were to retain their force, there would be no corrections. It was a risk that he took more often during the couillard phase of 1866-67 than before or after, and he took it with the greatest assurance in portraits and still lives.

LOUIS-AUGUSTE CÉZANNE, PÈRE DE L'ARTISTE, LISANT L'EVÉNEMENT (R 101), ca. 1866, 200 x 120 cm. National Gallery of Art, Washington, DC. *Volume 1 number 55.*

Neither the originality of pure knife painting nor its success on this small scale seduced Cézanne into adopting it as his sole style; in the couillard phase he could use the brush with a similar vehemence, and in large paintings the brush was actually the more natural choice. Youthful ambition could be satisfied just as well by a striking format, an important subject, or a monumental treatment, as by a bravura use of the knife. Cézanne's large portrait of his father, *Louis-Auguste Cézanne, père de l'artiste, lisant l'Evénement*, embodies just such an ambition, and uses these means; in part it also honors his father (and, we shall see, himself). The painting relies on the brush for the most part, and its broad sweeps remain distinct, their vigor undiminished. The obstinate firmness of the composition and pose reflect Courbet, as Fry has pointed out, as does the brown-black tonality[108]; the tall, narrow format - fully 2 meters in height - places the figure respectfully in distinguished isolation.

It is perhaps surprising that so ambitious a picture should come off so well. In some respects it is intended to satisfy too many wishes: it clearly represents admiration for

108 - *Roger Fry,* Cézanne: a study of his development, *p. 18.*

his father, but it is also meant to reveal a satisfaction with his own work, which hangs on the wall, and to suggest, to those who could read the hint, that the father read the newspaper which carried Zola's articles on that year's Salon rather than the paper he actually did read. Yet the whole is both good-humored and grave, and technically successful; the space is ordered and convincing, receding both obliquely, through the feet, thighs and armrests, and by superposition of planes - from the hands to the newspaper, and from there to the torso, the back of the chair, and the wall. In color it is luminous and balanced, pivoting on a cool, neutral grey in the trousers, balanced between the warm browns of the wall and the cool greens of the still life[109].

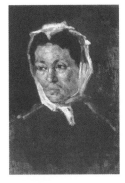

PORTRAIT DE LA MÈRE DE L'ARTISTE (R148), ca. 1869-70, 54 x 37 cm. St. Louis Art Museum. *Volume 1 number 58.*

Not all portraits of the decade, nor portraits done in the *facture couillarde*, are successful, but most are, and the exceptions are not especially instructive; they tell us only that Cézanne could fall prey to occasional heroism or sentimentality[110]. In the following year his style becomes more fluid and less insistent, and although it will return to other forms of ebullience soon again, it will never be quite as vehement. A portrait of a woman assumed to be his mother shows one of the forms the new restraint took. It is still painted in full paste, but mostly with the brush, and seems to have given up virtuosity in favor of a calmer self-assurance; as a result, the forms, more visible because the brushstrokes are less insistent, are perhaps stronger than in the portraits we have looked at so far. Not just the eyes and nose but the chin and jaw as well seem quietly firm. We are justified, I think, in reading into this portrait the closeness he is said to have felt for his mother, and to find the closeness expressed without ostentation, while his admiration for his father, allied as it was with a young man's rivalry, produced a portrait invested with a weight of complex meaning.

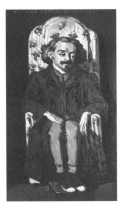

PORTRAIT DU PEINTRE ACHILLE EMPERAIRE (R139), ca. 1867-68, 200 x 122 cm. Musée d'Orsay, Paris. *Volume 1 number 56.*

Nothing in Cézanne's development prepares us - as nothing in 19th century painting prepared Cézanne's contemporaries - for the monumental and unique *Portrait du peintre Achille Emperaire* of c.1868. In some details, such as the undulating outlines, its style recalls other works of the period, but in all the crucial matters - the mercilessly flat, frontal conception and the self-consciously ungraceful surface - Cézanne presents a vision that is peculiar to this painting and is never used by him again[111]. There is perhaps no greater testimony to Cézanne's pictorial honesty than the choice of a heroic format for a figure with a large, noble head and withered legs, and no clearer example of the originality that is so apparent to us and was so disturbing to some of his contemporaries. The sitter is placed in the same chair as was Cézanne's father and the painting is on the same scale. But the figure is now seen more frontally and the space is kept shallow; the forms are barely modeled and there are few overlapping planes. Each form, no matter how small, is clearly outlined, as if it were a matter of the same literal honesty that dictated the pose.

Emperaire had in fact a handsome head, as Cézanne records in two drawings and a small oil portrait, and could strike a self-assured pose, as we know from a photograph reproduced by Rewald[112]. Cézanne could have painted him with his infirmity hidden or with his stature lengthened; seen from slightly below and one hand on his hip, Emperaire's proportions would go unnoticed. But that is neither in Cézanne's character nor in his nascent vision of painting. The portrait is no exercise of the kind of touch that calls attention to itself and proclaims virtuosity. On the contrary, there is a kind

109 - *See* Sucrier, poires et tasse bleue *(p. 91).*
110 - *As in* Tête de viellard *(R98) of 1866 and* Garçon accoudé *(R135), of 1867-68.*
111 - *The very late portraits of the gardener Vallier, R951 more than the others, are also lumpy in their surface - the result of multiple corrections before the paint had dried--but they are incisive in their outlines; we experience the figure as naturally weighed down with age rather than, as here, struck by cruel fate.*
112 - *PPC, vol. 1, p. 118.*

of renunciation of style that leaves us with only one thought: whatever its purpose, here is a new vision of painting. It is a vision embodied perhaps only in one other painting of the time, of which we have only a mocking newspaper cartoon; it is an apparently forbidding and raw female nude. But the mocking cartoon may have hit upon a truth: the complex painter may have wished to shock the jury as much as to portray his subject mercilessly. As with the Valabrègue portrait, however, shock could have been only a small part of his complex motives. Its graveness and its self-conscious simplicity are too important to throw away on mere shock[113].

Cézanne never painted portraits on so large a scale or with so grand a purpose again; those that follow shortly after, in about 1870, bring us back again to the more modest purpose of portrayal. The portrait of his friend Gustave Boyer sets off the face and hat against another grey ground, and is as elegant in its colors as it is doughy in the masses and robust in its lines. The yellow of the straw hat against the adjacent black hair and the cool grey ground is in fact a harmony taken from Manet, and it is used with straightforward admiration rather than the ironic ambivalence of *Le Déjeuner sur l'herbe*, above, with which it is nearly contemporary. But the lines are Cézanne's own; they resist the graceful flow of Manet's brush and, restlessly, find turns and bumps where they can. The face sits well in the frame, as it were, with the piercing eye located in dead center between the right and left edges of the frame and acting as an anchor that slows down the linear swirls. Because Cézanne painted Boyer twice more and drew him once, in ways that we can recognize easily, we presume that the likeness is good, or equally good in each version; and we sense that the face is in some way congenial to the painter, perhaps because its colors are similar to his own.

It is, I suspect, when a face was less congenial, or less striking in its structure or color, that Cézanne would shift the burden of expression to the composition. In an 1871 photograph, taken at about the time the next portrait was painted, Fortuné Marion has a smooth, oval face with only a wild shock of hair to relieve the plainness. In the portrait, however, Cézanne paints the head more massive and lumpy, with short, full-paste strokes that make the head and hair alive with movement, and inclines the whole sharply. There is no question about which version is the more interesting.

The inclination of the head is particularly puzzling, if we look at the picture as representing an actual pose, and disquieting, if we consider Marion's discomfort; but I suspect that we are to look at the picture formally, and that if we look at the rakish tilt of the shoulder, for example, we will see the composition as a superposition of three stable pyramids, which I believe was the intent. The shoulder and cravatte form the lowest one (a faint white line extending from the cravatte to the corner completes the shape), the hairline the second, and the top of the head the third, with the angular eyebrows a gentler echo; the juncture of collar and lapel then becomes a stable vertical helping hold the head in place well inside the frame. It seems a radical expedient for representing an undramatic head, but it represents a satisfactory compromise between the requirements of likeness, expression, and composition, and is witness to Cézanne's insistent grasp of form.

At the close of the decade Cézanne paints several group compositions from life which it would be a mistake to overlook. They are neither portraits nor figure studies, but they

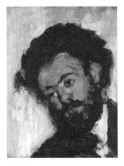

L'HOMME AU CHAPEAU DE PAILLE - GUSTAVE BOYER (R174), ca. 1871, 55 x 39 cm. Metropolitan Museum of Art, New York. *Volume 1 number 60.*

PORTRAIT D'ANTOINE-FORTUNÉ MARION (R177), ca. 1871, 41 x 33 cm. Kunstmuseum, Basel. *Volume 1 number 62.*

Antoine-Fortuné Marion.

113 - Athanassoglou-Kallmyer (1990) suggests that, rather than intending to shock, the portrait may have been intended to satirize; its object would have been Ingres' hieratic portrait of Napoleon I. I am fully aware that paintings are the products of complex motives, which in Cézanne's case may include shock or satire, but in judging the importance of a work one must give the various motives appropriate weight. Here, any wish to shock or satirize could certainly have been fulfilled with less effort, and if it were the main motive, it would have produced a painting of less substance. On occasion, Cézanne's apparent ineptness in portrayal may also be seen as willful (as pointed out by Cranshaw and Lewis, 1989, but to raise it to an explanatory principle for most of his early work, as they do, is to explain both too much and too little.

pose the same problem of integrating likeness with composition; and Cézanne's solutions in two of the paintings show how successful his restless search for form continued to be. Both are scenes with two figures, one nearer than the other, and both face the challenge of transforming a deep space into one that stays close to the plane of the canvas. Although they are presumed to be nearly contemporary – 1869-70 – they are far apart in style and conception. *Paul Alexis lisant à Emile Zola* has Alexis in a chair, close to us, with his head perhaps a bit lower than the painter; Zola, who sits on a mattress, is further back and lower down. We can read this in three dimensions without any problem, but for the

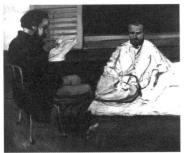

PAUL ALEXIS LISANT À EMILE ZOLA

(R151), ca. 1869-70,
130 x 160 cm.
Museu de Arte, São Paulo
Assis Chateaubriand.
Volume 1 number 63.

composition the problem is that he is certain to appear much smaller. Cézanne's solution is both simple and unobtrusive: he paints Alexis' torso and outstretched thighs about the same size as Zola's whole figure and joins the two figures at Alexis' knees; this creates a continuous arc, or a single mass, that sweeps from one head to the other and passes through the knees, and keeps the figures in nearly the same plane[114].

In the other picture, *Jeune fille au piano - ouverture à Tannhäuser*, Cézanne sets out to solve the same problem of unequal sizes but proceeds in a slower and more geometrical manner; nowhere is the painting sweeping or sketchy. It is probably the third picture in a series by the same title, and from the descriptions of the others is probably the simplest and most carefully worked out[115]. Two figures at different distances from the painter have again been made to appear the same size, and by the same expedient: if we discount the bottom of the pianist's skirt, they occupy about the same space. The whole is also kept flat by an emphatic symmetry: the two women lean away from each other on either side of a vertical midline, and the black piano mimics the white chair opposite. It is a sober arrangement, like the Byzantine mosaics at Ravenna, and equal-

JEUNE FILLE AU PIANO - OUVERTURE À TANNHAEUSER

(R149), ca. 1869-70,
57 x 92 cm.
Hermitage Museum,
St. Petersburg.
Volume 1 number 61.

ly monumental. It is lightened somewhat by the arabesques of the wallpaper, but only barely; they seem very earnest in their purpose, which is to incorporate the young woman's head into the plane of the decorative pattern.

By an apparently impulsive procedure in the one case, then, and a thoughtful, reductive one in the other, Cézanne has constructed compositions that call attention to the canvas as an object rather than as a window. In *Jeune fille au piano*, by using the simplest possible harmony between the dark olive of the wall and the dull crimsons of the sofa, armchair, and the arabesques, he has confirmed the painting's sober purpose. Had a listener been placed in the armchair, as in the lost versions, the painting would have been a domestic scene, a mere moment after dinner.

During this decade, Cézanne's many drawings from the model include both figure studies and portraits, but there are no watercolors. The figures are drawn with the same attention to proportion and modeling as the painting with which this section started, and further confirm, if confirmation should be needed, Cézanne's skill in representing the body. But they do little else; it is the portraits that engage us. None of them seem mere exercises in drawing; on the contrary, they reveal a Cézanne who is closely attentive to his model's appearance and expression, and, I am persuaded, close to him emotionally. They are portraits of friends in the first decade, of his family later, but not of clients[116]; and if they convince us by their expression, it is because Cézanne had responded to the emotional state of his sitters.

114 - *Tucking Alexis' shins so tightly under his knees extracts a price, however, at least for the viewer who looks for such problems: the foreshortening of the shins is so radical that they seem uncomfortably squeezed.*
115 - *Rewald in PPC, vol. 1, p. 125, quotes several letters that describe two paintings by the same title - which no longer exist - which had either Cézanne's father or Fortuné Marion sitting in the armchair. The painting that survives is therefore simpler - the product, most likely, of a reduction to essentials, somewhat like the much later series* Joueurs de cartes.

The sitter's emotional state may have been easier for Cézanne to feel and capture when drawing than when painting; painting is as much a commitment of time and patience for the sitter as it is an artistic commitment for the painter. One of the sketches for the large painting of Achille Emperaire shows just this difference: the sitter is clearly in a mood, perhaps thoughtful and somewhat tired, not a little vulnerable, but alert and focused. However one describes the expression, one feels the immediacy of it, and one feels the immediacy of Cézanne's hand, which is loose, yet self-assured, exact, and consistent. All the lines except the few that indicate shading weave with a kind of graphic pleasure to draw the unruly hair, mustache and Van Dyck goatee, and to establish a certain wistfulness in the unfortunate subject.

**PORTRAIT
OF ACHILLE EMPERAIRE**
(C230), ca. 1867-68,
49 x 31 cm. Kunstmuseum,
Basel.
Volume 1 number 57.

It is only one way for Cézanne to do a pencil portrait, and it may be presumed to fit the subject and the moment. In other portraits, such as a study of Boyer (*Portrait of a man*, C157, 1868-70) Cézanne worked with short, straight, incisive lines, and in a study of Delacroix with even shorter blocks made by a flat, soft pencil. The Delacroix sketch was done from a photograph[117], and the short blocks, far from constricting Cézanne's hand, gave him room to concentrate on modeling and expression; the painter he admired seems clear in gaze and purpose, and the very form of the lines suggests the intensity of his paintings.

Among the accomplishments of his first decade, then, we must count the transition in his portraits from idealization to candor: from heroic or brooding views of himself to the honestly observed images of the people he knew (and, in the next decade, to images of himself as well). Achieving a likeness presented no problems, certainly not after the middle of the decade, nor did portraying a credible expression; his greater challenge was to integrate a convincing representation into a large composition, and he met it in several highly original ways. One could say, as with the landscapes, that Cézanne had learned to do portraits well by learning how to observe. But while that would be correct enough, it would be incomplete: the portraits also come alive by a psychological openness that Cézanne is seldom given credit for - a closeness to his sitters (admittedly, all his models in this decade were people he knew well) that allows him to follow the particularities of their faces and portray their character. The demand that they sit absolutely still which Vollard recounts from his sitings in 1899[118] has been misinterpreted as a wish to have them as distant and inert as still lives; it seems best to see this merely as a technical requirement, and to credit psychological distance only to the portraits, such as the one of Vollard, where it is evident.

**PORTRAIT
D'EUGÈNE DELACROIX**
(C155), ca. 1864-66,
14 x 13 cm.
Musée Calvet, Avignon.
Volume 1 number 59.

Throughout his career, Cézanne was probably most at ease with his still lives; he painted them without any evident conflict and with a calm and pleasurable matter-of-factness. Only rarely was there a hint of an anecdotal burden, and only rarely do we feel any need to search for an interpretation behind what we see so plainly. It is therefore a surprise to find that only about a dozen still lives can be traced to the first decade.

STILL LIVES

In fact, only three still lives exist from the first half of the decade, and one is merely a copy of a small painting Cézanne saw in the Aix museum. The other two, both original, can only be seen in black and white reproductions[119], and it is not clear if they are of much significance. Most important about Cézanne's early work is his lack of interest

116 - *As far as we can tell; admittedly, we do not know the identities of several of the men.*
117 - *See* The Drawings of Paul Cézanne, *p. 82.*
118 - *Rewald,* Cézanne, *p. 190; his source is Vollard,* Paul Cézanne, *ch. VIII.*

in still lives. If the work that survives represents the range of his paintings accurately, then in the very first years Cézanne seemed rather to search for narratives to recount or faces in various attitudes to portray – unless he was painting landscapes, where message or anecdote could not intrude.

But in the middle of the decade, at a time when he paints the prolific series of landscapes of which *Paysage* was an example (p. 47), he paints four still lives of considerable power[120]. The first of them is presumed to have been submitted to the Salon of 1866 with the Portrait d'Antony Valabrègue and it, too, was rejected; whatever the reasons were, they could not have been the same, because the still life is cautious in both color and composition. Its brown-on-black palette makes a reference primarily to Manet,

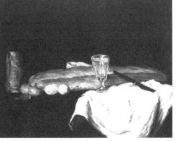

LE PAIN ET LES ŒUFS (R82), ca. 1865, 59 x 76 cm. Cincinnati Art Museum. *Volume 1 number 66.*

and through Manet to the Spanish painters; the bread is a rich red-brown against the cool grey of the milk can, and diagonal brushstrokes in the surface of the bread parallel the pink stripe in the napkin and the knife. All of this is thoughtful and perfectly competent, but also conservative and careful, and Cézanne appears to waver between placing the objects higher, for greater mass, or lower, for a more striking contrast with the black space; in any case, he reaches a timid compromise.

One cannot reproach Cézanne for wishing at one moment to rebel and at another to be accepted, nor can one say that the conservative half of his ambivalence was always inhibiting; on the contrary, there will come a moment when his greatest strength will lie in integrating the two. But in this painting, caution seems to have won out, as it does in the roughly contemporary *Le Poêle de l'atelier* (R90), which I do not reproduce. An attitude of rebellion, or a more aggressive self-affirmation, serves him

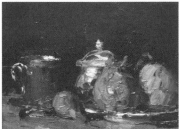

PAIN ET GIGOT D'AGNEAU (R80), ca. 1866, 27 x 36 cm. Kunstmuseum, Basel. *Volume 1 number 64.*

better. *Pain et gigot d'agneau* is also nearly contemporary – best placed, I think, with the palette knife pictures of 1866 – but it unleashes a violence of subject, of touch, of color, and of diagonal composition, that creates a magnificent still life, seemingly larger than its small size. More significant than its sheer intensity, and perhaps more surprising at this early period, seems to me the sureness and unity of the work: the weight of its elements is well distributed on the canvas, and the colors – the greens and reds – are in perfect balance.

A similar vehemence animates the slightly larger *Sucrier, poires et tasse bleue* and brings it an equal success. Unlike a severed leg propped diagonally against a loaf, cups and fruit offer only their simple, symmetrical and whole forms to combine; this runs the risk of tameness and repetition. Cézanne runs the further risk of assembling them in a shallow space. If there is to be drama, then, it must be embodied in something like the self-assured, alla prima, handling, and in a few formal devices such as the inclination

of the two stems which point us first right, then left, and in the swirling handle of the cup; and there is where we find it. Yet the painting is as straightforward and workmanlike as it is dramatic: the horizontal pear suggests depth very plainly, and four colors are balanced in a simple opposition of the two pairs of complementaries: red and green, blue and yellow.

That an impulsive process should lead Cézanne to paint successful pictures with such sureness would be a surprise if we did not already have the portraits of Uncle Dominique; but admittedly Cézanne is more often remembered for his careful reworking. The point that must be made about him, however, is that he worked in a variety of ways, and that although this degree of impetuousness would mark

SUCRIER, POIRES ET TASSE BLEUE (R93), ca. 1865-66, 30 x 41 cm. Musée Granet, Aix-en-Provence. *Volume 1 number 65.*

119 - *Their whereabouts are unknown, but black and white photographs can be found in Rewald, PPC, vol. 2, p.12.*
120 - *A fifth one, listed in Rewald's catalogue as No. 81, now appears as the possible work of another hand.*

only the couillard phase, some impulsiveness underlay his more careful procedure at all times. He himself spoke toward the end of his life of painting quickly as he began[121], and the young painter Le Bail saw him start on his canvases at full speed, without hesitation[122]; if a slower process of elaboration followed, it did so in order to achieve a more resonant range of colors and a more complex integration. In no sense was the later process obsessive; it was rather an elaboration in which the initial impulse would be realized more thoughtfully. In the part of his early work where impulse carries him directly through to completion, as in that exceptional year 1866, he resembles his nineteen-year-old self, the writer of bawdy poems in his letters to Zola[123].

That Cézanne's emotional life was complex is beyond doubt, of course, and that thoughts of death, often connected with sex, were close to him as a young man, is obvious; we have the evidence of his poetry. The one still life with a skull that he painted in his twenties, however, may or may not be the product of the same thoughts. *Crâne et chandelier* is in some ways too conventional - the burnt candle, spent flowers, open book of life - and too heavy. The composition never comes together, and it is impossible to say whether that is the result of his conventional thinking or the problem of painting over another composition. But the palette knife touch is compelling and the colors are very much alive. The knife is sometimes set down in touches, at other times dragged in thick paste, and the result is a painting that is more a firm object than it is an image. The colors, above all, have Cézanne's sense of sureness and balance: not especially the red-green complementary, to which we are becoming accustomed, but the cream-white skull against the cool grey ground.

CRÂNE ET CHANDELIER (R83), ca. 1866, 48 x 63 cm. Private collection, Switzerland. *Volume 1 number 67.*

Four still lives have been placed between 1867 and 1869, but only three of them are indisputably Cézanne's[124]. Two of those three are original and the second one I show here is masterly. *Pot vert et bouilloire d'étain,* the first, is a picture of exceptional solidness. Its color scheme has a black-white center point, somewhat like *Le pain et les oeufs* above, but it spreads out more broadly, toward the warm red and the cooler green; and because most of its whites are warm rather than neutral, the grey of the pewter pot is tinted blue. In broadening out from a black-white center the painting resembles *L'homme au chapeau de paille* (p. 58), or even *L'orgie* (p. 38), more closely than the *Le pain* still life, and is closer to them in time. And it resembles them, as well, in reintroducing outline, a firm outline that has a slow, meandering shape, consciously avoiding any hint of lightness or elegance. If we look back at the *Portrait du peintre Achille Emperaire* or *La Toilette funéraire,* and forward to *La Pendule noire* below, which are all roughly contemporary, we see the cumbersome outlines again. What these points of resemblance show is not a clumsy, too sincere, Cézanne - however much of a compliment may be intended by this - but a maturing painter of a strikingly original predisposition who is working toward a deeply personal style; and inevitably, the originality of the style has the effect of displacing the limits of painting itself, and this in a way that distinguishes him sharply from even his rebellious contemporaries.

POT VERT ET BOUILLOIRE D'ÉTAIN (R137), ca. 1867-69, 63 x 80 cm. Musée d'Orsay, Paris. *Volume 1 number 68.*

121 - Cited by Maurice Denis, in P. M. Doran, Conversations avec Cézanne, Paris: Macula, 1978, p. 176.
122 - See my discussion of Cézanne's starting points in Cézanne: Landscape into art, pp. 54-58, and in particular the full quote from the painter Le Bail, who said that, as he began a painting, Cézanne "drew with a brush with ultramarine blue diluted with much turpentine, setting things down with verve, without hesitation" (Rewald, Cézanne et Zola, Paris: Sedrowski, 1936, p. 170; my translation).
123 - Not all of which, admittedly, were happily and simply bawdy, but enough were so to establish that his emotional life could allow an uninhibited expression of impulse.
124 - Bouteille, verre, et citrons (R129), the exception, seems to me too crowded, too mechanically assembled, to be by Cézanne's hand. Presumably a gift from Cézanne, it belonged to Dr. Gachet, himself an amateur painter. This is not considered a reliable provenance; but whatever the authorship, it is an inadequate painting.

In *Pot vert* we also witness the first appearance of the broadened mouth of the pot[125], that is, an oval that is broader than the ellipse the eye would actually see. It is a device that flattens the receding space by tilting the oval upward, and it has the further advantage of being consistent with the purposefully inelegant outline. Ten years later he will go a step further and square up the sides while widening the mouth more. This distortion will eventually become an integral part of the Cubists' way of limiting the depth of a painting, and, in imitative paintings, a cliché. Here it represents one of the discoveries Cézanne made by which a painting would become as much an object in its own right as a window frame to look through. In a manner that is purely his, with no special echo in the future, he also pulls the shapes of all the objects toward the upper left, as in the *Portrait d'Antony Valabrègue*; and perhaps this reduces the knife, which in Manet and Chardin before him would give depth to a still life, to lying on the table as a mirror to the diagonal movements of the napkin. I confess to being unsure whether that knife is useful; it almost attempts too much and achieves too little.

The masterly painting is *La Pendule noire*. So perfectly and simply constructed is it that it can be grasped right away, eliminating any need for explanation. Its massive base - the starched tablecloth that seems like a marble pedestal - its disposition of forms along the horizontal midline, its calm verticals and horizontals, are all intuitively grave and monumental. Undulations in the folded-over corner of the cloth and the wrinkled back of the shell, and wedges cut into the rim of the glass vase, return us to decoration, delicacy, and movement. The red lips of the shell - so formally right in color and in diagonal movement - nearly overdo it and tip the balance too insistently toward organic forms; they disturb the analytic gaze and provoke uncomfortable thoughts of incorporation, oral or sexual. Yet without them the painting would be lifeless, and our gaze would be held by the clock's blank face.

It is perhaps one of the painting's triumphs that its symbolism is held in check so well by the strength of the composition. One could become attached to the handless clock, for example, and speculate on the role of time in the message of the painting. That seems to me unnecessary; I prefer to look at the clock's blankness from a technical, common-sense standpoint: from Cézanne's alternatives. Any position of the hands other than at 3, 6, 9, or 12 o'clock would be diagonal, and would alter the geometry of the picture; yet each of these other positions would also suggest too precise a time. If he wishes to avoid turning the still life into an anecdote, Cézanne must avoid all such referents. As it is, he runs a risk with the shell, but I believe that he steps back from it safely by having it play so strong a formal role: having it leaven the solid structure and remind us that we are seeing a painting conceived in color as much as lines and solids. I cannot resist an image of Cézanne as walking a tightrope here, and in some way the image is gratifying, because it turns what might have been a self-consciously momentous painting into one filled with tension. One is not always sure, looking at this picture, how secure his balance will be, but one cannot take one's eyes off it.

There are neither watercolors nor drawings of still lives in Cézanne's first decade, and this suggests that the role of these two media was initially to provide quick studies for oil paintings, particularly narratives. It is oil painting, in all four genres, that is Cézanne's focus and ambition. But if among the oils the still lives are the least numerous, it is a sublime paradox that he burst upon the scene after painting only a few still lives with pictures such as *Pain et gigot d'agneau*, and that one of the masterpieces of the decade should be *La Pendule noire*.

LA PENDULE NOIRE
(R136), ca. 1867–69, 54 x 74 cm. Private collection.
Volume 1 number 69.

125 - *Cézanne uses this device in the contemporary* Pot, bouteille, tasse et fruits *in the teacup, and it can be seen in the disputed* Bouteille, verre, et citrons *(R129).*

The strands of his first decade should not be woven together too tightly; his oscillation between tradition and rebellion and his sometimes uncertain rhetorical stance seem more striking than any single direction of development. But it can be said that by about the middle 1860s he had clarified some of his aims by clearly separating narratives from paintings based on observation, just as he relinquished dramatic expression in his portraits; and that in 1865-66 he burst forth with a series of paintings based on vision in which he used brush or knife emphatically and freely to produce exceptional portraits, landscapes, and still lives. They were unified in style, secure in touch, and well realized as compositions. Yet neither the freedom of this touch nor the emphatic mode served him in narrative painting; there, it was clarity of purpose and of rhetorical mode that he needed instead. By about 1867 he had found the purpose in small, informal paintings, and the rhetorical mode in the protective context of illustration, and his narratives could from then on be expressed more and more coherently. In all his pictures it had become clear that they were to be conceived as objects with their own inner dynamics, existing as self-sufficient compositions while representing things and events.

If the accomplishments of the first decade are to be measured by some of his exceptional paintings, then among narrative paintings I must include *La tentation de Saint Antoine*: it achieves a peculiar fusion of a brooding, personal purpose and an evident search for rhythm in the position of the figures. The equilibrium between expression and rhythm may not seem stable, but Cézanne has worked hard to keep them in balance. Among landscapes, *Paris: quai de Bercy - la halle aux vins* illustrates an achievement that very clearly anticipates his future development: the sense of landscape as the organization of space, a space that here recedes smoothly toward a firm plane in the distance but which will be built up of overlapping surfaces in his later work. In portraits, Cézanne had to overcome the need for dramatic expression, which he accomplished with the straightforward Uncle Dominique series, and he had to integrate likeness into a composition, which he did on a monumental scale with the portrait of his father of 1866 and the *Portrait du peintre Achille Emperaire* some two years later. The portrait of his father - the father admired by the young painter but also shown as admiring him - set the likeness into an ordered space that receded by discrete steps, while the Emperaire painting satisfied both his needs for truth - awkward and provocative, if need be - and for a new vision of painting: raw, flat, and brutal, as the case might require. The very same vision then became the vehicle for a gentler still life, *La pendule noire*, a masterpiece uniting architectural firmness, decorative delicacy, and inchoate fantasy ■

Detail of Sucrier, poires et tasse bleue *(R93), ca. 1865-66.*

1872–1879

From Impressionism to a disciplined touch

…a moment of crucial significance for Cézanne, but we must remember that it was only a moment[126].

Paul Cézanne (center), Camille Pissarro (right) near Auvers, ca. 1874.

126 - Roger Fry, p.35 (on Cézanne's time with Pissarro)

During the war of 1870, Monet and Pissarro fled to England, Manet and Renoir served in the army, and Bazille not only served but lost his life. Neither Cézanne's life nor his art seemed, however, to be changed in any discernible way. He went to L'Estaque to paint and avoid conscription, and he might as well have gone there only to paint; the style of 1870 that we have seen simply developed from previous work and continued after his half-year's retreat.

In 1872, back in Paris, he painted one datable landscape in the style of his Estaque paintings from his new apartment opposite the *Halle aux Vins* (p. 52), and perhaps others that we cannot date. By September he was ready, probably for a number of practical and artistic reasons, to accept Pissarro's invitation to join him in Pontoise, and the two years that he spent there and in nearby Auvers-sur-Oise are rightly understood to be crucial for his development. Pissarro and Cézanne had known each other since meeting at the Atelier Suisse in 1861, during Cézanne's first stay in Paris, and Pissarro, eight years older, was ideally placed to give him help and encouragement – he was one of the few who understood Cézanne's originality right away – as he helped the others of Cézanne's generation. In the late 1860s he moved to Pontoise and eventually gathered a small group of painters around him; after Cézanne joined him, the two remained in close contact, or painted side-by-side or on sites they could introduce each other to, either in Pontoise or Auvers.

Cézanne recalled later how much he had learned then, both technically and in attitude toward painting, so the period marks a natural starting point for this stage in his development. There is no doubt that Pissarro's exceptional character was one that Cézanne could trust[127], and no question about his civilizing influence or his dedication to hard work. As affectionately as Cézanne remembered the period, however, I think one must also see it as potentially limiting, and to fear that a longer apprenticeship would have inhibited his development; there is a calmness about some of his work, and a restraint in its expressiveness, that is out of character. Some of what happens may be a natural development: for example, narrative fantasies lose some of their aggression and become replaced, with time, by bathing scenes. But some of the landscapes also lose their tension; the tension returns only in the following years. However helpful Pissarro's example was in technique, vision, and attitude toward work in the short run, and however beneficial his calming effect on narrative painting, I think that for the sake of his future development Cézanne had to break away from it when he did. Of course, the break – the physical move back to Aix and the shift to new styles – came right after the 1874 Impressionist exhibit, so it was also a disengagement from Impressionism at the very moment that it had found its identity. The reasons will become clearer when we come to the landscapes; in any case, the separation was not a personal one, and Cézanne never lost his affection or his admiration for Pissarro and returned to paint with him. And six or so years later he paid what one could think of as a late and indirect homage to Pissarro's attitude toward hard work by discovering his own, systematic and disciplined mode of working.

When Cézanne accepted Pissarro's invitation, there had been an emotional change in his life as well; Hortense Fiquet bore him a son in January 1872, so we must add the effects of domesticity to Pissarro's calm support if we wish to explain the changes in style and subject that we observe then. His development was never again influenced so directly by anyone, not even by Pissarro during the two later periods they spent together, in 1877 and 1881.

127 - *Cézanne's exceptionally good-humored tone in a letter to his mother must have reflected his relation to both his mother and to Pissarro. He writes,* "Pissarro…is in Brittany, but I know that he has a good opinion of me, [and I have] a good opinion of myself. I am beginning to consider myself stronger than all those around me…" *Letter of September 26, 1874 (translation mine). See Rewald, Cézanne: Letters, p 141.*

During the years covered by this chapter, whatever evolution we can observe in Cézanne's subject matter, it is more important to follow his search for consistent and fitting styles. While until about 1879-80 his styles are coherent over short periods of time – and invariably within each canvas – the five years that follow witness the use of a single style that unifies his entire œuvre. It is a way of setting down the paint – the parallel touch – that fuses all his requirements of expression and composition; it becomes a mode of representing, a way of seeing, and a method for integrating the canvas, all at the same time. The touch develops over several years from about 1876 to about 1880, and for a time it serves him for most of his painting; when there are exceptions – it is the last to be developed in landscape and of least use in portraits – we shall see that the reasons are technical. We can define the end point of this period by the first uses of that style.

The parallel touch is so distinct that it helps even casual observers identify Cézanne. For the painter, however, it was neither a signature style nor an end point of his research into representation. It was the point of departure for further developments, which culminated in the overlapping patches of the mid-nineties. But it forms a useful terminal point for this chapter and reminds us, paradoxically, that integration of his canvases was something he had pursued all along, in different and often equally successful ways.

NARRATIVE PAINTINGS

It does not diminish an artist's stature in the least if we discover that he could paint ordinary fantasies, that he could do it awkwardly, and that the result could be embarrassing. We have to take it as a given that the painter is human, that he may paint for some ironic or prankish purpose, and that he may produce a silly painting now and then; one cannot imagine an artistic life spent thinking in terms of masterpieces solely and producing them predictably. On the contrary, trivial pictures help relax the painter's attitude toward painting and concentrate on the bigger work; and they help us see in what way the great ones are an achievement.

A very small picture (14 x 21 cm) painted in about 1872 called *Baigneuses et pêcheur à la ligne* is the one I have in mind: the surface is uninteresting, the women's figures are awkwardly painted, and the man's fishing rod is long enough to reach across the water. Some controversy exists about whether this caricature of fishing should be seen as an allusion to a sexual approach or not, and this puzzles me: why should one exclude the obvious? It seems best to accept that the picture is a private sexual fantasy, probably good-humored, certainly painted quickly and without attention to form – and to conclude that if Cézanne is to paint better narrative pictures he must in the very least gain a greater distance from his personal fantasy and paint with a view to communicating.

BAIGNEUSES ET PÊCHEUR À LA LIGNE
(R231), ca. 1872, 14 x 21 cm.
Private collection.
Volume 1, n° 70.

It is this effort to communicate that is apparent in *La Conversation*, painted at about the same time, and it is easily visible in the respectability of the figures and in the emphasis on composition[128]. That they should be dressed elegantly conceals, and makes acceptable, what is essentially an erotic or at least romantic fantasy; that a faithful dog should look lovingly at his mistress suggests that the encounter might be enduring; and that a series of diagonals should extend from the lower right to the upper left – between the three heads, through the woman's skirt, and along the branch – indicates Cézanne's effort after a coherent composition. Compared with the narrative pictures of the first decade, this one is neither sentimental nor rhetorically overdone

128 - *And in the existence of a preparatory pencil sketch, C252.*

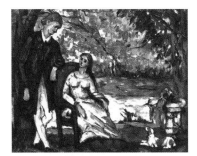

LA CONVERSATION
(R235), ca. 1872-73,
45 x 53 cm.
Private collection.
Volume 1, n° 72.

nor ironic, but rather down-to-earth, and the touch is applied consistently and with the same care that he gives his contemporary plein air landscapes. We shall see later that Cézanne is not immune to more emotional subjects and more forceful treatments, but he has at least realized the possibility of a civilized, domestic scene here. I remain puzzled by a minor technical matter, which we shall see often again, namely the awkward right leg of the man; a painter who could draw legs and feet as well as Cézanne did in his academic studies could have been more convincing here, and a painter as skilled in composition should have resisted placing the leg parallel to the woman's skirt.

Une Moderne Olympia was also painted during the time with Pissarro, but if it shows the older painter's influence at all, it might be in a more secure acceptance of fantasy than in the civilized restraint of technique. I can think of no clearer example of an unconflicted narrative picture in Cézanne's work than this one. All the risks augur an overdone painting: the wry comment on Manet's Olympia, which might suggest heavier, ironic treatment; the unashamedly voyeuristic subject, which might tempt the painter to try a more lascivious pose; and the example of Cézanne's own earlier

UNE MODERNE OLYMPIA (R225),
ca. 1873-74, 46 x 55 cm.
Musée d'Orsay, Paris.
Volume 1, n° 71

Olympia painting, from 1870, which is dramatic, humorless, and heavy (*Une Moderne Olympia* - also known as *Le pacha*, R171). Yet the picture is delicate and delightful: all its exaggerations seem like a well-intended tall story. The décor is sumptuous, the refreshment table uncontrollably baroque, the unveiling dramatic, the lighting on the nude woman theatrical, the position of the bed stage-high - it all seems less a picture of a voyeur than a parody of voyeurism. As a comment on Manet, it is good-humored and farcical rather than prickly (possibly because Cézanne had already vented his more acerbic tone on *Le pacha*); even the little dog here fails to look serious.

Its good nature is underscored, I think, by the vigorous alla prima brushstroke, dashed off without obvious corrections, and by its happy colors. The colors of the earlier picture are leaden; here they are delicate, and even their uncharacteristic profusion works to the picture's advantage. The fiery side-table - in many ways the focus of the composition - is alone in being so emphatic; the other colors are muted and balanced, with the warm green and the lavender playing key balancing roles.

Whether it is Pissarro's implicitly protective influence or something else that helped produce so felicitous a satire, Cézanne himself was pleased with the picture and submitted it as one of his three contributions to the first Impressionist exhibit of 1874[129]. In the exhibition's catalog it is listed as a sketch, which may indicate that Cézanne himself saw it as a first lay-in and decided to accept it as a painting only for the purposes of the exhibit. In this, we are fortunate, because an elaboration, no matter how successful, would have lost the happy vigor of the unbridled gestures.

Cézanne's development in 1874, after leaving for Aix, is difficult to follow because his paintings are hard to date with precision. There is no single style to help orient us. In subject, many narrative paintings will retain the calming influence of the Auvers period, but not all will; some of his troubled themes from the previous decade will emerge again and they will include a few expressions of strong conscience, aggression, and sexuality. A new, quite obsessive, theme will also appear in the middle of the decade: bathers. Bathers of all kinds will begin to replace the other narratives and overshadow them in sheer count, and this will be at the cost, I think, of some repetition.

129 - *With* La Maison du pendu *(below) and an unidentified other landscape, listed in the catalog as* Etude: Paysage à Auvers.
See The New Painting: Impressionism *1874-1886, p. 120.*

Irrespective of subject, however, in all his paintings done between 1874 and 1877 Cézanne will be searching for stylistic direction.

The conflict between desire and guilt that animated Cézanne's painting before his work with Pissarro will also reappear, although in a form that reflects the new importance of light in paintings. A second version of *La Tentation de Saint Antoine* appears sometime after about 1874, most likely in response to the complete publication of Flaubert's novel of the same name. Reawakening Cézanne's interest, the novel would also provide something not available at the time of the first version - a protective, legitimizing context for Cézanne's imaginings - and it could suggest a new treatment, one that would include the retinue that in Flaubert's book accompanies the Queen of Sheba[130]. The novel might also suggest - and legitimate - the central position and

blatant provocativeness of the Queen, as well as explain the theatrical gesture of the devil, who goads the saint to look at her; if so, it would also explain the dramatic, apparently desperate aversion of the saint's gaze. The painting is less rhythmical than the earlier one and much of its surface - the devil, the saint, even the sky - is labored and overpainted; only the putti remain sketchy, and only the leaves suggest a specific style (the one seen in the 1876 *Don Quichotte* and *La Vie des champs*, below).

LA TENTATION DE SAINT ANTOINE
(R240), ca. 1876, 25 x 33 cm. Kasama Nichido Museum of Art.
Volume 1, n° 73.

The colors on the contrary are cheerful (apart from the monk's robe), and the devil's cape is so saturated and commanding a red that it almost makes light of the saint's moral dilemma. It is difficult to recognize the voice in which Cézanne addresses us; but perhaps it is an ironic voice, given the contradiction between the histrionic form and the lively, balanced colors. Certainly the drama is now in the open rather than hidden, as ready for the public's scrutiny as the sensuous narratives of Delacroix.

Violence reappears once during this period as well, in *La Femme étranglée*, but I suspect that its direct expression represents less a return of insistent fantasy than an illustration of someone else's narrative; as such, it would serve to justify the brutal portrayal. But this has not yet been established, and if the subject is disturbing, the style at least expresses it exceptionally well. The touch is flowing again, somewhat like *the Meurtre* painting of c.1870, but the date is later, both because of the lighter colors and freer touch, and because of the mysterious head that looks in from the right: in its abstract rendering it resembles the skull in *L'Eternel féminin*, which is probably from 1880. Here the subject of murder allows, even calls for, a fluid alla prima handling and suggests to Cézanne the harshness of the interlocking A and V shapes. Muting the violence somewhat are the quite beautiful colors, but reminding us of it again, perhaps with a hint of warning, is the watchful skull.

LA FEMME ÉTRANGLÉE (R247), ca. 1875-76, 31 x 25 cm. Musée d'Orsay, Paris.
Volume 1, n° 74.

But Cézanne's development in the longer run is toward calmer subjects, and in his customary oscillations he sometimes searches in a very tranquil direction. Among the narrative pictures painted in this decade he sometimes set a number of figures in a landscape, or at least in a landscape invented for the occasion. Three of his compositions are straightforwardly bucolic; they are the two versions of *La Partie de pêche* (R245 and 246), which were possibly done while Cézanne was still with Pissarro, and *Au Bord de l'étang* (R244), done two or three years later. All are tepid in subject and the third, moreover, rigidly composed.

But other figure groups set in landscape are alive and moving, and they catch our attention

130 - *For an historical account of the iconography of Cézanne's three versions of this theme, see Theodore Reff, "Cézanne, Flaubert, St. Anthony, and the Queen of Sheba", The Art Bulletin, 1962, vol. 44, pp. 113-125.*

by some oddity of subject or forcefulness of touch. In them Cézanne is either uninhibited in the form of his fantasy or innovative and aggressive in his brushstroke. *Les Pêcheurs - Journée de juillet,* of about 1875, is of the first kind. It seems like a free flowing fantasy,

LES PÊCHEURS - JOURNÉE DE JUILLET
(R237), ca. 1875, 55 x 82 cm.
Private collection.
Volume 1, n° 75.

with Cézanne unclear about what he is saying and how he is saying it - whether with irony or mockery or seriousness - and all the figures seem caricatures: the men of concentrated fishing, the women of distracted chattering, the children of unruly tumbling. Only one figure seems to have a serious purpose, and that is the black figure in the lower left - no mere afterthought filling an empty spot, because the sandy ground he appears on is painted on top of the green bank, showing that Cézanne had reserved that spot for him - but the purpose remains unclear. The preparatory pencil sketch (*Imaginary scene,* below) does not help: there the figures relate to each other without mystification, with the black figure an artist sketching the scene and the others enjoying the sun, waving to each other, sleeping, or calmly bent to their tasks under a tree. The two shores are closer in the sketch and so are the figures, and the whole seems like a fête champêtre, happy and complete in execution. In doing the sketch, however, Cézanne encountered

IMAGINARY SCENE
(C321), ca. 1875, 9 x 15 cm.
A. Chappuis, Tresserve.
Volume 1, n° 76.

a technical problem that he had to correct, and the correction became the basis of the altered composition of the painting. He had drawn a tree that originally pulled the composition apart; but by crossing it with heavy lines, he turned it back toward the center, and created a shape that could easily become the sail we see in the painting. Still, what the purpose might have been of changing a close-knit fête champêtre watched over by a painter into a surreal, disconnected scene, has to remain unclear. Seeing it in the flesh in the context of the 1986 reconstruction of the third Impressionist exhibit[131], however, I was struck by the painting's power, and it is not out of the question that Cézanne was aware of the commanding effect the strange changes would produce.

If the *pêcheurs* picture returns us to the impulsive Cézanne we had come to know, paintings with a new, short touch introduce a Cézanne who is becoming aware of the power of discontinuous, angular strokes. The paintings include two illustrations of a Don Quichotte theme and seven pictures of life in the country. Although Rewald dates the Don Quichotte pictures in 1875 and the others in 1876-77, I think they should be grouped together at the later date thanks to their similar style: they all share the short, straight strokes which look like telegraphic notations of firm stance or resolute movement. Their style is in part explained by their small size; they look like sketches for larger paintings which Cézanne never got to paint. But they are more than mere outlines, several of them being themselves preceded by even smaller pencil or watercolor sketches, so we may take their expressiveness to be intended rather than incidental. Somewhat like the unfailingly accurate gestures of *Une Moderne Olympia,* their firm, diagonal hatchings show us the impulsiveness of the younger Cézanne, but displaced now from a continuous, graphic sweep into a built-up and assembled surface. This kind of surface will ultimately convey both tension and resolution, but in its earliest form the tension predominates.

Don Quichotte, vu de dos, a small painting based on an even smaller sketch[132], breaks new, stylistic ground with its use of consistent, diagonal touches. They define the back of the man and the rump of the horse, and, formally, underscore the two main intersecting diagonals of the picture, the movement of the horse and the cavalier's

131 - *The exhibit of 1877, where the picture first appeared. The catalog of the reconstruction was published as* The New Painting: Impressionism 1874-1886 *(1986).*

132 - *The sketch, C253, measures 16.5 by 10 cm, while the oil measures 22.5 x16.5. The other Don Quichotte painting, for which no preparatory sketch has been found, is* Don Quichotte, vu de face, *R238; it is slightly larger.*

**DON QUICHOTTE,
VU DE DOS** (R239),
ca. 1876–77, 23 x 19 cm.
Private collection, USA.
Volume 1, n° 77.

back. This unusually dynamic counterbalancing seems an homage to the hunting scenes of the admired Delacroix, as do the master's saturated colors. If in the oil the homage is rendered, on its small scale, by straight rather than sinuous touches, in the pencil sketch it is rendered literally with Delacroix's squiggly lines. It is difficult for me to understand why Cézanne did not turn this and the other oil painting into full sized paintings, when the sketches were so promising and so close to his admired model; but if we accept them as such, then at least they show us a Cézanne whose impulsive hand could be very accurate.

Seven scenes from the country, all dated at about the same time and related in style, form a unique group in Cézanne's work. They are distinguished by a precursor of the parallel touch – less systematic, more impetuous, but equally firm and equally expressive[133]– and their convincing groupings of rapidly dashed–off figures; they seem remarkable especially because the subject is new and the figures have been painted without the benefit of observation[134]. *La Vie des champs*, for example, brings together, without fanfare or sentimentality, a group of peasants at rest and a woman bringing

LA VIE DES CHAMPS
(R282), ca. 1876–77,
26 x 35 cm. Private
collection, Philadelphia.
Volume 1, n° 78.

them refreshment; the woman – centrally placed, isolated, wearing a red skirt, her height magnified by a jug – is made the painting's focus (the skirt is an Italianate touch from Corot, it seems to me). As a composition the painting is well balanced, neither too full nor too empty; and it improves on the watercolor sketch on which it is based (RW51) by adding a bit of dynamic asymmetry – by extending the canvas to the right and filling in the details in thin paint[135].

Only one of the seven paintings, *La Cueillette*, suggests that its figures may have originally been done from life; this is an attractive possibility, given the unassuming naturalness in the poses, both in the oil and in the preparatory pencil sketch[136]. A woman picks fruit while her companion prepares to soak her feet: it is a subject that stays close to the familiar and observable, and avoids the sentimentality and

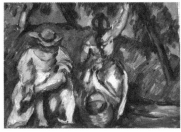

LA CUEILLETTE
(R284), ca. 1876–77,
16 x 23 cm.
Private collection.
Volume 1, n° 79.

occasional artificiality of the invented, bucolic pictures. To be realized, the painting seems to have needed only Cézanne's confident sketching hand for the figures and a balance of diagonals for the composition; and this was achieved by opposing the diagonal brushstrokes, and the arm reaching for the fruit, to the dark trees.

In about 1875 Cézanne's narrative paintings take a new direction. For the most part they become pictures of bathers, male and female, single and in groups, and with a few exceptions which we shall see below, they replace the religious themes of his earliest work, as well as the sexual and violent ones of the work that followed, and the bucolic ones that had appeared lately. His interest in bathers as such is natural enough, but the depth of it, in the sheer numbers of repetitive compositions, is harder to account for. Clearly Cézanne's interest is in some ways an aesthetic program rather than merely an emotional one, because the bathing scenes are seldom voyeuristic or sexual; but if it is an aesthetic program, then it does not have the quality of exploration, of freshness, of learning something new, that we find even in the repetitive apple arrangements

133 - *Besides the two paintings I reproduce, they include* La fontaine *(R283),* Les joueurs de boules *(R285), and* La partie de campagne *(R286),* Le déjeuner sur l'herbe *(R287) and* Les Ivrognes *(R288).*

134 - *I do not exclude, however, some borrowing from as yet unknown sources.*

135 - *The preparatory watercolor lacks the second tree on the right and presents the woman as smaller; the improvements in the painted version demonstrate the kind of thinking-through of compositional problems that sketches were useful for.*

136 - *Rewald thinks that the models could have been Madame Cézanne and Madame Gachet, and points to the lack of embarrassment in the woman raising her skirt; he might have added that there is even less embarrassment in the pencil sketch, where both feet are planted in the water (C370). On this interpretation, this figure would be Mme Cézanne.*

of this same decade. It is as if the bathers were the obsession of a picture-maker, while the landscapes, portraits and still lives are the passion of an observer intent on understanding the enigmas of representation and composition.

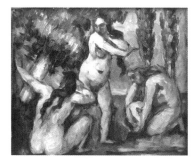

TROIS BAIGNEUSES
(R258), ca. 1876-77,
19 x 22 cm.
Musée d'Orsay, Paris.
Volume 1, n° 80.

As difficult as it is to date the bathers accurately, *Trois baigneuses*, below, is presumed to be one of the earliest ones; its figures are painted in continuous outline even though the background is close to *La Cueillette* in style. It is a fully realized composition, based on an arrangement worked out in a pencil sketch and a watercolor (C368 and RW62). This compact, successful group seems almost to have sprung fully formed from Cézanne's head. It is not enough to see distant predecessors for the individual figures in the 1870 *La Tentation de Saint-Antoine* (for the tall, gesturing one, for example, and the crouching one that anchors the group on the left; see p. 43) – one must credit Cézanne with the imagination to compose them in this new way. Here the figures move fluidly against the verticals and horizontals, and resonate with the diagonal tree as much as they oppose it with the gestures of the arms. This may perhaps be Cézanne's double purpose: to create a grouping of figures that is well balanced formally, and that, like the paintings of the Venetians he admired, gives form to a narrative. Cézanne will in fact find it easier to do the former than the latter, but will not stop trying until the end of his life. In the Introduction, we had seen him contend with narrative in one of the late *Grandes Baigneuses*, and in the present painting we see him not contend but succeed fully, albeit on a small and easily managed scale. Even the outstretched arm of the left figure is explained by her surprise: she has just seen a head appear in the upper left[137]. Composition and narrative are, for once, closely knit.

The happy instances of a seamless fabric of gesture and formal composition underscore what I think the bather paintings aspire to: the integration of coherent, dynamic, counterbalanced compositions with plausible movements, gestures, and implied narrative. Ideally, Cézanne would have made them as lyrically narrative as they are beautifully composed, but in the very least it was the composition that he had to get right. The pictures succeed variously, but whatever the results, the challenge is one that Cézanne sees facing him without letup. This is not a problem that painting from life would have solved, because live models only help one paint a single figure at a time; composing several nudes into a plausible group will almost always be a task for the imagination. Assembling groups is not a trivial challenge, and one can understand why a painter who sets out to paint as many bather groups as Cézanne did will resort to a limited number of groupings and elaborate on them.

As it is, his solutions to the challenge of grouping female figures seem more satisfactory. The convexities and volumes of feminine bodies, their more flexible poses, and perhaps the greater range of their positions in repose, do lend themselves better to coherent arrangements – men, as I said, seem always straight or sharply folded – and contact between female bodies seems easier for Cézanne to accept. We know that Cézanne feared being touched, although we do not know why, and while it would be good to know the fear's deeper meaning, in some ways it suffices to know its effects: in bather paintings, men must remain further apart and inevitably become harder to group coherently. One cannot imagine Cézanne painting the dense groupings males in the Battle of Cascina cartoon by Michelangelo or in the San Brivio Chapel frescoes by Signorelli[138].

137 - *Guila Ballas in her recent study* (Cézanne: Baigneuses et baigneurs, *p. 41) believes the theme to be that of nymphs surprised by a faun.*
138 - *Although he did copy two figures from the cartoon (in C354, 356, 358 and 359) sometime in the second half of the 1870s.*

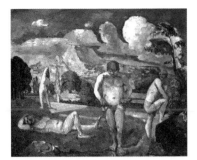

BAIGNEURS AU REPOS, III (R261), ca. 1875-76, 79 x 97 cm. Barnes Foundation, Merion, PA.

Volume 1, n° 82.

One of his earliest male groupings, that of four bathers represented in the series *Baigneurs au repos*, separates the men not only in the space in which they move but also on the canvas, permitting no overlappings in perspective. There are two smaller studies and a large, finished painting, which all bring together the same four figures and have the same focus: the figure that faces us and is about to step into the water. It is to him that the others must relate, both as figures or as abstract forms. The man on the right connects to him with his gaze, while the recumbent man provides a horizontal counterpoint; his bent knee also mirrors the mountain, while the leaning figure in the back points back toward it. These counterpoises hold for all three versions, with some variation in detail, and in the large version, reproduced here, we see in addition a very complex balance of tensions. Several objects point to the left - the tree, the clouds, the shape of the mountain, and the gaze of the figure on the right - and they are balanced by curves that point to the right: by the rightward slant of the same man's back, the curve of the distant figure, and even the long foot of the recumbent one.

Essentially the problem Cézanne sets for himself in the three paintings is to interlace a stable horizontal/vertical framework with a dynamic, diagonal one. With the men distant from each other and restricted in movement, it is in only this admittedly formal way that we can view the male bathers and judge their success. We can rely neither on naturalness in the groupings, nor meaning in the gestures, nor persuasiveness in the representation. In this version we are not left short: the colors are splendidly luminous. The pigments are built up slowly and concentrated near the edges, and this creates a bulge that acts as the contour; the contour is therefore defined by the furrow between two bulges, and the overall effect is closer to stained glass than to a picture based on painted outlines.

If I have praised the picture's formal complexity, it is because it has left me with little choice; there is no denying that it is also rigid and takes an effort to look at. It seems a paradox that Cézanne, a sensuous painter, should so often have displaced the sensuality of his paintings so far from its sources in the human body. To help understand why, we must do more than evoke his fear of the female body and his fear of being touched, documented though they are; we must look at his aesthetic purposes. A contemporary critic - the author of the only positive review of the third Impressionist show - points us in the right direction when he writes about this painting that he doesn't "know what qualities one could add to this picture to make it more moving, more passionate... The painter of *the Bathers* belongs to the race of giants... the future will know enough to classify him along with his equals among the demigods of art"[139]. It is vague praise, but it does take note of the painting's originality and monumentality, and it does place Cézanne's work at the avant-garde of painting; and in fact it responds to the same qualities in it that all the other reviewers rejected. If that was what was seen at the time, pro or con, then Cézanne may well have had some such striking conception in mind, and to make it clear he spared neither his friends nor his detractors.

With female bathers, Cézanne's search for the new leads him to more obvious stylistic explorations; relying on a small number of standard compositions, he can shift the burden of painting more easily to developing his style. Within a short two - or three - year period he paints four variants of another grouping of three women, this one with the visual weight placed on the bathers at the edges of the painting. Here no narrative is implied; on the contrary, the mere emphasis on the lateral bathers invites playing with their physical weight and with their place in the surface rhythms. In

139 - *The critic Georges Rivière, the only one to praise the exhibit and Cézanne specifically, was quoting approvingly from a friend, without mentioning that it was Victor Chocquet - who owned one of the other two versions (see Rewald, PPC, vol. 1, p. 180).*

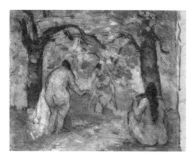

TROIS BAIGNEUSES
(R358), ca. 1876-77,
25 x 34 cm.
Elliott Wolk, Scarsdale.
Volume 1, n° 81.

the one that I think may be the earliest (R358, below), literal weight is the primary metaphor. The woman on the left is a rare nude in Cézanne's work - a realistically fleshy woman with a real bottom reddened by sitting - while the one on the right sits pear-shaped, holding down the right corner of the painting. But the consistent use of the round forms in the picture does seem Cézannian; the forms are echoed in the waves of the branches[140]. Formally, this painting, like the three others, presents the protagonist on the left side, leaning toward the center in the same way as the tree next to her, and then opposes a smaller antagonist to her who is identified with a tree on the right, which also leans toward the center. A more distant figure in the middle mediates between them.

One of the other versions of these bathers (R361) may have been painted in the same year, but it is difficult to be sure, since its composition is somewhat different and its handling is even freer and more self-assured. It is uncharacteristically expressive in its gestures and unsystematic in its touch - it is full of haphazard dashes in the trees and ground, and undulating lines in the bodies and the hair. In certain details, such as the two figures anchoring the composition at the sides, it belongs with the other three pictures; in others, such as the gesturing central woman, it provides what will become a climactic central figure for compositions of four and five women. What it does not do is set Cézanne on a course of graphic spontaneity, for Cézanne will turn, instead, to more and more systematic conceptions of the surface.

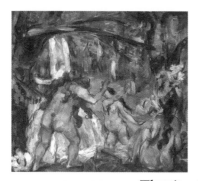

TROIS BAIGNEUSES
(R361), ca. 1876-77,
31 x 33 cm.
Private collection.
Volume 1, n° 84.

That is what we see in the other two versions: they evolve toward a closer and closer integration of the surface of body and the texture of foliage. This puts them later - the third (R359) later in 1876-77 because of the resemblance of its touch to *La vie des champs* (p. 73), and the fourth (R360, below) later still. It is this fourth version that commands attention: it uses the touch to integrate the composition. The diagonal strokes help assimilate the background to the protagonist on the left, and the horizontal touches give all three figures solid ground to stand on. The painting is also sensuous, but in a displaced way: the colors are beautifully balanced, the light cool and clear, and the skin tones luminous, and one all but forgets that the bathers have given up their feminine shapes[141].

Cézanne will never paint three bathers again, except for a small sketch for a larger painting[142]; he will turn to composing groupings of four and five or more, and if we judge by his touch, he will turn to these larger groups in about 1877. If we look at the technical question of arranging four figures convincingly, we may presume that one requirement is that a single figure be placed centrally; otherwise the four split easily into pairs. But there are no other constraints. For movement, in *Quatre Baigneuses* Cézanne makes the central figure point sharply across her chest, and for a stable anchor, he borrows the figure that had served as the protagonist in groups of three (a figure that will prove useful in the future as well). To balance her and give the picture a solid base, he puts a bather in the middle who leans to the left and sits with legs splayed; placing her this close to the standing woman also gives the picture a depth that is hard to achieve with bathers merely

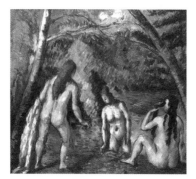

TROIS BAIGNEUSES
(R360), ca. 1877-78,
52 x 55 cm. Musée de
la Ville de Paris, Petit Palais.
Volume 1, n° 83.

140 - *Walter Feilchenfeldt has raised the possibility, however, of its being by another hand, based on a Cézanne pencil drawing (C366); see his "On authenticity", in Rewald's PPC, vol. 1, pp. 13-16. I am inclined to accept it as Cézanne's, however; it is different enough from the drawing to suggest a fresh treatment by the same artist, rather than an imitative one by someone else.*
141 - *It was owned and revered by Matisse, and possibly served as a model for Picasso's* Les demoiselles d'Avignon; *see Rewald, PCC, vol. 1, p. 239.*
142 - *R871, about 1900.*

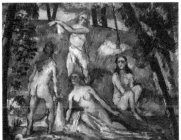

QUATRE BAIGNEUSES
(R363), ca. 1877-78,
38 x 46 cm. Private collection,
Japan.
Volume 1, n° 86.

**BAIGNEUR
AUX BRAS ÉCARTÉS**
(R370), ca. 1877-78,
73 x 60 cm. Private collection.
Volume 1, n° 85.

strung out in the same plane. Cézanne could have made other decisions, but once he made these, they became a formula which also served him for groups of five, with the mere addition of a figure in the lower right. In the present *Quatre baigneuses* he succeeds admirably: the left anchoring figure, backed up by the parallel touches in the hillside, pushes against the movements of the other figures and the dark tree, and the contrapposto movement of the central bather provides a measure of grace.

If the meaning of bather groups has to be sought more often in their composition than in their narrative, the meaning of a single figure, especially one of the same gender as the artist, seems inevitably symbolic. The more awkward it is, or difficult to understand, the more it raises the question of personal significance; and it is five paintings of a man with outstretched arms that Cézanne painted between about 1876 and 1879 that raise this question most insistently. In all the pictures the upraised arm is the same and the rest of the pose is similar, so I reproduce only the biggest and most finished one (*Baigneur aux bras écartés*). The difficulty is the pose: the man's arms are too long and are outstretched at an angle that makes no sense; and in this version, the hands are over-emphasized by their size, reddish tint, and literal finish. It is a not a study for a larger group, so it must be understood as such. Reff has proposed that its meaning is connected with Cézanne's sexuality, but this reasonable suggestion has been criticized; some have cited lack of evidence while others have seen it as reductive[143]. The criticisms unfortunately do not suggest any alternative explanation, and however much resistance some may feel toward psychological interpretations, the awkwardness and mystery of the five paintings (and several of the related drawings[144]) persists, and invites them. Some highly personal meaning must be seen here, even if we cannot be precise about it; it may possibly involve the sexuality of Cézanne's son, who would be between 14 and 17 while the series was painted, rather than his own. It surely combines conscious, narrative purposes with unconscious meanings, whatever we may suppose those to be.

Not having any clear evidence on the matter, we can turn to the use Cézanne made of his craft to integrate the painting formally. Here (and in one earlier version) I am taken with the very careful balance between the sky and the arms. The diagonal of the arms is here opposed, and balanced, by the diagonally placed parallel touches, and the painting is in greater equilibrium than the pose itself. In a simple way here, and a more complex one in later landscapes, the pulls and counterpulls of the parts of the canvas resolve before our eyes, and we are offered a unity. That is, simply put, the point of his development of this touch.

Cézanne painted twenty-nine bather pictures between 1875 and about 1879, and that is a remarkable concentration of interest. He did not altogether give up his other narrative interests and for a while painted several pictures of his old themes, and this with considerable power. In 1876-77 he did three paintings called *L'Après-midi à Naples* (the theme goes back to the mid-sixties among his drawings), which depict a couple in bed, presumably resting after making love, generally being attended by

143 - Reff, Theodore, "Cézanne's Bather with Outstretched Arms," Gazette des Beaux-Arts, 1962, vol. 59, pp. 173-190. In criticism, Rewald (in PPC, vol. 1, pp. 244-245) points out the scantiness of the evidence, especially in relation to the kind of rich material produced in psychotherapy, and Chappuis (in DPC, pp. 17-18) insists that it is irrelevant, because Cézanne the painter is more important than Cézanne the man. In Chappuis one detects a disdain for psychoanalytic interpretations in general, which detracts from his conclusions, but it must be admitted that such interpretations are most secure in the clinical setting and least so in the art historical one. But they cannot be dismissed out of hand; they can be convincing, and in the very least suggestive, when they are sensitive to the many levels of meaning inherent in all acts, including painting, and when they marshal the broadest evidence available. See, for example, Meyer Schapiro, "The apples of Cézanne: an essay on the meaning of still life," in Schapiro, Modern Art: 19th and 20th Centuries, New York: Braziller, 1978.
144 - C380-389.

a servant bringing refreshments[145]. The drawings are swift, sketchy, and persuasive, but two of the three paintings seem, inexplicably, quite labored.

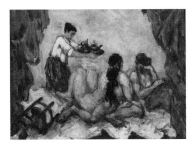

**L'APRÈS-MIDI
À NAPLES
(avec servante blanche),**
(R290), ca. 1876-77, 30 x 40 cm. Private collection, Paris.
Volume 1, n° 87.

The most successful of the series is the version with a white servant, *L'Après-midi à Naples (avec servante blanche)*, which, after one has come to terms with its carnal subject, reveals a subtle composition. It has a rhythmic order based on a shallow "V" whose vertex is at the bent knee of the man, a V which is then echoed in the crumpled sheets at the bottom, the folded body of the woman, the upset chair, and even the spout of the teapot. Color is no less expressive, but its balance is understated: the crimson curtain is complemented by the green blanket under the sheet, and the cool pink of the woman's skin (the crimson pigment itself, cut with white) contrasts with the warm ochres of the man's. Diagonals are, once again, Cézanne's metaphor for passion, but here they are carefully balanced; in the other versions the diagonals move precariously and without check, and only the paintings' brilliant color saves them from awkwardness. However rhetorically offensive Cézanne may have intended to be with this series (he presumably succeeded in 1867 with an earlier version that was rejected by the Salon[146]), here he has in fact succeeded in painting a picture of striking density, consistency, and discipline.

We are witnessing the gradual imposition of a consistent surface upon the paintings. It is a process that approaches the fully developed parallel touch of 1879-80, a touch which orders and dominates Cézanne's paintings for about five years afterward, and one by which his paintings are easily recognized even by casual visitors to the museum. Its development is not straightforward, however; even in the narrative paintings the developing touch follows no single direction. In 1877-78 (assuming that the dating is close to correct), Cézanne's touch is already quite structural: in some of the bather pictures we have just looked at, parallel touches serve to balance parts of the composition against each other. We shall see this happen in still lives just a little later, and in the landscapes later still, after 1879; it is this disparity that tells us the most about why the parallel touch was developed in the first place.

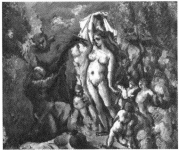

**LA TENTATION
DE SAINT ANTOINE**
(R300), ca. 1877, 47 x 56 cm.
Musée d'Orsay, Paris.
Volume 1, n° 88.

In the narrative paintings, the progression toward the parallel touch may be inexorable, but there is no evidence to suggest that it is linear. Its use seems to depend, in 1877-78, on Cézanne's expressive needs. In the third version of *La Tentation de Saint Antoine*, for example, which was painted perhaps no more than a year after the *L'Après-midi* painting, the touches are firm and distinct, suggesting a stylistic development, but they are curved and flocculent instead of straight, giving the painting a soft surface that seem at odds with its subject. There may be an expressive explanation, but we can only guess at what it might be; the touch certainly softens the otherwise humorless, even drastic, seduction, but whether this is what Cézanne intended to accomplish with it, we cannot know.

To the burden of temptation and anxious resistance we can oppose the much lighter mood of *Scène légendaire* - and its lighter touch. The subject is unclear and remains vague even when we are told that its other title was *Sancho dans l'eau*. In the very least the subject is a horseman, possibly riding a donkey if we take the animal's ears seriously, looking at a group of women in various stages of undress; and formally, it is

145 - *One of the paintings is also called* Le Grog au vin, *but the series title seems more apt. The afternoon dalliance was easily projected into a neighboring country, as shown in a drawing Cézanne did in the mid-seventies which was based on a painting called* Le coucher à l'italienne *(C310bis); there, a nude woman looks furtively, or invitingly, over her shoulder as she is about to enter a bed.*
146 - *See Rewald,* Cézanne, *New York: Abrams, 1986, p. 69.*

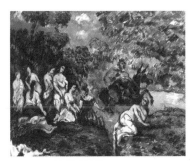

SCÈNE LÉGENDAIRE
(R371), ca. 1878,
47 x 55 cm.
Private collection
Volume 1, n° 92.

a composition done in loose touches of various kinds (some of which are parallel), reminding us more of the rural pictures of 1876-77 than of the tentation painting. It is clearly focused on the horseman and on the woman separated from her companions, and this division suggests any number of picaresque plots. It is a composition that relies on tension rather than simple balance: gaze connects the empty space between the group on the left and the two single figures, and we are aware that the tension of the gaze is in some manner the subject of the painting.

A troubling and famous narrative painting of a licentious subject – but done with a disciplined, fully developed parallel touch – is *L'Eternel féminin*. It is troubling in part because of its unclear subject, in part because of the touch, which would have been too well developed for 1875 or even 1877, the dates that have been presumed for it earlier. Harvey has argued convincingly, however, that the painting illustrates characters from Zola's novel Nana, which Cézanne read shortly after it was published in book form in 1880, and this both clarifies the date and makes sense of the subject[147]. Although by its date it belongs in the next chapter, its culminating place in the development of the parallel touch in narrative paintings best places it here.

Without knowing that the painting is illustrative (not of any specific scene from the novel, but of Nana and her admirers in general), one might waver between suspecting

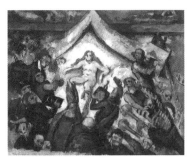

L'ETERNEL FÉMININ
(R299), ca. 1880, 43 x 53 cm.
J. Paul Getty Museum,
Los Angeles.
Volume 1, n° 89.

that Cézanne's imagination was overheated and the hope that his many excesses here were in fact ironic. Knowing that the painting was also given other imaginative names – *Le Triomphe de la femme, La Belle Impéria*, and *Le Veau d'or* – does not help, but it does suggest that many viewers had struggled to find its meaning. If the picture had been the product of Cézanne's imagination, it would have been overdone: too many men would have been gathered about the naked object of their admiration, all seriously pointing the straight implements of their trade at her, with others apparently trying to entertain her or give her gifts, or turning away in disgust.

But Harvey in fact connects all the men with characters in Nana, and all the gestures with actions from the novel. Now the density of the painting makes sense: it conflates the people of the book into one tableau. Its rigid style is another matter, however, and to understand it we must look at the preliminary sketch for the painting, the

L'ETERNEL FÉMININ
(RW57), ca. 1880 17 x 23 cm.
Private collection, Zürich.
Volume 1, n° 90.

watercolor by the same name. In it we find the same characters as we do in the oil, with the exception of some marginal figures fleeing the scene, which appear only in the painting; but it is done quickly and freely, the space is closer, the figures are larger, and their grouping is less formal. It is too informal, in fact; the woman is too large and the men jostle and trip over each other. Having done the sketch, Cézanne could then clarify the space in the painting, slimming the figures down so that they separate from each other, and placing the woman further back so that she appears life size.

But Cézanne does more than that. He also simplifies the orientation of the figures, aligning them mostly in two directions, and in this way gives the painting clear, diagonal rhythms as against the sketch's cacophony. Above all, he imposes the parallel touch on much of the surface: on the left he aligns it with the body of the bishop – the sanctimonious protagonist – and on the right, still in the same orientation, he places it at right angles to the trumpets and protruding bodies. On the right, then, the touch

147 - *Benjamin Harvey, "Cézanne and Zola: a reassessment of "L'Eternel féminin""* Burlington Magazine*, 1998, vol. 140, 312-318.*

moderates the simple diagonals but it also connects the surface with the simpler, left side; it is a process of ordering and simplifying. Therein, of course, lies a dilemma: for the sake of clarity of presentation, Cézanne gave up the chaos and the good-natured excesses with which he started[148].

With this painting, and three related ones from about 1878, Cézanne has given up his interest in violence as subjects of painting, and is approaching the end of his interest in illustrative paintings (as against the bathers); there will remain only three happy erotic scenes in 1880 after his adoption of the parallel touch, then a picture of gleaners, and finally a Bathsheba series and a preparation for a banquet, in the late eighties.

His narrative drawings from this period show a greater firmness of purpose than before. The touch is no longer feverish, as it was in *Studies for the Orgy*; on the contrary, it is steady and disciplined (in copies that he does after others), or free and undulating (in compositions of his own). Of greatest interest to me is the naturalness of his groupings of figures, as if their intimacy were more permissible in the relative privacy of the small sheet of paper. We have seen this in the preparatory sketch for *Les Pêcheurs*, and we can see it delicately illustrated in *Page of studies*, women bathers of about the middle of the decade. The group of four women at the top resembles the *Quatre baigneuses*, but what is new is the seated bather that anchors the composition in the lower left. The word "anchor" may seem forced here; although it springs readily to mind for the paintings, here the bather sits modestly and naturally, facing the others as if in an intimate conversation, and seems more woman than a mere element in a composition. The touch is much more rhythmical than in the sketch for *Les Pêcheurs*; there, it was more like a shorthand notation for establishing the grouping, while here it sculpts her pose and connects all the figures in a close space. It is a wonder that Cézanne did not use her in the paintings, and I suspect, as I have said before, that their more public purpose needed a less intimate, more impersonal statement.

PAGE OF STUDIES, WOMEN BATHERS (C373), ca. 1873-77, 20 x 30 cm. Kunstmuseum, Basel. *Volume 1, n° 91.*

The eight-year period which began with the time spent with Pissarro witnessed, then, a lightening in the subjects of Cézanne's narrative paintings; in Pissarro's company the paintings became either more good-humored or more civilized. His rhetorical stance continued to vary - irony and parody vied with simple exposition - and this will not survive into the next decade. After his time with Pissarro, his early interests in sexuality and violence reappeared, but they were either legitimized by illustrating events written about by others, or more often successfully integrated into resolved compositions. Then Cézanne altered course: he replaced his purely narrative paintings with scenes of bathers, and composed them, from the start, more in response to formal concerns than to illustrate anecdotes. Finally, near the end of the decade, the bathers began to come under the further discipline of the parallel touch - a touch that would help create order in landscapes, give rhythm to still lives, and clarify the facial planes of his portraits.

LANDSCAPES

Whether Pissarro had a greater effect on Cézanne's landscapes than on his other genres is difficult to say, but he certainly provided the clearest model for them and had the most specific advice to offer. Even if in later years Pissarro exaggerated a little when he wrote

148 - *The woman's bloody eyes, however, are less easily explained; in the watercolor the eyes are perfectly normal. Although they were not painted in directly but were left over as red ground under the flesh-toned surface, it is difficult to believe that Cézanne did not see their effect. Possibly he meant to refer to Nana's eventual hideous death from smallpox.*

that "we were always together",[149] Cézanne would have had the benefit of close contact and even side-by-side painting. Unfortunately, nothing survives to tell us what it was that Cézanne did witness as they worked together. However, we do have Cézanne's recollection of what Pissarro had told him - about cutting out black and painting only with the three primary colors[150] - and we do have a series of technical suggestions that Pissarro made to a young painter some twenty years later, which may well have captured the spirit if not the letter of his ideas in 1872: paint everything at once by placing tones everywhere; put down your perceptions immediately; look for shape and color rather than line; paint the essential character of things without bothering about technique; and avoid rules and principles in favor of what you observe and feel[151].

Not all of these specifics would become part of Cézanne's practice, but then they were not the whole of Pissarro's either. In two respect Pissarro was not as relentless an observer as these notes imply. He either finished his plein air work in the studio or painted entire landscapes in it from small sketches made on the spot; and he chose his subjects to fit his image of what landscape should be - he painted only a simpler and more rural Pontoise than the industrialized city that was springing up all around him[152]. Of course, even if Cézanne had faced greater consistency on Pissarro's part, he would probably have assimilated only what he needed. We should not look for a direct application of Pissarro's suggestions, nor for close technical parallels between Pissarro and Cézanne, but rather at their shared attention to the effects of light; this was becoming the unifying principle of the new painters, Pissarro included.

This we find in ample measure in paintings done in 1872-73, particularly when we compare them with Cézanne's landscape styles before and after. In *Carrefour de la rue Rémy à Auvers*, light is as much the subject as are the houses; it reflects brilliantly off the wall on the right and illuminates subtly all that is in the shade on the left. A photograph shows greater contrasts than we see in the painting, sacrificing either the highlights or the shadows, but the eyes see both, and one of Impressionism's nascent ways of attempting to be truthful was to make sure that vision is respected - that one be neither blinded by highlights nor unable to see in the shade. Cézanne learns the lesson immediately, as it were, and applies it during these two years consistently. He also follows Pissarro's example in the matter-of-factness of the composition: Pissarro's landscapes stay in place, neither fighting their frame nor straining to contain inner tensions, and so does rue Rémy. When compared to the steep *La Rue des Saules à Montmartre* or the unstable *Le Village des pêcheurs* that we have seen in the last chapter, this painting

CARREFOUR DE LA RUE RÉMY À AUVERS (R.185), ca. 1872, 38 x 46 cm. Musée d'Orsay, Paris. *Volume 1, n° 97.*

is a model of unforced equilibrium. It cannot be mistaken for a Pissarro, of course; its masses are simpler and the effort after stability is more visible (in the vertical dividing line at bottom center, for example). Above all, it shows Cézanne's utter independence in the treatment of the surface, a surface that never becomes detached or flocculent but strives to underscore the order of the whole. Here the order he articulates is that of the sloping roofs, which he reflects in little gable shapes that appear in the walls, the fences, and even some of the foliage.

Site 97, photo: Pavel Machotka, ca. 1977.

149 - *Rewald*, History of Impressionism, *p. 294, citing Pissarro's letter to his son of Nov. 22, 1895.*

150 - *Gasquet reports that Cézanne had said this to him: "In '65 [Pissarro] was already cutting out black, bitumen, raw sienna and the ochres. That's a fact. Never paint with anything but the three primary colors and their derivatives, he used to say to me." Although nothing in Gasquet is in fact a direct quote, he must have conveyed the substance of what Cézanne had said fairly well. See* Joachim Gasquet's Cézanne, *p. 164.*

151 - *Quoted more fully by Rewald from unpublished notes of the painter Le Bail, who would have heard this from Pissarro in 1896-97. See his* History of Impressionism, *p. 458.*

152 - *Richard R. Brettell*, Pissarro and Pontoise, *New Haven and London, Yale University Press, 1990, esp. pp. 201-204.*

Cézanne's sense for structure and firmness of surface yields only when he borrows his compositions directly from Pissarro. It is an homage he seems happy enough to pay, but his versions look more like tributes than realized paintings (see *Vue de l'Auvers-sur-Oise - La barrière*, below). When he paints light on his own, Cézanne is in many ways more truthful than Pissarro, who leaned toward amiability no matter how closely he observed his scenes - toward the charm of direct sunlight or the calm silence of a cloudy day. Cézanne's realism is on the contrary untouched by sentimentality, and paintings done on grey days imply neither mood nor attitude; they simply portray the light, neither reveling in it nor making an effort to disguise it.

During the two-year period spent close to Pissarro Cézanne therefore retained a fiercer honesty than his friend and tutor. He also found a landscape motif that his friend never painted, namely, turns in the road, the kind that first move into the picture and then turn left or right. Pissarro could have seen such turns around him as well, of course, but it was Cézanne who responded to them: to the small spaces and tight streets of Auvers. His connection with landscape was close and emotional, as he told Gasquet in 1896, and its effect on him was strong; and I think that anyone who has visited Auvers will have felt the effect for himself and understood the space and light in Cézanne's paintings. The village fills a narrow space between the river and the slopes above (the ancient river bank), its scale is small, and everything is readily accessible on foot[153].

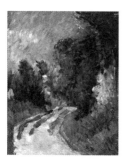

LA ROUTE TOURNANTE EN SOUS-BOIS (R197), ca. 1873, 55 x 46 cm. Guggenheim Museum, New York.
Volume 1, n° 93.

The space in *La Route tournante en sous-bois* of c.1873, almost certainly painted near Auvers, is just as close as it is in the paintings of village streets, but we are less likely to notice it here, thanks to the fleecy foliage; it is as if the turn in the road were a natural event in a country lane rather than a tight space in the layout of a village. To create his space Cézanne not only turns the road, but carefully distinguishes the planes of foliage one from another - by change of color and by overlap - and lets them recede toward the logical stopping point, the thatched roof that peers around the bend.

I said earlier that by the end of the previous decade Cézanne had begun to see landscape as space, and turns in the road such as these are a further step in this development. Pissarro characteristically constructs his space as either deeper, with straight, open recessions, or builds it up stepwise from spaces between figures (see *La Récolte*, p. 84); neither conception of space is Cézanne's. Or he constructs it by revealing objects behind a repoussoir - houses set behind trees, or framed between them - and in this Cézanne found a tentative model to follow. In *Vue d'Auvers-sur-Oise - La barrière*, he paints a picture that is barely distinguishable from Pissarro's, except for its coarser and more distinct brushstrokes. Its composition achieves the same purpose as Pissarro's: it confers a gentle, rustic meaning to the scene, nestling the quiet group of houses and emphasizing their secure position.

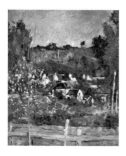

VUE D'AUVERS-SUR-OISE - LA BARRIÈRE (R200), ca. 1873, 45 x 35 cm. Nathan Halpern, New York.
Volume 1, n° 94.

A contemporary painting of a house behind trees, *La Maison du Père Lacroix, Auvers-sur-Oise*, might at first seem to strive for a similar effect of containment; it lets the house in question be revealed from behind foliage. But it is in fact unlike a Pissarro: it is a painting where management of space and the balancing of diagonals are primary. The house here is not merely revealed; it forces itself upon us, with the light wall and the black window pushing forward and subduing the containing trees. This reversal, this thrust forward, becomes the painting's subject and focal point.[154] The window itself stands in the exact center and arbitrates between opposing tensions: it helps resolve the rightward press of the roofs (and of the short leaning tree) and the leftward lean of

153 - *Van Gogh's landscapes from Auvers depict similar locations, and even identical ones (*La maison du père Lacroix, *for example), but their space is somewhat deeper because he prefers to view his subjects obliquely. He also painted in the flat fields that begin at the top of the ancient river bank, which offer very broad vistas; they attracted Pissarro, too, but not Cézanne.*
154 - *For a photograph of the house in the same morning light, see my* Cézanne: Landscape into art, *p. 40.*

the walls and the tree on the right. A small detail confirms that this is Cézanne's concern: he paints the slats of the fence as if they continued into the water, parallel to the tall tree, when in fact they should be mirrored. We are not necessarily meant to notice such details, but we are meant to take in their effect, and Cézanne's craft requires them to be right if the painting is to work as a whole. The painting is, of course, a happy one, the morning is cheerful, and the colors are a felicitous balance of reds and greens – but there are many happy paintings in the world whose effect, unlike this painting's, is spent on mere cheerfulness.

LA MAISON DU PÈRE LACROIX, AUVERS-SUR-OISE (R201), ca. 1873, 62 x 51 cm. National Gallery of Art, Washington, DC. *Volume 1, n° 95.*

Much the same kind of vision governs the form of a picture of a barn and house known as *La Maison du pendu*. At an obvious level a picture of rural serenity, it is at another level a highly finished work with a carefully studied composition. A narrow V in the exact center holds us securely in place within the frame, right above a steep dip in the road that leads down to the forecourt; there, the space is deeply congested, and as we follow it up it opens out into the distant view of other houses and eventually a clear sky, which we welcome as a necessary relief. We are kept busy returning to the space within the V because it is speckled with black roofs and red chimneys; it, too, is a kind of reversal of emphasis, not unlike the brilliant white wall of *La Maison du Père Lacroix*. The curved dip in the road itself might have sounded a jarring note in a canvas full of straight lines, but Cézanne saw it in the context of the undulations of the thatch around the narrow vertical window in the barn roof, and made

LA MAISON DU PENDU, AUVERS-SUR-OISE (R202), ca. 1873, 55 x 66 cm. Musée d'Orsay, Paris. *Volume 1, n° 96.*

it a natural part of his composition. His touch is once again consistent, and once again new: his brush is dragged over barely dried pigment from the day before, producing a pearly accumulation that unites the whole surface. (This is an effect that happens naturally in parts of other canvases, as a result perhaps of impatience; here, however, it represents a consistent discipline.) Presumably these formal successes are what Cézanne himself was happy with, because he exhibited the painting three times, at the first Impressionist exhibit and then again in 1889 and 1890; it is, in any case, one of his early landscape masterpieces.

When Cézanne and Pissarro come together to paint, and Cézanne chooses his own standpoint and composition, a comparison between their paintings invariably brings out Cézanne's interest in tension and structure. By this I intend to note their differences, not suggest – as if reflexively – that the tensions of space in a Cézanne landscape invariably produce the better painting. On the contrary, Pissarro's more overt closeness to people, or at least his much greater interest in integrating them into his landscapes, can work to his advantage; it depends on how well he uses them on the surface and in space.

PETITES MAISONS PRÈS D'AUVERS-SUR-OISE (R220), ca. 1873-74, 41 x 55 cm. Fogg Art Museum, Harvard University. *Volume 1, n° 99.*

For example, in Cézanne's *Petites Maisons près d'Auvers-sur-Oise* and Pissarro's *La Récolte des pommes de terre* we have – seemingly – a contrast between a mere landscape and a warm, narrative scene of peasants reaping potatoes, but we also have two thoughtful, painterly solutions to the question of organizing pictorial space. The artists address the same landscape at nearly the same time of day – late afternoon – without quite standing side by side or painting on the same day; Pissarro stands further back and his season is more advanced. Cézanne responds to the question of surface balance: the large house, just to the right of center, is pulled back leftward by the emphatic poplar on the hill, and the right-leaning small trees in front are countered by the leftward striations in the field. (Neither the striations nor the poplar were necessary for Pissarro's composition, but whether the one painter invented them or the other suppressed them, we cannot say). Colors are in simple equilibrium, too; an orange/pink light just offsets the cool greens. It is the unpretentious equilibrium and the decisive touches in thick paste that make the painting.

In Pissarro's picture, on the other hand, the house is subordinated to the peasants at work, and Pissarro faces instead the question of representing a deep space. He paints the figures plainly but convincingly, and by their movements attracts our attention right away. But the figures do more than convey a bucolic scene; by their placement they also create a finely structured three-dimensional recession. Pissarro leads us from the nearest woman in the right corner to the kneeling figure, and past her to the focus of the composition, the pair stuffing the potatoes into the bag; he also helps us leap past the small storage shed to the houses in the farthest plane. The whole is balanced on the surface and integrated in depth – and unified by the unusual late-afternoon light and color – and its rhythms are the steps by which we go from one figure, or object, to another.

It is not the presence of humans as such that makes this painting strong; it is Pissarro's ability to use them to make an effective composition[155].

CAMILLE PISSARRO, LA RÉCOLTE DES POMMES DE TERRE,
ca. 1874, 33 x 41 cm.
Mr. & Mrs. Sacerdotti, London.
Volume 1, n° 100.

CAMILLE PISSARRO, LE CHEMIN DE L'HERMITAGE, PONTOISE, SOUS LA NEIGE,
ca. 1874, 47 x 39 cm.
Private collection.
Volume 1, n° 98.

But when his figures are static, seemingly added to the landscape rather than an intimate part of its conception, a Pissarro landscape can become too diffuse in its purpose and leave us more with a sense of place, light, and season than clear structure. So it is with *Le Chemin de l'Hermitage, Pontoise, sous la neige*, a landscape of a house with its top bathed in a late-afternoon light, where the figures, rather than creating space, seem to obstruct it. Pissarro knew the site well, having painted it five times[156], but if he showed it to Cézanne, as is likely, the younger painter chose to stand in a different spot and capitalize on a view that was more peculiar and challenging. From both points of view the painters would see the house through the bare tree in front, and while for Pissarro that was part of a natural progression into deeper space, for Cézanne it was a challenge: a dramatic, shallow space inviting a study of its ambiguities and rhythms. Pissarro's version took as its subject the whole, gently receding scene: the path, the remnant of a stone wall, the tree, the houses on both sides. It was an orderly progression in a gentle S-curve, a slow stroll like that of the figures, leaving us above all with a feeling of light and season: the last of a winter day, with an orange spearpoint of light underscoring the darkening blue.

Cézanne's picture became both flatter and deeper: flatter by its emphasis on the wall, deeper in the twists of space from the house down toward the painter and then to the right, away from him. He saw this in part because he stood as he did with *La Maison du Pendu*, at the edge of the precipitous drop. Now the turns of that space could be seen reflected in other curves, in the trunk and branches of the tree, and this would set a consistent, undulating framework against the straight lines and flat planes of the rest of the motif. But rather than separating the tree from the house, he locked the two in the same plane, in a close space where windows clashed with branches and neither one gave ground to the other. Because this flattening is unexpected, it fascinates; and so does the merging of the wall remnant with the corner of the house, where the sunlit wall meets the wall in shade. We almost lose sight of the agreeable day and its warm afternoon light – similar to Pissarro's but in a warmer season – so compellingly does Cézanne force us through his space.

In June 1874 Cézanne left for Aix and in October Pissarro moved to Montfoucault, to a friend's farm. Both painters changed styles: Pissarro's brushstrokes became broader and his palette darker, while Cézanne moved away from atmospheric effects. But these

155 - When the figures were added in the studio, or posed rather than captured at work, the composition might turn out stilted. This painting suggests fresh observation and quick notation. See Brettell, Pissarro and Pontoise, Chapter 5.
156 - Rewald, PPC, vol. 1, p. 162.
157 - See Brettell, pp. 160-172.

changes were already underway while they were still together; in Pissarro's *La Récolte des pommes de terre* we see a solidness of composition and brushstroke that were not visible in 1872, and in Cézanne's *Maison et arbre* the emphasis on space all but obscures the late afternoon light. The changes are to a degree parallel, and appear to me more like similar evolutions than direct, mutual influences. If Pissarro said later that the two painters had influenced each other[158], the influence was a matter of imitation only at the beginning; that was probably in 1872-73, when Cézanne had the more to learn, but by 1874 the painters had been together long enough to evolve at a similar pace, with Cézanne's firm sense for structure probably leading the way.

In Cézanne's work the sense for the structure of the canvas is also a sense for the firmness of things and for clarity of touch. To emphasize light and to call attention to color, as Monet and Renoir knew better than anyone else, a painter must sacrifice firm outline. Perception is such that as one looks at a clear outline one first becomes aware of an object's identity and orientation in space, and color becomes secondary; the slightest blurring of outline, on the other hand, affirms the primacy of color, probably by suppressing space and identity – and if a painter records the light of a specific time of day, as Monet and Renoir do in 1874, and uses the flocculent touch everywhere, he also achieves a sense of enveloping atmosphere and a remarkable unity of surface. The price, as Cézanne must have been acutely aware, is loss of space and substance. He had come as far away from that as he ever would, and now began to return to – and perhaps reaffirm more strongly than before, having seen where the Impressionist emphasis led – the permanence of things. This is the meaning of the statement he made to Maurice Denis in 1906: "I wanted to make of Impressionism something solid and enduring like the art of museums"[159].

It should be added that to do this one does not have to give up light, or time of day, or season, and that Cézanne never did; we can identify the time of day in his landscapes from the play of light, as for example on the face of *Mont Ste-Victoire* in the morning, or from the shadow cast by a cornice on the church at Gardanne, but it is always light whose purpose is to define a volume or a shadow that helps create a composition[160].

PAYSAGE AVEC CLOCHER (R.264), ca. 1875, 65 x 54 cm. White House Historical Association (White House Collection). *Volume 1, n° 103.*

We can also identify the season if we wish, as in the northern *Paysage avec clocher* below, but we are unlikely to respond to the painting as an autumn scene. The red foliage balances the many greens and lightens the dark mass of the poplars, and contributes to our sense of the painting's firm touch, rough surface, and clear space. Each broad dab of paint is distinct, and each contributes to defining the objects and building up the recession from the bottom of the picture to the middle ground. The composition, too, is firm. Cézanne locates the bell-tower on the vertical midline and detaches it clearly from the mass on the right by a bit of sky - a small detail, it might seem, except for what it achieves, which is to call attention to the right slope of the steeple. This isolates the diagonal line that reveals the fundamental rhythm of the painting: the leaning trunks of the small trees on the left and the bare branches of the large one on the right, all of which move in unison toward the upper left.

In *Paysage provençal au toit rouge* Cézanne's task in not so much to reveal the underlying, natural rhythms, as to concentrate our vision. Here he gives the touch several distinct forms that focus the composition where they need to and yet preserve the flat integrity of the surface. In another four years the touch will be parallel, its purpose more obvious,

158 - *In his letter to his son Lucien of November 22, 1895.*
159 - *In Doran,* Conversations avec Cézanne, *p. 170.*
160 - *See, for example, my* Cézanne: Landscape into Art, *pp. 67-70 and 108-109.*

but here it is no less thoughtful: in the center the touches are vertical and form a kind of funnel that draws us down and in and holds the center in place against the diagonally striped fields and bushes. This central knot needs to be self-contained, as it were, to draw our attention away from what would be a more banal point of visual interest: the intersection of the house - the only spot of white and red - and the tree trunk. That is the point of greatest contrast and deepest leap into space, but Cézanne resists the repoussoir effect and pushes the house and the tree together, putting them on the same plane, and makes sure that the tree remains within the space of the scene.

Knowing that within four or five years Cézanne will rely on the parallel touch to organize his landscapes may tempt us to judge the paintings of the post-Pissarro period by how closely they approach it. But a picture such as *Paysage provençal* tells us that a clear purpose, not a specific touch, is all that a painting needs, and reminds us to resist the temptation. *Le Mur d'enceinte*, roughly contemporary with Paysage, makes the

point very clearly. Vertical touches in the bottom band ensure that we see the band not as a body of water but as a wall, and the swirling touches at the top push the foliage toward the right, weaving it between the tree trunks. All the touches, that is, clarify what they represent, and the swirling ones lend the composition movement; by their contrasts of light and color they also establish depth. It is an unusually happy picture, free of tensions and simple in its composition, and perhaps the scene did not put heavy demands on Cézanne's touch.

Much more is demanded of the touch, however, in a picture whose subject - serene and simple only if we consider the relation of the houses to the sea - is complicated by irregular, enveloping vegetation. In *La Mer à l'Estaque*, which is roughly contemporary with the preceding three pictures, Cézanne had to give careful thought to the hues he would use in the bushes and trees and the touches by which he would represent them. Just the right shade of green was required to balance the vivid reds and yellows of the roofs and walls, and the blues of the ocean and sky; he could not simply take it from the site, because its greens, as I noted in similar sites in Provence, would have been much more muted. The greens of pine needles are browner while those of olive

leaves are more silver, and neither color would balance the picture[161]; instead, a saturated cool green, probably viridian, was needed as the basic hue. But color balance was not his only requirement. The twisted trunk of the tree on the right must have suggested a way of animating the placid houses, even disturbing them a little, and Cézanne chose a touch in the vegetation that would to do just that. He set it down firmly and distinctly in zigzags that parallel the trunk; in this way - expressive and provocative - it became an inherent element of the composition.

It is landscapes that require the most thoughtful attention to the functions of brushstrokes, because it is there that the complex subject will almost inevitably compete with the need for a clear composition. We have already seen that although Cézanne seldom chose his brushstrokes to represent textures as they appear, he did take care to suggest them; this is already a constraint, because not just any touch will do. At the same time, he worked toward a single language within a given frame, and this led him to the kind of consistency we have seen in the landscapes of 1865, or in the *Carrefour de la rue Rémy* of 1872, and will see in paintings done with the parallel touch.

More and more during this period he came to emphasize the third purpose of touch

161 - *Dans Doran,* Conversations avec Cézanne, *p. 170.*

**PAYSAGE -
ORÉE D'UN BOIS** (R276),
ca. 1876, 60 x 50 cm.
Private collection,
Switzerland.
Volume 1, n° 107.

**ARMAND GUILLAUMIN,
PAYSAGE
EN ILE-DE-FRANCE,**
ca. 1876.
Volume 1, n° 106.

**CAMILLE PISSARO, ROUTE
DE SAINT-ANTOINE À
L'HERMITAGE, PONTOISE,**
ca. 1875, 52 x 81 cm.
Private collection, on loan
to the Kunstmuseum, Basel.
Volume 1, n° 110.

**LE CLOS DE MATHURINS
À PONTOISE**
(L'Hermitage) (R310),
ca. 1775-77, 58 x 71 cm.
Pushkin Museum, Moscow.
Volume 1, n° 109.

(after, that is, representation and consistency), which is to help establish the composition, as in the *Paysage provençal* and *La mer à l'Estaque* pictures. Although he left no evidence of how he thought about these matters as he painted, we can see these purposes most clearly in his landscapes. The functions of Cézanne's touch will become still more complex when we look at the landscapes of his last decade, when patches replace the parallel strokes. Part of the pleasure, and work, of looking at his landscapes is in trying to reconstruct his purposes – while remaining clear, whenever possible, about where Cézanne was headed.

If what mattered most about style were establishing its linear sequence, then it would be enough to say that with the next painting Cézanne approached the blockish style of 1877; but to show that here the style made sense of a confused scene would say much more. In thinking about what was most important for choosing his touch, we are helped by having two versions of the same landscape available, one of them painted by Guillaumin, which is more detailed and probably closer to the appearance of the site. Cézanne's *Paysage - orée d'un bois* is a simpler painting than Guillaumin's *Paysage en Ile-de-France*: it reduces the many accidents of the actual landscape - branches, fences, bushes - to a matrix of verticals, which are actual and physical, and horizontals, which are only touches of the brush. Only a few of the accidents Guillaumin painted remain in Cézanne's picture: he has kept the bare branches that make the straightest diagonals, and a few of the branches of the bush, and ignored all the rest. What remains are a few dynamic forms to play against the stable, vertical and horizontal, matrix. His touch, in other words, makes order out of disorder - and if the work of simplification goes deeper here than usual, surely it is because it was Guillaumin's site, not his own[162].

Cézanne faced a similar problem with a painting done during his second stay with Pissarro, in 1877, on a site Pissarro had painted before[163]. It was not a question of reducing excessive detail but of finding the right composition, and Cézanne solved it by standing far enough away from Pissarro's standpoint so that the site would present the composition he needed. Pissarro painted from partway up a hill, so that the hillside, and the road at the bottom, made a sharp diagonal slashing across the canvas (*Route de Saint-Antoine à Pontoise*). For Cézanne this created an unstable and unbalanced painting. By moving downhill and to the left, and close to the buildings, he obtained a ground line that was closer to the horizontal, and he had a full view of the buildings cascading downhill; whatever slope remained in the road would now be balanced by the roofs. Both painters used the red roof as a focus and as a complement to the greens, but Cézanne placed himself so that the roof would make a natural counterpoise to the mass of trees right of center, whereas from Pissarro's vantage point the roof had to be squeezed in tightly. Or so it appears when we see Pissarro's painting next to Cézanne's; it is in fact a painting with a different purpose, one in which the gentle portrayal of life in this rural quarter of Pontoise plays a much greater role than structure. We may never be able to decide whether the date of the painting is 1875 or 1877, which is the proposed span[164], but establishing the date is less important than noting

162 - *There are four landscapes painted from nearly the same point of view by Cézanne and Guillaumin, and two of them, the present one and* Village derrière les arbres, Ile de France *(R403), seem to have been painted side by side. In doing the* Paysage *picture, to judge by the slight changes in the spaces between the trees, Cézanne probably stood a little to the left of Guillaumin. None of the landscapes look like Cézanne's typical sites, and these two, which represent distant houses seen through trees, both undergo the same simplification. A fifth pair is a free copy by Cézanne of an original by Guillaumin (*La Seine à Bercy, d'après Guillaumin, *R293, 1876-78).*
163 - *See Rewald,* PPC, *vol. 1, p. 212.*
164 - *Pissarro's painting is signed and dated in 1875; Cézanne may have painted with him then or alone on a later visit in 1877. The problem of the composition remains the same in either case, however. Erle Loran recognized Cézanne's dilemma, too, but his conclusion - that Cézanne stood on the same spot but altered the geometry - is mistaken: the perspective on the red roof shows Pissarro to have stood higher than the edge of the roof and Cézanne to have stood much lower (Erle Loran,* Cézanne's Composition, *University of California Press, 1963, p.55).*

**L'ETANG DES SŒURS
À OSNY, PRÈS DE
PONTOISE** (R307),
ca. 1877, 60 x 74 cm.
Courtauld Institute
Galleries, London.
Volume 1, n° 108.

Cézanne's concentration on the qualities of his surface. That is what strikes one about the exceptional year 1877, in which Cézanne paints several masterpieces, one of which is the extraordinary palette knife picture, *L'Etang des soeurs à Osny, près de Pontoise*. Cézanne's use of the knife is so original here that it is difficult to see the connection between the last picture and this one. Although Cézanne is returning to the palette knife, having used it ten years before, here he finds an altogether new purpose for it: to lay down distinct patches of pigment, bounded on the top, to reconstitute the foliage, build up the space, and organize the composition, all at the same time. This is almost as much as will be expected from the patches of color that he will use as his main system starting in about 1895, and it anticipates them abruptly, without any connection to what happens before and after or to what Pissarro is painting at the time; the picture is unique. As if Cézanne had sensed the possibilities of this incisive touch, he takes a risk with the composition, ordering it primarily on one diagonal without the customary counterbalance, and it takes a prolonged look to see that the main tree bends in such a way as to contain the thrust of the patches.

The palette knife touch is so perfectly sufficient for the tasks of ordering the multiple layers of space, outlining the shapes, and unifying the surface, that one cannot think of any obvious reason that would impel Cézanne to search for another touch. But he did, of course, in narrative pictures (and still lives) in this same year, and in landscapes several years later. An early form of the parallel touch is evident in 1878, in the next painting, and its full flowering awaits the year 1880.

In *Le Bassin du Jas de Bouffan en hiver* we see touches laid down in parallel in the buildings and in the hillside. These are mere hints of the later, structural use of such touches; here the simple geometry and the stark, wintry subject, are central. The geometry is

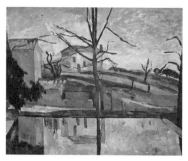

**LE BASSIN
DU JAS DE BOUFFAN
EN HIVER** (R350),
ca. 1878, 53 x 56 cm.
Corinne Cuellar, Zürich.
Volume 1, n° 111.

so simple that it seems too difficult to believe; the bare tree is doubled by its reflection in the pool and brought so close to its edge that it continues without interruption, and this unlikely continuity rivets our gaze. To those who see Cézanne as a painter for whom geometry is primary, the picture seems convincing proof, so clearly is it bisected vertically and horizontally. Cézanne invented nothing in the composition, however; the bisection is clearly visible in Rewald's photograph of the site from 1935[165], and would have been even more striking to Cézanne, who had a higher view of the motif from atop a small pavilion next to the pool. He confined his changes to suppressing the smallest and most confusing branches, which allowed him to emphasize the sloping fields and other straight lines, but he also took care to represent the clear light, which here seems to me a gesture of affection. And he did paint the buildings and walls slowly, building them up with a short, solid, vertical touch that suggests their structure literally, as the sloping touch indicates the fields. The touch is in that sense parallel, but it does no more than represent the flat surfaces; and it remains faint, giving the starkness full stage.

The steps toward using the parallel touch in landscape may never be completely clear, because the dating of his paintings may always remain approximate. We could arrange his landscapes in a sequence that would suggest a smooth progression, but then we would be begging the question. It is safe to say, however, that his work with landscapes in the late 1870s was dedicated to organizing his surfaces by various means – which include some parallel touches. This has the advantage of inviting a

165 - *For a photograph cropped to the dimensions of the painting, see my* Cézanne: Landscape into Art, *p. 48.*

reconstruction of his thinking, image by image, and allowing the sense of his evolving intentions to emerge. Three clear illustrations are at hand.

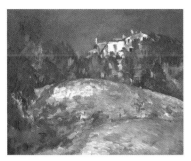

LA MAISON DE BELLEVUE SUR LA COLLINE (R377), ca. 1878, 54 x 64 cm. Fukuoka Broadcasting Corporation, Japan.
Volume 1, n° 113

In one of his landscapes from the latter part of the decade, *La Maison de Bellevue sur la colline*, each brushstroke lies next to, or at times across, another one, so that the whole surface is covered like a tapestry. The likely date is c.1878, roughly contemporary with the *Bassin* painting, but the conception seems to build more closely on the achievements of 1877; and it does so in a way that is more flexible, more advanced, and more directly inspired by the shape of its motif. The purpose of the various touches is not difficult to guess. The building is made of masonry, and by its brilliance and complex outline is the focus of the composition; those are good reasons for painting it in vertical and horizontal touches, and then extending them to the trees that partly obscure it. In this way the whole upper right corner of the painting takes on a quality of seriousness, with the house located on a round hill which is painted in touches that parallel its crown and reveal its soft shape. Why the touches for the framing tree at the left should lean into the painting is less clear, but they do succeed in providing a repoussoir that pushes toward the center, protectively, as in a Claude Lorrain landscape, and perhaps that is sufficient. Why the sky should consist of touches that either extend those of the tree or echo the shape of the hill is perhaps the least obvious, but at least the whole surface is felt to have a purpose, and if the touches are not small, oblique, and parallel, as they will be later, there seems little else to wish for.

In other landscape paintings, which must be attributed to his stay in Aix and nearby l'Estaque between the beginning of 1878 and March of 1879, persistent parallel touches begin to make their appearance; when they do, they represent recognizable textures and planes in some parts of the canvas and abstract notations, designed to solidify the composition, in other parts. In still other *l'Estaque* paintings assigned to the same period the parallel touch is consistent and even implacable, but I am reluctant to see them as contemporary; they would leap over the stylistic explorations that follow in the north, between April 1879 and March 1880. The most plausible stylistic development following *La Maison de Bellevue* seems to me an evolution of purpose: a progressive detachment of the touch from visible textures. On this assumption a painting such as *La Baie de l'Estaque vue de l'est* expresses the evolving aims of this period[166]. There, the vertical green touches, which correspond to nothing in particular, oppose the horizontal touches representing the surface of the water. To this balance of the literal and the abstract Cézanne adds an even more abstract ground, where his touch, this time slow and firm, balances the shape of the distant horizon rather than describing the slope of the hillside (which is gentler than the touch would imply). These deliberate decisions may reduce the nervous effervescence of the earlier painting done nearby (*La Mer à l'Estaque* of 1876, p. 86), but the saturated colors restore some of its intensity.

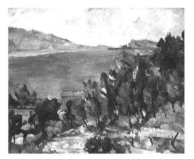

LA BAIE DE L'ESTAQUE VUE DE L'EST (R394), ca. 1878-79, 56 x 66 cm. Memorial Art Gallery, University of Rochester, New York.
Volume 1, n° 114.

The balance between impulse and deliberateness is inevitably altered by the introduction of parallel touches, particularly when they are applied slowly, in full paste[167], and even

166 - *The possible dates to assign to l'Estaque paintings of this stage in the development of his style are three: early 1878 to March 1879, November 1881 to March 1882, and October 1882 to May 1885. This is very broad indeed, but not unhelpful. If we take as earliest the paintings in which the touch remains the most literal, that is, the least abstracted from the actual textures, or the most tentative in its use, we can reasonably assign them to the first of these periods. I would agree with Rewald's dating of R391* (Montagnes en Provence), *394* (La baie de l'Estaque vue de l'est, above), *396* (L'Estaque vu à travers les arbres), *and 399* (Le Chaîne de l'Etoile avec le Pilon du Roi), *because they satisfy these criteria, but place R390* (Le golfe de Marseille vu de l'Estaque), *395* (La mer à l'Estaque derrière les arbres), *and 393* (Au fond du ravin), *in one of the later periods, because they do not; they are more self-assured.*
167 - *We must not take the full-paste surface for a different style, or a different period, at least not by itself; all we can conclude is that it represents a more finished surface - of a painting that may have been started more quickly and impulsively.*

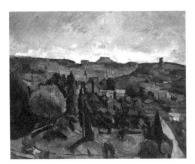

**LA MONTAGNE
SAINTE-VICTOIRE ET
LE PILON DU ROI**
(R400), ca. 1878-79,
55 x 65 cm.
Fujii Gallery, Tokyo.
Volume 1, n° 115.

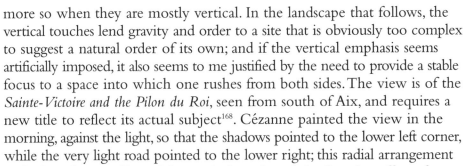

more so when they are mostly vertical. In the landscape that follows, the vertical touches lend gravity and order to a site that is obviously too complex to suggest a natural order of its own; and if the vertical emphasis seems artificially imposed, it also seems to me justified by the need to provide a stable focus to a space into which one rushes from both sides. The view is of the *Sainte-Victoire and the Pilon du Roi*, seen from south of Aix, and requires a new title to reflect its actual subject[168]. Cézanne painted the view in the morning, against the light, so that the shadows pointed to the lower left corner, while the very light road pointed to the lower right; this radial arrangement needed, I think, the calming effect of the vertical touch and the focusing effect of the tight complex of houses in the middle distance. He then placed a somewhat flattened Sainte-Victoire in the exact center of the horizon and outlined it in a near-white, and made sure that our gaze would always find in it a point of respite.

If the parallel touch in the early landscapes was at times abstract and at other times representational, it always served the ends that had been served by the various stylistic devices he had used until now. There was, I would think, nothing inevitable in its development, but its initial possibilities must have encouraged him to push forward until it became - for five years or so - a system that served vision and logic equally well.

In his drawings of this period Cézanne showed no interest in landscape at all; it is as if the medium served him only for studies from the figure, copies after paintings and sculptures, layouts of narrative compositions - all predominantly linear matters - and the occasional portrait or sketch of a still life object. In watercolors, his interest was barely greater at first, being limited to one sheet done during the time he was with Pissarro and a half-dozen others at about mid-decade. Toward the end of the decade, however, he painted several watercolors that were once again complete landscapes in their own right (as in the mid-sixties). They seem connected with the paintings of about 1878, whose surfaces were becoming more intensely rhythmical, but their own rhythm was tighter and more repetitive - surely helped by the natural movement of the wrist, which easily sets down parallel strokes in pencil or brush.

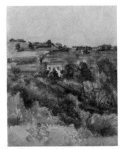

PAYSAGE PROVENÇAL
("Paysage d'Île-
de-France") (RW72),
ca. 1875, 36 x 30 cm.
Private collection,
Switzerland.
Volume 1, n° 112.

In a watercolor of the same subject as *Paysage provençal au toit rouge* (p. 86) Cézanne responds to the dense vegetation with equal intensity - but with less system. If we assume that the sheet is a study for the canvas, then we can say that the watercolor serves to aquaint him with the site, while the oil, building on what he has learned, gives him the detachment he needs to think of the composition in more abstract terms. In the watercolor (RW72)[169], relatively few touches are parallel; on the contrary, most seem to be the result of small, quick motions of the wrist, and as they accumulate they record the actual textures, rich and confused as they are, rather than suggesting abstract rhythms; and they present the house to us as something nested in greenery rather than as a flat object in the same plane as the tree. For Cézanne, watercolor has not yet become a medium for analytic vision - analytic in its ordered touches and limited colors - but remains a flexible system for quick notations; if it is followed by a canvas, then it will have also given him a close grasp of the motif.

168 - *The title,* Paysage d'Île de France, *cannot be right, if only because the roofs have the slope and color of Provençal roofs. A watercolor of the same motif,* R118, *found on the back of a sheet representing l'Estaque, is correctly identified by Rewald as being in the south (it is titled* Maisons à l'Estaque*), and the discrepancy needs to be resolved by making the titles consistent. (The two versions are presented together in* Cézanne, *a catalog of an exhibition published in Japan by The Tokyo Shimbun, 1986, pp. 44-45.) Having found the approximate horizon, though not the foreground, near Aix, I propose a title close to Venturi's original one, a title that describes the mountain and the stone pillar on the horizon, and I suggest a date that reflects the first of Cézanne's stays in l'Estaque.*
169 - *Its title should be* Paysage provençal, *not "Paysage de l'Île de France".*

PORTRAITS

Had we only Cézanne's portraits to look at, we would have little reason to suspect that he had spent two years close to Pissarro. They are his own in technique and in expression; with one exception[170], they bear little resemblance to the quiet, restrained portraits painted by Pissarro, of which there are very few in any case. Even if portraits had played a greater role in their contacts, however, it is unlikely that Cézanne would have been influenced more; his portraits seem more an expression of character, his own and that of the sitter, than of technique. Possibly that affects painters in general, although one can think of exceptions; in any case, the Cézanne whom Pissarro or Renoir see in their portraits of him is very different from the one Cézanne sees. The two colleagues see a quieter, less incisive man, and it is not because they see him more clearly or because they are objective and he subjective; it is that, like all painters, they project themselves into the portraits. Gombrich has shown with some choice examples that all the portraits by a given artist tend to have something in common – some aspect of the painter's appearance and character[171].

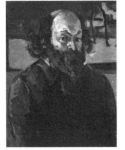

PORTRAIT DE L'ARTISTE
(R182), ca. 1872, 64 x 53 cm.
Musée d'Orsay, Paris.
Volume 1, n° 116.

Portraits are of course typically painted indoors, which would have limited Pissarro's influence further, and we have, in addition, Pissarro's relative lack of interest in portraits and still lives. (His effect on Cézanne's still lives is therefore no greater.) Cézanne simply does portraits in his own manner, and we can see this from the first portrait that we can date after his move to Auvers[172]. It is a self-portrait, and a powerful expression of a self-view or of some mood, perhaps of some of the turbulence of the previous decade, perhaps of some renewed confidence and determination; it is impossible to say. If Cézanne's other paintings are calmer, thanks to his domestic arrangements and to Pissarro's example, the calmness is not visible here. His eyebrows are insistent and emphatic, in the form of a circumflex when in fact they were quite flat. Vigor of expression and execution, rather than technique or style, seem primary here.

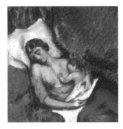

FEMME ALLAITANT SON ENFANT (R216), ca. 1872, 22 x 22 cm.
Private collection.
Volume 1, n° 117.

Expression is primary in his portraits of other people in his circle as well, I shall argue, and demonstrates, if there is still need, that he was closer to most of his sitters than he is given credit for. For an affectionate example, one has but to look at a very small picture (22 x 22cm) of a woman nursing, which probably portrays Hortense and little Paul; it is unstudied and intimate, graceful in expression and tender in the oval of the enclosing arms. Equally tender is an even smaller picture, *Jeune fille aux cheveux dénoués*, which Rewald believes may be of Hortense as well[173]; it, too, is unself-conscious in style. Until 1877, a year in which Cézanne paints most of his paintings with an emphasis on surface rhythms, he exempts portraits from the discipline of style, and even afterwards, when various systematic touches come to dominate his paintings, portraits are the least affected.

JEUNE FILLE AUX CHEVEUX DÉNOUÉS
(R230), ca. 1873-74,
11 x 15 cm.
Bettina Berggruen, Gstaad.
Volume 1, n° 119.

The obverse of this coin may be that portraits offer too little challenge to Cézanne's formal and stylistic ambitions and that, perhaps for this reason,

170 - *The 1875* Portrait de l'artiste au fond rose, *below, which bears some resemblance to the lighting and distribution of masses in the 1873 Pissarro self-portrait. This is noted by Rewald,* PPC, *vol. 1, p. 185, and by Platzman,* Cézanne: The self-portraits, *p. 87, where the comparison is illustrated in color. Even if the term "influence" were the* mot juste *for paintings done two years apart, it would be a less direct and less pervasive one than Pissarro's influence on the landscapes, and his restraining effect on the narrative pictures.*
171 - *See E. H. Gombrich's persuasive essay on the matter in Julian Hochberg's* Art, Perception, and Reality, *1972.*
172 - *All we know about the date with certainty is that it was painted after 1871, when Guillaumin painted the landscape that is visible in the background. Rewald prefers a date of 1875 on grounds of its resemblance to portrait photographs, but Gowing argues for 1872 on grounds of handling and color. The handling can also be seen in portraits dated between 1869 and 1874, so it is not a clear criterion, but the color may well suggest the earlier date. I am inclined toward 1872, but it does not affect my argument about Cézanne's independence from Pissarro in the matter of portraits.*
173 - *Rewald,* PPC, Vol. 1, p. 58.

he paints relatively few during this period. There are seventeen, while narrative paintings, landscapes, and still lives each number in the fifties and sixties. The portraits are no less significant, however; there is a frankness of expression and an originality and audacity in their execution that make them take their place in western painting as firmly as paintings based purely in stylistic achievements. Choosing pink wallpaper for the background of a self-portrait, for example, is an audacious decision; it is normally the last thing one would think of, yet in *Portrait de l'artiste au fond rose* of about 1875 Cézanne brings it off as if it were perfectly natural. The exact shade of pink matters, of course; it cannot be the pink of baby clothes because it would barely differ from skin tones, so it might as well be flesh color itself. And it is not flesh color alone that Cézanne depends on; he gives it life, both in the face and in the background, by interlarding it with complementary grey-greens. The dull green serves to model the head as well, particularly where it is in shadow, and also at the top and near the hairline; the placement is abstract, and it works to indicate the bends in the surface simply by being complementary to the skin tone. Finally, he brings the warm pinks into the black of the coat. His overall color scheme then has flesh tones, yellow highlights, greens, and a black, and retains a breathtaking simplicity and consistency. The composition itself is less a balanced arrangement of objects than a texture of squiggly shapes that unites the wallpaper with the details of the face and hair and with the outlines of the sleeves[174].

PORTRAIT DE L'ARTISTE AU FOND ROSE (R274), ca. 1875, 66 x 55 cm. Musée Granet, Aix-en-Provence. *Volume 1, n° 118.*

Close to this portrait in the expression of youth and self-assurance is *Portrait de l'artiste au chapeau de paille*[175]. In this self-portrait, almost certainly painted at the Jas de Bouffan in front of the wallpaper we saw in the 1870 *Jeune fille au piano - Ouverture à Tannhaeuser* (p. 59), he poses in the straw hat indispensable in the South, and finds several shapes coming together to suggest linear, decorative handling: the Paisley-like swirls of the wallpaper, the brim of the hat, and the curl of his hair. With line as the dominant principle, he also smoothes out the shape of the nose and eyes and simplifies the outline of the beard and mustache. As colorful as the painting seems to be, he actually uses color very economically: he assimilates two nearby colors to each other, (yellows, not pinks as in the self-portrait au fond rose, letting the highlights of the skin take on the color of the Naples yellow hat, and then does the modeling with greens. He positions the head in a way that he often favors, lit from behind and to the side, casting part of the face in shadow but leaving the nose in full light - offering enough play of light for very plastic treatment, but also enough shadow for the eyes to remain relaxed and the expression unforced and self-confident.

PORTRAIT DE L'ARTISTE AU CHAPEAU DE PAILLE (R384), ca. 1878, 43 x 26 cm. Museum of Modern Art, New York. *Volume 1, n° 122.*

As accustomed as we have become to Cézanne's ability to elude our attempts to impose order on him - his inventiveness outpaces the efforts of the critic - we are unprepared for either the mood or the style of the next picture. It must have been painted between the straw hat portrait and the one that shows grey in his beard (R385 below), but it is impossible to be more precise. It does seem from the sitter's lack of vitality to be a portrait of a much older man; a sense of acceptance or resignation, of revealing the slings and arrows of fate, is evident (and has suggested a natural comparison to self-portraits of Rembrandt's old age[176]). But the painter would be only forty years old by Rewald's dating and less than forty by mine, and he will in any case appear vigorous again in later self-portraits, so the effect he achieves here is meant to show a momentary disposition or self-image, not age. The effect is realized

174 - *If I have said nothing about the artist's expression, it is in part because it is less insistent than in the early portraits, and in part because, even if it could be read unambiguously, it would say less about Cézanne, the painter, than his original conception and vigorous facture. For a differing view - that this portrait functions as a statement of a newfound identity - see Steven Platzman, Cézanne: The self-portraits, p. 85.*
175 - *Rewald's date of c1878 seem to me too late. It would place the self-portrait with R385, where Cézanne's beard begins to show grey, and where the touches begin to be parallel; on both grounds, this self-portrait must be earlier.*
176 - *Rewald, PPC, vol. 1, p. 251.*

**PORTRAIT
DE L'ARTISTE** (R383),
ca. 1876-77, 61 x 47 cm.
Phillips Collection,
Washington, DC.
Volume 1, n° 120.

deliberately, by relating the head to the coat and suppressing features, and on prolonged viewing the painting appears as a thoughtful study of the structure of a face rather than an impulsive recording of a mood. For example, the collar is turned up and the head seems retracted protectively into it, so that the otherwise substantial face seems small and timid; the beard is painted scraggly, barely distinct from the coat, as if it, too, were to help hide the head in the collar, and the mouth is hidden under the overgrown mustache (a part of the mustache is then lightened in color to open the face back up, however). The scraped-away black paint in the shoulder, and the dark, grey-to-brown background, help point us to the brightly lit face, where the painter's work is concentrated and where we look all the more carefully at the fine modeling. Cézanne gives himself no eyebrows, no eyelashes, no mouth, as if to deprive himself of all the expressive marks by which he is recognized, and he makes his eyes appear small and tired.

Perhaps what is remarkable about this painting is the straightforwardness, the lack of demonstrativeness, in the handling. At first the face seems modeled very much as the portrait of Chocquet that follows, with red color accents in the same places, but it is in fact less labored and more secure. By omitting the eyebrows, Cézanne has forced himself to pay even closer attention to the modeling than usual; he has challenged himself, I believe, to have the face retain its character without relying on the obvious expressive traits. Fully confident in his ability, I think he has painted a portrait that conveys technical mastery at the same time as it suggests a frame of mind. He has done this, however, with no reference to the parallel touch.

Cézanne's exceptional portrait of Victor Chocquet was painted during the same two years, in 1876 or 77. His subject was the modest benefactor and immodest champion of the young painters whom Renoir had painted earlier and introduced to Cézanne, and who shared with Cézanne a passion for Delacroix; the painter's fondness for Chocquet became expressed in six portraits done over the sixteen years of their friendship. Anyone who has seen Renoir's painting[177] will be unable to suppress a memory of it when looking at the first Chocquet portrait by Cézanne, below: while Renoir's sitter is kindly and handsome, Cézanne's is leonine, thoughtful, ascetic. The power of Cézanne's portrait does not, however, depend on this comparison; by itself it is a painting of unusual gravity and substance. The sitter is seen from somewhat below, his already slim head elongated and his forehead brought to a high peak, and his quite short nose is given a pronounced Roman profile. We are reminded even more clearly of Delacroix's idealized portrait of Chopin than we were by *Portrait de Cézanne aux longs cheveux* (p. 54), and we may suspect that the resemblance was intended.

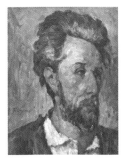

**PORTRAIT
DE VICTOR CHOCQUET**
(R292), ca. 1876-77,
46 x 36 cm.
Private collection.
Volume 1, n° 123.

But as striking as the structure of the head may be, it is the relentless application of paint to the hair and face, and even to the collar and the background, that is so compelling; it does not suggest a struggle - either with the likeness or with finding a consistent rhythm - but rather a desire to create a rich surface and achieve a concentrated effect. The range of skin tones from the whitest yellows to the darkest crimsons is remarkable, as is the choice of grey-blues, grey-greens, and even olive-greens and violets, in the background; it becomes clear, as one continues to look, that the painting achieves much of its brilliance through color, through, that is, intensifying the warmth of the face by a complementary ground.

In two unique portraits that follow, however, he submits the image of his sitters to

177 - *It is reproduced in Rewald's PPC, vol. 2, p. 204, and in Goetz Adriani's* Cézanne's Paintings, *New York, Abrams, 1993, p. 85, for example.*

the intense concentration on surface rhythms that typify the year 1877. That year saw the imposition of rhythmic discipline on the surface of the third *La Tentation de Saint Antoine* among narrative paintings, and *La Côte des bœufs* (R213) among landscapes, and witnessed a brilliant construction of landscape through touches of the palette knife in *L'Étang des sœurs*. Characteristic of some of the paintings we attribute safely to 1877 is a touch that relies on large, flat blocks of color, and we will see it in these two portraits; but almost all paintings attributable to that year, whatever their touch, reveal a profoundly new emphasis in his work. That emphasis stands out clearly in these portraits: it treats paintings as objects that honor the flatness and rectangularity of the surface and seek their deep unity purely from internal relations of color and touch.

The two portraits are the second portrait of Victor Chocquet and a portrait of Mme Cézanne in a striped skirt. Chocquet now sits as if he had been placed on the canvas rather than in his living room: his body is a series of verticals and horizontals parallel to the frame and even his crossed legs are squished together to remain close to the vertical. His locked hands form the one diagonal line, which is opposed to an implied diagonal: the receding bottom of the chair. In all respects the picture is flat - an object to hold or to look at, not a window to look through - and we gaze at its repetitive patterns rather than at a person in space. The repetitive patterns are everywhere: in the consistent widths of the many parallel lines - the picture frames, the bureau, the rug pattern, and even the interlaced fingers - in the size of the blocks of paint that define each surface, and in the brilliant spots of red that leap away from the wall and carpet.

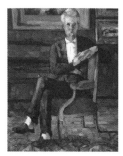

PORTRAIT DE VICTOR CHOCQUET ASSIS
(R296), ca. 1877, 46 x 38 cm.
Columbus Gallery of Fine Arts, Ohio.
Volume 1, n° 121.

If in portraits there is an inherent tension between likeness and the needs of the canvas, with this portrait it has been resolved in favor of the canvas. It is a resolution that Cézanne had to affirm, and perhaps overdo, in order to evolve further. It is not always overdone, however; the systematic rhythms of the Chocquet portrait animate the portrait of Hortense Fiquet much more gracefully, where they have a larger scale and simpler composition in which to develop. *Madame Cézanne à la jupe rayée*, in other words, turns the mere idea of a rhythmic surface into a fully realized masterpiece. The picture's construction is perhaps helped by the sculptural foundation provided by the voluminous skirt, and even more so by its vertical stripes, and it is helped, too, by the body's simple, pyramidal shape. With the composition so naturally established, the painter can relax, as it were; the figure can be allowed to lean slightly to one side, and the chair back can be distorted, to balance her, so that the mass of the back is well away from the head and moves to the right. This distortion of the chair is barely noticeable, so successful is the internal balance.

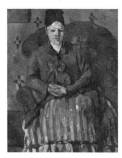

MADAME CÉZANNE À LA JUPE RAYÉE
(R324), ca. 1877, 73 x 56 cm.
Museum of Fine Arts, Boston, MA.
Volume 1, n° 125.

The color is as emphatic as in the small Chocquet portrait: the armchair is a frank crimson, but it is placed in the calm company of the mustard wallpaper and the various greens of the skirt, and fails to shock; even the blues of the jacket are reconciled to the red color, thanks to their many subtle greens and mustards. The painting is a tour de force of color use, and to see the subtlety beneath the brilliance, it repays careful study even in the reproduction. For Cézanne's development, however, the important matter is that the conception is flat and rhythmical[178], with no attempt at illusion; he has moved that far from Impressionism in that short a time.

It is in the company of the many portraits whose style reflects the sitter's character and Cézanne's feeling toward him, that the intimate little study of his son belongs[179]. The boy's head is all oval lines, gentle convexities, and smooth, nearly translucent skin

178 - *The wings of the chair, designed to cradle a tired head, would normally protrude toward the viewer, but here they lie flat; and the hands, interlaced as in the Chocquet picture, form a pattern similar to the stripes of the skirt.*

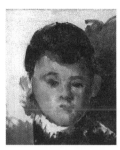

PORTRAIT DU FILS DE L'ARTISTE (R464), ca. 1876-77, 17 x 15 cm. Art Museum Princeton University.
Volume 1, n° 124.

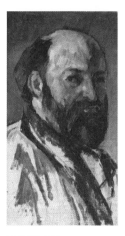

PORTRAIT DE L'ARTISTE (R385), ca. 1879-80, 26 x 15 cm. Musée d'Orsay, Paris.
Volume 1, n° 126.

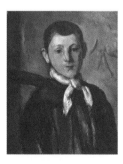

PORTRAIT DE LOUIS GUILLAUME (R421), ca. 1879-80, 56 x 47 cm. National Gallery of Art, Washington, DC.
Volume 1, n° 129.

tones; it is a loving though unstudied homage to that elusive quality, a child's innocence. To the extent that the handling of the brush can support the painter's fondness, it does: the paint is dabbed on the skin and rubbed in the background, hair, and torso; it is a first lay-in, of course, so we cannot place the style in a sequence. We also feel no need to ponder the style, because we seem led more directly to the head and its expression than we would be in narratives, landscapes, or still lives.

In a small self-portrait, which would be called a sketch were it not painted with an evident confidence and self-sufficiency, Cézanne turns his head to illuminate only half his face. The sharp, dividing shadow emphasizes the structure of his head rather than his expression, as self-assured as the expression seems to be. The painting shows him without any embellishment, stylistic or dramatic, and presents him at a robust age as the simple *homme du midi* that he thought he was. It is equally simple and self-assured in handling, relying on quick slashes of the brush to create the volumes of the torso and using a grey-green to do multiple work: complement the skin tones, model the head, and depict the grey hairs in his beard - a model of efficacy that loses nothing in sensuousness.

This self-portrait must have been painted later than the others of this decade because the beard shows traces of white; it is also painted in slowly applied parallel touches. Although I have argued against dating the paintings in a way that would create a smooth (but perhaps imagined) progression toward the full parallel touch, the later surface is consistent with the later age of the beard. The beard seems of the same age as the one in a portrait dated, correctly, 1879-80 (R416, p. 126), which would put the two paintings no more than a year or so apart.

Only the apparent age of the sitters helps us date some of the portraits done after 1877; it shows some progression toward a systematic touch, but not a smooth one, because so much depends on the paintings' degree of finish and on the painter's relation to his sitters.[180] If, however, we accept that the touch was as responsive to the subject in portraits as elsewhere, then we can shift our attention from the details of the progression to the ways in which Cézanne used the touch. As important as the touch became to him, it was neither an end point nor a signature but a way of ordering his sensations, and in using it he exercised more freedom than is sometimes assumed.

A particularly beautiful example of that freedom is a portrait of Louis Guillaume, a close friend of his son, which shows only the barest traces of the parallel touch even though it was painted during the time that Cézanne used it systematically in the still lives done in front of the very same wallpaper[181]. It is a portrait with a strong sense of place and light, and with an affectionate response to the sitter's face. Cézanne has placed him so that he catches the light nearly fully from behind Cézanne's own left shoulder; this locates him in a small room in front of a wall that obviously recedes toward the left. That, and the vividness of the boy's appearance, put the emphasis on the particular rather than the general - something that the parallel touch would certainly have made difficult. The needs of strong composition are met by selecting two stems from the

179 - *Although it is dated c. 1880 by Rewald, it is clearly a portrait of a boy younger than eight years, which would have been his age then. Four of the paintings with which it is grouped, R463, 465, 466, and 467, show a boy with a narrower head and larger mouth - a more mature head, quite possibly that of an eight-year-old. Five years, or even less, seems the age of this one.*
180 - *All the evidence of reliable dates has been brought together by Robert Ratcliffe in his* Cézanne's working methods and their theoretical background, *unpublished PhD. dissertation, University of London, 1960.*
181 - *The portrait must be grouped with the still lives that show the spray of leaves in the background that we see here. Whether that group was painted in Paris between late 1876 and early 1878, in March 1879 during a brief return from the south, in Melun between April 1879 and March 1880, or afterward again in Paris, is unclear. Below, I argue for the year in Melun (as does Rewald by dating the painting 1879-80), but for now it is enough to know that it is contemporary with still lives done with a fully developed form of the parallel touch.*

spray of leaves to echo the boy's kerchief, and indicating the back of a chair to support him on the left, but these are found in what Cézanne has before him rather than in the system of parallel lines. If in this picture Cézanne has pulled back from the systematic touch for the sake of individuality, he will do it again in Assiette à bord bleu et fruits (below), a contemporary still life, so that he may pay full attention to problems of color.

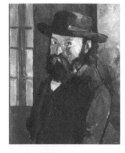

When his own face is in question - perhaps because it is his own, perhaps because he has explored it so much - he feels fewer constraints in using the new touch. The challenge is clear in the self-portrait *au chapeau à large bord*, and it is met successfully. The painting has some of the modesty of the last self-portrait, but on stylistic grounds belongs closer to the paintings of the next chapter. Here, the surface is laid down according to a simple system: all the brushstrokes follow his body as it leans back, even when they have to line up at right angles to the nearly straight brim. The painting gives me the impression of a self-imposed exercise: to see if a touch aligned in a single direction can be made to outline and model a set of features that go in all sorts of directions - the mustache, the eyebrows, and the hat brim, of course. I think Cézanne has proved his point here (if I am right in thinking that that was his point) and produced a remarkably disciplined painting. He has achieved this, in part, by being careful to balance the touches with diagonals that create several inverted Vs: the juncture of the face and the nose that outlines a sharp triangle, the shoulder, even the otherwise meaningless triangle of light color in the lower right corner that simply adds a broader base. When we look at his organization from this point of view, then the thin upper arm becomes justified; it lies close to the body and emphasizes the backward lean - unfortunately, however, diminishing the sitter's apparent stature at the same time.

Watercolor was never a medium for portraits for Cézanne, if we except the self-portrait done in the nineties that we saw in the introduction; there are twenty-one figure studies (with the sitter recognizable enough) and three portrait sketches, but no other full portraits - as if the medium had neither the precision of drawings nor the luminousness of color or unambiguous volume of paintings. Drawings, however, were ideal for catching likeness, expression, and character, and show us a Cézanne who is even closer to his sitters when he draws them than when he paints, and even more self-assured in his touch. Many drawings are of his family resting or sleeping, and are as tender as was the painting *Femme allaitant son enfant*, and visually even more immediate.

A sheet (C271) dated generally in the early seventies - but done earlier, I should think, in the part with the nude figures, and later in the three heads - is masterly in the execution of the portrait head in the corner. Unhesitating strokes outline the nose, give expression to the eyes and the lips, and produce both volume in the hair and light and shade in the face; perhaps the most self-assured is the economical drawing of the curve and volume of the lips. The disciplined hatchings of the hair and chest suggest that Cézanne had no difficulty ignoring the actual outline of the objects he was drawing and using the way the hatchings accumulate to produce shape and volume, and we may wonder why he did not translate them into the parallel touch in oils earlier.

In the late seventies, however, the hatchings in the face of Madame Cézanne resting, from another *Page of studies*, show a later stage in their use, one somewhat closer to what the parallel touch will become in painting. They shape the face more closely and finely, indicating both shading and volume, and generally run in fewer directions. But not too much should be made of the stylistic closeness to painting; hatchings are a natural movement for the wrist to make on this small a scale, and they are indispensable

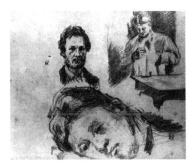

for indicating volume with a monochrome pencil. In a painting, where one works more often at arm's length, a small parallel movement is only one of several possible motions that a painter can make; larger movements are just as likely, including broad sweeps that begin at the elbow.

In portraits, then, we have followed the expectable division of attention - regard for likeness and expression on the one hand, and one's own vision or style on the other. Cézanne has shown himself surprisingly intimate with at least some sitters, and perceptive and open with others, with a relative disregard of style. It is not that he was ever less than consistent in his handling, but that style itself was seldom primary in portraits, at least until we come to the first portraits in which parallel touches begin to appear - the exceptions being the 1877 seated portrait of Chocquet and the magnificent painting of Mme Cézanne in the red chair. The still lives, however, will offer fewer distractions from the pursuit of a more focused and abiding search for style, and will point Cézanne in the direction of ordered rhythms earlier.

STILL LIVES

A painter who could claim *La Pendule noire* to his credit might be expected to take up where he had left off. But apart from the two other still lives he painted at about the same time as *La Pendule*, in about 1870, he seems to have waited at least three years before he painted any other still lives that could possibly be attributed to him, and they show none of the firmness, structure, even confidence of *La Pendule*. It is true that Pissarro showed only a minimal interest in still lives, and this might have discouraged him; the painters' shared attachment to landscape was perhaps enough of a focus for the time. Cézanne did leave room for self-portraits, but those only require a healthy attachment to one's own image and an available mirror; setting up a still life is more demanding.

Nor can one say that the return to still life was particularly significant for him before the year 1877. Of the fifteen still lives attributed to Cézanne during the years with Pissarro (R203 - 214, and 223, 226, and 227), painted presumably in Dr. Gachet's house, the first twelve fail to come up to Cézanne's standards. The touch is too pusillanimous, or the composition too weak, or the conception of the painting too decorative. The first two of these problems are decisive, in my view, in making them appear to be by someone else's hand, and the third contributes significantly. To the judgment of their quality one must add that all but one of these paintings were owned initially by Dr. Gachet himself - an amateur painter with an especially close interest in Cézanne's still lives. He once let Cézanne paint a still life he had set up for himself (*Dahlias dans un grand vase de Delft*, below, whose authorship is undisputed), and in turn copied one of Cézanne's presumed compositions; eventually, Gachet's son copied three others (of which one is also in the disputed category). There was, then, a shared interest, much copying, an overlap in subjects, and for eleven of these twelve paintings only Dr. Gachet to speak to their origin - enough reasons to make one hesitate to accept them as Cézanne's[182].

Even in the three undisputed paintings of 1873 Cézanne had given up the simple, massive forms of the end of the previous decade and at least momentarily turned to

182 - *Similar doubts are raised by Walter Feilchenfeldt in his "Doctor Gachet - Friend of Cézanne and Van Gogh?", reprinted in his By Appointment Only, 2005. Rewald, however, in PPC, opts for including them. He may well be justified, given the purpose of his book - his is an inclusive catalog, while mine is a critical study. See also Walter Feilchenfeldt's prefatory article, "On authenticity", pp. 13-16 of the same catalog.*

decorative subjects - the beauty of vase and flower arrangements. We see decorativeness in three flower paintings done in 1873, in a copy of an engraving done in the mid-seventies, and in six more paintings done in 1877. *Dahlias dans un grand vase de Delft*, the one set up by Dr. Gachet, is clearly not Cézanne's in conception: he divides his attention equally between the attractive vase and the flowers, as if subject were more important than visual emphasis or clarity. But in its handling the picture is clearly Cézanne's. It is firm and self-confident, even with its considerable overpainting, and it is forthright in the compact massing of the dahlias. The picture may be conservative in composition and color - so much more so than *La Pendule noire*! - but it does stand on its own.

DAHLIAS DANS UN GRAND VASE DE DELFT (R223), ca. 1873, 73 x 54 cm. Musée d'Orsay, Paris. *Volume 1, n° 131.*

Between this still life (and two similar but smaller ones done at Dr. Gachet's) and the still lives painted in the significant year of 1877 there is only a copy of an engraving of a Rococo vase, which need not detain us. But two flower arrangements from 1877 return us to Cézanne's forceful handling, the first in its rapid execution, the second in its choice of colors. *Le Vase de fleurs* is the quickly painted one, and it is seemingly careless in its dashes and jabs but in fact carefully thought out in its composition. The left side of the painting is heavier, relying for mass on the compact round heads of the flowers, while the right side is smaller, darker, and more jagged; the whole is full of tension and movement even quite apart from the undisciplined background. The vase becomes a mere rectangle which connects the mass of flowers with the bottom of the frame, and in this way Cézanne turns our attention to the picture - to what is happening within the frame - rather than what is sitting on the table.

LE VASE DE FLEURS (R314), ca. 1877-78, 31 x 36 cm. Private collection, Japan. *Volume 1, n° 132.*

Cézanne will return to flower compositions again in another three years, and they will be painted with the discipline of the parallel touch. Between 1877 and 1880, however, he will turn to painting simpler objects, arranged in more complex compositions, and do many small studies of apples and other simple fruit. What will connect the different subjects and their arrangements in space will be the primacy of painting over illusion - and that primacy will take on different guises, including one of flat decorativeness, as in the next picture, *Le Plat de pommes*. It is, among other things, a play upon space; a collection of fruit is placed in front of a painted screen of forceful arabesques (a screen that he had painted himself for his parents' home in about 1859). The play is in making a single subject from an actual foreground and a painted background, by rendering both with the same touch and making them appear equally solid. This is not a philosophical point about reality - as such, it would be trivial - but a point about the conception of a still life picture, and here Cézanne underscores the conception by subjecting everything to the same tension - a slight lean to the left, in defiance of all symmetries.

LE PLAT DE POMMES (R348), ca. 1877, 46 x 55 cm. Metropolitan Museum of Art, New York. *Volume 1, n° 134.*

These two still lives together with others done in that year suggest that the year 1877 has become as significant in still lives as it was in all of Cézanne's other painting. The next still life, *Nature morte à la soupière*, is a still more significant canvas. Admittedly, the suggested date of 1877 is not a firm one, but that matters little: the painting would be original whether it had been done four years earlier or eight years later (both extremes have been proposed). In touch it stands apart from the known styles of all those years, but it does at least share one quality with the 1877 still lives we shall come to: the broadened and squared-off lip of the soup tureen. What would be

183 - *The arguments are summarized in Cachin et al., Cézanne, 1996, p. 143, with the proposal that the painting was done in 1873-74; 1877 still seems to me the more likely date.*

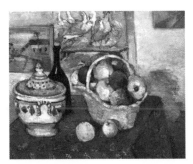

**NATURE MORTE
À LA SOUPIÈRE**

(R302), ca. 1877,
65 x 83 cm. Musée d'Orsay,
Paris.

Volume 1, n° 133.

original in any of the proposed years is that the canvas is now above all a set of internal relationships, which are so compelling that they almost make us lose sight of the objects. As real and as plausibly lit as the objects are, they seem subordinate to a grander design. The basket is turned so as to mirror the movements of the geese in the picture; the soup tureen flattens out and sits immovably on the table; and the basket and the tureen are separated by a flat space that emphasizes their outlines. All of this calls attention to the canvas rather than to the space the objects inhabit. What space remains is a constructed space rather than an illusionistic one: the table recedes toward the upper right while the basket recedes to the upper left, achieving a balance more complete than we dare expect from ordinary objects around us.

If the painting seems studied and formal, it is the first still life to shift the balance away from delight in objects to pleasure in formal connections, and to create an independent, inner world. In a few still lives done in 1877 Cézanne remained more conventional, sometimes by choosing more conservative coloring (in *Poterie, tasse et fruits sur une nappe blanche*), at other times by relying on older devices (in *Fiasque, verre et poterie*), still at other times by escaping toward an opulent materiality (in *Compotier et assiette de biscuits*). To say this is neither to impose a judgment on him nor to suggest loss of courage, but to point out that in the late 1870s he tried relentlessly and with an almost daily commitment to compose new arrangements and work out fresh ways of representing them, as he was to do with the great still lives of the 1890s.

The first of these other still lives from 1877, *Poterie, tasse et fruits sur une nappe blanche*, reverts to a frontal composition that he had favored earlier (as had Manet, and Chardin before him). The colors and dark tonality recall Dutch still lives such as those of Willem Kalf, that Cézanne could also have seen in the Louvre[184], as does the napkin draped over the edge of the table; so do the massed objects, rather than the separate ones in the soupière still life. The painting is more conservative on all these counts. In all other respects the still life has the Cézannian character of tensions created and resolved. The jagged edges of the wallpaper pattern threaten to overwhelm the foreground, but are put in their place by the still stronger vertex at the bottom of the napkin; we are held firmly in the center - by the white cup and the saturated red apples as well - and kept in balance by the red-green complementaries.

**POTERIE, TASSE
ET FRUITS SUR
UNE NAPPE BLANCHE**

(R322), ca. 1877, 61 x 74 cm.
Metropolitan Museum of
Art, New York.

Volume 1, n° 135.

The year 1877 is also the year in which Cézanne rediscovers the device of opening up the mouth of his round containers, be they cups, jars, plates, or bowls as in *Nature morte à la soupière*. The oval is not merely opened; if it were, to the eye it would remain the ellipse that is it, only wider. It is also made more square, with the front edge generally becoming more straight and the two tight curves at the sides more open and awkward. The effect is actually complex: the top does seem tilted upward, as is often noted, with the canvas appearing more flat where this occurs, but the graceful ellipse that one expects also becomes bulky, allowing it to fit the other shapes of the composition better and compelling the eye to look more slowly. If Cézanne uses the device deliberately, he also uses it sparingly; in the Poterie painting he uses it only for the cup, as if to confirm its commanding position.

Fiasque, verre et poterie is a simpler picture, with a Manetian knife to add depth to the plane the objects sit on, and with a greater emphasis on light and color than on composition.

184 - *Carol Armstrong, in her* Cézanne in the Studio, *p. 54, reproduces such a still life - which, though not in the Louvre, illustrates Kalf's light and frontal conception.*

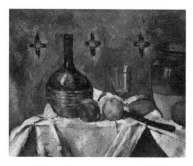

**FIASQUE, VERRE
ET POTERIE** (R326),
ca. 1877, 46 x 55 cm.
Guggenheim Museum,
New York.
Volume 1, n° 136.

**COMPOTIER
ET ASSIETTE
DE BISCUITS** (R325),
ca. 1877, 53 x 63 cm.
Private collection, Japan.
Volume 1, n° 137.

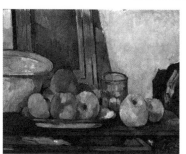

**NATURE MORTE
AU TIROIR OUVERT**
(R343), ca. 1878, 33 x 41 cm.
Private collection, Paris.
Volume 1, n° 138.

The wallpaper we have just seen takes on the color of the bread roll here, a rich, warm yellow-brown that contrasts with the crisp, blue-white tablecloth, while the green pot - greener here than previously - contends with a crimson apple. It is a thoughtful and pleasant painting, one that it is impossible not to feel a great deal of affection for, but it has an awkward problem with the wedges of the tablecloth and with the intersection of the tablecloth and the knife. It has a near-problem with the green-black flask, too, which could jump well forward of the other objects, but Cézanne has put a very dark blue into the crosses of the wallpaper, pushing them forward and pushing the flask backward, and has solved the problem.

In *Compotier et assiette de biscuits* he reintroduces a material vision of still life that had been so dear to Dutch painters - it is almost, but not quite, an after-dinner composition - but unlike them he makes the paint itself as tangible as the edible objects (and the inedible ones). The result is dense and lush, but rhythmical enough to resolve into a satisfying composition. To create one pattern across the whole canvas, for example, he restores the diamonds to the wallpaper and paints a strong diamond shape at the bottom of the cloth that connects to them; the top and bottom are now joined by repetition. He makes other connections as well. He links the cross in the top middle with the rightmost point of the tablecloth by a diagonal that leaps right through the fruit bowl; and he ties the foreground to the background by a progression of shallow steps, from the bottle to the tablecloth and from there to the massed apples to the wallpaper. With the weight of the painting on the right, he needs to lead us to the left, and uses the precarious bottle and the receding apples to do that. If in this painting Cézanne has chosen a dense grouping and thick handling, then he has also created connections that unify the canvas and rhythms that add grace.

If the still lives of 1877 are at times original in their handling, and at other times conservative, like the other paintings from that year they are united by the painter's dedication to the consistency of their surface. In one still life he pushes that consistency a step further and paints some of the objects with a touch that appears to be a bridge between the blockish style of 1877 and the parallel touch, which in my view would date it about 1878[185]; this gives us a glimpse of the next stage of Cézanne's thinking. In *Nature morte au tiroir ouvert* the background is a leaning mirror, which slides forward to meet an open drawer in the front; this gives the painting a space we have not encountered before, one that pushes out toward the viewer. The connection is interrupted, and the movement is slowed down, by the brilliant red apples. In the flat plane, the composition is significantly inclined toward the left, and it is to counter it that Cézanne employs the parallel touches, which go in the opposite direction; this is most obvious in the basin and just perceptible in some of the fruit. This kind of touch consolidates the composition rather than depicting objects, as in *Portrait de l'artiste au chapeau à large bord*, (p. 96) with which it can be compared. Distorted ovals can be seen here, too, transformed more deeply than in the *Poterie* still life and with a somewhat different purpose: they keep the space shallow. The front edge of the plate is flattened the most, because Cézanne needs to have it close to the edge of the commode, and the basin and glass are transformed least, being further back.

In trying to trace Cézanne's progression toward the parallel touch beyond this point, we are hampered by a roughness in the dating. At least the still lives assigned to 1877

185 - *In Rewald's catalog,* PPC, *the date given is 1877-79.*

are clearly connected by their scrupulous attention to surface, and several of them are also connected through the wallpaper in the background, which is a single pattern of diamonds from which Cézanne chose whatever he needed for each painting. One could wish that this would date them precisely, but Cézanne lived in the Paris apartment where we presume this paper lined the walls between late 1876 and early 1878, then went south, and returned to the apartment again briefly in the spring of 1879; this leaves an uncomfortably broad margin. But he spent most of 1879 in Melun, where we may have a more precise marker, a wallpaper pattern with leaves which enters the next series of still lives. Because the first full-sized still lives based on the small, dense, parallel touch appear with the later wallpaper, we at least have a plausible date – 1879 – for their beginnings. But we have no ending date for the previous styles; some still lives without the parallel touch also appear with the second wallpaper pattern (*Assiette à bord bleu et fruits, below*).

What also remains unclear is the dating of still life studies where the parallel touch appears, either partially or fully developed, but which have no wallpaper in the background. There are twenty of them, all small studies, and the ones with the parallel touch have been assigned dates as early as 1877 and as late as 1879. Because of their stylistic resemblance to the Melun still lives, however, and their exploratory character, it would be best to assume that they were done just before the Melun period or near its beginning – circa 1879.

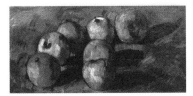

SEPT POMMES (R333), ca. 1879, 17 x 36 cm. Private collection, Japan. *Volume 1, n° 139.*

We can look at three of the studies to illustrate the technical matters that Cézanne addressed. *Sept pommes* is one of these; it relies on a parallel touch but seems primarily to address the question of organizing its fruits in space. It aligns its apples in a receding arc not unlike the one we saw in the Compotier painting, but it keeps them less crowded and distributes them from warm red ones in the front to cool green ones in the back; so it is not unlikely that Cézanne was testing out the spatial effects of the touch and this color progression. But if we look closely, we will see that he was also studying the transitions from one apple to the next: the lines separating them are generally thinner than the ones next to the table surface, bringing them close together into one mass. Contrasts of color appear where he needs a separation (red against green or yellow, for example), while identical colors appear where he needs the apples to remain close (green to green). Where, exceptionally, Cézanne uses a thin outline between an apple and the table surface, he changes the table to green to avoid too close a fusion. It is probably the finer technical question of exactly how the apples will behave in space, given all such variations in their points of overlap, that is the subject of this study; and the fruits of these labors, if the affectionate expression may be excused, will be seen most clearly in the great still lives of his last decade. The touch defines the sculptural planes of the apples and the flat surfaces of the shadows, but on the table surface it appears only as a kind of shorthand notation.

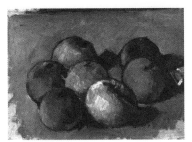

SEPT POMMES ET TUBE DE COULEUR (R332), ca. 1879, 17 x 24 cm. Musée Cantonal, Lausanne. *Volume 1, n° 142.*

In *Sept pommes et tube de couleur*, the parallel touch serves to manage a different task: giving movement to a static grouping of apples. Cézanne achieves this, I think, by opposing the parallel touch to the alignment of the apples in space; that is, while they progress toward the upper left, the touch points toward the upper right. They also separate progressively as they approach the right edge, finally to be drawn off by the tube of paint, and this gives us a welcome decompression to the right. The paint handling is slower and more elaborate than in the last picture (which makes it later, I believe); it is repeated with so much regularity that we welcome the diagonal slashes that cut across the touches just below the center. Boundaries

function quite differently here, helping hold the tight group of five apples together against the group of two; perhaps this calls attention to the loosening of space on the right, but we cannot be sure. Cézanne's exacting requirements are not always transparent, and when we cannot reconstruct them, we probably fail to grasp something that was important to him.

The third study is attributed to the Melun period because of its wallpaper - the bluish floral design with pendant leaves, about the size of apples. It fitted Cézanne's requirements nicely: the leaves would merge with the real fruit as nicely as they echoed Louis Guillaume's kerchief (p. 95). In *Assiette à bord bleu et fruits* Cézanne creates in essence a single grouping of real fruit and false leaves, and two of these leaves crown the fruit on the plate and make a hill-shaped mass - a very complete composition for so small a study.

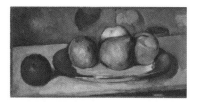

ASSIETTE À BORD BLEU ET FRUITS
(R356), ca. 1879-80, 19 x 38 cm. Národní Galerie, Prague.
Volume 1, n° 140.

But there is no parallel touch in *Assiette*, and if the painting is a study, then we need to ask what is it a study of. Only an intuitive and emotional response comes to mind, and it cannot be far off the mark: it is a study of color integration. The colors are so finely balanced here, in spite of their saturation, that the painting can only be about their affinities. We have just seen a color scheme that is balanced by simple opposition - reds against greens in the *Sept pommes* painting - but here we have two kinds of reds and a yellow, two greens, and a cobalt blue, all of which risk unforeseen clashes. To avoid having them pull away from each other, Cézanne models the fruit with colors borrowed subtly from neighboring fruits - a stratagem that becomes clear when we block out the odd colors.

If we obscure the green modeling on the red peach on the right and the yellow one at the back, the peaches pull away from the green pear dramatically; if we hide the two orange spots in the middle of the pear, leaving only the yellows and greens, the pear too pulls away from the peaches, although more subtly. To bring the three saturated fruits together, then (but not the central peach, which is already muted by blue-grey peach fuzz), Cézanne has had them borrow each other's hues. This achieves integration but not balance, however; an orange-green harmony by itself can be quite stuffy. We would be right to suspect that the unusually saturated cobalt blue is there to restore balance, and we can demonstrate this when we block it out: we produce a stuffy painting.

Even in so small a study there is the question of fitting the background and the plank into the scheme established by the fruits. Cézanne finds what seems a simple solution, building on the colors already present; he uses a blue-green for the background, for the table a light orange, and for the shadow cast by the plate an atypical green - atypical, but justified by its closeness to the green of the pear. He uses that same light orange, by the way, to give volume to the thin, horizontal format: he brings it down from the peach to the edge of plate for the highlight, and then even further, down to the bottom of the painting.

Spending so much time describing so small a study may seem odd, but it is necessary; it lets us follow Cézanne's technical solutions more clearly than in a more ambitious painting - and it is technical subtlety that creates the conviction of rightness and grave authority in Cézanne's work. In a sense, we can also be led to another aspect of his thinking: the question of when to rely on the parallel touch and when not. Having ourselves become immersed in the color problem, we can assume, I think, that when color relationships were this complex - and the passion for color this unrestrained -

the parallel touch would only distract; it would call attention to arrangement and composition and lead us away from the more passionate interrelations of color. It is quite likely that, when Cézanne reverted to a less systematic touch, he was protecting his attachment to color, as here, or the sitter's individuality and the ambient light, as in *the portrait of Louis Guillaume*.

And we can remind ourselves that if painting is a complex matter, Cézanne's painting is more so than most, and that a finished and fully resolved picture can hide only too successfully the work that went into making it. I am always suspicious of hyperbole, but the words of an early owner of one of the still lives from this period become plausible after we have looked intensely at Cézanne's studies: "*I saw Cézanne dwelling for a month on one apple and saying, getting up from his thirtieth session, that the work was not yet finished*[186]."

In this period, unlike his final decade, Cézanne does not rely on drawings and watercolors to rehearse this exacting work of integration, and produces very few of either. The drawings are generally studies of single objects[187], and they add little to the paintings to illuminate the development of his style. There is a carefully drawn cup (C347), nevertheless, that illustrates Cézanne's deliberate, thoughtful effort to achieve the compositional effect we see in the paintings. It is probably the same cup as in the *Poterie, tasse et fruits* picture (R322); it has the identical broadening of the lip and the flattening of its near edge. But because it stands alone, its purpose is puzzling; if the effect of broadening the lip is to control the depth of an entire composition, the effect cannot be seen in an isolated cup. Perhaps Cézanne wished to see just how much inconsistency his vision could tolerate between the distorted lip and the rings on the outside of the cup; but this is only a guess.

A CUP, CIVIL MARRIAGE CEREMONY (C347), ca. 1877-80, 13 x 22 cm. Mr. and Mrs. Leigh Block, Chicago.
Volume 1, n° 143.

POMMES ET TUBE DE COULEUR (RW109), ca. 1878, 11 x 19 cm. Private collection, Boston.
Volume 1, n° 141.

The one watercolor that clearly belongs to this period, a cognate of the *Sept pommes* picture, looks at the same problem of organization as the oil, but solves it differently. *Pommes et tube de couleur* brings together the same apples, and keeps the group dense on the left and open toward the right; but it places the tube in front, fully extended. With the point of view lower and the apples more crowded, here the full length of the tube is needed to create the movement to the right, and it is helped by the vague object in the right background. The touches - parallel only in the apples, where they define the planes of the spheres - are much more flexible: after the painter's hand has set down three or four touches in one color, it picks up another color and turns the touches in another direction, as if we were meant to attend an improvisation rather than listening critically to a finished piece.

Note on the development of the parallel touch

Cézanne's development of the parallel touch was, it is generally agreed, a signal achievement. It enabled him to compose his canvases with something akin to the intricacy of a fugue and, at the same time, to represent objects fully in their form, volume, color, and complex affinities. No painter before him had detached himself so radically from the textures of objects as we see them, and yet given us the sense that we are looking at the way things "really" are: more solid, more alive, more intimately a part of a trustworthy universe. We must not, however, look at the touch as an attained state, or a signature style, but rather view it as a process: as a means of achieving the

186 - *Eugène Murer, of Auvers-sur-Oise, who owned* Pommes et biscuits, R327. *Unpublished ms. cited in Rewald, PPC, vol. 1, p. 222.*
187 - *There is one arrangement of five apples on a plate (C351), drawn simply and precisely with a hard pencil on a page with figures drawn in a different style, but it does not address any clear compositional questions.*

painter's ends, a flexible means that would always be responsive to the character of what he was painting, and a means that would evolve further. The greatness of Cézanne's work does not depend on the parallel touch itself; many paintings done before it and even more after it are unquestioned masterpieces, and what sets them apart is something about their organization, their resolved tensions, their rich internal resonances – the sense they give us of nothing more needing to be said. But the parallel touch is, admittedly, both splendidly original and remarkably powerful, and if Cézanne had died in about 1885 we would have thought his life's work complete.

In looking at its early stages we had seen that its origins were complex and uneven. Because it developed in different genres at different times, it was not a mere stylistic change but an evolution in purpose. It developed in narrative pictures first, and in other genres later, and something about the nature of narratives propelled its development, while perhaps something about the nature of the others delayed it. We can now look at the sequence more closely.

A loose form of a detached touch appeared in the series of narrative pictures of country life that Rewald dates in 1876-77, of which *La Vie des champs* and *La Cueillette* were good examples (p. 73). It is not visible in *Trois baigneuses* (p. 76), which Rewald takes to be the contemporary, but if my dating of c.1875 is more plausible, then these baigneuses were earlier; if a later date seems better, then the least we can say is that the touch did not appear in all of Cézanne's narrative paintings at the same time. It is visible but not prominent in the 1877 *La Tentation de Saint Antoine* (p. 43), and then again it is fluid in form in the 1878 *Scène légendaire* (p. 79). But the touch does appear highly developed in the *Trois baigneuses* (R360, p. 76) that I think should be dated in 1877-78 (a year later than Rewald), and in *Baigneur aux bras écartés* that Rewald himself dates in 1877-78. Whatever imprecision there is in the dating, the touch seems to be well developed in several narrative paintings by about 1877-78.

But we must remember that 1877 was also the year of Cézanne's most consistent commitment to the canvas's unity so far, whatever the genre and whatever the specific touch that he may have invented. *The Portrait de Victor Chocquet assis* (p. 94) and *Madame Cézanne à la jupe rayée* (p. 94) were done in a consistently blockish touch, while *L'Etang des sœurs à Osny* (p. 88) was done in blocks of color laid down with the palette knife. If that is the year, at least approximately, of the appearance of the parallel touch in narrative paintings, then initially the parallel touch was used to give clear organization to paintings that had no structure in the visual world to rely on. In other words, the touch was at first Cézanne's way of giving form to the imagination[188].

We should also look at the matter in reverse, and ask why the touch came to landscapes and portraits only later. We did see an early, zigzag version of the touch in the foliage of a landscape from 1876 (*La Mer à l'Estaque*, p. 86), where it animated an otherwise calm composition, but it then disappeared in favor of other ways of organizing the surface. It reappeared in a simple form only in 1878-79 in *La Baie de l'Estaque vue de l'est* and *La Montagne Sainte-Victoire et le Pilon du Roi* (pp. 89 - 90). I am persuaded that painting

188 - Lawrence Gowing, in his essay, "Notes on the development of Cézanne" (The Burlington Magazine, 1956, vol. 98, pp. 185-192) seems both to agree and to disagree. He presents the most cogent account we have of the progression of Cézanne's styles and of their dates. But he implies that the styles characterize all, or most, of the work of a given period; references to "the style of 1877", "the style of 1886", and many others, inform the essay. The parallel touch, on this assumption, would have developed after "the style of 1877" and before the parallel-touch still lives of 1879, which would place it in 1878, during an unhappy year spent in Aix and l'Estaque. It is difficult to agree with such narrow dating, and with the implication that a style is akin to handwriting. But he also anticipates my discussion when he writes that "Possibly the parallel touch was used initially to enforce a pictorial unity in the absence of the direct sensations on which the painter was accustomed to depend" - a conclusion with which I agree, and which requires, I think, the broader span of time and the more independent strands that I have tried to weave together.

from vision, far from requiring the touch or encouraging it, in fact inhibited it. Landscapes at first may have seemed too complex to submit to its discipline, while the face of a sitter would be too individual to submit to its abstract regularity (although in 1877, exceptionally, Cézanne could treat the whole figure abstractly with the blockish touch); perhaps that is why the parallel touch appears as late as 1879-80 in *Portrait de l'artiste au chapeau à large bord* (p. 96), and why, as we shall see, it was used in portraits only for a short time. In brief, it seems that Cézanne's intense response to what he studied directly, as against what he imagined, competed with this analytic device, and did so for perhaps two years[189].

Still lives seem to have stood halfway between the narrative paintings and the landscapes and portraits. In small studies, the touch appeared as early as about 1877, by Rewald's dating, or at least by about 1878 in the ones we looked at: *Sept pommes* and *Sept pommes et tube de couleur* (p. 101). But if this dating is plausible, it raises an obvious question: why would the still lives have offered less visual resistance to its development than landscapes and portraits? Here I can only offer another supposition. Many of the still lives were studies in the proper sense, that is, small-scale exercises, and in them Cézanne would concentrate on technique: on testing how this new touch might make the simplest possible object - the spherical apple - both complex and interesting, on giving it a dynamic orientation on the canvas surface, and on finding ways to join it to other apples. Having succeeded on this small scale, he could then take the more difficult step of connecting the apples to other objects and to the composition as a whole. By then, however, in 1879 or 1880, during his stay in Melun, he would be seeing these possibilities in landscapes as well.

By setting short, straight strokes next to each other, at first only in parts of the canvas, Cézanne accomplished various purposes in different paintings, and it was not until he grasped that the aims could all be satisfied at once by having the touch inform the whole canvas that we can speak of the parallel touch proper. The year spent in Melun seems to have been the time when he brought these strands together, and it marks the beginning of a period when the touch became his principal way of organizing the surface, representing things, and, as he himself said, seeing reality ■

189 - *Reff has proposed that Cézanne developed the touch to help him gain control over his poorly modulated impulses (Theodore Reff, "Cézanne's constructive stroke", The Art Quarterly, 1962, pp. 214-226). He based his argument on its early appearance in L'éternel féminin (p. 79) and La tentation de Saint-Antoine (the third version, p. 78), both of which are pictures of sexual celebration or temptation. But the argument also rested on dating L'éternel féminin as early as 1875, that is, on placing this sexually charged picture well ahead of more neutral ones, and this now seems to be five years too early. I agree with Reff that it was important for Cézanne to achieve mastery over fantasy in his paintings; I implied a similar process when I emphasized, for example, Cézanne's ironic stance toward his material. The question is, however, whether the parallel touch was part of that mastery, or whether the touch developed in response to something more purely visual, such as the need for pictorial coherence. I think it is the latter; the parallel touch, in every case where it is laid down systematically rather than in a gestural way, has a clear function in the composition.*

1880–1884

The eye and the mind: the parallel touch

Every particle is set moving to the same all-pervading rhythm[190].

Cézanne in about 1875.

190 - Fry, p. 75.

It seems a paradox that a touch that was developed for giving form to the imagination should, in just a few years, become better suited to analyze vision. Naturally, in its fully developed phase, it always had to serve the needs of the composition, whatever its subject; it would be expected to organize the painting's surface and guide the viewer's gaze. By about 1880, however, to judge by the whole oeuvre of that year, Cézanne seemed to expect it to let him "see" all motifs in its terms. For a time, given the import of his discovery, this was not unreasonable; but some subjects turned out to be less well suited to the touch than others, and there Cézanne gave up the touch early. It served best and longest in landscape - from its first confident use in 1879 or 1880 to its culmination in the intricate compositions of about 1884. In still lives, it served for a shorter time, admittedly helping integrate the surfaces of a number of masterpieces, but it was far from indispensable. In portraits it served him only occasionally, because its analytic divisions conflicted with the smooth planes of the face and head; only for his own head and that of his son would Cézanne make exceptions. So in reality, during the five years that Cézanne used it, the touch did not translate all kinds of vision equally: as we shall see, looking through its prism at a landscape turned out to be different from looking at a still life or a person's head.

The touch lost its promise most quickly in the genre with which it had started: in narrative compositions. After 1880 it appears in only two large paintings, *Léda au cygne* (p. 110) and *Cinq baigneuses* (p. 112); then it gives way to a looser touch. (In any case, he painted fewer narrative paintings in relation to those based on observation than before.) It was the human body that resisted the parallel touch first, and then inevitably the leafy backgrounds followed; they soon regained the impulsiveness they had in the narrative paintings of 1876. If this half-decade was dominated by the parallel touch, it was because it was dominated by landscape; as against the fourteen or so narrative pictures, twenty portraits, and thirty still lives, there were over ninety landscapes - more than the total of the other three.

Cézanne's words about the touch, from a later time, when he recalled that it had been his petite sensation, his way of seeing things (one that Gauguin had "stolen" from him, as he remembered it), may have been intended to refer to vision as a whole, but implicitly they leaned toward landscape. Still later, when he said that he "saw" nature by means of his late style - the colored patches following a law of harmony[191] - he referred to landscape only: it was landscapes that the patches represented best. Both statements are useful metaphors for imagining the painter at work - choosing a site and anticipating how he will handle it - but they are not precise descriptions of vision itself. Vision is in fact independent, and Cézanne admitted as much when, in the same document, he described vision as working together with thought:

> "There are two things in the painter, the eye and the mind; each of them should aid the other. One must work at their mutual development, in the eye by looking at nature, in the mind by the logic of organized sensations, which provides the means of expression[192]."

A given touch is therefore a thoughtful response to vision, and vision is ultimately a partner who constrains the kind of touch with which she will work.

191 - "To read nature is to see her under a veil of interpretation by colored patches, which follow one another according to a law of harmony." This is one of the "opinions" on art that the young Emile Bernard collated in 1904 from conversations he had had with Cézanne, and from statements he had extracted from his letters, which reflect what Cézanne had said and written. They may be found in the original in P. M. Doran, Conversations avec Cézanne, Paris: Macula, 1978, pp. 36-37 (here in my translation), and in the English version on pp. 38-40. The complaint about Gauguin was quoted by the critic Geffroy, and an abstract from his 1894 article in which this is reported appears in the same book, pp. 2-4.

192 - Conversations avec Cézanne, p. 36, my translation. See also Lawrence Gowing's use of this phrase in interpreting Cézanne's middle and late work, published in William Rubin, ed., Cézanne: the late work, New York: Museum of Modern Art, 1977, and in the English edition of Doran's Conversations.

Nevertheless, the period covered by this chapter is generally identified with the parallel touch and with little else. This, too, is understandable; the touch was a momentous development, and Cézanne's life, as glimpsed in his letters, is relatively uneventful. The touch seems to evolve from an inner necessity rather than from any developments in his life, and so does his reliance on it in the years that follow. Although he maintained contact with other painters, with one minor exception they seem not to have influenced the use of the touch[193]. He painted with Pissarro in 1881 and 1882, met Gauguin through him in 1881, and painted with Monticelli and Renoir in 1882 (and nursed Renoir during his bout with pneumonia – an affectionate act that deserves more notice than it generally receives[194]). There is also a record of visits from Monet and Renoir in 1883. Apart from these contacts, he worked in isolation, and the firm structure of his work, even when it does not depend on the parallel touch, is evidence, if any more be needed, of his irrevocable movement away from Impressionism.

At the beginning of this period, his work was done in and around Paris, but from the mid-point on it was done in the South. His stay in the North included the fertile year in Melun, followed by a year and a half in Paris and Pontoise, but then except for another eight months spent in the North in 1882, all his time was spent in Aix and nearby l'Estaque. Because landscape is so crucial in his work during these years, his whereabouts are more important to note than usual; his response to the clear, "terrifying" light and intense colors of the south, which he had written about already in 1876, was itself intense, and there his parallel touch reached its highest point of development.

NARRATIVE PAINTINGS

Cézanne's narrative interests, displaced as they were by his devotion to landscape, also became narrower in subject and much less emotionally intense. Beside painting bathers in groups, and doing individual studies for them, Cézanne turned his imagination to only two themes of any pungency – Léda and the swan, and the struggle of love – and, by about 1880, treated them rather stiffly (although a year or so earlier he had done one of the themes with surprising deftness). It is hard to discern a connection between the touch and his narrative subjects, and even harder to form a sense of their stylistic progression; and for reasons that are unclear to me, a gap is presumed in the narrative paintings between 1882 and 1887, filled – with no certainty about their dating – by only two pictures.

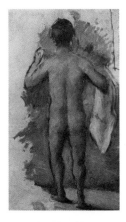

**BAIGNEUR DEBOUT,
VU DE DOS** (R.453),
ca. 1879-82, 28 x 17 cm.
Art Museum Princeton
University.
Volume 1, n° 144.

We respond to the pictures individually, I think, not as a developing series. Some are loose in touch, others tight; some reveal a plausible purpose behind the direction of the touch, while others do not. *Baigneur debout, vu de dos*, is one of the freely painted ones; it has an unusually fresh and convincing surface, and the pose turns out ultimately to be very useful. If the pose was modeled on another work, among which Signorelli's drawing *The Living Carrying the Dead* seems the most likely[195], it shows Cézanne remarkably at ease with his brush, scumbling where he needs to fill space and modeling

193 - *In about 1889, he painted a view of the Mont Sainte-Victoire* **(p. 254)** *that seems affected by Renoir's version of the same motif, dated 1889: it is the only painting in which his touch is uncharacteristically woolly.*
194 - *In 1882 Renoir wrote about this to Chocquet: "I can't tell you how nice Cézanne was to me. He wanted to bring me his entire house. We're doing a great farewell dinner at his house with his mother because he has to return to Paris. …Madame Cézanne made me a brandade of salt cod which is I think the ambrosia of the gods rediscovered." Rewald,* Correspondance, *p. 209, my translation.*
195 - *The head is larger, however, and the legs shorter, so the model is by no means certain; on the other hand, one other study and most of the figures in the full compositions have smaller heads and longer legs again. As with the many drawing of this figure, Cézanne may have used his own figures as models after initial studies of the Signorelli; and in the compositions he might have varied the proportions to fit the dimensions of the painting or the size of the surrounding scenery.*

carefully but naturally around the back, arms, and legs. Here he uses the touch unself-consciously and comfortably, and nothing we know about him helps explain why he is comfortable in this painting but not in another; I have in mind a contemporary study of the same figure (R452). But he did use the pose in ten or so compositions of male bathers, and also made twenty drawings of it, which are themselves free in execution; they raise only the question – without suggesting an answer – of why there should be a full twenty of them.

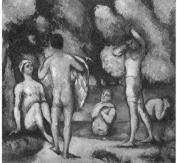

CINQ BAIGNEURS
(R448), ca. 1879-80,
35 x 38 cm. Detroit
Institute of Arts.
Volume 1, n° 145.

In *Cinq baigneurs* the same figure stands facing a seated bather, suggesting a conversation between two men who have already bathed, while two others are still splashing themselves or stretching. I propose this scenario not because I believe that it explains what is going on, but because it is not implausible, and because I wish to call attention to what I believe Cézanne needed: a vague narrative to justify what is essentially a carefully composed arrangement. The standing figures alternate with the ones seated or bathing, and the one stretching is placed slightly higher, with the point of his elbow creating a summit – here extended by the clouds of foliage which run alongside it. The parallel touch is used only in the background, and seems to have no other purpose than to give the canvas a measure of order; it is a degree of order that Cézanne will soon find unnecessary.

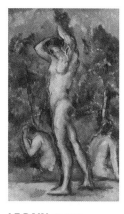

LE BAIN (R451),
ca. 1880-82, 35 x 22 cm.
Private collection,
Switzerland.
Volume 1, n° 147.

In the presumably contemporary *Le Bain*, however, the touch – although again confined to the background – is connected closely to the movements of the figures and as a result adds a much welcome nervous vitality to the picture. Just as the torso of the standing figure splays upward, and the two bathers in the water splay away from each other, so the touch points diagonally, left or right. In this way, without representing anything specific, it creates a sense of wholeness, as if the various parts of the picture were bound together by necessity, and we welcome the unity the more, the harder Cézanne found it to achieve elsewhere. The colors, too, connect the figures with the ground, and the juxtaposition of the various pink and orange skin tones against the greens and saturated cobalt blues is felicitous. The standing figure is one of two studies for the figure with upraised elbow that we have seen already and will see again in bather pictures fifteen years later.

In attempting to date a picture, I have argued that mere resemblance to a known touch is insufficient, especially when we look at isolated qualities such as lightness, straightness, or density. But I would have much less hesitation in dating a touch by its use in a composition, and therefore agree that *Léda au cygne* is appropriately dated c.1880 by its resemblance to still lives of the 1879-80 period. In them, the touch is made to carry the full burden of representation, balance, and consistency of surface. It is laid down in one predominant direction (except where it would run parallel to a limb), as in the contemporary *Nature morte au compotier* which we shall see later in this chapter, and is used pointedly to give an analytic, faceted shape to what is normally smooth. It contributes only minimally to the interplay of forms on the canvas, and is perhaps a shade too severe. Here, it contrasts, sometimes in an odd way, with the sensuous twists and oppositions of the sinuous curves: with the swan's neck, the modest cloth, and the line from the head to the left elbow. These curving shapes all oppose Léda's torso, her left forearm, and the hair that caresses the breast, but the parallel touch is irrelevant to them; it offers almost too rational an opposition to the sensuous shapes and to the swan's possessive grasp of the wrist. It does model the torso successfully, giving us no impediment to reconstructing Léda's voluptuous form, and it does oppose some perfectly chosen blue-green tones to the rich variety of flesh tones (which Ingres used as underpaint, and Cézanne uses

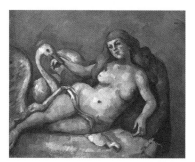

LÉDA AU CYGNE
(R447), ca. 1880, 59 x 74 cm.
Barnes Foundation,
Merion, PA.
Volume 1, n° 146.

as the final surface), but it also seems too intellectually conceived. The painter's sensuousness is ultimately invested in the luminousness of the body against the blues and greens of the ground, an incandescence that is even clearer in the original than in the reproduction.

But the touch cannot guarantee every transposition of a sensuous subject into luminous of color; sensuous movement, for example, is more readily rendered in curved outlines than in short hatchings. Cézanne gives us a very clear example of this in his two ways of handling the same subject, a scene with eight figures locked in a *lutte d'amour*, pressing their case or resisting. In the earlier version[196], a loose touch - reminiscent of paintings done at the end of the previous decade - creates an almost happy bacchanale, and its playful quality in no way inhibits him from arranging the figures in a firm, convincing composition (a forceful, angular and symmetrical "W"). The curved touch creates a fleecy surface that comes close to suggesting a dalliance (one that even the frisky dog finds interesting) - a dalliance that almost succeeds in evoking the light subjects of Watteau. A more rigid touch could only congeal the picture, one feels, and indeed the later version of the picture, painted with the parallel touch, does just that. What was suggestion in the first version becomes a statement in the second; what might have been a dalliance is now a struggle. The composition is now tightly integrated, with the touch in the earth and sky seconding the figures' movements, but

there seems little escape into lightness, humor, or ambiguity. It is not only the touch that creates the new atmosphere - Cézanne makes the figures relatively large, uses ominous blacks, and transforms the dog into a formless mass that fuses with one of the resisting women - but it does make the ultimate contribution. And it is perhaps just this kind of unintended ambience that pushed Cézanne into abandoning the touch in his narrative paintings.

If one of Cézanne's lifelong aims was to paint like the Venetians, which for him meant painting sensual scenes with the masterly Venetian realization in form and color[197], he made what seems to me a detour in submitting his narrative pictures to the severe discipline of the parallel touch. He did come close to his goal with the late *Grandes Baigneuses* - not in their subject but in their generous size and sensuous color[197] - but with the smaller bather pictures he only achieved the drama he sought, and the gracefulness he admired, when he sketched; when, that is, he could forget about the eventual surface. At least that is what is suggested by his small pictures such as *Baigneurs et baigneuses*, also dated near the beginning of the decade. It brings

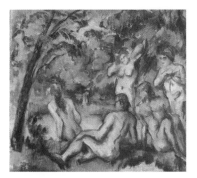

men and women together - a rare event in his work - and it gives them an appropriate degree of tension: the men obviously admire the back of the woman entering the water. The composition is unforced but perfectly satisfying, requiring no culminating point or repetitive angles, but instead distributing the bathers naturally: the admired woman is set apart from the group of four, balancing them by her isolation and serving all the better as the object of their gaze. Not only are the five figures grouped credibly, but as individuals they are also rendered convincingly. At no point do we inquire about the touch; it is whatever the surface - skin or foliage - suggests.

196 - *Entitled* La Lutte d'amour, II *by Rewald, who thought it was later than his number I. See his* PPC, *vol. 1, p. 306, for his arguments, as well as Gowing's arguments to the contrary. Gowing's reasoning seems more persuasive to me.*
197 - *See, for example, Bernard's report in* Conversations avec Cézanne, *p. 57, ("Réaliser! Comme les Vénitiens,") or Rivière and Schnerb's article, pp. 89-91, or Gasquet's, p. 129 ("Je n'aime que Rubens, Poussin et les Vénitiens"). The Venetians he would have seen in the Louvre with Gasquet in 1898 include Giorgione, Titian, Tintoretto, and Veronese, and Gasquet reports him admiring something about all four. We have already looked at the indirect derivation of his L'Orgie from Veronese's Les noces de Cana in Chapter 1.*

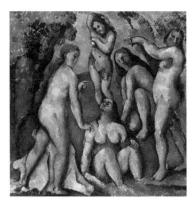

CINQ BAIGNEUSES
(R554), ca. 1882,
65 x 65 cm.
Kunstmuseum, Basel.
Volume 1, n° 152.

But in *Cinq baigneuses*, Cézanne moves away from the Venetians once again. I confess a deep admiration for what looks like his willingness to see a conception through to its logical end, that is, to concentrate on the roundness, rhythm, and density of the bathers' forms, disciplined by the parallel touch. This thoughtful painting once again emphasizes formal composition (a composition fully worked out ahead of time in a complete sketch, C517), and it underscores the formality with pale, unsaturated color: the figures seem more sculpted than painted. One can fully agree with Fry, who explained his reservations about the pictorial design by saying that "it would at least make a remarkable sculptural relief"[198].

Cinq baigneuses cannot be dated precisely, but at least thanks to the intellectual use of its touch it belongs clearly to the period covered by this chapter[199]. We are also safe in noting that by about 1887, two years after the relaxation of the touch, Cézanne's bathers once again took on color, tension, and sensuousness, although not necessarily all three qualities at once. What we can say about this half-decade is that when the touch was used rigidly in the narrative pictures, it inhibited their expressiveness. Whether Cézanne had momentarily abandoned the goal of painting like the Venetians in favor of some other goal, or simply let himself be led elsewhere by his touch, I cannot say.

If in the narrative paintings of this half-decade Cézanne's touch was at times parallel and at times not, in the drawings it could not be described as parallel at all. The natural trace of the pencil is line, and it is line that represents the contour of the body and gives it expression and movement; hatchings of one form or another are necessary to give the body volume and indicate the negative spaces, but they work only by exclusion, that is, when blank spaces are left for the highlights. For this reason it makes little sense to apply a term such as the parallel touch to them. The work of making a convincing drawing of the body requires skill in proportion and outline and whatever discipline one wishes to bring to the shading; in this we shall see Cézanne gaining increasing consistency and mastery - a development that is distinct from the imposition of a consistent touch.

There are, in fact, two kinds of drawings, each with its own purpose and therefore with its own quality of line: those done after prints and sculptures, which represent volume by a careful application of hatchings and are the more closely studied, and those conceived from imagination, which are sketchier and rely on repeated outlines for volume. The former translate vision while the latter emphasize expression; and although both can be used as studies for paintings, with the former the effect is indirect - a figure may be inserted into a later composition - while with the latter it is direct: for the most part, they are preparatory studies.

Of the drawings, the studies done from sculptures tell us more about Cézanne's use of the pencil to represent light and volume than the quick sketches. Admittedly, sculptures present the artist with an established composition and a monochrome surface, but this could be either a drawback or a challenge, and for Cézanne it was the latter[200]. His drawing, *After Puget: Perseus rescuing Andromeda*, done like so many other drawings from the sculpture in the Louvre, has the full force of the driving diagonals of the

198 - Fry, Cézanne: A study of his development, p. 81.

199 - Rewald dates the painting c.1885, while Chappuis dates the sketch it 1879-82. It is unlikely that both are right; arguing for an earlier date than 1885 would be the unyielding parallel touch, but that in itself is inconclusive.

200 - Gowing sees the sequences of forms in Baroque sculptures as requiring the same faculty as the sequences of color that Cézanne set down in his paintings. Although he is discussing Cézanne's late work, the argument applies to the drawings of the present period as well; they reveal similar concerns for rhythm and sequence. ("The Logic of Organized Sensations", In William Rubin, ed., Cézanne: The late work).

AFTER PUGET: PERSEUS RESCUING ANDROMEDA (C499), ca. 1879-82, 47 x 31 cm. Present whereabouts unknown. *Volume 1, n° 154.*

original, its interlocked limbs, but above all a firm sense of space achieved by an unhesitating outline and a disciplined use of hatchings. The hatchings model the convexities of the body and the hollow spaces with equal precision, and we need no key to read them at once.

A comparison with any one of the drawings based on imagination shows us immediately that translating vision and giving expression to fantasy are different matters. In imaginative drawings Cézanne uses outline to express roundness and suggest fullness, and he uses it repeatedly, both to emphasize and to approximate; in Women bathers in a landscape, for example, he makes the bodies all the more sensuous by drawing them with unhesitating curved lines, and all the more playful by repeating the lines so that the bathers never settle down to a fixed position. Hatchings do none of the work of modeling; instead, they suggest vague foliage, provide a generic background, and locate the figures in space. Because the two kinds of drawing are so different, they cannot be compared; where the studies after sculpture are self-assured[201], the narrative drawings are imprecise, but also vigorous and dramatic.

WOMEN BATHERS IN A LANDSCAPE (C650), ca. 1883-86, 13 x 22 cm. Mrs. Enid A. Haupt, New York. *Volume 1, n° 153.*

The few narrative watercolors of this period are equally expressive, and in purpose nearly interchangeable with the drawings (and some are, in fact, only drawings with touches of watercolor added). Only two are done after other works of art - *La Médée, d'après Delacroix* (RW145), and *Caracalla, d'après l'antique* (RW146) - and another one may have been done from the model; all the others are studies for the kinds of bather paintings we have seen or for narrative paintings that were never painted. The majority, the properly narrative ones, are therefore similarly quick and unstudied in their technique. What is significant is that four of them, all variants of the Olympia theme, are more overtly erotic than any drawings; it is as if the freedom and softness of the sable brush did more to disinhibit Cézanne's hand than the precision of the pencil or the stiffness of the oil brush.

LA TOILETTE DE LA COURTISANE (RW137), ca. 1880, 15 x 19 cm. Waddington Galleries, London. *Volume 1, n° 150.*

La Toilette de la courtisane is one of these watercolors; it is a small, intimate drawing, done very freely both in the outlines of the three figures and in the study for what would be very sensuous drapery. In loose touches that are designed to convey a balancing diagonal in the red curtain and a stable vertical in the blue-green one, Cézanne indicates the intended richness: warm and cool reds in the one and blues and greens in the other. As formally as the drapery might have been treated had it been done in oil, and as distracting as its sensuousness might have been, it would not have masked the unashamedly voyeuristic subject: a client watching the woman being prepared for him.

In his narrative work during this half-decade, then, Cézanne was curiously divided: technically the most free in the watercolors, where he was also the most emotionally absorbed, and the most systematic and even repetitive in the oils, where he tried to bend the material to the discipline of the parallel touch. With the later relaxation of the touch the two extremes could be brought closer together, but only somewhat; as we shall see now and in later chapters, his touch was the most thoughtful and convincing when giving form to observation.

201 - *Exceptions to this are few, but they include the nine studies of* Venus de Milo *done between the mid-seventies and the mid-eighties. Her sensuous torso and idealized proportions seem to elude Cézanne, and he returns to his subject each time with a somewhat different, and not invariably graceful, result.*

LANDSCAPES

In landscapes the question of reconciling the unity of the painting with vision was always more acute than in portraits and still lives; there was more to represent, more to compose, more to subsume under a single system of notation - more to reconcile. Cézanne's turn toward landscapes at the expense of narrative pictures signaled a firmer attachment to observation, and his unceasing attempts to translate the structure of his motifs into the parallel touch were part of that attachment.

Although Cézanne began to use parallel notations for foliage as early as 1878 in the landscapes in the South - in Aix and in l'Estaque - it is in 1879, in Melun, that he gave the touch its clear structural purpose. The Melun landscapes can be dated from the recognizable sites, and those from the Paris region, including Pontoise, must be either from just before (March 1879) or just after (March 1880 to October 1881). It is in the following years that the dating difficulties begin, with Cézanne in the South from November 1881 to March 1882 and from October 1882 to May 1885 (the period once again in the North, from March to October 1882, is easier to date). This is too long a period within which to assign dates, and the best way to discuss them is to group them in clusters by the way they use the parallel touch and try to form an approximate sense of their evolution. This rougher kind of grouping is in fact an advantage, because it keeps our attention focused on the work and its meaning; a sensible progression emerges in any case, one that culminates in the most closely interwoven landscapes such as the 1883-84 *Maisons en Provence* (p. 121) and *Les Grands arbres au Jas de Bouffan* (p. 122).

Like all formal terms, "structural purpose" has an intuitive ring and unclear boundaries, because it is difficult to think of any dab of paint that Cézanne might set down - or set down after a quick, initial lay-in - as having no compositional purpose whatever. Horizontal touches for a body of water, as in *La Baie de l'Estaque vue de l'est* (p. 89), serve a double purpose, to represent the surface of the water and to contribute to the picture's stability - and the latter makes the touches in part structural. It is when a touch is related to the actual textures only arbitrarily, as in the vertical green notations for the foliage, that its purpose becomes purely structural; and it is when a whole painting depends on the interplay of the various directions the touch takes that we see the structural purpose fully realized. In landscape, that is the logic of Cézanne's development during these five years.

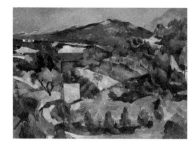

**MONTAGNES
EN PROVENCE
(près de l'Estaque ?)**
(R391), ca. 1879, 54 x 72 cm.
National Museum of Wales,
Cardiff.

Volume 1, n° 156.

A landscape from the South takes us to the beginning - to an interplay of representation and the full parallel touch. In *Montagnes en Provence (près de l'Estaque?)* the touch resembles the one in the somewhat earlier *La baie de l'Estaque vue de l'est* (p. 89) in the horizontals for the water, verticals for the trees, and diagonals for the ground. But the diagonal touches are more variable here, inclined as they are in both directions, and they seem to have a harder time settling down. The problem is actually in the motif: although it has a clear focus with which the artist can begin - the gentle slope of the roof and its exact echo in the mountain - it quickly becomes complicated, presenting the painter with a dense series of shallow diagonals in the cuts and hillocks of the middle ground. He represents them with various slanted touches and tries to manage them structurally with calming verticals. While it is the mixture of depiction and management that seems nervous, it is in fact the site that is unsettled, and Cézanne's struggle with it seems to me thoughtful and mostly successful. Even judged by his later standards it is firm in its purpose, forceful in its colors and touches, and well resolved in the interplay of its elements[202].

SOUS-BOIS (R376),
ca. 1879, 55 x 46 cm.
Lady Keynes, London.
Volume 1, n° 157.

Only a short time later, in the Melun period, Cézanne relies on a similar strategy to resolve the problems presented by a quite different motif. In *Sous-bois* he is faced with a hillside that dominates the largest part of his composition and will have to be balanced against all the smaller elements. Having chosen a touch that runs parallel to the hill, which depicts its slope unambiguously, he finds it running diagonally across a full half of the picture; this makes the hill so heavy that it needs to be balanced at once - which he does here by emphasizing a number of bare branches which all point in a direction opposed to the hillside[203]. Once he has achieved a near balance of diagonals, there is no purpose in complicating matters further, and he leaves all the other touches - except the irregular ones for the sky - vertical; the vertical autumn foliage then steadies the competing diagonals. But these touches do a bit more: they are grouped in sloping sets which run parallel with the branches, turning the entire leafy area into a counterpoise for the hillside as well. The composition becomes balanced, but in comparison with the work he would do within another year or two its equilibrium is perhaps too labored.

It is not necessarily an inexperienced touch or an undeveloped vision that can cause difficulties with realizing a landscape picture; a painter can choose a difficult site to see if he can handle it, or the site may simply not fit his vision, and he may then have to remain content with having done the best he could. It is in fact the opposite that would be worrisome: an invariably competent handling of whatever came one's way - which would be an indication of boredom, of repetition, of having nothing but one's formula to contribute to the world. This not something that Cézanne can be accused of, and the courage to tackle the new is a quality that, like Fry, I value highly: Cézanne seems always to be fully open to the challenge of each site and deeply engaged in realizing it in paint.

GROUPE DE MAISONS, PAYSAGE D'ILE DE FRANCE (R401),
ca. 1879-80, 46 x 55 cm.
Ashmolean Museum, Oxford.
Volume 1, n° 155.

A site may, on the contrary, present no difficulties whatever. I suspect that may have been the case with the northern motif that came to be realized as *Groupe de maisons, paysage d'Ile de France*. The ground at the left edge slopes down at the same angle as most of the roofs, the two providing a consistency and rhythm of movement that needs very little work to be balanced. The parallel touch is admirably suited to this: without labor or emphasis, the work is done with a few diagonal touches in the trees and a few rougher ones in the distant hill. So important is this balance to the picture that Cézanne elaborates the middle ground, where the sharpest interplays occur, with repeated applications of paint; but he does not smear them - not there - retaining instead their distinct hues and values and keeping their rhythms clear.

Perhaps no use of the parallel touch is more satisfying during its early years than when it integrates a mass of enveloping foliage with a simple masonry framework, as it does in *Le pont de Maincy*. I confess to a particular closeness to this painting, and have written about it already, but in the present context the achievements of its touch seem all the more clear. Thanks to a photograph, we know the givens that Cézanne worked with: a nearly symmetrical composition, an opposition between dark greens and warm pinks, some vertical tree trunks, and an unruly profusion of leaves. It is a lovely site - on the outskirts of Melun, at Trois Moulins, and therefore dated easily - and yet when photographed it makes no more than a happy postcard; the painting,

202 - *Its first owner and admirer was Gauguin, who wrote in 1883 that it was "unfinished and very advanced", and added, "It believe, quite simply, that it is a wonder." (Rewald,* PPC, *vol. 1 pp. 259-260)*
203 - *I have no doubt that the branches were there, and that they suggested the final balance to the painter, but I am persuaded that to balance the picture more work was needed here than with most other sites.*

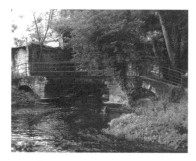

LE PONT DE MAINCY
(R436), ca. 1879-80,
60 x 73 cm.
Musée d'Orsay,
Paris. *Volume 1, n° 158.*

LA CÔTE DU GALET A
PONTOISE (R410),
ca. 1879-81, 60 x 73 cm.
Private collection, Japan.
Volume 1, n° 160.

L'HERMITAGE
À PONTOISE (R484),
ca. 1881, 47 x 56 cm.
Von der Heydt Museum,
Wuppertal.
Volume 1, n° 159.

on the other hand, joins everything together in a resonant unity. It not only aligns the scraggly branches with the bridge supports, but it groups the parallel notations for the leaves - with particular care in the upper center - in a way that makes them, too, participate in the picture's rhythms.

That some of the touches should be literal and others abstract seems inevitable here; this is a site that requires the interplay of the actual and the arranged. Cézanne, in fact, devotes even more thought to the space in the picture than to the leaves. Having painted the bridge parallel to the picture plane - more parallel than it appeared from where he stood - but needing to push the left supporting arch further back, he must use the tree to divide the bridge; now part of it can be in the picture plane and another part can recede, and the painting becomes both a flat physical object and a scene in real space.

If the touch in the *Maincy* picture seems like a natural elaboration of an already structured site, in the contemporary *La Côte du Galet à Pontoise* it looks more like the dominant force. Here, it allows Cézanne to paint a grand panorama not as a scene but as a tightly woven fabric of similar-sized patches, each equally clear, each of the same weight. There is, in fact, some difference in weight, but it is reversed: the houses in the distance, red and clearly bounded, push back toward us rather than remaining in the background. They draw our attention to the top, to a palpable location in space. Thanks to this emphasis, Cézanne's tapestry of brushstrokes remains perfectly legible: the density of the surface is leavened by our being able to follow clearly the ins and outs of the painting's space. We look between the poplars and catch a clear glimpse of the houses at the bottom of the valley, or we follow the road as it leads us toward the top; in either case the sense of space alternates with the cadence of the surface. That the touch does not always work this well in other landscapes confirms that it was far from a spontaneous movement of the hand: it worked or not depending on the givens of the site and Cézanne's patient, labored, response to them.

In 1880 and 1881 Cézanne paints several landscapes with a thickened, still more regular touch; one is from a visit at Zola's in Médan and several are from the time spent with Pissarro in Pontoise. The thicker touch is clearly a later development, although it alternates readily with other touches, and its first form is systematic, even rigid, in comparison with still later ones. In *L'Hermitage à Pontoise*, below, the touch is vertical and horizontal in all areas except the roofs. An interplay of static and dynamic touches, when used with less well ordered motifs, would be playful and quirky, but with a motif such as this one it risks becoming a grid. Cézanne stood in the middle of a narrow path between the vegetable beds and allowed it to rise seemingly straight up; this was unlike Pissarro, who had painted the site in 1867, who stood from a few feet to the left and created greater depth. Cézanne then flattened the picture plane further by painting the path equal in width throughout, and, again unlike Pissarro, he kept the edges of the roofs close to the horizontal, painting them almost as a flat backdrop. Only the diagonal that starts in the lower left and rises through the little black roof suggests movement, and only the decorative interplay of the roofs suggests rhythm; our gaze can focus on the cluster of houses, where the space is dense and articulated.

Skirting this closely to flatness is an impulse that passes; Cézanne's compositions are normally less formal and his touch less stiff. In the same year, in 1881, he in fact adopts

a very informal, curved touch to paint two pictures in the Pontoise region, which give him a very fresh surface – and perhaps, since there are only two, move him farther from formal unity than he would wish. They both rely on a clear focus in the center and a loose pattern of detached, fleecy touches that weave around it, and the result is deceptively artless; both pictures are in fact carefully thought out. The one I reproduce, *Paysage*, is balanced asymmetrically between the dark trees on the left and the small structure close to us on the right[204], and it is divided horizontally in the exact center by the dark outline of a roof. Whether the foreground would have remained equally fluid if Cézanne had gone beyond the first lay-in, I cannot say, but the painting gives every evidence of having reached a happy state – a happy interplay between the fluid and the firm. Perhaps its author realized as much and left it alone.

PAYSAGE (R 496), ca. 1881, 50 x 61 cm. National Gallery of Art, Washington, DC.
Volume 1, n° 161.

The contemporary *La Route tournante*, on the other hand, is worked out more elaborately and with a more equal emphasis. All the parallel touches work in concert with the interplay of roofs, and in the center, in the patch encircled by the road, they indicate that the ground is raised rather than flat. In all other respects the expressiveness of the painting lies in the composition: in the slow turn in the road that leads us to the center (a boxy curve that reminds us of the squarish ellipses of the vases and plates in the contemporary still lives, and with the same function), in the oscillations of the roofs, pointing this way and that, and in the red roof in the middle of all the greens – which arrests the view, takes us back us toward the center, and brings the turn to a full stop.

LA ROUTE TOURNANTE (R490), ca. 1881, 60 x 73 cm. Museum of Fine Arts, Boston, MA.
Volume 1, n° 162.

Several landscapes from about 1881-82, from the South as well as from the North, follow the discoveries of *Le pont de Maincy* and integrate irregular textures with solid forms that Cézanne has to accept as givens. Their touch is not a tight or obtrusive one, and it feels, as in the *Maincy* painting, natural to the site. Surely this is because we understand each motif's invitation and challenge: the touch may need to indicate a slope; make a body of water appear solid; balance other diagonal movements; and of course always to integrate the painting's surface. In *Le Bassin de Jas de Bouffan*, the challenge was the awkward angle in the receding edge of the pool, which would have made a highly unbalanced composition unless something were done with the foliage in the small tree; had it been painted fluffy, as it normally appears, the only movement within the canvas would have been toward the upper left[205]. I suspect that here he would not have even begun to paint without the solution already in mind - namely, to balance the receding wall with parallel touches for the foliage, laid down in the opposite direction. No other way of achieving what he normally needs in a painting occurs to me, and in any case the bare canvas that is visible between the touches shows that they were laid directly on it, without overpainting. The composition comes alive through the opposition it sets up; it is both dynamic and resolved.

LE BASSIN DE JAS DE BOUFFAN (R380), ca. 1881-82, 74 x 60 cm. Albright-Knox Art Gallery, Buffalo.
Volume 1, n° 164.

Dense touches become much more than a solid base, however, in a painting done in the North in 1882, *Maisons à Valhermeil vues en direction d'Auvers-sur-Oise*, during another visit to Pissarro; this was another site shared with Pissarro, and painted from only a few feet away. It represents another stage in the development of the parallel touch, with the strokes smaller and more tightly spaced, at least in the finished and intentionally emphatic portions of the canvas. The green touches in the center are vertical and surround

204 - *A small, isolated structure at the edge of a canvas carries as much visual weight as a large grouping close to the center. See R. Arnheim,* Art and visual perception, *Berkeley: University of California Press, 1974, chapter on balance. This principle also applies to* Baigneurs et baigneuses *(p. 8).*

205 - *For a photograph of the site as it appears at present, without the tree, see my* Cézanne: Landscape into Art, *p. 125.*

MAISONS À VALHERMEIL VUES EN DIRECTION D'AUVERS-SUR-OISE
(R493), ca. 1882, 73 x 92 cm.
Private collection, Japan.
Volume 1, n° 165.

the roofs in so close an embrace that the roofs fairly leap out from it; and if our eye should fail to be attracted to the center by this contrast, it would be directed there by the light, perfectly centered chimney, and the path that leads right up to it.

Pissarro's version of this site, *Sente et coteaux d'Auvers*,[206] shows us that these coincidences are not a construction, but a real view clarified by emphasis. Pissarro stood where the ground would partially obscure the house, so that it barely peered in from behind. With his standpoint he allowed for a deeper foreground, and with his attention to its textures, he painted a sensuous evocation of the pleasures of being in the country. Cézanne, on the other hand, stood to the right and a little to the front, and made sure he saw the house clearly and in the center; we are barely aware of the foreground. The house and its chimney are surrounded by all the clear, structural touches, which are vertical by contrast. His is an incisive solution, troubled only by too clear a hillside to the left of the chimney (noted more gently by Pissarro), where it creates a swirl of forms that, to me, distracts from the center.

In every case, then, the touch has helped Cézanne order his composition. We could say, in specific paintings, that it either joined foliage to masonry *(Le Pont de Maincy and Le Bassin de Jas de Bouffan)*, provided a rhythm of intersecting wedges *(Groupe de maisons)*, created a tapestry *(La Côte du Galet)*, or helped focus our gaze *(L'Hermitage à Pontoise and Maisons à Valhermeil)*, but these would only be variants of the common purpose - to make the composition work by clear emphasis and balanced rhythm.

LA VALLÉE DE L'OISE
(R434), ca. 1882, 72 x 91 cm.
Private collection.
Volume 1, n° 167.

In *La Vallée de l'Oise* the common purpose is harder to see at first, so repetitive and even nervous does the touch seem, but each stroke is in fact carefully considered there as well. Since we have evidence that the houses and trees were where Cézanne painted them - a more literal sketch of the same motif in gouache, made from a little to the right where the saplings closed the gap in the center (RW88)[207] - we can see the site offering a clear invitation: the roofs, the fields, the trees on the right, all push toward the left, to be stopped by the vertical trees at the left edge, inviting a painter such as Cézanne to make the most of their opposition. To emphasize the opposition, Cézanne uses the parallel touch. On the right, in the sandy area, he uses a diagonal touch to strengthen the leftward push, and incidentally calls our attention to the otherwise insignificant diagonal sapling by making it border the sandy area; and on the left, in the trees, he uses vertical touches, almost relentlessly, to provide the firmest possible resistance. In this way the pushes and the resistances are made all the more clear, and,

DANS LA VALLÉE DE L'OISE (RW88),
ca. 1882, 32 x 50 cm.
Metropolitan Museum of Art, New York.
Volume 1, n° 166.

rather than being felt only as a tension across space, as in the gouache sketch, have become inherent to the weave of the fabric.

This sense of close interweaving is more complex, more subtle, than what we had seen in *La Côte du Galet à Pontoise*, and perhaps more self-assured than in *Maisons à Valhermeil*. It reaches a higher level still in *Le Verger (Hattenville)*, where the touches are made to oscillate like the needle of a nervous compass in synchrony with the irregular branches of the trees. The touches and the branches that contain them seem more

206 - *Reproduced next to Cézanne's in Leopold Reidemeister, Auf den Spuren der Maler der Ile de France, Berlin, Propyläen Verlag, 1963, pp. 72 - 73.*

207 - *Only contemporary evidence, such as a watercolor study or a photograph (see Bernard's site photograph on p. 367) will show impermanent details such as branches and saplings; later photographs can only show more long-lived forms, especially houses and rocks. In every photograph taken of a site, the long-lived forms can be found where Cézanne saw them. I think one should date the painting in 1882, by the way, not 1880, because the touch is used very much as in the* Maisons à Valhermeil *picture.*

LE VERGER (Hattenville)
(R506), ca. 1882,
60 x 50 cm.
Thyssen-Bornemisza
Collection, Madrid.
Volume 1, n° 163.

closely joined here than in *La Vallée*, with the outlines of the branches more prominent and the touches in turn less so; and I presume that Cézanne felt that the touches had to be muted so as not to compete with the broad movements of the branches. On the contrary, by their quiet presence the touches reinforce the movements imperceptibly. The painting becomes a series of arabesques of the orchard's trees, each painted with a firm outline, which draw into their rhythm even the undulations of the thatched roof in the background; and all this takes place against the stabilizing vertical stakes and trees. The movements play out as if on a flat stage, so deeply filtered is the light, so narrow the differences in the brushstrokes' hues and values, and so stuffy the red-brown and dull green colors[208].

Cézanne's touch is, as always, only a means to an end, and the end is always a well integrated composition, with the touch as only one of its elements; balance of color is another, rhythmical movement through space yet another. For example, having introduced yellow into the greenery of another painting of this orchard (*Le Clos normand*, R507), Cézanne felt compelled to balance it, I believe, by painting some of the foliage blue; the whole color scheme then became complete, with two pairs of color contrasts at work - yellow and blue, and violet and green. To open up the space under the trees he cut across two of the trunks; this made the ground continuous but let the trees retain their actual size as well[209]. The compromise was a kind of respect for the reality of the site that I spoke of in the introduction (pp. 20-21), and it created a kind of ambiguity of presence and absence that reminds us that we are looking as much at a painting as at a scene.

Back in l'Estaque, Cézanne responds once again to its open space and intense light, saturated colors, and violent contrasts; they rivet his gaze and inhibit the kind of intellectual detachment that we saw in these northern landscapes. The touch is not softened by the dark light of Chocquet's orchard but remains clear and forceful; its clarity, and Cézanne's ever more complex motifs, produce a number of very dense paintings. Four paintings exemplify this stage in his evolution. Three have been assigned to 1878-79 and the fourth to 1882, but this dating is not necessarily the most likely: all four could have been painted within a close time span, and if they were, I would suggest the year 1882 by their stylistic closeness to *La Vallée de l'Oise*. Whatever the merits of reassigning the dates may be, however, it is the use of the touch that is important and that requires that they be considered together.

The touch is short and straight, quite narrow, applied in full paste, and oriented in several directions. Its complex character can be seen in *Le Golfe de Marseille vu de l'Estaque*, where it is set down simply and confidently in the distant hills, but irregularly, though strikingly, in the foreground. It points for the most part toward the upper right, but it also forms a semicircular swirl, somewhat as in *Maisons à Valhermeil*, in the lower left corner. It cuts across so many details in the foreground, and depicts so many small objects, that it loses much of its ability to organize the composition. Although in the distant hills it is grouped in long strings that parallel the near shore, in the foreground any simple grouping would eliminate the many details. Instead, Cézanne has to search for individual correspondences to help guide us through the composition: for example, the red object which extends the smokestack and forms the composition's

LE GOLFE DE MARSEILLE VUE DE L'ESTAQUE (R390), ca. 1882, 58 x 72 cm. Musée d'Orsay, Paris.
Volume 1, n° 169.

208 - *This original color scheme, rare in Cézanne's work, can also be seen in the late landscape done in the Fontainebleau forest,* Intérieur de forêt *(R905).*
209 - *He will do it again, with an even more powerful effect, in* Les grands arbres **(p. 355)**, *from 1902-04.*

focus, or the distant jetty which opposes the near shore. But they do not quite work, and I cannot avoid thinking that the site was simply too scattered to be unified, either with the parallel touch or with any other device[210].

**LA MER À L'ESTAQUE
DERRIÈRE LES ARBRES**
(R395), ca. 1882,
73 x 92 cm.
Musée Picasso, Paris.
Volume 1, n° 170.

That impression is strengthened by another *Estaque* picture which, too, copes with an irregular mosaic of houses. In *La Mer à l'Estaque derrière les arbres*, however, that mosaic is constrained by the framing trees; they point toward the upper left, to balance the shoreline and most of the roofs, which point toward the upper right. The branches are fluid in contrast to the scatter of houses, which are angular, and their improbable smoothness is the product of simplifying their sinewy shapes; these can be seen in an earlier and rougher version, which is more spontaneous and, in the trees, more realistic (*L'Estaque vu à travers les arbres*, R396). With this broad equilibrium in place, Cézanne is free to indulge in a spree of color, as vivid in the surface of the water as among the houses: in the bay he ranges not only from blues to greens, but also over pale violets and ochres, and among the houses he places earth tones, blue-greys, and a brilliant red which underscores the central, solitary house outlined against the water. Since the village of l'Estaque is quite irregular in the layout of its streets, the parallel touch alone could not possibly organize the views of its buildings; making a virtue of necessity, then, Cézanne kept the touches fully as irregular as the diffuse motif (except in the vegetation, where he set them down in one direction), and based the organization and equilibrium of the painting on color instead.

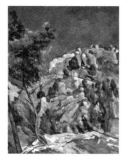

AU FOND DU RAVIN
(R393), ca. 1882,
73 x 54 cm.
Museum of Fine Arts,
Houston.
Volume 1, n° 171.

In *Au Fond du ravin*, however, the colors of the motif are perfectly simple (the three colors that are most characteristic of Provençal landscapes: blue, green and Naples yellow), and Cézanne turns instead to following the accidents of the rock face - its convolutions and erosions - to establish the composition. The base of the picture is a slab of rock that leans up toward the left, while the central part of the rock face leans toward the right, and this oscillation follows broadly the twists of the foreground tree and defines the basic lines of the composition. The parallel touch sometimes follows what it represents, as in the base, and at other times is set in opposition, as in the center; when set in opposition, its top edge is sharp, so it can help define the incisions in the rock. The movements are too many, however, to describe by consistent touches, and Cézanne responds to the convoluted surface by letting the touches oscillate with each crag, with a result that is magnificently solid on the one hand and difficult to grasp at once on the other. What simplifies the composition is the near balance of the three color groups present in the site[211], and what perfects the balance is the addition of grey-blues to represent the shadows amid the relentless yellows; they make us aware of the painter's pursuit of color harmony and remind us that the parallel touch had yet another splendid advantage: it allowed Cézanne to set down his desired juxtaposition of colors in a way that seems natural and logical.

For the parallel touch perhaps the most difficult technical task was counterintuitive: to represent long, curving lines with short strokes running at right angles. This is the challenge in the fourth Estaque picture, *L'Estaque*, where alternating green and light brown fields curve upward to the right. Cézanne had tackled a similar composition in the north only shortly before, using loose touches that were parallel to the long lines, but that picture (*L'Arbre au tournant*, R504) is only a first lay-in and the surface

210 - *It is scattered even today, but as a result of rebuilding and subsequent demolition. It was identified by Xavier Prati and Georges Reynaud; see my* On Site with Paul Cézanne in Provence, *p. 22.*
211 - *The cobalt blues and Naples yellows are probably very close to what he saw, as we have seen, while the greens are probably cooler; see earlier, p. 132.*

L'ESTAQUE (R491),
ca. 1882, 73 x 54 cm.
Angela Rosengart, Lucerne.
Volume 1, n° 173.

we see there is unlikely to have been his last word. Here, however, the picture is finished, and the task for the carefully placed short touches is to preserve the flow of the principal lines and allow the composition to sweep up toward the right. On the whole the touch succeeds, thanks to its careful alignment of the top and bottom ends. It is then asked to create another center of interest, a much more important one, around the red house, where the tight clustering of forms naturally draws our eye. The composition that results is calm and well balanced - in fact, well resolved in spite of the centrifugal pull of the path - and my only question is whether in the fields the parallel touch was specifically useful. Merely raising the question, as rarely as one does, is a useful counterpoint to the sense of naturalness and perhaps inevitability that Cézanne's work with the parallel touch normally evokes.

The culminating use of that touch is, if not altogether natural, then certainly splendid, and it is found in six landscapes where Cézanne reconstructs his complex sensations of landscape with an orderly yet seemingly natural system; I shall discuss four of them[212]. I am speaking of the logic of the touch, of its being taken as far as it will go, and of its almost improbable success - all the more surprising as good things carried to extremes disappoint so easily. Nothing tells us with certainty when in this half-decade these paintings were done, and a broad range has been proposed[213], but the greatest likelihood is, I believe, that they were painted close together in time, between 1883 and 1884. They seem like the natural precursors of the relaxation of the parallel touch that follows in 1885; any other, less intense, phase, would not have required such respite[214].

What is so striking about the paintings is their insistence on unity and articulation;

MAISONS EN PROVENCE (la vallée de Riaux près de l'Estaque)
(R438), ca. 1883-84,
65 x 81 cm.
National Gallery of Art,
Washington, DC.
Volume 1, n° 172.

the affection for the complex accidents of the sites that we have just seen is gone. *Maisons en Provence - la vallée de Riaux près de l'Estaque*, for example, essentially plies every undulation in the hillside into a well-defined form that bends with the terrain and responds to the angular oscillation of the roofs of the small house. Not only does each fold build up the hillside, but it also reflects the balanced inclinations of the roofs to the left and of the meadow to the right. Of course, we are also given a solid point of reference in the center, with the houses resting on a solid rock[215] and with their walls painted with a flat touch, but the sense of an organically articulating surface remains. The painting is so successfully integrated that I am astonished with each fresh look that the stiff touches should produce so gentle a movement.

Nearly identical touches are used for a more complex balancing act in the painting *Rochers à l'Estaque*. I should ideally like to talk about it knowing only the painting, but having seen the site, which was preserved essentially intact until recently, I can no longer do so; I can see the painting only as a series of solutions to the motif's difficulties. Perhaps it is less of a problem than I fear; some questions arise about the painting whether one knows the site or not. One puzzle is the horizon: why is this the only painting of the Bay of Marseilles where the horizon is tilted? A clear answer does, however, depend on knowing the site. The meadow leans markedly toward the right, more so than is evident in the painting, and the rock at the left extends up higher;

212 - *The others include another version of* Les Grands arbres au Jas de Bouffan *(R547), which is better known than the one reproduced here, and* Maisons sous les arbres (Provence) *(R545). There are also landscapes from the decade of the 90s that revive the style that Cézanne perfected with these six landscapes.*

213 - *1879-82 for the first two, 1885 for the third, and 1885-87 for the fourth, in the Rewald catalog.*

214 - *In adopting this dating I am agreeing with Gowing (in his "Notes on the development of Cézanne",* The Burlington Magazine, *1956, vol. 98, pp. 185-192), and following the argument that I see implicit in the article.*

215 - *For a photograph of the much-altered site, see my book on the landscapes, p. 50.*

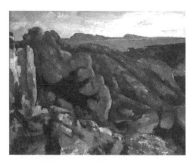

ROCHERS À L'ESTAQUE
(R.442), ca. 1883-84,
73 x 91 cm. Museu de Arte,
São Paulo
Assis Chateaubriand.
Volume 1, n° 174.

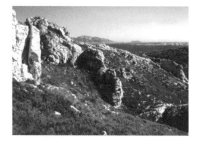

Site 174, photo:
Pavel Machotka, ca. 1977.

SOUS-BOIS (R.543),
ca. 1884, 47 x 56 cm.
The Saidye Bronfman
Foundation.
Volume 1, n° 177.

LES GRANDS ARBRES
AU JAS DE BOUFFAN
(R.546), ca. 1884,
73 x 59 cm. Maspro Art
Museum, Nisshin
Volume 1, n° 175.

together they create a pronounced imbalance. The leftward tilt of the horizon and the shrinking of the rock are clearly part of Cézanne's solution: he turns the composition counter-clockwise and restores some stability. He then painstakingly sets down the parallel touch in the meadow behind the rock at right angles to its surface, and slows down its precipitous slide.

Part of Cézanne's challenge here was to create a stable painting from a problematic motif - a challenge he rarely had to face, but one he took on thanks probably to the exceptional beauty and isolation of the spot. He also must have felt that the rock, the compelling focus of the scene, pulled away from the meadow; he reintegrated it by painting its surface with the same touch as the rest, but made it vertical, for stability, and varied its greys from violets to ochres, to animate them. With our attention focused on the rock, we would be likely to neglect the messy lower left corner momentarily, but as soon as we turned to it, we would see that the mess provides support for the rock and the diagonal stones echo the slope of the meadow.

The dense yet independent touch is put to a quite different use in *Sous-bois,* a picture that would be merely a richly saturated carpet were it not organized as clearly as it is, on the surface and in space. To frame and contain the textures, thin saplings reach up toward the light and bend toward each other in an implied arch; to create a layered space, foliage interrupts their trunks. A fragment of a path then enters the picture at the bottom, and a patch of light establishes a middle ground beyond which the wood becomes deep again. Having understood the space, we can begin to notice the different uses of the touch - the warp and weft of the brushstrokes between the saplings left of center, which suggest the leaves and the spaces between them, the parallel touches that make a convex hedge that blocks our progression, and the general and indispensable denseness that an enclosed space requires. If it is a first lay-in - and the spaces between the touches suggest that much of it is - then Cézanne had a clear idea from the start how he wanted to proceed, and except for the buildup of paint in the center, which gave him the needed emphasis, achieved his purpose without further elaboration. He achieved the color balance, too, at one go: within the constraints of a two-color scheme, he varied the color of the leaves from yellow through warm green, then cool green, and then blue-green, creating a broad spectrum to oppose the warm reds.

Les Grands arbres au Jas de Bouffan - the vertical version of two paintings by the same name - returns us to three colors and to a more open space. The blue sky immediately establishes both the space and the third color; the blues complete, and give us relief from, the stuffy warmth of the greens and brown-reds, and they make an instant and sensuous complement to the golden color of the prepared canvas. (The light blue indications near the right edge, set down as they are right against the golden ground, are as abstractly sensuous as they are representational.) Even where the blue color is laid down over the leaves, as in the all-important center where the touches of all the colors accumulate and overlap, it contributes to the sense of openness. The space between the central trees is, of course, the most elaborately finished, as it is in the other version; it is as if Cézanne had wanted to make sure there was a core to anchor our vision and give us relief from the relentless diagonal movements.

In this version, however, he has painted that core in a masterly way, free of the fussiness of the other (leading me to believe that this version was the second one). The touch,

although set down slowly in tight, parallel clusters, allows the surface of the painting to remain alive. It establishes the balance of the three colors, depicts the pulsating space between the near and far branches, gives the irregular branches a plausible rhythm[216], and even depicts the depth of the narrow strip of ground at the bottom of the painting with overlapping bands of strokes. The touch has come to its logical conclusion, and surely accomplished more than Cézanne might have hoped from it a mere five years before - and left him, a restlessly innovative painter, with little other choice than to pull back a little, allow impulse a greater role in forming the surface, and give smoother textures a role in the painting.

This is the direction that he takes sometime around 1885. We can only guess at the timing of this development, but it probably began in early 1885 and was in place by late summer. What he accomplished with the new, lighter touch belongs to the next chapter, but here we can look at how the stylistic transition may have taken place.

Three southern landscapes, one from the Jas de Bouffan and two from l'Estaque, are most probably from this transitional period[217]. Together they tell us that what distinguishes the new paintings is a relaxation of the touch: simpler surfaces for the solid objects, softened parallel touches for the vegetation, and a gentler transition between adjacent areas. In a first lay-in, as we shall see more clearly in the next chapter, the surface generally remains granular; short, parallel lines are set down rapidly in liquid paint. Those quick hatchings define their objects immediately and then leave room for further elaboration, if desired; or the paintings will stand as such - thin, perhaps, but fully satisfactory, with the painter content simply to leave them alone. In the first two paintings (*Le Golfe de Marseille* and *Marronniers et ferme*) we see much careful reworking; it is a matter of necessity in the first because the surfaces need to remain flat while articulating with each other, and a matter of choice in the second because Cézanne is striving for a surface unified by rhythm. In the third painting we see an interplay between the earliest touches and later ones - an interplay that helped Cézanne connect the textures of vegetation with the simpler, rigid forms of buildings.

LE GOLFE DE MARSEILLE, VU DE L'ESTAQUE (R.626), ca. 1885, 80 x 101 cm. Art Institute of Chicago. *Volume 1, n° 168.*

In the first painting, *Le Golfe de Marseille, vu de l'Estaque*, Cézanne takes as his subject the magnificent expanse of the Bay of Marseilles, by itself, with only a narrow foreground to help articulate the space. Taking on so broad and saturated a sheet of color requires a certain obstinate determination. The color itself is not a problem, because an intense blue can play against the saturated yellows and yellow-reds of the houses, but the large surface of the water could easily go flat and appear empty. Cézanne solves the problem simply by varying the blues and laying the touches horizontally and densely; this establishes the bay as lively but palpable and solid, and the planes of the walls and roofs, no more solid than the bay, can articulate with it naturally. To help bridge the near and far shores, he spans the space with an implied line extending between the smoke and the jetty at the Marseilles end, and this imagined diagonal gives us an inclination repeated in the distant hills and in the broad shape of the nearby shore. What remains of the parallel touch in the hills balances this diagonal, by the way. All of these expressions of his craft turn a seemingly placid scene into a painting with discreet tensions. To convince oneself of the way they work, one might try blocking out these

216 - For the other version, and Rewald's photograph from 1935, see my book on the landscapes, pp. 56-57. The photograph shows that the branches were indeed irregular and natural, with only the gentlest suggestion of an inclination to the right. Having been taken fifty years later, the photograph also shows that the tree trunks had thickened - although their shape had remained essentially the same - and that the space between the central trees had filled in densely.
217 - Rewald dates the paintings between 1883 and 1885. Since they are all painted in a less insistent manner than the earlier Maisons en Provence or Rochers à l'Estaque, the simpler notation "c.1885" is preferable.

MARRONNIERS ET FERME DU JAS DE BOUFFAN (R538), ca. 1885, 66 x 81,3 cm. Private collection. *Volume 1, n° 176.*

elements one at a time, and then one might try obscuring the spot of red at bottom center to see how important it is for holding the composition together[218].

In the second painting, *Marronniers et ferme du Jas de Bouffan* Cézanne has reworked the touch even more carefully, but as a matter of preference rather than necessity: here the touch oscillates rhythmically with the branches and creates a containing frame for the intrusion of the brilliant Naples yellow. Leaves and sky oscillate together, and occupy much the same space thanks to the dark blue touches that bridge the contrast between them. The dark blue finds its way - surely for color balance - into the orange leaves that obscure the residence. As against these diagonal patches, the lawn and the buildings are done in horizontal and vertical touches, and this separates them from the containing framework of trees (as well as representing their actual planes). The whole is carefully unified, clearly defined, and, in color, balanced and saturated. The riveting focus, however, is the juncture of the tree and the luminous fragments of the yellow farmhouse, which pushes back out toward the viewer on either side.

In fact, it is one of the enviable successes of Cézanne's technique that he achieves a rich color without recourse to the accumulation of individual dots or dashes of the Impressionists: his touches, distinct to begin with, are laid down in equally distinct groups - and these in turn retain their independence even when they are closely interconnected by color. Cézanne achieves a rare sense of unity of the whole while protecting the distinctness of the parts.

The happy *Vue sur l'Estaque et le Château d'If* is an equally good example of this kind of unity. Even though Cézanne used three groups of saturated colors that would normally compete for attention - greens, blues, and orange-reds - he found ways to make when isolated in the center as here, but he has set them in the middle of equally saturated greens, their color complementaries, and this has united the two colors by a stark opposition. He then spread flecks of red all over the canvas, in unexpected places, to bring the tight group of roofs out of its isolation. He similarly introduced flecks of green into the blues, and blues into greens. But he also chose to handle the transition between the greens and the blues as in the *Marroniers* painting: by introducing a dark blue at the point of their contact. I should point out that although this is a device for keeping the canvas surface unified, it is also a record of a visual experience we can duplicate ourselves when looking at trees against the sky: with eyes half closed, we will see a darker blue at the edges of the leaves, and of course the darkest blue where the spaces between the leaves are smallest.

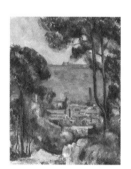

VUE SUR L'ESTAQUE ET LE CHÂTEAU D'IF (R531), ca. 1885, 71 x 58 cm. Fitzwilliam Museum, Cambridge. *Volume 1, n° 180.*

The five-year evolution from the tentative use of the parallel touch to a consistent and eventually pure and abstract handling, and then partway back to a self-confident loosening of its grasp, is not matched by anything that happens in the drawings and watercolors. In part this is because the media are different, and in part it is because Cézanne still uses them as studies for oils; but in part it is also neglect - his energies are invested in oil painting. After 1885, on the other hand, watercolors will become a medium of innovation, and still later, drawings - of the figure especially - will become splendid exemplars of line, shading, and expression.

The drawing *View of l'Estaque* is a study for a vertical composition such as that of the *Château d'If* painting: it works out the relations between the horizon, the buildings jutting

218 - *The site now appears hopelessly filled in with jetties, ships, and cranes, but may be seen in my On Site with Paul Cézanne in Provence, p. 20.*

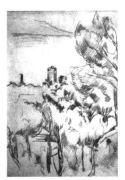

out into the bay[219], and the voluminous vegetation in the frontal plane. It is in fact a view of the same scene, although seen from a different standpoint – the same square building appears at the edge of the bay, and similar pines frame the scene. But the medium of drawing works differently, making linear traces only, which can be used to outline form or define volume but not soften transitions by blending, for example; the inconsistency would be messy (as it sometimes is when the trace is smudged). That is how Cézanne uses the lines here, simply and effectively and as often for outline as for volume. The outlines of the buildings are firm, sometimes doubled or set down with emphasis – in this way the square building becomes the focus of the composition – and the tree trunks are linear and solid (solid particularly under the square building, where they connect to it visually). Curling lines indicate the outlines of the pine needle clusters, and simple hatchings hint at volume; and in every case, the point of the volume closest to us is the blank paper itself.

Later, Cézanne will do drawings conceived purely in volume, where hatchings will define everything in a forest scene except for a few indispensable lines for the tree trunks, or on the contrary do purely linear drawings where the interplay of branches will carry all the expression. These will be more consistent, more virtuoso uses of the medium, drawings that one can view as ends in themselves. But here he is at least perfectly secure in his means, firm in his composition, and clear in what he wishes to emphasize.

A watercolor brush, on the other hand, can create both lines and planes. It can be dry or loaded with liquid, and it can make razor-thin lines, nervous textures, or broad planes; it can give planes a sharp or feathered edge, and build them up in patches that had been allowed to dry. (It can also blend them wet, but this was not in Cézanne's vocabulary). Textures, lines, planes (and white spaces) are all elements of *Les Grands arbres du Jas de Bouffan*, the same subject as the oil and probably contemporary. Here there is a mix of the literal and the abstract: curls for indicating the leaves (or, more ambiguously, the spaces between them), and flat patches of color, which represent nothing in particular, for providing color balance and a sense of space and density (and a hint of the yellow fields beyond). In both the literal and the abstract he is self-assured, allowing each touch to dry so that it will not run into the one next to it or on top of it, and in the few abstract patches he anticipates the extraordinary devices of his later watercolor work: the patches which will represent real objects as well as signaling abstract rhythms and building up dense spaces while remaining transparent.

PORTRAITS

When we look at Cézanne's portraits, at any point in his development, we see that he resolved the tension between style and appearance differently: if in landscapes he could let the brush could find its own rhythms, independent of the textures of the site, in portraits his touches were constrained by appearance and character. Cézanne was close enough to his sitters to be unable to treat their face as an inert object; their likeness, or their character, or both, could not be denied[220].

219 - See Xavier Prati, L'Estaque au temps des peintres, L'Estaque: Association Collège-Quartier, 1985, p. 21, who explains that this was what remained of a crenellated 13th century tower.
220 - The problem of likeness becomes more acute with each step toward abstraction. Picasso, in the analytic phase of Cubism, painted the faces of his sitters much more realistically than the rest of the body; the fragmentation that would be understandable in a torso or arms was less tolerable in the face. His Portrait of Ambroise Vollard from 1910, for example, is a remarkable likeness of the sitter, in the shape of the head, the downturn of the mouth, and the flare of the nostrils; only the sharp, linear breaks between the elements of the face recall the fragmented treatment of the rest of the figure. When a figure study is not a portrait, then there is no such constraint, as in his Woman Sewing, from the same year, or Man with a Guitar, from 1911. See William Rubin, Picasso and Braque: Pioneering Cubism, New York: The Museum of Modern Art, 1989, p. 175, 152, and 191, respectively.

The only exception so far was the extraordinary year 1877, as I have said, when the portraits of Victor Chocquet and Madame Cézanne yielded to the blockish touch. During this half-decade a further exception will be made for his own face and that of his son; and in his last decade, it will be made for large compositions and figures in landscape.

This reluctance extends to the new, masterly analytic device, the parallel touch. It is a reluctance that we see to some extent in the still lives as well, and there we must presume a different reason: with the surfaces of apples and faces, where it has to exact distinct planes from smooth, continuous ones, it must – on the evidence – seem to him less natural. It appears in only about one-half of his still lives, in only a few finished self-portraits and some small studies of his son, and never in portraits of his wife. In still lives, then, the objects are simpler in form and interconnections between them can be made by other means, and in portraits, we add the reluctance born of the integrity of the face: beyond the question of retaining likeness, there is the process of analysis and resynthesis itself, which may feel too aggressive as one paints. I think that for Cézanne the femininity of his wife's face, and that of the few other women he painted while they were still youthful, was a matter to be respected, and their portraits, with the one exception we have seen, were not to be roughened[221]. With his own face, however, he was both sitter and painter, and could more easily submit it to patient, analytic, and detached study; and perhaps his son's face could be that kind of object as well, at least during the same brief time early in the decade, because it too was masculine.

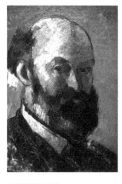

PORTRAIT DE L'ARTISTE (R416), ca. 1879-80, 34 x 25 cm. Sammlung Oskar Reinhart, Winterthur. *Volume 1, n° 184.*

His analytic gaze is at its purest and most self-consistent in a very small self-portrait painted at the beginning of this period. Similar to the still lives done in the slow, full-paste, and systematic manner, it is best dated at the same time, about 1879-80. In the beard the touches are familiar from the small self-portrait (R385, p. 95) that we saw in the last chapter, and look at first like mere realistic representations, but they extend into the forehead and cheeks, and this is new. No part of the skin, however small, escapes the rigorous analysis of the parallel touch. The touch both sculpts the part of the head that is in light and creates a transition into shadow; ranging from pinks to oranges in the illuminated part – with touches of grey-blue and grey-green to relieve the burden of this warmth – it creates a luminous mosaic, then as it turns toward the shadow it makes a sharp transition through green, and eventually attenuates into a more muted harmony of dark flesh tones, browns, red-browns, and greens.

Perhaps because it is a head only, with the painter's gaze undistracted by shoulders, lapels, or background, Cézanne could give all his attention to the internal relationships of color, and achieve a jewel-like brilliance through a masterly juxtaposition of parallel touches. Here they serve to analyze form, and then return it to us whole, rather than lend order to complexity as in landscape. It seems remarkable to me that in portraits Cézanne should have been able to use the touch with such sureness so early in its development, and so much more intricately than with apples. Grouped, the touches sculpt the head; individually, they control light, space, and color balance. The single touches of red, for example, are obviously willful, and although their purpose is not at first obvious, we can guess what it was by blocking them out, one after the other. We find that at the end of the eyebrow they seem to clarify the change of plane at the orbital ridge; in the beard and in the middle of the forehead they serve to introduce a faint trace of light; and where the illuminated nose meets the shadow cast by the eye, the single red dot softens the shadow and brings it back out. These effects may

221 - *Unfortunately, we will never know how he would have painted his wife in older age; his last portrait of her is dated in 1892, when she was 42.*

be difficult to describe precisely, but they are palpable: they add intensity and light, and they balance the warm yellow cast of the skin tones.

When Cézanne paints his own head against a background of strong forms, however, he paints a different kind of picture; he has committed himself to a composition rather than to a mere portrait, to a canvas in which the forms of the face must all reflect the rhythms of the whole. The parallel touch, if used, must also bend to the needs of the composition. So in the modest but magnificent *Portrait de l'artiste au papier peint olivâtre* of only about a year later - modest in its subject, delicate yet grand in its realization - there are too may other visual matters at stake to allow the parallel touch to dominate. The head is now part of a framework of diagonals imposed by the wallpaper, and the painter focuses on its shape: it becomes flatter and more angular, with the eyebrows, eyelids, and beard all becoming more pointed, and even the top of the skull being drawn upward into a gentle gothic arch. The parallel touch still treats the head and face as interlocked planes, but they are now more independent, angular, and schematic.

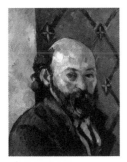

PORTRAIT DE L'ARTISTE AU PAPIER PEINT OLIVÂTRE (R.482), ca. 1880-81, 34 x 26 cm. National Gallery, London. *Volume 1, n° 182.*

Fry was deeply touched by this picture[222]; he found the modesty of the head and its analytic submission to the larger scheme very moving, and the color gradation within the surfaces, and the well balanced differences between the cool and warm colors, perfectly delicate. I agree with him fully, and accept his emphasis on the painting's play on our emotions; he reminds us in effect that in great art all technique has a larger purpose. If the parallel touch deserves as much attention as I give it, it is because it is one of the vehicles that creates those emotions: here, the beauty of the human skin; there, the profound orderliness of nature; elsewhere, the rhythmic unity of the work of art. As its purpose shifts, so does its form. And, parenthetically, only its inventor used it flexibly, because only he knew why he had developed it[223].

Fry also responded to Cézanne's seeming physically small here, but I see the "smallness" differently. He says that "Cézanne has descended from the fiery theatrical self-interpretation of his youth to this shrunken and timid middle-aged man". The response is poetic enough, but it should have been tempered with technical understanding. Cézanne will in any case paint a number of self-portraits in the future where he will look self-possessed and strong again, so any sense of smallness would at best be temporary. In this case I believe the impression of smallness is merely the effect of a technical decision. To give equal emphasis to the head and the wallpaper pattern, Cézanne locates his head squarely in the middle of the canvas (rather than higher, as is more common); the result is a kind of modesty, a matter-of-fact place of the painter in a broader and equally interesting world, rather than a diminished self-view. One might equally well have seen the upturned lapels as a youthful gesture, but it would be more pertinent to see them as a pattern that finds its place in the diamond lattice-work of the painting.

This self-portrait is the only portrait during this half-decade that compels the head to be shaped to fit the whole. In all his other portraits of this period he paints the head either alone or next to a single object, and when it is alone, he can redirect his attention to shape, likeness and expression. While this is natural enough in life studies, it is difficult to achieve in portraits done from a photograph: the pose - quite long in Cézanne's time - is normally so stiff that it is ill suited for painting. It is a surprise then that

222 - Cézanne: a study of his development, *pp. 53-54.*

223 - *I have in mind Gauguin, who used it in some of his paintings after meeting Cézanne in 1881; he used it inflexibly, and it seldom fails to appear as a borrowed technique. Had Cézanne been less sensitive on the matter, he might have seen that Gauguin had in no sense "stolen" it from him; he had borrowed the parallel strokes, but not the vision that governed their use (see Geffroy, "Extrait", in Doran, Conversations avec Cézanne, p. 4).*

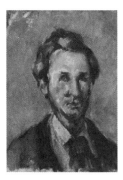

**PORTRAIT DE
VICTOR CHOCQUET**

(R461), ca. 1880,
20 x 16 cm.
Private collection.
Volume 1, n° 183.

**ESQUISSE
D'UN PORTRAIT
DU FILS DE L'ARTISTE**

(R534), ca. 1882-83,
20 x 12 cm.
Von der Heydt Museum,
Wuppertal.
Volume 1, n° 181.

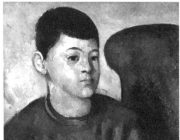

**LE FILS DE L'ARTISTE
AU FAUTEUIL ROUGE**

(R465), ca. 1883–84,
34 x 38 cm. Musée
de l'Orangerie, Paris.
Volume 1, n° 185.

during this period Cézanne does two portraits of Victor Chocquet from a photograph, because he had already done two convincing ones from life[224]. They are less animated, but at least the better one of the two (shown here) has something to offer us: an example of Cézanne's extraordinary sense for color. Although stiff in pose and expression, like the photograph, this very small picture comes alive through the contrast between the cool blues and greens of the ground and the warm tones of the skin; the skin, although painted without a model, is made luminous against its ground. Cézanne had done two pencil studies of the same pose earlier, with the same jacket, cravat, and sloping shoulders, so it is possible that he felt confident enough of the likeness to give his attention to color; unfortunately, this would not explain the dull tones, and lifeless photographic stillness, of the other portrait (R460)[225].

Cézanne is once again on secure ground in two contrasting portraits of his son from life: a study done in 1882-83, when the boy was about ten or eleven, and a more formal portrait done about a year later. Earlier, in 1880, he had done a small sketch of his son's head still using the parallel touch, but by the time of *Esquisse d'un portrait du fils de l'artiste*, there was no longer any question of using it in portraits of others. In *Esquisse*, Cézanne's response to the face became more intuitive and his brushwork seemed to be chosen more impulsively. He outlined the face and bust with strokes that resemble Chinese calligraphy: he loaded the brush with small amounts of black, liquid paint as if it were ink and applied it with quick, sure touches (over penciled lines, however, which helped him prepare the likeness), leaving the touches distinct and letting some of them run out of paint before they were completed. The modeling of the skin was done in lighter, less insistent, hatchings, in closely related colors, and the result of all this agile work was spontaneous in appearance and, in the absence of corrections, definitive.

The second portrait, which places the boy next to a red armchair - which should be dated in about 1883-84, if the boy is eleven or twelve years old - is conceived not in analytic touches but in strong shapes instead: the round chair back intrudes toward the head and nearly meets it, acting as an adversary, not as a comforting background. Such an opposition, and such awkward proximity, seem to contradict the most basic assumptions about painting, but in fact they both work well. The sinuous shape of the chair back actually points to its mirror image, the distinct S of the boy's hairline, and it is these two lines that form a unit - at a comfortable distance from each other. The chair's push to the left also balances the turn of the head to the right, a turn that would otherwise seem a shade too pronounced. We are aware, too, that absolutely all the forms in the painting are round, and that the chair is part of the swirl of forms; the painting is unified by the consistent language of its forms.

Knowing the history of art after Cézanne, one is tempted again and again to see him on the cusp of it. Even in simple portrait heads his canvases were always consistent in touch, and in more complex paintings his heads would adapt to the broader pattern. But if by modernness in portraits we refer to signature styles and the primacy of surfaces and constructions, then Cézanne's painting does not fit; he seeks a balance between representing and composing, and that balance brings out the tension that the paintings communicate.

224 - *For a reproduction of the photograph, see, PPC, vol. 1, p. 311.*
225 - *Rewald suggests that the present portrait may have been done from one of the drawings, which in turn would have been done from life. But unless Chocquet also had himself photographed in the identical pose, this does not seem likely.*

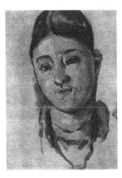

**ESQUISSE
POUR UN PORTRAIT
DE MADAME
CÉZANNE** (R533),
ca. 1883, 20 x 18 cm.
Erix Alport, Oxford.
Volume 1, n° 188.

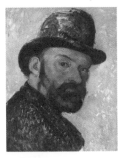

**CÉZANNE
AU CHAPEAU MELON,
ESQUISSE** (R584),
ca. 1884–85, 45 x 36 cm.
Ny Carlsberg Glyptotek,
Copenhagen.
Volume 1, n° 189.

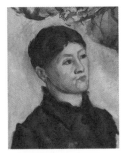

**PORTRAIT DE
MADAME CÉZANNE**
(R532), ca. 1885, 46 x 38 cm.
Philadelphia Museum of
Art.
Volume 1, n° 186.

Even in the smallest sketch of a head, with no other objects as a foil, Cézanne would seek rhythmic correspondences, and of course he would have to find them within the head itself. Since Madame Cézanne's head, seen in full face, was almost certainly oval, oval shapes would suggest themselves: the oval of the top of the head and the hairline could be inverted in the chin, and shape of the chin might in turn be repeated in the opening of the blouse. He brought out these correspondences in *Esquisse d'un portrait de Madame Cézanne*, of about 1883, setting the shapes down simply, decisively, and with a great economy of means. He painted even the modeling in the face where the cheek lies in shadow with a simple oval line rather than the usual short, opposed touches; this is because in so small a sketch they would have weakened the rhythm. The result may not have been flattering, but it has the power of its economy and directness.

In his portraits we should look for neither flattery nor denigration; they are, for the most part, outcomes of close observation and the application of a consistent style. In the three self-portraits of about 1885 he does allow himself to project a hint of self-satisfaction, yet in all of them he tempers it with analytic detachment, visible in the parallel touch. One of these - which should be dated by its finished surface in the face and beard rather than by the first lay-in of the hat and coat - shows him self-assured and even jaunty. The cocked head, extended upward by the bowler hat (which was extended even further as an afterthought), is self-confident, while the sinuous outline of the cheek and the smooth curves of the hat brim, eyebrows, beard, and lapels are dashing. But it is less of a sketch than the title suggests; the face is fully finished with a firm parallel touch, and every principal plane, convex or hollow, is patiently noted. If he gives himself a measure of self-importance, he does so honestly and without drama.

Having Mme Cézanne look up, in three-quarter view, Cézanne finds the angular lines and planes of her face. Here, in a *Portrait de Madame Cézanne*, the burden of finding the right form is placed on an expressive and uniform outline (which, given its prominence over analytic surface, suggest a date of 1885 rather than earlier). The set of the sleeve at the shoulder, the frill of the blouse at the neck, the relaxed disorder of the hair, all become part of a decorative conception. So do the mysterious squiggles at the top, which, thanks to their abstract nature, seem all the more purely decorative. They are in fact painted over an area left over from a previous painting, and made to look like leaves; that at least makes their shape consistent with the forms of the figure, although it does not explain their presence[226]. Whatever the original shape or sequence, the transformation of the top into a leafy surface, alive with the same rhythms as the figure, is what matters. Accepting the top as a pattern makes it easier to notice the other patterns: the correspondence between the splay in the parted hair and the splays in the leaves, between the frilly blouse and the squiggles in the leaves, and between the shape of the chin and the neckline. Cézanne has kept in mind a linear cohesion throughout, and it should be said that to achieve it he did not paint his wife thinner than usual, as has been suggested, but that the oval face simply presented a straighter cheek and thinner chin when the head was turned to a three-quarter view[227].

If in painting portraits Cézanne faced two choices - between the parallel touch and a continuous surface on the one hand, and between volume and line on the other -

226 - Le See Rewald, PPC, vol. 1, pp. 359-360, for an account of the various unsuccessful attempts to explain the origins of the pattern.
227 - This effect can be seen in three other three-quarter portraits of Mme Cézanne. In R536, both the cheek and the nose become straight; in R576, the cheek becomes thin and the chin pointed, and in 606 (p. 167) the cheek is painted straight while the chin becomes square. While respecting the changes produced by the turn of the head, Cézanne would also alter the shape of the chin just enough to make it consistent with each painting's language of forms. The chin would be flattened, for example, whenever there were corresponding blockish shapes elsewhere in the figure. This also holds for at least two drawings assigned to the end of the 1870s or the beginning of the 1880s, C717 and C720 (p. 130).

in drawings he faced only one: between line and mass. As in his drawings of other subjects, there was no particular role for the parallel touch; hatchings, which came closest, might establish volume but would contribute little to expressiveness or composition. Line and mass, however, did have consequences for the drawing's character and Cézanne chose between them in a way that always created a consistent and expressive drawing.

To speak of these technical matters is not to suggest that the portrait drawings are primarily exercises. Quite the contrary, they are subtle portrayals and masterly drawings. Some catch his wife with head on pillow or sleeping, or his son or Zola bending over a sheet of paper, while others, including the self-portraits, are posed sitting up; but whether intimate or matter-of-fact, all are closely observed, expressive, and personal characterizations of the sitter.

MADAME CÉZANNE AND ANOTHER SKETCH
(C720), ca. 1877-80,
22 x 12 cm.
Fogg Art Museum, Harvard University.
Volume 1, n° 187.

Joining incisiveness to delicacy, Cézanne might carefully model the forms of his wife's face with subtle hatchings and also define them with firm outlines - not merely at the start, to get everything in place, but also afterward, for clarity and emphasis. This is what he does in *Madame Cézanne and another sketch*, dated from the end of the previous decade or the beginning of the present one: the gently stated volumes of the head, and of the nose, lips, and eyes, are sharply delineated by clear lines emphasizing their edges - clear everywhere except where they must imply roundness rather than a cutoff edge, as in the multiple outlines of the head and hair. This balance between the linear and the modeled is not specifically directed at feminine portrayals - it works equally well with Cézanne's own face - but in the portraits of Madame Cézanne it is softer and less experimental in execution.

When he drew self-portraits, on the other hand, Cézanne explored the full range of conceptions of the portrait - line and volume - and the breadth of his solutions says much about his extraordinary resources as an artist. Perhaps the most satisfactory drawings are those which balance the two conceptions; their technical balance itself is the most definitive and the face is the most expressive. But drawings that emphasize one method over the other are of the greater interest, because they illustrate just what it is that line and volume in a drawing can achieve.

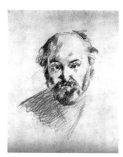

SELF-PORTRAIT (C612),
ca. 1880, 33 x 27 cm.
Walter C. Backer, New York.
Volume 1, n° 190.

Perhaps it is impossible to draw a portrait head without some reliance on outline, however minor - or so it may have seemed with Cézanne's head, where only an unbroken line would represent the bald crown without ambiguity - but apart from such a line and one or two others, the self-portrait, C612, is a nearly pure instance of a drawing that relies on hatchings. Here the hatchings come closest to resembling the parallel touch, because all the ones in the face, and most of those in the beard, run in the same direction; if the date of c.1880 is right, then this is also the time when Cézanne is very much preoccupied with the parallel touch in painting. The hatchings give us a well-rounded head, a full beard, a foreshortened nose - and a sense of fleshiness everywhere, even around the eyes, as well as an absence of expression. It is difficult to say whether the absence of outline makes the expression vague, or whether in order to emphasize volume, Cézanne gave up outline and expression; perhaps these are only two different ways of saying the same thing.

It is certain, however, that outline lends a portrait expression. In a self-portrait of about the same year, C614, line defines every feature, whether the face has been given volume already or not. Not only is the all-important nose defined by a sharp outline, even where the shadow begins, but so are all the other features: the beard, the ear, the bone above the left temple, and the transition from light to shadow above the right

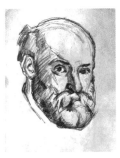

eye; most important, the irises are large, dark, and clearly outlined. It is outlines that make each feature so clear, and therefore so individual; and it is outlines that give this portrait an intense, even magisterial, expression. Even the eyes, equally black in both drawings, communicate more directly with the viewer when they are outlined than when they are not[228].

In the portrait paintings of this half-decade, then, Cézanne was reluctant to use the parallel touch to portray the face; he subjected only his own likeness, and sometimes that of his son, to the analytic gaze, and he did so only at the beginning of this period. In his drawings, however, he was uninhibited by technique, as if both line and hatching were natural ways of portraying individuality, expression, and volume, in whatever proportion served his purpose and for whatever sitter. Compared with narrative and landscape drawings of this period, the portrait drawings are both more definitive – that is, ends in themselves – and more personal, that is, physically and psychologically closer to their subject; and as against the paintings, the portrait drawings are more immediate. They foreshadow, in a way, the more natural connection between subject and style, between the eye and the mind, that his further development will bring.

STILL LIVES

Like the portraits of this period, only some still lives are organized rigorously by the parallel touch, while others mute the touch or do without it altogether. But unlike the portraits, the still lives offer few clues as to why they had been painted in one style or another; the subjects in them are essentially the same. They were also painted during a very narrow interval – between 1879 and 1881, with none painted again until 1885 – and while this seems as difficult to explain as it is to believe, there is no evidence to suggest that the dates are wrong. The backgrounds do point to the Melun period and the one that follows, which means that we cannot date the first paintings later than 1881; and if we wished to fill the gap with paintings normally dated after 1885, we would only create another gap later.

It is clear that for at least two of the years that Cézanne spent at l'Estaque, he painted no still lives; his already close attachment to landscape became a passion under the brilliant light and saturated colors of the South, while the cooler light and the longer time spent indoors in the north invited the painting of still lives. But Cézanne's response to the indoor work was no less passionate, and during these two years, 1879-80, he produced some of his masterpieces in the genre.

The styles of the still lives tend toward one of the two poles: still lives based on color, where we respond to the brilliance of the color relationships, and those based on form, the grave, architectural constructions that represent, in Fry's words, "one of the culminating points of material quality in painting". Several unfinished paintings fall in between, with their present state only suggesting which pole they may have tended toward, and the masterpieces combine the qualities of both. We have seen one example of the first kind of still life already: it was *Assiette à bord bleu et fruits* (p. 102); smooth in surface, it emphasized the close interweaving of contrasting colors[229].

To let us become absorbed by color, without distraction, Cézanne may also compose a painting informally, or more exactly in a way meant to appear informal. In *L'Assiette bleue*

228 - *If I have simplified the argument by failing to emphasize other differences which contribute to the vagueness of the first drawing, such as the full-face pose and the downcast eyes, it was to make clear the advantages of line, that is, clarity and affirmation. These effects are more evident in three-quarter views and are reinforced by a direct gaze.*
229 - *The surface was originally finely granular, but it has been flattened by unfortunate remounting.*

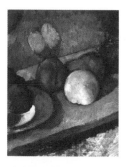

L'ASSIETTE BLEUE
(R433), ca. 1879-80,
26 x 22 cm.
Ise Cultural Foundation.
Volume 1, n° 196.

**PÊCHES, POIRES
ET RAISIN** (R432),
ca. 1879-80, 37 x 44 cm.
Hermitage Museum,
St. Petersburg.
Volume 1, n° 193.

**CARAFE, BOÎTE À
LAIT, BOL
ET ORANGE** (R430),
ca. 1879-80, 26 x 35 cm.
Dallas Museum of Art.
Volume 1, n° 194.

the composition is so seemingly accidental that we may be excused if we feel, inno-cently, that we are dealing only with rich and perfectly balanced colors - both the red-green and the blue-yellow complementary poles. Cézanne helps us feel this by cutting off half the plate and two of the fruits[230], as if not the objects but the pure colors mattered; but he also makes sure that the strong diagonal of the plank is balanced by a leaf from the wallpaper. The touch is laid down in parallel, gently, not in way that would affect the composition; just enough of it remains visible in the fruit to let us see the green and red flecks in the peaches. *Pêches, poires et raisin*, surely contemporary and painted in the same spot, succeeds in letting the colors dominate by suppressing the touch; this results from careful overpainting that hides an earlier canvas, and draws our attention to the two pairs of saturated complementaries. The composition seems equally informal - in the apparently accidental placement of the support for the plank, for example, and in the cutoff wallpaper pattern - but it is just as carefully balanced, in a way that does not call attention to itself.

These happy results belie the hard work that went into them. We can see how much work remained to be done after the first lay-in from an unfinished still life in which the colors are still dull (*Carafe, boîte à lait, bol et orange*). Admittedly the final state of the colors might have been limited by the objects' naturally narrow range, but it would not have been as limited as it is here, and there are indications in the painting that the colors would have developed further. Bernard had reported that Cézanne had told him to start his paintings with nearly neutral colors and build up[231], and we can see that Cézanne had just begun to move toward a build-up in the light green color inside the bowl. We can guess at the further possibilities: given the main complementary axis of orange-brown to blue-green and blue-grey, we can imagine heightening its saturation by making the fruit more orange and creating a denser interplay of greens and blue-greys. We can foresee some of the orange color being brought into the brown of the table and some of the green into the milk can; a hint of green could appear in the leaf pattern in the wallpaper, and the tablecloth could be modeled subtly with light blue-greys, blue-greens, and orange-browns. The composition, dark, ascetic and dense, might have been solidified by a better elaboration of the leaf pattern, and better integrated by recording the reflections of the green bowl and the orange on the surface of the milk can.

A sense of what may be missing in a painting, and how Cézanne might have changed it had he gone on, is the honest counterpart of the admiration one feels otherwise, and a check on the integrity of one's perception. Perhaps even the sense that a painting has reached a dead end can be justified. This is the impression that *Assiette de pêches*, another unfinished still life, gives me. It does succeed bringing light to an arrangement of very dark fruit, by setting it against an even darker background, and it does integrate the fruit with the tablecloth: the greens, blues, and red-browns of the plate of peaches find their way, in much lighter form, into the modeling of the cloth. But the background remains close to monochromatic, with too few indications of the direction that an elaboration might take, and the one swirl in the wallpaper on the left is too unclear in form to make the required connection with the two peaches below it. Perhaps it is the untypical conception of still life - more like a 17th century

230 - *Rewald suggests that the canvas is a fragment of a larger composition (PPC, vol. 1, p. 289), but, although painted over another composition, it seems to have been conceived as such; see the bare canvas at the edges.*

231 - *Cézanne had recommended that the initial, nearly neutral tones should be built up toward greater saturation, keeping them in close harmony as one progressed. Bernard, "Souvenirs sur Paul Cézanne," in P. M. Doran, Conversations avec Cézanne, p. 73. For a discussion of Cézanne's various starting points, see my book on the landscapes, pp. 54-58. We have seen landscapes in this chapter, however, that appear to have been conceived and painted with the parallel touch from the start.*

ASSIETTE DE PÊCHES
(R423), ca. 1879-80,
60 x 73 cm. Guggenheim
Museum, New York.
Volume 1, n° 192.

Dutch composition, with objects made luminous by being set against near-black - that inhibited Cézanne; he seems on more familiar ground when he conceives of the entire composition in color terms.

Assiette de pêches, then, remains an exception. The very same wallpaper, which we have seen in six still lives so far, provides the background for seven more still lives; many of them achieve Fry's much-admired synthesis between the objects' appearance and the painting's material reality. Six in all are painted in full-paste parallel touches with overworked edges, and we can understand why they are sometimes taken to be emblematic of Cézanne's genius. Four of them were, in fact, bought early on by painters or art critics[232]. All are as brilliant in color as they are firm in composition, but in all of them the work of construction is so rigorous that it almost overwhelms our response to the color. In each one, as in the two we shall look at, we follow not only the stiff bends of the napkins, the open, boxy oval of the fruit bowls, and the clear planes of the apples, but also every distinct touch; so compelling is the substance of the paintings that our gaze grapples with their surface rather than resting comfortably in some imaginary space beyond.

VERRE ET POMMES
(R424), ca. 1879-80,
32 x 40 cm.
Kunstmuseum, Basel.
Volume 1, n° 195.

We must presume that the still lives were painted close together, almost as if they were part of a program of research. In all of them the spray of leaves is integral to the composition, the background is light enough to let us see the parallel touch do its work throughout the composition, and in three the fruit is arranged in a white bowl. Of these, *Verre et pommes* is the smallest but not the least monumental. The firm, horizontal string of apples is dominated by the vertical, compound object of leaf pattern and glass[233], and these two reminders of gravity - the horizontal dimension having given in to it, as it were, while the vertical one resists - are allowed to meet softly, through the mediation of the napkin. The color of the fruit is luminous, not in contrast to a dark ground but in the relation of its warm colors to the cool ones of the background[234].

Nature morte au compotier is the more famous painting, and it is certainly the more ambitious in structure. It has one more plane - the front of the chest of drawers, which is located firmly thanks to the hasp that Cézanne so clearly places before our eyes - and a subtle transition into space through the transparent glass; it also has a pronounced diagonal movement from upper left to lower right (balanced, as one would expect,

NATURE MORTE AU COMPOTIER
(R418), ca. 1879-80,
46 x 55 cm. Museum
of Modern Art, New York.
Volume 1, n° 198.

0by the leaf pattern in the upper right, and by all the movements of the parallel touches). Here, where things might so easily become just a little out of place, everything seems splendidly in place: the knife leading us back in the same way as the napkin, for example; the red apple balancing the heavy fruit bowl; the leaf pattern coming close to the solid objects (touching but not overlapping); the firm, deceptively simple, overall balance of the canvas. This still life, even more than the others, is a perfectly self-contained world, one where tensions are created and resolved, where paint balances illusion and permanence denies decay[235].

232 - *R417 was owned by the critic Duret, R418 by Gauguin, R420 by Mary Cassatt, R424 by Degas.*
233 - *An object so closely fused that even Degas thought that the leaves had been placed in the glass (Rewald, PPC, vol. 1, pp. 284-5).*
234 - *I am unable to explain the object in the upper right corner, however; it resembles the swirl in Assiette de pêches, above, but that does not tell us what either of them were. Visually, it does perform a role, since it fills a gap that would be felt if the space had been left empty.*
235 - *Fry reserved some of his most poetic writing for this picture. Looking back, we can see it as embodying all that he needed to say about art to an unsophisticated audience, and as requiring him to compress much of what he thought of Cézanne's development into the description of this one painting. If I have made similar observations, I have been able to attach them to different periods and other paintings. His entire passage is recommended, but this excerpt conveys its tone and substance:*

One might be tempted to see this picture as a kind of essence of Cézanne's discoveries about painting so far, as Fry did, and the temptation would be hard to resist. I prefer to see the painting only as one pole of his work, however; as a splendid and hard won position. This firm a touch, as I said, is reserved for only some of the still lives; several others are done in a less insistent touch, and some, perhaps half of those from this period, are not done in a distinct parallel touch at all. I can see from my own hard work in looking at this still life that this kind of synthesis required much hard work and self-denial on the painter's part; it needed a selection of the simplest objects, a denial of the pleasure of line, an intense intellectual calculation. Some fifteen years later – as in the still lives discussed in the Introduction – he would achieve even greater complexity with simpler and more effective means. For now, at this level of his development, the hard work and the denial required some respite. He found it in paintings of flower arrangements, in a return, that is, to the comfort of painting objects whose appearance, sensuous or complex, was reason enough to paint them.

**LE VASE
BLEU SOMBRE, II**
(R473), ca. 1880,
32 x 27 cm.
Private collection, USA.
Volume 1, n° 197

One can almost feel the painter's pleasure in assembling a few peonies in a vase, finding a background for them that would complement their color, and beginning to paint without the weight of the world sitting on his shoulders. However fanciful the expression, the relief in painting something beautiful in itself, and perhaps even frivolous, must have been palpable. Of three related arrangements in a dark vase, *Le Vase bleu sombre II*, is the most sensuous and delicately realized; nearly symmetrical (but not quite: the leaves push off to the right), it requires little additional balancing, and it needs only Cézanne's gift for color to transform it into a minor jewel. We can think of the colors in terms of complementaries – pink against green, and in the background a Naples yellow against a pale grey/blue – but we can also simply experience them directly: the delicate interweaving of the grey/blues and the pinks in the peonies, the warmth of the yellows in the green leaves, and the luminescence of the peonies against the dark vase. We can also conjure up memories of Chinese vases – the comparison is with the whole arrangement, not the vase itself – which seem heavy and awkward too high up in their body yet could not be altered without trivializing them or destroying their balance.

Located at some half-way point between relatively complex construction and undemanding portrayal are two closely related still lives from the latter half of this brief period[236]. Even if only one of them remained, we would be struck by the originality of the conception: the asymmetry of the composition and the close fit of the colors of the flowers with the background. But we have two versions, and each offers a different

"The question of material quality depends, of course, to a great extent on the artist's 'handwriting', on the habitual curves which his brush strokes describe. In his earlier works, as we have seen, Cézanne affected an almost florid and exuberant curvature modeled upon that of the Baroque painters, but, one has to admit, without ever attaining to their elegant incontinence. It was, one may suspect, the expression rather of his willed ambition than of his fundamental sensibility to form. Under Pissarro's influence he holds himself in. The new conception of external vision which he was practising evidently absorbed his attention, and he became of necessity far less conscious of his handling. He had, as it were, to leave his hand to manage, as best it could, to convey the ideas he was intent upon. His gestures, in consequence, were more restrained. In this still life the handling has recovered something of its older spirit, but it remains far more restrained and austere. He has adopted what we may regard as his own peculiar and personal method. He has abandoned altogether the sweep of a broad brush, and builds up his masses by a succession of hatched strokes with a small brush. These strokes are strictly parallel, almost entirely rectilinear, and slant from right to left as they descend. And this direction of the brush strokes is carried through without regard to the contours of objects. This is the exact opposite of Baroque handling. In Rubens, for instance, what strikes us is the vertiginous rapidity and dexterity with which his hand adapted itself to the curved contours of his forms. The grave, methodical but never lifeless handling of Cézanne's Compotier is the exact antithesis to that.

"We have already guessed, behind the exuberances of Cézanne's Baroque designs, a constant tendency towards the most simple and logical relations. Here that simplicity becomes fully evident. One has the impression that each of these objects is infallibly in its place, and that is place was ordained for it from the beginning of all things, so majestically and serenely does it repose here. Such phrases are, of course, rather fantastic, but one has to make use of figurative expressions to render at all the extraordinary feeling of gravity and solemnity which the artist has found how to evoke from the presentment of these commonplace objects. One suspects a strange complicity between these objects, as though they insinuated mysterious meanings by the way they are extended on the place of the table and occupy the imagined picture space....

236 - The diamond pattern suggests the stay in Paris after the year spent in Melun, like the self-portrait, R482 (p. 127).

**FLEURS DANS UN
VASE ROUGE** (R476),
ca. 1880-81, 46 x 56 cm.
Private collection.
Volume 1, n° 201.

**FLEURS DANS UN
VASE ROUGE** (R478),
ca. 1880-81, 47 x 55 cm.
The Norton Simon
Foundation, Pasadena.
Volume 1, n° 202.

**STILL LIFE
WITH CANDLESTICK**
(C553), ca. 1881-84,
13 x 20 cm.
Kunstmuseum, Basel.
Volume 1, n° 199.

solution to the question of integrating figure and ground. The still life with the simple rectangular background (the object is unclear) relates the flowers to an object that belongs more to the painted world than the real one; the truncated vase has no physical support and might as well float in space. We are in a world defined by Cézanne, one where the thrust of the vase to the left is only balanced by the rectangle's pull to the right. The color harmony is one of only secondary colors - greens and red-browns - and while it is less obvious and less appealing than one made of primary colors, it works perfectly well, thanks to the close unity of the bouquet and the ground; and it is balanced by a few cool blues and pinks[237].

The second still life has essentially the same bouquet[238], gently rearranged, and is of the same size. Here - in R478 - the bouquet becomes one with the apartment's wallpaper. This, too, is an original construction, even though its beginning was probably a visual response to finding an interesting placement of the vase in front of the pattern. The wallpaper was probably light olive-brown, to judge from the self-portrait on p. 127 and another still life, R479, and both the color and the diamond shape were reflected in the colors and forms in the bouquet. If the harmony of the bouquet and the wall was a kind of given, Cézanne's use of the wallpaper pattern became vehemently willful. The pattern was made to extend, fill, and balance the vase of flowers. Cézanne retained one sharp V from it (it was continuous, of course), and made us see the flowers as splaying upward while calling attention to the neck of the vase and its notches; he used the cross shape to fill the empty space on the left; and he balanced the heavy left side with two cross shapes on the right. To do all that, parts of it had to be suppressed - the diamond lines eliminated, the fleur-de-lis pattern turned into an abstraction -but nothing, I think, would have been invented. The promising knot of correspondences between the bouquet and its context was progressively refined and clarified in the painting. The parallel touch, by the way, here became barely noticeable, appearing more as a habit than a structural force.

If we turn to drawings and watercolors for confirmation of these developments, we will be disappointed. As with the other works on paper, and for much the same technical reasons, the parallel touch had no specific place in representations of still lives. But the drawings and watercolors are often wonderful works in their own right, though for other reasons. As difficult as they are to date securely, the drawing *Still life with candlestick* is probably from this period, and is without question an example of Cézanne's concern with structure, that is, in this instance, with the objects' interconnections in space by whatever touches will create depth. This drawing may or may not have been intended as the middle part of a larger composition, but it could work both ways, given how it centers the convoluted candlestick and the edge of the spirit stove against two very simple round containers. The candlestick dominates by its position and above all its undulating outline, which Cézanne draws with a kind of loving emphasis and forced asymmetry. The other shapes being simple, the drawing merely explores their volumes and the spaces between them. Quick soft-pencil hatchings define nearly everything: curvature, shading, reflections, and empty space, depending on where they

237 - *The color pink, although in pigment derived from red, in fact seems cool. Anyone who has attempted to lighten a red pigment by adding white will have felt a sharp disappointment when the mixture turns pink. To retain some warmth, yellow would have to be added at the same time, but the color would then tend toward orange-pink. There is, in short, no light red, as there is, for example, a light blue.*
238 - *Rewald must be right that the flowers were probably made of paper; one cannot imagine real flowers surviving the time it took to paint two such thoughtful paintings.*

TROIS POIRES
(RW196), ca. 1882,
13 x 21 cm. Museum
Boymans-van Beuningen,
Rotterdam.
Volume 1, n° 200.

are used, and they do so clearly, simply, and perhaps intuitively. Watercolors, like the drawings, stand apart from the developments in oils. *Trois poires*, which seems safely located within this period, is straightforward in its use of color: the hatchings define the color of the wall, the table, the pears and their shadows, and what appears to be a napkin with a red stripe. They do more, of course. As colors, they not only indicate the local hue but they weave together as in a fabric: the blue background contains green patches, the table blue ones, and the pears are modeled by a progression from olive to blue-green. However satisfactory the result, it does not come close in complexity to any of the oil paintings of this period, and the color use seems, by Cézanne's own later standards, relatively safe. The composition is idiosyncratic, however: the stems of the pears lean rakishly to the left, in the same direction as the receding table edge, and create a tense uncertainty about whether the direction is backward in space or merely leftward.

The half-decade that I have described was defined by the vicissitudes of the parallel touch. The touch is so original for its time, so well known now, and so easily taken for a signature style, that it inevitably becomes the focal point of any discussion of this period. But it should not be mistaken for its subject. I cannot emphasize enough that what defines Cézanne's development is a search for ever deeper integrations, integrations for which words seem just short of adequate: of vision and system, for example, or of impulse and reason, of subject and style, or even of just the painting's surface.

The parallel touch was a stage in that development, and in the balance between the eye and the mind it was closer to the pole of mind, or perhaps more precisely to mind restrained by attentive vision. It was the vehicle for that vision and it was the instrument that evokes the emotions we experience before his paintings. But the balance itself shifted inevitably, even during the five years we looked at. We have seen the touch abandoned only after a few years in narrative paintings, portraits, and still lives. In portraits, what got in its way was individuality and even tenderness, and in still lives, it was most likely the sheer intellectual effort and the ascetic denial of sensuous color and line. The touch probably failed to serve him in narrative paintings for the same reason that it served him so well in landscapes: it was ultimately a medium for translating complex, visible relationships and textures.

The following decade will see a more supple relationship between the dictates of style and those of vision, only to culminate in the brilliant styles of his last decade, styles which will transcend the parallel touch in originality and express the painter's vision with a just balance of structured touch and incandescent color. But the immediate decade that follows is also one of personal disappointment and emotional retrenchment, and reveals new and sometimes paradoxical connections between his life and his art ■

Maisons en Provence
(la vallée de Riaux près de
l'Estaque)
(R438, ca. 1883-84, detail).

1885-1895

From mid-life crisis to renewed vigor

....1885 - another of the points at which the direction of his work shifted, and evidently the time of an emotional reverse as well. It was a stage in Cézanne's progressive process of sublimation[239].

Paul Cézanne in about 1890.

A painter's work - its substance, its style, its emotional tone - will inevitably reflect his personality. The influence can be striking or subtle, life-long or temporary, and no rule will account for the form that it will take[240], but several examples easily come to mind where the influence is dramatic and pervasive. Rubens, for example, an unusually robust and well-balanced person, is visible in his work in the sensuality of his touch and in the honest and forthright stance he takes toward human events and the human form. Mondrian, on the other hand, himself fastidious, ascetic, and tightly controlled, finds a perfect expression for his personal structure in his abstract work, which is precise and abstemious, far from the messiness of life. Or Picasso, of variable disposition and more impulsive than disciplined, reveals himself in his vivid responses to external events - in recording his emotional state on particular days or in changing his style after every important change in his intimate relationships.

In Cézanne's life the connections were subtler and depended on the stage of his development. In his first decade as a painter an uncommonly powerful temperament competed for expression with the emotional constrictions of his upbringing; his work reflected the opposed pulls of these two sides. But it also reflected something more complex: an abiding search for styles appropriate to his subjects. This was more purely an artistic impulse, one that helped him transcend the simpler dilemmas of his character. In giving his various subjects form, he seemed to be searching for a personal evolution as well, that is, for a progressive imposition of self-control on his animated emotional life. Later, in the early 1870s, his personal as well as artistic development was affected by the calming effect of the more mature Pissarro and the emotional satisfactions of his attachment to Hortense Fiquet and their son.

Still later, when he was in his late thirties, his character seemed to be submerged in his art; his search for consistent styles became ever more resolute, and his mastery of several of them, particularly the parallel touch, was so central to his work that we could no longer see his character expressed in it. We did not think of inquiring into his emotional life, perhaps because we saw no specific disturbances; on the contrary, we saw a relative stability, and (in his portraits) evidence of a tender attachment to his son and a not unsatisfactory relationship with Hortense. The intense development of his art from his late thirties to about his mid-forties both required and reflected this stability.

Between 1885 and 1886, however, his equilibrium was disrupted, his character became visible in his letters once again, and his painting changed; the change was admittedly in part intrinsic and developmental, but in part it must have been precipitated by the crisis. He confessed to being anxious and unable to concentrate; in 1886, in an intimate letter addressed to Chocquet, he was resigned and disappointed with his life. By 1887 or 88, with his painting firmly in hand and the crisis apparently passed, the person seemed to recede behind his art again; the one letter that might have revealed him - written in 1889, to Choquet - is formal and distant. Reports of his state of mind between then and 1896 are inconclusive: early in 1891 his friend Alexis writes that Cézanne is "expansive and alive" (although furious with his wife and happy to live with his mother and sister), but another friend, Coste, writes only one month later that Cézanne "has become more primitive and younger than ever". He adds, "It is one of the most touching things I know, to see this good boy holding on to his childish

240 - For illustrations of other relationships that may exist between the artist's personality and his work, see Gedo, Mary M., (ed.), Psychoanalytic Perspectives on Art. For an in-depth study of the effect of painters' cognitive styles on the styles of their painting, see my Style and Psyche: The Art of Lundy Siegriest and Terry St. John; and for a more general investigation of personality in relation to art, see my Painting and Our Inner World: The Psychology of Image Making. For studies of the three painters I mentioned, see Christopher White, Peter Paul Rubens: Man and Artist; Peter Gay, Art and Act (chapter on Mondrian); and Mary Gedo, Picasso: Art as Autobiography.

naiveness, forgetting the disappointments of his struggle, and, resigned and suffering, relentlessly pursuing work that he cannot give birth to."[241] Nevertheless, the innovations in Cézanne's painting during these years seem independent of the little that can be seen of his life. And he re-emerged vividly as a person only in 1896: he then became acquainted with the poet and son of a boyhood friend, Joachim Gasquet, and he revealed himself once more in his letters. By then his art, more free and innovative than at any other period of his life, was a sublimation whose form followed its own course.

Let us return to the crisis of 1885 and to the changes that took place in Cézanne's art. The crisis is announced in his letters without warning: in the Spring, while in Aix or l'Estaque, he writes a love letter. It is a draft only, on the back of a drawing, so we do not know if he sent it, but the intended recipient is believed to have been a maid in the Jas de Bouffan household. He writes that she had allowed him to kiss her, and that since then he has been troubled by a profound torment which he hopes he has the right to confess to her. The declaration breaks off abruptly at the bottom of the sheet, before Cézanne had revealed what he intended to do, but he makes himself clear in a letter he addressed to Zola shortly after, asking him to receive some mail for him in Médan in the north; he was going north, or being sent off by his family, but he wished to continue the contact at least by correspondence. He settles briefly in *La Roche-Guyon* – close to Médan, where Renoir happens to be staying – and contacts Zola regularly, asking if he can stay with him and if there had been any mail. Presumably there had been none, but he also confesses that "he had been an idiot" and forgot to pick up Zola's letters at General Delivery. By August, after a restless two months, he is back at Jas de Bouffan and begins painting in nearby Gardanne.

We would be right to see his return as a defeat; Cézanne as much as confesses it in his note to Zola in August: "…for me, there is only the most complete isolation. The brothel in town, or something like it, but nothing more. I pay – the word is dirty – but I need rest, and at this price I deserve to have it."[242]

His relationship with Hortense had obviously been distant, but the distance was not uncomfortable; now an infatuation seemed to promise him hope and relief, but it was no sooner promised than it was blocked. The impediments were in part external – his family's expectable opposition to an entanglement – but also and more importantly internal: we saw that he was ambivalent about picking up his mail. After a few months of work in Gardanne, in April 1886, he marries Hortense, probably at the insistence of his sister Marie. This legitimizes his son and settles the future inheritance while the father is still alive – and the marriage is timely, from that point of view, because the father does die about six months later, at age eighty-eight.

More had happened, however. Zola had not written to him since the *La Roche-Guyon* episode, and this should have served as a sign of some cooling. Cézanne did not seem to notice it, and only when he received a copy of Zola's *L'Œuvre* in April 1886, which was just off the press and told the story of an artist-suicide who was modeled in part on Cézanne, did his feelings suddenly become clear. He wrote his boyhood friend a brief and distant thank-you – and wrote no more. His marriage took place only a little later that month.

He described his state of mind in the letter to Chocquet that I had mentioned, and, to anyone who knows his earlier correspondence, his tone was radically different. It was a measured, sad tone, not the jaunty, lively tenor of most of his previous correspondence.

241 - *Alexis' and Coste's letters are quoted in Rewald's* Correspondance, *the French edition only, pp. 234-235; my translation.*
242 - *Letter of August 25, 1885; my translation.*

The letter says, in part: "Now, I would not wish to weigh heavily on you, I mean in the moral sense, but since Delacroix has been our intermediary, I will let myself say this: that I would have wished to have the intellectual equilibrium that characterizes you and lets you attain the goals you seek.... Fate has not put similar gifts on my plate, and it is the only regret I have among the things of this earth. As for the rest, I cannot complain. I am always attracted by the sky and the boundless things of nature, and they give me the opportunity to gaze at them with pleasure.

"As far as realizing my wishes for the simplest things is concerned, which should come about by itself, an unfortunate fate has decided to thwart my success, because I did have a few vines, but unexpected frosts came and cut the thread of my hope.... I can only wish you success in your plantings and a beautiful growth for your vegetation: for green is the most happy color and the best for the eyes. To conclude, I must tell you that I am always painting and that there are treasures to be taken away from this land; it has not yet found an interpreter worthy of the riches it offers."[243]

During the period that begins in 1885 and for a year or two after, some of the changes in Cézanne's art follow his emotional state. His landscapes, in spite of his insistence that he is happy painting, seem drained of their normal passion and his touch is occasionally listless; in and around Gardanne his landscape subjects favor arid architecture, and the two portraits he does there are stiff. There are more wintry subjects with bare trees and even the occasional lone tree. He turns again to the intimacy of still lives, after the long hiatus of the previous period – and the first small paintings, often arrangements of just a few fruits, have neither the affirmativeness of the ones that preceded them nor the magnificent expansiveness of the ones of his ultimate phase.

If there is a constriction of subject and form in some of his work, in other work assigned to the period there is none, and we do not know whether this is because his mood may have been more buoyant at times or because the paintings may have been dated wrong. Some of the changes in his art had certainly been prepared earlier and have nothing obvious to do with the crisis; for example, the tight, full-paste parallel touch became looser, being applied in liquid paint with a quicker rubbing motion, and this loosening may have had its own logic to pursue, and may have begun earlier. What we can say safely, judging from the landscapes, is that by about 1888 the crisis was over and Cézanne had regained his density and vigor as a painter.

Although it is right to see this as a reestablished equilibrium, it is that of an older and less buoyant man, one often suspicious even of his old friends and colleagues; it is the equilibrium of the painter, not the man, of the person who, although less and less able to cope robustly with daily life, can turn to painting for support, peace, and ever more originality of thought and expression. It is an equilibrium that, by 1888 or 1890, makes possible figure paintings such as *Le grand baigneur* (p. 146), landscapes such as those done at *Chantilly* (pp. 156-157), figure studies such as *Mardi gras* (p. 169), and still lives such as *Pot de gingembre* (p. 189). It then makes possible the efflorescence of about 1895: a new intensity of color in his paintings, a secureness of the hand, and above all a fertile balance between the closely focused eye and the thoughtful, inquiring, logical mind. That point will mark the beginning of the next phase. We will have a sense for Cézanne the man again, but it will be a man whose age and instability, which he confesses fully in his letters, will be eclipsed brilliantly by the passion and inventiveness of his painting.

243 - *Letter of May 11, 1886; my translation.*

NARRATIVE PAINTINGS

There is little hope of finding a specific effect of Cézanne's crisis on his narrative paintings, because he seems to have painted only two canvases of bathers in the broad gap between 1882 and 1887: the rigid *Cinq baigneuses* from the previous chapter (p. 112) and *Femme nue*, below, which Rewald dates 1885-87, which is light in its touch. The most we can say is that narrative paintings were done in the lighter touch at about the same time as the others; but there are very few such paintings during this decade in any case: only about 30 – mostly bathers – as against about 220 of all the other kinds, which include nearly 100 landscapes and about 60 still lives.

Cinq baigneuses had signaled a return to painting bathers after a three year hiatus, and *Femme nue*, perhaps painted only a little later, is part of that return as well. It is a puzzling painting with which to open the discussion of this period, because it stands

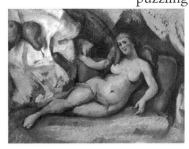

FEMME NUE (Léda, II)
(R590), ca. 1885-87,
44 x 62 cm.
Von der Heydt Museum,
Wuppertal.

Volume 1, n° 204.

alone and introduces no new direction, but it does exemplify the stylistic relaxation of the middle of the decade. The touches, although laid down in parallel, are less insistent. The best point of comparison is with the earlier *Léda au cygne* (p. 110): it is the same subject and the same figure, but now we see an emphasis on outline rather than on the touch. The puzzling matter is the painting's purpose: the swan has disappeared and a still life has replaced it in the upper left corner, upside down. It is not the beginning of a new painting – a new composition would be sketched over the whole canvas rather than begun, and finished, in the corner – but an upside down addition to this one, with the edge of the tablecloth where the swan's neck had been and the familiar pink stripe perfectly parallel to it. Léda's modest cloth has been in part painted out, too, and her modesty replaced with an abstract division between the legs. I think that for once Cézanne has allowed a process of condensation and displacement to operate, and it is possible – but only possible, because we cannot be sure of the date – that he did so under the pressure of the crisis that he was going through. The two pears are after all bisected by the pink stripe, that is, by a line with the shape of the swan's phallic neck, suggesting sexual entry; and if so direct an allusion is unusual in Cézanne, it is not unheard of, and does occur once again in an otherwise perfectly proper still life. There (*Nature morte*, p. 183), a pear sits astride the edge of a plate in a position that would be merely awkward for a pear but is genuinely uncomfortable for human buttocks, which, for once in his work, it resembles. *In Femme nue* Cézanne complicates matters even more with a rainbowlike object that bridges the tablecloth and Léda's hair: formally a useful shape, but with no obvious meaning.

If the private symbolism of *Femme nue* suggests an overwrought response, other narrative paintings of female figures are more straightforwardly seductive. The dates proposed for them are so broad – 1885-90 – that they tell us nothing about the progression of Cézanne's thought or style, but the paintings' intense color and thin touch argue for a date well after Femme nue. They include three paintings of Bathsheba – not merely a figure for us to look at but a subject whose whole point is erotic looking – and one of a woman at her toilette before a mirror. All of the Bathshebas are being attended by a dressed woman, and two of them are sprawled before us, as in the version reproduced here. What strikes us, given the voyeuristic subject, is that the colors are fresh and happily balanced, and that the flesh tones are unusually delicate: here, a pastel harmony of oranges, blues, and barely perceptible pinks. The fluid, curving outlines are vigorous and technically self-assured, and it can be said that both the touches and the colors are those of a painter who, at least in this small format, fully accepts his wish to gaze, and takes pleasure in it.

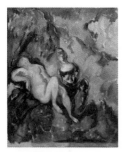

BETHSABÉE (R591),
ca. 1885-90, 29 x 25 cm.
Musée Granet, Aix-en-
Provence.
Volume 1, n° 203.

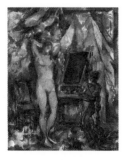

LA TOILETTE (R594),
ca. 1890, 32 x 24 cm.
Barnes Foundation,
Merion, PA.
Volume 1, n° 205

SIX BAIGNEUSES
(R588), ca. 1887,
33 x 44 cm.
Private collection,
Switzerland.
Volume 1, n° 207.

The wish and the pleasure are satisfied equally well in the little painting he does after Delacroix's *Le Lever,* where he paints the woman not so much at her toilette as simply admiring herself in the mirror. Cézanne's voyeuristic wish is more straightforward than his predecessor's: Delacroix's painting had more of an elegant veneer, justifying the position before the mirror by having the woman adjust her hair, and placing her elbow so as to cover one breast. But if Cézanne's subject is less modest, his form is without question happy and attractive; like *Bethsabée,* seen on the wall of a museum the painting rivets us by its colors even before one has recognized the subject. Warm oranges and crimsons vie with cool blues and greens to give the painting a harmony that is as rich as it is complete, and vivid scraps of color and short dashes of dark outlines, most of which indicate nothing in particular, invite simply a passionate visual investment, like the painter's. The secure ease of these detached scraps and dashes suggests a work well past the mid-eighties, certainly closer to 1890.

It is the small format that makes it easier for Cézanne to paint with so direct an erotic investment. Whether the small size felt more intimate to him, or whether the painting was not intended for public showing, is unclear; what is clear is that neither of these subjects was ever made into a larger painting. If we attempt to imagine how such a larger picture might look, we come up, I think, with the uneasy sense that Cézanne would have worked hard to give it a consistent surface - as he did with *Femme nue* - and lost all the spontaneity of the small painting; at this stage in his development no room would have remained in a finished surface for flecks of unjustified color or fragments of sketchy outline. The problem will be partly solved later in the decade; in some of his large, finished bather groups he will leave room for saturated colors and cursory treatments.

Intense color returns, then, in the late 1880s. It returns to compositions of bathers whose origins we have seen in earlier pictures, but which now become more saturated and complex in form, more narrative in subject and more ambitious in scale. An example is *Six baigneuses,* a painting whose execution is happy and persuasive, and which resembles the earlier *La lutte d'amour, II* (p. 111) both in its light touch and the alternating diagonal movements of its figures. The touch here is slightly curved and quite transparent; the colors are once again intense. Like the two nude figures, this painting seems the product of a restored equilibrium, and like them it is a quick, first lay-in; what is new is the intensity of the color and a conception that suggests a broad narrative; there is also a more ambitious integration of the figures with their sylvan setting. The tree on the left, for example, is both more natural and more closely integrated with the figure standing at its base; the painting seems like a successful study for an effective, large composition. As it turns out, however, his large compositions - the late large bathers - will be integrated quite differently; they will be schematic again, but their large scale and intense color and forceful composition will justify that. Here, in *Six baigneuses,* we are witness to a clear return of his Venetian ambitions and a splendid illustration of what fulfilling them might have looked like if he had succeeded in translating the playful vision into a large format.

One can read a similar ambition into the nervous and luxuriant *La Préparation du banquet,* which must be nearly contemporary. It evokes a curious sense of the familiar leavened by the new. The figures might have been bathers in past compositions and will certainly be bathers in future ones; the exaggerated opulence of the setting and the impossible size of the amphoras and the still life objects recall the excesses of *L'Orgie;* and the parted canopy attempts the kind of control over an overwrought scene that we saw

in *L'Eternel féminin*. But the drawing remains fresh and quick and the colors are delicate, balanced, and laid down as lightly as watercolors; the painting is as sensuous in its form as it was intended to be in its subject. As much as we would have welcomed a successful translation into a larger format, however, we may wonder if it would have been possible. As with the two single figures above, there would have been a loss of spontaneity in the surface; Cézanne would surely have felt the need to organize it more formally, and he would have found it difficult to leave so much of the surface blank. But perhaps the difficulty would have been inherent in the format and altogether independent of technical questions: a large format invites, I think, too serious a statement from the painter. The sense of light irony, which I think is meant to leaven the opulent sincerity here, would be lost; even the lightest Venetian touch would not prevent a larger version from carrying too much rhetorical weight. If Cézanne translated so few such scenes into large paintings, we may presume that he was aware of the problem.

LA PRÉPARATION DU BANQUET (R640), ca. 1888-90, 45 x 53 cm. Osaka National Museum of Art.
Volume 1, n° 208.

An illustration of the problem is at hand. The contemporary *Quatre baigneuses*, which develops from a series of earlier bathers with a culminating central figure such as R363 (p. 77), is a finished painting and an unusually large one. Here, the central figure no longer points across her chest but stretches her back, or rather exhibits herself to an admiring friend. Everything about the painting is carefully worked out: her dominance, which is carefully established by her luminous skin; the unity of the figures' arrangement, which is achieved by the various parallel orientations; and the fit between the figures and the background. Connection to the background is guaranteed both by the direction of the individual touches - parallel to the central bather - and by their grouping, which follows the slope of her shoulders. (The touch appears like a reversion probably because the background was invented and its only purpose was to resonate with the figures.) The colors themselves are carefully integrated: the skin tones contain just enough pink to detach them from the background, but also enough browns and blues,

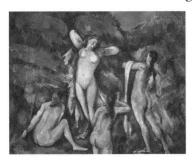

QUATRE BAIGNEUSES (R667), ca. 1888-90, 72 x 92 cm. Ny Carlsberg Glyptotek, Copenhagen.
Volume 1, n° 206.

which they take from the earth tones and the sky, to connect them. It is a most thoughtful work and a splendid achievement - but whatever movement it retains, it has paid for in lightness and spontaneity.

I must emphasize that the price is technically inevitable, because large size itself is akin to a somewhat raised and resonant voice, and that the price may be well worth paying, depending on one's purposes. But surely continuing to use the parallel touch for ordering the larger surfaces - and we must remind ourselves that in narrative paintings the touch is used for ordering, not representing - would raise the price. I have argued that soon after its first use the parallel touch came to interfere with representation in all paintings but landscapes, and now the parallel touch raises another problem: that of expression, or more exactly the translation of expression from one format into another. Once again we can only presume what Cézanne thought from the evidence of the paintings, but in *Quatre baigneuses* we have one possible response to the dilemma: scumbling. In the drapery behind the central figure, to our left, the paint is smeared irregularly; this is a way of maintaining a seemingly careless freshness and emphasizing, or reintroducing, the vigor of the painter's hand.

Scumbling is a technique he will use seldom, generally at the beginning of some of his late paintings and only in portions. But it is a powerful instrument when used consistently, and its power is clearly evident in one finished figure painting: in the monumental *Le Grand baigneur*, where it is Cézanne's technique of choice and where it fits perfectly the rhetoric of the format. If one wished for a single example to

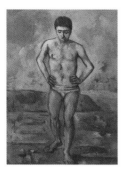

LE GRAND BAIGNEUR
(R555), ca. 1890,
127 x 96,7 cm. Museum
of Modern Art,
New York.
Volume 1, n° 209.

demonstrate how deeply Cézannian a painting can be without recourse to any of his systematic touches, this painting would serve. It is scumbled throughout, sometimes to paint out an inconvenient bit of background, at other times to give the background a solidness in paint that it does not have in reality. It locates the figure firmly on the canvas surface, even in the sky, and on either side of the legs it emphasizes their carefully sculpted outline. The scumblings allow Cézanne to remain focused on what is essential: the dynamics created by the forceful asymmetry of a normally symmetrical body. Its elbows create a diamond that points up to the left and down to the right; the shoulders are inclined similarly; the head is elongated toward the upper left as well; the hands and feet are large, dark, and firmly drawn with angular outlines that point down to the right; and even the right nipple, drawn as a large diamond, moves along this diagonal.

A single figure is inevitably to some degree a projection of the painter, if not in physical resemblance then in psychological state[244], and here we respond as strongly to the projection as we do to its technical achievements. But in the absence of any relevant evidence, just what Cézanne might be projecting must remain a guess. The painting is surely closer to 1890 than to 1885, the date usually assigned to it[245]; nothing so bold in conception or technique would have been painted within a few years of the crisis of 1885, but a similar boldness begins to appear in still lives and portraits from 1889-90. The painting could reflect some aspect of the painter's view of himself at the age of fifty or perhaps an identification with his son, aged seventeen to eighteen, but nothing in the record tells us what that might be[246]. There are, however, qualities that Cézanne brought to this figure that give it a clear psychological cast. *Le Grand baigneur* was painted, as is well known, from a photograph of an academic model, but there is a balance, grace, and musculature here that are entirely supplied by Cézanne. They help relieve the oppressive sense of him as unable to cope with life; the figure is fully as large as the figures in the late *Grandes Baigneuses*, but here it stands alone and is therefore larger in its frame. The well worked out and solid bottom half of the frame implies a man with his feet once again firmly planted on the ground, while the bowed head is thoughtful or perhaps hesitant, and the forward step into the water is a venturing forth; but these are merely metaphors for a profound response to the painting, a response which we should acknowledge in ourselves at least, in the absence of a record of Cézanne's intention.

This exceptional work stands alone by its subject, its size, and its pure, scumbled surface; nor does it fall neatly into the otherwise coherent category of narrative paintings. If we knew more about the circumstances of its execution, we might be able to relate it more closely to his other work, but for now we must simply see it as unique and psychologically crucial. His other narrative work continues as in the previous period, with bathers; the proportion has changed, however, there being more male groupings than female. Of the ten groups of male bathers, almost all develop from the composition we had seen in *Cinq baigneurs* (p. 110), that is, one figure left of center (the one presumably based on the Signorelli drawing) standing upright and seen from the back, another right of center twisting its shoulders sinuously, and then others variously sitting or partly submerged; it is in the others, and in the kind of vertical support that Cézanne gives the groupings near the center, that the pictures differ. With one exception the paintings are quite small, and, as we have come to expect, the smaller they are the freer is their touch.

244 - *See E. H. Gombrich in Julian Hochberg's Art,* Perception, and Reality, *and Meyer Schapiro,* Cézanne, *p. 68.*
245 - *Rewald,* PPC, *vol. 1, p. 375.*
246 - *Cézanne does, however, paint other portraits of adolescents between 1888 and 1890 - Cézanne fils (Arlequin, p. 170), Walter Guillaume (Mardi gras, with Cézanne fils, p. 169), and Michelangelo di Rosa (Le garçon au gilet rouge, p. 171); this underscores the importance of the theme of adolescence, but it does not tell us in what way Cézanne's feelings about himself might be involved.*

In *Baigneurs en plein air*, a medium-size painting finished with a careful touch, the brushstroke is short, straight, and diagonal, oriented in both directions, and in this it follows the diagonals established by the upper arms of the figure with the towel and the forearms of the one that twists his shoulders - and of course the branch of the central tree. The composition seems to have developed in stages, in response to a problem; it apparently started with four figures, spaced at rhythmic intervals, and the central figure was added later. If I picture the painting without it, it seems to divide into two halves, requiring something in the center to unite them. But the space left for the fifth figure was too small, so Cézanne painted him in less noticeable tones and left him in part transparent; the painting does come together now, but the figure remains a compromise. That this comment comes to mind is in fact a reminder of what this painting and the others like it are about: not about bathing as an event, but about the art of creating compositions, that is, about establishing satisfying, rhythmical, relations between the figures on the canvas.

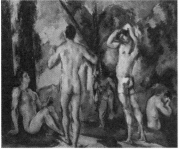

**BAIGNEURS
EN PLEIN AIR** (R748),
ca. 1890-91, 54 x 65 cm.
Hermitage Museum,
St. Petersburg.
Volume 1, n° 210.

In larger and more finished bather compositions Cézanne's search for formal connections becomes more insistent. *Baigneurs*, also from about 1890, is ambitious: no less than nine figures can be clearly seen and there is the suspicion of a tenth one. The nine are disposed rhythmically on either side of the tree just off-center, and, to make so large a grouping work, Cézanne feels safest in arranging them in a symmetrical shape. This seems a good choice: it compels him to incline the outer figures diagonally, so that the one at the extreme right seems ready to run or plunge, and it makes him invent a comparably athletic figure in the center background; the otherwise formal composition comes alive with dynamic tension. Here the two figures in the center have been given ample room between the large figures, and the tree that towers above them has been painted in white so as not to crowd them.

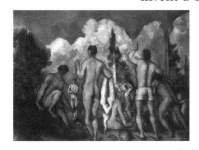

BAIGNEURS (R665),
ca. 1890, 60 x 81 cm.
Musée d'Orsay, Paris.
Volume 1, n° 212

Our response to these paintings cannot help but be formal; we follow Cézanne's calculations of space, rhythm, and balance, as it were. If he chooses not to have a tree in the center, for example, he will have to shift the weight to one side or the other; so in another version (R666, not shown) he will extend the tree on the left all the way to the top and lead us there diagonally from the lower right corner. The variations could be infinite, and it is not clear how Cézanne would have decided which ones worked well and which ones did not. With the *Baigneurs* painting above, my own response is unmixed: beside the satisfactory composition, he has created a luminous surface with sensuous colors, well balanced between the cool cobalt blues and the warm orange pinks and reconciled by the dull greens. It is a simple harmony, one easy enough to borrow from his southern landscapes but all the more admirable because it is difficult to bring off in precise shades in an invented scene.

Only three paintings of women bathers are ascribed to this period after the unique *Quatre baigneuses*, all much broader than they are tall, and each suggesting a narrative; they explore new, larger groupings of figures, as if, released from an obsession, Cézanne had more freedom to innovate. Two of them assemble a group that will reappear in the Barnes Foundation *Grandes Baigneuses* (R856, p. 207), but it is the third one that is the most interesting, because it is as exceptional among the female bathers as *Le Grand baigneur* was among males: the figures are new (or freshly handled) and they are assembled in an original way; the colors are muted; the touch is more like dabs of the brush than dragged strokes. Since this painting, *Groupe de baigneuses*, has no precedent in Cézanne's work, not even in pencil or watercolor studies, it is in the nature of an experiment, but given the size of the painting the experiment is a serious one and

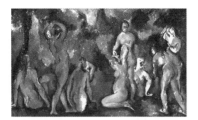

**GROUPE
DE BAIGNEUSES** (R751),
ca.1895, 47 x 77 cm.
Ordrupgaard Collection,
Copenhagen.
Volume 1, n° 211.

we have to wonder all the more why it has no progeny. One's immediate impression is of a graceful disposition of volumes; the bodies are well anchored on the ground, their weight is as well distributed as must be in balanced sculptures, and the women are well proportioned and move naturally in relation to each other. The abstract setting for their movements itself pulses with harmonious volumes and voids, quite unlike some of the structured, even forced, vegetation that we normally see, and the short touches with which it is rendered let it stay in place rather than moving nervously about. Most remarkable are the pastel tones - tones made necessary by setting half the figures in the shade, where the modeling is muted and the volumes are flatter. I am hard pressed to think of a bather painting to which so little drama has been added and in which there is so little tension.

The date assigned to the painting, c.1895, seems reasonable in view of the originality of its conception; dating it by style would be difficult, however, because in that respect it is unique. So is a small narrative painting - a small sketch for an *apotheosis of Delacroix* - that Cézanne was photographed working on in 1894 and had had in mind since the late seventies. It is quite different in style again, but this is probably because it is small and sketched in without correction. In it, Delacroix is being borne to heaven by angels and applauded from the earth by Cézanne and his friends; clockwise from the easel they are Pissarro, Monet, Cézanne, an unidentified kneeling figure, and Chocquet[247]. It is therefore as much an homage to the friends as to the admired painter. It is a paradoxical work: on the one hand, its subject has been copied almost literally from a watercolor from 1878-80 (to serve as preparation for a major work, which Cézanne never painted), and on the other it is as vigorous and fresh as if the painter had just thought of it. It is important to us much in the same way as the drawings, because it

**APOTHÉOSE
DE DELACROIX**
(R746), ca.1894,
27 x 35 cm. Musée Granet,
Aix-en-Provence.
Volume 1, n° 213.

shows Cézanne thinking in terms of expressive line and working quickly and firmly. It is difficult for me to imagine the completed canvas; I can see every line stiffening up, every shape examined for its connection to every other shape, and the diaphanous grouping of angels becoming opaque. The lovely sketch is a reminder of a fundamental point about Cézanne's narrative work: it may be conceived as narration and expressed with the illustrative power of line, but as Cézanne elaborates it, will tend to take on the stability of a frieze and the solidity of a bas-relief. From his expressed desire to paint like the Venetians it is clear that he would have preferred to retain his freshness; I cannot help but think, however, that the world was better served by the direction in which his strengths, rather than his wishes, led him.

If narrative paintings are less important to Cézanne in this period than paintings based on observation, so are narrative drawings and watercolors; and it may be said that they are also less original. The drawings are sketches, not studies; they do not explore new ways of representing things such as reversals of voids and solids and rhythms of repetitive forms, which we can see in landscapes. They work out a pose needed in a composition, or they try out a narrative scene that may or may not eventually become a painting, and they accomplish this with either deliberate thought or graphic vigor, as if by themselves they mirrored the whole of Cézanne's complex character.

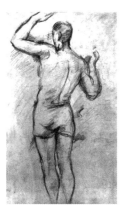

STANDING BATHER
(C949), ca. 1885-88,
45 x 23 cm.
Present whereabouts
unknown.
Volume 1, n° 214.

A sketch for the "Signorelli" figure illustrates the deliberate side. Cézanne's purpose seems to be to master the gentle, uninsistent lean of the torso and to work out the body's modeling. He seems quite sure of the pose: the multiple outlines of the body are not corrections or approximations but deliberately vague referents that allow the

247 - *See Rewald, PPC, vol. 1, p. 458.*

BATHER STEPPING DOWN INTO THE WATER (C962), ca. 1886-89, 20 x 12 cm. A. Chappuis, Tresserve. *Volume 1, n° 215.*

BAIGNEURS (RW133), ca. 1894, 21 x 27 cm. Metropolitan Museum of Art, New York. *Volume 1, n° 216.*

figure to move in space, and they are drawn close together, in parallel, without impatient emphasis. The hatchings model the figure sparsely but sufficiently and – we must not forget that Cézanne will think ahead, especially in so large a drawing - locate it in space; they do so at points that are hollow, such as the armpits and the crooks of the elbow. Other lines will establish how high the figure is standing or emphasize the bend in the waist: I refer to the curved lines to the right of the thigh and the little hook to the right of the waist.

Much quicker and more impulsive is a sketch for the seated bather that had been inserted into *Baigneurs en plein air*. Since the figure is intended for the background, working out its shape will be more important than studying the modeling; Cézanne therefore sets out to master the pose, and does so with an emphatic line and corrects it as he needs to. But it will also sit on a grassy bank, so Cézanne makes sure he tries out fuzzy, spiral textures that pulse in and out and let the figure make contact with the ground where it needs to - at the feet, the hands, and the buttocks. The drawing suffices for its purpose and no more need be asked of it.

In representing the figure itself, watercolors do little more than the drawings. They outline the figure or a composition of figures but do not, for example, use color to study volumes or flesh tones. But because in works based on observation Cézanne had by now begun to divide his transparent hues and assemble them in carefully ordered series, we would look for some reflection of this technique at least somewhere in his narrative watercolors. In the very few that can be assigned securely to this period, we find it only in the backgrounds. The figure is outlined, as surely with the brush as it had been with the pencil, but is left empty; it is the implied background that is elaborated. In *Baigneurs*, which from its detached touches should date from the mid 1890s, the bather is made to settle into his space as in the drawing, with a connection at the hands, buttocks, and feet; but it is what he settles into that Cézanne emphasizes - a grassy bank, at the edge of the water, and a bit of sky above. I do not believe that the setting is intended to be realistic; if it were, the sky would not begin right at the top of the low bank. But the setting does have what it needs, that is, color, color balance, and volume, and the figure does lean convincingly toward the water's edge. Above all, the watercolor has a nervous intensity that easily communicates itself to the figure. It is the intensity of the irregular patch of color, allowed to dry before the next one is set on top of it: precisely the technique of the mature watercolors and the model for Cézanne's work in oil from about 1895 on.

LANDSCAPES

Between the first use of the parallel touch in 1879-80 and the style changes of about 1895, Cézanne's landscapes give us the clearest sense of his stylistic development. Many of them can be placed in a specific setting, and when his movements are known they can also be dated, more or less securely, depending on how long or how often he stayed in a given region. Knowing their sequence is of immeasurable help: it makes clear that his landscape style underwent an orderly development. If the evolution of his style in portraits and still lives also seems clearer, it is because we liken it to that of landscape, but it is landscapes of which we are the most sure, and it is they that suggest that after 1885 the coherence of Cézanne's development was, above all, a response to his intense study of the landscapes' structure.

Only the paintings done during the difficult years of 1885–86 form an exception. We can place one painting squarely in the middle of Cézanne's crisis, that is, in the summer

of 1885: it is a view of a turn in the road at *La Roche-Guyon*. Its touch continues the development that was just suggested in the *Marronniers et ferme du Jas de Bouffan* and the *Vue sur l'Estaque et le Château d'If* that we saw in the last chapter; it is light, and the liquid paint is rubbed on quickly, and these early notations establish the composition, the color scheme, and the ins and outs of the space. This first lay-in was surely intended as the basis for further elaboration in the manner of those two landscapes, and its final surface would have resembled theirs had Cézanne stayed with the painting longer. But it was abandoned at an early stage - although not so early as to obscure Cézanne's intentions.

LA ROUTE TOURNANTE À LA ROCHE-GUYON
(R539), ca. 1885,
62 x 76 cm. Smith College
Museum of Art.
Volume 1, n° 217.

His intentions become even clearer if we compare the painting with its site photograph. Taken from where Cézanne had stood, the photograph shows that things were essentially where Cézanne had painted them, of the size and color that we see now - except for the cliff on the left and the turn in the road itself. He has made the chalk striations in the cliff horizontal and parallel to each other, as he has done the cliff base, and has made the road turn more slowly, very much like one of the open mouths of the cups in his still lives. The road slopes down, in fact, but seen in perspective from where he stood it points up, and this gave Cézanne pause when painting the bottom of the cliff: there are pencil traces of both orientations on the bare canvas, but they were given up in favor of the horizontal. This decision gave him a stable framework, a serene and monumental landscape instead of an undistinguished turn in a road - an analog of his ennobled groupings of everyday objects in a still life. But I think that this monumentality is achieved at the cost of some dryness of color and space, and that it may indicate a momentary narrowing produced by his anxious state, a search for the safety of a stable framework - an overstatement of an equilibrium he normally found with less effort.

Site 217, photo:
Pavel Machotka, ca. 1977.

The stability that I think Cézanne was searching for was offered to him, without further modification, by the hilltop town of Gardanne, where he painted after his return in August 1885 and for most of 1886. He painted two vertical views there and one horizontal one (of which only the horizontal one is finished), and thanks to the site photographs of the vertical views, we need be in no doubt that the arrangements he painted were the ones he saw[248]. Both of the vertical paintings are subtle as well as reassuringly stable; in one, a series of curving lines leads the eye to the belltower, and in the other (below), two diagonals - the slope at upper right and the path at lower right - lead the gaze toward the center of the painting. The colors in the paintings differ considerably, in response to the seasons when they were painted[249]. Here, the season is late and the sun is quite low even in the early afternoon, which reduces the brilliance of the light, and Cézanne has also made an aesthetic decision to simplify the colors: he has painted all the shadows the same grey-cobalt as the sky. With the reds and yellows very close to each other, this narrows his harmony to three color groups, and the result is unified and gentle. It is, I think, the flat light that sets him off on this course: nowhere does the painting have the incisive rhythm of touches set down in parallel, nor any sharp outline or modeling to create deep space - not even in the foliage, where we find it in the other vertical version. The painting that results is more like a vertical Sung dynasty scroll than any other landscape that he painted, because it climbs up more than it pushes back into space, and in the context of his other work it is essentially decorative.

GARDANNE
(vue verticale) (R570),
ca.1886, 80x 64 cm.
Metropolitan Museum
of Art, New York.
Volume 1, n° 218.

248 - *See Erle Loran,* Cézanne's composition, *University of California Press, 1985, p. 123, for the site photograph of this painting, and my* Cézanne: Landscape into Art, *p. 68, for the site photograph of the other. In Provence, it should be added, spires tend to be made of wrought iron, to offer less resistance to the seasonal mistral, and they appear transparent, as here.*

Perhaps we can think of this kind of decorativeness, at this moment in Cézanne's life, as a way of making a virtue of his tentative touch and the shallow space. A decorative treatment may also be his only choice if he chooses to paint bare trees, as he does with the chestnut avenue at the Jas de Bouffan in winter (probably of 1885-86). There he has only the linear rhythm of branches to work with, and in order to translate their rhythm into paint, he must set them out next to each other, in the plane of the canvas, so that the brush strokes do not pile up and become muddy; this inevitably creates another kind of shallow space and another decorative painting. The trees then become a filigree against the bare sky, either set out at equal intervals, as in one painting

LES ARBRES DU JAS DE BOUFFAN DÉNUDÉS (R552), ca. 1885-86, 60 x 73 cm. National Museum of Western Art, Tokyo. *Volume 1, n° 219.*

(*Les Marronniers du Jas de Bouffan en hiver*, R551, not shown), or massed at the left with a small and indispensable counterweight on the right, as in the one below: *Les Arbres du Jas de Bouffan dénudés*. There, the touch is light, detached and tentative, carelessly scumbled in the sky, and the atmosphere is pale. If Cézanne's psychological state is visible, so is his abiding dedication to the painter's craft: for example, the predominantly warm colors are separated by the blue strip of hills at the horizon, and the branches in the very center of the painting point toward the ones on the right and almost touch them.

If these naked trees reflect Cézanne's predominant mood, a few other landscapes done at about the same time tell us that there were lighter moods as well; the mood was certainly not constant, even if in 1885-86 it affected his painting more often than at any other time. *Grand Pin et terres rouges (Bellevue)*, below, also seems tinged with by it, but less in its subject than in its unresolved composition. Not all its problems are

GRAND PIN ET TERRES ROUGES (Bellevue) (R537), ca. 1885, 81 x 100 cm. Galerie Yoshii, Tokyo. *Volume 1, n° 222.*

Cézanne's, it must be said; although he abandoned the painting at a very early stage (which may suggest that he was dissatisfied with it), it was above all altered by one of its first owners, the painter Emile Schuffenecker, who added paint to the areas at the top and sides and compounded its problems[250]. But Cézanne's touch was at odds to begin with with what I think was his point of interest: the intersection of the trunk and branches, the branches' centrifugal burst, and their relation to the fields and houses below. He was successful in conveying the tree's complexity in three watercolor studies (*Etude d'arbre*, RW 285-287); there, he gave the branches a strong linear definition in pencil and brought the space between them to life in a masterly way. But here he allowed the touches that define the leaves at the top and the bushes at the bottom to be too detached, too insistent; they do not give us a clear sense of emphasis and release; our attention is scattered. The painting's problems are worth noting, however, because they show us to what degree the success of a composition may depend on the touch. Cézanne was able to correct these problems some ten years later, in a version of this site that uses his late touches, the ones grouped in patches, and established a natural density throughout and a robust interplay between all the parts (p. 215).

The rubbed-on, liquid touch was obviously not equally suited to all landscape compositions, or not suited in such an emphatic, repetitive manner. The abandoned *Grand pin* picture reassures us, I think, that Cézanne was aware of the problem, and the contemporary *Arbres et maisons* painting makes clear that he knew how to solve it. *Arbres et maisons* is a complex composition that could not afford the distracting fussiness we have just seen, and Cézanne wisely sets the touch down irregularly and without insistence. Here two planes compete for attention: the angry, perversely twisting branches in front,

249 - *The other two paintings were painted in mid-summer and their colors are saturated.*
250 - *See Rewald, PPC, vol. 1, p. 364.*

and the placid farmhouse they reveal and divide into pieces. The branches do not merely grow away from the tree trunk; they also point back toward the ground, double back on themselves, and twist relentlessly all the way to their tips. And yet within this turmoil there is a painterly order: each of the enclosed spaces contains a different, independent, part of the scene. The touches begin afresh in each polygon, as it were. The farmhouse is enclosed in the largest polygon, touching the vertical trunk as if connected to it and pointing back toward the exact center, and then disappears in the narrow spaces to the left, to reappear again at the edge of the picture. The house is not continuous, but we reassemble it while looking, and where it has disappeared altogether, it gives us room to breathe. The other polygons each have their own piece of the whole, distinct enough to carve out a section of the picture for themselves yet similar enough so we can bring the pieces back together without effort. If the snarling branches are an expression of feeling, the painting as a whole is a product of thought; a calm sense of apportionment tames the unruly movements. The two planes come closer together, and the painting becomes not just a representation of the scene but also a shallow image that exists close to the canvas plane.

ARBRES ET MAISONS
(R550), ca. 1885–86,
60 x 81 cm.
Nasjonalgalleriet, Oslo.
Volume 1, n° 221.

The surface of *Arbres et maisons* is thin enough to indicate that Cézanne knew from the start that he would use the new touch differently than in *Grand pin*. There, he used it primarily to draw objects and represent their volumes – at the same time – while in *Arbres et maisons* he used it principally to fill space between branches with rhythmic areas of color. There is yet another use that he has for the touch, or at least another primary use: to strengthen an outline in the early stages of a composition. This is useful when the planes of the pictures are broad, and a few indications of the local color at the edges of the main outlines can clarify how the composition will work; at the same time, the touches will remind him of the balance of colors the painting will strive for.

**LA SAINTE-VICTOIRE,
VUE DES ENVIRONS
DU PONT DE BAYEUX**
(R574), ca.1886, 87 x 92
cm. National Gallery of Art,
Washington, DC.
Volume 1, n° 220.

Cézanne makes this evident in the layout of a picture with a fork in the road in the foreground, a central house in the middle ground, and the Sainte-Victoire in the back – seen from near Pont de Bayeux, and appearing as the plateau that it really is[251]. (The familiar views are from the west, where the plateau is seen on its edge.) The stage it has reached reveals the intended composition: the various diagonals point to the house, or skirt around it as they echo the slope of its roof; or to look at it the other way, the central house embodies and concentrates the many diagonals that plunge down in parallel with the roof. They are drawn clearly, sometimes doubled or tripled, and then they are emphasized by the strings of parallel strokes in various colors that touch them. In this way we know the composition, we know how the planes are to be separated in space, and we also know that a blue-grey will balance the warm, stuffy colors. This starting point is perfectly adapted to this kind of distant view of fairly simple planes; it establishes a map of a relatively flat terrain.

When the scene is detailed, and framed by two trees at either end, the painter's task is quite different: in *La Montagne Sainte-Victoire au grand pin*, the fields of the patchwork quilt are so small that if Cézanne had noted the colors only near the boundaries, the result would be irritating to the eye. One has but to imagine a chessboard with only the edges of the black squares shaded in to see the difficulty. In this picture a few touches have filled in fully all but the largest polygons, and for simplicity they were generally painted parallel to one of the edges. The painting has gone a little past the first lay-in; Cézanne has

251 - *See Denis Coutagne,* Les sites Cézanniens, *Paris, La réunion des musées nationaux, 1996, p. 120, and Machotka, Coutagne, and Frey,* "Rochers à Bibémus *and* La Sainte-Victoire, vue des environs du Pont de Bayeux," *in* Année Cézannienne, *1999, No. 1, pp. 25-28.*

**LA MONTAGNE
SAINTE-VICTOIRE
AU GRAND PIN** (R598),
1886–87, 60 x 73 cm.
Phillips Collection,
Washington, DC.
Volume 1, n° 223.

**LA MONTAGNE
SAINTE-VICTOIRE
AU GRAND PIN**
(R599), 1886–87,
66 x 90 cm. Courtauld
Institute Galleries,
London.
Volume 1, n° 224.

elaborated above all the areas next to the branches, where he superimposed a bit of blue or various greens to create a subtle transition between the branches and their background. It, too, has reached a stage where it could remain as it is or be pushed further.

Where might Cézanne have taken the painting had he decided to elaborate the surface? One attractive possibility is offered by a larger and more saturated version of the same scene, in which the touches are denser and less distinct, and the branches swirl more tightly around the mountain. In that painting, which bears the same title, Cézanne has painted intricate transitions between the needles and the sky, ensuring that the whole will make one dense mass. It is tempting to think that, with elaboration, the first painting would have turned into the second. But in fact the composition of the first canvas is different enough, and responds to different enough light conditions, to suggest that Cézanne had good reasons to leave it where it is. The first composition takes in more of the foreground and guides us by a path from the bottom to the house at left center; the mountain is faint and leaves a nearly empty center band on the canvas that makes it easy to connect the top with the bottom, as if the main dialog took place between the branches and all that happens below the level of the viaduct. In the second composition, the mountain, now substantial and alive with pinks, oranges, and grey-violets, is centered on the canvas; the painting is a dialog between the branches and the mountain's contours, and the branches now caress the mountain, with their swirling touches, rather than merely echoing it[252].

It is very probable that the one day was grey and the other sunlit, and it is certain that the seasons were different[253]; this, too, suggests that the first composition may have said all that it needed to say. In the second picture the season is more advanced, with several fields ripened to a golden yellow and the green fields darker. If the first picture represents an overcast spring day and the second one a sunny mid-summer one, as I believe they do, then we can consider the pictures to be equally finished. There is a flat light in the one and a brilliant light and saturated colors in the other; the contrasts are greater in the second and the sky bluer, making accomplices of the dark blues and greens – and requiring, or at least suggesting, a richer touch to express all this.

By the year 1887, it is clear that Cézanne found it easier to respond to the invitation tendered by a brilliant day and be moved by the affectionate feelings it evoked. Grey days and bare trees had begun to mean less to him, although images of buildings, of reassuring solidness, remained important; yet if the concern with stability was still there, it did not hinder his invention. In *Maison et ferme du Jas de Bouffan*, there is pleasure taken from the morning light of an early spring day, and from the intense oppositions of reds and greens, and dull yellows and blues; the color brightens the dense concatenation of the spectacular forms. Cézanne makes the most of the Jas de Bouffan's wedge-shaped farm building, which tapers toward him where he stands in the meadow and shows him three of its sides, and paints it with a kind of merciless awkwardness that keeps us coming back to look at it as if it would answer some unstated question. We seem to find it hard to believe that the shape could be what we see[254], and it draws our eyes away even from the congested forms in the center, which are meant to be the focus.

252 - The tips of the branches of the Provençal variety of the umbrella pine often curl inwards, as in these two paintings, so Cézanne's bringing them together like this is no invention. For an illustration—relevant to another site—see my book on the landscapes, pp. 144-145.
253 - Just such a difference seems to account for the different tonalities in two versions of the Château Noir site; see my book on the landscapes, p. 110.

The painting is conspicuous above all by the very pronounced counter-clockwise tilt. This calls attention to the painting as a construction, of course, and naturally makes one ask to what degree the rest is a construction as well. The 1935 site photograph,

however, shows us that - apart from the tilt - the canvas represents the site as it appeared[255]. But the tilt of the buildings is powerful, disquieting, and arresting, even more so than in the many other paintings where the verticals lean left, away from the vertical midline. Cézanne never explained his practice; in 1905, when he was asked about a leaning bottle in a still life, he merely said that his eye was lazy[256]. Surely this answer is too simple and modest, since his acute sense for the consequence of the smallest brush stroke would make the tilt highly obvious. We must trust our response to the painting. It is much more interesting this way than with a safely vertical and horizontal orientation, more dynamic and even disturbing - and at the same time, it has achieved something that the normal orientation would not have allowed: it is now seated securely on a horizontal base[257].

The matter of Cézanne's putative, lazy eye is resolved by a painting in which he observes strict verticality in the walls. In *Arbres et maisons*, from about the same year, the house visible through the trees is perfectly vertical and serves as a point of stability in a storm of branches. It calms a canvas that would have had a difficult time settling down; or put

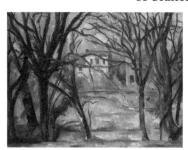

another way, by allowing us to return to a calm port when we need it, it lets us experience the swirl of the branches freely. Unlike the *Arbres et maisons* painting we had seen previously (p. 152), this one is less impulsive and more formal. It has a deeper space, one in which the near and far planes are equally important, and the planes are joined subtly by a curving path that leads from one to the other. This requires that what appears between the branches not be carved up, and that the farther plane remain continuous; it needs to be a stable point of respite against the plane in front.

If the point of this painting is the relationship between the two planes, the technical challenge was the painting of the frontal one. The branches are intricate and overlap in complex ways, and the technical question is how to represent them so that they convey the progression from solid trunks to filigree textures without confusion. Cézanne achieves this by outlining the trunks with a single clear line - single but interrupted, so that they do not appear carved out of their background - and gradually doubling it as he reaches the branches; this produces a certain vagueness, a sense of motion, and the filigree effect, all at the same time. Where the branches overlap, he separates them forcefully, leaving the front branch continuous and the one behind it divided by a broad gap. To paint those branches is in fact hard work: looking up from one's easel, changing focus and scale, and quickly finding the spot where one had looked last, requires considerable dedication. We know, however, from a painting of wintry branches that he did from a photograph in 1879 or 1880[258], that he did not

254 - It is wedge-shaped in fact, as both Rewald and Loran have shown; see Loran, Cézanne's composition, pp. 52-54, and Rewald, PPC, vol. 1, p. 400. In spite of the temptation to see the representation of the farmhouse as anticipating Cubism, it is painted as it appears.
255 - In the photograph, there is one apparent difference: the boundary wall slopes down to the right, while in the painting it appears horizontal. But if we take into account the photographer's higher point of view, which exaggerates the slope, and the counterclockwise rotation of the whole scene on the canvas, then the differences almost disappear. See my discussion of the site and the painting in my book on the landscapes, pp. 71-72, and Loran's quite different conclusions in his Cézanne's composition, pp. 52-54.
256 - "Je suis un primitif, j'ai l'oeil paresseux," he said to R. P. Rivière and J. F. Schnerb who visited him in 1905. Their article, reprinted in Conversations avec Cézanne, pp. 85-91, is thoughtful and precise, and makes fine observations on the painter, his painting, and his theoretical thinking.
257 - Both effects are easily verified by turning the reproduction clockwise and masking the edges. When the edge of the house has become vertical, the boundary wall will slope down, in perspective, as in the photograph - but the picture will no longer have a stable base. By rotating everything counterclockwise, Cézanne had in effect exchanged a firm, horizontal foundation for a dynamic, precarious top - an exchange I must assume he was aware of and found satisfying.

shrink from the task or simplify it, and we can assume that the present branches were painted in the same painstaking way. And it is the touch by which the tree trunks are filled in that is of interest here: it accumulates between the outlines in small patches, either parallel to the outlines or oblique to them, and in this way it produces the volume, the changes of color, and the texture that give the trunks their substance and nervous intensity.

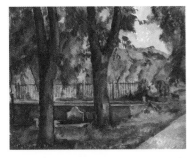

BASSIN ET LAVOIR DU JAS DE BOUFFAN
(R566), ca.1889, 65 x 81 cm.
Metropolitan Museum
of Art, New York.
Volume 1, n° 226.

Two later paintings done at Aix are, I think, a measure of Cézanne's distance from the unhappy year 1885. Touch plays a distinct role in them again, but it is as unassuming as it is effective, and color is once again intense, but more thoughtful than demonstrative. Standing in the middle of the chestnut avenue at the Jas de Bouffan to paint the first picture - to the left of where he stood to paint *Maison et ferme* - he could look obliquely past the two final trees in the row at a rectangular pool; the trees would undulate gently above the first fork in the trunk. The pool would form a useful back stop for the receding space, so that Cézanne could let himself paint the avenue as going off to the right, and if that were not control enough, the rump of the lion at the right would do the rest. The trees would be in shadow, but the filtered morning light would model them from the right. The result should be a graceful, unforced composition[259]; and indeed the painting *Bassin et lavoir du Jas de Bouffan* is elegant and uncontrived, unaffected by tensions and the need for resolutions. What one is unprepared for is the extraordinary, cool, almost astringent tonality: the blues, blue-greens, red-browns, and even pink-violets. It is unique in Cézanne's work and perfectly satisfactory, arising fully-formed, it seems, from the painter's head - arising in response to the prevailing light, of course, but also informed by his unfailing sense of color. Nor is one prepared for the subtle way in which the touches strengthen the composition, crisscrossing between the two trees at angles that imitate the forked branches, and sloping gently, to the right of center, in line with the central tree.

It is the use of the touch that argues for a date late in the decade - 1887 at the earliest, but more likely after his return from the north in 1889 - as it does in a painting of a house that closely resembles the Jas de Bouffan, the *Maison au toit rouge*. The layout of the grounds would be familiar to Cézanne - the house at the end of an avenue of trees seen by a late-afternoon light - but it is possibly a different house[260]. What is striking, however, given the similar sites, is the difference between this picture and the *Maison et ferme* one (p. 154): this one is lighter in conception, affirmative, seemingly impulsive. It is in fact carefully thought out, of course. The stab of the roof toward the right, for example, is balanced by the leftward turn in the road, with particular emphasis on the tree that marks the turn; the spray of leaves above the roof points toward the lower two corners, following the roof in one direction and the left edge of the road in the other. The touches are grouped in clusters that overlap, with one cluster clearly in front of another so as to build up a solid mass. At the right, the touches that represent the shrubs - which are also clustered and built up in space - contain this centrifugal movement by pushing back gently against it. But these constructions are just there, without ostentation, and the painting, like *Bassin et lavoir*, represents an unconflicted and unified moment in Cézanne's development.

258 - Neige fondante à Fontainebleau, *R413. The photograph is reproduced in Rewald's PPC, vol. 1, p. 273.*
259 - *I have let myself speak of the site as if the painting had not yet been done. As a manner of speaking it is justified in this case because Rewald took an excellent black and white photograph in 1935 and I have seen the site in the flesh. For both photographs, see my book on the landscapes, p. 132.*

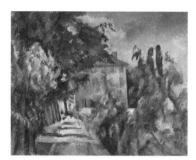

**MAISON
AU TOIT ROUGE
(Jas de Bouffan)**
(R603), ca.1889,
73 x 92 cm.
Private collection.
Volume 1, n° 227.

If I suggested the date of 1889 for the painting, it was in part because it seemed to take advantage of a touch that Cézanne had adopted in the north, specifically in *Chantilly*, in 1888. I am aware that I have argued against seeing touch narrowly as handwriting, as a graphic habit that marks a moment in a painter's development, but I do not hesitate to look at touch as form, as a purposeful manner of organizing the canvas. The touches on the right of *Maison au toit rouge* are significant not because they are curved and parallel, but because they are grouped in clusters with a clear compositional purpose. They have a different feel to them than previous styles, a feel that can be seen in paintings done in the forest of the *Château de Chantilly*, and one that in fact anticipates the patches of his late work.

Cézanne did three paintings at Chantilly of bridle paths that cut through the forest; they begin with a mere suggestion of the touch that we have just seen and end with it fully realized. In all three paintings he looked straight down the middle of the receding path, creating a vertical, nearly symmetrical composition; the path was in each case segmented by shadows or interrupted by wooden barriers[261]. So simple a framework – the composition presented ready-made, as it were, and already in full balance – invited the painter's attention to the treatment of the surface, and Cézanne response was a stylistic leap forward: clusters of brushstrokes fully capable of organizing the space of a painting.

In the last and most developed version, entitled *L'Allée à Chantilly, "I"*, the touches are detached from each other, abstract in form, and set down with an equal emphasis over the whole canvas. If the painting testifies to a very rapid stylistic progression, it also responds to a site with the least defined structure – there is empty space at the end. The touches are thin and laid down without corrections, and this suggests that Cézanne had chosen them as soon as he had begun to paint – that, having developed a new touch, he could see the motif it its terms. The touches would, in any case, bear the burden of creating the composition, since the empty space at the end removed the only object of interest – the château. A moment's patient looking, or simply holding the picture up to a mirror, tells us how he chose the touches: he aligned them only with the clearly defined left side of the path. In this way he built up the space along that diagonal, slowly, by steps, rather than by rushing toward a point. He made the touch do the same work as the emphatic shadows that segment the path.

What the three pictures have in common is the clustering of the touch and a new subtlety in its purpose: to unify the paintings by echoing and underscoring the main thrusts of the composition. As Cézanne progresses through this series, his composition becomes increasingly detached from objects of interest and the touches evolve in parallel with his detachment. As he masters his way of representing the symmetrical recession, the touch takes over the work of organizing the canvas, and requires that the motif be simpler and demand less attention. This progression places *L'Allée à Chantilly, "III"* (R616) at the beginning of the series and our *Chantilly "I"* at the end, with *Chantilly "II"* (R615) in the middle because it combines elements of both.

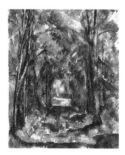

**L'ALLÉE À
CHANTILLY, « I »**
(R614), ca. 1888,
82 x 66 cm. National
Gallery, London.
Volume 1, n° 229.

The ultimate direction of his development in landscape will be just that: the canvas will take its form more and more from the elements from which he assembles it, and paradoxically these elements will seem ever more naturally connected with the subject of the painting.

260 - *Among the difficulties in identifying this as the Jas de Bouffan, one must point out that the avenue of trees seems to be a single row; that there was no road to the right of the avenue but a path down the middle; that the chimney is much broader than in the photographs of the house and all of Cézanne's other paintings; that the french windows on the ground floor were taller, and that there were no bushes, and above all no poplars, on the right. On the other hand, no one has found any other candidate for the site, so the question remains open.*
261 - *For a comparison of one of the paintings with its site photograph, see my book on the landscapes, p. 130.*

The Chantilly paintings are the first step in the progression toward that final phase. But this sense of direction must not obscure for us Cézanne's varying response to individual sites or his different approach to portraits and still lives; if his progression seems irregular, it is above all because as his subjects change, his response changes with them.

L'ALLÉE DES MARRONNIERS AU JAS DE BOUFFAN
(R617), ca. 1889, 80 x 64 cm. Barnes Foundation, Merion, PA.
Volume 1, n° 231.

The chestnut avenue, which in *L'Allée des marronniers au Jas de Bouffan* is also viewed from the center, poses a variant of what was required in the Chantilly series. The trees receded rhythmically into space and so did the shadows they each cast from the left (looking toward the house in the late afternoon); the stepwise recession was therefore a given, and it was emphatic enough to need no additional support from the touch. Perhaps the space that the shadows created seemed even too flat, because Cézanne crossed the horizontal touches with lines that converge on the end of the path, and joined the bases of the trunks with a single, nearly unbroken line; these are rare expedients for him, and I suspect that he felt that he needed them because he had actually widened the avenue at the end, so that the space would seem flatter.

The principal compositional question, however, had less to do with space than with balance on the surface, and here again the touch came to play a crucial role. The line that joins the trees at their base on the right makes a powerful diagonal and needs an equally powerful counterweight, and Cézanne creates it from the long strings of short touches - or from the branches, if you will - that point down toward the left. It is unclear which came first, but it is evident that the result was the needed balance. The blond tree trunk at lower right, by the way, pulls rightward and forward, stretching the space toward us and adding its weight to the tense interplay between shallowness and depth.

To make clear Cézanne's unique contributions to painting one must discuss his subtle constructions of space in detail, as I have, even at the risk of making it seem as if the painting had been done only in black and white. But in fact the painting is alive with brilliant color. For example, the brown-yellows and their complementaries, the violets

LE GRAND PIN (R601), ca.1887-89, 84 x 92 cm. Museu de Arte, São Paulo Assis Chateaubriand.
Volume 1, n° 230.

and blue-greys, convey the intense summer light and the relieving shadows; and the greens are balanced by the brown-red tree trunks. The stability of Cézanne's space is the necessary counterpart of the passionate color - although one might say with equal accuracy that his carefully balanced color is the right counterweight to his passionate feeling for space. It is by barely adequate metaphors such as these that I attempt to convey the complexity and strength of his paintings.

Not all of the paintings of his maturity are this closely balanced, however; a more direct emotion, borne of a close identification with his subject, can overwhelm the architectural impulse. It is a rare moment, but it can be seen, I think, in *Le Grand Pin*. The pine unfurls in a centrifugal spiral and nothing stands still; no straight, parallel touches order the surface, no verticals and no horizontals anchor us in space[262]. We tilt leftward

Site 232, photo: Pavel Machotka, ca.1977.

with the ground and the trunk and then again are swept to the right by the branches. Cézanne could never be unaware of composition, of course; he extended this canvas twice at the top to achieve the balance he needed. But composition was not primary here. In *Grand Pin et terres rouges*, which we saw earlier, we noticed the rhythm of the lines that branched out from the trunk, the sweep of the longest branch, the nestling of the houses against the trunk, the choice of brushstrokes - any number of carefully calculated relationships and technical decisions; in this painting, however, we are likely to think about the painter and the significance of the painting for him. The pine is tall, mature, windblown, alone among its neighbors but taller than they are; some such meaning must be what informed this picture and served as the impulse for painting it in the first place.

LA COLLINE DES PAUVRES PRÈS DU CHÂTEAU NOIR, AVEC VUE SUR ST-JOSEPH (R612), ca. 1888-90, 65 x 81 cm. Metropolitan Museum of Art, New York. *Volume 1, n° 232.*

BORDS DE LA MARNE, I (R623), ca. 1888-90, 65 x 81 cm. Hermitage Museum, St. Petersburg. *Volume 1, n° 234.*

AUGUSTE RENOIR, MONTAGNE SAINTE-VICTOIRE, ca. 1889, 53 x 64 cm. Yale University Art Gallery, New Haven. *Volume 1, n° 233.*

We can trust that the pine was a tree that he knew or had studied; all the research on Cézanne's sites points to actual sources for his landscapes, and tells us that he painted them with an intense attachment to the structure and color relationships he saw. But an object can evoke primarily an emotional response, as this one did, or principally a visual one, as most broad landscapes did. Even when a site is woolly and unanchored in space, Cézanne will normally find in it whatever order it allows him to see. In *the Colline des pauvres* painting below he finds order by selecting the frame: by locating the yellow building in the exact center. Fixed in its immovable spot, it becomes our point of reference when we need it, and allows a profusion of billowy vegetation to swirl around it without confusion. The vegetation can become the subject, as it were, and Cézanne can concentrate on the complex colors that it reveals: oranges, crimsons and violets, and greens that range from olive-browns to blue-greens. In comparison with the photograph of the site, the color is heightened, but less so than it would appear. Seen in the flesh, these pines and scrub oaks display a broad range of colors from grey-green to brown-green, and show spots of red at the inner tip of the pine needles; the visual experience is closer to Cézanne's painting than the photograph. The site also shows us a warm red in the bare ground at the right, which by a gentle stretch of the imagination (and the need for color balance) could become the crimson of the painting. If it is not lines and volumes that provide the impetus for organizing a canvas, it will be colors; by late in the decade, innovations such as these tell us that Cézanne has once again regained the requisite inner freedom.

Nevertheless, Cézanne's response to each site is individual enough to frustrate any attempt to fit his development into a simple formula. Back north, working on the banks of the Marne river at the outskirts of Paris, he paints three quite conservative pictures, conservative, that is, in that they respond cautiously to the green-black tonalities of the cool, local light and the close, moist vegetation. They each contrast a white, red-rimmed house with dark green foliage - a choice that is perfectly justifiable, but one that is also safe, reflecting only too closely the quiet site. Nowhere do we see the color range broadened or the local colors divided, or sense a mood elevated by the simple view of a familiar southern hillside. In *Bords de la Marne, I* the touches seem mechanical, the off-center composition workmanlike but uninspired, the colors cautious. I do not wish to suggest any generalization from these Marne paintings; they are his response to this particular site at this moment. On the contrary, as we shall see in a moment, his stays in the north eventually released a flow of analytic thinking that drew out the tensions that are there to be seen.

It must be said that the years 1888-89 were variable in the quality of their landscapes, and not only or even principally in the north. A *Sainte-Victoire* that he painted from where Renoir had done it on his visit of 1889 is listless, unable to find its center or establish a resonance between its parts. It seems too closely influenced by Renoir's version, by that sensuousness that served Renoir so well with the female figure but in landscape led him to love every object with too equal an affection and accept every color with too equal an emphasis. We do not know whether the painters worked close to each other; one painting has olives in the foreground while the other does not, and the seasons certainly seem different, but since in other ways the compositions are strikingly similar (except for Cézanne's narrower angle of view), some influence must be assumed. In one respect, however, Cézanne remained fully independent: in his trenchant, balanced color. In a

262 - *This makes the painting very hard to date, and I see little alternative to giving it the margin that Rewald proposes, with a preference for the later date.*

LA MONTAGNE SAINTE-VICTOIRE (R631),
ca. 1888-90, 65 x 81 cm.
National Gallery, London.
Volume 1, n° 235.

MAISON ET ARBRES
(R629), ca. 1888–90,
64 x 80 cm. Barnes
Foundation, Merion, PA.
Volume 1, n° 237.

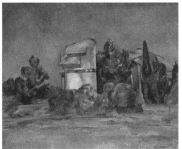

PIGEONNIER DE BELLEVUE
(R692), ca. 1889–90, 64 x 80 cm.
Cleveland Museum of Art.
Volume 1, n° 238.

nearly contemporary painting of another house framed by trees, *Maisonet arbres*, Cézanne once again finds his own subject and his way of portraying it. Readers who have followed what I have been emphasizing are by now perhaps prepared to look for brushstrokes in the foliage that resonate with the angle formed by the roof – that being the point to which we are drawn – and they will not be disappointed; the patches achieve just that in the upper half of the picture, while in the lower part they provide horizontal stability. The interplay of colors is delicate, and the grey-blues are a just and welcome balance to the brown-yellows. But the interest of the painting does not lie in the expectations that it meets. On the contrary, there is an unresolved area just right of center that draws the eye and that, I think, attracted Cézanne to the site: three diagonal lines – the two drainage pipes and the leaning tree – cross the wall, and none of them quite align with any part of the roof. They tighten the vertex of the angle and loosen it again, squeezing and opening the space. This awkwardness transforms a potentially stolid composition into an absorbing one, a predictable painting into an original one.

The joyful, morning view of the pigeon tower at the Bellevue farmhouse might at first seem predictable as well; the painting neither perplexes us nor makes any demands on our ability to understand it. It presents the scene as it looked, and its subtle elaborations are not visible at first[263]. But those elaborations produce a painting that is more imposing, more unified, and more satisfactory, than the scene itself. The tower, for example, was located so as to create tension: it was placed to the left of center and then slightly tilted to the left, to point out of the frame rather than into it; it seems to strain forward as if trying to move. Its roof is elongated upward, giving it a more commanding appearance. To these tensions is opposed a carefully achieved balance of forms and colors. To stabilize the forms, the right edge of the tower is placed firmly in the center, and the pronounced slant of the roof is balanced by the opposed, and just perceptible, blue touches in the sky; the result is that the tensions between the forms, while remaining palpable, are contained within a stabilizing framework. The colors are made to balance better on the canvas: the blues and the orange-browns, natural complements, are set down essentially as seen, but the greens, which are more yellow in the scene, are painted in a cooler viridian.

The painter would not wish his painting to be understood only after a comparison with the site; it should work as it does without any exegesis, and I certainly do not wish to imply that this painting, or any other landscape, needs it. It is sufficient to know that one finds the painting joyful, dynamic, and balanced. But the comparison does confirm our visual response and does help explain some of the painter's craft, and in directing us to his craft perhaps helps us remain aware of how fertile the end of the decade of the 80s has become.

Some paintings, in fact, show us the craft just as the painter might have wished, directly and immediately. In the roughly contemporary *L'Aqueduc*, for example, the very complexity and minute attention to the surface speak for themselves, and allow us to follow Cézanne's attempts to unite the composition, clarify the space, and direct our gaze. We can imagine his starting point. Somewhat to the left of where he painted the two versions of *La Montagne Sainte-Victoire au grand pin* (p. 153), he would see the mountain and the viaduct[264] through a group of trees at the edge of the Bellevue property. Some bushes would be in the sun, while others would be shaded, but they would all be close enough to constitute

263 - *See my* Cézanne: Landscape into Art, *p. 76, for a photograph of the site.*

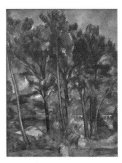

L'AQUEDUC (R.695),
ca.1890, 91 x 72 cm.
Pushkin Museum,
Moscow.
Volume 1, n° 236.

a single plane and break up the profile of the mountain. The site is not unlike other distant views through trees, but here the mountain requires a shift in emphasis: normally it is the main subject, or is at least seen in its entirety, but here it is subordinate. The challenge then is to paint a unified picture in which the two planes will be closely interconnected and equal, without sacrificing one to the other.

The labor of making the painting work as he wished may have been considerable, but the result is splendid. The part that most engages our attention is the band between the viaduct and the top of the mountain; it is the part that seems to have cost him the most effort. The foliage is overpainted with light blue, to simplify it; trunks and branches are interrupted here and there, to prevent congestion or extend a compositional line; and the mountaintop is partly painted out, to hide its awkward intersection with the dark tree. Very light browns, which stand for nothing in particular, are painted in its place, around the trunk and branches of the black tree, and they open up the space and create a compelling contrast. That is the point where Cézanne makes us concentrate our gaze. Having done that, he has lost the mountain, as it were, but he gives us a copy of its profile in the yellow four-sided patch just underneath it, as if to compensate us; and then, if we are willing to follow the shapeless masses of yellow-browns across the bottom of the picture, we can essentially retrace the profile of the mountain, the saddle to its right, and the slope that rises gently toward the right edge.

The whole is beautifully woven together and then unraveled again, to give us a rhythmic space, a space that is congested and clear in turn, in response to Cézanne's sense of texture and substance. We are presented with a canvas that seemingly depicts the trees but in fact never lets go of the hidden mountain; with indirect reminders, it brings back its essence and shape.

Cézanne's touch in the crowns of the trees is very much like that of *Le Grand pin*, that is, without any special purpose or form, but in the foreground he gives it the form of overlapping tiles. This is the touch we saw in *La Maison au toit rouge* (p. 156) and, like it, it anticipates the patches of his last phase, but here even more directly: each cluster is bordered firmly on top. We must assume that in about 1890 this touch was one of several ways of proceeding, a newly discovered and persuasive way of building up a mass. Patches of color would create depth by interrupting each other: a patch with a sharp top edge cutting across another one would invariably appear closer to the viewer, and a sequence of these would seem to recede in space. In another five years, the clusters would take on different forms and represent other surfaces, transforming the touch we see here into a full system; we have seen an example of this already in the Introduction, in *Rochers près des grottes au-dessus du Château Noir* (Introduction, p. 20). But there is nothing inexorable in the progression toward that late system at this stage; Cézanne's response to his sites is too fresh for a routine to be established. If the site is already a rhythmical one, for example, as was the subject of the contemporary *La Route en Provence*, below, then it may constrain the abstract inventiveness he might have shown elsewhere.

It is the rhythms of the site, then, not of the touch, that we see in the finished *La Route*. We may assume that the stimulus for painting was the rhythm of shadows lining the road, which at a certain point in the late afternoon would be parallel to the cut of the rocks on the left; a gentle progression of diagonal lines would then move across from left to right[265]. A house in the back, and the border of one or two fields, would carry the diagonal rhythm into the hillside. With the rhythm established on the canvas, there would be little

264 - *It is a viaduct, not an aqueduct, the same one as in* La Montagne Sainte-Victoire au grand pin *and other paintings.*

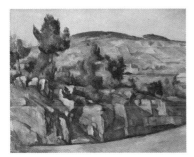

LA ROUTE EN PROVENCE (R718), ca. 1890-92, 65 x 81 cm. Tate Gallery, London. *Volume 1, n° 239.*

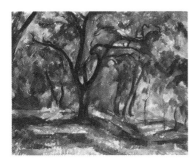

SOUS-BOIS (R699), ca. 1890-92, 73 x 92 cm. The White House Historical Association (White House Collection). *Volume 1, n° 241.*

AU BORD DE L'EAU (R724), ca. 1890-92, 73 x 92 cm. National Gallery of Art, Washington, DC. *Volume 1, n° 240.*

else to do than use simple, straight touches to represent the rocks; and in the sparse trees and bushes above them Cézanne could revert to something like the earlier parallel touch. There is a mastery of economy here, an unforced response to the invitation in the landscape, and, it should be added, a gentle balance between the upturned curve of the road and the downturned curves of the hills.

The roughly contemporary *Sous-bois*, is, on the other hand, ferocious in the choice of its subject. Here we respond as did Cézanne's style as strongly to the violent swirl of the twisted branch as we do to the profusion of colors and the clarity of the light that penetrates the canopy of trees. Speaking technically, the touches here are systematic only where they need to convey the recession of the forest floor; there they are arranged in long, horizontal patches that stand for the pattern of light and shade. In the crowns of the trees there is no system; the only requirement for the touches is that they remain independent enough to let the colors vibrate against each other like a mosaic. The colors do this brilliantly; the predominant cool blues and blue-greens are relieved and balanced by the yellows and warm pinks of the patches of light.

Cézanne's extraordinary sense for color is closely connected with his sensitivity to the nuances of light; following the light he was working with, he could lose himself in a passionate display of saturated hues - or on the contrary, using paler and greyer colors, adopt a more detached, analytic stance. He was not a painter of light as such[266], but he did portray its character unambiguously; it is the light of a given season and time of day, and the light of the north or his native south. But in the decade of the nineties, in the north, we are often less certain of the time and place; there is an emotional detachment from the landscape that is not evident in the south, a less sensuous attitude, a more analytic stance. This response to the light of the north is, I believe, the source of the innovations in his touch that lead up to his late style.

The abstract, rhythmic organization of the *Chantilly, "I"* painting (p. 156) was, it is clear, a step toward the late style, and now, in about 1890, we observe still other steps in other northern sites, in landscapes where the views are more open and distant. In *Au Bord de l'eau*, for example, Cézanne records the kind of light we had observed in *Bords de la Marne* (p. 158), but now he sees the canvas in terms of a rhythm of large clusters of paint. The clusters themselves are not abstract (they are less abstract than in *Chantilly, "I"*), but their disposition on the canvas is; they are each about the same size and the same distance apart, and their rhythm is independent of what they represent: whether it is the trees, the solid bits of houses and boat-houses, or the blue notations for the sky. Thanks to these units, whether they are merely suggested or fully painted in, the painting seems perfectly complete; whatever Cézanne's final intention may have been, we can even accept the many blank spots - set out as they are with a similar cadence - as part of the rhythmic construction. The cooler light of the north is seen not as an absence of color here, but as part of the subject; the two warm patches that intrude into the picture, one red and the other orange, call our attention to the tonality of the rest.

265 - *This is clearly an east-west road at Les Lauves, north of Aix, and Cézanne is looking north. The region has been built up now, and there is no hope of finding the site, and if this group of rocks should still exist, it would have become part of the surrounding construction.*
266 - *I think that it is difficult for a painter to emphasize structure and the quality of light equally. The more he attends to light, for example, the more he will emphasize the momentary illumination over the material presence; at the extreme, this will mean blurring the edges of the objects so that it is the light, and not the objects, that the viewer will see. Monet, of course, made that choice more single-mindedly than any Impressionist painter. Cézanne did not make the opposite choice, contrary to the way he is often described. He did portray the light that illuminated his sites; but he made the edges of his objects so clear that we notice above all their volumes, their location in space - their material presence.*

PAYSAGE (R604),
ca. 1893-94,
64.5 x 81 cm.
Ohara Museum, Kurashiki,
Japan.
Volume 1, n° 242.

As we come closer to the year 1894 - a year in which we have a secure date for two landscapes done in Giverny - the emotional disengagement becomes more pronounced and, I think, propels the next innovation in his touch. In the roughly contemporary northern *Paysage* the composition is based, admittedly, on the correspondence of the low wall and the building just behind it, but it does not work well and the rhythms of the foliage are listless. The light is cool in the north, of course, and the buildings and the vegetation are less saturated in color; but we are also distracted by the smudges that darken the surface and the pencil hatchings that signal a major correction. When we take all that into account, we are left with a point of view that seems psychologically distant (it is "only" a progression of roofs, with no culminating object to give it a clear focus or meaning), and, technically, with patches of color that lie in a flat plane rather than building up space. It is perfectly possible that the flat patches are only intended to reflect the even, grey light, in which case they respond to vision. But they are also more informal and messy; Cézanne seems to paint as if he were distant or distracted - but also thoughtful, as if the material reality of the site mattered less. Certainly the flat patches are new, and appear in no first lay-in of a roughly contemporary landscape from the south[267].

These three paintings, then - *Chantilly, "I", Au Bord de l'eau*, and *Paysage* - are more analytical in their treatment of the surface; the innovations they represent are, in fact, progressions toward Cézanne's late style, and seem to reflect a different balance between analytical thought and sheer love for the landscape.

Whatever imprecision there may be in the dating of these pictures, there is no question about two landscapes datable to Cézanne's visit to Monet's at Giverny in September, 1894. The style they reveal takes us even a step beyond that of *Au bord de l'eau*. The paintings are built up from detached groups of touches spaced at relatively equal intervals, without accumulating and condensing at points that might have needed emphasis. Giverny, the one shown below, even has the patches strung together to form horizontal bands above the level of the roofs. They represent the outline of the hilltop in the distance and the strata on its near side, and, I should think, are meant to underscore the horizontal character of the site[268]. As devices, however, these long bands are abstract, more abstract than the tightly woven patches that we shall see in the roughly contemporary *Sous-bois* from the south (p. 164); they reduce the site to a two-dimensional pattern. The lack of emphasis in both paintings - and here the uncertain touch, which is liquid in some places and dry and smudged in others - suggests more of the disengagement we had seen in *Paysage*.

GIVERNY (R778),
ca. 1894, 65 x 81 cm.
Private collection, Texas.
Volume 1, n° 243.

The horizontal bands are only ways of setting down the essentials of the landscape, of course; in finished paintings they become partly obscured by patches which break them up or by horizontal and even diagonal touches which complicate them. But even when they are partly obscured, they reveal a new conception of the landscape surface, one in which the individual objects, the large forms, and the composition as a whole, are built up from patches of pigment. Unlike the overlapping groups of the *Chantilly* series, which Cézanne adapted readily to landscapes in the south, the flat patches of *Paysage* and the horizontal bands of *Giverny* were not so easily transplanted; flat patches found their way south later, and horizontal bands only rarely. The first lay-ins of southern landscapes,

267 - *Rewald dates this picture 1888-90 - with the suggestion that it might be later - but that would make it leap ahead of the other 1888-90 northern landscapes in style. A comparison with the 1894* Giverny *would be more appropriate. A later date, but one slightly earlier than* Giverny, *is preferable: 1893-94. This also narrows the difference between these touches' appearance in the north and south to a more plausible band of time.*

once Cézanne had begun to use patches, were mostly done in compact, saturated groups. In the flatness of the unfinished northern paintings, then, we see what I think is an analytic response to the cooler landscape, and in a few of them we even witness a distance and a lassitude that might have explained the pictures' abandonment after the first lay-in. In the south, on the other hand, unfinished pictures have an incisiveness and denseness that suggests a regrettable interruption; Cézanne seems more attached to the landscapes' physicality and sensuous appearance. This is not to draw an absolute or invidious distinction but to describe a just perceptible difference in attitude, and to emphasize that the one he adopted in the north may have actually impelled the development of his late style.

In the south, the style of several landscapes that would be roughly contemporary with the northern *Paysage* is more dense; it is based on closely grouped touches, more like those of *Au bord de l'eau* than the later *Giverny*. In them, the fabric has been woven even more tightly together and every interval more carefully placed. Among them are two masterly paintings: *La Meule et citerne en sous-bois* and *Sous-bois*. They seem to be the embodiments of all that Cézanne had learned about landscape (landscape that he was passionately attached to); they are like the final pronouncements of a painter who had found a technique adequate for depicting passionate color, uncovering firm structure, and representing expressive character - all at once and with equal emphasis. Of course, they are far from final, but they would have justified his place in the history of painting even if they had been. One is tempted to say that the paintings shimmer with a nervous yet carefully placed touch, but the verb "shimmer" does not quite fit; the touches remain where they need to be, firmly on the surface of the canvas, not hovering above it as scintillating reflections do.

La Meule et citerne en sous-bois is the less formal of the two. Its touch is varied more, with horizontal and vertical strokes reserved for the painting's focus (the cistern and the various rocks strewn around it), and with strokes that oscillate freely in the two diagonal directions depicting the foliage. The surface is dense, but not in a way that would hinder us from finding our way about: the diagonal touches, which might have confused matters, are placed parallel to the upward splaying trees, creating a surface that is in fact consistent and rhythmical.

The starting point of Cézanne's thinking about the touches must have been the linear cadence of the trees - the fan shape of the eight trees nearby and the sinuous forms of the small oaks in the middle distance - and the brilliant patch of sunlight on the cistern. All of these details - still visible some 30 years later -provided Cézanne with the lines and volumes of the composition[270]. The intricacies of Cézanne's touch were reserved for the profusion of leaves in the background, which had to be tamed; and the touch I have described both represents the vegetation coherently and organizes the surface musically. Of course it is the intense colors that strike us at once. There is a surfeit of yellows here - unexpected in a wooded landscape - and it is all the more arresting because the green-yellows of the foliage are so close to the Naples yellows of the path and the cistern. This is not an easy risk to take, but Cézanne makes it work by balancing the yellows with grey-blues and grey-violets. They suffuse the painting, not only defining the shadows in the lower part but also appearing randomly throughout the foliage and tree trunks. The painting is fully as happy and affirmative as *Pigeonnier de Bellevue* above, but it also represents a more complex response to a more difficult site.

LA MEULE ET CITERNE EN SOUS-BOIS (R764), ca. 1892-94, 64 x 80 cm. Barnes Foundation, Merion, PA. *Volume 1, n° 244.*

268 - *For a small photo of the site taken from the hotel where Cézanne stayed, see Rewald, PPC, vol. 1, p. 471.*
269 - *There are two exceptions to this: two unfinished versions of the eleven paintings of* Le Mont Sainte-Victoire vu des Lauves, *R916 and 917, painted in the last four years of his life. In both we see something like these horizontal bands in the middle strip of the landscape at the foot of the mountain. But these two paintings seem to have been painted on a grey day, and, as in the north, Cézanne's flat touches were probably intended to record this more even light. This analytic response, in any case, came to the south later, even on grey days, and remained rare.*

SOUS-BOIS (R815),
ca. 1893-94, 116 x 81 cm.
Los Angeles County
Museum of Art.
Volume 1, n° 246.

An even more severe challenge must have been presented to the painter by the site for *Sous-bois*; there, the terrain is uneven, and there is no ground line or solid oblong such as a cistern to anchor the composition. Whatever touch he chose would have to organize a space that never settles down, and in fact one that meanders irregularly between two sinuous trees. Having chosen to work on a large canvas - over a meter in height - Cézanne must have known from the start that the surface would require a carefully chosen touch, and his solution now seems that much more a tour de force. To represent the vegetation, he uses short touches that either parallel, or lie at right angles to, the branch they touch, giving order and rhythm to the confusion. To focus the composition he has recourse to an invention: a radial pattern of touches just above the exact center. One thinks of the rose window of a gothic cathedral, which occupies the same secure place in the façade, a little above the exact center, and gives the façade its balance and focus[271]. Here, our eyes are drawn to the center inexorably, no matter where else we might wish to direct them, and the result is a painting in which we experience the complexity and its resolution in equal proportion. It is a painting that easily dominates a museum wall, and of all the inadequate words for describing its effect perhaps the word "authority" will have to do; it is not the grave authority that had so impressed Fry, however, but a happy, joyous one.

Rewald assumes that the painting was done shortly before the 1895 exhibit organized by Vollard, where it was shown, and perhaps as early as 1893, the date suggested at the and emphasizes the differences between Cézanne's landscape work in the north and in the south. This dating also tells us that Cézanne's life and his art had begun to move inevitably in different directions. Nothing in his life could be connected to both developments at the same time; instead, to understand the evolution of his painting, we must look to his emotional and thoughtful response to the visual world, in particular to landscape.

The distance between his life and his art is underscored by the constrictions of the one and the flourishing of the other. He had begun to suffer from diabetes in 1890, and the following year had become a devout Catholic; the former rebel, the painter of the facture *couillarde*, now felt so ill equipped to deal with life that he needed the moral support of religion, and the practical support of people "stronger" than himself, such as his sister and his son. In 1893 he lost two friends who had collected his work, the painter Caillebotte and the art supplier Tanguy. If in his life he had begun to suffer the losses typical for his age, in his art he was ever more inventive, self-assured, and buoyant. It is an unusual disjunction, and perhaps it is his work with landscape - where we see the clearest changes and most rapid strides - that helps us understand it. His attachment to vision directed him to what was outside of him, and, paradoxically, provided the kind of firm support that, in life, he sought from the church and the people he trusted. And the very competence and inventiveness that he must have felt while painting, and could watch unfold over time, must have made his life as a painter seem that much more attractive and stable than his life as a man.

His landscape drawings and watercolors have also undergone a significant development during this decade, one that is especially remarkable in the watercolors. What in the past might have been mere sketches for works in oil now seem - however they may have been meant, which is hard to know - like works of art in their own right. The drawings not only capture, say, the complex interchange of branches at the fork of a tree, but also work out the character of the spaces in between them and set up the

270 - *See Loran's 1927 photograph in his Cézanne's composition, p. 66, and Rewald's 1935 photograph in PPC, vol. 1, p. 464.*
271 - *See R. Arnheim, Art and visual perception, p. 32.*

basic rhythms of the composition. The watercolors take another and profound step: they set down a limited number of colors, at distinct intervals, which reconstruct the objects that Cézanne is painting. This is an innovation that we first see in about 1885 and follow, with its ever greater complexity and refinement, for the rest of the painter's life.

LITTLE HOUSE SURROUNDED BY TREES

(C931), ca. 1886-89, 31 x 47 cm.
Heidi Vollmoeller, Zürich.
Volume 1, n° 245.

A drawing from the late eighties, *Little house surrounded by trees*, illustrates the evolution of Cézanne's thinking since the last landscape drawing we looked at. In a superficial sense it is a sketch of the trunks and voluminous crowns of a group of trees, and if it were only that, it would be a perfectly good preparatory study for a painting, precise yet suggestive. But it also stands by itself, as an elucidation of the intervals between these trees and of the character of the space they leave between them. It is the rhythms of their distances, of the graded steps by which the crowns are modeled, and of the nearly equal blocks of touches - whether they represent volumes or voids - that command our attention; and all that has been left unsaid, all the white of the untouched paper, invites filling and completing. Having responded to all this, we no longer think of this as a sketch for a painting; the drawing is whole, independent, and self-sufficient.

ARBRES ET BÂTIMENTS

(RW357), ca. 1890-95, 32 x 51 cm.
Museum Boymans-van Beuningen, Rotterdam.
Volume 1, n° 247.

To these qualities the aquarelles add not merely the physical presence of color - a colored drawing would do that quite well - but a disciplined system of notations that establishes local color, volume, and light. Gowing was the first to describe its origins, in about 1885, and the first to connect what Cézanne had begun to do in watercolors with his late comments on the logic of organized sensations[272]. Translating the system into oil paint could not be done directly, of course; the opacity of oils hides the layers underneath. But in a broader sense, the analytic work done with discrete, transparent colors could not help but stimulate the painter's thinking about oil painting.

The large sheet *Arbres et bâtiments* is a splendid example of this new, analytic work. In pencil, Cézanne establishes a fan-shaped rhythm in the tree trunks, and then constructs another fan from the patches of color that represent the crowns. The patches, as always with Cézanne, have been allowed to dry so that when they overlap they create another distinct hue - and, more crucially, retain their spatial location on the sheet and combine to form volumes and voids. Here, a spectrum of about six colors gives us a luminescent equivalent of the cool greens of the foliage and its highlights (in an improbable, but effective, orange-yellow), and in the two upper corners, where the cool blue and dark green touches have been built up, there is the suggestion of darker background trees. But after we have spent a few moments interpreting what the patches stand for, we return to them as such: to their musical distribution, to their balance, to their system.

PORTRAITS AND GROUPS

Because portrait heads were ill suited to the analytic touch, Cézanne stopped using it by the early eighties, and this complicates any search for a clear stylistic progression in the present decade. But some portraits do clearly come later than others - judging from the age of the sitter, for example - and in them we can see another kind of evolution. They are sometimes more complex, at other times more audacious in their colors, or yet again simpler but more experimental and self-assured; they are paintings

272 - Lawrence Gowing, "*The logic of organized sensations*" in William Rubin, ed., Cézanne: the late work, *New York: Museum of Modern Art, 1977, pp. 55-71.*

in which we can increasingly see higher goals than mere portraiture. Cézanne also turns to figure groupings again, after a hiatus of nearly twenty years – that is, after the 1869-70 *Paul Alexis lisant à Emile Zola* (p. 59); he paints *Mardi Gras* in 1888 (p. 169) and the *Joueurs de cartes* series (pp. 173-176) between about 1890-96. Unlike the bathers, they are paintings of recognizable figures, done from life (or from individual studies which must have been done from life), so except for the unrecognizable *Arlequin* figures they are also portraits. Although we judge them by their composition, and find some of them to be indisputable masterpieces on that account, the quality of the figure and of the face also enters into our judgment.

If the inhibiting effect of Cézanne's crisis of 1885 can be seen clearly in his landscapes, it can also be seen the one portrait we can date from that time: the *Portrait de Jules Peyron*[273]. Not much is known about Peyron other than that he was a witness at Cézanne's wedding in 1886 in Aix, and Rewald presumes that the two knew each other in Gardanne; we certainly know nothing about his character or appearance. The painting would therefore be roughly contemporary with *Gardanne (vue verticale)*. But where the landscape was tentative, the portrait is stiff and listless, and even if we knew that this reflected what M. Peyron looked like, we could easily imagine Cézanne doing a better portrait. The pointed face – hairline, eyebrows, nose, beard – is admittedly consistent with the sharp points of the collar and lapels, and the skin tones do range from pink highlights to grey-blue shadows, but these formal qualities here seem more the habits of a lifetime than fresh perceptions.

PORTRAIT DE JULES PEYRON
(R578), ca. 1885,
26 x 20 cm.
Fogg Art Museum,
Harvard University.
Volume 1, n° 253.

There is little else that we can say definitively about the effect of Cézanne's crisis on his portraits. They have been dated only approximately, and while we would be free to rearrange them slightly, in a plausible order that fits what we know about the landscapes, we would always have to remain aware that we are guessing. One portrait of Madame Cézanne that Rewald assigns to the Gardanne period on stylistic grounds does fit our image of a painter momentarily unsure of himself; it is both dour in mood and uncertain in execution. But in another, *Portrait de Madame Cézanne* (R580), we see no such tentativeness. The sitter's gaze is focused, the colors are fresh, the mouth is firm, and the brushwork in the face and background has a clear purpose. The head is seen full-face and the face is modeled by opposing saturated, warm colors to unsaturated, cool ones, and then is contrasted sharply with the background; but the grey-blues in the face and dull yellows in the background bring the face and the ground together again. The picture is, in short, balanced and complete.

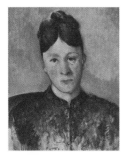

PORTRAIT DE MADAME CÉZANNE (R580),
ca. 1886-87, 46 x 38 cm.
National Gallery, London.
Volume 1, n° 249.

It also gives evidence of a thoughtful handling of the slight asymmetry in the body, which I do not wish to overlook even though I am not sure I can explain it. His wife leans very slightly to her right, just perceptibly, but Cézanne redresses the slant by adding the back of a chair of nearly the same color behind her right shoulder. He also raises her right eyelid by painting it as a single, steeply arched line, and this both lifts the right side of the face and ensures that we will be drawn to that eye. This produces a tension akin to that in the 1866 portrait of Valabrègue (p. 55), but here it is not quite openly declared, and seems less certain in its purpose.

Madame Cézanne's eyes raise some questions in another portrait, *Madame Cézanne à l'éventail*, but the puzzle pales in relation to the magnificence of the realization. It is a portrait that Cézanne must have begun in Melun in 1879-80, in the very corner

273 - *There is another painting of Peyron (R577), dated at about the same time, which is even more tentative. Whether it would add anything to our picture of Cézanne's state of mind at Gardanne is unclear, however; its provenance is less certain, and it is harder to be sure that it is by Cézanne's hand.*

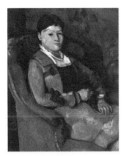

**MADAME CÉZANNE
À L'ÉVENTAIL** (R606),
ca. 1879-88, 93 x 73 cm.
The E. G. Bührle
Collection, Zürich.
Volume 1, n° 248.

where he had painted the young Guillaume (p. 95); the light is identical, the spray of leaves is located in the same spot, and, as Rewald points out, the dress is roughly from the late seventies. But the treatment of the dress is clearly from a later time - it is almost as scumbled as the surface of *Le grand baigneur* - and the face and hands are much worked over, while the near arm of the chair and parts of the wallpaper remain done with the parallel touch. The most likely explanation is that the painting was partly repainted later, perhaps in about 1888[274]. It is - and must have been from the start - a more ambitious portrait than the one of Guillaume. It enfolds the sitter in a close space, which is provided by the armchair, and separates her from the background by the chair's wing; it also strengthens that separation, and provides a parallel enclosing frame, with the extended left elbow. The fan, on the other hand, points toward the second spray of leaves and reconnects the figure and the background again; and if we feel intuitively that the painting is unusually well resolved, it is in part thanks to such thoughtful measures.

The black almond shape for the right eye must be part of the repainting, but I must admit that I find no way of accounting for it that is fully convincing. It does locate the eye in the same plane as the other black objects, such as the hair, the bodice, and the outline of the chair, and it does make us concentrate on the painting's form rather than the sitter's likeness; as a result, the painting becomes all the more a carefully crafted object rather than a mere portrait. Perhaps this is what Cézanne intended, though we cannot be sure; but this sacrifice of likeness to composition is what elicits the deep sense of the painting's grave authority.

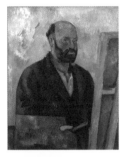

**PORTRAIT
DE L'ARTISTE
À LA PALETTE** (R670),
ca. 1886-87, 92 x 73 cm.
The E. G. Bührle
Collection, Zürich.
Volume 1, n° 252.

We must think of his great self-portrait, *Portrait de l'artiste à la palette*, as a companion piece to the portrait of his wife. However it may have been intended, it carries the same gravity, even monumentality, and a sense of a truth deeper than the artist's momentary appearance on a particular day; and it is fully as large and ambitious. But it seems to have been painted in one stage rather than two[275]: the brushstrokes, although parallel in parts and scumbled in others, seem to be of a piece. The sense of understated grandeur would have been present from the start: the jacket is massive, the palette makes a firm, horizontal base, and the face connects calmly with the canvas on the easel, not with us. The face is also painted with same selection of browns as the easel and the palette, with some grey-greens borrowed from the background, and this is possibly the result of elaboration; but its effect on us is immediate, and it is one of unforced, simple unity. That the face is without expression or idealization[276], and that nearly all of it should be in shadow, seems like a tribute to Cézanne's art, as if to say that it is not the face of the painter that matters here: it his concentration on the fully illuminated canvas[277].

In three portraits ascribed to the end of the 1880s Cézanne paints his wife in an equally everyday setting, wearing a frumpy, blue housecoat. No less plain than the pale blue

274 - Rewald, PPC, vol. 1, p. 402-403.

275 - The date assigned by Rewald, c.1890, seems unlikely, given the color of Cézanne's beard; in a photograph taken in 1889, it was already salt-and-pepper, closer to white. Here it shows signs of greying only at the angle of the jaw, as in Cézanne au chapeau melon, esquisse from 1885-86 (p. 206). Ratcliffe's suggestion that it was painted between 1886 and 1888 seems more plausible (Robert Ratcliffe, Cézanne's working methods and their theoretical background, PhD thesis, University of London, 1960, p. 19).

276 - The face is without expression in part because Cézanne has turned the more distant eye toward the nose. This is a puzzling practice -and it is a practice, because we see it in Madame Cézanne à l'éventail and other portraits - and I cannot offer a fully convincing explanation for it. We may make a reasoned guess if we obscure the problematic eye: the other one then becomes very focused, staring at the canvas almost ferociously, and we become more aware of the quality of the gaze than the structure of the painting. Presumably this would be an anecdotal distraction that Cézanne would not welcome.

277 - Schapiro, in Paul Cézanne, p. 34, gives these same formal qualities a more psychological interpretation. "A purely formal interpretation is hardly just to the expression of the painting. The devices mentioned not only reduce the depth and adapt the picture to the rectangle and surface plane of the canvas. They carry also an affect of self-isolation in forms that otherwise advance boldly into the spectator's space. ... Concentrated on his canvas, he is absorbed in the closed world of his own activity."

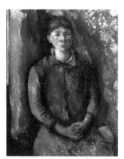

PORTRAIT DE MADAME CÉZANNE
(R607), ca. 1888,
99 x 77 cm.
Detroit Institute of Arts.
Volume 1, n° 251.

of the coat, in each of them, is her hair, which is merely brushed down and back, and her face, which is without expression. As portraits of the effects of daily routine, if that was their intent, they are successful, almost too mercilessly so, and I find that my emotional response to them makes it difficult to see their formal qualities. Of the three[278], the *Portrait de Madame Cézanne* (R607) is the most ambitious; Cézanne has picked out a blue-grey water drop pattern from the wallpaper and matched it in color to the dress, and furled a fabric behind her right shoulder to enclose her back. As a color composition the painting works very well - it has two sets of complementaries, for example, an orange and grey-blue one, and a crimson and green one - but the brushstroke in the house coat is fussy and busy and the balance of forms is imperfectly resolved.

If the portrait was done in 1888, as Rewald suggests[279], it does not have the self-assurance of the contemporary Chantilly landscapes. It is not that its touch is different, because portraits have different requirements, but that it is listless; it is equally listless in the other two housecoat paintings, but not in other portraits of the time. We must credit the mood of the three sittings (having little else to go by), and note that Cézanne, in renouncing a clear touch, has suceeded in making his touch fit the sitter's expression and creating a consistent ambiance; whether this was a sacrifice or not is difficult to decide.

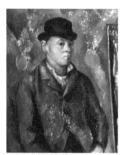

PORTRAIT DE PAUL CÉZANNE,
fils de l'artiste (R649),
ca.1887, 65 x 54 cm.
National Gallery of Art,
Washington, DC.
Volume 1, n° 250.

Among other portraits of the late eighties there is one of Cézanne fils, painted in the same light and possibly in front of what seems to be the same background, but done with a much firmer sense for what the wallpaper pattern could offer to a coherent composition. Here Cézanne let only one water drop survive - whether it is the same shape or a different one from an obviously complex pattern is unclear - and let it echo the form of the boy's head; otherwise he relied on the repetitive diamonds, more specifically on their lower half, to provide the leitmotif for the structure. That is reflected in the emphatic V of the figure's lapels and, upside down, in the opening of the coat below the lowest button; and as soon as we notice this, we also notice how comfortably the chin is nestled in the opening of the shirt. What might have been a picture of a faintly overweight adolescent in a wrinkled coat becomes a painting with inner rhythmical repetitions[280]. The screen at the right, by the way, acts to give the figure stability; if we cover it, we see him lean backwards, and when we uncover it again, he straightens up, as if he were pushing back against it.

A painting in which Cézanne brings together two costumed figures, in some physical relation that needs to be tied to the costumes, easily becomes a much more formal statement than a mere portrait would be. The monumental *Mardi Gras* of 1888 brings together Cézanne fils and Walter Guillaume, as Harlequin and Pierrot, not only as actors in a scene but as themselves. The painting was carefully prepared from sketches and executed painstakingly; and if at first sight the final result seems stiff, on closer look it is rich in resonances and alive in its surface. I must confess that until I had seen it in the flesh, I was unable to see this; because it is large, the details of its surface become lost in reproductions, and the "hard look" is impossible; but the resonances become immediately apparent when one faces the original. In the reproduction the white tunic of Pierrot's costume seems dull, for example, at best workmanlike, while in the original it is composed of subtle touches of faint reds, grey-blues, brown-yellows, and green - each of these colors being a pale version of some other color in the painting and serving to make the white fabric an inseparable part of the whole. The background drapery, which we shall soon see in some of the still lives, is a dull olive, a comforting and

278 - *The others are* Portrait de Madame Cézanne, *R581, and* Portrait de Madame Cézanne *R650, both assigned to 1888-90.*
279 - *PPC, vol. 1, p. 403.*

solid hue in the clash of reds and blue-blacks. And even the risks in that clash of colors are more clearly visible in the painting itself; pure red is a most difficult color to integrate into a composition, and an even more difficult one to oppose to blue.

The diamond pattern in Harlequin's costume is itself risky as well, but in a different way; it is repetitive and decorative, not easily subject to integrating into a larger structure. Cézanne has gone as far as one can: he has made a broad enclosing frame for the diamonds with Harlequin's white stick and Pierrot's white shape, and in this way contained their impact; and because they lean backward with Harlequin's torso, they became part of the movement of push and resistance between the two figures. Pierrot's push and Harlequin's reluctance are in balance, of course, but there are two other forces that we can feel here: a line that extends from the fold in the drapery above Pierrot's head down through the tunic and the bottom of the pant leg, which parallels Harlequin's slant, and a series of lines that push toward the lower right corner - the bottom of Pierrot's sleeve, his pocket, the bottom of the tunic, and three of the four feet - that give us a sense of the figures' movement forward. If the balance of all these forces seems too carefully weighed, we can find relief in the impulsive swish of the drapery and the intricacies of its irregular pattern.

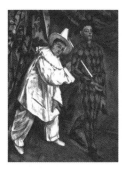

MARDI GRAS (R618), ca. 1888, 102 x 81 cm. Pushkin Museum, Moscow. *Volume 1, n° 254.*

If Cézanne's formal aims in *Mardi gras* can be reconstructed from a hard look at the painting, I confess that they are harder to grasp in the three single Harlequins. They are almost certainly not studies for *Mardi Gras*; there would be little need for three of them, and in any case in all of them the figure stands rather than being pushed, the hat is altogether different, and the face is made small, pointed, and mouthless. If Cézanne fils had posed for them, then the painter invented the head he put on him; and no matter whose head it is, his mouth has been suppressed (as it is, mysteriously, in the preparatory drawing, C941, which would normally be more realistic). So the three Harlequins are paintings in their own right, large and ambitious; R620, below, is nearly as tall as *Mardi Gras*. What formal challenge they may have been intended to meet, and what it is that they have accomplished, is less clear to me. I have to attach myself to details I can understand, such as the small pointed head, which almost becomes one of the diamonds, and the drapery at the top, which gives us a volume that helps replace the small head (and enclose the awkward hat). And I suspect that the contrast of the red with the blue-black in the costume is another self-imposed gauntlet, which Cézanne runs by reproducing the two colors in the background and then relieving the whole with the ochres of the drapery. But the result is not as convincing as Cézanne's other color harmonies, and the paintings are neither portraits nor figure studies with a clear purpose, so I must content myself with understanding their parts and admiring some of them technically.

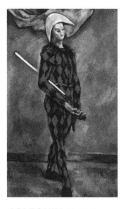

ARLEQUIN (R620), ca. 1888-90, 100 x 65 cm. National Gallery of Art, Washington, DC. *Volume 1, n° 255.*

If we can view the four portraits of Madame Cézanne in a red dress and four paintings of a young Italian boy in a red vest as further explorations of this difficult color, then it is clear that they have succeeded. They are also, of course, portraits of two distinct people in different circumstances. The poses in the first group are repetitive and confined, and the color harmonies subtle; in the second the poses are loose-limbed and the colors are striking. Madame Cézanne's dress is a dark, unsaturated crimson while the Italian boy's vest is a pure vermilion, purer than the red of Harlequin's costume, but both colors require ingenuity and audacity to find the right complements.

280 - *Rewald dates the picture 1888-90, but there are convincing arguments for placing it earlier. By 1888* Cézanne fils *was taller and slimmer, to judge by his appearance in the 1888* Mardi gras *and above all in the detailed sketches which precede it (C938 and 939), where he also wears the beginnings of a moustache. Cézanne fils later placed* Mardi gras *in 1888, and the present portrait in 1885 - but that, on the other hand, seems too early.*

In the four portraits of Madame Cézanne the principal complement is a combination of green and yellow-mustard; in one (R652, not reproduced), the combination fills the whole background, while in the others the two colors are separated into green in the background and yellow-mustard in the chair. The red-vest series, on the other hand, is more direct; it balances the saturated red by straight green and blue touches.

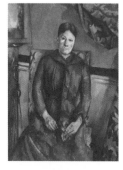

**MADAME CÉZANNE
AU FAUTEUIL JAUNE**

(R655), ca. 1888-90,
116 x 89 cm. Metropolitan
Museum of Art, New York.
Volume 1, n° 256.

In the four portraits of Mme Cézanne, no less significant than the color harmonies are their firm, unerring compositions; even the simple wainscotting behind the yellow chair in one of the simpler versions (R653, not reproduced) serves Cézanne to achieve a dynamic balance[281]. In *Madame Cézanne au fauteuil jaune*, below, the most complex and ambitious of the four both in color and composition, a fourth color has been added, a complex green-blue, and a number of objects: the curtain that we have seen in *Mardi gras* and a fireplace with mirror and tongs. Paradoxically, the fourth color simplifies matters, because it gives us two pairs of complementaries (yellow/blue and red/green), but the painting remains intricate and imposing; the geometry calls for sustained attention. We can look at the composition as an interplay between upright rectangles and inclined organic forms, or we can see it as a series of increasing inclined shapes which start vertical at the left and fan out step by step toward the right, until they are stopped by the massive curtain - at which point the whole background is inclined as well. In this array, the figure of Madame Cézanne occupies a halfway point; she both leans and sits upright; she is also center stage, dominant by her large form, the simple oval of her arms, and the red of her dress. She is dressed for posing once again - in the other versions, too - and her elongated head restores to her the elegance she was deprived of in the housecoat series.

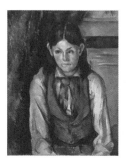

**LE GARÇON
AU GILET ROUGE**

(R656), ca. 1888-90,
66 x 55 cm.
Barnes Foundation,
Merion, PA.
Volume 1, n° 258.

Whether some change had occurred in Cézanne's relation to his wife, or whether, as I think more likely, he had found a clear sense of direction in exploring the uses of a crimson red, the pictures present a self-possessed Madame Cézanne in focused, firm compositions. A different but equally clear use of red can be seen in the *Le Garçon au gilet rouge* series: the poses all differ, the color red is a more challenging, saturated vermilion, and the handling of the surface is rougher, freer, though equally secure. Of all of Cézanne's figure studies these seem the most responsive to the sitter's physiognomy - to his adolescent gangliness, his large hands, and his loose joints and relaxed spine - and are therefore among his freshest and least formulaic.

The smallest, and by no means the least significant, is the frontally posed *Le Garçon au gilet rouge* (R656). As frontal as it is, it is also quite asymmetrical. To the gentle leftward slant of the body Cézanne adds a head that he elongates sharply to the left and up, and then to contain this imbalance he has the figure lean into a solid curtain; so balanced is the result that we are barely aware of the stratagem, yet so dynamic is the composition that at no time does it become still. The vermilion hue is balanced straightforwardly, as I said: it is surrounded by green tones in the white shirt. The green is handled subtly, so as not to compete; instead, it pops up only as a component of other local colors, such as the blue touches in the shirt and the background, the dark red-browns in the curtain, and the flesh tones in the face. This is perfectly sufficient for color balance, and it does not take away from the red's dominance; the red must remain the painting's focus, but it also must not shock, so patches of it (more than skin normally justifies) are added to the face.

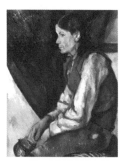

**LE GARÇON
AU GILET ROUGE**

(R657), ca. 1888-90,
81 x 65 cm. Museum of
Modern Art, New York.
Volume 1, n° 257.

In the version in which the model is seen from left profile (R657), the face remains lighter and yellower, but this, too, has a technical justification: the head must be allowed

281 - See, for example, Rudolf Arnheim's discussion of the balance in R653, in his Art and visual perception, *2nd edition, Berkeley: University of California Press, 1974, chapter on balance.*

to stand out in order to emphasize the profile. In fact, the clear outline and its contrast with the near-black curtain make this the most incised profile in Cézanne's work, and we may imagine Cézanne asking the model to pose tentatively from the side so that he can look for resonances between the profile and the rest; he would see the bridge of the nose echoed in the curve of the back, and the slope of the nose doubled by the vest front and the upper arm, and know that he could make the most of them. We may suppose that he would have then arranged the curtain to confirm these rhythms (it does not hang naturally), because every line of the profile, except for the forehead and the upper lip, now reflects either the right edge of the curtain or the left one. As we look at the painting, having noticed this unostentatious unity, we may be alerted to the touches, which double the left edge of the curtain even in the beautifully articulated sleeve. For a painting that risked so strong a presence of red and so violent a contrast between the face and its background, this one is remarkably unified and resolved.

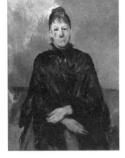

**PORTRAIT
DE MADAME
CÉZANNE** (R683),
ca. 1888-90, 90 x 71 cm.
Barnes Foundation,
Merion, PA.
Volume 1, n° 260.

All of Cézanne's analytic work in the late portraits was directed to such formal inventions. We must count among them a new harmonic link between dark violets, greens, and blues, which we see in two portraits of Madame Cézanne from around 1890[282]; this is a harmony we will also see in later landscapes. It is an irresistible invention, sober and elegant yet alive, and it sets off flesh tones equally happily, whether the composition is simple and sculptural, as in *Portrait de Madame Cézanne*, or ornate and flamboyant, as in *Madame Cézanne au chapeau vert*. In the simpler painting (below), Madame Cézanne is huddled in a cape with her hands apparently in indirect light and her bare head illuminated sharply; there, flesh tones, reds, greens, and blues model her face and concentrate our gaze. So little is present in the scene that we have only the simple pose and the exacting choice of colors to respond to, and the sense of the colors' rightness takes a while to disentangle; but I think we can point to such fine balances as the warm green against the cool blue in the background, the surprising eruption of brown-red in the hair and at the bottom of the skirt, and the subtle intrusions of little flecks of flesh color, brown-red, and even blue, in the dark cape. The unity of the painting may seem unforced, but it has been achieved by a thoughtful exercise of Cézanne's unfailing sense for color[283].

In the more flamboyant painting, the focal point of the harmony is the delectable relation of greens to violets. Except for the flesh tones and red-browns, these two color groups form an insistent interplay, sometimes warmer, sometimes cooler; violets turn into blues, and yellow-greens into blue-greens. Only so concentrated a harmony can justify the nearly expressionless eyes (eyes which in the other painting are dark to match the cape) and defend the absurd hat, but it is a defense I would gladly spring to. The conception of the painting is ornamental, not sculptural: the curves of the chair reflect the interlaced fingers and the folds of the dress, and the picture is flattened at the bottom by foreshortening the left arm of the chair, which would have otherwise disappeared below the frame.

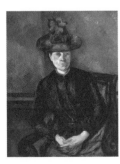

**MADAME CÉZANNE
AU CHAPEAU VERT**
(R700), ca. 1891-92,
98 x 80 cm. Barnes
Foundation, Merion,
PA. *Volume 1, n° 259.*

The portraits of Madame Cézanne culminate with another decorative picture, a happier, lighter, and more complex one than *Madame Cézanne au chapeau vert*. It is lighter because it was painted in a conservatory - at the Jas de Bouffan in about 1891, as *Cézanne fils* remembered later - and this explains the warm, flat light, the small tree, and the many plants located in odd positions. Nothing that we know about Cézanne's life, however,

282 - *Linking them by their common tonality is easier than dating them, but dates around the end of the eighties or the beginning of the nineties seem probable; I cite Rewald's more exact dates, but am not sure whether we can say as much - not even whether one was painted before the other.*
283 - *Perhaps one could say, "nearly unfailing", given the problems with the Arlequin series, but that is so small an exception that the qualifier is unnecessary.*

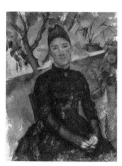

**MADAME CÉZANNE
DANS LA SERRE**
(R703), ca. 1891-92,
92 x 73 cm. Metropolitan
Museum of Art, New York.
Volume 1, n° 261.

explains why he had chosen to paint so happy a picture, surrounding Madame Cézanne with flowers and making her look unusually content. We must accept the mood as we find it, and turn to the technical ways by which the harmony is established. The angle of the tree behind her plays a crucial role. It parallels her head, the back of the chair, and by implication the small of her back. If we block it out, it is her head that we see differently, because now it leans to its right and back at a coy angle; if we uncover it again, it becomes oriented normally. But the tree is not sufficient for the balance of the picture; it also needs the counterweight of its other branches and the emphatic top of the low wall which goes so far as to interrupt the trunk, and it needs the plant in the upper right corner. So the picture is decorative in a sense, but the figure of Madame Cézanne is simple and sculptural, and the whole is balanced without ostentation.

This is the last portrait that Cézanne painted of his wife. Most of his portraits from 1892 on are of men, and the few that he did of women are, with one exception, of older and plainer models. The choice was in part practical, of course; models could be recruited from among people who worked for him or his family, and friends could easily be persuaded to pose. But from now on there is also an inescapable sense in his portraits of the older painter, of someone who identifies with people close to him in age; it is a sense that, already in the early nineties, brings to his portraits a forthright simplicity, and in the following decade a quiet, resigned dignity.

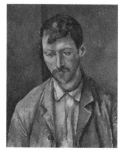

LE PAYSAN (R704),
ca. 1890-92, 55 x 46 cm.
Private collection.
Volume 1, n° 263.

The portrait of a peasant that he painted at about the same time as the one of Madame Cézanne in the conservatory could not be more different: angular everywhere (in nearly everything about the face and clothing: hairline, eyebrows, ears, nose, moustache, chin, collar and lapels, and the set of the shoulders), downward pointing and heavy (in the cast of the eyes and the massive bottom), and bristly in its touch (with the touch giving form to the unkempt hair, the unshaven cheeks, and the rough coat). But it is far from the lesser picture; seemingly informal, its forms are in fact carefully considered (note the light that Cézanne introduced into the neck to elongate the mass of the head), and all resolve into a perfect consistency of form and a unity of touch with meaning. The color – that is, the color chosen to complement the skin tones – is once again new; it is a dirty grey-green composed of olive tones and blue-greens, and it both balances the deep reds in the skin and emphasizes them.

The touch in this portrait is subordinate to the color and to the angular texture of the whole. As in most other portraits, the touch is generally not a system, but an instrument that serves the whole: it can be either faint and uneven, in which case it simply does not matter in the composition, or it can be visible and uniform, in which case it may convey character, age, or situation. Whatever Cézanne's formal intentions or achievements, in a portrait there would be neither complex textures to organize nor a deep space to manage, as in landscape, and the composition would be dominated by the face; this would limit the responsibility that could be placed on the touch. Cézanne's need for form would be satisfied by composition, color use, and internal consistency.

In group compositions, however, much of the burden of formal treatment falls on the arrangement of the figures. In the bathers we have seen so far, and in the great bathers of his last years, the arrangement was imagined and often looked artificial. But in the early nineties he painted two compositions of card players and onlookers from life, posed by people who worked at the Jas de Bouffan[284], and followed them with three paintings of just two card players. Whether or not he might have wished ultimately to depict a story, such as in the Le Nain brothers' The *Card Players* that he

knew[285], he certainly chose the right poses for his mode of working - people concentrating on their cards or quietly watching - and the right point of view, from the side, which let him remain a detached observer and gave him a simple, potentially symmetrical arrangement. In their realization the arrangements would become monumental.

Since there are several drawings, watercolors, and even preparatory oil paintings for the figures in the compositions of four and five players, we may assume that as he painted them he anticipated how he would assemble them; whether they posed again for the final paintings, however, is unknown, but given the quality of the sketches it would not have been necessary (except in one case). The four-player version is the more immediate and seems to me first[286], the five-player version would follow, and the two-player versions are a separate series, done later in a different setting and in a different light, with their own preparatory studies.

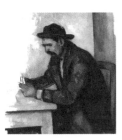

LE JOUEUR DE CARTES (R709), ca. 1890-92, 50 x 46 cm. National Gallery, London. *Volume 1, n° 265.*

One of the studies for the player who will appear on the left in the two large compositions, facing the other way, is a portrait; his pose, his clothing, and the modeling on his face, are closely observed. He is the one who may have had to pose again for the large painting; his pose is not only reversed, but he is more erect, and his posture is aligned better with the standing figure. The figure is clearly studied under a particular light and in a certain spot, and then it is studied again in the opposite light, and only the unfinished space on the left tells us that he was to figure in a larger painting.

Of the two beautiful compositions that result from these studies, the four-player version, *Les Joueurs de cartes* (R707), is the smaller, but it is more direct - less grandiloquent - and more simply realized. Both are masterpieces, but of a different kind. This one is asymmetrical, oblique, with no object clearly in the center except perhaps for the legs of the central figure, which are barely visible, and his hands, which are saturated in color and dense, and highly visible. Yet the heavy drapery and the massive back of the man in the blue smock balance the figures on the left, and everything points to the cards: everyone's gaze, several of the arms, and even the pipe rack on the wall. We always know, as it were, what part of the picture to come back to, and we come back to it inevitably, thanks to these concentrated forms. The figures inhabit their space easily, leaving each other ample room. (In the other picture, twice as large as this one, the composition is more symmetrical, the space is more dense, and more complex diagonal lines connect the figures). The left side establishes the direction of the light by placement of the standing figure's shadow, and we can see the same light illuminating the heads. The immediate impression of rightness and balance that we form is the effect of all these carefully thought through relationships.

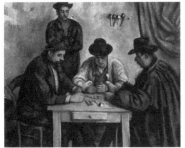

LES JOUEURS DE CARTES (R707) ca. 1890-92, 65 x 81 cm. Metropolitan Museum of Art, New York. *Volume 1, n° 262.*

284 - *See Joseph J. Rishel's discussion of this series, its models, and its sources, in* Great French paintings from the Barnes Foundation, *New York: Alfred A. Knopf, 1995, pp. 122-127.*
285 - *Gasquet tells us that Cézanne stopped in front of the Le Nain brothers' Card players in the museum in Aix and said, "That's how I would like to paint!" But Cézanne stopped in front of other genre paintings as well, with the same exclamation, so Cézanne's model of genre painting was more general (and it included his admiration for the compositions of the Venetians). If the painting of figure groups was Cézanne's lifelong ambition, his card player series was only one way in which he satisfied it, and the only one done, at least originally, from life. (See Joachim Gasquet's Cézanne, London: Thames and Hudson, 1991, p. 48)*
286 - *It is generally assumed that the largest, R706, was done first, and the others later, by a process of distillation. It seems to me more likely that the version with four players, R707, was first. The life studies of all four figures, in pencil, watercolor, or oil, resemble the figures in the four-player version more closely than in the five-player one (I refer to the hat and ascot of the standing figure, the chin of the figure in the blue smock, and the hat of the figure in the center, which is missing in the five-player version). More important is that the four-player version seems more immediate: the table is set at a slight angle, the two figures on the left seem more engaged, the golden drape and the blue smock are more textured - and the space behind the standing figure is not beset by problems. The five-figure version seems to be modeled on the four-player one, but it is more formal and ambitious, with room - but not quite enough room - made for the head of a little girl.*

The painting is finely realized in its details as well. The light-colored table, for example, seen in the flesh, is a carefully laid down surface of blues, reds, ochres, browns, and greens - the very colors of the cards on the table and of the painting as a whole; as he has done before, Cézanne has used that neutral surface to recapitulate the entire color scheme, and he does so in the wall as well (and adds green to balance the intense reds).

Cézanne's narrative ambitions seem to have been fully realized by this picture's complex attainments; it is difficult to believe that he might have aimed at an anecdotal statement of a moment in card playing, such as the revelation of a hidden card. On the contrary, with a deeply felt sympathy for the commonplace activity and appearance of his sitters - and with an incomparable ability to resolve tension, or infuse tension into balance - he has produced a painting that must be compared to paintings of the early and high Renaissance. Roger Fry compared Cézanne to Rembrandt and the Italian primitives[287], and while the comparison is appropriate with Rembrandt, the Italian painter to evoke is, I think, Piero della Francesca; one thinks of the power of stillness and balance to contain tension and convey an underlying drama.

Cézanne's other three paintings of card players transpose the scene to a darker setting - perhaps a café - and reduce the players to two. It is generally agreed that they are independent of the first two paintings, portraying at least one sitter who had not appeared in the other series (the one on the left; the one on the right could have sat for the first series). They must have been as important to Cézanne as the first two were; they were preceded by several studies, painted in three versions, and one of the paintings is a full 130 cm wide.

In all three paintings Cézanne reduces the scene to the stillness and slowness of the card game between the men, but with only two facing players he creates a tension not felt in the first series: we easily imagine them as adversaries. In all three versions the man at the right leans forward and thrusts his cards toward the other, who sits straight up; we note the intrusiveness of the one and the calmness of the other, and we respond to the slant of all the forms: the table, the tablecloth, the bottle, and the wall behind them, all of which push to the left with the more active player. The nearly symmetrical situation is charged with formal tension, then, and although the tension is perfectly visible as we look at the paintings, one should hold them up to a mirror to feel its full extent.

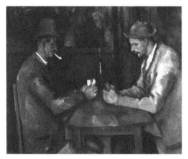

LES JOUEURS DE CARTES (R714), ca. 1893-96, 47 x 56 cm. Musée d'Orsay, Paris
Volume 1, n° 264.

The smallest of the three, *Les Joueurs de cartes*, R714 - also thought to be the last to have been painted[288] - is the masterpiece in the series. At first sight it is the calmest and most balanced, but paradoxically it is the most inwardly charged with tension. One crucial difference is that the man on the right, whose head is below that of his fellow player in the other paintings, is painted larger here, so that their eyes are at the same level; the two players are more equal as antagonists, but paradoxically this only intensifies the asymmetry of the space. We also do not see his back, which is slack in the other paintings, so that here he appears more upright; and his eyes look down while the eyes of the other are altogether invisible, which makes both of them more thoughtful, poised rather than in overt competition.

The colors are once again new in this series, and they progress in complexity toward this picture. As against the first two pictures, in which the men's coats contrast more

287 - Fry, p. 68.
288 - See Françoise Cachin, Isabelle Cahn, Walter Feilchenfeldt, Henri Loyrette, and Joseph J. Rishel, Cézanne, New York: Abrams, 1996, pp. 335-341.

in color and stand out more against the dark ground, the third version has subtler connections between the coats and less light-dark contrast; the dark brown-red unifies the scene and creates an odd, darkly luminous light. The light smock of the man on the right, which is quite bleached in one of the other pictures and very yellow in the second, is here a delicate, pale ochre, tending in spots to browns, elsewhere to greens and blues: a splendid choice to oppose the red-browns, and – especially for so neutral a color – a subtly elaborated and exciting surface.

Words always seem inadequate for describing why a painting is extraordinarily moving, and even the detailed enumeration of what sets this painting apart from its two cognate pictures barely helps. But it is to me one of the most poignant paintings I know, and words such as "quietly contained" and "charged with tension", or even "superbly balanced" and "darkly luminous", risk sounding like advertising copy for a product that – here – can speak perfectly well for itself. It is a risk that one has to take, as great a risk as a comparison with other painters would be; but I come back again to Piero della Francesca, this time to the mysterious Flagellation of Christ at Urbino; that is also divided into two halves but there one half is open and shows us three thoughtful men conversing, close to us, while the other half, closed and distant, gives us a glimpse of Christ's flagellation as rhythmic choreography. An emphasis is reversed; an aggressive tension is seen from afar and contained; and the scene inhabits an ordered space. These are not parallels to Cézanne's picture in any literal sense, but they help describe the uncanny effect that these exceptional pictures evoke.

L'HOMME À LA PIPE
(R712), ca. 1893-96, 73 x 60 cm. Courtauld Institute Galleries, London.
Volume 1, n° 268.

The man on the left of this *Joueurs de cartes* was obviously tall and thin, as he appears in all three versions and in a preparatory study of his head in profile, pipe in mouth (*L'Homme à la pipe*, R711), and in the portrait that Cézanne did of him full-face. He also seems to have been a serious man, perhaps thoughtful or slightly depressive; or so he appears in *L'homme à la pipe*, R712, below. This painting is a masterly understatement, with most of it painted in colors that range from dull browns to blue-blacks; but against this unattractive ground the skin tones appear luminous -almost as a relief from the torpor of the ground. Most important for me is the simple detail of the pipe and shirt, which is done not in white but in a light blue with touches of light green: a masterly color balance (blue-green against the mass of dull browns) and color use (fresh air introduced into the oppressive atmosphere). There are fine details, such as the single line that extends from the hat brim above the sitter's right ear down through the tip of the nose, the pipe, and the shoulder, which brings a certain dash to the laconic man. We cannot know if the painting has captured the sitter's character, but we can feel that it would not have displeased him; it is free of hesitations or contradictions, and no matter how muted, it is an important picture.

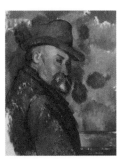

CÉZANNE COIFFÉ D'UN CHAPEAU MOU
(R774), ca. 1994, 60 x 49 cm. Bridgestone Museum of Art, Tokyo.
Volume 1, n° 266.

Cézanne would paint only three more self-portraits in his life and of these one can be dated from his stay in Giverny in 1894, when he visited Monet. Like some of the heroic self-portraits from his younger years, *Cézanne coiffé d'un chapeau mou* shows him from slightly below, looking at us over his shoulder; the skin is ruddy, the flesh is full, the beard is incisively trimmed. But the head is turned just a bit farther from us and the eye looks at us more askance, and the expression seems more suspicious, so we are inevitably reminded of Cézanne's unfortunate reply to Monet, who welcomed him in company with warm affection and praise, only to have Cézanne say in dismay, "You, too, are making fun of me[289]," and leave. But whether the portrait reveals a state of mind or not, it is above all a splendid painting. The whole is done with a beautiful economy of secure brushstrokes - secure in the incisive modeling of the face, of course, but secure also even when merely scumbled to contrast with the head. Cézanne takes

interesting risks with the composition: he confines the figure to the left half of the canvas and fills the space around it with irregular patches taken liberally from the wallpaper pattern behind it. The darkest ones touch the brim of the hat and abut his beard, prolonging the sharp diagonal of the jaw and giving it a massiveness that balances the heavy torso. They create a simple, unobtrusive color scheme, with their dull purples set against dull greens, against which the face appears even more ruddy.

We must recall that the portrait was painted at about the same time as the landscape *Giverny* (p. 162), and that the simplified planes with which he was beginning to represent the northern landscape have no parallel, and no use, in portraits. A regard for the sitter, or for the likeness, constrains the degree of abstraction the head will be allowed to reach; with a recognizable portrait head, the canvas will then either become a bust, with or without background to complement it, or a large study in which the head, though still a likeness, will become only part of the pushes and pulls of the whole composition.

**LA FEMME
À LA CAFETIÈRE**
(R781), ca. 1893,
130 x 97 cm.
Musée d'Orsay, Paris.
Volume 1, n° 269.

Cézanne set himself a more ambitious task in a portrait in which the setting was, paradoxically, humbler and the sitter less formidable: *La Femme à la cafetière*. Fry thought that the pose was in fact natural to the sitter, since she was a servant[290], and he may well be right; but if this implies that the pose was the origin of the composition, then it puts the onus of explaining the painting on the sitter rather than on Cézanne's alertness to the complex relationships that make a composition - even in a more homely setting. Setting up the pose probably involved work comparable to setting up a still life: moving her in front of different walls, putting this or that object next to her, choosing the right tablecloth. Of one element of this preparation we may be sure: anticipating doing a large canvas, Cézanne might first do a study of the head. There is such a study (*Etude pour la femme à la cafetière*, R780), and it shows us in what way it was useful; it pointed out to Cézanne that in order to fit the head into the painting's simple shapes (which include the oval of the arms), he had to simplify and enlarge her very small jaw.

We therefore know the painting to be a portrait, and if the face should be the first thing we look at, we would see that it is a magnificently concentrated distillation of all the colors of the painting (with the addition of a few spots of red). The painting is in fact carefully elaborated everywhere; the least panel on the door and the smallest flower in the decorative panel on the left all matter as much as the face, and it becomes clear that the portrait is an ambitious, formal, fully realized, painting. It is unapologetically frontal, with the woman's dress divided symmetrically by a straight midline, and it is organized with the utmost simplicity: the midline runs parallel to the doors, the spoon, and the coffee pot. But it is far from a still painting. The pull to the left of all the slanted verticals, and the woman's left-of-center position, are balanced by her gaze to the right of center and by the coffee implements; and there is a compressed knot of energy in the center, where the pleats of the dress parallel the shape of the arms and seem to expand outward against a resistance.

The achievements in the portraits of this period are best judged by their exceptional color harmonies, and above all by their gravity. The word "gravity" is easily overused, but with the portraits it refers to the seriousness of the sitter and the pose, to the

289 - In the original, "Vous aussi, vous vous foutez de moi!" *The vulgar "foutez", in company, is testimony to the depth of his feeling, however unjustified. It is in sharp contrast to the politeness and even cordiality he had shown to everyone else at Monet's. Cézanne did write a cordial letter to Monet later and did thank him for his support (July 6, 1895). For Rewald's account of these events, see his Cézanne, pp. 187-188, and for the French original, see his Cézanne et Zola, Paris: Sedrowski, 1936, pp. 145-146. Cézanne's exclamation comes to us from the testimony of Marie Gasquet, widow of Joachim Gasquet, so it is not a first-hand account, but the rest is based on documents.*
290 - *Fry, p. 63.*

complex balance between tension and resolution – or perhaps more precisely to the near invisibility of the craft that resolves the tensions, which in front of the best portraits produces a quiet awe. The portraits are not, in any case, judged by their touch; touch remains crucial in landscapes and narrative paintings, but the humanity of the sitter and the small space of portraits draw Cézanne's attention away from the surface toward composition, tension, and color balance. It is not an uninteresting exercise to try to imagine where he might go next, having achieved so much. As it was, in some of his late portraits he let himself be influenced by his advances in landscape; he neglected the figure in favor of a rich setting, and represented the latter with an analytic, shorthand detachment. Fewer elements, more independent of each other, came to convey form and color. The result was freer and richer – but at the inevitable price of relinquishing some likeness. It is a price he had paid once before, however, in the 1877 portraits of his wife and Chocquet, and a small one to pay for the brilliant results obtained in the last decade.

In the portrait drawings, Cézanne was, as we would expect, as independent of technique in this period as he was in the last one, and we look at them for what they are rather than for signs of stylistic development. Only a few drawings would be judged by their gravity, like the paintings, and they were studies for the card players (C1092 and C1093, for example, which are large and precise studies of the players who are seen from the side). Most drawings would be judged by their immediacy, by the rightness of their touch, and by their economy of means; and among these the drawings that served as ends in themselves are the most alive. *A Portrait of Madame Cézanne* from the early nineties, for example, is immediate in the physical closeness of the sitter to the painter and in her eye contact with him, and it is intimate in its pose, which is at rest rather than arranged in a specific way. It is also a masterly drawing, convincing in the way the relaxed head is pulled down and to the side, and economical in the way it suggests the face, the hair, and the details of the dress; but then again, it is not merely economical, it is lavish as well, especially where the artist has accumulated the dark strokes behind Madame Cézanne's head and the free, undisciplined ones in the shadow itself. If we cannot be precise about Cézanne's stylistic evolution, we can be clear about his technical mastery: the strokes are both disciplined and free, and they convey line, volume, light – and expression – at once.

PORTRAIT OF MADAME CÉZANNE (C1065), ca. 1890–92, 49 x 32 cm. Boymans-van Boyningen Museum, Rotterdam. *Volume 1, n° 267.*

The economy of Cézanne's pencil stroke is even better seen in smaller, quicker, and obviously more naturally posed drawings. Cézanne sketched his son several times when he was resting, reading, or writing, or, on the evidence of the pictures, working on his homework; the boy's head always seems heavy, and when he is writing he seems to be struggling with the task. The painter, who doted on his son, portrayed this with acceptance and sympathy – and given the radical inclination of the head, with a quite challenging foreshortening. The result in *The artist's son writing* and a number of related drawings is economical and elegant. With little more than a dozen light strokes he portrayed the boy's hand grasping the pen, and with a few longer lines, the hunched shoulders; then, with quick hatchings, the volume of the head and the shadow it casts. Finally, with only the orbital ridge and the tip of the nose visible, he gave himself a little help with a line that describes the convexity of the forehead, and then he hatched in the eyebrows and the space below them.

THE ARTIST'S SON WRITING (C867), ca. 1887, 15 x 24 cm. Mr. and Mrs. Paul Mellon, Upperville, VA. *Volume 1, n° 270.*

Toward the end of the period Cézanne painted the only watercolor portrait that we know, and it is the *Portrait de l'artiste* discussed in the Introduction (p. 24)[291]. That there were no other portraits than this suggests the technical difficulties I mentioned earlier: to render a head with all the sequences of color that work in landscapes and

still lives would be to make too complex an image, and would lose the advantages of the medium. As the *Portrait de l'artiste* showed, a watercolor portrait may be spare in color and convincing in likeness, but then it may make none of those revelations about structure that we have come to expect from oil. Still lives in watercolor will be different, however; in them, sequences of color will begin to render volumes, and distributions of color across a sheet will begin to work out problems in composition. In the final decade, watercolor will become self-sufficient. Cézanne will use the medium not only for studies, but for works of art in their own right, works that might even suffer if he attempted to translate them into oil.

STILL LIVES

Discussing the painful years 1885-86, I said that one of their effects on Cézanne's art was to turn him toward the intimacy of still lives. Turning inwards is by itself a healthy response; it may be quietly restorative and allow a person to gather energies for fresh efforts. But it must also be said that the first few still lives of this period lack the ambitious affirmation of the flower vases that preceded them; they are small again and exploratory, somewhat like the small still lives done with the parallel touch in 1879-80 but without their resolute technical purpose. They are often beautiful in their own right and promise some quality that we will find in the great still lives of the final decade. There are also larger still lives, and in them we see something new: they seem designed to be striking and unusual in some way - in complexity, asymmetry, or brilliance of color, for example. Then in about 1890 Cézanne finds a new calmness and unity of form in his still lives, and the paintings seem more forthright - undemanding, directly stated, substantial - and more directly the precursors of the final still lives. All of Cézanne's still lives are finely balanced, and to see the subtlety of the balance I recommend holding them up to a mirror when the normal orientation has gotten too familiar; and I recommend this all the more with still lives painted after 1890.

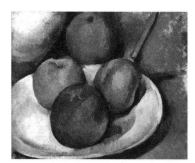

QUATRE POMMES ET UN COUTEAU (R562), ca. 1885, 22 x 26 cm. Stiftung Langmatt Sidney and Jenny Brown, Baden. *Volume 1, n° 271.*

The still lives can be grouped within bands of several years both by style and by the objects that appear in them, and from this rough grouping it is clear that the first ones painted after 1885 emphasize unusual subjects. *Quatre pommes et un couteau* is a painting from the early group; its style is close to the Gardanne pictures, with small, light touches that are consistent but not repetitive. Composition seems to matter more than the surface; the apples are arranged on a diagonal that slopes sharply up to the right, with the reddest apple at the top and the greenest one at the bottom, and the diagonal is underscored by the peculiar flattened apple and the rakishly inclined knife that nearly pierces it. If it is not an important still life, it does play in an interesting way with space: the upper apple just touches the three objects it is closest to, which places it not behind them or in front of them but next to them, and this willful contradiction of the depth we expect catches us by surprise and holds our attention.

Nature morte avec pommes, on the other hand, is stable and well anchored on the tabletop. It is perfectly simple in its color scheme, relying on a balance of primary colors grouped

291 - *There is, however, the profile study of* Vallier *(RW641), and there are, however, several studies of the whole figure where the head is too small to qualify as a portrait. Two are studies of the boy in the red vest, which work out the color relationships between the dark pants, the red vest, and a green background; another five are studies for the card players and the* Fumeur accoudé *(R756 or 757). There are also four studies of the child who modeled for* L'enfant au chapeau de paille *(R813), and one of Madame Cézanne and one of another woman. As to the self-portrait, questions have been raised about its authenticity, but the consensus seems to favor accepting it as Cézanne's. See Rewald,* Paul Cézanne: The watercolors, *p. 204-5. The proposed date of 1895 seems to me too late, given the whiteness of Cézanne's beard by 1895, but 1893-94 seems perfectly possible.*

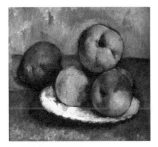

**NATURE MORTE
AVEC POMMES**
(R637), ca. 1885–87,
29 x 30 cm.
White House collection.
Volume 1, n° 274.

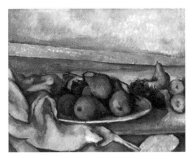

**NATURE MORTE
AUX POIRES** (R556),
ca. 1885, 38 x 46 cm.
Wallraf-Richartz-Museum,
Cologne.
Volume 1, n° 272.

**NATURE MORTE
AU PLAT DE CERISES**
(R561), ca. 1885–87,
50 x 61 cm. Los Angeles
County Museum of Art.
Volume 1, n° 276.

by complementaries: red/green and blue/yellow. Like the previous picture, but unlike the last still lives of the preceding period, it is a fiercely three-dimensional painting, and like it, it offers us a little quirk that holds our attention: it is the topmost apple, solid, highly involuted (and painted in the only secondary color, orange) that sits on top of the three smaller ones. We would have expected something smaller to complete the pyramid, but are surprised by something heavy and dominant. It is as if in both paintings Cézanne were searching for an arresting peculiarity, something – in the absence of a technical tour de force such as the parallel touch – to lift the still life out of the ordinary.

He will not need to do that when he turns to the large still lives of the latter part of the decade, and even less in the great still lives of the late nineties, because their composition – their heightened tensions and the complexity and balance of their arrangement – will immediately arrest our attention. In several other still lives of the present period, however, peculiarities of the subject will dominate the painting. In *Nature morte aux poires*, for example, which is densely crowded, the subject is puzzling. Some objects are hard to identify: we may never know what the fuzzy, dark thing is that sits between the two groups of pears, or what rigid protuberance prolongs the napkin. Others can be identified, but may play an unclear role in the composition: I refer to the sawhorse that supports the still life, whose diagonals seem never to articulate with the rest of the picture, and to the wainscoting behind the fruit, which makes too forceful an effort to balance the plank. In many ways it is a beautiful painting, light and airy and handsomely balanced between the red pear and the green ones, and I must admit that it is a matter of choice whether we prefer to be puzzled by the hard work that Cézanne does here, or simply be moved by the utter novelty of the composition.

Cézanne seeks an entirely different kind of originality in *Nature morte au plat de cerises*. Seemingly stilted in composition, it is rich in color contrasts, and it takes an interesting risk with the solid plateful of identical cherries. Having always seen Cézanne do his best to avoid mechanical repetition, we may be surprised by that homogeneous mass; but Cézanne had the example of Chardin before him, who had painted a lovely pyramid of raspberries, and he had the evidence of his own senses: the red mass could be balanced by the vivid greens of the olive jar and the tablecloth. As it is, he chose two greens and two reds, in each case one warmer and one cooler, all highly saturated, and achieved a dazzling harmony at once. Nor did he neglect the composition; it is neither frontal nor symmetrical, but arranged to lead us around the demanding cherries – the table leg in the back leads us away, to the upper left, and the fold in the hanging cloth (and the slight elongation of the mouth of the jar and the plate with the cherries) leads us to a point to the right of the olive jar where the space seems to fold in on itself.

The restless innovations in composition continue until about 1890, until, that is, he discovers a new kind of unity, one which no longer needs surprises but instead achieves a secure and firm distribution of objects; after 1890, objects may be intimately connected by the undulations of a rug, for example, or they may be clearly subordinated to a dominant object, or they may be effectively distributed in size and color. In each case, the impression will be one of a simpler solidity. But until then he will continue to paint still lives whose effect depends on finding something odd or novel to astonish us.

Nature morte au panier is the most astonishing of these. Most arresting is the large basket imposed on an already self-contained still life, which sits perched awkwardly at the edge

NATURE MORTE AU PANIER (R636), ca. 1888-90, 65 x 80 cm. Musée d'Orsay, Paris. *Volume 1, n° 275.*

of the little table and dwarfs the ginger jar which would have been the natural culminating point of the still life in front. The basket also helps confuse the role that should be played by the large, dull-green pears; the one on the right, in particular, would normally have been intended as a substantial counterweight to the ginger jar and now it all but disappears. But clearly Cézanne conceived of the composition all at once, or he would not have placed the small table so low on the canvas, and we must try to see this amassing of objects as intentional and attempt to follow its resolution.

In the welter of orientations of all the objects in the still life, it is clear, after a moment, how he decided to order the profusion: one set of vertical lines leads us almost straight up the left edge and back to the screen in the background, and another leads us diagonally from the same left edge to the upper right. This second set starts at the front edge of the work table and leads to the chair slats in the back - so it is parallel to the all-important basket handle. The resolution of these two sets of lines is at their intersection, that is, at the mouth of the ginger jar, where we would have expected the culminating point of the small still life to be. The basket handle now reveals its complex function; it guides our gaze backwards over the profusion of fruits inside the basket, and points us forward to the ginger jar, the composition's focal point. Cézanne's procedure is admittedly complex here, and reminds us more of a keyboard fugue than a graceful minuet, but it repays careful study if only to understand the depth of his knowledge of composition; I suggest holding the painting up to a mirror to bring all these forces out clearly[292].

Nature morte: fleurs dans un vase, a deceptively simple still life from the second half of the 1880s, surprises us, on the other hand, by an unresolved ambiguity. The flowers are arranged

NATURE MORTE : FLEURS DANS UN VASE (R672), ca. 1888, 47 x 56 cm. Private collection, New York. *Volume 1, n° 277.*

on either side of the vase, so that the arrangement is seen in profile, frontally, and the vase has a flat base that makes it appear cut out of paper; it also sits on a flat table that could be mistaken for a wall. But the bouquet is set off-center, at the edge of the table, so we see that it occupies space, and it casts a shadow that tells us that the table is three-dimensional. Cézanne helps us out of this uneasy ambiguity by reinforcing the three-dimensional reading: he places the still life in front of a nearby wall and that, in turn, in front of another wall, and makes sure that the distance between them is about the same as the depth of the table. There is no logical connection between them, but the suggestion of depth helps. But this is not a painting in which Cézanne will resolve all ambiguities; on the contrary, its effect depends on them. The yellow flowers climb on a diagonal that seems to extend the table; this could make them appear part of the receding space when in fact they are flat, and we are meant to remain unsure, I think, whether we are looking at a line in space or one on the surface. I believe that we were also meant to feel the tension of the rakish diagonal, but at the last minute Cézanne tempered it gently with a wispy sketch of a fallen flower.

Why Cézanne should choose the unresolved tension of rakish asymmetry as the basis of some of his compositions is beyond my ability to explain. Sensitive to the other arts, and a craftsman in his own, he would know - and feel personally - the value of tension in art; but normally he would seek a closer balance between tension and its resolution. He would know about this balance in music, having been interested in it, and following what was current, as early as the 1860s[293]. But here he favors tension by itself, and we may simply have to see the painting as an impulsive moment in his development; we have seen a similar tension in *Maison au toit rouge* and in *Chantilly, I* (both p. 156) of about the same time.

292 - *The break in the front edge of the small table should be seen as part of the ordering of the space. If we obscure the left part of the table with our finger and imagine the edge as continuous, the table begins to sag on the right, and to work against the lines that move upwards along the table legs.*

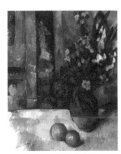

**LE VASE DE FLEURS
ET POMMES** (R.660),
ca. 1889-90, 55 x 47 cm.
Private collection,
Switzerland.
Volume 1, n° 273.

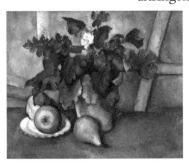

**POT DE PRIMEVÈRES
ET FRUITS** (R.639),
ca. 1888-90, 45 x 54 cm.
Courtauld Institute Galleries,
London.
Volume 1, n° 278.

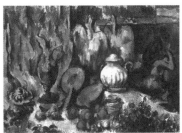

NATURE MORTE
(R.642), ca. 1888-90,
ca. 27 x 51 cm.
Private collection, Japan.
Volume 1, n° 280.

Asymmetry is the basis of *Le Vase de fleurs et pommes*, too. The still life is crowded on the right side of the canvas, and the flowers in the olive jar point all the way to the upper right corner - forms which would make the picture very unbalanced, especially if, with no indication of depth, they sat as cutouts on a flat surface. But three forms place the bouquet in space - the two fruits, the shadows, and the hint of wainscotting in the back - and these let the bouquet point diagonally backward and forward, and open up the space; and since in a painting the background carries as much weight as any other object, the vertical stripes on the left restore the balance. Much tension remains, however, in the two-dimensional plane: the olive jar bulges to the left, for example, as if straining against the stems of the flowers and trying to reach the left edge of the canvas.

There are two other examples of Cézanne's restless contributions to the vocabulary of still life compositions that we should look at. One is found in the centrifugal forms and astringent colors of *Pot de primevères et fruits*, and the other in the opulence of *Nature morte*. In the first, the centrifugal pattern is created by the leaves of the primrose, which has a small pink blossom at the center and heavily lobed leaves pointing outward from it, and which Cézanne outlines with thin, repeated outlines to make their pattern all the clearer. To balance the colors he puts red and yellow pears near the green leaves, and to contain the centrifugal movement he encloses the plant in two axes - a vertical / horizontal one, and one that tilts clockwise away from the vertical. This is a satisfactory enough resolution, but it seems artificial and takes perhaps longer to grasp than it should. There is also a somewhat astringent combination of pinks and blues in the background, as in the contemporary *Arlequin* (p.169), and in both cases I presume that a certain degree of tension is what he wanted to achieve. And in the opulent *Nature morte* of about the same time, which seems much less the product of observation than of imagination - of a vague memory of Dutch still lives or some detail of a banquet scene[294] - Cézanne startles us with an unaccustomed world of food and sensuousness rather than of structure and balance; but then it must have ultimately had a narrative intent, and been in some way connected with *La Préparation du banquet* (p. 145).

But toward the end of the decade of the 1880s, as I said, Cézanne's conception of still lives develops into something more forthright and substantial, as if he were returning to the compositions of 1879-80 but without the help of his austere touch, and it is these still lives that anticipate the spirit and grave authority of the work of his final decade. Like the earlier still lives, these will often be dominated by a tall form which will center the arrangement and compel the other objects into a relationship with it; but unlike them, the new still lives will not depend on the touch to organize the canvas surface; they will stand or fall, as it were, on the strength of the composition alone. *Le Vase bleu* is one of the earliest of these, and although it was probably painted in the same room as the *Pot de primevères* still life, it is thought to be later; in its quiet austerity, at least, it seems closer to the paintings that follow than the ones that went before. The narrow vase dominates the painting by its central position and its almost mystical cobalt blue color; it is as if whoever

293 - *Mary Tompkins Lewis documents Cézanne's interest in Wagner in the 1860s; he even joined the Wagner society with Zola in Marseille in 1865. He apparently intended the narrative painting* Pastorale *of 1870 (R166) to be a direct illustration of a scene in* Wagner's Tannhäuser, *and he added the title* ouverture du Tannhäuser *to the picture of a young woman at the piano (pp. 1-48f.) These observations only show, of course, that in 1870 he was interested in the romantic excesses of Wagner, not the structure of music as such; but he had played the clarinet as a young man, and I am inclined to believe that he must have understood at least the rudiments of musical composition. See Lewis's* Cézanne's early imagery, *pp. 139, 186-187, 190-191.*

294 - *Couture's Les Romains de la décadence comes to mind, as it had done in connection with Le festin in chapter 1 (p. 50), but the sources for the still life may have been different, and as far as one can tell, would have been at best dimly remembered.*

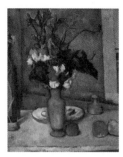

LE VASE BLEU (R675),
ca. 1889-90, 62 x 51 cm.
Musée d'Orsay, Paris.
Volume 1, n° 282.

named the painting could think of little else worth suggesting as its subject, even though the exact center is occupied by a much more brilliant, but less easily noticed, spot of vermilion. The vase is just to the left of center so that it will be in balance when seen together with the leaves, which reach far to the right, and it cleaves in two equal halves the pale blue plate behind it, almost merging with it and taking on some of its width and substance. The apples - arranged carefully, as always, but here not even hiding the fact - are set in the same plane as the bottom of the vase, to locate it firmly on the table and complete the composition on the right.

The still life is seen frontally, but Cézanne opens up space behind it by orienting it obliquely with respect to the wall. He does not open it up very much, however, because he brings the yellow frame at the right forward again, to the plane of the leaves, at the point where it touches one of the twigs. He also cuts the bottle at the left in the exact middle of its straw cover, so that it attaches itself to the frame rather than moving freely in space. Thanks to these devices the space in the picture remains shallow; only the bottle's oblique shadow adds a bit of depth. The whole is a curious, and in my view deeply thoughtful, interplay of the deep and the flat, of the oblique, which seems real, and the frontal, which is so willfully and cannily arranged.

It is not clear to me why the cobalt blue should work so well with the red here - whether it is more because the two colors are separated by the spots of white, or more because the cobalt of the vase merges with the duller blues of the background, or both equally - but nothing in our intuitive response questions the harmony; and ultimately, after all has been said about the composition, it is the successful risk that Cézanne has taken here with the colors that is the source of our deepest feeling.

Nature morte: pot à lait et fruits sur une table is, on the other hand, straightforward in color and composition and seemingly less carefully studied; the apples seem set out as if naturally and the painter has certainly taken fewer risks with the colors. He has once again oriented the table at an oblique angle with respect to the wall. But here the reason is simpler; it is not, as in *Le vase bleu*, to give us space around a flat arrangement of

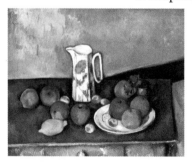

**NATURE MORTE :
POT À LAIT ET FRUITS
SUR UNE TABLE**
(R663), ca. 1890,
60 x 73 cm.
Nasjonalgalleriet, Oslo.
Volume 1, n° 281.

objects, because this one is seen from high up to begin with and takes up space by itself. It is to give us a sense of movement across the frontal plane and to balance the spout of the milk pitcher. Running through the apples arranged horizontally is a diagonal grouping that parallels the wainscotting: it starts with the lemon and continues to the apple to the right of it and then on to the apple hiding behind the violet. Once we notice that movement, the spout of the pitcher becomes more prominent, and the equilibrium of the composition becomes evident. So does the necessity of the violet: we are pulled toward it from the lemon, because yellow and violet are color complementaries.

Cézanne used this milk pitcher in five still lives altogether, always turning it to the left, and in four of them he placed if left of center; this creates a centrifugal tension requiring something to point to the upper right to balance it, as the lemon and apples do here. The same tension is visible in an exceptional still life (*Nature morte*) that was started in the center of the canvas and finished there, without suggesting the rest of the composition; there, the two oblique forces are balanced right in the center, with two pears placed very close to the pitcher, pointing in opposite directions. But unlike other still lives that use this pitcher, this one is exceptional both in starting point and technique. It is painted on a very fine portrait grade canvas, one that suggests an emphasis on details, and Cézanne has left no gaps between the touches. This makes

NATURE MORTE
(R662), ca. 1890,
46 x 55 cm.
Sammlung Oskar
Reinhart, Winterthur.
Volume 1, n° 279.

the starting point all the more remarkable: rather than being the beginning of a larger composition, it seems already complete - an image of indefinably close crowding, almost of whole beings in intimate contact rather than actors in small roles scattered across the stage. Perhaps his peculiar start went hand in hand with an intention to concentrate the forms so close to each other - as if the painter were realizing a private anecdote, or finding in his forms some inchoate meaning that began to interest him. But no documents exist to explain Cézanne's purpose and we can only guess. Earlier I had alluded to the strange way in which the pear sits on the edge of the plate, and I cannot escape the sense that the pear belongs in some narrative way to the dense forms.

No other still life will seem this personal. However opulent and dense, or ascetic and sparse, Cézanne's still lives are almost always what they seem to be at first sight; if some of them need hard looking, it is to do justice to their complexity, not to uncover their private meaning. Even with paintings that puzzle us by some technical difficulty we should, with rare exceptions, attempt to understand them visually. The partially obscured *Bouteille et pêches* is an example. It must have run into some difficulty in the bottom left corner, and Cézanne painted most of it out with flat grey paint; the grey is not particularly attractive and may seem unfortunate, but there is no reason to think that it had been intended as his final word. The picture is unusual in its nearly square format and the way the format is used: the still life grouping that fills it is itself as tall as it is broad. Both the height and the width are achieved without stretching; the transparent bottle extends naturally down toward the broad napkin, and the piled up peaches (as tall as they are broad themselves) make a single massive form rather than a thin, horizontal string. The black bottle connects the diaphanous top with the bottom and offers substance in the middle of the picture.

**BOUTEILLE
ET PÊCHES** (R679),
ca. 1890, 49 x 51 cm.
Stedelijk Museum,
Amsterdam.
Volume 1, n° 286.

There are two puzzles, it must be admitted: the heart-shaped form in the lower right is indecipherable, and the bottle vanishes into thin air at the top. But each of these can also be understood. The heart form anchors the vertical column of the bottles and sits on an imaginary line extending from the mass of peaches along the knife; so it stands at the vertex of the two lines. One could imagine other forms doing so equally well, but it does sit firmly where it needs to. And the top of the bottle, if it had been painted in, would have made a point of excessive interest; with our gaze fixed on it, even if only from time to time, we would have been distracted from the interplay of the forms near the middle.

The free movement of forms within a canvas is crucial to Cézanne, and he communicates the devices by which he achieves it more clearly than any other painter of his time. The movement does not require a bottle to remain unfinished at the top as a matter of principle; in some compositions it may be finished, but then it must be part of the movement of forms - as when the bottle is used to divide the canvas into two halves, for example, which it does in *La corbeille des pommes* (R800), or when it extends a movement upward to balance the downward fall of a fabric, which it does in *Nature morte aux oignons* (p. 244). It is not bottles as such but all objects that come to a point that have to be checked for their effect on the composition; even *the Sainte-Victoire*, in paintings from the last four years of his life, will see its summit painted as open, and if not open, then connected to the sky by an arbitrary line.

In the little *Nature morte* below Cézanne faced a similar problem of connection: the top of the green pear was going to be so close to the edge of the table that our gaze was

likely to get stuck in the gap between them, unsure about whether they were touching or not. He simply cut the Gordian knot and attached them and separated them at the same time, by breaking the continuity of the table edge. Other solutions would have been possible, of course: he could have placed the plate closer to him and made sure the outlines were far apart. But he chose this one because he was interested, I think, in the paradox between the fusion of the pear with its background and the dramatic detachment of the orange; it is as if the former were a restraint on the latter.

NATURE MORTE
(R677), ca. 1890,
28 x 41 cm.
Thomas Gibson Fine Art,
London.
Volume 1, n° 284.

That, of course, is a technical point; the still life has other claims on our interest. Its touch is very free, set down with liquid paint and without any evident system, and the color scheme is simple and beautifully balanced. We can think of it as progressing along the spectrum from blue to green, then to yellow and a red-orange, or we can think of it as presenting two simple complementary pairs, blue and yellow, and green and red-orange. The two ways of seeing the color are equally valid and depend on what we are looking at: if we are studying the background, for example, then it is the complementary presence of three patches of green above the oranges that will leap to the eye. And then, of course, the solitary cool colors, blue and green, are given the burden of the dynamics in the picture; with the plate and the pear both highly tilted, the one leans toward the oranges, while the other – the pear – leans away.

The dynamics that we feel almost physically in Cézanne's still lives were in fact physical in their origin. Here the point is obvious, of course, because Cézanne lets us see the prop that supports the plate. In other still lives we might not be sure; the slant of a plate might conceivably be an adjustment made on the canvas. But we know from his landscapes that he sought to reproduce the structure of the site as he found it, and from the one record that we have of Cézanne at work on a still life we must conclude that there his purpose was the same. I have mentioned this in the Introduction, but the record is worth quoting at length because it also refers to the kind of color we just saw. Le Bail saw Cézanne compose a still life in this way: "The napkin was draped lightly upon the table, with innate taste. Then Cézanne arranged the peaches, contrasting the tones against each other, making the complementaries vibrate – he greens against the reds, the yellows against the blues – tipping, turning, and balancing the fruits as he wanted them to be, using coins of one or two sous for the purpose. He brought to this task the greatest care and many precautions; one guessed that it was a feast for the eye for him."[295]

If this was Cézanne's procedure in setting up still lives, then painting them became the same kind of analysis of their structure as painting landscapes; the only difference was that, for the painting to work, it was set up by the painter himself to his highest standards for composition. It was only with a solid basis in vision that Cézanne could release his capacity for ordering his sensations, as in the simple example above of the greens added to the background. This point is also made by Bernard, after he had spent some time with Cézanne in the studio and on the site, and seems all the more convincing as it was said with much ambivalence. "...*if he had had a creative imagination,*" Bernard writes:

> "*he would have been able to avoid going into the countryside and arranging still lives in front of him; but he was lacking in the kind of imagination that has marked the greatest masters; his only strength was the intelligence that was so closely tied to his taste.*"[296]

295 - See Rewald, PC, *p. 228, and his footnoted* Cézanne et Zola, *p. 168. My translation from* Cézanne et Zola.

As much of a debt as we owe to Bernard for his first-hand observations, we can find his opinions quaint, and unlike him we know that the world of painting would have been impoverished had Cézanne had the kind of imagination Bernard would have admired. I have often thought about Fry's concise statement of his admiration for Cézanne, and believe that he would not have made it had Cézanne's paintings been the products – no matter how brilliant – of imagination; when he says that "we cannot in the least explain why the smallest product of his hand arouses the impression of being a revelation of the highest importance,"[297] he can only be referring to the sense we have that Cézanne is making discoveries about the nature of things and the ways to represent them.

GROSSES POMMES
(R701), ca. 1891-92,
44 x 59 cm. Metropolitan Museum
of Art, New York.
Volume 1, n° 285.

Some still lives can be understood fully only when we remind ourselves that Cézanne is representing what he sees. *Grosses pommes* would be even more awkward if we saw the red apples as exaggerated for the sake of expressiveness; they would of course remain the unwieldy center of attention that they are, but we might have asked why the painter had bothered. But the simple awareness that they are large apples tells us that Cézanne saw in them an opportunity for something new in a still life and proceeded to find fruits of complementary colors, and a complementary size, to make an effective arrangement; and it lets us see the painting as a statement of a graceless but interesting reality. As a composition, it works perfectly well: the small green fruits are far enough away to retain some independent weight; two of the apples and one of the pears point diagonally to the left, guiding us toward the back with the angle in the wall; and the apple whose navel is pointed toward us gives us a calm respite in the welter of planes that point this way and that.

These large apples remind us that Cézanne's still life objects have a material presence – that they are more than visual patterns to translate into paint. It is perhaps for this reason that the still lives of the early 90s follow a different direction from the one taken by the landscapes: they have none of the landscapes' abstract notations for objects, textures, and planes. They will never have them, in fact, or certainly not to the same degree[298]. I would presume that in the intimacy of the small space the still life objects became all the more real, and that abstraction would distance the painter too much from them and impugn their presence. The crucial relationships of forms and colors can, in any case, remain fully visible in the objects themselves; the objects are typically simple and self-contained, and our attention naturally turns to how they are grouped or contrasted.

POTS EN TERRE CUITE ET FLEURS
(R702), ca. 1891-92,
91 x 72 cm. Barnes Foundation, Merion, PA.
Volume 1, n° 283.

No still life is wholly invented; if a rug already has a strong design, then its place in the composition will result jointly from what the rug suggests and what the painter wishes to achieve. The more complex and immovable the design – plants on a shelf as in *Pots en terre cuite et fleurs*, for example – the more it will seem as a given, and the more it will constrain Cézanne's choice of objects to complement it. The preparation for painting *Pots en terre cuite* may have therefore proceeded somewhat like this: the plants in his conservatory may have been interesting as a flat pattern, but only as a pattern; objects of other sizes and colors were needed, to provide complementary colors, break up the monotony, yet still echo the pattern. Having found at least the cloth and the bottle, he may have tried them in various arrangements until he found one that was interlaced, focused, and balanced in color. Possibly all the colors were still too stuffy,

296 - Bernard, "Souvenirs sur Paul Cézanne," in Doran, Conversations, p. 60.
297 - Fry, pp. 83-84.
298 - In the still life watercolors of the last decade, however, Cézanne found ways to use his touch and his colors abstractly, to bring out resonances that were only suggested by the objects. These, too, differed from the patches he used in his landscapes.

and some white would be useful for separating them; the jar, now added and tinted blue, would also relieve the color torpor. Whatever the actual order, of course, the point is that the original pattern had constrained him. Far from needing abstraction, the painting required the rhythms of the original objects to be observed; this explains why the leaves have been so carefully outlined. The sprays of leaves are naturally echoed in the crossed straw on the bottle and in the red fabric, and individual leaves are reflected in the shape of the vase. It is by its nature a decorative painting, and only a fragment of a shelf placed at right angles gives it a sense of depth.

In his choice of the color white Cézanne followed a rule we can discern in the other pictures with flowers: the rule that if the colors are too close, or run the risk of clashing, they could be held apart with a bit of white. It might be a white vase as here, or it might be small white blossoms, as in three earlier still lives: *Nature morte: fleurs dans un vase* (p. 180), *Le Vase de fleurs et pommes* (p. 181), and *Le Vase bleu* (p. 182). In this way the colors are not only held apart; they are also darker and more intense by comparison.

About a year later, and presumably over a period of no more than two years, Cézanne painted a series of still lives dominated by a heavy jug, glazed with grey. If there is a risk in choosing so bloated and colorless an object, which is elephantine in size but not in grace, there is also an advantage in compelling the painter to conceive of still lives in more massive terms - adding large fruits, for example, or larger groupings of small ones. The color grey also offers a rare opportunity for Cézanne to integrate colors; he can compose grey from the colors of its surroundings so that while still appearing grey it will connect with them naturally. In each of the seven pictures where Cézanne uses the pitcher the grey is different, and in each case it is perfectly adapted to the other colors.

In most of the paintings we see Cézanne very hard at work trying to integrate the pitcher into the composition[299]. But we must also view this work with considerable sympathy: if the painter's struggle with the pitcher is heroic, many of his solutions are highly original. In *Pichet et fruits sur une table* the solution is to use a very broad format, so that the pitcher can be given ample breathing room and allow the composition to feel uncrowded. The colors that make up the grey glaze reflect the entire composition (as they do in all the versions); here there is some red, but less than in paintings with redder fruit, and ample green and blue. The pitcher, austere, is of one mood with the blue rug, the cool greens of the fruits, and the greys of the wall. But the pitcher does remain a problem; separated from the rug, it towers over its neighbors and exists in an unwelcome, splendid isolation, and the only solution is to nestle it in a larger mass. To do this,

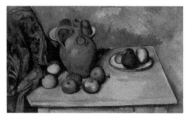

PICHET ET FRUITS SUR UNE TABLE

(R742), ca. 1893-94, 41 x 72 cm. Takahashi Building Company, Ltd., Osaka.

Volume 1, n° 287.

Cézanne put the stemmed fruit bowl behind it, choosing a vivid red apple to push forward and grip the side of the jug, and reduced the jug to manageable size. On the right, well separated from the mass in the center, a small plate with highly contrasting fruit provides the needed counterweight.

Another one of the seven still lives, *Nature morte à la cruche*, reached a point that is ideal for catching a glimpse of Cézanne's thinking (it was abandoned after a first lay-in, for reasons we cannot possibly reconstruct). His hand is rapid and flexible, with outlines sketched decisively in liquid paint, doubled now and then to keep their placement vague while he works, and corrected by adding new lines rather than wiping out old ones[300]. All the local colors are indicated - there are three: a dull green, a range of reddish

299 - *In two of the still lives, R737 and 741, Cézanne reduced its size in relation to the fruit, and enlarged its neck and mouth; it almost seems a different pitcher - a stratagem which I think testifies to the difficulty of using it.*

**NATURE MORTE
À LA CRUCHE** (R738),
ca. 1893-94, 53 x 71 cm.
Tate Gallery, London.
Volume 1, n° 289.

browns, and a bluish white - and so is some of the modeling. Fruits that overlap with others are finished at the top, which locates them precisely in relation to each other (and, be it said, exemplifies the thinking that will lead him to the patches of his late landscapes). The pitcher - the pachyderm in the living room - is already the focal point; it already incorporates the grey-greens, blues, and reddish-browns of the rest of the still life, and it is already firmly nestled against its ground.

But the sketch is most valuable for what it suggests about Cézanne's plans for the composition. Clearly, the jug was going to be restrained by placing it in front of a dark fabric, and the plate in the center was going to be flattened on its near edge; gentle diagonal movements were going to be established by the orientation of the tablecloth in one direction and the knife in the other, and a line was going to be added to the backdrop, near the top of the jug, to parallel the knife. Some forms are unclear, such as the oval form in the lower left and the triangular form under the bread roll; the one seems too wobbly to become a plate and the other is too vague to be anything specific. And clearly not all of the lines would have retained their present emphasis. For example, the diagonal line that seems like a fold in the backdrop, to the right of the jug, would have had to be supported from elsewhere on the canvas, or suppressed; its purpose is vague in the painting's present state. With all this said, the painting is decisively composed and the touches which sketch it in are firm; the colors, especially, are already in balance and the grey tone of the pitcher is carefully worked out. Cézanne's starting point here is entirely different from that of *Nature morte* (p. 183), where the forms were concentrated in the center and finished; here it is the distant relationships, across the entire canvas, that Cézanne has decided to work out from the start. It is generally assumed that this was the more typical procedure, and it certainly appears appropriate for a large, formal - not to say challenging - composition.

ASSIETTE DE PÊCHES
(R731), ca. 1892,
31 x 40 cm.
Sammlung Oskar
Reinhart, Winterthur.
Volume 1, n° 288.

What the starting point may have been in small still lives, to which the painter could turn with a certain gentle playfulness, may never be known. He does paint several of them in between the more major paintings, and some show no obvious corrections; it is possible that in them his first lay-in would have been simpler and the progress quicker. One of these is *Assiette de pêches*, a still life marked by warm intimacy among the peaches and lush folds in the blue rug. So gentle is the impression it gives us that it seems coldly technical to point out that, even on this small scale, the composition is carefully thought out; the double line in the rug at the far right, for example, points us from one end of the canvas along the upper edges of the peaches to the upper left, while the junctures of the peach halves point up to the right, parallel to the overall shape of the rug. But the overall sense is one of amiable compactness; if the red peaches are separated by the green leaves, reds also find their way into the leaves, and greens into the peaches (and into the blue fabric).

The even smaller *Grenade et poires dans une assiette*[301] is equally intimate, but Cézanne's impulse is more incisive: the painting has a sharp focus in the pomegranate, which is located in the crook of the rug, and everything points away from it toward the upper right or down toward the lower right. The surface is as carefully finished as any of the large still lives. Here it is the white color, not the grey, that Cézanne makes up from the

300 - Le Bail watched Cézanne begin a canvas in just this way: "He drew with the brush, with ultramarine much diluted in turpentine, putting things down with verve, without hesitation." See Rewald, Cézanne et Zola, p. 170.
301 - Rewald's proposed dating of c.1885 must be too early, as much on stylistic grounds as physical evidence: the blue rug was not used in any other composition that Rewald dates before 1892. A dating of 1893-94 seems to me preferable.

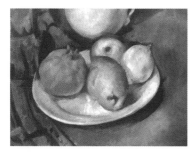

GRENADE ET POIRES DANS UNE ASSIETTE

(R558), ca. 1893-94,
27 x 36 cm. Stephen Hahn
Collection, New York.
Volume 1, n° 290.

colors of the painting: the yellows, the blues, and the toned down corals, which appear as warm pink. The finish extends, of course, to the very striking pear, which is of two sizes: a longer one that overlaps the apple (but would have to twist around the pomegranate if finished), and a shorter one that sits next to the pomegranate (but would leave too much of the apple exposed if left short). It matters little which was the original size; what matters is the usefulness of the ambiguity. I cannot imagine this correction being anticipated in the first lay-in, because the problem would appear only when the painting was close to finished.

It is in the large still lives that one senses immediately the exceptional care that went into composing them and the relentless invention that produced so many different arrays. Only the card player series, which is roughly contemporary, shows a comparably grave purpose, and it, too, is based on Cézanne's gift for assembling forms. This gift, already highly developed, would be honed further: in the still lives, the sense of unity between objects would be deepened, and the feeling of harmony between colors would become more insistent.

A still life from 1893-94 illustrates both points. In *Nature morte aux aubergines*, a pattern of crosses and a perfect balance of hues are immediately apparent. Not only the familiar ginger jar, but also a branch with eggplants hanging from it, participate in the rhythm,

NATURE MORTE AUX AUBERGINES

(R769), ca. 1893-94,
73 x 92 cm. Metropolitan
Museum of Art, New York.
Volume 1, n° 293.

and then the pears and the center of the blue rug are arranged subtly to do the same. The result is so pervasive a sense of unity - seemingly so unforced - that the crossed shapes no longer stand out on any single object. The small patches of red, orange, and yellow balance the expanses of greens and blues; and forming a unit of complementaries with the green melon, they sit well in the center without pulling away from the canvas. When we have been satisfied by these vivid colors, we are likely to notice the grey-violets in the ginger jar and in the dark part of the drapery in the lower right, which are subtler and more serious in tone, and play the role of a calming presence.

This much seems to leap to the eye, but there are some less obvious, and more puzzling, matters to look at as well. It is not clear right away, for example, why the plate of pears should be tilted. We have to obscure it to see what it does for the painting, and when we do, its role becomes clear: the composition stands up straight, stiff in its verticality in spite of the dynamic drapery. The napkin under the plate joins in the diagonal movement, but it is not clear why it should be pointed in this improbable manner; yet under the force of the diagonal patterns, the pointed end becomes less visible and extends one of the lines in the ginger jar. And finally the whole arrangement seems improbable: it was either placed close to the ground, since a normal table towers above it, or the table behind it was put on a pedestal. But here, too, the question becomes moot when we obscure the table and see its function in the composition: it reduces the size and the individuality of the bottle and the jars.

The blue rug was capable of being folded in so many ways that Cézanne was able to use it in several quite different compositions[302]. As I said, however, the nascent monumentality of his still lives was not dependent on any physical object. A simple, white napkin served him equally well. In three pictures (R734 - 736, below) he actually kept the same napkin, always folded in the same way, with the same plate and the same large apple sitting on top of it; above this group, in two of the canvases he placed the ginger

302 - *Among which the quite formal* La bouteille de menthe, *R772, is the most often reproduced. There the rug is seen frontally, and made to echo the ovals of the carafe and fruit, giving the still life a decorative, almost hieratic, Byzantine quality.*

POT DE GINGEMBRE

(R735), ca. 1894-95,
47 x 56 cm.
Phillips Collection,
Washington, DC.
Volume 1, n° 296.

jar and in the third, a skull[303]. This simple arrangement has a magnificent weight and density; it dominates each picture and gives each an equal claim on our attention -and through the variations in emphasis, space, and color, gives us invaluable insights into Cézanne's thinking about form.

The most complex of these is *Pot de gingembre*. It is a very formal arrangement of objects, with its space framed at the top by drapery and on the left by a table with books on it; the highest book is at the painter's eye level, and all the rest is below. This produces the strange effect we saw in *Nature morte aux aubergines*, with either the scalloped table placed quite high or the still life quite low, but we soon see the necessity of it. With a framing drapery, the ginger jar had to be placed low in the composition, too low to dominate the still life as it usually does, and Cézanne had to find a way to enclose it by other forms. The heavy books placed high above it, and the swirls in the drapery that reach down to it, both restrain and incorporate it. What now becomes apparent is the continuity of solid objects from top to bottom on the left side, rather than any one object's dominance. This helps us see the canvas surface as a whole and note the many resonances: for example, the tip of the drapery at top right pointing down to the pink stripe in the napkin, or its broad V shape echoing the broad V in the ginger jar, or both recalling the identical V in the napkin (formed on the left by a fold and on the right by the pink stripe). We are also meant to notice, I think, the broken edge of the table; it follows the movement of the book that protrudes toward us, at an angle, and points toward the baseboard at bottom right.

These resonances make the painting beautifully interconnected, but they are also unusually complex and, in a way, diffuse. I believe that when he composed the still life Cézanne felt the need for a unifying focus - a focus that would not draw away from these resonances, but give us a visual foothold from which to view them more securely - and chose the large, red, centrally placed apple for it. The apple is supported by the other reds in the picture, so that it remains an integral part of the color scheme; but it still dominates this painting much more than it does the other two.

**FRUITS ET
POT DE GINGEMBRE**

(R736), ca. 1894-95,
33 x 46 cm. Stiftung
Langmatt Sidney and Jenny
Brown, Baden.
Volume 1, n° 297.

In the second picture, *Fruits et pot de gingembre*, the apple's color was painted closer to orange, and this placed it very close to the colors of the other fruit, the wood, and the straw of the ginger jar. This allowed the ginger jar to regain prominence, by its crisp grey-cobalt blues as much as by its size; and now its crisscross network became more visible, its high position dominant, and the handle which reaches up more emphatic. With the ginger jar lighter and bluer, the napkin could regain some of its bluish whites, and it could be turned into a more solid, more broadly diagonal base for the jar. All of this has been made possible by a change in the light. Cézanne turned the table around so that it was illuminated from the left, casting a stronger light on the jar and on the left edge of the plate. This also changed the shadows on the napkin and made it unnecessary to retain the pink stripe (which would overlap with the diagonal shadow, as it does in the third version); and with the closer point of view that the painter adopted, the widest point of the napkin was brought in touch with the bottom of the frame. The painting came to be based on a simpler geometry, with round fruits - fewer in number to begin with - balancing straight, diagonal lines.

303 - In Rewald's PPC (vol. 1, pp. 454-455), the three paintings have been assigned three- or four-year ranges which begin in 1890 and end in 1898, and the watercolor which is perfectly cognate with one of them, Fruits et pot de gingembre, (RW290 and R736, below), was assigned the dates of 1888-90. Given the orientation of the ginger jar, the locations of the plate with its apple, and above all the identical folds in the napkin, which could not have remained this way for more than a few weeks at best, if span there must be, it should at least be the same for all three paintings. The most likely dating would place these still lives close to the three large still lives with the blue rug; I would propose 1894-95.

In the third still life, *Nature morte au crâne*, Cézanne turned the table still further; this made the folds of the napkin deeper and more voluminous, and the shadows it casts on the table longer. This is no momentary whimsy; having chosen to replace the jar with a skull, Cézanne had different colors to balance and a fearsome object to integrate into the composition[304]. A simple, geometrical setting would now clash with the hollows of the skull and its vacant expression; what was needed here was a more irregular, sculpted base, and some objects akin to the triangular opening of the nose to reflect and contain its complex form. The deeper folds in the fabric gave Cézanne the appropriate base, and their saturated blues balanced the beautiful ochre color of the skull; the three pears, replacing apples, could be pointed sharply upward to restrain the frightening nasal opening. So do the leaves in the wallpaper, and so does the wedge of ochre color that comes down from the top of the frame; and, it should be added, so does the line that extends down from the nose, past the leaf in front of the apple, and through the right edge of the napkin.

NATURE MORTE AU CRÂNE (R734), ca. 1894-95, 54 x 65 cm. Barnes Foundation, Merion, PA.
Volume 1, n° 295.

Seeing three closely related paintings next to each other does more to illuminate Cézanne's acute sensitivity to form and the complexity of his craft than the longest explication de texte of any single one; and it demonstrates how original his vision of each new composition could be and how sensitive his response to the slightest changes in the appearance of one of its parts. The objects that reappear in his still lives seem different each time, equally convincing and freshly seen, and equally well integrated into the whole. It is a way of seeing that begins neither with favorite objects, which would place the painter's affection ahead of his grasp of patterns, nor with formulas for composing, which would guarantee a dull repetition. Freshness of perception is one of Cézanne's greatest strengths, and it is most clearly evident in his still lives.

As in the preceding half-decade, in this period still lives do not figure prominently among Cézanne's drawings and watercolors. Nor is the style of the drawings as important; still lives seem not to invite the kind of disciplined abstractions we have seen in the landscape drawings nor the sweeping freedom of touch that we see in the drawings after sculptures. What we do see in the finished still lives is a greater clarity of purpose, and in the sketches (sketches of all sorts of things, including cushions and unmade beds), a disciplined search for the essentials of line and space; in this sense there is a distinct evolution.

The drawing "*Pain sans mie*", which Chappuis dates 1887-1890 and which makes an instructive comparison with the *Still life with Candlestick* (C553, p. 135), exemplifies the new firmness. It is also much larger and more formal; but even if we make an allowance for its more public purpose, the drawing does rely on a more incisive touch for outlining its objects; they appear drawn with a harder pencil, and they are doubled and redoubled, rather than thickened and emphasized as in the earlier drawing. The relationships between the objects are made that much clearer, and the drawing looks like an end in itself rather than a study for an oil.

The lettering on the box by no means suggests an early Cubist still life; it is the oval shape of the label that counts - not its meaning, whether serious or whimsical - and it is the oval shape that becomes the visual leitmotif of the composition. The label nearly merges with the pitcher and is then reflected in all the ovals of the drawing, down to

304 - *The distracting spots of ochre color to the left of the skull and across one of the eye sockets are accidents; some object, perhaps a palette, seems to have been allowed to lean against it. It is difficult to understand why they have never been cleaned off.*

the shadow of the plate. The left side, however, is more incisive, and has the kind of focused weight that we see in the typical compositions in oil: our eye goes inevitably to the busy spirit stove, the equally busy wallpaper, and eventually the deepest and darkest point of the composition between the spirit stove and the carafe. In complexity and balance, the drawing is masterly, and within the limits of the medium it stands head to head with the oil paintings.

A small watercolor of a green jug that Cézanne painted near the beginning of this period signaled a new way of thinking about modeling in color. For Gowing, the change was that Cézanne no longer relied on darkening a color to indicate the part of the vessel in the shade, or the part that turns away from the observer, but on an arbitrary system of color progressions[305]. Gowing saw the new system first in this watercolor, *Le Cruchon vert*. To represent its convexity, Cézanne started from the point closest

to the observer, which he called le point culminant and left blank, and proceeded to model the surface from blue to green (its local color) to ochre. This progression is not something the eye would see, but as a progression on the sheet it was enough to establish the volume. That the local color was green rather than one of the other colors had to be made clear as well, and that is why the green band was made broader, and why the point at which the jug meets its blue shadow was painted green again rather than remaining blue.

We have seen a similar division of color in the landscape *Arbres et bâtiments* (p. 165). There the represented surface was admittedly complex, and the local color was a different green, but the color progression was equally arbitrary: the yellows were closest to us, and blues and blue-greens the farthest away. The assurance that any progression – almost any progression – would do was a capital discovery. However, the possibilities it offered for painting watercolor still lives were not to be fully realized until sometime after 1895. Then Cézanne's watercolors would become ends in themselves: large, elaborately arranged, quite finished, always original. In the present period, they remained mostly studies of small groupings of fruit or preparatory sketches for oils, and less was demanded of them. *Pot de gingembre avec fruits et nappe* is an example: it is a study for the composition of *Fruits et pot de gingembre* (p. 189), not an independent work based on color relationships. The fruits are painted in their local color rather than in an abstract system. The fruits

are where they will be in the oil, and in that sense it is a preparatory sketch; the background is simple and static, however, and in that sense the watercolor served Cézanne by showing him that more should be done with it in the painting. Unlike the later, self-sufficient watercolors, where we literally cannot imagine why an oil version would be necessary, this study is meant to be useful. But it is also precise, trenchant, and self-assured.

305 - In his "The Logic of Organized Sensations", in William Rubin, ed., Cézanne: The late work, N.Y.: The Museum of Modern Art, 1977, pp. 58.

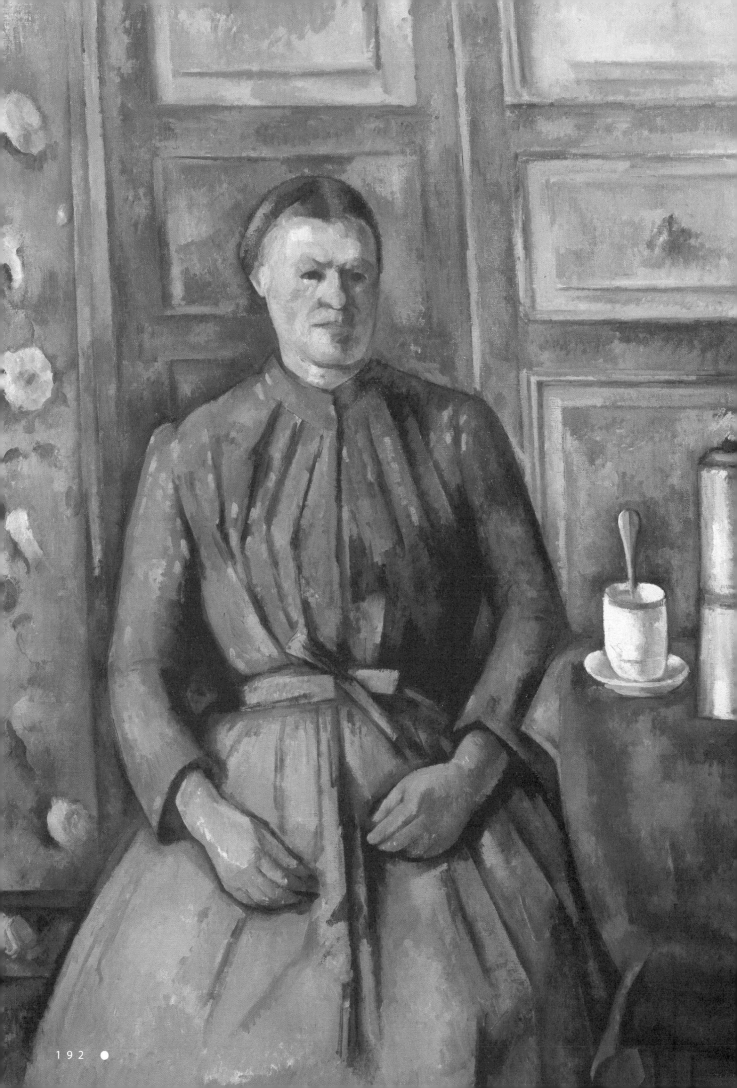

Perhaps what strikes me as most significant about this decade are the technical developments in landscape, the gravity and color of the portraits, and the relentless inventiveness of the still life compositions. Landscape, as always, seemed to drive Cézanne's technical innovations; changes in his touch were clearer, more purposeful, and more responsive to specific sites and regions. In this decade, changes in touch were slower to develop in the south than in the north, probably because his attachment to his native countryside brought out his sense for the particular. This could be seen in the landscapes' substance, structure, and passionate color; *Sous-bois* and *La Meule et citerne en sous-bois* (p. 164) are characteristically southern in this way, both masterpieces of close involvement with the scene's texture, light and intimacy. In the north, we saw a greater emotional distance, and with it a greater role for perception and thought; there, we witnessed the first appearance of the abstract, patchy notations for recording vision that would eventually dominate all of Cézanne's landscape work. The innovations of the *Chantilly* series in 1888, and the flat, detached planes of *Paysage* and *Giverny* of 1894 (pp. 162-163) preceded any comparable stylistic developments in the south. And it was in landscape watercolors, both northern and southern, that Cézanne's discoveries, which Gowing first noted in a still life, saw their first full development: the use of detached points on the color spectrum, set down in discrete and rhythmic patches, to represent volume, shading, and local color.

The achievements in portraits and still lives are equally important but they are not technical. Cézanne's sitters remained individual for him, in their face or in their posture, and this left much less room for the abstract notations used in landscapes. But composition, color scheme, pose, and a subtle distribution of weight and tension, were crucial, and it is their rightness and exceptional harmony that are the measure of Cézanne's development; the rightness is felt in individual figures (*Femme à la cafetière*, p. 176) as much as in groups such as the card players. It is felt in the still lives as well, and our admiration for them begins inevitably with his ability to compose his groupings in the first place. We saw him searching for the novel and unusual at first, and then discovering the more timeless graveness of beginning with simple objects and assembling them intricately. With these paintings, from about 1890 on, composition and color would be in so fine an equilibrium that words seemed barely adequate for describing what we see; there was a perfect distribution of mass between the objects, a coherent and fresh color scheme, and yet always a complexity and a tension that make us return to the paintings time and again.

Natural endowments must be accepted as a given, that is, as something that we cannot try to explain. Even the progression of the painter's way of using them is difficult to explain, although a few conditions of that development do occasionally become clear. Cézanne's mid-life crisis, for example, constrained his landscape and portrait painting. But within a few years he was obviously able to invest much energy in innovation again; this meant that he was less preoccupied with the conflicts which had come to a head during the crisis. Whether this indicated a permanent resignation, such as the one he described to Chocquet in 1886, or a robust displacement of energy from issues of living into painting, or simply the dwindling of life energies, is unclear and will remain so. It is in any case certain, as I said in connection with the landscapes, that his health and his mental robustness gradually declined. It is all the more remarkable that his best work was ahead of him: that his hand would be freer yet more secure; that his color would become more forceful; and that his ever more intense vision would be in balance with an inquiring and logical mind ■

La Femme à la cafetière
(R781), ca. 1893,

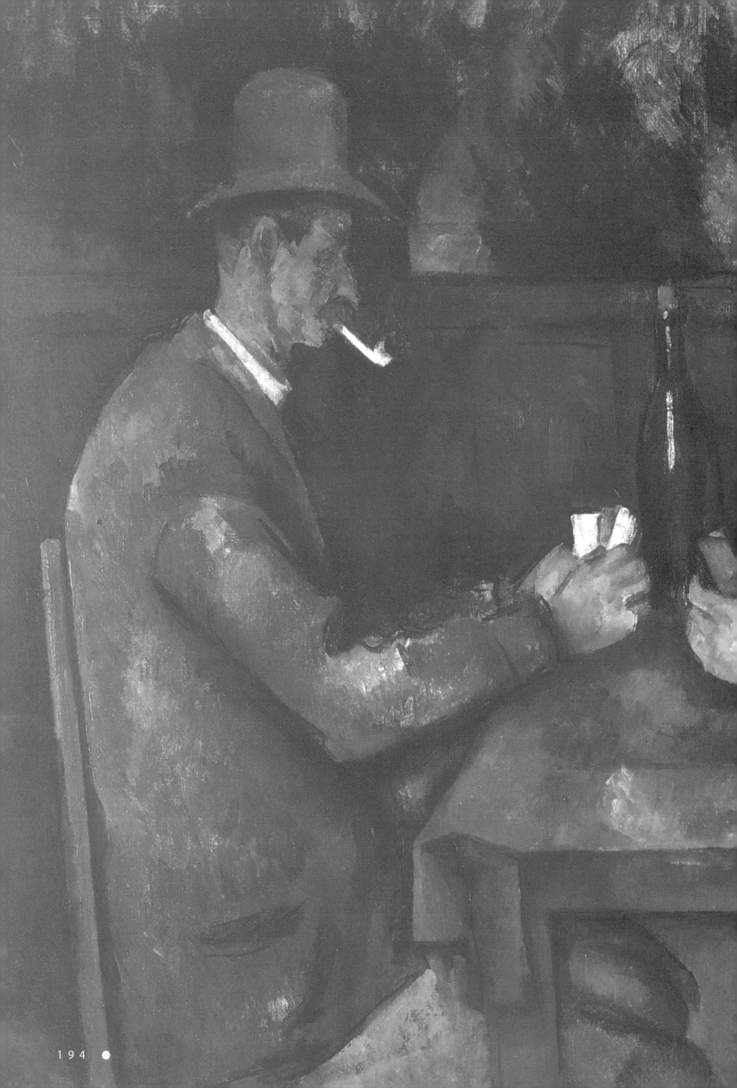

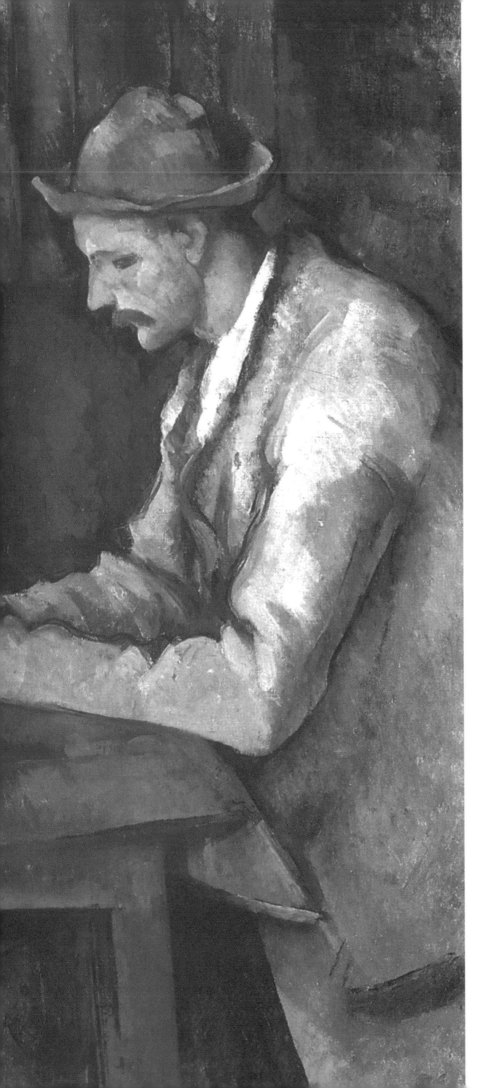

Les Joueurs de cartes
(R714), *ca. 1893-96*.

1896–1906

Emotion and
the logic of sensations

*The move toward a disintegration
of the object in some of the most memorable
works of a painter so passionately attached
to objects is the attraction and the riddle
of Cézanne's last phase[306].*

*There comes a point in life when the artists
one has known cease to be objects of research
and become friends[307].*

Paul Cézanne in front of the Grandes Baigneuses *(R856).*
Photo Emile Bernard, 1904.

306 - *Lawrence Gowing, "The Logic of Organized Sensations" p. 56.*
307 - *John Pope-Hennessy,* The Piero della Francesca Trail, *p. 13. p. 13.*

CÉZANNE THE MAN; HIS THOUGHTS ON PAINTING

It is in the mid-nineties that Cézanne emerges vividly as a person again. We have first-hand pictures of him as guest, host, painter at work, and genial companion reflecting on painting; we also find him unsure, volatile, and easily disillusioned. His circle of admirers has gradually widened, and soon young painters, having heard of him, look him up in Aix; twelve altogether have left us accounts of their meetings and many indispensable observations on his character. Those who wrote up their impressions include the critic Gustave Geffroy, whom Cézanne met in 1894 at Monet's, and who soon after sat for the portrait we saw in the introduction; and they include Joachim Gasquet, poet and son of a boyhood friend, whom Cézanne remained friends with for six years after they met. Later, Cézanne did a portrait of his dealer Ambroise Vollard, who also recorded a few vivid observations on Cézanne at work, and from 1901 to only a few months before his death in October 1906 he received a number of the young artists who had heard of him and wished to meet him - of whom seven have left first-hand reports. The twelve accounts inevitably differ in their style and in the observations they were based on - and in reliability - but they converge on the principal points.

How different these portraits might be from the character of the younger Cézanne is difficult to say, except in broad outline[308]; one thing seems clear, and that is that Cézanne was well past the disappointments of the years 1885–87 and more accepting of his age and the role that went with it. However much the accounts differ in style, they manage to be vivid and even touching, and are vital for seeing the man who was behind his work; invariably, they also portray a painter all of whose energy is now devoted to painting, and unavoidably they help us see the passion and technical brilliance of his late painting in its personal context. The most moving narratives are, to me, those that were written with an objective restraint, because simple, lucid prose shows us Cézanne rather than the author of the observations. None of the accounts can be dismissed, and even the occasional, patent distortions - seen in dramatic language or in obvious but unacknowledged borrowing - can be distinguished reasonably well from their substance[309].

The accounts are invaluable in two other respects. Some give us a direct picture of Cézanne's working methods and thoughts on painting and painters, and others make critical observations on the nature of Cézanne's painting and its place in history; these reflections seem balanced, a full century later, even if the critical language we would use would no longer be the same.[310]

The accounts present Cézanne as direct and simple in manner and remarkably welcoming, open, and modest. Rivière and Schnerb, until then unknown to Cézanne, were "welcomed unpretentiously, à la Provençale, with the handshake of a colleague who

308 - Certainly both the generosity and the suspiciousness described in these accounts was documented much earlier, and it is likely that while the generosity remained constant, the suspiciousness, and Cézanne's sense of weakness and dependence on others, only grew with age, particularly after about 50. See Rewald, PC, passim, for a much fuller portrait and for all the other evidence regarding Cézanne's character at different ages; read, if you will, Rewald's edition of Cézanne's Letters to form a first-hand picture of the man.

309 - For a critical view of Gasquet's reliability, see John Rewald's Preface and Richard Shiff's Introduction to Joachim Gasquet's Cézanne, 1991.

310 - For an example of such a judgment, see Maurice Denis's comments cited in footnote 1 of the Preface. All these narratives were brought together by P. M. Doran in the book I have referred to throughout, Conversations avec Cézanne, which appeared in English in 2001. All passages in English are my translations from the French edition; page numbers refer to the French edition, and differ by at most one or two from the English edition except where noted. Quotes and citations from Bernard are found on pp. 36-37 (these are Cézanne's "opinions" or principles), 57-58, 62, 64, and 71; from Borély, on pp. 18-20; from Denis, on pp. 94, 176, and footnote 83 on p. 212 (the latter is on p. 255 in the English edition); from Gasquet, on pp. 130-131, 136, 141, 142 and 145, and in Joachim Gasquet's Cézanne on p. 121; from Geffroy, on p. 3; from Larguier, on p. 12; from Osthaus, on pp. 98-99; from Rivière and Schnerb, on pp. 86 and 88.

asked for news from the capital, who would not let himself be called master, and who would say, when asked about his work, 'I am an old man; I paint - what else would you have me do?'" The archeologist Borély, also unknown and arriving in Aix unannounced, simply waited in front of Cézanne's studio for him to return from painting, and when Cézanne appeared, looking like some craftsman who had been working nearby, introduced himself and said he wished to see his paintings. Cézanne replied,

> "*Monsieur, you are too kind! Shall I show you some of my attempts? Alas, although I am already old, I am only starting out. However, I am beginning to understand, if I may say so; I think I do understand. Ah! You love painting. I would like to show you some Monets - but I don't have any; they are too expensive these days. I have a Delacroix. Are you a painter, sir?… Oh, you are. Would you believe, I am at the point of formulating a method and the principles for my vocation. I have searched for a long time; yes, I am searching still - that's as far as I have gotten at my age! Don't let my disjointed talk surprise you; I have lapses. Do you want to see my painting?*"

When Borély replied that he had heard his painting spoken of in a way that made him "burn with the desire to see it", Cézanne said simply:

> "*Monsieur, we are alone here in the country; between you and me, let's be sincere: no flattery. Yes, I believe myself to be a painter. What's more, people acknowledge it, don't they, since they buy my impressions. Nevertheless, these are imperfect things - oh, yes! I say so; it's that I don't capture the local colors. Ah, Monet! You know him. Monet? In my opinion Monet is the most gifted painter of our time.*"

During the course of the afternoon, Cézanne showed Borély his studio, talked about himself and other painters, and replied to Borély's questions; and when he asked if Borély liked Degas, and the latter replied that he did, with the reservation that the painting seemed to him like cabinet painting, Cézanne liked his reply and said:

> "*I know what you mean. So, from now on if any small thing comes between us, let a small thing bring us back together.*"

Such openness, however, also left Cézanne vulnerable. He might follow a moment's expansiveness with a sudden, "C'est effrayant, la vie!", and go on to complain that he was weak, that he could not realize his paintings, and that he needed the support of more balanced people such as his interlocutor of the moment. In 1894, in very distinguished company at Monet's - with Rodin, Clemenceau, and Mirbeau present - Geffroy saw Cézanne happy, witty, and relaxed, yet also overwhelmed. Cézanne at one point took him aside to say, "Monsieur Rodin is not proud! He shook my hand - he, a man honored with decorations!", and a little later he got on his knees to thank Rodin for the handshake. Clemenceau regaled him with his witticisms and made him completely at ease; yet much later Cézanne confessed to Geffroy that he could never become Clemenceau's supporter because he in turn was not strong enough to support the weak Cézanne; only the Church could do that.

Cézanne's openness is noted by the writers almost with a surprise, but there is no question of its genuineness, especially toward young artists, and especially at the beginning of their acquaintance. To the young poet Larguier he impulsively gave his copy of Baudelaire's *Les Fleurs du Mal*, with his favorite poems noted in the table of contents. But eventually Cézanne would need to protect himself and would attenuate the relationship or break it off; it was generally not a matter of objective differences

(which are not difficult to find), but rather his fear of being touched, his difficulty in maintaining contact, and his suspiciousness. As it was, the relationships with Gasquet and Bernard were relatively long, in Gasquet's case in part because he was the son of his boyhood friend, in Bernard's because Cézanne persuaded himself to trust him as a painter, not merely a critic; with Bernard he went out to paint and even gave him a lesson in painting. For a while he replied conscientiously to Bernard's queries about art – if in a didactic and stilted way – and Bernard was able to put the replies together with Cézanne's conversations, and establish a list of his "opinions" on art which have become indispensable. But the side of Bernard that was more theoretical than artistic did become evident to Cézanne in the long run, and he ultimately grew bored with Bernard's penchant for theories and systems. Perhaps Cézanne felt some personal reserve on Bernard's part as well, which was revealed only many years later – even to Bernard himself, I would think – in an article where he expressed his doubts about Cézanne. Yet Bernard's account, too, is informed by rich observations.

In an expansive mood Cézanne would easily reveal his wit, perceptiveness, and erudition in literature and the arts, citing passages in Latin from memory, or poems by Baudelaire. "At table he was very cheerful; he had a heartfelt gaiety I had never suspected, a gaiety that was almost from another era, so frank and unrestrained it was. At these moments one could come to know the man, apart from the painter, and one could see all his goodness," wrote Bernard. To Osthaus, a one-time visitor, Cézanne was generous with his time, with his demonstrations of where he had succeeded or failed technically, and with his discussion of painters – and later, sitting on the terrace of his studio, "was extremely amiable and in an excellent mood". Smiling, wrote Osthaus, he let his wife take a photograph to commemorate the meeting. No one else has made a point of seeing Cézanne smile, and as the photograph could not be found, we have simply had to trust his words; but it has resurfaced and confirms what Osthaus said: Cézanne looks welcoming, content, and trusting.

Photo of Cézanne taken by Mme Osthaus.

Those open and generous moments, perhaps reflecting his real nature, had their obverse side: the fear of people getting their hooks into him. Unfortunately it is the obverse that has received the most attention, and it has given us a distorted image of the painter. His openness was also a thin-skinned vulnerability, which would almost guarantee that his initial idealization of his visitors would give way to disillusionment. The physical form the vulnerability took was the fear of being touched – the best-known instance being his outburst at Bernard for having restrained him from falling[311] – and the artistic form of the fear was the difficulty in bringing the patches of color in his late landscapes into contact with each other (see below, p. 226). In his everyday life, there seemed to be no resolving the opposition between the fear of contact and the wish for it, nor the contradiction between his sharp, critical intelligence and his dependence on the Church, nor the contradictory views that he held of his place in art. At one extreme, as Bernard reports, he was the painter who wished to be received in the "*Salon de Bouguereau* ", and who could not bring his painting to fruition – a failure like Balzac's Frenhofer. At the other extreme, he was the only painter of his time[312]; and somewhat uneasily in the middle he was making progress every day or, for Bernard, he was the pioneer *(le primitif)* of a new way of painting. Ultimately it was the complex genius he brought to his vocation, and the native intelligence harnessed by his broad education, that allowed him to minimize these contradictions; and it was his painting that allowed

311 - *There is no question about Cézanne's fear of being touched; it is confirmed by his housekeeper Madame Brémond. But it was not altogether unrealistic, however exaggerated it may have been: Cézanne mentions fearing the hooks of priests, and, I think, he had reason to fear Bernard, who was ingratiating and yet took so much more than he gave. See Bernard's account in Doran's* Conversations, *pp. 69-75.*
312 - *Both his brother-in-law and his son reported this phrase, and the young painter Le Bail reported the quote, "There are two thousand politicians in every legislature, but there is a Cézanne only every two centuries". In Rewald,* PC, *p. 251, and in his* Cézanne et Zola, *1936, p. 174.*

him to express and integrate them. He was, in his last decade more than ever before, closely attached to his subject yet analytic; passionate about color yet balanced in his compositions; conservative yet revolutionary.

When the reports turn to Cézanne's opinions of other painters, we begin to read them not only as admiring portraits but as evidence of the deepest wellsprings of his art. We have become accustomed to viewing Cézanne's paintings as splendid syntheses of reason and passion, or form and color. But his views on past painters make clear that, given a choice, he felt more deeply about color than either form or line. Gasquet, for example, reports from a visit he and Cézanne made to the Louvre that the Italian early Renaissance painters had no appeal for him. He has him say,

> "I will surprise you perhaps. I almost never go into the little room with the primitives. To me that's not painting, I am perhaps wrong, I admit it; but when I have stood for an hour contemplating the Concert Champêtre [by Giorgione or Titian] or the Jupiter and Antiope by Titian, when I have my eyes full of the moving crowd of the Noces de Cana [by Veronese], how do you want me to be moved by the awkwardness of Cimabue, the naiveté of Angelico and even the perspective of Uccello? There is no flesh on these ideas. … I love muscles, beautiful tones, blood. I am like Taine, I am, and besides, I am a painter. I am a sensualist."

Cézanne had rarely spoken of sensuality and the love of flesh and muscle before, but here (and not only in Gasquet) he is clear on the matter; and obviously he also prefers the more brilliant and technically accomplished styles of the later painters such as the Venetians and Delacroix. He said to Osthaus that he did not like Gauguin or Van Gogh for what he saw as the facile shortcuts to representation through flat planes bordered by lines; to him, representation of volume was crucial ("tout est sphérique et cylindrique", he said to Rivière and Schnerb). But technically it is the ability to express emotion through color that is at the heart of his admiration. Line, by itself, certainly meant little to him. He speaks of line to Gasquet in these terms:

> "I do take pleasure in line, when I want to. But there is a snag there. Holbein, Clouet and Ingres have only line…. And that's very fine, but it is not enough. Look at this La Source [by Ingres]: it's pure, it's tender, it's suave, but it's Platonic…. In trying to paint the ideal virgin, he did not paint a body at all." In front of the Noces de Cana, he says, "You love them if you love painting. You don't love them if you are looking for literature on the side, if you get excited by the anecdotes, by the subject. A painting doesn't represent anything. It must first of all represent colors only…. The painter doesn't want anything more. His psychology is the meeting of two tones. That's where his emotion is."

Although Gasquet has surely simplified Cézanne's view of the purpose of painting – Denis's report, that for Cézanne a painting is essentially a flat surface covered with colors set down in a certain order, is more nuanced – there is little question about the conviction that it is relationships of colors that most move one in a painting. As I noted in the first chapter, Cézanne says to Gasquet about Delacroix's Les femmes d'Alger,

> "When I speak of the joy of colors for their own sake, here, this is what I mean…. These tones make you lighter and more pure…. The tones interpenetrate, like silks. Everything is stitched and worked in together."

These statements tell only part of the story. Cézanne also spoke of liking the Spaniards, all of whom among other qualities used black elegantly, and admiring Courbet ("only

Courbet knows how to slap down a black without making a hole in the canvas").
I think that it is not the color black that is in question here, but, with Courbet at least, about whom he said more than about the Spaniards, an admiration for his firm structure and almost an envy of his sensuality. He also says this to Gasquet:

> "*Courbet - a builder, a tough mixer of plaster. A grinder of colors. He constructed like the Roman masons.... He is profound, serene, silky. There are nudes that he has done, golden like the harvest, that I am crazy about.*"

The words Gasquet quotes, as dramatic as they may be, cannot be far off the mark in their substance. Denis reports essentially the same penchant:

> "*He loved exuberant movement,*" he writes, "*the bulge of muscle, impetuousness in the hand, bravura in the pencil stroke.... He needed fluency and vehemence in execution: surely he would have preferred the graceful airs of the Bolognese to the conciseness of Ingres.*"

And Larguier lists the poems Cézanne had marked in the edition of Baudelaire that he had given him - poems that are inevitably sensuous in their language, and, in the ones Cézanne liked, also voluptuous in subject, whether it be beauty, irresistible desire, or the stench of decay. "Don Juan in hell" and "Sed non satiata" reveal their subject in their title, "*L'Idéal*" defines the ideal color red by Lady Macbeth's crime, and "*Une charogne*" speaks of the discovery in the woods of a putrid carcass that reminds the poet of the final end of even the beautiful woman who is with him. Cézanne recited the latter by heart for Bernard.

These reports, then, not only confirm the importance of sensuality for Cézanne's work - of a definitely ambivalent sensuality in the narrative work up till 1875 - but also suggest, in a way that helps us place the right emphasis on the work of the last decade, that the sensuality was transposed unambivalently into creative form: into relationships of color, either lively or subtle but always endowed with emotional meaning. Although the beauty of all flesh will become ambivalent, even repugnant, in painting the beauty of color and of the emotion it conveys will remain intact.

Cézanne's thoughts on painting do not address these sensuous wellsprings directly, although they make clear what form they took. But he does address the relation between vision and representation explicitly, in several of the "opinions" Bernard set down. In 1902, when he said to Borély that he was on the point of formulating his principles, they were probably in a fairly developed state; Larguier published them (albeit much later) as if they were the fruit of his own 1902 visit. It was Bernard in 1904 who extracted them once again from Cézanne; and as impatient as Cézanne was with Bernard's systematizing bent ("I don't have a doctrine, like Bernard," he said to Denis, "but you do need theory - sensation and theory"), he gave him a richer and more thoughtful list of principles than the one Larguier obtained, and Bernard had the discipline to set them down in an understandable order.

Gowing got to the heart of their meaning in the article I have already cited[313]. He points out that one of the principles essentially incorporates the other, more technical ones - by addressing the stance the painter takes toward representation - and in this way sums up Cézanne's preoccupations of his mature years. I have quoted it in connection with the development of the parallel touch:

313 - "*The Logic of Organized Sensations,*" in William Rubin (ed.), Cézanne: The Late Work; *also in Doran,* Conversations, *English ed., pp. 180-212.*

*"There are two things in the painter, the eye and the mind; each of them should aid
the other. One must work at their mutual development, in the eye by looking at nature,
in the mind by the logic of organized sensations, which provides the means of expression."*

Having followed the development of Cézanne's touch, we may be inclined to see this
principle as a natural statement of an approach we have been following all along.
But in fact it goes further: seen in the context of its immediate neighbors in the list,
it emphasizes the specific synthesizing style of his last years - the overlapping patches
which make up objects and construct space - and the ever more intense colors and
color relationships that create the richness of his form. So the sentence, "Reading nature
means seeing her under a veil of interpretation by colored patches which follow each
other according to a law of harmony" translates the term "organized sensations" into
the colored patches of the late landscapes in oil and the even more independent patches
of the watercolors; and it alludes in retrospect to the earlier parallel touch and the
various rhythmical styles of 1877. At the end of that paragraph, the phrase, "Painting
is registering one's sensations of color" affirms the primacy of color in creating form.
This primacy is turned into an explicit principle in the eleventh opinion:

*"Drawing and color are in no way distinct: as one paints, one also draws. The more harmonious
color becomes, the more precise the drawing will be. When color is at its richest, form is at
its fullest. The secret of drawing and modeling is in the contrasts and affinities of hues."*

Gowing was also the first to clarify the relation of color harmony to drawing that
Cézanne, almost without warning, refers to here. It is in the watercolors in the late
1880s that it first appeared, and Gowing showed how it worked in *Le Cruchon vert*,
(p. 312). Cézanne represented the convexity of the pitcher by an orderly progression
that Gowing saw as following the spectrum - that is, starting on either side of the point
closest to us ("*le point culminant*"). This progression was an arbitrary one, but it worked,
and it could be made to work to represent the distinct planes of a landscape equally
well (*Arbres et bâtiments*, p. 266). In the final decade, for Gowing, this system became
more and more distinct from the system used in oils, where the local hues and the envelope
of light, reconstructed from more opaque and less abstract components, remained
closer to the data of vision. Both systems, in my view, represented an utterly original
use of their medium, and it is difficult to say which is the greater achievement.

If, in Cézanne's theorizing, color holds a preeminent place for giving full and satisfying
form to a painting, it is also the vehicle for conveying the deepest emotions. He was
clear enough about this in his unguarded expressions of enthusiasm for the Venetians;
and from his attachment to bathing scenes and his ambitious *Grandes baigneuses*, it
is clear that, now and then, he would have liked to paint like Veronese and Tintoretto.
That he was a man of his time with other aesthetic battles to fight and a painter with
different talents to develop, and that his attachment to vision led him in a different
direction, is our fortune; it is difficult to imagine that he would have given us so complex
a way of seeing the world if he had had the Venetians' elegant facility.

It is one thing to understand the simultaneous and equal emphasis on *une optique* and
une logique (these are the words he used with Bernard) and see it exemplified in his
late paintings, and another to grasp just what it means to the painter as he works.
The equal emphasis may be a goal to reach, but it is neither a prescription nor a guideline.
In lesser hands, it could seem like a mere compromise between style and observation,
a kind of "this is the way I see it" justification of whatever one does. In Cézanne's
hands, however, it implies both hard looking and thoughtful painting; it sets up a challenge

not to sacrifice one to the other, but to create a work that is in some ways rhythmical and complete in itself and that still reveals the full nature of the subject. The hard looking is not a mere supposition: Gasquet testifies to it (with drama, as ever) when he says,

> *"He drew back a little then to consider, and his eyes referred again to the objects; slowly they passed around them, related them to one another, penetrated and grasped them. With a wild look, they fixed on one point. 'I can't tear them away,' he said to me one day… 'they're so tightly glued to the point I am looking at that it seems to me they are going to bleed.' Minutes, sometimes a quarter of an hour, would flow by."* [314]

And yet, we have to remind ourselves, the hard looking was not a search for detail or a more faithful portrayal; Cézanne warned specifically against excessive faithfulness in the last of his principles when he said,

> *"One is neither too scrupulous, nor too sincere, nor too submissive to nature; but one is more or less master of one's model and, above all, of one's means of expression. The goal is to penetrate what lies before you and to try to express yourself as logically as possible."*

Hard looking, when painting, must have meant something like a hypnotic awareness of the finest color variations in surfaces, a grasp of their relations to other surfaces, and a mental rehearsal of the pigments they might translate into.

Cézanne, then, treaded a fine line each time he set brush to canvas, and balanced many self-imposed demands. The demands that he defined relatively clearly were those of coherent representation, and I have spoken as if they were the only ones – but there were, of course, also the demands of emotional expression. In his late work, however, emotion can no longer be seen as a separate requirement but as the inevitable effect of good painting. If in his earlier narrative work emotion entered into the narrative itself, and if in the work of others he could still be attracted to exuberant movement or the bulge of muscle, in his own late work color would carry almost all the emotional expression – or almost all, for line remained important in some of the bathers, and anecdote intruded into a few. We might guess reasonably that if he had been asked to add emotional expression to his list of principles, he might have let Bernard put it this way:

> *"When color is at its richest and form at its fullest, emotion is at its highest".*

But it might have seemed a tautology; the coherence of vision and means of expression, and the integrity of the canvas, implied the rest. With age, his emotional nature was affirmed and strengthened – by being allied with form and becoming its wellspring.

NARRATIVE PAINTINGS

Why older age pushes some artists to do their best work, while it dilutes, weakens or stiffens the works of others, is not at all clear. With Cézanne, we have an impression: it is that by accepting his advancing years rather than protesting against them, he was able to shift his ambivalent physical sensuality more and more firmly into the abstract sensuality of color and form. Yet, as plausible as this is, it does not say enough: it defines a possible condition of his development, not the form that it took. Beyond the sensuality of color and openness of form, his technique became more secure, his hand remained

314 - J. Gasquet, Cézanne, p. 184.

firm but its movements freer and more relaxed, and his "hard" gaze became to all evidence more focused and even more unrelenting.

If the landscapes are our best evidence for his concentrated vision, the narrative paintings bear clearest witness both to the shift in sensuality and to the relaxed technique. A five-year hiatus seems to separate the first ones in this decade from those of the last chapter - we do not know why - and abruptly they seem different. No scenario more physical or emotional than bathing seems to occur to Cézanne now; in this decade there is a complete shift toward an almost innocent sensuality, one of color and rhythm, and in the case of the bathers, line as well[315]. (His three ultimate great bathers, however, will be complicated by their size and an insistent rhetorical purpose, and one of them will be informed by a disturbing scenario.)

To judge by two small examples from after 1900 - in one, he barely sketched in the few rudiments of his composition, while in the other he set down a full, first lay-in - his touch was well practised and sensuous; his hand was firm yet flexible; and, as is more natural in narrative pictures, the painting was first conceived in terms of line rather than space or volume. *Esquisse de baigneuses* begins as a light sketch done with very diluted paint and establishes the arrangement of three of his standard figures against the single framing tree. The trunk seems to have been done without hesitation or correction, but the bathers are drawn with multiple lines, some of which correct the pose (as in the left leg of the left bather and the head of the central one) while others merely create a vague placement in space; and just enough of a blue wash is set down in the background - not very precisely - to bring the left figure forward. All the lines undulate as if caressing the bodies.

ESQUISSE DE BAIGNEUSES
(R.868), ca. 1902-06, 32 x 40 cm. Private collection, Stuttgart.
Volume 1, n° 298.

BAIGNEUSES (R.867), ca. 1902-06, 29 x 24 cm. Private collection, Kansas City.
Volume 1, n° 304

One might ask how it could be otherwise: a body cannot very well be sketched without an outline. But landscapes begin differently - with nearly straight lines and indications of color immediately next to them, and with the whole composition set out at once - so this curvilinear beginning, as casual and almost playful as it is, and as unanchored in space, reveals a different initial engagement with the image: more sensuous and more tentative. Further elaborations, at least in the small paintings, set the figures solidly in space but retain the sinuous lines in the bodies. The smaller the painting, of course, and the more quickly done, the more evident the curved brushstrokes are. In *Baigneuses* (R.867), for example, also from the second half of the decade, it is not only the bodies but also the mass of leaves and the vague shape that might be a cloud that moves with this sensuous rhythm. Even more significant are the touches of color that define the skin tones and the volumes: they are placed at arbitrary intervals, and they call attention to themselves as colors rather than as body parts. And as such they are luminescent: they range from cool grey-blues for the shadows through very warm, light violets to red-oranges and yellows. We could take almost as much pleasure from the many greens in the foliage, but they heighten the bathers' skin tones by contrast, and help return us to them.

In this last decade Cézanne painted only twelve *baigneuses* and seven *baigneurs*, but this should not be read as a waning of interest; on the contrary, three of the female groups are monumental. Several of the smaller *baigneuses* could be viewed as studies for the large ones because they portray one or another of its figures (Introduction, pp. 17-18, and just above), but they might equally well be independent compositions.

315 - *Recall that what he disliked about line was its potential for excess: to deny volume and color. For himself,* "I do take pleasure in line, when I want to."

BAIGNEUSES (R.877),
ca. 1902-06, 74 x 93 cm.
Private collection.
Volume 1, n° 299.

Whatever their intent or their sequence, there is one painting that dominates them. It is larger than the others and spacious, and contains enough figures to seem like a preparation for the great bathers – but its composition is altogether original and its handling free, and as much as I would like to imagine it very large, I am convinced that it would lose most of its unforced spontaneity. Its figures are situated between two sets of trees, on the near side of a body of water, as in the Philadephia great bathers (R.857, below), but here the center is filled rather than empty. Four central figures huddle closely together in an intimate knot, with their round backs outlined in short, curved touches; they are nestled as if naturally within the trees that parallel their backs, and the nervous swirl of the concentric lines draws us inward and away from the sides and the opposite shore. The outer figures are only outlined, with bare canvas sometimes sufficing for their skin, and it is not what they might or might not be doing that interests us, but the sensuousness of the lines forming the bodies and the trees.

Cézanne's emotion is once again expressed in form: not only in the energetic touches or the effortless enfolding of the figures, but in color. Here a curious reticence makes him paint the skin tones a neutral brown and create the kind of diffuse light one might expect in a forest clearing. It is hard, however, not to see the bodies as pink; so alert is he to induced colors that he can rely on the dark blue-green surroundings to push the browns toward the more fleshy pinks. The painting is masterly in its restraint, balanced in its colors, and alive with movement.

Cézanne could use vigorous line as an equally expressive vehicle in male compositions, quite independently of the movements that they might imply. In two highly original groupings from about the turn of the century he set his bathers into forceful motion, and it is difficult for us to decide whether it is the bathers' movements or the emphatic, squiggly outlines that give this painting its vitality. The composition is the same in both pictures, and in the one shown here, *Esquisse de baigneurs*, which is smaller and less

**ESQUISSE
DE BAIGNEURS**

(R.866), ca. 1900,
20 x 33 cm.
Kobayashi Gallery, Tokyo.
Volume 1, n° 300.

finished, we see a quick, liquid lay-in, as first set down by the painter, without apparent second thoughts. If our first pleasure in looking at it comes from the composition's vigor, can we also understand the painting as a narrative? It seems doubtful: whether we see some of the figures as females (in masculine poses from the other picture, R.865), or whether they are all males, the action does not make sense. The composition reminds us of *La lutte d'amour* (p. 111), with the figures set out rhythmically as in a frieze, but here, some twenty years later, they are neither paired off nor interested in each other in any way. And this may be the very point: with no scenario made plausible, the painting stands or falls by how well it works formally.

In an unrelated painting, *Groupe de sept baigneurs*, Cézanne's ability to exploit line is even more arresting, because we see the line as his final statement rather than his starting point. Most of the surface has been partially painted out, inside the outlines by skin colors and outside them by the colors of the background. This reduces the confusion and gives the figures more volume, but not by much; the busy sketch with which Cézanne had started remains very much in evidence. The outlines are still incisive and repetitive and never converge on a single, dominant one, forming open alternatives to each other instead. They are not attempts to get the outline right, but approximations to where the outline might be, and in this way the figures move in space even when only standing or sitting. They neither settle down nor become solid; we are constantly reminded that they exist only as figments of the artist's hand. This way of treating the surface – the sharp lines and the incomplete and emphatic painting

**GROUPE
DE SEPT BAIGNEURS**
(R.860), ca. 1900, 37 x 45 cm.
Ernest Beyeler, Basel.
Volume 1, n° 303.

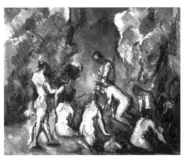

BAIGNEURS (R.873),
ca. 1902-04, 23 x 26.6 cm.
Barnes Foundation,
Merion, PA.
Volume 1, n° 302.

- out - is rare in his work in general and unique among Cézanne's bathers; only the multiple outlines find their way into his other paintings, and rarely at that.

If the angles and incisive lines of the seven bathers affirm their masculinity, the soft, undulating lines of the very small *Baigneurs* sketch would seem to deny it. But it is not at all certain that all the bathers are male; Cézanne was perfectly clear on the matter of gender whenever he wished to be, and here three of the figures seem more female than male. Perhaps again it is the ambiguity of the subject that tips the balance of our gaze toward form: in its nearly miniature size, the painting has the incandescence of a cloisonné panel. As on a cloisonné surface, the colors are contained within clear, curving outlines; and they set each other off by contrast, with saturated cobalts and greens emphasizing the brilliant array of orange hues and the occasional flecks of red. The effect of a cloisonné is brought out by the space between the figures as well; it is equally unclear, neither flat nor deep nor clarified by a horizon line, and several of the figures simply float within it.

This kind of free touch, and decorative conception of space, is easiest to achieve when working on a small scale. On a very large scale, movements of the painting hand may give way to movements of the forearm, creating lines of a different character; the brush may feel small in relation to the canvas surface and may have to be set to canvas more often; above all, whatever the painter does will appear more serious and his rhetorical stance may be pushed toward the grandiloquent. In undertaking his three great bathers, Cézanne must have faced these problems as well as perhaps others, and he must have also been aware that such exceptional paintings would represent a summation of his art.

Cézanne began working on the first one in 1894, as he told Rivière and Schnerb[316], and worked on it at least until April 1905 when Bernard noticed that it had changed since his last visit in 1904. He began working on the second later, although it is difficult to say exactly when, and continued working on it, as on the other, probably until his final year. The third was done relatively quickly; it was begun sometime between Denis's visit in January 1906 and Osthaus's in April, and the only matter that remains unclear is whether Cézanne had continued working on it after Osthaus's visit.

With paintings as significant as these, knowing their sequence in Cézanne's work is helpful, because it reveals a process of reduction; not in number, but in progressive detachment from narrative. The first painting, in The Barnes Collection, is the most obviously narrative of the three. We cannot interpret its story exactly, and if we could, and focused on it, we would only satisfy an extraneous kind of curiosity that Cézanne himself had spoken against[317]; we would be substituting an intellectual reconstruction for the sensuous and aesthetic response that he considered fundamental. But we do sense that there is a story here; it is suggested by the tension between the figure striding in on the left and the startled figure right of center. We are even more certain of this when we compare the finished picture with the well-known photograph taken by Bernard in 1904, in which the striding figure is a tall, bearded male whose feet reach down

**LES GRANDES
BAIGNEUSES**
(R.856), ca. 1894–1906,
133 x 207 cm. Barnes
Foundation, Merion, PA.
Volume 1, n° 305.

316 - *In* Conversations, *p. 91. The chronology has been clarified by Reff, in his article "Painting and Theory in the Final Decade," in* Cézanne: The Late Work, *1977, pp. 13-53.*

317 - *Recall that apropos of* Les Noces de Cana *Cézanne said to Gasquet, "One doesn't love them if one looks for literature on the side, or gets excited by the anecdote or the subject." (*Conversations, *136). The point, for my purposes, is not that the subject is irrelevant, but that dwelling on it - or worse, attempting to reconstruct it from ambiguous evidence such as the origins of the individual figures - easily makes one forget that all the crucial questions about Cézanne's painting are aesthetic.*

to the bottom of the canvas. In the final version, the figure has become smaller, more female than male - and its head is replaced by a phallic stump.

It is enough, I think, to be aware that there is an implied narrative and to feel that it is sexually charged and inhibited at the same time; our aesthetic response then becomes sharpened by this ambiguity, by the mere suggestion of a plot. As "Venetian" as this version may have been in intent - in size, lushness, and sensuality - its subject is on the contrary opaque; so the painting must be judged by the tension between the implication of a subject and the form Cézanne has achieved.

My immediate response is a sense of apprehension; a little later, it is relieved by the vitality and rhythm of the figures. At the core of the uneasiness is the startled woman, whom Cézanne singles out for us by giving her red hair, and the figure that she is responding to: the distorted, headless, phallic intruder. She and the woman standing behind her are the only ones to notice the intrusion; their gaze creates a tension that connects the three across the empty space. (I think that we would feel the tension even if Cézanne had not pointed us toward it with the three branches that parallel the gaze.) The other bathers, with one exception, are oblivious or unconcerned, and calm the painting down; I view them formally, as gentle figures leaning this way and that but always in parallel with one of the bathers at the edges.

The exception, the figure at the right edge, reintroduces a narrative tension again; she seems to be a counterpoint to the striding figure[318]. But she, too, is ambiguous, with breasts that could belong to either gender, and with a long vertical line where pubic hair would be - a line that looks, again obscurely, like an erection. It was after 1904 that her proportions were made less feminine, that her head was made vague and her neck thick, and the pubic line was added; she may now be a he as much as a she, and, on this supposition, as intrusive as the striding figure. The striding figure, incidentally, leans into the painting all the more resolutely thanks to the erect trunk that extends from its shoulders and the improbably heavy fabric that trails behind.

These ambiguities and even excesses matter to our response. The evidence of Cézanne's painful elaboration is secondary, and only helps explain the conclusion we could have reached by visual means alone: that Cézanne had a narrative purpose but was ambivalent about it. The painting's form therefore seems all the more moving. The colors are closely interwoven and simply luminous. The skin tones extend from warm pinks to pale oranges and are made incandescent by contrast with the dark, blue and green background; and they glow all the more thanks to the saturated flecks of blue and green that model the bodies (complementaries, and reminders of the background). To make the skin tones yet warmer, the white areas - clouds and the many pieces of fabric - are cool in color, but remain an integral part of the canvas through their tints of pale pinks, oranges, blues, and greens. And the composition oscillates, as I said, between the figures that lean to the left and those that lean to the right; a palpable energy suffuses the canvas.

If the Barnes great bathers are animated by an implied narrative, it is one that Cézanne thought up only for this painting. Two small versions of this composition exist (of which *Baigneuses*, below, is one), where the figures are arranged in a nearly identical way but create neither drama nor tension; in place of the intrusive figure there is a gentle bather walking in, whom no one seems to notice. We may view them as precursors, but

318 - *Krumrine calls her the "temptress", because her only function seems to be to display her body. This would be a reasonable interpretation if the figure were indeed feminine, but that is not certain. In two smaller* baigneuses *paintings (in R668 below and in 669) she is clearly feminine, but also modest, and there is no male antagonist at left. "Her" function is best viewed as more formal than narrative, as a figure that provides balance. See Krumrine, Mary Louise,* Paul Cézanne: The Bathers, *London: Thames and Hudson, 1989, p. 218.*

BAIGNEUSES (R.668), ca. 1890, 61 x 90 cm. Musée Granet, Aix-en-Provence. *Volume 1, n° 301.*

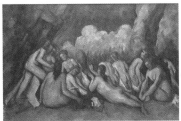

LES GRANDES BAIGNEUSES (R.855), ca.1894–1905, 136 x 191 cm. National Gallery, London. *Volume 1, n° 306.*

not as preparatory studies for the Barnes narrative. The London great bathers painting (R.855), however, is accompanied by two small *Baigneuses* paintings (R.858, and – the one discussed in the Introduction, p. 17 – R.859), which certainly are studies, because together they explore the disposition of about the same number of bathers. They each work out the same Tiepolo-like challenge (see below): to create a plausible arrangement of bathers against two framing trees. Cézanne solves it, in the studies and in the London painting, by aligning the figures either with the trees or against them (or bending their limbs so they do both). None of the three paintings seems to carry a hint of narrative.

But in the London canvas the two groups have been fused into one mass, with only the dog and the apples to mark where they had been separated in the small paintings. It is this change that leads me to believe that the two small pictures are preparatory: the fused composition is more risky, more dependent on working out the two independent groups first. The two groups can still be distinguished, but the prone bather now reaches across the mid-point, toward the nearest bather from the left group, and becomes an extension of her. The painting turns into a solid wall of bathers, all located in a shallow space, all distinguished by emphatic diagonal movements that make up a composition, not a story; if there is a hint of anecdote, it is in the small, sad figure on the extreme right, and in the one in front of the tree that seemingly turns toward us to engage our attention – but that hint is barely perceptible.

Is the composition successful, then? Cézanne clearly thought initially that there was a problem with the crowding, because he restretched the canvas on a taller frame, allowing more room at the top and bottom; but recently the top strip has been hidden again, so I must discuss the painting as it appears now. Were it not for the painting's color, it might seem too carefully assembled – but its exceptional color *is* compelling and we feel immediately relieved from the sense of crowding. Once again the bodies are luminous against the blue and green background, and once again – even more subtly – the skin tones are masterfully enriched by touches of pale blue; the touches are of the same value as the pinks and oranges to make clear that their purpose is chromatic. The colors and contrasts are more restrained than those of the Barnes painting, and the surface, although much reworked, is more uniform; the painting as a result seems to be the product of a more consistent impulse.

It is a still more perfect consistency of impulse, touch, and color, that distinguishes the last painting, the Philadelphia version. Painted relatively rapidly, with little visible reworking, it also seems remarkably unswerving in its intention. Its surface is a uniform one of near-

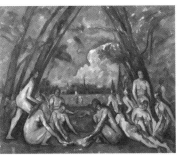

LES GRANDES BAIGNEUSES (R.857), ca. 1906, 208 x 249 cm. Philadelphia Museum of Art. *Volume 1, n° 310.*

ly equal patches which establish a rhythm in the canvas plane; but it should be noted that the patches exist only on the surface, not in depth as in the unerring modeling that we see in Cézanne's late landscapes. The simple color scheme of browns and blues is ascetic; the skin tones are dull, tending toward ochres and umbers rather than the pinks and oranges of the other versions. The rare greens are too muted to appear as separate colors, and they merely hint at mediating between the blues and browns; even with them present, the color scheme is almost binary. Not merely ascetic, the painting is also the most free of anecdote; nothing obvious ties the figures together beside the arch of the trees above and its inverted form in the center, below – and the close coupling of the poses with the trees.

The space in the painting is, however, generous; it opens up in the center once again, and it opens toward the top as well as toward the back. It is in the central space that the only hint of narrative appears: a vague swimmer who simply passes by, and two

equally vague figures who seem to gaze at the nude women. But that is too little to matter; the painting remains cold and formal. I am ready to believe that Cézanne's intention would have been to push the colors toward a greater richness; we have the evidence of his practice and his advice to Bernard (to begin painting with nearly neutral tones and build up[319]). But whether the figures would have been connected less mechanically, and the ambiguities of the representation resolved, is unclear. The ambiguities are many: for example, the missing head of the crouching woman on the left, the uneasy connection between the arm of the standing woman on the right and the neck of the one she touches, and the peculiar transparency of the figure at far right. Certainly the painting seems the least Venetian in its intention and would suffer from the comparison with the genuine article if it were appropriate to make one; I have in mind a perfectly resolved composition of bathers under trees by Tiepolo, *Diana Bathing*.

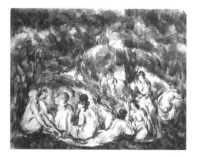

GIOVANNI BATTISTA TIEPOLO, LE BAIN DE DIANE,
ca. 1755-60,
79 x 90 cm.
The E.G. Buehrle
Collection, Zürich.
Volume 1, n° 307.

There is no reason to think that Cézanne had seen it in any form, but it illustrates how sinuously a Venetian painter can interweave bathers on the canvas, and how convincingly he can connect them to a canopy of trees.

None of these comments impugn the easy grace of a few of the figures, however, and the innovative, abstract painting of the faces. It is to them that my own gaze returns: to their simple, convincing presence, to their reduction to essentials that the painting of the early twentieth century appropriated (within a year of his death, in fact, beginning with Derain's *Bathers* and Braque's *Nude*, both from 1907-08)[320]. I cannot decide whether Cézanne had failed to achieve something here (perhaps because he did not push the painting further) or had achieved something unintended (by his unrelenting inventiveness); perhaps both conclusions are appropriate. I cannot agree, however, with Fry's attributing some of the difficulties of these paintings to Cézanne's old age[321]; the landscapes, portraits, and still lives of his last years are adequate proof of his unflagging powers.

So are, of course, the watercolors. The movement of Cézanne's hand is so supple and precise, the buildup of his space so suggestive and convincing, and the color harmonies so abstract yet complete and balanced, that even with no other evidence at hand we would know that we were looking at a painter at the height of his powers. Landscape and still life watercolors reveal something different from bathers; in them we follow the progressively more abstract and incisive reconstruction of vision, while in the bathers we see a greater acceptance of fantasy and feel Cézanne at peace with himself, with fewer hard edges to display. One form easily flows into another: in *Baigneuses* (RW608)

a gentle curve descends from the shoulders of the woman seated at left through the legs and torso of the prone bather, culminates in a brown head that makes contact with the woman at the foot of the tree, and then becomes a calm vertical. The short tree trunk has no sharp point to make, and the bathers seem unostentatiously content in each other's company; it is as if the bathers, nestled in lush foliage - and Cézanne himself, in painting them - had found the beautiful isle of Baudelaire's most sensuous poem, *L'invitation au voyage, ici tout n'est qu'ordre et beauté, luxe, calme et volupté.*

BAIGNEUSES (RW608),
ca. 1902-06, 21 x 27 cm.
Private collection, Zürich.
Volume 1, n° 309.

Such is the effect of the medium on Cézanne's form; the sharp, public voice of the oils gives way to a gentler, inner one. Even the watercolors which portray a subject similar to that of the Barnes or London great bathers (RW602 and 603), or compositions of opulent figures lying on a lively diagonal (RW606), all resist making too insistent

319 - *In Conversations, p. 73.*
320 - *See Rubin, William, "Cézannisme and the beginning of Cubism," in his* Cézanne: The Late Work, *New York: The Museum of Modern Art, 1997, pp. 151-202.*
321 - *In his* Cézanne: A Study of his Development, *p. 78.*

a point; they are burdened neither by menacing sexuality nor by massive volumes. In their fluid movements these watercolors resemble the *Néréide et Tritons* of thirty years before (p. 38) more than the monumental bathers of the last years.

Masculine subjects with no lyrical intent are no less suitable for this suggestive, delicate manner: A picture of fishing, *En bâteau (La pêche)*, below, only implies the few indispensable, diagonal fishing lines, and barely indicates the solidness of its one rigid object, the boat: instead, it is built up of repeated, transparent touches, as is the whole scene. At no point does Cézanne set down a sharp, defining outline of a dark or saturated color, which would constitute a literal emphasis or explanation. The dictum that Bernard listed as Cézanne's tenth is embodied in the late watercolors as clearly as in the late paintings: "Drawing and color are in no way distinct. By degrees, as one paints, one draws; and the more harmonious the color becomes, the more precise will the drawing be."[322]

EN BATEAU (la pêche) (RW604), ca. 1900-06, 13 x 21 cm. National Museum of Western Art, Tokyo. *Volume 1, n° 308.*

LANDSCAPES

With landscapes we are on familiar ground once again. *The Grandes baigneuses* were puzzling; it is as if Cézanne had asked too much of them and had let go of the simple mastery with which he painted the smaller bathers, forcing us to balance their undisputed qualities against their awkward problems. The late landscapes present no such problems; they simply represent the splendid unity of vision and logic that Cézanne spoke about to his visitors. Unlike the great *Baigneuses*, however, they do not point toward the future in any literal sense; shortly after his death, landscape painting became dominated by styles that had more to do with invention – construction, analysis, arbitrary color – than with vision. The Fauves had gone off in an independent direction, using brilliant, clashing, colors set down in detached brush strokes, and the early Cubists, although they looked over their shoulder at Cézanne, immediately began simplifying forms and limiting colors in a way that made sense on the canvas but left the motif a distant reminder[323]. But that is irrelevant to how we look at Cézanne's landscapes, and perhaps makes matters easier; we need not be burdened by hindsight.

We can see a broad evolution in Cézanne's style during this final decade but few details; Cézanne responds vividly enough to the character of each motif to frustrate any search for an even progression. The end points of his development are clear, however. There is an earlier style in which distinct parallel touches are grouped in blocks laid next to each other, without much overlapping, which we saw already in *La meule et citerne en sous-bois* and *Sous-bois* p. (164), and a later style, in which the touches are indistinct and the blocks prominent, sharply bounded at the top or not, overlapping or detached; this depends on what he is representing with them. It is likely that the styles overlap in time, because Cézanne was aware of having a choice to make when painting ("*yesterday … I began a watercolor of the kind I used to do at Fontainebleau,*" he wrote to his son on August 14, 1906), and it is equally clear that there is a continuity with the previous decade, not a disjunction as with the bathers. When Cézanne uses the first kind of style, he often takes new risks with his compositions and pushes his colors to more luminous extremes (as in the Bibémus paintings, below). With the second style, at least at its logical end point, his vision even begins with distinct patches; it

322 - In Conversations, *p. 37.*

323 - *I refer specifically to Braque's landscapes done in L'Estaque in 1907 and Picasso's landscapes from Horta in 1909. Braque later said this about trying to follow in Cézanne's footsteps: he had to fight* "against the habit of painting before the motif—which makes detachment more difficult." *See Rubin,* "Cézannisme and the beginnings of Cubism," *in* Cézanne: The Late Work, *1977, and his* Picasso and Braque: Pioneering Cubism, *1989.*

reconstructs the appearance of the site by approximation, to the degree that he can make the patches join up.

A commonly asked question about painting is whether new subjects elicit new styles, or whether styles determine the subjects the painter will undertake. The answer may well be different for different painters, but for Cézanne, whose work is informed by coherent styles and at the same time responsive to each new site, the relationship must be reciprocal. But if the mutuality – the flexibility as well as the analytic vision – is a quality we admire, its results also make it difficult to date the paintings. With *Eau courante en sous-bois* (below), for example, one could argue that the style is from the end of the previous period, but one could equally well argue that it is the style most appropriate to the subject; on the first argument the date would be earlier, and on the second it would be later. (Perhaps it was for that reason that Rewald proposed a five-year bracket for it.)

With the date made uncertain, the proper focus becomes the relation of the style to its subject. Cézanne has obviously been hard at work, and the work is done entirely by the touch – which, given the meandering layout, must have been an exercise requiring considerable thought. Almost at no point does the touch describe the textures

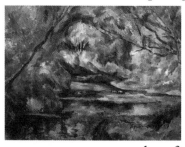

EAU COURANTE EN SOUS-BOIS (R766), ca. 1895, 60x 81 cm. Cleveland Museum of Art. *Volume 1, n° 311.*

of the objects, except perhaps in the water, where it is horizontal (but that also gives the picture a needed base). Elsewhere, the touch needs to perform many other roles as well: to support the diagonal recession of the brook, to balance each of the branches, and to provide a certain measure and order in all this confusion. In the upper left quadrant, the touch slants up toward the corner and opposes the near branch; there, it supports the recession and keeps the corner from closing the scene[324]. Elsewhere, especially near the center, a different touch provides horizontal and vertical stability. But it all seems a lot of work, and I think that Cézanne must have felt intuitively that it was color that would cut through the effort asked of the viewer: the harmony is fresh and crisp and the play of light and shadow is incandescent.

In *Château Noir derrière les arbres* a similarly fine touch is used to create a different composition: an almost willful geometry of slanted vegetation enclosing the vertical building. The geometry is not willful in the literal sense, of course, since the trees really did lean to the right and some branches did point upward, as photographs of the site

CHÂTEAU NOIR DERRIÈRE LES ARBRES (R522), ca. 1895, 73.5 x 92.5 cm. Sammlung Oskar Reinhart, Winterthur. *Volume 1, n° 313.*

show[325]. The composition was a matter of choice and the touch was a matter of emphasis: the choice was of that particular view through the trees and the emphasis was on the touch echoing the diagonal branch. With the branch as a given, the painting is integrated by the logic of Cézanne's touch. In *La Meule et citerne en sous-bois* and *Sous-bois* (p. 164) the touch had many more structural lines to respond to and could take many directions; here, it has above all the emphatic diagonal to support and subdue. Minor touches are also placed against the small branches that enclose the building on the left side – the local balance being more important, and more interesting, than imposing the scheme arbitrarily. The touches balance the geometry and soften it; their effect, in spite of the logic of their construction, seems natural. The colors of the sky and the pine needles

324 - *The corner was also left bare, but an insensitive restorer has filled it in with an opaque touch. This interrupts the rhythms of the other touches and encloses the scene in a sealed space. Perhaps nothing demonstrates so clearly Cézanne's difficulty in bringing his patches together; every touch had consequences for the whole, and if it was not quite right, the blank canvas was preferable.*
325 - *Rewald's 1930s photograph is reproduced in PPC, vol. 1, p. 254, and mine from the 1970s in my book on the landscapes, p. 134. Rewald dates the painting "c. 1885 (possibly later)", but it is clear, from the resemblance to* La meule et citerne en sous-bois *and* Sous-bois *(p. 164) that it must be from about the mid-nineties. I follow his dating for the other landscape paintings discussed here, but I remind the reader that many are unavoidably speculative.*

are very much as we see them now, but the building in the painting is darker and the door redder; whether they have bleached with time, or whether Cézanne made then more saturated to balance the color, is unclear. In any case, all three hues are here of about the same value, and the building and door are warm and saturated; the painting is splendidly unified and balanced, and happily resolved in the swirl of its tensions.

To this harmonious painting we may oppose the rakish *La Maison Maria sur la route du Château Noir*, a site visible from further back, with the house called the *Maison Maria* in the foreground and the *Château Noir* itself, and the *Mont Sainte-Victoire*, in the background. There is no way to check the appearance of the site now, since it is thickly overgrown, but I would presume that what caught the painter's eye was the brilliant contrast between the house and the sky and the subtle continuity between the mountain and the road. But this extended diagonal, interesting but immovable, fled deeply into space to the right; Cézanne would have felt the need to restrain the movement and balance the sharp angle. He achieved both by leaning the perfectly vertical house sharply to the left and supporting it with the incisive diagonal touches in the sky. Yet the result is not a painting that aims to resolve all its tensions; on the contrary, they

LA MAISON MARIA SUR LA ROUTE DU CHÂTEAU NOIR

(R792), ca. 1895, 65 x 81 cm. Kimbell Art Museum, Fort Worth. *Volume 1, n° 312.*

remain deeply felt. The sky is a saturated cobalt and is opposed to the brilliant variety of yellows, oranges, and reds in the house; the vegetation is a sharp viridian green, standing cool and trenchant, half-way between the harsh warm and cool opponents. Only the strong center - the yellow wall - provides a point of focus and respite. None of these devices are new of course (we had seen them in *Pigeonnier de Bellevue*, p. 159, and other paintings done in the 1880s), but here they are more needed than before, and they are honed to a sharper edge.

No single formula can tell us in advance how Cézanne will balance his touches, nor does it seem possible to think that he followed one. What seems reasonable to suppose is that each site would present some constraints - a strong diagonal as above, a flat riverbank elsewhere - to which the touch would need to respond. When the constraints were subtler, the work to be done would become more complex, and our attempts to reconstruct it must be more intuitive and tentative. Nowhere is this more evident than in the Bibémus quarry outside of Aix, where Cézanne found his most irregular, complicated, and unbalanced motifs - fascinating in themselves even to the casual visitor - and undertook to paint some of his riskiest compositions. The resolution of these intricacies seems to me heroic and the appeal of the paintings is not primarily to the senses but to our willingness to stay with the painter's problem of integrating the canvas. There is one appeal, however, that the quarry does make to the senses: it is the pale-orange to red-brown hue of the rock faces, luminous especially in the late afternoon light, which makes so simple and effective a harmony with the greens of the pines and the intense blue of the sky. But the rock faces slope inward, to sometimes quite a narrow base - that is how they were quarried from Roman times to the nineteenth century - and easily loom over the spectator, depending on where he stands, and almost invariably present problematic subjects to paint.

Cézanne's response is to treat the overhanging slopes not as a physical menace, nor as an embarrassing tilt, but as an opportunity for creating an interplay of forces trying to maintain balance. The rock in the upper right corner of the motif of *La Carrière de Bibémus* does in fact splay upward, but it leans to the left, into the picture, rather than standing up straight[326]. In one version, he preserved this tilt, and allowed the bit of ground in the middle to balance the composition unobtrusively as it pushed back.

**LA CARRIÈRE
DE BIBÉMUS** (R.838),
ca. 1898, 65 x 54 cm. Stephen
Hahn Collection, New York.
Volume 1, n° 314.

But in *La Carrière de Bibémus* (R.838), painted later when the foreground tree had grown tall and insistently vertical, he straightened out the cliff to extend the tree, and now the whole scene had tilted clockwise; he had created a canvas that almost explodes upward. Yet the newly created vertical was crucial; it offered restraint and respite.

Of all the peculiar formations created at Bibémus by quarrying, the one Cézanne chose as a subject for *La Carrière de Bibémus* is the most unpromising: too massive in the center, too light on its feet, and too cluttered on top. Loran was able to photograph it in the late 1920s[327]– it has since disappeared – and from the priceless photograph we learn that Cézanne was aware of the problem and changed two aspects of the composition. He narrowed the middle bulge, lightening it, and tilted everything in the upper half of the composition to the right, balancing the many lines that lean to the left. Among landscapes this is the only change of this extent that I know, and I am not

**LA CARRIÈRE
DE BIBÉMUS** (R.797),
ca. 1895, 65 x 80 cm.
Museum Folkwang, Essen.
Volume 1, n° 315.

always convinced that it was the best solution to the problem of imbalance; but as it is, the painting is a dynamic and vigorous construction, audacious in the risks it takes, if a bit relentless and stubborn.

Not every view of the Bibémus quarry was a challenge to Cézanne's touch. There is one simply poetic view of the rocks that requires no sophistication or visual labor to move us: it is the view of a bank of the cut cliffs across a small ravine in the late afternoon. The Sainte-Victoire rises as if from right behind the rocks, although it is in fact several kilometers away, and it is cool, grey-violet in appearance, set against the burning oranges and orange-browns of the rocks. Rewald's photograph from the 1930s tells us that the composition we see in the painting is the one Cézanne saw in the site, while my later one (shown) confirms that the hues, with one exception I shall come to, were this brilliant in the late-afternoon sun.

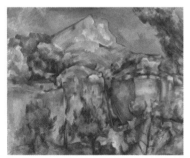

**LA MONTAGNE SAINTE-
VICTOIRE VUE
DE BIBÉMUS** (R.837),
ca. 1897, 65 x 81 cm.
Baltimore Museum of Art.
Volume 1, n° 316.

The kinds of complex relationships that Cézanne normally clarified and balanced seem to have presented themselves ready-made, as it were, or ready for a very attentive eye. Not every painter might notice, or make careful use of, the resonance between the shallow Vs of the mountain's strata (which are perfectly visible, though not in this photograph) and the point where the two central rocks nearly meet. There, the vertex of the angle centers our gaze. Nor would another painter necessarily see that the hump of the rock just to left of center also has an echo in the mountain's inner structure, or that the white uppermost stratum of the rocks can give us a convenient horizontal dividing line. Or, seeing these correspondences, the painter might not make them the foundation of a deeply integrated composition. The buoyant feelings aroused by the site are easily shared, but the sense of a world full of affinities is Cézanne's own.

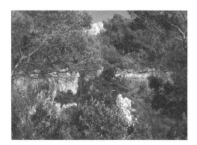

*Site 316, photo:
Pavel Machotka, 1962.*

There is one respect, however, in which the site was out of balance for Cézanne: in one of its colors. The blues and oranges were perfect complementaries as such, and the grey-violets were a good bridge between them (a bridge which Cézanne strengthened with his touches of both blue and orange in the grey-violet). On the site, however, and in the photo, we can see that the greens of the trees are too brown; as pigments, they have too much yellow and red in them.

326 - *See the 1927 photograph of the site in Erle Loran,* Cézanne's composition, *p. 115, or in Machotka (ed.),* On site with Paul Cézanne in Provence, *p. 86.*
327 - *In* Cézanne's Composition, *1944, pp. 60-65; or* On site with Paul Cézanne in Provence, *p. 83.*

To represent them, Cézanne chose a viridian green that is more sharply separated from the oranges and offers needed support for the cool colors; we recognize this as the stratagem he used in the two previous paintings, as well as in the earlier *Pigeonnier de Bellevue* (p. 159) and in any painting based on the characteristic color triad of the provençal landscape.

If these Bibémus paintings, and a few others like them, were painted within only a few years of each other, as is probable, then it is clear that Cézanne's style responded to the character of whatever composition he was working on. Over time, of course, his style evolved, but it never locked him into a single manner of handling the brush; even his most consistent manner, the earlier parallel touch, had responded to genre – portrait or landscape – and to the requirements of the subject. In the Bibémus paintings, the tight groups of small touches are used only for foliage, in part because they depict it, in part because they can be turned and grouped so as to balance or clarify the composition.

The developments that follow cannot be laid end-to-end, then, not only because the dating is speculative (with very few exceptions), but because there was no reason for Cézanne to have painted quite in the same way unless he had been working on very similar sites. Of course, there are the grand lines I have mentioned. By 1896, as is evident from the confirmed date of *Le lac d'Annecy* (below), his landscapes came to be conceived in broad patches of color, not merely organized by touches balancing the surface; his paint became more liquid; and his color became an ever more fundamental part of his painting. But neither up to that point nor after it can we discern an even progression.

**GRAND PIN
ET TERRES ROUGES**

(R761), ca. 1896,
72 x 91 cm.
Hermitage Museum,
St. Petersburg.
Volume 1, n° 317.

In the magnificent reworking of the *Grand pin et terres rouges* motif of ten years before (p. 151) Cézanne uses an already known touch, the Bibémus one, for the leaves, and an entirely different one for the foreground: there the patches have no sharp boundaries, allowing them to float in space. Some are much darker than others and appear further back, but a vagueness about the foreground remains. As we look at the composition, however, it soon seems justified by the space that it gives to the pine. The painting is more centrifugal than the earlier picture, with the tree expanding freely away from its trunk; the tree does not compete for attention with a busy foreground, as in the other picture, but contends with the solid sky for the space immediately next to it. Undistracted by the foreground, whose structure is left vague, I can remain riveted by the violent contortions of the branches. The saturated colors, the abstractness of the patches at the bottom, and Cézanne's utter clarity of purpose, argue for a date closer to the 1896 *Le lac d'Annecy* than to Rewald's proposed 1890-95.

One can compare the two paintings thanks to their nascent reliance on color patches. In *Annecy*, however, the patches are bounded on top, and made to overlap in a way that creates recession. Both uses describe Cézanne's later style, and since the painting was done during Cézanne's visit to the lake in the summer of 1896, the style must have developed by then. The painting is also marvelously resolved and finished, somewhat like *La Montagne Sainte-Victoire vue de Bibémus*, and like the latter, it builds on a perfectly satisfactory, even pretty, postcard view that it transforms into a sensuous and rhythmic construction. Early in the morning, at the time that Cézanne painted, the lake could be perfectly still[328] and mirror the buildings and hills; this explains why Cézanne could see the château's reflection without inventing it, and why greens could be seen in the

328 - *As seen in early twentieth century postcards, purchasable locally.*

LE LAC D'ANNECY
(R805), ca. 1896, 65 x 81 cm.
Courtauld Institute
Galleries, London.
Volume 1, n° 318.

Site 318 : photographie,
Pavel Machotka, 1976.

LE PONT
SUR L'ÉTANG (R725),
ca. 1895-98, 64 x 79 cm.
Pushkin Museum,
Moscow.
Volume 1, n° 319.

VILLAGE DERRIÈRE
LES ARBRES (R831),
ca. 1898, 65 x 81 cm.
Kunsthalle Bremen.
Volume 1, n° 323.

water on either side of a pure blue center: this is a reflection of the two hills and the open sky between them. This is not an everyday occurrence, but Cézanne had to see it like this at least once, to know that a composition based on the view would be connected from top to bottom naturally, rather than divided by the distant shore. But if the suggestion of unity was in the site, its realization was Cézanne's. In the upper half of the painting, the two hills are painted in distinct, diagonal patches that reconstruct their curvature and recreate the valley between them; the patches also emphasize the natural alignment of the hills with the roofs of the château and the hanging branches, and create, on the basis of this suggestion, a magnificent, interwoven fabric. The interweaving may seem more naturally conceived and more easily accomplished here than in paintings done at the Bibémus quarry, but the achievement is no lesser: a view merely lovely to look at has been made into a robust yet buoyant statement.

We are following a point in Cézanne's development in which the mastery of his touch allows him to paint sites that earlier would have seemed unpromising, or to find new rhythms in perfectly promising ones. I am reminded of the position he had reached with the fully mastered parallel touch of about 1880-84, but now his touch, even when parallel on occasion, responds to the site in more flexible ways. *In Le Pont sur l'étang*, below, it simply echoes the diamond-shaped supports of a bridge, and creates a Harlequin pattern for the whole painting, including the large group of trees on the left. The result is an extraordinary unity. The unity is forced, perhaps, but then this is only the first lay-in; I suspect that the rough hatchmarks were meant only to suggest the desired rhythm, and were intended for further elaboration. But because they are still uncorrected, they show us something crucial, namely that Cézanne had conceived his composition in just these terms from the beginning. It is not quite "reading nature… under a veil of interpretation by colored patches", but reading her through the possibilities of one's rhythmic touch.

Cézanne's masterly use of the brush for balancing a composition may be less visible in paintings where the motif was already rhythmical, because the touch appears to have less obvious work to do, but in such cases he may provide something else to fascinate us about the construction. That is what strikes me about *Village derrière les arbres*, which is without a doubt a northern landscape. The motif of houses visible through a gentle rhythm of trees is something we have seen before, but here a beautiful self-assurance is visible in the surprise he reserves for us in the central group: there the houses are turned at a sharper angle, converging toward a tight vertex, and they are surmounted by green foliage rather than golden fields. The result is an irresistible focus of interest, a break from the repetitious horizontals of the calm, lowland village. The fields and the rest of the village form an interplay of oblongs and trapezoids done in a smooth, liquid touch but bordered with new, thick outlines, sometimes continuous, sometimes not.

It is this kind of patch that places *La Montagne Sainte-Victoire vue de Gardanne* in the late 1890s, I believe, rather than in the early nineties, as proposed by Rewald. It is a composition that depends solely on the rhythmic recession of sharply bounded planes and their indispensable intersection in the center (otherwise the center would not hold); were Cézanne to attempt this with the parallel touch of c1883 only, or some other patches, the result would be static and deeply congested. As it is, the painting is surprisingly light; the boundaries, having been set down repeatedly in short, overlapping segments of a fairly light color, remain both tentative and definitive, and of course

LA MONTAGNE SAINTE-VICTOIRE VUE DE GARDANNE
(R768), ca. 1898,
73 x 92 cm.
Yokohama Museum of Art.
Volume 1, n° 320.

LA CARRIÈRE DE BIBÉMUS (R839),
ca. 1898-1900,
65 x 54 cm. Private
collection, Kansas City.
Volume 1, n° 321.

ROCHERS ET BRANCHES À BIBÉMUS (R881),
ca. 1900-04, 61 x 50,2 cm.
Musée de la Ville de Paris,
Petit Palais.
Volume 1, n° 322.

they dash nimbly across the canvas. A massive repoussoir makes sure that the rest of the painting is seen in three dimensions rather than in a flat plane, and that we are led diagonally from lower left to the upper right – to the end of the plateau.

I said that it is impossible to know whether new motifs instigate a new touch or vice versa, and *La Carrière de Bibémus* reintroduces the question. Returning to the quarry, Cézanne chooses two other unusual sites to paint which require confidence in his touch to integrate them; we can at least say that the touch and the composition are closely connected. In the first picture, he paints a solitary umbrella pine growing out of one of the blocks of stone left over from quarrying. The pine and the blocks compete for attention; they are so different in shape that we do not know which is the real subject, and one is massive and vertical while the others are light and slanted. It is the diagonal forms that solve the problem: one is the natural, solid triangle formed of the debris at the base, which extends to the block to the right, while the other is the dynamic accumulation of touches in the vegetation. Pine and rock are enmeshed on all sides in a dense growth of smaller pines, and it is they that can be painted with a slanting touch. The touch, applied from upper left to lower right, forms one direction, and when grouped in a way that points from lower left to upper right, forms another. The two directions balance each other (as they had done, more gently, in 1880 in *Le Pont de Maincy*, p. 116), but the movement to the upper right is stronger and sweeps the pine along, justifying its slant perceptually.

What faces Cézanne in the much more radical *Rochers et branches à Bibémus* is a downward pointing branch in front of a background of cut rocks and accumulated debris. The interlacing of the forms is straightforward for the eye to comprehend, but not for the painter to represent; he faces two choices: to portray the subject as a figure against a ground – branch against rocks – so that all the forms are clearly defined, or to interweave both into a single fabric that remains essentially in one plane, but which may become hard to read. In the first case Cézanne would have had to account for the position of the branch, clarify the shape of the rocks, and perhaps even justify the peculiar coincidence between the tips of the branches and the zigzag line of the rocks. All this could be done, but its effect would be altogether different.

Cézanne's decision to do the other, to make the painting a single tapestry, is more radical than any he had made in landscape so far. It may have been made from the start or later, by degrees; we certainly cannot tell from the evidence, because the surface has been carefully finished. As it is, however, the center is where I would expect him to concentrate his elaboration, and it is there that the integration is the tightest, with the touches all lying in the same plane. The orange touches lie next to the green and blue ones, obscuring whether the rock lies at the same level or behind, or even in front; the horizontal lines, real or implied, define either branches or creases in the rock, we cannot tell; and the tips of the branches may be in front of the zigzag, or next to it, or behind it. Cézanne had always made clear that his canvas was no window to look through, but never with this opaque a determination – and yet, he takes care not to enfold us in a mechanical world: we also follow his graceful line, from the top down to the first turn and then outward, as if we were following the spread fingers of the hand.

From roughly the turn of the century on we witness the culmination of Cézanne's way of seeing and portraying landscape: the self-assured use of liquid paint, the extraction

of more intense colors from the landscape - and the recourse to the color patch as the starting point of the composition and its ultimate building block. If in retrospect the late style seems like a logical development from all his previous work in landscape, to the painter it must have at first seemed like uncharted territory, and even in 1905 he was well aware of its complexities when he wrote to Bernard about his struggle to bring the patches together[329]. The work arouses such strong responses that it is difficult for me to speak about it only analytically; although superlatives are quickly exhausted, no term less definitive than "masterpiece" comes to mind for most of the landscapes of these last six years.

We feel this even when we can only witness his starting point, because it often has the explicit promise of the final vision written into it. Two vertical landscapes take us to the two end points, one to the first lay-in and the other to the finish. Both represent a path in the forest with sky peering through the trees at the top, and although it is not the same path, nor is there an overhang of rock in one of them, the challenge is the same. In *Sous-bois*, Cézanne reads the site exactly as he said in his sixth principle: under a veil of interpretation by colored patches. A broad range of greens sets down the foliage, a narrow range of grey-blues gives us a few openings to the sky (and suggests some shadows), and narrow patches of brown-orange define the path. The shape of some of the patches already supports the composition: their vertical orientation on the right has begun to provide a stable column, and the diagonal one on the left a dynamic recession. The colors are muted; one thinks again of Cézanne's advice to Bernard (p. 210).

In the finished *La Route tournante en sous-bois* it is as if Cézanne had followed just this advice, and brought the color up to a more saturated level by degrees. We cannot be certain of this, of course, because the colors of the site may have been different to begin with, but the difference is suggestive (and in any case, we know of no landscapes where a first lay-in is more saturated than a finished surface). All we can be certain of is that the patches have been woven together into a tight fabric. The colors are more perfectly integrated: the cobalts of the sky reach down into the yellow-greens of the leaves, setting up an incandescent tension between the warm and cool hues. The turn in the road is outlined clearly, as is the curve in the cliff above (with a few branches sketched in to prolong the cliff on the right), so that the two curves now balance each other.

As abstract as these two paintings seem, they must not be taken to suggest a movement toward abstraction as such; Cézanne's means - the patches - are increasingly abstract, but his aim is always to give us a construction that parallels reality rather than substituting for it. These two sites simply had fewer irreducible elements in them, and the patches did more of the work of giving the painting form. In *Arbres et rochers dans le parc du Château Noir* Cézanne is more constrained. The luminous rock and the web of trees have their own dynamic thrust and balance, one that turns the whole scene clockwise away from the vertical; it is a striking subject. To paint it, Cézanne understandably emphasizes the linear outlines of the rocks and the trees, in this way preserving the most arresting aspects of the motif. What he can ask the touch to do is to portray the actual robustness of the rock[330] and then lend the robustness to the green undergrowth and pine needles. There is a full-bodied, muscular unity to this painting; and there is, even more remarkably, the luminousness that Cézanne gives the cliff by balancing it with a dark, saturated sky.

SOUS-BOIS (R.884), ca. 1900-02, 81 x 65 cm. Ernst Beyeler, Basel. *Volume 1, n° 324.*

LA ROUTE TOURNANTE EN SOUS-BOIS (R.889), ca. 1902-06, 81 x 65 cm. The Selch Family, New-York. *Volume 1, n° 325.*

329 - *Letter of October 23, 1905. See Rewald's* Correspondance, *or* Letters.
330 - *See my* Cézanne: Landscape into Art, *pp. 100-101, for photographs of the motif.*

ARBRES ET ROCHERS DANS LE PARC DU CHÂTEAU NOIR
(R908), ca.1904, 92 x 73 cm. Stiftung Langmatt Sidney and Jenny Brown, Baden. *Volume 1, n° 327.*

CHÂTEAU NOIR
(R937), ca. 1900-04, 74 x 97 cm. National Gallery of Art, Washington, DC. *Volume 1, n° 326.*

CHÂTEAU NOIR (R919), ca. 1904, 70 x 82 cm. Private collection. *Volume 1, n° 328.*

Only in one painting do the patches lose some of their normally clear purpose. The site, the *Château Noir* building itself, is below that of *Arbres et rochers*, and in this view of it there is none of the ordered lyricism of the version we have already seen (p. 212). Here, a subject that generally inspires a powerful but well constructed canvas has evoked a harsh, dissonant, even violent response. We will never know whether the picture's vehemence represents a threatening moment such as a storm, or an inner state of the artist, or yet some conscious intention. We can presume that an actual branch intruded into the scene from the right - it looks like the dead limb of an umbrella pine - but that would not explain the jagged, repetitive, and heavily built up touches with which he painted it, nor the thickened, incised branches on the left, nor the confusion of the patches representing the vegetation. Perhaps most arresting is the upper right corner, with its cacophony of unresolved and incomplete patches which, uncharacteristically, lie neither in front of one another nor in the same plane, and only underscore the disorder of the whole. It seems an angry or frightened picture - but it is also fully finished, in spots heavily built up, and perfectly consistent in its style. If it was inspired by an event or a mood, it came to represent it deliberately; and in this deliberateness it resembles the only other violent painting in Cézanne's late work that I can think of, a still life: the roughly contemporary *Nature morte: rideau à fleurs et fruits* (below). Quite possibly, both paintings merely illustrate Cézanne's restless invention.

By contrast, the view of the Château Noir that Cézanne painted in about 1904 took as its vantage point a spot to the right where no trees framed the building; this calmed the turbulence, simplified the composition, and set the house into the close embrace of the Sainte-Victoire and Mont du Cengle, the plateau at its foot. Here it is not intrusive lines but rhythmic patches that give the canvas its character, and they are harmonious - unsaturated, low in contrast - because they represent trees and bushes in shadow, with the sun still behind them and just rising. There are two systems of patches here: the rhythmic ones, which are bounded diagonally so that the one on the right is always in front of the one on the left, and flat ones, laid end to end, which define the building and the sky. But the contrast between them is minimal, because Cézanne, responding to the appearance of the site, takes care to hold the entire composition in a shallow plane: only the three walls of the buildings that face south reflect the morning sun and the rest remains in shadow. Perhaps there is also a slight haze, but this is only conjectural; the site in any case appears flatter than it will in the late afternoon and the colors are less distinct. None of this prevents Cézanne from painting a masterly canvas that integrates the house perfectly into its setting, gently opposes grey-violets to light olives and grey-blues to dull oranges, and places every local color in some small measure into all surfaces of the painting.

The magnificent *Le Mont Sainte-Victoire au-dessus de la route du Tholonet (avec pin parasol)* achieves an equally happy integration, all the more difficult to do because the painter must contend with the challenge of greater contrasts, more saturated colors, and a deeper space. The composition here must take into account the intense red patch of bare earth in the lower left corner and some reds visible at the base of the mountain. Balance is achieved easily by letting the greens of the pines remain unusually dull, but integration - for Cézanne - requires the colors to interpenetrate rather than standing apart; so he brings the reds into the face of the mountain, in places where they are just suggested by the slight variations the naked eye can see, but with a more intense pigmentation; and he introduces them here and there into the vegetation. No single color remains unmixed with at least one of the other two, and yet - such is Cézanne's

**LE MONT
SAINTE-VICTOIRE
AU-DESSUS DE LA
ROUTE DU THOLONET
(avec pin parasol)** (R900),
ca. 1904, 73 x 92 cm.
Cleveland Museum of Art.
Volume 1, n° 329.

*Site 329, photo:
Pavel Machotka, ca. 1977.*

LES GRANDS ARBRES
(R904), ca. 1902-04,
79 x 64 cm. National Gallery
of Scotland, Edinburgh.
Volume 1, n° 330.

LA ROUTE TOURNANTE
(R930), ca. 1902-06,
81 x 65 cm. National Gallery
of Art, Washington, DC.
Volume 1, n° 331.

fine calculation - we see the earth as red and the vegetation as green, while sensing a world that is interconnected and whole at the same time. In the letter to his son of August 14, 1906 he said, "it is all a matter of putting in as many relationships as possible". He was referring to water-color - to *Le Pont des Trois Sautets*, RW644, which he was working on - but he might have been describing any deeply cohesive painting such as this one.

A similarly saturated color, but a greater linear fierceness, animates *Les Grands arbres*. A massive, gnarled tree reaches toward a smaller, straighter one, which in turn reaches back; we seem to be witnessing the beginnings of a wary encounter between two antagonists. The branches shoot past each other, never quite meeting, but the leaves enmesh the two trees; several smaller branches move in and out of space above the straight, diagonal one, and may belong to either tree. It is this steely bridge across the nearly empty space that unifies the risky composition, and the vibration of the irregular patches of color that gives it nervous movement. It is an exceptional painting, full of movements that begin but do not end, lines that will not stay in place, and many rich ambiguities.

An ambiguity does leave one uneasy, however: the peculiar patch of orange that cuts across the trunk of the right tree, without apparent justification, and that confuses the space in the vicinity, as if the part of the trunk above the path could be located further back than the part below. A watercolor of the same motif (RW574) tells us what the tree really looked like, however: it ended at the level of the orange patch, which means that it stood next to the left tree, not in front of it; this worked well as a horizontal composition. But having chosen a vertical canvas for the oil painting, Cézanne faced an empty, dead space at the bottom; he therefore gave the trunk a seeming extension - a single line that takes us forward and down, but really stands for nothing in particular. It is only a line, not a solid, so Cézanne cannot be said to have made something up; but it gives the painting depth, movement, and a tense ambiguity.

So accustomed are we to seeing the patches of color as the building blocks of surface and space that their expressive use in *Les Grands arbres* - sharp, detached, and emphatic, in a tense composition - startles us. The construction of *La Route tournante* is more familiar. The surface of the road and the cliff are made to recede by patches bounded on top, so that the patch above always lies behind the patch below, and the foliage at the bend in the road is done in patches that have no specific edge and lie in one plane. In order to keep the overlapping patches from flying apart, Cézanne gives them all a similar value; on the other hand, to show that the flat patches move in and out, he makes some dark, some light. That describes the mechanics of this kind of painting, but not its power to move us. Here, I think, the power is in the painting's simplicity. The colors may be brilliant - indeed, Cézanne is at the height of his powers in finding the most saturated colors, among them reds, that still remain in harmony with each other - but the whole seems put together simply and undemonstratively, with an understated mastery. Its effect on me is quite the opposite of *Les Grands arbres* but I would be incapable of choosing between them.

If it were possible to date the paintings precisely, we might be able to judge whether in these last six years Cézanne's emotional expression came to depend progressively more on the relationships of his shapes and colors and less on the actual subjects. If there was such a progression, it was probably not a smooth one; but some of his

ARBRES - LE THOLONET (R.879), ca. 1900–04, 81 x 65 cm. John de Menil, Houston. *Volume 1, n° 333.*

late work, such as *Arbres - Le Tholonet*, is certainly dramatic in an almost purely abstract way. Each time we go to a forest, branches crisscross before us, but it is the way in which they lash out, interrupt each other, and vie with the seemingly solid space that fills the gaps between them, that strikes Cézanne. Or, we should say, that Cézanne sees in terms of pigment; and if the patches are the units of his vision, then for consistency he also must turn the solid lines into fragments, and yet keep it all connected by affinity of color. The composition is like a spontaneous eruption of bits of trees and saplings from somewhere near bottom left, and of inchoate masses of foliage; but the painting is in fact equally dense throughout – therefore contained – and uncommonly unified. Fragments of sky are indistinguishable from bits of the distant, blue hill or from the shadows at the foot of the trees, and the sky merges with the foliage all the way down to the bottom. So closely woven together is this universe that between the large tree and the first sapling any distinction between forest, hill, and sky disappears. It is as if in his own way and with these innovations Cézanne had succeeded in achieving that which he admired about Delacroix: "the tones interpenetrate, like silks. Everything is stitched and worked in together."[331]

Very close to the site for the *Arbres* painting and looking toward the same hills, Cézanne painted the puzzling *Vue vers la route du Tholonet près du Château Noir*. What is puzzling about it is that it is finished in a peculiar way, with the whole lower quarter left in outline form, and that the outline itself is multiple; one edge of the roof, for example, is done in eight distinct lines. Three possible explanations come to mind. One is that, having painted a single outline (and brought the colored patches down to it, as is obvious near the roof), he found the bottom part either too light or too heavy, and proceeded to move the outline up and down, hoping to settle on the one that worked best. But drawing eight lines would have been an inefficient way to do this, since it is difficult to focus on a single solution when several stare you in the face; in any case, we will see multiple outlines in his last portrait of Vallier (p. 239) and in the watercolor study for it, where they are used not to find the right outline but to allow the figure to occupy an undefined space in relation to the ground. Another possibility is that he deliberately sought out this ambiguity to induce movement, since the lines move up toward the left corner and back down again, and echo the movements of the patches. The third is that he found his patches too repetitive and uninteresting, and decided to relieve his boredom with a commanding vagueness of outline. We cannot know which of these impulses moved him, of course; and although I lean toward a combination of the second and third options, I am more certain of the canvas's effect: it shows us painting as a process, as an unrelenting series of questions with several answers, each possible yet none definitive.

VUE VERS LA ROUTE DU THOLONET PRÈS DU CHÂTEAU NOIR (R.942), ca. 1900–04, 102 x 81 cm. Art Museum Princeton University. *Volume 1, n° 332.*

The similar rhythms and ambiguities of these two landscapes suggest that they were painted close together in time, not because Cézanne used a signature touch but because the similar subject, light, and direction of view, elicited the touch. The evolution of the paintings of the Mont Sainte-Victoire done from above his studio at Les Lauves between 1902 and 1906 itself argues against the handwriting view of style; the evolution has its own apparent logic, one dependent on Cézanne's accumulated experience of his site. It was Gowing who reconstructed the sequence most convincingly[332], seeing in Cézanne's proposed ordering a progressive detachment from the appearance of the motif. Whatever uncertainty there might be about the details, Gowing's grounds for proceeding as he did are persuasive, and the ordering that he proposes indicates a development whose end point is more radical than in any landscapes painted only once.

331 - *Doran,* Conversations, *p. 141.*
332 - *In "The Logic of Organized Sensations".*

LE MONT SAINTE-VICTOIRE VUE DES LAUVES
(R913), ca. 1902-06, 65 x 81 cm. Nelson Gallery of Art-Atkins Museum, Kansas City.
Volume 1, n° 334.

LA MONTAGNE SAINTE-VICTOIRE
(R914), ca. 1902-06, 65 x 81 cm. Private collection, Switzerland.
Volume 1, n° 335.

*Site 335, photo :
John Rewald, ca. 1935*

LE MONT SAINTE-VICTOIRE VU DES LAUVES (R910), ca. 1904-06, 84 x 65 cm. Art Museum Princeton University.
Volume 1, n° 336.

The "site" of the late Sainte-Victoires was, with one or two exceptions, never exactly the same; Cézanne moved right or left, or toward and away from the mountain, and the seasons changed. Each view had different consequences for the composition. One of the early views in oil, R913 - there are eleven in all, and seventeen watercolors - is composed of three distinct bands: a sloping meadow with a scattering of olives in the foreground, a deep plain reaching to the base of the mountain, and the mountain itself. The space is clearly defined and is, in a way, the organizing principle: the largest tree is a repoussoir that throws the mountain into the distance - but then brings it back, because it also shares the mountain's profile and touches it right at a break in the mountain's shape. Horizontal and vertical touches, interlocking at their edges, lead us from the meadow to the mountain across clumps of trees and patches of fields, and there the touches are again diagonal, conforming roughly to the shape of the mountain. The silver-grey tones of the olives inform even the middle ground (where it is not clear what the plantings were) and the mountain's face and the sky as well; so do the oranges of the one visible house and the autumnal meadows.

Cézanne's response to the site in another early painting (R914), where he stands further back and to the right and the season seems to be late summer, is flatter and more abstract; most of the patches are vertical or close to it, not only in the middle ground, but also in the foreground and the mountain. It is above all the difference in touch that makes this seem a different view, because in fact the views are quite close. Rewald's photograph, although closer to the view in R913, shows the olives that are visible in both (and mine shows the colors of the motif white in mid-summer, but with a different foreground). Here Cézanne depicts the olives only as a foreground layer of silver which then passes over the sunburnt middle to the same colors in the mountain's face. If there is deep space here, it is palpable only in the leap between the house and the mountain; and if there is tension, it is only in the exaggerated saddle of the mountain's profile. In other respects the painting is more static and calls our attention to patterns; for example, the mountain's shape is roughly reflected in the orange-brown middle.

The unique vertical version, R910, is conceived in depth once again; the mountain appears farther away and the fields leading up to it seem to span a greater distance. This is not only a matter of the chosen touch, but also of the format - a vertical view will seem to span more of the middle ground - and of Cézanne's standpoint: he has moved forward again to where he can see the beginning of the flat terrain. I suspect that this constrains his touch, and I cannot imagine the painting done in the touch of the previous version. Here it is diagonals that govern the composition: the magnificent hump of the mountain's back and its inverse, the lines of the little red roofs and the fields just above them. The picture fans out toward us from the middle of the left edge (where Cézanne respects the slight rise in the ground at the left, which contributes to the movement) and it also recedes backward from the large olive in the front, now a mere grey-violet blur, to the mountain's peak. The mountain is unable to stand still; its profile heaves back and forth and it seems to reach for a vague horizontal line in the sky that it almost touches.

The watercolor of this site is nearly identical in its point of view - Cézanne stood a little to the left and the large olive hid the three houses - and reveals the kind of rhythms that he must have thought about for his oil painting, perhaps from the start

LA MONTAGNE SAINTE-VICTOIRE VUE DES LAUVES
(RW588), ca. 1902–06,
48 x 31 cm. Private collection,
Philadelphia.
Volume 1, n° 337.

LA MONTAGNE SAINTE-VICTOIRE VUE DES LAUVES
(R917), ca. 1904–06,
54 x 73 cm. Private collection,
Switzerland.
Volume 1, n° 339.

LA MONTAGNE SAINTE-VICTOIRE VUE DES LAUVES
(R931), ca. 1904–06,
60 x 72 cm.
Kunstmuseum, Basel.
Volume 1, n° 338.

of each one. It is not a study for the composition, because it is too narrow for the kinds of canvas sizes Cézanne would have used; nor does it suggest Cézanne's actual starting point. But it addresses some of the same compositional questions, and with its different responses illuminates Cézanne's thinking. The olive is clearer and more substantial and more like an inversion of the peak than a mere repoussoir pointing to it; this emphasizes the relation between the olive and the peak. Diagonal lines appear in the middle distance, a little higher than in the painting, and they also fan out from the left, so the conception of the composition is essentially the same; but given the prominence of the foreground olives, the diagonals crisscross and balance more obviously.

As a portrayal of the mountain in another medium, rather than as a study, the watercolor is a masterwork in its own right. Sparse in its means (a mere four pigments) but sensuous in the way it uses them, graceful in its lines yet substantial in the volumes it builds up, delicate in suggesting its subject but definitive in its accents, it is a consummate work of art.

Only two of the paintings, R916 and R917, of which the second is illustrated on the left, were left at a stage where we can witness Cézanne's earliest lay-in. Both begin with patches of color, all abstract and of about the same size, which are set down independently and eventually brought together. They appear to resemble the watercolors, and some of their liquid drawing has the watercolors' tentativeness, but they are in fact quite different: their patches are large and always intended for an ultimate integration. I presume with Gowing that they represent the next stage in Cézanne's vision of the mountain, not because they began with the abstract patches but because even in a more finished state they would have retained them. In R917 Cézanne proceeds as he had said in his eleventh principle: with the exception of the outline of the mountain (done once, firmly, and realistically), he draws as he paints, that is, he uses the patches to indicate specific objects, set out the color scheme, and work out the painting's composition and balance. The movement downwards of the patches at the bottom is just that: an indication of how the mountain will be balanced.

With such a splendid beginning I am unable to suggest why Cézanne had stopped, but the reasons might have been purely fortuitous, such as an unwelcome interruption; he seemed securely headed toward a well resolved composition, more dependent on flat patches of color than the first three paintings we looked at. In the last two paintings in the sequence, we see the surface almost as an end in itself. In one these, R931, Cézanne has abandoned the shape of the mountain, painting it as a vague protrusion into the sky rather than the physical, continuous form that it is, and he has abandoned light; the meadows and the mountain, rather than reflecting the sun, are almost phosphorescent, and project an inner light onto the dark surroundings. All the elements we had seen in the previous landscape are there: the little houses still mirror the peak, and the path still balances the mountain's back (although it is short here, because the mountain is short). But there is no illusion of space or volume; the painting exists on the canvas surface. If Cézanne has detached himself from vision here more than in any other landscape painted toward the end of his life, it is, I suspect, because of how much he has done with the motif already; he is free enough – or restless enough – to look for new ways of seeing it.

The other late version is the agitated, impulsive, fierce R932. The mountain once again lunges forward, pushed by its incisive back, and in fact strains uphill on a plateau arbitrarily tilted upwards. The dynamic lines – the outline of the mountain and the slashes in the

LA MONTAGNE SAINTE-VICTOIRE VUE DES LAUVES

(R932), ca. 1904–06, 60 x 73 cm. Pushkin Museum, Moscow.
Volume 1, n° 341.

middle ground - suggest that the painting was conceived differently again; here, large patches matter only in the sky and the framing masses of trees. But they do matter, and are painted carefully, in many layers, often in full paste. In certain parts Cézanne returns to earlier styles, as in the peripheral patches, which on the left are done in a parallel touch that we would have seen in the early 1880s; but in others, such as in the detailed middle ground, he is more relentless and free at the same time, rejecting vertical and horizontal touches in favor of tight, diagonal ones that funnel toward the center, to reflect the hump of the mountain. He impels his vision and his sense of the possible far forward; colors, for example, interpenetrate more than in any other landscape. Greens pop up everywhere, sometimes in very small touches, and greens are his final addition to the surface: small, lime-green flecks placed on top of the darker greens, turning reflected light into inner luminousness. If he had started out with detached patches of color, as seems almost certain, then he succeeded only too well in joining them at their edges - and had to find his way back to a rhythmic surface by adding to it these vivid, detached touches.

While I think it is perfectly appropriate to see the painting as agitated, it is to the painting and not Cézanne's inner state that the word applies; with no evidence of his inner state, we must assume that Cézanne is simply painting as the master of his means of expression. This becomes clear when we look at the watercolor done from the very site, perhaps from only a few feet forward, where the tree on the left disappears. The sheet has none of the restlessness, none of the forced dynamic of the tilted horizon; on the contrary, the horizon follows its natural incline and sweeps down and outward to the

LA MONTAGNE SAINTE-VICTOIRE VUE DU BOSQUET DE CHÂTEAU NOIR

(R902), ca. 1904, 64 x 80 cm. Edsel and Eleanor Ford House, Grosse Pointe Shores, Michigan.
Volume 1, n° 340.

right. The sheet opens out rather than closing in on itself as does the painting, and, internally, leaves ample spaces for our vision to leap over (as between the nearby tree and the mountain) rather than guiding us through dense color patches.

The sequence of views of the Sainte-Victoire had its own logic, then, a logic that responded to the understandings that accumulated as the sequence progressed; and in this the logic was independent of other developments. Nothing illustrates this as clearly as the style of another view of the mountain, painted from closer up, where Cézanne was separated from the mountain only by a rolling hill. It was a view painted just once (though also studied in watercolor), and it seems to say all there is to say, on this single occasion; the style responds closely to the textures of the hill, the craggy face of the mountain, and the time of day. Cézanne painted in the morning, when the side-lit face of the mountain took on a pink cast, and he was close enough to see the hill as a texture of oaks and the shadows they cast; this is all visible in the photograph (which, however, had to be taken to the left of Cézanne's standpoint). I mention the shadows because from this distance and at this hour they form streaks that point down toward the left corner and parallel the back

Site 341, photo: Pavel Machotka, ca. 1977.

of the mountain. This helps us understand the patches by which Cézanne represents the receding hillside as not only a stylistic matter, but as a simultaneous question of creating volume and representing the texture of the hillside. All the diagonals add up and climb to the right, but below the peak they all stop where the hill curves down and meets a twisted stratum in the mountain's face; the involution points back down and balances the picture. The face of the mountain, scraggly from close up, becomes a jumble of short, hatched touches, enough of which point down to the right to strengthen the balance. And a progression from the greens closest to the painter to the grey-blues farthest away mirrors the site exactly, while the pink cast, picked up by the eye better than by the camera,

completes the color spectrum. The painting would be the same masterpiece with or without the photograph, but with it, we can also understand the logic of Cézanne's sensations; he has found a perfect equilibrium between representation and logical expression.

PAYSAGE BLEU
(R.882), ca. 1904,
102 x 85 cm. Hermitage
Museum, St. Petersburg.
Volume 1, n° 343.

We can judge the extraordinary landscapes for which there is no photograph only by their finished appearance. With *Paysage Bleu* we do not even have a firm sense of place; it has been claimed both for the north and the south. The style is one that I think he reserved for paintings done in the south, such as *Château Noir* (p. 219) and others of c1904; it is more plastic than that of paintings done in the north in 1904 and 1905[333]. But whatever the site, the painting is exceptional in the hold it has on the spectator. A calm fragment of a house occupies the center and creates a tranquil point to return to whenever the rest becomes too violent; but around it, vegetation billows out, mounds up, and squeezes the house. The dark sky and the even darker foliage hang heavily over the bit of free space given to the path, and seem sculpted from the same solid matrix. Above all, the curved branch, alternately graceful and threatening, either adds lightness to the lumpy foliage or forms a grapnel that holds us in. All these are metaphors only, but they help say that the effect of the painting is emotional, disturbing, but also profoundly satisfying. Most satisfying is perhaps the painting's unity; its character and balance depend on each of these parts and perhaps others, and the painting changes radically if we block any of them out with our hand.

LA ROUTE TOURNANTE
(R.921), ca. 1904,
73 x 92 cm. Courtauld
Institute Galleries, London.
Volume 1, n° 344.

Cézanne had remained in the south for about five years, from 1899 to 1904, and then made two visits to the north, in 1904 and 1905. His stylistic response to the northern landscapes was similar to what we had seen in 1894 in *Giverny* (p. 163): a greater emotional distance, cooler colors, and a flattening of the touch. This is in no way an aesthetic judgment; on the contrary, it could be argued that Cézanne's detachment allowed him to see his canvas's surface more closely, to feel its flatness more intensely, and let the rhythm of patches dominate. The result is almost always splendid, sometimes in a quiet manner, at other times in a dramatic one, but it seldom betrays the painter's emotion. *La Route tournante*, for example, is a seemingly straightforward view of a distant village dominated by a bell-tower; we are separated from it by horizontal fields, and connected to it, at least in part, by the suggestion of a road. In some ways it is an unpromising subject or perhaps a clichéd one, but it makes the painting all the more compelling. Cutting across the tranquil fields, all done in strings of vertical touches, is a tension between the road on the right and the trees on the left, whose top forms a line that prolongs the road. The bell-tower is caught between them, but not in the static center, where it seems to be at first, but well to the left – and it leans to the left as well, as if claiming affinity with the trees. A doubling of its outline on the right, however, so apparently accidental, dislodges it from what would be too firm a perch and makes it strive rightwards again. These are subtle effects, but more distinct than they seem at first, and one has but to hold the painting to a mirror to see them.

**PAYSAGE AU BORD
D'UNE RIVIÈRE**
(R.922), ca. 1904,
65 x 81 cm.
Private collection,
Germany.
Volume 1, n° 345.

In *Paysage au bord d'une rivière* (like the next one, a northern site), there is no calmness in the site and no room left for subtle effects. All the movements of Cézanne's hand, whether creating patches or suggesting roofs, echo and help constitute the main compositional thrust, which is toward the dense vertex where the one diagonal meets the verticals and horizontals. It is a pure kind of painting, or pure at the stage where he was finished with it, one in which every touch suggests an approximation

333 - *I agree with Rewald that the hill in back could be les Lauves, and would add that it is unlikely to be the forest of Fontainebleau, whose surroundings are flat.*

to some final state, and no detail, no outline, helps you guess what the final state is intended to look like.

This is a mode of thinking, or a procedure – the two are really the same – that is not found in the work of any of Cézanne's contemporaries, and it is a procedure difficult enough even for him to carry through to completion. Cézanne had explained to Bernard that bringing the patches together to delimit objects was difficult for him "when their points of contact are fine and delicate"[334], and while at times this must be understood as a psychic inhibition (I allude to the fear of contact I mentioned on p. 200), and at other times a technical problem, here I think the gaps are allowed as an aesthetic matter. The composition converges toward a single vertex, at the implied crossing of the riverbank and the diagonal wall; but because the crossing is only implied, it can be marked by concentrating the patches – while allowing them to remain further apart closer to the edges. The patches' rhythm is so prepossessing that any touches filling in the gaps, whether to make the objects clearer or for some other purpose, might risk muting it. The painting has gone as far as it can – unless Cézanne were to change the composition; and I think we would be the poorer if he had.

BORDS D'UNE RIVIÈRE
(R920), ca. 1904,
61 x 74 cm. Museum
of Art, Rhode
Island School of Design.
Volume 1, n° 346.

The composition of the contemporary *Bords d'une rivière* is at first sight similar and the vertex where the horizontals and diagonals meet is located in the same spot. The patches seems to be closer together, given the grey background. The crucial difference is in their orientation: here, in the middle band, they are vertical and horizontal. Surely the clear view of the river helped Cézanne decide what patches to use: what we see, in any case, is a painting that is firmly composed, its tense choppiness well resolved, and its welter of patches clarified by an occasional outline. The terrace on the right meets the river at a point, and by meeting it points more firmly to the left; so do most of the confused patches on the ground. On the left a happy, commanding patch of red draws us away from the congested bottom (and, of course, balances the colors). The occasional outlines that border the houses, the river, the red barge, and even the horizon – added after the fact – help the middle band give the painting stability and respite. We must understand that the statement "as one paints, one also draws" is only an approximation; in this painting (and others), what Cézanne did was to compose as he painted, and he clarified the drawing later, with an occasional outline, as needed.

In the very same year, the incisive abstractions of this northern painting give way to a closer, more sensuous connection with a southern site close to home, near the Lauves studio; in it, the surfaces and volumes are once again intrinsically connected with their edges. A contemporary photograph shows us what Cézanne's motif looked like. So many of its details correspond to the painting – standpoint, time of day, height of the trees – that the photographer must have been present, at least once, while Cézanne worked; and this was most probably Bernard in 1904. The photograph is exceptional. Although several sites have been well preserved and can still be photographed, as I have attempted to do, the passage of time is always perceptible, and this is the only record of a site as Cézanne saw it.

Cézanne had also painted a watercolor of the turn in the road, and I suspect that the watercolor came first, because the painting is better balanced. But the sheet does shimmer with an unusual intensity. A dense hillside frames the view on the left and blocks the

334 - Letter of October 23, 1905.

Site 351, photo:
Emile Bernard, 1904.

MAISON PRÈS D'UN TOURNANT EN HAUT DU CHEMIN DES LAUVES
(RW629), ca. 1904, 48 x 63 cm.
Mrs. Henry Perlman,
New York.
Volume 1, n° 347.

LA ROUTE TOURNANTE EN HAUT DU CHEMIN DES LAUVES (R946), ca. 1904,
65 x 81 cm. Fondation Beyeler,
Riehen/Basel.
Volume 1, n° 348.

LE JARDIN DES LAUVES
(R926), ca. 1906, 66 x 81 cm.
Phillips Collection,
Washington, DC.
Volume 1, n° 351.

space; it also offers a supportive mass for the house to huddle against. But, dark and massive in the motif, it could easily become muddy and opaque in the watercolor, and much too heavy for the rest of the picture; so Cézanne's separate touches, each fully dry before the next one is superimposed, skirts both difficulties. On the contrary, the hillside remains light in weight (and is made even lighter toward the corner, so as not to weigh down the left side), and with its colors taken from the rest of the sheet, remains closely integrated with it. The result is clear, deeply unified, and fully comprehensible, and I suspect that in lesser hands any one of these qualities might have been sacrificed.

With the watercolor finished, there was a matter of emphasis to resolve: the central, static position of the house. To compose a more dynamic painting, Cézanne took in a broader view on the right and down: now the house moved left of center and made a hub from which the fields and road could radiate. The nearby trees were detached from the distant hill, and, both now visible, they restrained the precipitous descent of the road and the fields. This is the view of the photograph.

Although the colors in *La Route tournante* are similar to those of *Bords d'une rivière*, and the compositions have a similar focus, the feeling aroused by the former is deeper: the painting is denser, more passionate. I sense once again a detachment from the site in the north that produces larger, less closely knit patches, and a flatter effect. It is not that the one painting is the lesser accomplishment and the other the greater; they merely reflect a different intensity of attachment. Both are masterly representations; *La Route tournante* is also an intimate experience of space, movement, and habitation.

I must admit that the flat patches with which Cézanne did the half-finished *Le Jardin des Lauves* at first resemble his northern style more than his southern one, and that it is impossible to be certain how the finished surface would have looked. But there are indications of the southern passion for landscape in the contrasts of light, the brilliantly juxtaposed colors, the swirling touches, and the sense of denseness; the painting, if finished, might have had the surface of *Le Mont Sainte-Victoire au-dessus de la route du Tholonet* (p. 220) or *Homme assis* (p. 237). Since we know from photographs, and even from a watercolor, that the painting represents an overhanging branch at the top, a view of Aix with the St-Sauveur cathedral underneath it, and the terrace wall below[335], we can assume that the spire would have become more than a hint, and that the patches would have coalesced more. But it is the conception of painting that this lay-in reveals that is most significant: a fervent rhythm of the colored constituents of the landscape, awaiting, but not dependent upon, the suggestion of larger, more legible, forms. The painting stands poised, it seems to me, between a first lay-in and a full integration; it is more than a promise but less than a fulfillment, a poem that alludes to its subject rather than an essay that explains it.

Le Cabanon de Jourdan was almost certainly painted in the summer of 1906 and if, as is believed, it is Cézanne's last landscape[336], then it suggests that his ultimate aim always was to join the patches of color into a unified surface. It also illustrates a remarkable union of the two ways of conceiving a painting we have just

335 - *See Rewald, "The Last Motifs at Aix," p. 95, and Rewald,* Paul Cézanne: The Watercolors, *No. 637.*
336 - *Rewald, PPC, vol. 1, p. 555.*

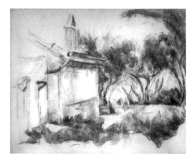

**LE CABANON
DE JOURDAN** (RW645),
ca. 1906, 48 x 63 cm.
Private collection, Zürich.
Volume 1, n° 352.

**LE CABANON
DE JOURDAN** (R947),
ca. 1906, 65 x 81 cm.
Galleria Nazionale d'Arte
Moderna, Rome.
Volume 1, n° 353.

**ARBRE TORDU
ET CITERNE DANS
LE PARC
DU CHÂTEAU NOIR**
(RW532), ca. 1900–02,
45 x 30 cm.
The Henry and Rose
Perlman Foundation,
New York.
Volume 1, n° 349.

seen: it integrates the patch system with a powerful linear design without showing the independent traces of either. Cézanne did not look at the site through the veil of interpretation by colored patches right away, at least not without a large, preliminary study in watercolor, which is conceived differently. (I assume that the watercolor preceded the painting because it is closer to the literal appearance of the motif.) The composition, a shade broader in the painting but otherwise identical, was normally uncongenial to Cézanne and all the more original: a flat wall receding sharply into space. The recession is stopped, however, by placing the end point of the wall in the center of the sheet, at a point of equilibrium, and is then opposed by the counterthrusts of the curving branches.

In the watercolor, Cézanne made the trees the focus of the composition, and reflected their graceful rhythms in the scattering of bushes at the bottom of the sheet. He left untouched the sky and the left wall - possibly to make clear that the movement of the trees was the subject, or, if he was thinking ahead to the painting, to remind him not to let the inevitable weight of the building interfere with these movements. To judge by the finished painting, the concern was unnecessary. Although with the walls painted in, the weight of the composition did shift to the left, Cézanne took a broader view of the scene and brought in the wall at the right edge; this redressed the balance. Now there was less onus on the curved lines of the trees to oppose the flat plane of the house; the trees could join the dense, opaque sky to create a massive counterweight. The blue and the dark green interpenetrate, and curve together at the top toward the chimney.

The ground, now also done in patches, became a series of diamond shapes that interconnected like the tiles or parqueting of a floor, and at the blue door the green diamonds were joined together in a curve to mirror the principal curving branch. As in the watercolor, the roof was left off - perhaps to keep the diagonal movement as simple as possible - but the sky filled the space the roof had vacated and even invaded part of the chimney. The chimney has taken on a sharp point here, as if it were meant to attract the eye - an exception to his rule - but this, too, has an incisive effect on the composition: it strengthens the dynamics of the receding walls. *Le Cabanon de Jourdan* is not a "last" landscape in any sense except that none have followed it; on the contrary, as if looking to the future, it takes risks, and is as clear in its purpose as the hand that painted it was firm.

Cézanne's achievements in watercolor, which seem to me of equal rank to those of his oils, are surely apparent from the comparisons I have made with the paintings where the subjects were the same. Cézanne made use not of the medium's precision of line, liquid washes, or contrasts of light and dark, but of its transparency, its layering, and its white voids. Local color, light, denseness, depth - all can be represented by color patches set down in overlapping layers, while white voids invite us to fill them with surface or space. This makes his late watercolors masterpieces of paradox: suggestive yet precise, tentative yet definite, independent in color and rhythm yet evocative of the order they describe.

We gain one kind of understanding of the watercolors when we look at the ones that are studies for oils, and another when we look at the ones that remained independent. *Arbre tordu et citerne dans le parc du Château Noir* seems like it had to remain independent; it is too satisfactory as such, concentrated as it is in the center, emphatically linear, suggesting a vaguely continued space beyond the right edge. A painting would have

SLOPING TREES
(C1181), ca. 1896-99,
31 x 47 cm.
A. Deuber, Basel.
Volume 1, n° 350.

had to complete the top and bottom, integrate them with the composition, and contain the space on the right more clearly. Here, all is rhythm and suggestion; even the outlines are interrupted and taken up again, inhabiting the same tentative space as the color patches, yet describing their objects (cistern, tree, branch) as accurately as is needed.

Cézanne's late drawings may also be either studies or independent works. *Sloping Trees* seems to me independent because it would be as difficult to translate into paint as was *Arbre tordu*. It is fiercely linear; here the spaces in between the trees have no structure or cadence of their own, as they had in *Arbres - Le Tholonet* (p. 221) and would inevitably have had if done in oil. Since line always describes character better (and events as well, but that is not in question here), each trunk here can be individual, of its own form and with its own history of growth. Cézanne never forgets balance, and here a few diagonals rectify what would have been a vertiginous slant; but he no more imposes an aesthetic program on his medium than he did on his choice of motifs, and remains responsive to the possibilities of each.

PORTRAITS

In the work of the previous decades, Cézanne rarely applied the logic of his touch to portraits, and this decade is no exception; although after about 1900 he paints portraits in new styles, with some of the abstract elements of landscapes, he remains responsive to his sitters (their character, role, or setting). In portraits where expression is crucial (*Portrait de Paul Cézanne*, R876, p. 230, and *La Dame au livre*, R945, p. 236), small touches will be most appropriate; where symbolic meaning dominates, a somber accumulation of wet pigment dragged over drying paint may be used (*Le Marin*, p. 239); where a figure is identified with a setting, it may remain undefined while the setting is elaborated (*Le Jardinier Vallier*, R950, p. 239). There, likeness would cease to matter; the person would be described by the pose, the setting, or the character of the touches or colors. The late portraits and figure studies, in all their forms, are as splendid an achievement as the landscapes; each carries a painterly weight of some kind, by its simple placement of forms, its color balance, its gravity, certainly even by its bodily expression.

Cézanne is often seen as being psychologically distant from his sitters. I have argued otherwise for his earlier work, but I admit that it is true for some of his late portraits. The reason is simple, I think: Cézanne now paints fewer people who are close to him. There are no more portraits of his wife or his son; the sitters closest to him are the elder and younger Gasquet, and of those only the father seems to be viewed with affection. There are also sitters of Cézanne's own age who were not close friends, both old women and old men, and there are young girls in head-and-shoulders poses or quietly holding dolls; generally these portraits have - to me - a strong presence of their own, apart from their connection with Cézanne. Two three-quarter length portraits are such complex masterpieces that the question of psychological distance seems irrelevant (*Jeune italienne accoudée* and *Jeune homme à la tête de mort*). Only the pictures of two persons of some standing, Vollard and Geffroy, maintain a respectful distance, while the picture of the young man he barely knew, the painter Hauge[337], is unmistakably stiff and aloof.

337 - *Hauge's brief account, written in 1899 and only recently published, is the only one with a negative tone; he writes, "[Cézanne] has diabetes, is in much pain, and sometimes is impossible to be with." Whether it was Cézanne's indisposition or something in his relation to the young man, the atmosphere seemed tense and the portrait is formal and cold. See Rewald, PPC, vol. 1, p. 500.*

I am not suggesting that Cézanne was consistently empathetic with his sitters; my interest is only in showing that his response varied. I also wish to emphasize that whatever the degree of his closeness, he always went beyond mere description: he revealed a person. It might be merely age or station in life, but it might also be attitude or character - a physical being or psychological presence expressed in body type and pose.

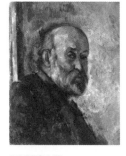

**PORTRAIT
DE PAUL CÉZANNE**
(R876), ca. 1894,
55 x 46 cm.
Private collection.
Volume 1, n° 356.

In his self-portrait dated about 1894 - to judge from his appearance, as Ratcliffe does[338] - Cézanne sees himself as a vital being, fleshy and perhaps wily or suspicious, or in the very least dramatic: he turns his normally flat eyebrows into alert circumflexes, as in the 1872 portrait (p. 91), and looks out at us intently. The right eye is set deep in its socket and its eyelid is fully modeled, so that there is no question about the point at which our gaze will be held; the left lapel and the left shoulder are suppressed by white overpainting, so that the chin juts out aggressively over the torso. It is a pose, of course, and a welcome one, but it is his touch that ultimately engages us: here and there it is scumbled, elsewhere hatched in parallel strokes, and everywhere it creates animated surfaces and dramatic contrasts between the greens, the burgundies, and the flesh tones. The overpainting loosens the boundary between the face and the background, and the head as a result oscillates between jutting out and settling back, remaining suspended in space just enough to create movement rather than stasis.

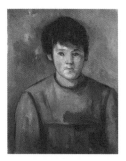

PORTRAIT DE FILLETTE
(R807), ca. 1896,
55 x 46 cm. Museul
National de Artâ al
României, Bucharest.
Volume 1, n° 358.

Perhaps it is the very vitality of the self-portrait, its sense of the particular, that made Cézanne adopt a conservative style; most of his portraits of the past few years had sharper, more abstract surfaces. With a portrait of the head and shoulders of a little girl of about two years later, however, he turns to a flatter, simpler style. Here, he has no dramatic or psychological presentation to make. The girl is posed frontally and painted with a minimum of modeling, and the simple mass of the body and the repeated ovals make the calmest possible statement. But these few words fail to convey the extraordinary impression that the portrait makes. The figure seems perfectly self-sufficient and carries an authority we do not normally associate with a child. The head is luminous against the background and the dress. We first notice how beautifully its color separates from the apparently neutral background, and as we look longer, we see that the face and the ground in fact have many hues in common; grey-greens and grey-violets appear in both, as do dark crimsons. We soon see the apparently neutral dress and wall divide into their color components, that is, into blues, grey-blues and grey-ochres as well as the greens and violets. In color, then, the painting is as deeply unified as it is radiantly contrasting. Nor is its form as simple as it appears at first. The head is elongated toward the upper left (a device seen in the 1866 portrait of Valabrègue, p. 55), and even a touch of crimson is introduced above the right temple; this produces a tense asymmetry whose full extent can only be seen in a mirror. Completely deprived of drama or psychology, the portrait relies purely on formal means for its expression, and seems the greater for it.

The portrait of Cézanne's schoolmate, Henri Gasquet, is, however, once again physical and psychological. The man had grown prosperous and, according to Rewald, had a dignified face and manner, looking like a small-town notary[339]. He seems very present here, dominating the composition by his contented air, inclined head, rakishly tilted hat, and unlit cigar. As formally as I look at paintings, I find it impossible not to take pleasure from Gasquet's self-assurance here, and not to enjoy what I take to be Cézanne's own self-confidence, expressed in his straight, definitive, uncorrected touches. And yet the formal pleasures are considerable as well: the hat brim, the cigar, the shoulder,

338 - *In his* Cézanne's working methods, *p. 21.*
339 - *See his preface to* Joachim Gasquet's Cézanne, *p. 9.*

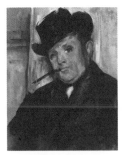

PORTRAIT D'HENRI GASQUET (R810), ca. 1896, 56 x 47 cm. M. Koogler McNay Art Museum, San Antonio. *Volume 1, n° 355.*

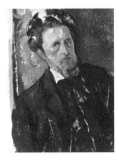

PORTRAIT DE JOACHIM GASQUET (R809), ca. 1896, 65 x 54 cm. Národní Galerie, Prague. *Volume 1, n° 354.*

LA VIEILLE AU CHAPELET (R808), ca. 1895-96, 85 x 65 cm. National Gallery, London. *Volume 1, n° 357.*

one of the lapels, all make for one simple movement, while the other shoulder and lapel, and the cut of the coat, create a natural counterbalance. (But since the balance is only partial and the head leans strongly to the left, Cézanne contains it subtly in a rectangle that leans to the right.) The balance of diagonals is not forced, as it had been with the portrait of Fortuné Marion (p. 58); it seems a natural expression of the man's dignity.

The portrait of Henri's son is less easy to understand. We see in it neither the sitter's vivid presence nor the formal gravity that distinguished the other three portraits. It cannot be objected that the portrait is unfinished, although it is, because Cézanne's ultimate intentions can normally be guessed from where he had left the composition. The difficulty is that nothing balances the sharp lean of the head and torso, not even the left lapel or the right cut of the coat, whose edges were left white to make them visible; and there is nothing to suggest that further elaboration would have changed matters. Possibly it was the peculiar left eye, which is set far below where it should be, that was intended to redress inclination of the head; but Cézanne had begun to scrape the paint down, as if to change his mind. A photograph shows Gasquet's face to be symmetrical, and he is said to have been handsome; Rewald even cites a description of him as a young Dionysos. I cannot avoid the sense of some ambivalence about the young Gasquet's character, here expressed both in the unbalanced composition and in the visual distortion. Although eloquent, devout, and a strong supporter of the provençal regionalism – all of which would have appealed to a part of Cézanne's character – he was also flowery in his prose, even breathless, and in his interpretation of painting he was literary and symbolist, which was foreign to Cézanne. Although this portrait was begun only a few months after Henri had introduced them, Cézanne had already shown signs of wishing to avoid him; and although their relations continued and even included the visit to the Louvre in 1898, the differences between them must have been obvious and to Cézanne occasionally onerous[340]. Perhaps something else altogether explains the peculiarities of this portrait, but the unease remains.

Cézanne's emotions, or the emotions he intends to portray, are entirely transparent, however, in *La Vieille au chapelet*. The heavy slope of the bonnet and shoulders, the triangle of blue apron, the vacant, obsessive concentration, all point massively downward, depicting both the burden and consolation of old age. The painting is, if anything, too simple in its form and too didactic in its meaning, unlike, for example, the later images of old age such as *Le Marin* or *Le Jardinier Vallier*; yet it is also very deliberate, carefully composed, and fully finished, showing a gradual buildup of the left shoulder upward – in two, possibly three stages – to thrust the head forward and show the figure as more heavily weighed down.

When a painting is formally this clear, any attempts at a further literary interpretation are superfluous, yet its first owner, the young Gasquet, wrote that the model was a defrocked nun of seventy whom Cézanne took in out of charity and kept on even though she stole from him; but he also wrote that when Cézanne painted her he had an indefinable hallucination of a color given off by Flaubert's *Madame Bovary*. Here we must distrust Gasquet; both statements could not be true - probably neither one is - and in any case they add nothing to our aesthetic response[341].

A portrait of a small child probably done in 1896 during Cézanne's visit to Talloires,

340 - *In the same preface, pp. 9-13.*
341 - *See the account in Françoise Cachin et al., Cézanne, p. 408. The account also quotes Flaubert's description of an old woman from Madame Bovary, which fits this painting very closely—further muddling the attempts to create a literary interpretation of the painting.*

**L'ENFANT
AU CHAPEAU
DE PAILLE** (R813),
ca. 1896, 69 x 58 cm.
Los Angeles County
Museum of Art.
Volume 1, n° 360.

where he painted *Le Lac d'Annecy* (p. 216), is also simple in its construction but without the slightest suggestion of external meaning. confess to being fascinated by the painting without quite being able to say why. Its many straight lines are certainly puzzling in a portrait depicting a very small child (that he or she is small is clear from four watercolor studies where the real size is obvious[342]), and the flattening of the folds of the smock curiously deprives the figure of playfulness and substance; the simply painted, sharply sloping shoulders, raised to deny the figure its neck, are much less understandable here than in the *La Vieille* painting. Yet all these lines point to the face, and this may be why they are so straight. The face is painted very delicately, with sure touches of what seems to be a single layer of liquid pigment, in a subtle violet-pink on a field of orange; this makes the face a unifying area for the colors of the smock and the left background. It is perhaps this formal arrangement, this contrast between the child's innocent face and the geometry of what surrounds it, that is so touching. Nor is "touching" an adequate word; the composition is in fact full of tension, with an asymmetrical leftward thrust in the gaze, a distortion in the oval of the face and the hat, a bulge in the right sleeve, and a forward projection in the woodwork. It is an asymmetry we adapt to altogether too quickly and must see in the mirror to appreciate afresh. Ultimately it is these willful contradictions, this paradoxical joining of Cézanne's tenderness and craft, that must account for the painting's strength.

If we were inclined to view this painting as part of an inexorable progression toward a modern sensibility, we would be frustrated by the portraits that follow. Shortly after the *L'enfant* painting, Cézanne paints three portraits of great complexity and careful finish. They are undisputed masterpieces, each with a different relation to the sitter and each with its own, original juxtaposition of colors: *Jeune homme à la tête de mort*, *Ambroise Vollard*, and *Jeune italienne accoudée*. *Jeune homme*, the most complex, is a painting of great specificity: we cannot imagine the young man apart from his setting. The figure is less a portrait than an embodiment of a philosophical attitude; he is placed with willfulness and care against a table containing books and a skull, which seem remote from him, and a piece of paper that seems more immediate. The painting suggests a clear, traditional, and almost textual reading: the contemplation of mortality[343]. But whatever explicit meaning Cézanne intended to convey, it pales before the paradoxical fusion of sensuousness and monumentality. The sensuousness is invisible in black and white reproductions; the painting looks stilted and its meaning too obvious. I will confess to utter astonishment at seeing the painting in the flesh for the first time, because the stiffness was gone and its place was taken by vivid, vibrant color. The juxtaposition of hues is compelling: Cézanne opposes dark blues to mustard colors, the first in the boy's jacket and the second in the skull and the suspended rug. This in itself is original and highly satisfying, but he also adds warm reds to the hands and face to give life to an otherwise impassive pose, and he carries this through to the table and the chair. As complex as the touch is, and as close as the mutual interpenetration of the pigments may be, there is a simple chromatic principle guiding the color use: the composition is conceived in three principal color groups; the blue/mustard pair, as an aesthetic opposition of complementaries, and the flesh tones, as an infusion of life and light.

**JEUNE HOMME
À LA TÊTE DE MORT**
(R825), ca. 1896-98,
127 x 95 cm. Barnes
Foundation, Merion, PA.
Volume 1, n° 361.

It is impossible to know whether Cézanne developed the color to its present intensity gradually, in response to finding the beginnings too intellectual, or whether he had conceived it as such from the start. The saturation here is, in any case, greater than usual, and more necessary. The composition is equally complex - multiple diagonals set against a framework of verticals and horizontals, and closely interlocked with them

342 - See RW480-483 in Rewald's Paul Cézanne: The Watercolors.
343 - See Joseph J. Rishel's comments on this meaning in Great French Paintings from The Barnes Foundation, p. 150.

in unexpected ways: note, for example, the line that goes up from the boy's shoulder through the hairline at the temple, to the branch in the rug pattern. But if this thoughtful construction at times appears as too logical, the evidence of our eyes - our intense response to the color - sets the balance right.

The portrait of Ambroise Vollard, a comparable masterpiece, is equally complex in its construction but more natural in its pose and subtler in its dominant harmony. Only the vacant eyes suggest the psychological distance that is so often claimed for Cézanne; but it is just as likely that they were left vacant to emphasize the composition. The sitter seems seated quite comfortably, although surprisingly high (he was in fact seated precariously on a chair placed on a platform, as he notes[344]); he leans back a bit, but not far enough to affect the pictorial balance. The figure is more firmly set in the composition than the sitter must have been in reality, because an emphatic diagonal anchors him in the lower left corner and leads up through the right thigh to the left elbow. With the eyes vacant we can more easily see the rhythmical descent of V shapes from Vollard's hairline through the beard, the waistcoat, and the lap, and another pattern of oval shapes between the incised outline of the top of the head, the ears, and the oval objects in the window. These are correspondences that Cézanne conceived only after doing a preliminary pencil sketch. The sketch was a faithful likeness, to judge from photographs and portraits by other painters, and showed him balding and pudgy, but neither the painting's internal resonances nor the figure's relation to the setting had been worked out in it. And in the painting, Cézanne restores hair that was no longer there in order to - I should think - create the two ovals at the temples, which reflect the ears and the shapes in the window.

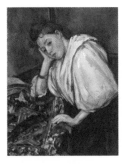

Once again, the color in the painting is magnificent. It is both spare and dense: spare in opposing only two groups of hues, red-browns against blue-greens, and dense in their close interweaving. If the blue-greens of the window and shirt front seem in opposition to the rest of the painting, they are also united with the red-browns in the face and the suit. These relationships seem all the more important to point out as the painting is often displayed in poor light, making it less legible than good reproductions. The shirt-front is visible even in poor light, however, and integrates all the color groups in its small space[345].

Jeune italienne accoudée is conceived again in relation to her setting, like *Jeune homme*, but with no text or meaning implied; hers is also a pose inconceivable without the composition, but for reasons that are purely visual. One does not need to see her as anything more than an attractive young woman dressed in a blouse with an opulently billowing sleeve, wearing a lemon yellow scarf, leaning on a table covered with a richly patterned rug. Nor is there any need for formal geometry, of the dour, masculine kind as in the skull picture; the volumes, undulations, and colors of the fabrics are more right for her. In spite of the opulence of the setting, she is very present; the face may well be a very good likeness, having been painted clearly and incisively. If the picture

344 - *Vollard, Cézanne, p. 76.*
345 - *Several of Vollard's observations that are regularly cited in connection with this portrait should be read with some caution. Vollard's query about the two bare spots on his hand received this well-known reponse: "If the copy I'm making in the Louvre turns out well, perhaps I will be able tomorrow to find the exact tone to cover up those spots. Don't you see, M. Vollard, that if I put something there by guesswork, I might have to paint the whole canvas over starting from that point?" I assume that the quote is close enough to the original, but am inclined to see the statement as a good-natured exaggeration, perhaps designed to épater the good bourgeois dealer. Cézanne's parting words, "The front of the shirt is not bad," should, I think, be understood the same way. Vollard's observation that Cézanne used very liquid pigment is, however, useful confirmation of the visual evidence; the cracking around the multiple outlines would easily result from a build-up of diluted pigment. As to the number of sittings of three and a half hours each that the picture required - 115 - I am not quite persuaded, but surely the painting took a long time. That Cézanne made slaves of his models, as Vollard says he confirmed for himself, must be a breezy hyperbole; Cézanne could not have done so with small children, for example, but he may well have required tremendous patience from some adults. (Vollard, Cézanne, pp. 76-88).*

is carefully composed - and it is, with the massive rug supporting her as much as her own skirt does, subtle lines in the walls converging on the face, and the sleeve balancing the weight of the rug - it is also arranged without ostentation.

In this - in the affinity of spirit and simplicity of volumes - the painting reminds one of Corot's portraits of young women, such as the *Italian Girl* in the National Gallery in Washington, DC. There, too, the figure's appeal is immediate yet the painting ultimately moves us by its form; as he does so often, Corot unobtrusively composes the figure as a series of simple polygons. Both painters remind us (Corot as a matter of course, Cézanne this once) that in painting, a woman becomes beautiful only in a beautiful composition. In Cézanne's *Jeune italienne* it is color that is prepossessing, and it is his comments on Veronese's *Noces de Cana* that one thinks of (p. 201): "…the meeting of two colors. That's where [the artist's] emotion is." Although, from infancy on, we are attracted to the face more than any other form, here the lemon yellow scarf on its field of light blue is more compelling; the sleeve is crisp and the scarf is sensuous against it. It is a yellow more often seen in Manet than in Cézanne (Cézanne preferred the browner Naples yellow), and it is made all the more saturated by intrusions of blue. This is the dominant complementary opposition, but there is also a dark, red-green contrast in the rug.

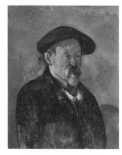

PORTRAIT DE L'ARTISTE AU BÉRET (R834), ca. 1898-1900, 63 x 51 cm. Museum of Fine Arts, Boston, MA. *Volume 1, n° 365.*

The energy with which Cézanne endowed the sitters for his last four portraits is missing from his last self-portrait, the *Portrait de l'artiste au béret* of about the turn of the century. Gone, too, is the abundant self-confidence of the self-portrait of 1894 (p. 230); the eyes are blank and the brows are raised in a vacant stare. If in the self-portrait of 1877 (p. 93) he seemed tired and small, his shoulders at least were substantial and he looked out toward us; here he appears shrunken and turned inward. But Cézanne is never anything less than a painter, and he turns his appearance into a simple and effective composition. The beret becomes the leitmotif of the canvas and its form reappears in the eyebrows, the eyelids, the red armchair, and in the curve of his left shirt collar; even the left shoulder is rounded off to take part in this series of arcs. Nor do these forms point predominantly downwards; they thrust vigorously to the right, in the direction of the artist's gaze (as they did with *L'Enfant au chapeau de paille*, in the opposite direction). The physical vitality with which he endows most other sitters is here displaced onto the abstract forms.

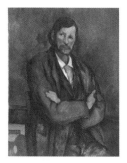

L'HOMME AUX BRAS CROISÉS (R851), ca. 1898, 92 x 73 cm. Guggenheim Museum, New York. *Volume 1, n° 364.*

Physical vitality is precisely what animates a portrait of a man with crossed arms; it is one of two paintings of the man, similar in pose and looking sharply to his right. In the one shown here, the body is turned a little away from the viewer and the slant of the eyes is more pronounced, and two items from the artist's paraphernalia are braced in the lower left corner for balance. The head is elongated to our upper left, as we have seen in other male portraits, but here much more radically; the mouth and the chin follow, as do the shoulders and the wainscotting. I think we may assume that the sitter's face was somewhat asymmetrical and that Cézanne made the most of this (as he did in the other portrait), stretching it beyond its real appearance and producing a painting of uncommon authority. In spite of the deformation, the painting is balanced and well anchored; this is because the stretching is confined to the part above the hands (except for the wainscotting). This portrait, then, is a study of a man's character, as expressed in his physiognomy, and it is unlike any other late portrait except perhaps the *Portrait de paysan* (p. 239); but it is more physical, with all the parts of the figure modeled as if for a sculpture and rimmed with repetitive outlines (to prevent them from settling into a fixed place). As with other portraits where I have emphasized the asymmetry, I recommend looking at the painting in the mirror to see the full extent of the distortion.

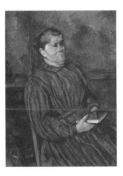

PORTRAIT DE FEMME
(R853), ca. 1898,
93 x 73 cm. Barnes
Foundation, Merion, PA.
Volume 1, n° 363.

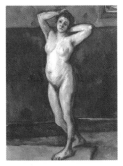

FEMME NUE DEBOUT
(R897), ca. 1898–99,
93 x 71 cm. Private collection.
Paris.
Volume 1, n° 369.

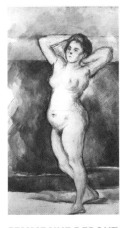

FEMME NUE DEBOUT
(RW387), ca. 1898–99,
89 x 53 cm.
Cabinet de Dessins,
Musée du Louvre, Paris.
Volume 1, n° 368.

The only comparably solid portrait of a woman is roughly contemporary with the man with crossed arms, and it is equally large. Although it is also very physical – almost unsparingly so – it is conceived much more in terms of color. Its risky harmony of red and blue-black is the one that Cézanne first studied in *Mardi gras* and *Arlequin* (pp. 169–170) and here he pushes it further, by giving the red dress a greater mass than was possible with the harlequin's slim costume. Cézanne gives the dress the same color balance internally and the same relation to the background; but there is more green in the background than in the harlequin pictures, and it is simply laid down in large, formless spots, almost as an afterthought. With the sitter turned as far away from the viewer as she is, and with her rigid expression and pose, the emphasis is on the volumes and the colors, not on her identity, and one must agree with Rishel that she was probably a household servant[346]; this would help explain the stern features, the uncomfortable, almost obedient pose, and the unlikely position of the unread book in her hands. It seems more a study of physique and role than of character; yet the composition is always exacting, with balance achieved here by massing fireplace implements in the lower left, and with stability guaranteed by a vertical poker on the right.

One figure painting done at about the time of the Vollard portrait is a life study that shows that Cézanne could, at least on one occasion, paint the female nude from life. The model was named Marie-Louise and the painting was done in the same studio as the painting of Vollard[347]. It is neither a portrait nor a study of an individual, as were the two previous paintings, but rather a venture into a category of painting; but I am not altogether clear what aspect of the nude is being represented, whether it is the kind of exhibitionism needed for *Quatre baigneuses* (p. 145), as Rewald suggests, or something else. It is a seductive enough pose, but a less seductive execution. We can confirm this by looking at a preparatory watercolor study, which as we would expect is more realistic, and which in fact shows us rounder breasts, a more sensuous belly, a more lifelike head, and legs that are shorter, firmer, and more proportionate. The study is large – a mere 3 cm or so shorter than the oil – and is done on three sheets of paper glued together, so Cézanne's preparation is of the utmost seriousness. The painting was not done directly from it, however, which was a possibility Rewald raised, because there are realistic shapes in the oil that do not appear in the watercolor – for example, the sharp point of the elbow and the puckers of skin at the juncture of the leg and torso. The painting is certainly based in part on observation; but it also reflects a translation from watercolor to oil: the face is stylized, the belly understated, and the pubic area fused with the shadow cast by the belly. All of this – and the legs, too, which taper precipitously and then end in outsized feet – seems less fleshy, less feminine[348]. But even with this evidence of Cézanne's careful preparation, we are no closer to understanding the retreat from his sensuous beginnings in the watercolor, nor the ultimate purpose of the final image.

There is never any question about purpose, however, nor any hint of hesitation, in clothed portraits. In *La Dame au livre* Cézanne uses an equally fine touch, but it is self-assured, rhythmical, visually lucid: whether it sculpts the folds of the skirt, draws the curves of the hanging rug, or follows the volumes of the sleeves, it is never less than clear in its objectives. As in the nude study, Cézanne records the quality of light

346 - *In* Great French Paintings from The Barnes Foundation, *p. 138.*
347 - *For these and the other observations about the model see Rewald's PPC, vol. 1, p. 527.*
348 - *I have never been able to explain to myself why Cézanne's legs and feet occasionally give him problems; besides the taper of the shin and the size of the feet, one often sees knees crossed in an awkward manner. Among the paintings reproduced here, some problem or other can be seen in R150 (Une lecture de Paul Alexis chez Zola), 235 (La conversation), 291 (L'après-midi à Naples [avec servante noire]), 370 (Baigneur aux bras écartés), 618 (Mardi gras), and 855 (Les grandes baigneuses). On the other hand, his portrayal of the feet of the* Grand baigneur, *R555, is exact and expressive.*

LA DAME AU LIVRE
(R945), ca. 1900-02,
66 x 50 cm. Phillips
Collection, Washington, DC.
Volume 1, n° 367.

**PORTRAIT
D'ALFRED HAUGE**
(R835), ca. 1899, 72 x 60 cm.
Norton Gallery, West Palm
Beach, FL.
Volume 1, n° 370.

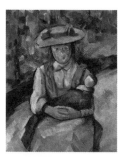

**FILLETTE
À LA POUPÉE** (R896),
ca. 1902-04, 73 x 60 cm.
National Gallery, London.
Volume 1, n° 371.

and the direction of its source, not because that is still his style, but because the pose faces away from the light and requires modeling; in another portrait of this sitter (*La Dame en bleu*, R944), where she faces the light, Cézanne created a shallower space and portrayed the figure as flatter. *La Dame au livre* retains the model's full material coherence; she sits with a book between her hands which, pictorially, gives the plane of her lap a clear recession into space, toward the upper right corner - and this imaginary line cuts across her backward tilt and balances it. The straight chair back, of course, and the carefully detailed rug, keep the figure firmly contained. The light blue rectangle of the painting in the upper right draws our gaze forward of her head, as if she herself were looking ahead rather than somnolently upward. The face is modeled splendidly, once again with all the colors of the rest of the painting, including the dull olives of the rug; its reddish tint, and that of the hands, make the skin tones appear luminous (as they do in the later *Homme assis*, below). I mention these technical matters in part to establish how conservative and classical is the construction of this portrait, in part to introduce the grounds for my intuitive judgment: the painting is an understated masterpiece.

With the head-and-shoulders painting of Alfred Hauge, Cézanne began to paint portraits in a new style, rougher and seemingly flatter, with emphatic outlines and larger and more detached patches; but the change in style was a matter of choice, not inevitability, because the portrait was done earlier than *La Dame au livre* and about the same time as the portrait of Vollard. As I said above, this is one of the few distant, stiff portraits in Cézanne's work. The sitter, 23 at the time, was a young Danish painter; his photograph shows a man with large eyes set far apart and an abundant head of hair[349], and this portrait shows him to be a very correct, carefully dressed, prim young man. He spent at least enough time with Cézanne to be hosted and have his portrait painted, but beyond that we know nothing about him; in his letter to a friend right after the visit, he was as critical of Cézanne as he was admiring, and something of his ambivalent attitude may have become apparent to the painter. It is perhaps the brushwork in the coat and background that betrays Cézanne's attitude: the touches move rigidly in one direction only, and while this has its formal use - it thrusts the body forward - it seems mechanical and listless. The outlines of the coat have the vigor of those in the portrait of Vollard, however, and the color scheme is almost as spare: a burnt siena against a blue-black. This simple scheme carries into the face as well, with the result that he seems as bloodless as he should be artistic; the mouth, on the other hand, sensuous to begin with, is outlined in very puzzling brown touches.

The brown color around Hauge's mouth might at first glance seem to be a shadow, like the dull color of the young girl's face in the later *Fillette à la poupée*, but that is not likely; the shadow of Hauge's nose is blue. In *Fillette* the hat, in full sun, casts the face into deep shadow, and Cézanne avoided blue for the change in skin tone because the clothes, the doll, and much of the background were blue already; as it is, however, he seems not quite comfortable with the brown as skin color, although formally it is a perfect bridge between the hat and the hands. The style of the vegetation in the background is the style of his late landscapes, which suggests a date after 1900, and in fact if we assume that the painting was done on the terrace of the Lauves studio, then it was painted after 1902. The style of the figure, too, is a late style: sharp changes in planes, as at the girl's knees, abrupt changes in color, as in her face, and unexpected breaks in outline, as in her hat. The touch in the outlines is firm and liquid, and set down so as to simplify the shapes at the expense of representation. As we have seen in landscapes, all these new, incisive devices call attention to form and color rather

349 - *See his photograph and the text of his letter to a friend describing his meeting with Cézanne, in Rewald, PPC, vol. 1, p. 500.*

than to the objects. Here Cézanne has in effect welded the girl's hands into a single form, and his purpose, I believe, is to help emphasize the much needed orange hue; seen as an abstract shape, the hands become an oval counterweight to the all-important hat.

These new forms are parallel to the ultimate style of his landscapes. Their dating is, of course, only approximate, but the 1899 portrait of Hauge gives us a starting date; more developed forms of the style appear by 1902. What the last portraits share with the last landscapes are the liquid pigments, the abrupt changes in planes and colors, and the incisive outlines; what is unique to them are simpler compositions and more repetitive poses - the men's knees, where visible, are crossed in the same way, for example, or the figures are posed simply and with little expression. There are exceptions to this; but it is impossible to avoid the impression that the last portraits, unlike his other paintings, are subject to the projection of Cézanne's old age.

One of the pictures with crossed knees is *Homme assis*; the knees, like those of *Vallier* and *Portrait de Paysan* below, point to our right. His face has been replaced by patches of color that match the hat and the wall and find their way into the suit and the slippers, and even into the landscape in the back; we are aware of color more than of individuality, and all these oranges and coral reds are placed where they are in order to integrate the canvas as tightly as possible. The background landscape is very much like that of *Paysage bleu* in color (p. 225), but it has little structure of its own; its one recognizable shape is the forked tree, whose form inverts the split of the legs below the knees. The greens of the dark foliage also balance the oranges and the reds - by opposing them above the horizontal midline and joining them below it, at the bottom of the low wall (where they may also represent moss or lichen).

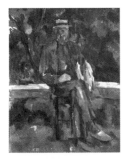

HOMME ASSIS
(R952), ca. 1905-06,
65x 55 cm. Thyssen-
Bornemisza Collection,
Madrid.
Volume 1, n° 375.

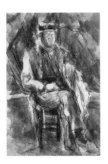

PAYSAN AU CANOTIER
(RW638), ca. 1905-06,
48 x 32 cm.
Art Institute of Chicago.
Volume 1, n° 374.

This reading of the canvas is confirmed by the preparatory watercolor; it, too, attempts to integrate the colors closely. Lacking the coral reds, however, its color balance depends on an even, three-way division between browns, greens, and blues. Its surface is a series of rhythmic patches representing foliage and echoing the long diagonals - the leaning tree continuing into the chair leg, and the line from the lapel of the jacket through the right shin. But this rhythm is perhaps too insistent, and too inadequately balanced by the few verticals. Cézanne seems to have been aware of this and corrected it when transposing the watercolor portrait onto canvas. The color patches, now irregular, allowed the verticals to do their work, and the verticals themselves were made more emphatic: the walking stick was painted light brown, the hand was painted orange and placed right under the face, and a fold in the left trouser leg was made prominent, as if it were another leg of the chair. At the same time, the diagonal rhythms gave way to the splendors of chromatic contrasts. Cézanne's thinking about the color balance must have responded, in part, to the logic of the two media: the opaque oil pigment could not rely on the vivifying power of the white sheet - where all hues appear more saturated in contrast to the white - and had to create its vibrancy by more striking contrasts. But the conception itself was thought through afresh: light became an abstract principle, with direct sunlight illuminating only the top of the garden wall, and the painter allowing the rest of the wall to bathe in light reflected from the unseen house and the hands and face to radiate their own light from within.

This logic of oil paint is imposed on all of the portraits that follow watercolor studies; the canvases are more saturated and the relations of colors more abstract. That is not to say, however, that the studies were designed to address the same questions in each portrait. A study might record the forms of the figure, only to have them displaced into the rhythms of the background in the oil; another study might elaborate the

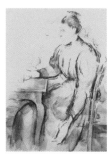

FEMME ASSISE
(RW543), ca. 1902-04,
48 x 36 cm.
Jan Krugier, Geneva.
Volume 1, n° 372.

PORTRAIT DE FEMME
(R898), ca. 1902-06,
64 x 53 cm.
Stephen Mazoh, New York.
Volume 1, n° 373.

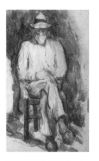

PORTRAIT DE VALLIER
(RW640), ca. 1906,
48 x 32 cm. Interart Ltd.,
Zug, Switzerland.
Volume 1, n° 377.

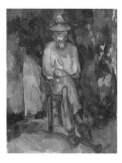

**LE JARDINIER
VALLIER** (R950),
ca. 1906, 66 x 55 cm.
Tate Gallery, London.
Volume 1, n° 376.

background and ignore the person from the start, even before translation into oil. *Femme assise* is an example of the first. The watercolor is a study of the billowing volumes of the woman's form and the related curves of the table; she is all puffs from the top of her head through the sleeves, bodice, and voluminous skirt. Nothing in the watercolor prepares us for the canvas, however, where the swelling forms have been displaced into the background and become its dominant rhythm, and where the figure has been left characterless. In the finished state one must presume that the figure would have been distinct from the ground, as was *Homme assis*, but with the ground defining the rhythm of the whole. This kind of evolution from watercolor to oil, or as much as we can see of it, would seem to have promise, but here the first touches in the figure have not been successful.

The aquarelle of the gardener Vallier, an example of the second approach, is on the other hand as distinguished as the oil painting; it is complete in itself and stands alone as a work of art. Cézanne seems to have asked less of it than of *Paysan au canotier*, and achieved more: he neither started out realistically, drawing details that would later be suppressed, nor imposed a rhythm on the background that might not work in the oil, but addressed directly the interplay of light and shadow. The slight, thin-legged figure of Vallier is already without a face, as if anticipating the abstractions of the canvas, and is insignificant in relation to the lush background; he sits in the sun in front of a climbing plant which is in shadow, with the color of his shirt and pants bleached. All the subtleties of Cézanne's watercolor technique are lavished on the complex relationships of the hues in the foliage. There, blues, greens, reds and orange-browns are laid in patches one on top of the other; they almost create a landscape, although it is a landscape with a limited purpose: to throw the figure into full sunlight.

Almost the same words could be used to describe the canvas, except that the patches are opaque, and that the greens and blues cannot absorb the intrusion of red; the red is displaced further outward. Where the only way to portray the intensity of the sun in the watercolor was to leave the white of the paper in reserve, on the canvas its place can be taken by yellows and yellow-browns. Now it makes sense for Cézanne to have broadened the canvas to take in the blue area: the blue stands in the same relation to the yellow wall as the pants do to the shirt, and both yellows are that much more intense. In neither work do we see the person of the gardener, however; in both, he is a pretext for a work that is defined by intense relationships of color.

Of the late portraits, *Portrait de paysan* is the most incisive; there is no question of the sitter's individuality, as there was with *Homme assis* and *Vallier*. The coat is painted with multiple outlines, emphatic, heavy, and even craggy, as if it always protected him from the elements or from an unfriendly world; the hands are so flat as to seem cut away from the figure. The painting is powerful, at every point consistent in its purpose; it fits its model, who himself is a strong figure used to hard work, with large hands and strong legs. Where the drawing is forceful, however, the colors are understated. Browns are set against a curious mixture of blues and greens, an unassuming harmony of unsaturated, secondary colors that one might fail to notice were it not for the way Cézanne uses them: he weaves them relentlessly into all the areas of the painting. The seemingly black coat and the dark trousers are in fact, light brown, green, and blue, as well as blue-black; and the brown wall is in turn suffused with greens. If the color scheme gives us an effect of sparseness, it also provides a carefully calculated setting for the face, whose browns, yellows, and reds concentrate our gaze and complete the color scheme in the same way a capstone completes an arch; the colors convey the sitter's character fully, it seems, even without the second eye. The portrait is as

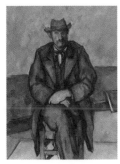

PORTRAIT DE PAYSAN
(R943), ca. 1904–06,
91 x 76 cm.
National Gallery of
Canada, Ottawa.
Volume 1, n° 378.

LE MARIN (R951),
ca. 1902–06, 100 x 81 cm.
Private collection,
Switzerland.
Volume 1, n° 379.

**LE JARDINIER
VALLIER** (R954),
ca. 1906, 65 x 54 cm.
Private collection.
Volume 1, n° 380.

much a study in character as was *L'Homme aux bras croisés* (p. 234), but it is done with willfully restricted means and a finer color integration.

It is inevitable that a painter will project something of himself into at least some of his portraits, and we are justified in seeing an image of Cézanne's own age in the late portraits of Vallier and the various seated peasants. In no painting does the projection seem clearer than in the portrait called *Le Marin* - for which Vallier is also assumed to have served as model[350]- so heavy and formless is the body and so unfocused the expression, therefore so inviting of projections. The pose can be guessed clearly enough: Vallier sits with legs splayed, back bent, one hand on the thigh, the other hidden under the cloak; but the effect is uncanny and the meaning of his pose - seemingly tired but also thrusting aggressively forward - hard to fathom. Cézanne's touch is no less mysterious, being overworked in a way we have not seen before; in the head and coat, as far down as the hand, the paint accumulates to the point of granularity in the outlines and at the edges. The accumulation is easily explained technically - it results from liquid paint being applied repeatedly over a surface that had not yet dried - but hard to understand aesthetically. It may indicate an obsessive impatience to keep on painting, or a frustrated wish to perfect the contour, or on the contrary an expressive decision to introduce ambiguity; I feel unable to favor one suggestion over the other. Nor can I say whether it is in spite of this touch or because of it that the painting is so deeply moving, so simply convincing, as a picture of old age; it is a masculine version of *La Vieille au chapelet*, but less theatrical, technically more innovative, and in color more alive.

A profile portrait of Vallier is said to be Cézanne's last painting, the painting he worked on in the morning following his collapse the day before, on October 15[351]. There is no reason not to believe this account, because it is consistent with the internal evidence of the painting, where Vallier faces an early morning sun low enough to illuminate his forehead under the brim of the hat. We must also assume that the painting was well along, because Cézanne could add only that one morning's work to it; he returned to his studio in town in a state of collapse again and died a week later (on the 23rd). The early morning light presents a sharp challenge for the painter: the wall behind is in shadow yet the light smock is brightly illuminated, and the great contrast risks pulling the figure and the background apart, with the one too light or the other too dark. Cézanne rose to the occasion: the scene retained its illumination, the smock its color and volume, and the background, with its just perceptible greens and browns, its close connection with the figure. The result is fully as harmonious the *Portrait de paysan*.

In the portrait there is no sense of the exhaustion that Cézanne felt in the days and weeks preceding his collapse. Already on September 21 he wrote to Bernard saying *"I find myself in such a state of mental disturbance, in such great trouble, that I fear that my sanity might give way."* On October 13 he was still exhausted and wrote to his son, more openly and telegraphically, *"The weather is stormy and variable. Nervous system much weakened, only oil painting can sustain me. I have to carry on. I simply must go on painting after nature".* On the other hand, on the 15th itself, to his son, he claimed that he was "not feeling too badly. I take care of myself, and I eat well[352]." Clearly he was declining but had good moments. But the portrait is more than the product of a good moment; it is original in its conception and sustained in its vigorous

350 - See Rewald, PPC, vol. 1, p. 557, for this identification and for evidence of Cézanne's intention to complete the eyes.
351 - See Rewald, PPC, vol. 1, p. 558, and Rewald, Cézanne, p. 263.

handling (as is the watercolor study for it, RW641). A horizontal light is rare in painting, and the first light of day even rarer – one thinks of Caravaggio, but his comes generally from a window, and not necessarily in the morning – and it is new for Cézanne; so are the repeated, independent stabs at outlining the profile. Both are studied effects, not momentary impulses; the preparatory watercolor was done by the same light and with a similar touch. One might be tempted to see the touch as tentative, but if it were so, then the touches would converge on the outline that came closest to his wishes; instead, here – as in many late drawings and watercolors – all the touches have equal weight. Whether there was a single effect that Cézanne sought after can be doubted, and here, in any case, the touches call attention to the rhythm of the profile: the angle where the crown meets the brim of the hat is repeated first in the nose and then in the distant arm.

It is Cézanne's ability to find the correspondences that underlie the things we see that gives his work its weight and persuasion. This is as true of portraits as of landscapes and still lives, and it is a faculty that he refines and perfects until his final moments before the easel. In saying this I do not include the narrative paintings, because they do not represent things seen; we look to them to express something of Cézanne's wishes rather than reveal something about the world. But the others appear to us as striving to grasp the underlying structure of things and to record the emotion they arouse in the painter. Portraits may seem the least likely candidates for so ambitious a purpose: we think of them as intended to depict a likeness. But we sense intuitively that Cézanne's portraits, although they achieve likeness whenever he wishes, aim at something higher, because most of them are great paintings on other grounds.

These grounds are in fact many. In the last decade alone, among the paintings we have looked at, there were four portraits where character, either of face or of bodily attitude, was convincing and arresting: *Portrait de Paul Cézanne*, *Portrait d'Henri Gasquet*, *Portrait de l'artiste au béret*, and *L'Homme aux bras croisés*. There was another group where it was the plain expression of the face, the simple distribution of weight, and the straightforward harmony of color, that achieved their understated power: *Portrait de fillette*, *Fillette à la poupée* and *La Dame au livre*. Still other portraits depended on minimal form to describe, compellingly, a role or feeling state; among these I would include *Portrait de femme*, *Portrait de paysan*, *Le Marin*, and *Le Jardinier Vallier*. Finally there were the grand compositions of great complexity and subtle or brilliant color that stretched the narrow confines of the concept of portrait: *Portrait de M. Ambroise Vollard*, *Jeune italienne accoudée*, *Jeune homme à la tête de mort*, and, going back to the Introduction, *Portrait de Gustave Geffroy*.

For so narrow a class of painting this represents an uncommonly broad range of achievement and reveals a lively, supple imagination. If form is the ultimate criterion for judging art, then it is thanks to the form that Cézanne gives to character and mood that his portraits rank with his other great paintings.

352 - *My translation after* Correspondance; *see also* Letters.

STILL LIVES

As with a portrait, we are most deeply affected by a still life when we sense that it reveals something of the nature of the world it portrays. Form in a still life seems most moving when it renders its subject well; instead of the sitter's individuality, attitude, or character, we respond to convincing relationships between apples, vases, tables and fabrics. The late still lives, even more than the ones that precede them, seem like great portrayals of the way objects around us should be connected, and in this sense they appear as revelations of the highest importance[353].

We may not always know just what is being disclosed. The objects do seem to belong together by some kind of necessity, by just the exact juxtaposition, and they do seem to inhabit their space by right and with ease, as a great actor might inhabit a role he is portraying. But they are not like the revelations about the natural order of things that we sense in a landscape; we are always aware that still lives are a construction, that the objects have been brought together by the painter – that, as with great acting, the sense of naturalness has been created by artifice. It is perhaps our easy acceptance of this paradox, our acknowledgment of the created as natural, that makes the great still lives so breathtaking as paintings.

Cézanne's objects are, in a way, relatively simple in their components and bare in their rhetoric. Unlike 17th century Dutch still lives, for example, Cézanne's compositions are not testimony to the opulence of a table or to the pleasures of a meal just eaten; their objects, even fruits, are assembled on a table just to be there and to call attention to their complex affinities. We may be aware that the fruits are edible, but they are above all simple in shape and surface, and they are kept bare of gustatory associations by being neither sensuous, nor translucent, nor peeled, nor half-eaten. Their arrangement may be complex, but we respond to the complexity rather than to some thought of material richness; an object or a thick rug may be decorative, but that is to make a contrast with the simple shapes. The effect of the painting may be opulent, but it is an opulence above all of colors and volumes; and the richness is in any case well contained in a carefully constructed space that supports, contains, and leaves room to inhabit. The late still lives are closer to Chardin than to anyone else, although Chardin did leave the occasional fruit peeled and a very perishable oyster open.

As little as the late still lives rely on the everyday meaning of objects, they do rely on it to a degree, and they would be too ascetic if they did not. Apples themselves mean more than just edible fruit; they suggest ripeness and voluptuousness as well, and for Cézanne they also mean the gift of love[354]. The rugs on which they may be draped decorate a still life as a flowered dress might a woman, and their wooly texture comforts, reassures, and encloses. A sculpture of Cupid is fleshy and young even in its lifeless, plaster copy from the original. And of all the objects, skulls are the simplest and most direct in meaning, and become almost excessively clear when they are placed next to a candlestick. But perhaps with the exception of skulls, which we cannot look at as merely abstract forms for very long, such meanings inform the still lives without dominating them, and quicken our emotional response without interfering with our aesthetic one.

In painting still lives, Cézanne relied as heavily on vision as when he painted landscapes, which meant that he had to set them up as he wanted to paint them; no painterly logic

353 - *The phrase is Fry's, of course (p. 84).*
354 - *See Meyer Schapiro, "The apples of Cézanne: an essay on the meaning of still life," in his* Modern Art: 19th and 20th Centuries, *New York: Braziller, 1978.*

would have made him tilt plates or fold tablecloths convincingly on the canvas, after the fact. As I said in the last chapter (p. 185), Le Bail told Rewald that sometime in the late 1890s, when he watched Cézanne at work, he saw him set up his still lives with consummate care. Perhaps this helps explain why we respond to them so vividly, and clarifies why, as representations, they are fully as convincing as landscapes and portraits: once set up, they were scrutinized as exactly. This may not be evident in the first lay-in, but it becomes clear as Cézanne elaborates his surface. To see this we may contrast two pictures of Puget's plaster Cupid, the one just laid in, the other elaborately

L'AMOUR EN PLÂTRE (R782), ca. 1894-95, 63 x 81 cm. Nationalmuseum, Stockholm. *Volume 1, n° 382.*

finished. They are both from about the mid-nineties, and they develop from a line of dense, masterly, and ambitious still lives that had begun in about 1893 (see *Nature morte aux aubergines* and related paintings, p. 189ff).

L'Amour en plâtre, a horizontal composition with a roughly eye-level view of the top of the sculpture's head, is laid in just enough to reveal a complete composition. The pudgy Cupid stands off-center, backed and balanced by the vertical cone of a blue rug (the one familiar from *Nature morte aux aubergines* and other still lives); he is flanked by peaches on the right and a mixture of pears and peaches on the left. Given the contrasts in color and shape between the fruits on the left, Cézanne did not have to finish them in order to make them convincing; to the right of the midline, however, the pure mass of peaches needed an overlay of pastel colors to make their fuzz unmistakable. The ripples of flesh find a correspondence in the hump of blue rug behind Cupid and in the massed fruit at his base, especially on the left, where the pears undulate with a sensuous wobble. This is a perfectly satisfactory composition, integrated in all but surface. We can make an informed guess about the intended finish from the extraordinary *Nature morte avec l'amour en plâtre*, where the smooth finish (in all but the floor) forces the sensuality of the Cupid upon us, not just in its undulating outlines but in the internal surfaces as well. The white plaster, lifeless in fact, shimmers with life in the hues that make it up, which are the colors of the rest of the painting, cut with white: pinks, light greens and blues. The lifeless Cupid contrasts with the living, rich and vivid apples and onions, but in the undulations of his forms also joins them, both in the way they are arranged and in the swish of the onions' leaves.

NATURE MORTE AVEC L'AMOUR EN PLÂTRE (R786), ca. 1895, 70 x 57 cm. Courtauld Institute Galleries, London. *Volume 1, n° 381.*

The still life does much more than suggest what the previous picture might have looked like had it been finished. Its perspective is rakish and opens up new opportunities to integrate the sculpture with its space: Cézanne looks down at an acute angle, from above the top of Cupid's head, so that the table on which the fruits sit becomes sharply tilted, and the floor underneath even more so. I suspect that he chose this angle so that the oil sketch of another sculpture, a flayed man attributed to Michelangelo, could be seen in the far background. The angle also makes the canvas at Cupid's back recede on a sharp diagonal, paralleling the back and the tilted shoulders and incorporating them into the space of the painting. In fact, the perspective also allows Cézanne to show us the corner of a third painting, his own *La Bouteille de menthe* (R772), which is crucial to the composition: its painted drapery flows into the "real" drapery under the plate of apples just as the leaves of the "real" onion reach up into it and replace its table leg. It is a still life that plays with the nature of representation, depicting three levels of painted reality, or three levels of illusion, and cutting across two of them with another illusory device.

All of this is a reconstruction of what Cézanne may have intended from the internal evidence of the painting; he had not explained it to anyone. Nor do we know whether the composition was set up all at once or evolved by degrees; we can only say that the green apple in the back is too big to have been real, and that it was painted in this

way for a purely pictorial purpose – perhaps to hide the inconvenient corner where three planes meet, or to give us a firm volume at the most distant point, or both. (A realistically small apple would have made the painting awkwardly deep.) It is also possible that surrounding this large figure with brilliant fruit and embedding it in a philosophical conundrum was a way of containing its imposing presence, its uncomfortable closeness to the viewer; I do see this as its effect, but there is no way to know if that was Cézanne's intent. Amid this kind of speculation, which the painting invites, there is for me a point of firmness: the painting is masterly and original, and seen in the flesh it is sensuous and brilliant, and its effect is immediate.

Cézanne's still lives never ventured into such questions again. With the exception of the still lives with skulls, he returned to compositions whose effect is above all visual, and channeled his originality into new arrangements of forms, juxtapositions of colors, and orders of complexity. The plain table with a drawer that we saw in three still lives done perhaps a year before (pp. 189-190) serves him in the next picture, *Un coin de table*; he views the arrangement from about the same distance but a little to the right, so that it is the bare corner that is closest to the viewer. This new angle requires certain adjustments in the nearest edge, which is interrupted by the customary napkin. This adjustment is not as mysterious as it is sometimes made to appear, and Cézanne's earlier work actually prepares us for it.

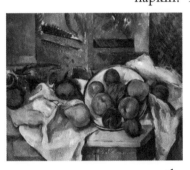

UN COIN DE TABLE
(R801), ca. 1895,
45 x 54 cm. Barnes
Foundation, Merion, PA.
Volume 1, n° 383.

In *Un Coin de table*, Cézanne's palette is based on the simple opposition of the complementaries red and green, with grey-blues in the napkin and plate to cool down the nearly overheated harmony. The focus of the composition is the arrangement of peaches and pears on the plate. They are densely assembled, contrasting in color, and very busy in the center, where two thin leaves cut across the red peach and rivet our attention (beside strengthening the diagonal movement to the upper right); and they are carefully painted, with pastel tones over the saturated ones to make clear that it is peaches, not apples, that we are seeing. A green pear points right, and a yellow one to the left and back, in parallel with the screen in front of the wall, a device that incorporates the fruits into the space of the picture.

It is the discontinuity of the front edge of the table that has always seemed as puzzling as it is original. It is no more a signature than was his parallel touch; it is a device that serves him when it is useful, but not at other times, and we must look at the complex of forms in each painting where it occurs, or to his perspective, in order to explain its use[355]. Here, Cézanne stands closest to the corner of the table, and sees both edges move into space diagonally, the right one sharply, the left one gently; he preserves the sharp recession in order to create depth, but denies the gentle one in order to have a surface parallel to the canvas plane. Of course it does recede a little, and Cézanne seems to need to represent that as well. His solution is to set the divided part further back. He knew about this device early; he used it, for the same purpose, in the 1880 *Le Pont de Maincy* (p. 116), but there it would have escaped our attention if we did not have the site photograph to show us the actual space. It is a gentle effect, obtrusive only when we insist on mathematical perspective rather than optical balance, but it is one that each viewer should verify; to see how it affects the dynamics of the painting one should block out the displaced line and imagine it elsewhere.

The effect does not appear in a contemporary still life, *Nature morte*, in which Cézanne's view of the corner is the same and the interrupting napkin is of about the same size,

355 - *This is not, as is sometimes thought, a compensation for the so-called Poggendorf illusion, in which a line interrupted diagonally will seem displaced after the interruption. See Arnheim's discussion of the illusion in his* Art and visual perception, *1974, p. 420.*

NATURE MORTE
(R802), ca. 1895,
44 x 61 cm. Private
collection, England.
Volume 1, n° 384.

but where the segment that remains is very small. The still life occupies a shallow space, having been set up with a flat wall at its back, and even its frontal plane seems best left alone. Its dynamics depend rather on the nervous surfaces, awkward curves, and deep cuts in the fruits; the lines move from the lower right toward the upper left by fitful curves and culminate in the ginger jar, where they continue at the expense of simplifying the basket work. The ginger jar handle, the slices of melon, the right edge of the table, and the touches in the wall, all strive to balance this forceful movement. The whole is tense, passionate, even violent; it is also complex in its color, opposing both reds to greens and oranges to blues.

It is difficult to imagine a greater contrast to this still life than *Nature morte aux oignons*, which reduces the color scheme to two muted, secondary colors, and establishes a calm, unconflicted relation among its elements. Only the linear connections of the previous still life are shared with it, and here they become the painting's organizing principle. The canvas is so unlike the image that we hold of a Cézanne still life that we have to search hard for an understanding of its workings. We are on familiar ground when we notice the culminating object, in this case the wine bottle, and a secondary focus, the single onion that the knife points to; and we feel at home with the massed onions and the connection that the tablecloth makes between the upper left corner of the painting and the lower right. But the place of the lacy onion leaves is unfamiliar, and we have to block them from view to see what purpose they serve. When we do that, we find that the ones on the left help pull up the bottle, while the ones on the right pull up the heavy, cascading tablecloth; without them, the table with its onions would be squat and heavy. In fact, then, the still life is as well balanced as any other, with the principal tensions resolved by the ephemeral lines. At the same time the lacy weavings echo the scalloped edge of the table and confirm that this earthy mass can also be decorative.

**NATURE MORTE
AUX OIGNONS** (R803),
ca. 1896-98, 66 x 82 cm.
Musée d'Orsay, Paris.
Volume 1, n° 385.

All these analytic comments risk drawing attention away from the success of all this artifice: the composition appears perfectly natural. We barely notice that the plate is tilted away from the viewer, toward the bottle, rather than opening up toward us; that the knife, beside pointing toward the isolated onion, pulls the mass of the bottle downwards; that the cascading portion of the tablecloth takes up disproportionate room but anchors the painting. The canvas is utterly original, independent of any expectations we might have formed of what a still life by him would look like.

**BOUQUET DE PIVOINES
DANS UN POT VERT**
(R875), ca. 1898, 58 x 66 cm.
Private collection.
Volume 1, n° 386.

We are no more prepared for the quick, self assured lay-in of *Bouquet de pivoines dans un pot vert* than we were for the careful interplay of mass and decoration of the onion still life. The painting is a radial explosion of slim leaves and stems from the squat vase, contained, at its extremes, by the elegant masses of the peony blossoms. Very little in Cézanne's still life work anticipates the graceful sketching of the leaves and their assured, uncluttered placement. It is also remarkable that Cézanne had already decided upon the color scheme, having worked out a violet-tinged, ochre background for the greens of the foliage and vase; with the sprinkling of orange reds we find the colors already balanced between the warm and cool hues. How he would have finished the most sculpted part of the leaf mass in the center is not easy to imagine, because he left no indications for it; but we do have examples of his ability to do it convincingly, in *Nature morte: fleurs dans un vase* (p. 181) and *Pots en terre cuite et fleurs* (p. 186). The asymmetry of the bouquet would have probably been emphasized by extending the leaves to the upper right corner; and the uncertain, blank spot on the left, once he had found the precise hue for it, would probably have pulled the gaze down.

The painting is a happy, exuberant one, with a light center of gravity. With its self-assured composition it achieves as much as would more solemn still lives with a heavier base and a more studied placement of fruits and curtains. Yet those have an indisputable graveness, and by their sheer size and density seem intended to achieve that which we see in them: lasting contributions. One should resist the word "monumental", because it is imprecise and overused; but they are certainly complex and extaordinarily well resolved, splendid testimony to an ability to create physically the rich resonances that, in other circumstances, the painter would have to find already present.

NATURE MORTE AVEC RIDEAU ET PICHET FLEURI (R846), ca. 1899, 55 x 74 cm. Hermitage Museum, St. Petersburg. *Volume 1, n° 388.*

Nature morte avec rideau et pichet fleuri is, however, majestic in spite of its medium size; it is intimate, with a close point of view, its fruits and crockery enclosed in rich folds of fabric. It works by opposing the stark, white pitcher to the dark background, and by reducing the individual fruits - fully thirteen - to three simple groups; it is as dramatic as it is harmonious. Yet it was not conceived all at once; the corner of the table was originally bare and was obscured only later by an added napkin. If we try to imagine the painting in its original state, then the corner does seem too weightless, and the pitcher too heavy; with its crisp blue-white color - much lighter here than in any other still life where it appears - the pitcher was surely meant to dominate the composition, but not overwhelm it. Without the added napkin the still life would have had too light a base, and the rug, although beautifully painted, would have been too heavy; the new napkin gives weight to the lower right corner and moves toward the pitcher as it wraps around the apple that had been the previous anchor. But Cézanne seemed to need to compromise; the composition was at a point where an opaque napkin would have been too dense and too white, so he allowed some of the original transparency to remain. In every other respect the composition was well worked out from the start; the rug leaves no awkward point of contact, being placed well behind the pitcher and tucked well under the plate and the napkin.

Nature morte au vase pique-fleurs is a conservative painting in its colors, ambitious in its intricacy and stately in its grave composition[356]. Most of its hues are warm, with the browns chosen from a narrow range - burnt siena to olive-brown - and the fruits are yellow and orange; only in the two apples are there any spots of red. To this potentially stuffy atmosphere Cézanne adds the indispensable blues and blue-violets, which pop up in the rug and in the areas of white, and achieve an uncomplicated, direct balance.

NATURE MORTE AU VASE PIQUE-FLEURS (R936), ca. 1899, 81 x 101 cm. National Gallery of Art, Washington, DC. *Volume 1, n° 387.*

The size of canvas that Cézanne chose was closely linked, I think, to the composition, as it was in the *Nature morte* of the Introduction (R848, p. 25), although it is impossible to say which choice was made first. Both still lives are about a meter in width, broader by about 8 cm than any other still lives of this decade, and the difference is palpable. In both paintings, had the rug enclosed the whole upper corner, it would have been much too heavy; Cézanne, profiting from the room he had, moved it toward the center and gave the upper left corner space to breathe. The rug now moved up and down diagonally rather than sitting still - and in this painting Cézanne accelerated the movement by splaying it, as he splayed the right edge of the table (if followed in the reverse direction, however, the rug seems to converge on the pitcher). All the objects on the table were then made to lean against the rug: pitcher, vase, napkin,

356 - *Rewald dates it from about 1905, but in its tonalities and slashing outlines it resembles the 1899 portrait of Vollard (p. 63); a date around 1899 seems more likely.*

and all the fruits but one. The exception is the subtle apple behind the white napkin, which bridges the space between the napkin and the pitcher.

POMMES ET ORANGES
(R847), ca. 1899,
74 x 93 cm. Musée
d'Orsay, Paris.
Volume 1, n° 389.

If the *pique-fleurs* still life seems stately, Cézanne's complex and magnificent still life, *Pommes et oranges*, simply breaks new ground. It departs radically from the view of still life as a collection of fruits on a table that lies parallel to the picture plane. It also works out afresh the relationship between a dominant object – here the pitcher – and a background curtain; they are no longer counterpoised, but closely integrated. In *Pommes et oranges* both of the rugs that we know (the geometric one from *Jeune italienne accoudée*, p. 233, and the leafy one from the previous still life) have been placed behind and under the other objects, containing and supporting them rather than offering a backdrop, and the leafy one even builds up to a culminating hump that surmounts the pitcher. The pitcher is made just a bit smaller and becomes more intimately enclosed in the wealth of fruits and folds.

The break with traditional space becomes visible only when one tries to reconstruct the physical arrangement. The fruit is set out horizontally from the viewer's point of view, but the lower edge of the table is on a slant; this can only mean that the table is turned away diagonally, and that Cézanne had arranged the fruit at an angle to it. The rugs obscure the angle, and Cézanne's perspective on the tablecloth, as well as his equal treatment of its horizontal and vertical planes, make it unclear where it drapes over the edge; so we are free to see all that is on the table as horizontal. This helps explain why Cézanne needed so many fabrics: they confuse the space, allowing the horizontal reading of the fruit, but also reveal enough so that we can decipher the space if we care to. The effect seems to me a little like a high-wire act: there is a strong risk of balance being lost, but it is always restored.

Not all is clear to me in the painting – the bluish oval at the left, for example, half-obscured by the fold of cloth, is indecipherable – and some things become clear only with time: the red oval in the lower left is not an object but a swirl in the pattern of the geometrical rug, and it is identified easily in *Trois crânes sur un tapis d'orient* (p. 248) and other paintings. Some of the devices that make the composition work as well as it does are applied subtly: the exact center of the canvas holds the largest apple, and the flower on the pitcher is made a firm purple, like the apple below it (against its blue, pink, or lavender color in other still lives). But above all there is a hospitable, ruddy glow here, balanced gently by greens and grey-blues, a happy congestion of opulent spheres, and a richness of contrasts between the masculine straight lines and

LA GROSSE POIRE
(R842), ca. 1900,
45 x 55 cm.
Barnes Foundation,
Merion, PA.
Volume 1, n° 390.

the feminine oval folds. There is the risk of making the cool reds of the apples clash with the warm reds of the oranges, which Cézanne avoids by assimilating both colors to the dark orange-reds of the geometric rug. He also cools down the ruddy warmth with grey-blues in the tablecloth and grey-greens in the leafy rug, and this is so fine a balance that it is easily upset by the slightest exaggeration in the colors of the reproduction. This is a painting that unites craft with originality in a splendid synthesis, and perhaps the best example of how we might imagine the intimate connections between things to be.

For all its innovations in composition, *Pommes et oranges* is conservative in its touch. A smaller painting such as *La Grosse poire* is more radical, with Cézanne using a rougher touch, bringing out simple oppositions of color, and experimenting with odd arrangements. Because it uses the kind of liquid pigment that we saw in landscapes and portraits of

the turn of the century, it should be dated around 1900 or later. It is its color use that strikes one first: the use of the cobalt from the rim of the plate in the outlines of the fruits and in the shadows they cast. It is as if the whole lower half of the canvas had been conceived in terms of color opposition, of the cool blues against the browns, oranges and yellows, and that opposition is what I always return to, even when I am inevitably distracted by the powerful florid design in the background screen. The design destabilizes the composition; although flat, it is portrayed as voluminous and made to occupy the same deep space as the fruit, and produces a seeming explosion above the perfectly calm apples and peaches. The lines pointing to the upper left balance the right edge of the table, of course, while one of the leaves parallels it, so the composition is resolved and restabilized, but in adding these movements and complexities, Cézanne has once again played with the limits of the still life (as he did, less audaciously, in the 1877 *Le Plat de pommes*, p. 98).

LE VASE FLEURI
(R892), ca. 1896-98,
70 x 57 cm.
Barnes Foundation,
Merion, PA.
Volume 1, n° 391.

Color is almost the entire subject of the radical *Le Vase fleuri*, a painting in which Cézanne dispenses with outlines, at least in the center, and emphasizes the immediate contrasts between his yellow, red, and pink chrysanthemums. It is a risky undertaking; it creates a ball of fire that is hard to contain, and I am not persuaded that he has contained it. Vivid greens give him the much needed complementaries, and a patch of blue gives him the one cool hue, but the effect is one of an ongoing rather than a resolved struggle. Cézanne also made a forceful attempt to simplify the pattern by aligning the straight, diagonal lines in the geometric rug with a few stems in the leafy one, and then carrying that diagonal to the fold of rug around the base of the pitcher; this, too, works well as far as it goes, but does not subdue the ball of chrysanthemums. However, the originality of his technique, and the courage of his undertaking, cannot be denied; nor can the beautiful painting in the vertical cone of rug on the right. Having said all that, I do feel closer to his apparent intention, and to some details of his execution, than to the painting as a whole.

By reading art books and visiting museums, we have formed an image of still lives as pictures containing pleasant images of food, fruit, flowers and vases, all set upon a table with perhaps a decorative tablecloth. Most still lives may be like that, but there is no rule about what a painter may put into them. Cézanne, normally conservative in his choice of subjects, combined onions with paintings of onions in one painting (p. 242) to address a question about the nature of illusion, and in four still lives of skulls painted between about 1898 and 1904, spoke to our common concern with death. Two of the pictures are ascetic – mere arrangements of three or four skulls – and appeal more to thought than to the senses, another is on the contrary sensuous both in color and form, and the fourth places a single skull next to an expectable candlestick. With the exception of the last, which is prosaic, Cézanne seems to have addressed two questions: the purely pictorial one of arranging the skulls to make an interesting composition, and the deeper one of giving the subject meaning through form.

Given Cézanne's consummate skill in portraying the nuances of surfaces, even a simple array of skulls next to each other on a brown tabletop, facing the same way, is an aesthetic experience: the crania, presenting an even greater challenge than apples – having little color of their own – can be modeled with even closer attention, changing hue as the light passes over them and showing every change of plane with utmost clarity. Visible differences in the skulls' color, shape, and above all in the character of the orbital socket, can be amplified – and the painter will have brought us into a world where each skull stands for the person whose mind it had contained. Cézanne painted

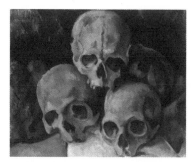

PYRAMIDE DE CRÂNES
(R822), ca. 1898–1900,
39 x 47 cm.
Private collection.
Volume 1, n° 393.

two such arrays, one of three skulls in a row and the other of four arranged in a pyramid. The pyramidal construction is the more elaborate and more symbolic. The skulls are not on display, as in the version where they sit as if on a shelf, but are piled on top of each other as if in an ossuary; the difference in meaning is palpable. If we imagine them in an ossuary, then they appear neglected and forgotten; they seem to bear witness to some unnamable fate. One of them dominates the grouping, standing erect, endowed with an impossible vertical fontanelle and pushing another skull out of the way. Their eye sockets are very different from each other and seem to express a state of mind - one skull seems puzzled, another pleading, the third naïve. Cézanne obviously had more than one skull to paint from, but not enough to create the six or so different expressions of eye sockets that we see in the various paintings and watercolors; there is no evidence that he had more than three[357]. The picture's meaning was, for once, neither inherent in the subject nor purely visual; the expressions were added so that the skulls might seem to speak to us. The implicit boundary which allows us to look without being seen is broken.

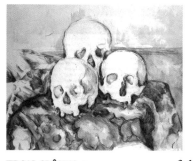

TROIS CRÂNES (RW611),
ca. 1904, 48 x 63 cm.
Art Institute of Chicago.
Volume 1, n° 392.

Several years later, in a different style, he broke the boundary again, but placed the three skulls on one of the familiar rugs and distracted us with a sensuous display. The base chosen for the pyramid is the flowered border of the rug rather than its geometric center, and the skulls now sit on top of an opulent row of swirls and blood-red blossoms, as if to contrast their desiccation with the life below. But this contrast may not have been Cézanne's first intention; in a watercolor study of the same arrangement (*Trois crânes*) the skulls were connected to the flowers by line, with the irregular teeth corresponding to the wavy outlines of the flowers. Cézanne made the most of this connection, of course, using a wobbly touch to give the entire watercolor a tremulous intensity. To carry the same conception into the oil version (*Trois crânes sur un tapis d'orient*), would have been difficult technically; the opaque pigment works by depicting surface literally rather than suggesting it through outline and withheld space. In rethinking the composition for the version in oil, Cézanne pulled back a little to reintroduce the very edge of the rug, which brought in a triangular mass that supports the pyramid and calls attention to the dome of the central skull; that skull is now white, large and pointed. The painting becomes closely woven and architectural, but, paradoxically, rather than taking attention away from the skulls, it gives them greater prominence. They are no longer a part of a linear pattern, no longer vacant in expression or chalky in texture, but actors in their own right. Cézanne points two of them straight at the viewer and gives them each an expression which is different again from all the other skulls; they look directly at him with - a reproach? a reminder of his own destiny? a plea not to be forgotten? We do not know; but we also cannot dismiss them or avoid their gaze.

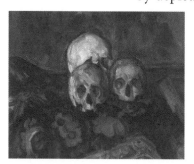

**TROIS CRÂNES SUR
UN TAPIS D'ORIENT**
(R824), ca. 1904, 55 x 65 cm.
Kunstmuseum, Solothurn.
Volume 1, n° 394.

Cézanne has reached deeply into himself, deeper than even with the other skull paintings, and brought us with him into the space of the painting. The transgressed boundary reminds us of some of his early narrative paintings, where he stepped out of the role of painter and put himself directly into the picture as an actor; but here we are the ones who are too closely engaged. The painting obviously absorbed him intensely; Bernard saw him working on it during the whole month that he spent in Aix, and reported that the colors and forms changed daily although it looked finished at

357 - Borély in Doran, Conversations, *p. 22.*

every point[358]. Its surface betrays the assiduous labor, especially at the edges of the skulls and inside the eye sockets; there, it is built up from repeated applications of thin paint as Cézanne works out the right distance between the skulls and elaborates their expressions. Its texture is closest to that of *Le Marin* above, and I think we may take this as revealing the same psychological stance: a direct and intimate projection of a coming to terms with mortality.

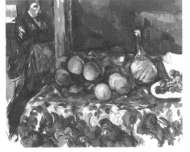

**PÊCHES, CARAFE
ET PERSONNAGE**
(R.843), ca. 1900, 60 x 73 cm.
Stiftung Langmatt Sidney
and Jenny Brown, Baden.
Volume 1, n° 395.

Both *Le Marin* and the still life are exceptional in taking this as their subject; Cézanne was not done with life. They are preceded and followed by happier subjects and more vigorous styles, and, to judge by one exceptional still life, by restless experimentation. In *Pêches, carafe et personnage*, which was done earlier, he seems to have set up his easel next to a dinner table still laden with after-dinner fruit, as Manet or Fantin-Latour might have done, and created a still life that suggests a time and a place much more literally than usual. And he seems to have placed a person in an adjacent room, at about the same height as the painter, standing up and addressing someone. This certainly seems unlike Cézanne; and as one looks, the tablecloth turns out to be the rug of the previous painting and other still lives, so we are looking not at a dinner table but at a still life. If that is so, the personage cannot be in another room, because he is standing behind an image of the same rug. This is possible only if the scene is reflected in a mirror, which in turn means that the painter is looking at a reflection himself. I can think of no alternative to this reading, but I am fully aware that at least one of the planes of the reflected rug is angled impossibly. Still, it is easier to imagine Cézanne setting up a composition with a mirror than seeing another person in an adjacent room, and one can see him using the reflection to balance and restrain the left-leaning carafe. The painting is lively and brilliant, with Cézanne's late, liquid touch and firm outlines, and it offers us a rhythm of spheres and circles concentrated on the plate of peaches – a point of respite between the dynamics of the left and right sides.

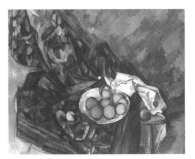

**NATURE MORTE :
RIDEAU À FLEURS ET
FRUITS** (R.935),
ca. 1904-06, 73 x 92 cm.
Private collection.
Volume 1, n° 396.

No late painting of Cézanne's offers so forceful an arrangement of forms, so uninhibited and aggressive an intersection of diagonals, as the later *Nature morte: rideau à fleurs et fruits.* Here we see little solid space and few palpable objects, and experience no support from reliable tables and walls. The curtain and the rug flow into one form: on the left their edges almost become one, and they are seen from the front, with almost no indication of where the vertical surfaces turn to horizontal ones. They have been made flat; we see their designs as geometry rather than as material, woven fibers, and the painting as an abstract pattern rather than a view of real things. Although the right edge of the table leads us back into space, the sharply tilted plate – which looks even more tilted when compared with the table edge – tips the apparent surface of the rug back up toward the vertical. The plate of fruit is surely meant to offer us relief from the turbulence: lines lead from it vertically through the wine glass to the fold in the curtain, and horizontally along the edge of the table, where it is supported visually by the pattern of the rug underneath. Together these objects give us a set of normal coordinates, but as much as they help, and as askew as the painting would be without them, they master only part of the turmoil. The painting remains a tense assemblage of triangles and parallelograms, or better put, an arena of unresolved conflict between a vertiginous space and a few well settled fruits. And it is a canvas of incisive outlines, uncompromising touches, saturated colors, and frank contrasts.

358 - *In Doran,* Conversations, *p. 58.*

The painting exemplifies all the self-assurance of a vigorous painter who is setting out in a new direction. There were no other still lives like this one, however; and in view of how little we know about the exact dates of his paintings, or even their order, it is difficult to suggest why. If this were his last still life or close to it, one might think that he simply died before he could go on; but we do not know this. The other paintings that resemble it in style, *Le Mont Sainte-Victoire vu des Lauves* (p. 224), *Château Noir* (p. 219), and *Portrait de paysan* (p. 239), are also uncertain in date; they may or may not have been done in his final year, but each seems to have been followed by paintings done in yet another style (*Le Cabanon de Jourdan*, p. 228, and *Le Jardinier Vallier*, p. 239). If the last landscapes and portraits were done in different styles and moved in more than one direction, then we cannot assume that the development of his still lives would have been any simpler; what his death interrupted was not one incipient style, then, but tireless invention.

The watercolor still lives of his last years are equally inventive and accomplished; they would justify his fame by themselves if they could be more easily displayed, that is, if their fragile pigments did not require them to be covered most of the time and then displayed only in dim light. As with the paintings, although we can reliably call a watercolor "late", that is, done after about 1900, no progression leaps to the eyes; even the one that is thought to date from 1906 does not look very different from the others[359]. All are composed of transparent, superimposed patches of pigment, and all are handled with an exquisitely free but economical touch. But if there is no clear progression, there are three discrete ways of using the medium that can be distinguished.

NATURE MORTE AVEC GRENADES, CARAFE, SUCRIER, BOUTEILLE ET PASTÈQUE (RW562), ca. 1900-06, 30 x 40 cm. Private collection, Switzerland. *Volume 1, n° 398.*

One manner of conceiving a still life is to emphasize the progression of objects in depth. This is best done by remaining close to local colors and modeling the objects predominantly with those colors themselves. In *Nature morte avec grenades, carafe, sucrier, bouteille et pastèque*, for example, each object is recognizable by its usual hue, and the hue distinguishes it from others; even the green of the bottle is different from the green of the watermelon. Cooler hues are used for modeling, that is, blues model the white objects and the watermelon, while cool reds model the pomegranates. The hues distinguish the objects more than uniting them; very few colors, in other words, are borrowed abstractly between neighboring objects. Here, only the warm browns (apart from the ubiquitous blues) find their way across the sheet, but they do so because in all but a few spots the browns are in fact local, not because they need to establish an abstract rhythm. Except for the wine bottle, the result is a solid, opaque, three-dimensional array of spherical forms, and, as if to underscore his intent, Cézanne has even let the glass carafe appear opaque (the same carafe as in *Pêches, carafe et personnage* above). It now stands firmly in front of the others.

Quite the opposite happens in *Bouteille, carafe, cruche et citrons*, where the space is built up from the back to the front, as it were. The wall is the most solid object here, and I suspect that the decision to make it so, or the accident of beginning with it, constrained the rest of Cézanne's procedure. The pitcher and two of the three lemons take their color from the white of the paper, and as natural as that may seem in order to contrast them with the dark ground, it is also done without modeling; looking back on the sugar bowl in the pomegranate still life, we can see that modeling would have been possible here as well. Nor is the bottle in the upper left modeled much; it simply stands in front of the wall. The pitcher is outlined in repetitive touches, which I think was necessary so that it would not seem a mere cutout, and in this way it hovers a bit in space. In view of these decisions,

359 - *La Bouteille de cognac; see Rewald,* Paul Cézanne: The Watercolors, *p. 258.*

BOUTEILLE, CARAFE, CRUCHE ET CITRONS
(RW614), ca. 1902-06, 44 x 58 cm. Thyssen-Bornemisza Collection, Lugano-Castagnola.
Volume 1, n° 399.

NATURE MORTE AVEC PASTÈQUE ENTAMÉE (RW564), ca. 1900, 32 x 48 cm. Ernst Beyeler, Basel.
Volume 1, n° 397.

it is puzzling that the carafe should have been done with such close attention to the way it refracts the table and tray; it is, in other words, not merely transparent, but also as solid as a glass sphere.

The distinction I am making is in Cézanne's procedure, not in the quality of the result. It is impossible for me to say which gives the greater pleasure or seems the greater work. What is notable is Cézanne's absence of formula or habitual gesture; and perhaps equally significant is his sheer sense of the medium's possibilities for constructing space and making objects inhabit it as if they had always been there.

The splendid *Nature morte avec pastèque entamée* is painted with yet a third system; it is neither built from back to front nor from front to back. The background is painted with the same touch and the same weight as the figures in front of it, giving the sheet an equal density throughout; and although we know unambiguously where each objects stands - it is enough for it to overlap another - we are less aware of the space taken up than of the rhythm of distributed forms and colors. The reds are scattered in four nearly equidistant patches, and the greens and yellows are dispersed as independent spots rather than as coherent surfaces. Even the yellows and greens in the skin of the watermelon look like separate pigments rather than modelings from light to dark. With the white of the paper a full partner in the process, the watercolor is allusive and rhythmical, and Cézanne has stopped - so our sensibility tells us today - at just the right moment.

I take Cézanne's mastery of the medium so much for granted that the only question that I ask about the watercolors is whether he had found the right stopping point. The greatest works in the medium, I think, resemble these three; by only suggesting their objects, they call attention to the process of painting and to the artist's vision. Some of his most finished and largest watercolors are, on the contrary, too dense in pigment and too solid in appearance, and present their subjects as statements rather than as intimations; visually they seem to me too close to the oil paintings. Because those sheets are among his largest, his intent may have been more formal in the first place, and his stopping point would naturally come later in the process; but the point reached with *Nature morte avec pastèque entamée* seems to me perfectly placed between a bare awareness of intent and a fully formed declaration. Looking at it, we hover between completing the incomplete visually and accepting it as such, for its revelations about things and the way we see them ■

Epilogue

No pithy phrase, no concise summary, can hope to do justice to Cézanne's work without reducing it to something less than it is. There is in his work no singular style, no persistent subject-matter, no one way of translating sensation into paint, no single aesthetic program – none so simple, that is, as to describe in a word. Even his place in the history of painting resists easy generalization; one cannot assign him a brief title, for example – a natural enough practice when putting on an exhibit of his work – without distorting his significance. The well-intentioned expression "father of modern art" is especially reductive and not a little patronizing: Cézanne's work was the splendid thing that it was, not a precursor of something greater, nor even a direct precursor of what did in fact follow[360]. But while it made sense in this book to present Cézanne in his full complexity and remain close to what is most alive about him – the structure of the paintings, the intensity of our response, and the choices and dilemmas apparent in the process – I may also reasonably be asked to pull the material together.

Paradoxically, it is the independent direction of the painters who followed him – that is, their movement away from the essence of his contribution while responding to aspects he would have considered trivial – that best clarifies the sense and direction of his work. By asking what the history of painting at the beginning of the twentieth century might have been like had his influence been what he had hoped, had the young painters in fact followed him as "the primitive of the way he had found"[361], we can remind ourselves of what was central to him. One way to think about the matter is to ask where Cézanne himself might have gone next if he had had another five years to live; might his evolution have led him toward greater abstraction, for example, or toward a more arbitrary use of color, toward reliance on conception rather than vision, as it did those who came immediately after? Whatever the answer – or rather whatever its details – how might his development have influenced the immediate future if he had had faithful students rather than distant admirers?

In thinking about the direction his own painting might have taken, we should look both at its general character and at a few late works exceptional in the freedom of their touch. Certainly the general character of his late style was variable; we have seen that, since the style remained at the service of his visual response rather than a conceptual aesthetic, it was bent to the requirements of each subject. This is not to say that we

360 - *A recent exhibit of paintings done by other painters during the first ten years after Cézanne's death brings home vividly just how complex the new painters' response to him was. See the catalog,* Cézanne and the Dawn of Modern Art. Museum, Museum Folkwang, Essen, *September 18, 2004 to January 16, 2005, published by Hatje Kantz in 2004.*
361 - *Said to Bernard, in Doran,* Conversations, *p. 73.*

cannot recognize a painting as a "late Cézanne" immediately, but that there are several things that the lateness may mean: a surface assembled from patches, either overlapping or flat ones, or on the contrary a continuous surface, overworked and granular; a figure treated as volume or on the contrary as delicate, reserved space; bathers as abstractions or on the contrary as participants in a narrative; and so on. In the most general sense, he would surely have remained as responsive to his vision, and therefore as variable in his stylistic response, as before.

But there are three late paintings whose style leaps ahead of the others and which, variability aside, might have served as models for future work. Among landscapes, there is *Le Mont Sainte-Victoire vu des Lauves* (R932, p. 224), among portraits *Portrait de paysan* (R943, p. 239), and among still lives *Nature morte: rideau à fleurs et fruits* (R935, p. 249). In each, Cézanne has stepped beyond an earlier self-imposed boundary: he has now made the outlines more jagged and the color patches more independent, and he has detached the parts from each other more completely before joining them up again. His fundamental aim has not changed – to reconstruct the subject, to achieve the reconstruction through color, and to create a color balance that will constitute our ultimate emotional satisfaction – and I cannot imagine its ever changing; but his way of achieving it in these paintings is sharper, more incisive, more sensuous in the forceful relations of color than in any qualities of the subject. It seems to me a significant step further, and had he lived on, I think that his style would have continued to develop in the direction of these three paintings: using more abstract, detached means for achieving the same representational and expressive ends.

Nor can I imagine Cézanne conceiving of the development of painting by any potential followers in any other terms. If we assume that the new way of which he was *le primitif* would be a perfected manner of doing what he felt he could not quite bring off[362] – and this is surely one of his meanings, because the whole quote reads, *"I am too old; I haven't known how to realize my goals and I won't do so now. I remain the primitive of the way I have found"* – then, had painters continued in his footsteps, the developments to follow would have retained the intimate union of color and form.

The opposite occurred in fact. Picasso in 1906, Derain in 1912, and Matisse in 1918, did self-portraits with a palette which, although paying homage to the subject of *Portrait de l'artiste à la palette* (R670, p. 167), did not honor the union of color and form; they were simply done in the painters' own style[363]. Derain and Vlaminck painted several landscapes that look quite Cézannian - for example, *View of Cagnes* (1910), *Undergrowth and Rocks at Sausset-les-Pins* (1913) by Derain, and *Riverbank of the Seine* (1909) by Vlaminck[364] - but they, too, are closer to Cézanne in subject or mood than in the fundamentals of his technique. Among those who literally followed in Cézanne's footsteps in l'Estaque itself, Braque, although trying to use a rough version of Cézanne's touch and color for a short while, soon abandoned the motif for the studio[365]; and the Fauves, discovering new colors and color sequences, even before Cézanne's death gave up the visual model for a more intellectual kind of painting[366]. Art that claimed descent from him in fact gave up observation, separated color from form, and went off in a more cerebral direction[367].

362 - *To Rivière and Schnerb, he also used the term primitif to mean "undisciplined", in the context of explaining why he had left his bottles tilted, but that is a colloquial, self-deprecating use.* Conversations, *p. 87.*
363 - *In* Cézanne and the Dawn of Modern Art, *pp. 17-19.*
364 - *In* Cézanne and the Dawn of Modern Art, *pp. 134, 129, and 119.*
365 - *William Rubin, "Cézannisme and the Beginnings of Cubism," p. 161.*
366 - *John Golding,* Cubism: A History and Analysis: 1907-14, *p. 64.*
367 - *Admittedly, Derain painted a view of a farmhouse (*Landscape near Cagnes, *1910, reproduced in* Cézanne and the Dawn of Modern Art, *p. 121) that bears a striking resemblance in brushtroke and conception of space to Cézanne's* La maison de Bellevue *(R691);*

If the art that followed was not what Cézanne had foreseen or wished, we must ask whether painting might have followed a different course if he had had a few devoted students. I think that to this there is a clear answer: it would have made little difference. A mode of painting that is the fruit of all the complexities of an individual's development, and of all the attempts to resolve his contradictions, is almost destined to remain individual. If it is as finely balanced between the eye and the mind, as attached to passion and order equally, and as dependent on an acute sensitivity to color and formal balance as was Cézanne's art, it can perhaps be imitated, but it cannot serve as the basis for a new school. Nor would having imitators have fulfilled Cézanne's hopes: the imitator, like Derain in the paintings where he is very close to Cézanne, is sentenced to a minor role, always known for what is Cézannian in his work rather than for what is his own. No one can speak for Cézanne, but I would suggest that although he would have disliked his progeny, he was lucky that they were who they were. Having at first taken one or another trait from the master, with questionable success, the best ones developed into great painters in their own manner, owing a debt to Cézanne that is so distant that he would not have recognized it. The paradox of a great painter's legacy is that the closer he is followed, the more mechanical and technical are his achievements made to seem.

If Cézanne is a painter altogether distinct from the movements he inspired, to define him we are forced to return to the particular configuration of wishes, frustrations, talents, and discoveries that had formed him. His development seems like a series of resolutions of internal contradictions, in part through the discipline of observation, in part through the restraints of the styles he had developed. His earliest works swung between piety and robust rebellion, but, when they could rely on vision, managed to avoid both extremes and become original; even in the best works of the *couillard* phase the impassioned touch would be restrained by vision. In his mid-thirties, having mastered observation as a kind of discipline from Pissarro, he needed again to turn away from a mere reliance on it and return to the idea of tradition and solidness[368]; this meant giving up atmospheric effects. By about forty, he had found a style - the parallel touch - that imposed a tight structure on narrative paintings, and by degrees learned to use it to extract the structure and rhythm of real things. But this style, too, eventually contradicted his visual sensitivity, and he soon abandoned the touch in portraits and relaxed it in landscapes.

A brief but difficult period followed, with paintings drained of passion, but three or four years later, by the age of fifty, he emerged again as a fully formed and vigorous painter, a painter secure and flexible in his touch, balanced finely between his closely focused vision and his thoughtful, inquiring, logical mind, and making incalculable contributions to landscapes, portraits, and still lives, and some notable ones to narrative paintings. It is at this stage that it is tempting to speak of a satisfactory resolution of his paradoxes, and were there not yet a greater phase to follow, this would be a reasonable formulation. It is certain that by the age of fifty he had found what styles he needed - the plural is required - to paint all that he had chosen to paint, and to let his visual response to individual subjects, and often his emotional response, bend each style as needed. But his last decade, almost inexplicably yet more original, revealed what had remained unresolved yet achieved a higher synthesis: the unfulfilled, original wish to paint like the Venetians was displaced into intense color, new color relationships, and a secure yet loose, liquid

even the touches of blue sky on the cream canvas are strictly Cézannian. But, paradoxically, the closer his paintings approached Cézanne's, the more derivative and insubstantial they came to seem. Only Matisse managed, on two occasions known to me, to unite Cézanne's color use - a purple/green harmony for flesh tones - with his own touch, lighting, and sensitivity to the human figure; the results, Standing Model (1900-01) *and* Model (1901), *reproduced on pp. 63 and 66 of* Cézanne and the Dawn of Modern Art, *are powerful and original.*
368 - "Something solid and enduring like the art of museums". Cited by Maurice Denis, in Conversations, *p. 170.*

touch. In this formal way – but not only formal, for there were new depths of feeling revealed in his portraits and still lives – he ultimately conveyed the very passion that he saw, and envied, in their paintings.

The effort to resolve the various oppositions is visible only when we follow his whole development; the single work either succeeds, or in very few cases fails, and we see it as a single entity, as the object to analyze or admire, as the thing to possess or more likely to travel to see. That is as it should be; the painter makes paintings, not his autobiography. It is all the more remarkable that Denis, close to him physically and in time, should be able to see as much of Cézanne's essence as he did:

> *"The artist, as complex as his time and whom we are trying to explain, has found in this method both his equilibrium, the profound unity of his efforts, and the solution of his paradoxes. It is moving to see a canvas by Cézanne, most often unfinished, scraped with the knife, overloaded with diluted touches, repainted several times, encrusted until it becomes a relief. In this labor we glimpse the struggle for style and the passion for nature; the acceptance of certain classical formulas and the revolt of an untrammeled sensibility; reason and inexperience, the need for harmony and the fever of original expression."*[369] ■

369 - *In Doran*, Conversations, *p. 174.*

References

Previous pages : the great trees at the Jas de Bouffan (site),
see volume 1, illustration 175, photo John Rewald, ca. 1935.

2 5 8 ●

Adriani, Goetz, *Cézanne's Paintings*, New York, Abrams, 1993.

Andersen, Wayne, *The Youth of Cézanne and Zola*. Geneva and Boston: Editions Fabriart, 2003.

Armstrong, Carol, *Cezanne in the studio*, Los Angeles, The J. Paul Getty Museum. 2004.

Arnheim, Rudolf, *Art and Visual Perception*, 2nd edition, Berkeley: University of California Press, 1974.

Athanassoglou-Kallmyer, Nina, "An artistic and political manifesto for Cézanne", *The Art Bulletin*, 1990, vol. 62, pp. 482-492.

Ballas, Guila, *Cézanne: Baigneuses et baigneurs*, Paris: Société nouvelle Adam Biro, 2002.

Brettell, Richard R. *Pissarro and Pontoise*, New Haven and London, Yale University Press, 1990.

Cachin, Françoise, Isabelle Cahn, Walter Feilchenfeldt, Henri Loyrette, and Joseph J. Rishel, *Cézanne*, New York: Abrams, 1996.

Cézanne, catalog of an exhibit, published by The Tokyo Shimbun, 1986.

Cézanne: Finished - Unfinished, catalogue of exhibition at the Kunstforum, Vienna and Kunsthaus, Zurich; Ostfilden-Ruit: Hatje Cantz, 2000.

Cézanne and the Dawn of Modern Art, catalog of an exhibit at the Museum Folkwang, Essen, September 18, 2004 to January 16, 2005; Germany: Hatje Kantz, 2004.

Chappuis, Adrien, *The Drawings of Paul Cézanne*, Greenwich, Connecticut: The New York Graphic Society, Ltd., 1973.

Coutagne, Denis, *Les Sites cézanniens*, Paris, La Réunion des Musées Nationaux, 1996.

Cranshaw, Roger & Lewis, Adrian, "Willful ineptitude", *Art History*, 1989, vol. 12, pp. 129-135.

Doran, P. M., *Conversations avec Cézanne*, Paris: Macula, 1978. In translation: Doran, Michael, *Conversations with Cézanne*, Berkeley: University of California Press, 2001.

Feilchenfeldt, Walter, "Doctor Gachet - Friend of Cézanne and Van Gogh", IFAR Journal, 1999, vol. 2, No. 3, pp. 8-11.

Feilchenfeldt Walter, *By Appointment Only*, London: Thames & Hudson, 2005.

Fry, Roger, "Le Développement de Cézanne" *L'Amour de l'art*, 1926, pp. 389-418.

Fry, Roger, Cézanne: *A Study of his Development*, Chicago: University of Chicago Press, 1989.

Gasquet, Joachim, *Cézanne*, Paris: Les Editions Bernheim-Jeune, 1921.

Gay, Peter, *Art and Act*, New York: Norton, 1991.

Gedo, Mary, *Picasso: Art as Autobiography*, Chicago: University of Chicago Press, 1980.

Gedo, Mary, (ed.), *Psychoanalytic Perspectives on Art*, Hillsdale, New Jersey: Lawrence Erlbaum Associates, 1985.

Geffroy, Gustave, "Claude Monet, sa vie, son temps, son oeuvre," extract in P. M. Doran, *Conversations avec Cézanne*, Paris: Macula, 1978.

Golding, John, *Cubism: A History and Analysis: 1907-14*, London: Faber and Faber, 1968.

Gombrich, Ernst, "The mask and the face: the perception of physiognomic likeness in life and in art," in Hochberg, Julian, Gombrich, Ernst, and Black, Max, *Art, Perception, and Reality*, Baltimore: The Johns Hopkins University Press, 1972.

Gowing, Lawrence, "Notes on the development of Cézanne", *The Burlington Magazine*, 1956, vol. 98, pp. 185-192.

Gowing, Lawrence, "The Logic of Organized Sensations," in William Rubin (ed.), Cézanne: *The Late Work*, New York: The Museum of Modern Art, 1997. Reprinted as *Cézanne: la logique des sensations organisées*, Paris: Macula, 1992.

Gowing, Lawrence, ed., *Cézanne: The Early Years*, London: Royal Academy of Arts, 1988.

Great French Paintings from The Barnes Foundation, New York: Knopf, 1995.

House, John, "Cézanne and Poussin: Myth and History," in Kendall, Richard, *Cézanne & Poussin: A Symposium*, pp. 129-149.

Harvey, Benjamin, "Cézanne and Zola: a reassessment of 'L'Eternel féminin'," *Burlington Magazine, 1998*, vol. 140, 312-318.

Kendall, Richard, *Cézanne and Poussin: A Symposium*, Sheffield: Sheffield Academic Press, 1993.

Krumrine, Mary Louise, *Paul Cézanne: The Bathers*, London: Thames and Hudson, 1989.

Lewis, Mary Tompkins, *Cézanne's Early Imagery*, Berkeley: University of California Press, 1989.

Lewis, Mary Tompkins, *Cézanne*, London: Phaedon, 2000.

Loran, Erle, *Cézanne's composition*, Berkeley, University of California Press, 1985.

Machotka, Pavel, *Cézanne: Landscape into Art*, New Haven and London: Yale University Press, 1996.

Machotka, Pavel, *Style and Psyche: The Art of Lundy Siegriest and Terry St. John*, Hampton Press, Cresskill, NJ, 1999.

Machotka, Pavel, Denis Coutagne, and Louis Frey, "*Rochers à Bibémus* and *La Sainte-Victoire, environs de Gardanne*," in Année Cézannienne, 1999, No. 1, pp. 25-28.

Machotka, Pavel, *Paul Cézanne: Les Sites provençaux*, Marseille: Editions Crès, 2005. (English edition, 2006, titled *On site with Paul Cézanne in Provence*.)

The New Painting: Impressionism 1874–1886, The Fine Arts Museums of San Francisco, 1986.

Novotny, Fritz, *Cézanne und das Ende der wissenchaftlichen Perspektive*, Vienna: Anton Schroll, 1938.

Pemberton, Christopher (transl.); *Joachim Gasquet's Cézanne*, London: Thames and Hudson, p. 270. 1991.

Platzman, Steven, *Cézanne: The Self-portraits*, London: Thames and Hudson, 2001.

Pope-Hennessy, John, *The Piero della Francesca Trail*, New York: The Little Bookroom, 1991

Prati, Xavier, *L'Estaque au temps des peintres*, L'Estaque: Association Collège-Quartier, 1985.

Ratcliffe, Robert, *Cézanne's working methods and their theoretical background*, unpublished PhD thesis, University of London, 1960.

Reidemeister, Leopold, *Auf den Spuren de Maler der Ile de France*. Berlin: Propylëan Verlag, 1963.

Reff, Theodore, " Cézanne's Dream of Hannibal," *The Art Bulletin*, Vo. 45, 1963, pp. 148-52.

Reff, Theodore, " Cézanne, Flaubert, St. Anthony, and the Queen of Sheba " *Art Bulletin*, June 1962, vol. 44, pp. 113-125.

Reff, Theodore, " Cézanne's Bather with Outstretched Arms," *Gazette des Beaux-Arts*, 1962, vol. 59, 173-190.

Reff, Theodore, " Painting and Theory in the Final Decade," in William Rubin (ed.), *Cézanne: The Late Work*, New York: The Museum of Modern Art, 1997, pp. 13-53.

Rewald, John, "Cézanne and his father," in *Studies in the History of Art*, Washington, D.C.: National Gallery of Art, 1971-72, pp. 38-62.

Rewald, John, *Cézanne et Zola*, Paris: Sedrowski, 1936.

Rewald, John, *History of Impressionism*, 4th edition, 1973. New York: Museum of Modern Art,

Rewald, John, "The Last Motifs at Aix," in William Rubin, (ed.), *Cézanne: The Late Work*, New York: The Museum of Modern Art, 1997, pp. 83-106.

Rewald, John, *Cézanne: Correspondance*, Paris: Grasset, 1978.

Rewald, John, *Paul Cézanne: The watercolors*, Boston: Little, Brown and Company, 1983.

Rewald, John, *Cézanne: Letters*, New York: Hacker, 1984.

Rewald, John, *Cézanne*, New York: Harry N. Abrams, 1986.

Rewald, John, Preface to *Joachim Gasquet's Cézanne*, London: Thames and Hudson, 1991.

Rewald, John, *The Paintings of Paul Cézanne*, New York: Abrams, 1996.

Rishel, Joseph J., "The Card Players," in *Great French paintings from the Barnes Foundation*, New York: Afred A. Knopf, 1995, pp. 122-127.

Rubin, William, "Cézannisme and the beginning of Cubism," in his *Cézanne: The Late Work* New York: The Museum of Modern Art, 1997, pp. 151-202.

Rubin, William, *Picasso and Braque: Pioneering Cubism*, New York: Museum of Modern Art, 1989.

Schapiro, Meyer , "The apples of Cézanne: an essay on the meaning of still life," in Schapiro, *Modern Art: 19th and 20th Centuries*, New York: Braziller, 1978.

Schapiro, Meyer, *Paul Cézanne, London*: Thames and Hudson Ltd, 1988 (first published in 1962)

Sheon, Aaron, *Monticelli: His Contemporaries, His Influence*, Pittsburgh: Museum of Art, Carnegie Institute, 1978.

Shiff, Richard, *Cézanne and the End of Impressionism*, Chicago, University of Chicago Press, 1984

Shiff, Richard, introduction to *Joachim Gasquet's Cézanne*, London: Thames and Hudson, 1991.

Shiff, Richard, review of John Rewald in collaboration with Walter Feilchenfeldt and Jayne Warman, *The Paintings of Paul Cézanne in Art Bulletin*, Vol. LXXX, No. 2, 1998.

Smith, Paul, *Interpreting Cézanne*, London: Tate Publishing, 1996.

Stokes, Adrian, *Cézanne*, New York: Pitman Pub. Corp., 1950.

Verdi, Richard, *Cézanne*, London: Thames and Hudson, 1992.

Vollard, Ambroise, *Paul Cézanne*, Paris Crès 1919.

White, Christopher, *Peter Paul Rubens: Man and Artist*, New Haven and London: Yale University Press, 1987.

Index

EDITIONS CRÈS

Village d'Entreprises de St-Henri 2
Lot n°3 - 13016 Marseille
Site : www.editions-cres.com

Sponsored by

Designed by Jacques Baret

A catalogue record for this book is available from
The British Library.

Title page illustrations :
PORTRAIT DE L'ARTISTE À LA PALETTE (R670),
ca. 1886-87 (detail)
and *PAUL ALEXIS LISANT À EMILE ZOLA* (R151),
ca. 1869-70 (detail)

ISBN : 978-2-7537-0047-5